COLLECTOR'S ILLUSTRATED VINYL BIBLE Ⅱ

DISCOGRAPHY OF DECCA - LONDON RECORDS

黑膠唱片聖經

收藏圖鑑 Ⅱ 笛卡-倫敦 唱片

Alfred H.C. Wu

吳輝舟 編著

COLLECTOR'S ILLUSTRATED VINYL BIBLE II

黑膠唱片聖經
收藏圖鑑 II

作　　　者	吳輝舟（Alfred H.C. Wu）
編　　　輯	楊志雄
美 術 設 計	劉錦堂
發 行 人	程顯灝
總 編 輯	呂增娣
主　　　編	徐詩淵
資 深 編 輯	鄭婷尹
編　　　輯	吳嘉芬、林憶欣
編 輯 助 理	黃莛勻
美 術 主 編	劉錦堂
美 術 編 輯	曹文甄、黃珮瑜
行 銷 總 監	呂增慧
資 深 行 銷	謝儀方、吳孟蓉
發 行 部	侯莉莉
財 務 部	許麗娟、陳美齡
印 務	許丁財
出 版 者	四塊玉文創有限公司

總 代 理	三友圖書有限公司
地　　　址	106台北市安和路2段213號4樓
電　　　話	(02) 2377-4155
傳　　　真	(02) 2377-4355
E-mail	service@sanyau.com.tw
郵 政 劃 撥	05844889 三友圖書有限公司
總 經 銷	大和書報圖書股份有限公司
地　　　址	新北市新莊區五工五路2號
電　　　話	(02) 8990-2588
傳　　　真	(02) 2299-7900
製 版 印 刷	卡樂彩色製版印刷有限公司
初　　　版	2018年11月
定　　　價	新臺幣2000元
ISBN	978-957-8587-49-6（精裝）

http://www.ju-zi.com.tw

三友圖書
友直 友諒 友多聞

國家圖書館出版品預行編目(CIP)資料

黑膠唱片聖經收藏圖鑑. II：笛卡-倫敦 唱片
/ 吳輝舟作. -- 初版. -- 臺北市：四塊玉文創,
2018.11
　面；　公分
ISBN 978-957-8587-49-6 (精裝)

1.蒐藏品 2.唱片
999.2　　　　　　　　　　107019229

作者簡介

吳輝舟，華裔奧地利維也納人，1952年生於臺灣桃園，雙子座。

興趣與專長：

　　音樂、藝術、高爾夫、水肺潛水、斯諾克、美食、雪茄、品酒以及旅遊。經典的黑膠唱片收藏有，DECCA 和 LONDON 唱片出版的全部立體聲類比錄音；全套的 LYRITA 和 MERCURY 唱片的 SRCS 及 SR 系列版本；全部的 EVEREST 唱片採用 35mm 母帶的錄音以及 RCA 唱片 Living Stereo（LSC 和 LDS）系列，從編號 LSC 1806 到 LSC 3045，影子狗與白狗版本的錄音；另外未系列收藏的許多選擇性名家錄音約一萬多張。

簡歷：

1970 年新竹中學畢業，合唱團團員，受教於蘇森墉老師。

1974 年中國文化大學勞工系畢業，華岡合唱團團員兼助理指揮。

1976 年中國文化大學勞工系研究所

1977 年 9 月移居奧地利維也納

1978-1982 年就讀於維也納商業大學及維也納大學音樂學研究所，此間創辦旅奧同學會及臺灣留學生刊物《多瑙河》，負責散文及詩歌寫作，開始黑膠唱片的收藏。

1992 年擔任「維也納臺北室內樂團」團長，指揮家呂紹嘉為創辦人及音樂總監。

1999 年擔任旅奧中國人協會理事長

2011 年起擔任奧地利台商會會長

2015-16 年擔任歐洲台商會聯合總會總會長

2016 之後擔任歐洲台商會聯合總會名譽總會長

　　旅奧期間曾創辦奧地利綠茵高爾夫球隊，也曾經營開設維也納 147 斯諾克撞球俱樂部（147 Snooker Club）；Casa Bella 義大利餐館；東風、東來順、曰本燒烤餐廳及德語系美食雜誌列入 Haube 推薦的第一家中國餐廳 - 皇園餐廳。1988 年之前也從事維也納中文專業導遊工作，之後，為順應當時時局，開展了早期臺灣人赴東歐與俄羅斯的旅遊簽證管道，而成立了「東歐旅遊中心」，且開闢了之後的旅遊行程與觀光市場，直到現在發展為經營全歐精緻旅遊的「歐洲之星 DMC 旅遊目的地管理公司」並擔任總裁。

1.新聆聽室
2.全部 TAS HP 榜單的收藏
3.全部 Decca 及 London 唱片收藏
4.全部 Mercury 及 Everest 唱片收藏
5.全部 RCA 唱片及其它收藏

AUTHOR PROFILE

Alfred H.C. Wu
Born in Taoyuan, Taiwan in 1952, a Gemini, now lives in Vienna, Austria.

Interests and expertise: music, art, golf, scuba diving, snooker, gourmet food, cigars and wine tasting; senior tour guide with knowledge of history of multiple European destinations.

Collection of classical vinyl records: the complete analog stereo recordings from DECCA & LONDON RECORDS; the complete SRCS & SR Series from the LYRITA & MERCURY RECORDS; all the 35mm master tapes recordings of the EVEREST RECORDS and the complete RCA Living Stereo (LSC & LDS) Series from LSC 1806 to LSC 3045 (All Shaded dog & White dog labels).

In addition, the non-series collections from many selective famous recordings are

approximately 10,000 records in total.

Profile:

1967-1970 Hsin Chu Senior High school. A member of the chorus and studied under music professor Su Sen-yong.

1974 Graduated from the University of Chinese Culture, Department of Industry and Labor Relations. A member and assistant director of the college chorus, Hwa-Gang chorus.

1976 Graduate School of the University of Chinese Culture, Institute of Industry and Labor Relations

1977 Immigrated to Vienna, Austria.

1978-1982 Studied in Vienna University of Economics and in Vienna University Musicology Institute. Established the Taiwan Student Association and was one of the initiator of the student journal 〈Danube〉, started to write the prose and poetry, and to collect the vinyl records.

1992 Director of the Vienna Taipei Chamber Orchestra, the founder was the chief music director, Mr. Lü Shao-chia.

1999 President of Oversee Chinese Association in Austria.

2011 President of Taiwan Commerce Association in Austria.

2015-2016 President of The Council of Taiwanese Chambers of Commerce in Europe
From 2016 Honorary President of The Council of Taiwanese Chambers of Commerce in Europe

1982-2018 The founder of Austria Green Golf Club and opened a "147 Snooker Club" in Vienna. Used to be the owner of the Italian restaurant "Casa Bella"; Japanese grill restaurant; Chinese restaurant "Ostwind","New Ostwind" and the "Imperial Garden" with German gourmet magazine accreditation.

In order to accommodate the trend, established "East Europe Travel Service", acted as chairman, and became one of the pioneers for developing the tourism market of Taiwanese traveling to East Europe and Russia. Under the leadership with art-loving and enthusiasm, "EETS" is now an unique and exquisite Europe travel agent for all Asian Chinese.

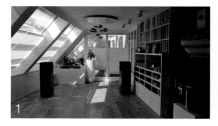

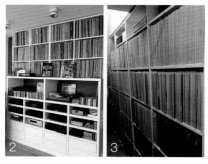

1. New Listening Room
2. Collections (All TAS HP's List)
3. Collections (All Decca & London Records)
4. Collections (All Mercury, Everest Records)
5. Collections (All RCA Records & others)

自序

「是你把理想當車馬炮　還是生活將你當兵卒」
「是鐘錶為時間把脈　還是時間為鐘錶算命」
收藏是生命中，愛心、耐心、期許與智慧，結下的愉悅果實！！

從我上一本書「 黑膠唱片聖經收藏圖鑑 」自序中的最後一句話，開始來談一談這一本書！

　　生活中的追求，充滿著感性與理性好惡的選擇，透過更多的知識與智慧的增長，我們才能將許多費心與期許的收藏，轉化成生命中永恆的愉悅！

　　在上一本收藏圖鑑中，我已介紹了許多上一世紀的收藏名盤，包括美國絕對音響雜誌（TAS）已故主編（哈利・皮爾森）多年來推薦的全部新舊發燒黑膠天碟榜單以及 TAS 雜誌的許多優良推薦、Sid Marks 專欄的優良評點，其中包含水星（M ERCURY）唱片的最佳 40 張音效名盤，另外一節附上 TAS 雜誌 Mark Lehman 及 Johnathan Valin 推薦的 20 世紀古典音樂 100 張最佳榜單，含黑膠唱片及 CD 的編號與圖鑑；在第三章中特別編列 James Mitchell 的書，「RCA 唱片之黃金年代」中最值得收藏的唱片；第四章則是大家熟知的英國留聲機雜誌古典百大唱片，含新舊榜單目錄，黑膠及 CD 的編號與圖鑑；最後第五、六章，附上最早採用 35mm 磁帶錄製唱片的 EVEREST 公司全部經典名盤以及筆者所收藏的全部立體聲版 DECCA-LYRITA 唱片的所有目錄與圖鑑。出版後，美國賓州的讀者 Gerry Cross 先生，花了兩年的時間，幫我找到了一張，在 TAS 榜單上很難買到的私人錄音唱片（Penn State Glee Club, AJC 8），讓我非常感動！另外，非常感謝音響論壇總編劉漢盛先生在他的雜誌第 288 期以及美國 Bruce Kinch 先生在他的 "Primyl Vinyl Exchange（PVX）Positive Feedback" 第 66 期中的推薦，還有荷蘭 Rudolf A. Bruil 在他的音樂網站 http://www.soundfountain.com 中熱心的評論，加上許多黑膠唱片收藏家的鼓勵，促使我更加用心的去編輯並完成此圖鑑！

　　唱片的收藏與個人的喜好和經驗有著相當的關係，音樂欣賞與生活美學也有著密不可分的關聯，經常在音響室裡面欣賞張張喜愛的唱片，美好的音樂帶領我們進入演奏現場的時空，這種音色美感的喜悅，促使我們不斷地去尋找更多的名盤，去收藏更多優秀的錄音！有時在陽台上，手提式舊唱機，播放一張 78 轉帶著雜音的義大利歌曲，古老的音色加上一杯小酒或咖啡，或有佳人作伴，一根蠟燭，一碟小點，這又是怎麼樣的一種情趣啊！ 同樣是音樂，一張古老唱片的錄音與一支手機上的 YouTube，是不能相提並論的。因此，主客觀的收藏美學，產生了很多追求的角度，有人喜歡古老的音色；有人要求亮麗的音效；有人只收藏稀有的錄音；也有少部分人只是收藏唱片封面的設計（特別是唱片封套改良的始祖 Alex Steinweiss，早期為 Columbia, Remington, Westminster, Everest, Decca 還有 London 等唱片公司，所設計的多采多姿的唱片封面），但是客觀來說，具有優良的錄音與製作，加上被行家公認為經典演奏的唱片，才是大家主要收藏的對象。

　　20 世紀 50 年代之前，許多有名的音樂與演奏家例如：卡魯索（Enrico Caruso），吉利（Benjamino Gigli），Albert Spalding, Ossy Renardy, 福特萬格勒（Wilhelm Furtwängler）， 老克萊巴（Erich

Kleiber），托斯卡尼尼（Arturo Toscanini）等人，因為在發行立體聲錄音唱片之前已過世，沒有留下能被現在 Hi-End 音響重現的美聲唱片，我們只能從 Columbia, Deutsche Grammophon, DECCA, LONDON, EMI, RCA, Remington 或 Westminster 等唱片公司，去尋找翻製較佳或者後期製作較好的單聲道錄音來收藏。

從 20 世紀 60 年代開始，立體聲錄音有著日新月異的發展，本圖鑑所編纂的英國 DECCA 唱片公司，是黑膠唱片黃金時期中世界三大音樂集團之一，因為擁有了比別人先進的 FFRR（全頻段錄音）技術和 Decca Tree 麥克風錄音系統，加上多位高水準的製作人以及優秀的錄音工程師，所以它發行的唱片，至今也還廣受收藏家的喜愛。

DECCA 在美國發行的唱片品牌叫 [LONDON]，從 1958 年出版立體聲唱片開始，都以 FFSS（全頻段的立體聲）作為商標特色來推廣市場，1964 年 LONDON 的 ED2 出版，有溝紋的內標改成小寫的 London ffrr, 中間 FULL FREQUENCY STEREO SOUND 字樣改成 STEROPHONIC 之後，FFSS 成為英國 DECCA 的商標，FFRR 則為美版 LONDON 的商標，最受歡迎的迪卡唱片立體聲系列，在英國發行的 DECCA SXL、SET 系列唱片與在美國發行的 LONDON CS、OS、OSA 系列唱片，大多是同樣的錄音製作，但是有多張錄製卻只在英國 DECCA 發行，同樣的情況，也有多張錄製也只在美國 LONDON 發行，加上他們有自己不同的系列編碼以及封面設計， 對於一般的收藏者來說，非常容易造成混淆，所以我們需要一個詳細正確的對照表。

感謝 Phil Rees 在他的 "Audiophile Record Collector's Handbook" 中，有非常詳細的介紹，在許多唱片網站如 Discogs 也有許多資料，可惜都有些不完全；在 Robert Moon 和 Michael Gray 的 "Full Frequency Stereophonic Sound" 一書中，也只是整理到早期的發行，筆者未能找到詳細的一本 DECCA 或 LONDON 的唱片分類目錄。因此，我將所有的收藏整理並且參考其它資料，編輯這本對照圖鑑，也在 Remark & Rating 中標註版本資訊及一些重要的評價，讀者可以從系列資料中，查出版年份與版本先後，避免混淆與錯誤。

例如：卡欽（Julius Katchen）錄製的布拉姆斯鋼琴作品 1-8 全集，SXL 系列編號為 SXL 6105, 6118, 6129, 6160, 6217, 6219, 6218, 6228；而 LONDON CS 系列對等編號為 CS 6396, 6404, 6410, 6444, 6473, 6477, 6474, 6482，我的收藏以 DECCA 系列為主，少了一張 SXL 6218 (Volume 7)，因為許多資料都介紹 LONDON CS 6158 的對等編號在 DECCA 為 SXL 6218，而我已經有了此張 1960 年出版的唱片 LONDON CS 6158 首版，就沒有去買 DECCA SXL 6218，其實這張並非同樣的錄音（CS 6158 無 SXL 的發行，參見本書），DECCA SXL 6218 的 LONDON 首版是 ED2 的 CS 6474, 威爾金森 (Kenneth Wilkinson) 在 1962 年的錄音，1965 年出版，我在編寫此書時才發現，十年後才再補買上此張布拉姆斯鋼琴作品 Volume 7 的唱片。

因為篇幅有限，筆者只能整理從 1958 年到 1983 年間，與上述系列有關的所有類比錄音對照資料，依系列編號順序編輯，上冊是 DECCA 對照 LONDON 唱片，下冊則是 LONDON 對照 DECCA 唱片。另外也將德國 Speakers Corner 唱片公司，後來陸續復刻的多張唱片，在原始序號後加上星號來表示，以便讀者參考，其中若有遺誤，還望讀者不吝指正。

收藏本書中 DECCA 及 LONDON 全部的唱片，所有的音樂錄音（除了莎士比亞戲劇及語音的錄音之外），費時 15 年，需要用心地去尋找其中稀有的唱片，例如非常稀有的 DECCA SXL 2100 德國音樂家 Kurt Leimer 的 "Piano Concerto No.4"，十多年來在 Ebay 網站上只出現兩三次，我是很辛苦地在柏林的一家唱片行找到，DECCA SXL 6078，奧地利鋼琴家 Herbert Halm 的 "After The Opera"，一張不起眼的唱片卻也難找，一開始我只買到單聲道的錄音，後來卻在韓國網站找到，只好托韓國朋友買，再寄回奧地利，DECCA SXL 6031 瑞典管風琴家 Åke Levén 的 "Organ recital"，德國壓片在瑞典發行，也是最後在英國的 Ebay 上買到，目前只剩一張唱片未能尋獲，是西班牙哥倫比亞公司採用笛卡的錄音設備錄製的唱片，由 Ataulfo Argenta 指揮 Tomás Bretón 的西班牙輕歌劇，LONDON 唱片 OSA 1102，此張唱片只在美國 LONDON 唱片公司發行，非常稀有，我只好去買西班牙哥倫比亞公司出版的唱片，可惜封套上只有西班牙文，無英文解說。因為 DECCA SXL 2000 系列的 BB 首版，價格昂貴也比較稀有，同樣的錄音，我的收藏一開始則以 LONDON BB 首版為優先，之後則交差選購，最近幾年也加購二、三十張德國 Speakers Corner 復刻的版本，非常感謝英國 Classicalvinyl 公司 Dave Parsons 先生，幫忙提供此書中 DECCA SXL 2000 系列中我缺少的封面照片，他也提供所有英國哥倫比亞公司 SAX 2000 系列以及 EMI ASD xxx 系列的封面照片，可是非常抱歉與遺憾，我沒有時間能夠完成所答應的圖鑑編纂。特別感謝我的妻子張春娟女士對編纂此書的支持，我的家人吳向穎先生與林佩霈女士的英文翻譯與校訂！同樣的情況，筆者也曾計劃將我所 RCA 唱片的收藏，立體聲系列從 LSC 1806 到 LSC 3050 的所有影子狗版及白狗版（包括 LDS 系列），另外加上 VICS 系列的對照，編纂圖鑑與讀者分享，然而精力實在有限，希望以後的生活有著更多的空間，能讓這些理想來幫我的時間把脈！

 吳輝舟 Alfred Wu

Vienna, 2017

PREFACE

"Are you wielding your dreams to fight for you, or has life pegged you as its pawn?"

"Is the clock keeping track of Time? Or is Time dictating the clock's fate?"

A collection is the delightful fruit of labor from a life filled with love, patience, hope, and wisdom!

From the last sentence of my book [Illustrated Collector's Discography], let us continue the conversation in this book!

The journey of life is filled with emotional and ethical choices, and only through our personal growths in experience and knowledge, that we are able to transform our collectibles into a continuous source of joy in life!

In my previous book, I've introduced many of the last century's collections, including the old and new Super Disc List by the late TAS's editor Harry Pearson, the 40 best sound quality recordings from MERCURY by Sid Marks, the 100 Best-of-Century Classical Compositions by Mark Lehman and Jonathan Valin from the magazine 'The Absolute Sound (TAS)'.

In Chapter III, I put together the most collectible records of "Golden Era of RCA".Chapter IV is the well-known Gramophone Top 100 Greatest Classical Recordings of All Time. The complete old & new list, vinyl and CD numbering, and illustrations are included. Last but not least, Chapter V and VI include a list and illustrations of all the 35mm film recordings produced by EVEREST between 1958 and 1960, as well as all the stereo pressing of LYRITA records I have collected.

After the book was published, Gerry Cross, a reader in Pennsylvania, USA, spent two years helping me find a Penn State Glee Club (AJC 8) which was hard-to-find on the TAS list. I was really touched! In addition, I am grateful to Mr. Jack (Hansheng) Liu, Editor-in-Chief of Audio Art magazine, for his magazine number 288, the recommendation of Mr. Bruce Kinch in his Primyl Vinyl Exchange (PVX) Positive Feedback 66, and the Dutch Rudolf A. Bruil in his enthusiastic comments from the music website http://www.soundfountain.com; coupled with the encouragement of many vinyl record collectors, had collectively motivated me to edit and complete this book.

A collection of records is closely related to personal preference and experience. Music appreciation and lifestyle choices are also very closely related. Often, enjoying music through my high-fidelity system feels like transferring myself to the place recorded as if I was sitting right in front of the performer. This kind of beauty and joy brings me to continue to find more quality vinyl and to collect more excellent recordings! Sometimes sitting on the balcony with an old gramophone playing an Italian song with a little distorted 78rpm record with wine or coffee and good company, along with a candle and a small dish, can make the most enjoyable pastime! Music played from an ancient record recording cannot be compared with that from a mobile phone on Youtube. There is a subjective aesthetics to sound from recordings resulting in a lot of pursuit of perspective. Some people like the ancient tone; some people require the beautiful bright sound; some collect only rare recordings. Others only collect record cover designs (especially those early variety of designs from the ancestor of record cover modification Alex Steinweiss for labels like Columbia, Remington, Westminster, Everest, Decca, and London). Objectively speaking, a record with excellent recording and production, accompanied with recognition by experts, is the main reason a record will become a collector's piece.

Before the 1950s, many famous musicians and performers such as Enrico Caruso, Beniamino Gigli, Albert Spalding, Ossy Renardy, Wilhelm Furtwängler, Erich Kleiber, and Arturo Toscanini have passed away before the release of the stereo recordings and did not leave the acoustic records that could now be reproduced by the Hi-End sound. One can only find better produced mono recordings or better-replicated copies by Columbia, Deutsche Grammophon, DECCA, LONDON, EMI, RCA, Remington or Westminster to collect.

Since the 1960s, stereo recording had developed rapidly. The British DECCA Record Company, illustrated in this book, was one of the three largest music groups in the world during the golden age of vinyl because of its advanced FFRR (Full Frequency Range Recording) technology and Decca Tree Microphone Recording System, plus a number of high-profile producers and excellent recording engineers, the recordings it had released are still popular with collectors.

DECCA issued in the United States were under the brand called "LONDON". Beginning from 1958, Stereo Records all had "FFSS" (Full Frequency Stereo Sound) on the label as a trademark feature to promote in the market. In 1964 LONDON ED2 started publishing their inner labels under the new brand "London ffrr" and changed the middle of the label from "FULL FREQUENCY STEREO SOUND" to "STEROPHONIC". FFSS became a trademark only for the United Kingdom DECCA. The most popular Decca album stereo series, DECCA SXL & SET issued in the United Kingdom and the LONDON CS, OS, OSA issued in the United States are mostly the same recording

production, but many recordings were only released through the United Kingdom DECCA, others were only issued through the United States LONDON. Plus, they have their own different series of coding and cover designs, which can be very confusing for the average collector. A detailed equivalent index is needed to understand the differences.

I am grateful for all the sources like Phil Rees who has a very detailed description of records in his "Audiophile Record Collector's Handbook". There is also a wealth of information to be found on websites like "Discogs", but unfortunately, those are mostly incomplete. Another great source for me was Robert Moon and Michael Gray's "Full Frequency Stereophonic Sound", they cataloged the early distributions or records, but I could not find a detailed and complete catalog of DECCA or LONDON's albums. Therefore, I have organized my collections with the help of all the references made above, and my own sources to complete this book.

I have compiled this book with pictures and noted some important comments in the Remark & Rating section. The readers can find out the year and version of the publication from the discography and avoid confusion and mistakes.

An example of how easily a mix-up can occur is demonstrated below. The complete works of Brahms Piano Works Volume 1-8 by Julius Katchen have the following series number for DECCA: SXL 6105, 6118, 6129, 6160, 6217, 6219, 6218, 6228; the same recordings for the LONDON CS series are CS 6396, 6404, 6410, 6444, 6473, 6477, 6474, 6482. The information I received at the time of writing this book was that for the DECCA record SXL 6218 (Volume 7) has the equivalent number of LONDON CS 6158. Since I already had the first edition of the 1960 record LONDON CS 6158, I did not buy the DECCA SXL 6218 version since they are essentially the same. As it turns out this information was wrong and the equivalent number of DECCA SXL 6218 for LONDON was CS 6474 of ED2, recorded by Kenneth Wilkinson in 1962 and published in 1965, CS 6158 was an early recording from Katchen and was never issued in the SXL series, which meant that my collection was incomplete and I had to then purchase the missing record.

Because of publishing constraints, I can only organize all the analog recording data related to the above series from 1958 to 1983, edited in serial numbers; the first volume is DECCA compared to LONDON, the second volume is LONDON compared to DECCA. The records which were reissued by German Speakers Corner record company have added asterisks after the serial numbers and are also listed for the reader's reference. If any errors were made in any of the chapters, I hope the readers would contact me and correct my mistakes.

Hunting down the whole collection of DECCA and LONDON recordings in this book, excluding the spoken words collection by Shakespeare's plays and voice recordings, took me 15 years. Many rare recordings, such as the very rare DECCA SXL 2100 German musician Kurt Leimer's "Piano Concerto No.4" were very hard to find and had appeared on eBay for only two or three times in in the last decade. Luckily, I came across it in a record shop in Berlin after searching everywhere. DECCA SXL 6078 "After The Opera" by The Austrian pianist Herbert Halm, an obscure record, was nowhere to be found and I initially only bought the mono recording. Later I found it on a Korean website and had to ask friends from South Korea to buy and send it to Austria for me. DECCA SXL 6031 Swedish organ "Organ Recital" by Åke Levén, pressed in Germany and released in Sweden, was at last acquired through ebay in the UK. As of now only one record is missing, recorded by a Colombian company using a recording device made from DECCA, the Spanish operetta by Tomás Breton conducted by Ataulfo Argenta, with the series number of LONDON OSA 1102, and was only distributed in the United States. Unable to find this rare record, I had to buy the Spanish Columbia publishing company version, but unfortunately the sleeves were written in Spanish and has no English explanation.

Due to the DECCA SXL 2000 series Blue BB first edition being very expensive and relatively rare, I prioritized purchasing the same recordings from LONDON BB first edition in order to finish my collection. Later I started purchasing from both Labels in random selections. In recent years I've also added 20 to 30 records by Speaker Corner who reprinted some of the DECCA records from this series. A special thanks to Dave Parsons from the British records shop Classicalvinyl for helping to provide the missing cover images of the DECCA SXL 2000 series in this book. He also provided covers of all British Columbia SAX 2000 series and EMI ASD xxx series in order for me to compile a collection, but regretfully, I did not have the time to complete the compilation as promised.

Special thanks to my wife, Jenny Wu, for her continuous support on my books; and to my son Ying Wu, and niece Pei Pei Lin, for translating and correcting the English text.

I had also planned to include my whole RCA record collection, stereo series from LSC 1806 to LSC 3050 (and LDS series), all the shadow dog version and the white dog version, along with the comparisons of the VICS series, and compiled them into illustrated guides to share with my readers. However, my energy is limited, and I hope that in the future I would be able to find more time to finish all of my goals!

 吳輝舟 **Alfred Wu**

Vienna, 2017

推薦序

　　我不知道吳輝舟是如何把這本「黑膠唱片聖經收藏圖鑑 II 笛卡 - 倫敦 唱片」寫完的？對於我而言，這根本是不可能的任務。如果您看過這本書，就會知道這是一本非常難寫的書。說「寫」其實是不精確的，這本書的重點不在於以鍵盤敲出多少個字，而是在於如何去全世界搜尋到這麼完整的唱片版本，並且要花多少時間去整理，編輯。如果這本「黑膠唱片聖經收藏圖鑑 II 笛卡 - 倫敦 唱片」的稿費是以字數來計算，那麼吳輝舟肯定拿不了多少稿費，因為字數不多。但是，如果要以收集這些唱片的苦心來計費，那麼這本書的稿費不是出版社能夠付得起的。是的，雖然這本書有標價，但是對於廣大黑膠迷而言，這本書是無價之寶。

　　1981 年，當 CD 推出，大家看到小小一片光碟竟然能夠儲存六、七十分鐘的音樂，而且播放的過程簡單，CD 又不需要保養，這個世界簡直瘋了。大家紛紛拋棄手中的黑膠唱片，轉而擁抱 CD。到了 1990 年，基本上 CD 已經完全佔有音樂軟體市場，黑膠被大量的拋售，黑膠迷只能躲在幽暗的角落點著蠟燭孤芳自賞。

　　說「孤芳自賞」是寫情寫景的，在那個 CD 鋪天蓋地的時代，僅剩少數黑膠迷緊抱著自己的黑膠唱片死也不放。黑膠唱片的紙質封套散發出一股淡淡的紙味，完全有別於 CD 的塑膠味。而黑膠迷也只能自己躲在家裡一遍又一遍的播放這些已經被歸類於「過去式」的唱片，其心中的孤獨可想而知。

　　不知道什麼時候開始，愈來愈多人開始討論數位錄音的短處，相對照之下，也重新挖掘出黑膠唱片的長處，音響迷開始覺醒，在雜誌的推波助瀾之下，加入挖掘黑膠寶藏的人愈來愈多。拜網路之賜，二手黑膠唱片的交易開始慢慢熱絡起來，原本一張 1 美元、2 美元一大堆隨人撿的二手唱片開始標價 10 美元、20 美元。過了幾年，又翻數倍成 100 美元、200 美元。有些被雜誌媒體貼上發燒標籤的黑膠唱片或稀有版本甚至標價 1,000 美元、2,000 美元或更高。黑膠唱片的價值終於第一次被彰顯。用「第一次」並沒有說錯，當年黑膠時代，唱片行中所賣每張唱片的身價都是一樣的，今天黑膠唱片的價格能夠賣得那麼高，絕對是第一次。

　　到底黑膠唱片有什麼價值？第一、擁護黑膠的類比派音響迷認為黑膠唱片的音響效果不是數位錄音能夠比得上的，而且這些黑膠的錄音時期正是唱片公司的黃金時期，也是音響工業的黃金時期，這段黃金時期已經逝去，不可能再複製。第二、現在已經證明 CD 光碟在經過 20 年、30 年之後，內部鍍層是有可能氧化的，一旦鍍層氧化，這張 CD 就毀了，無法復原。反而，黑膠唱片如果能夠保持平整，若不發黴，

可以保存上百年不會損壞，後代只要有黑膠播放唱盤與唱針，永遠可以重播這些隱藏在細微溝紋裡的音樂。第三、第一次出版的黑膠唱片 (ED1) 數量原本就不多，再經過幾十年的歲月淘洗，能夠留下來的更是稀少。物以稀為貴，這些稀少的 ED1 首版黑膠唱片就成了收藏的標的，而且價格愈來愈高。

既然 ED1 黑膠唱片那麼珍貴，而且又四散在全世界眾多黑膠唱片收藏家手中，生得也晚的後輩黑膠迷哪有機會窺得全貌？為了幫助黑膠迷搜尋方便，英文世界中早已經有相關的 Handbook，而中文世界雖然已經有很多散見於雜誌、網路的相關文章，但一直沒有完整的整合性著作，一直到吳輝舟出現。

吳輝舟，台灣人，文化大學畢業，1977 年與同是文大的太太張春娟（吳輝舟曾任合唱團指揮，太太曾任國樂團指揮）來到維也納唸音樂，先後唸過維也納商業大學與維也納大學音樂研究所，不過因故沒有完成學業，夫妻倆反倒在維也納開起餐廳、旅行社、擔任過奧地利台商會長、歐洲台灣商會聯合總會長等。收藏黑膠唱片逾萬張，並編成「黑膠唱片聖經收藏圖鑑」一書。我跟吳輝舟的關係始於「黑膠唱片聖經收藏圖鑑」。

幾年前，有一天我突然接到一通電話，電話那頭是吳輝舟的太太張春娟，問我是否有興趣出版他先生吳輝舟花了幾年時間編寫的一本有關黑膠唱片收藏的書。當時普洛文化早就停止音樂書籍的出版，所以我告訴她，這本書找專業的圖書出版公司合作會更有效，這是我第一次聽到吳輝舟的名字。為何張春娟會找上我要出版這本書呢？二個原因，第一個原因是吳輝舟起心動念寫這本書的源頭是普洛文化那本幾乎音響迷人手一本的「唱片聖經」。第二個原因是當時還在功學社音響部任職的音響界美魔女王雪真經理的推薦，王雪真與他們夫妻都是文大校友，也是合唱團前後期團友，吳輝舟夫婦回台時都還會聚會。

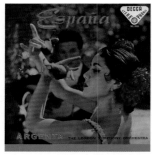

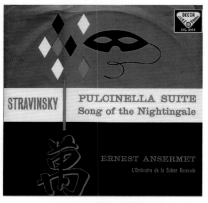

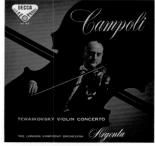

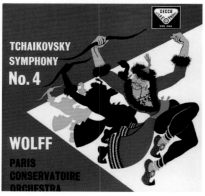

又過了一、二年吧？有一天我收到一本厚重的書，那本書就是「黑膠唱片聖經收藏圖鑑」。趁著吳輝舟回台期間，我聯絡上他，請他吃飯見面，這是我們第一次接觸，那時我才知道原來他跟我是新竹中學的校友，我們相差一年。不過，我們的音樂老師同樣都是蘇森墉，當年新竹中學的王牌音樂老師，帶領新竹中學連續九年獲得高中合唱冠軍，從這裡我們產生更進一步的聯繫。吳輝舟從高中就喜歡合唱，大學唸的雖然不是音樂系，但仍然持續加入合唱團，也曾擔任文大的合唱團指揮。而太太張春娟在文大唸國樂，主修琵琶，也曾指揮文大國樂團。二人就是因為音樂而結縭，大學畢業後相偕來維也納想要進修音樂，沒想到陰錯陽差，竟然在維也納創出一番事業，他們夫妻倆開過幾家餐廳、撞球俱樂部、導遊、旅行社，最終所經營的歐洲之星旅行社 Europe Express Travel Service 成為歐洲精緻旅遊的頭牌。而太太張春娟則是最大的功臣，在這個行業中，沒有人不認識她。

吳輝舟告訴我，他從學生時代就喜歡音樂，參加合唱團讓他對音樂有更深入的認識。1977 年與太太張春娟來到維也納時，雖然是窮學生，但仍然沒有停止對唱片的熱愛。他回憶當時只能在維也納國家歌劇院後面的二手唱片行中買便宜唱片，還有看無數的經典電影，買唱片、看電影這二項嗜好一直到今天都沒有降溫。他說 Netflix 的影片都快被他看完了，而對於唱片的收集更是不遺餘力，只要有缺的黑膠唱片，想盡辦法一定要收藏到手。

早期吳輝舟買黑膠唱片並沒有特別的目的，只是單純地聽音樂而已。有一次他回台，買到我剛出版的「唱片聖經」，看到我在內容中留下搜尋無著的空白，瞬間點燃他心中熊熊烈火，他興起要把這些空白填滿的想法，於是從那時開始，有系統的搜尋「唱片聖經」榜單中的黑膠唱片，這已經是二十幾年前的事情了。從 TAS 榜單、企鵝三星帶花、RCA LSC Living Stereo 唱片、Mercury 錄音、Everest 唱片、Decca、London、EMI、Lyrita、Westminster 唱片等等，有系統的收集名版。至今，TAS 榜單甚至更新到 2017 年版，不過他說自從 TAS 的創辦人 HP 上天堂後，榜單上有些唱片不對他的音樂胃口，所以也不是張張都收。目前，吳輝舟說他大概擁有超過一萬張黑膠唱片，其中放在「黑膠唱片聖經收藏圖鑑」中的大約二、三千張，在「黑膠唱片聖經收藏圖鑑 II（笛卡 - 倫敦唱片）」及「黑膠唱片聖經收藏圖鑑 III（倫敦 - 笛卡唱片）」兩集中，每本各有一千五百多張。

這兩本「黑膠唱片聖經收藏圖鑑 II（笛卡 - 倫敦唱片）」及「黑膠唱片聖經收藏圖鑑 III（倫敦 - 笛卡唱片）」可說是「黑膠唱片聖經收藏圖鑑」的第二集及第三集，內容主要是將英國 DECCA 與美國 LONDON 唱片的封面、編號並列對照，並且還有詳細曲目，參考價格以及相關註記。能夠把這些音響迷追逐搜尋的黑膠唱片名版收集得那麼齊全，吳輝舟所下的苦功真的可以用鐵杵磨成繡花針來形容。對於想要收藏 DECCA、LONDON 黑膠唱片的人而言，這本書是可以信賴的工具書，也是無價之寶。

劉漢盛

音響論壇、新視聽雜誌總編輯

前言 | 英國 DECCA 與美國 LONDON 唱片

● 英國迪卡唱片-DECCA RECORDS

迪卡（DECCA）唱片公司1929年在英國成立，[DECCA] 的名字如何產生，眾說紛紜，可能由「Dulcet - 美妙的聲音」及「Mecca - 聖地（麥加）」兩字組成。DECCA 唱片公司，因為在五、六十年代擁有了比別人先進、嶄新的 "FFRR - Full Frequency Range Recording"（全頻段音）技術，加上為了錄製大型樂團演奏，研發出的 Decca Tree 麥克風錄音系統，能製作比其它公司更清晰、更具高傳真音效的唱片，所以在 1958 年開始出版立體聲唱片時，以 "FFSS"（Full Frequency Stereo Sound），「全頻段的立體聲」 作為市場的商標特色而成名。DECCA 公司，除了擁有強大陣容的一流演奏家之外，所製作的許多傳世名盤，應該歸功於他的傑出製作人約翰·卡肖（John Culshaw, 1924-1980），以及 DECCA 的錄音大師威爾金森（Kenneth Wilkinson, 1912-2004）。約翰·卡肖在 1958 年開始改良歌劇錄音的製作，追求具有動態的舞台音場，花了七八年的時間與 Georg Solti 以及維也納愛樂管弦樂團合作，在維也納錄製了 DECCA 公司成名之作，全套華格納的歌劇 [尼伯龍根的指環]，威爾金森在 DECCA 以及幫 RCA 在英國製作的許多錄音中，都有極佳的定位、平衡度和實體感，並且具有動態與深度感，廣受專家及發燒友的讚許！其他 Decca 公司有名的製作人與錄音師還有：Arthur Haddy; James Walker; Roy Wallace; Peter Andry; James Brown; Gordon Parry; Alan Reeve; Ken Cress; James Lock; Arthur Lilley; Colin Moorfoot; John Dunkerley; Michael Mailes; Simon Eadon; Stanley Goodal; Phillip Wade; Tryggvi Triggvason; Martin Atkinson; John Pellowe 及 Cyril Windebank 等人，在本書圖鑑中，筆者除了將威爾金森的錄音特別註明之外，也盡力將其他錄音師列出，並編輯索引，供讀者參考。

在黑膠唱片的黃金時代，DECCA 古典音樂唱片的主要出版，分早期 SXL 2000（1958-1962）系列和 1962 年之後的 SXL 6000 系列，套裝版則是 1960 年開始出版的 SET 系列。它們的版本一般以大、小 DECCA（Wide Band & Narrow Band）兩種內標，以及內標有否溝紋（Groove）來判斷出版的先後，所有系列編號先後的順序，並不代表出版時間的先後，有些編號在前，卻在後來才出版，DECCA 唱片的製作年份，都打印在商標，但是發行版本的辨識，還需要從其它方面來鑑定（早期在英國出版的 LONDON 唱片，都未打印製作及出版年份）。1958 到 1959 年，DECCA 早期發行的唱片封套，首版片有藍框封背 (Blue Border Back, ED1-BB)，但是到了 1959 年，系列號 SXL 2115 之後，內標一樣是 ED1 的首版片，則沒有了藍框封背，所以這八十多版有藍框封背，代表一定是首版的唱片，以及英國 DECCA SXL 系列，沒在美國 LONDON 唱片發行過的多張稀有唱片，成為許多收藏家爭購的對象，價格特別昂貴！

DECCA 以及 LONDON 唱片，因版本的不同，價差甚大，其中因素並非在音效的優劣，而是在收藏的難易，雖然在 1968 年後的刻片與錄音技術，比早期第一版時期進步很多，唱片品質以及音效也好了很多，在 Arthur Salvatore 的網站上，以經驗與知識來探討許多有關 DECCA FFSS 與 FFrr 的差異，肯定了在唱片製作的歷史過程中，科技的發展對音效改良的認知，非常的有意義，然而對於喜愛首版的收藏家來說，歷史與時空交錯的美惑，就如同收藏郵票的首日封以及珍貴古玩一樣，也有著追求另外一種價值的樂趣！

　　DECCA 公司唱片的發行，除了 SXL、SET，（BB、Dxxx 及數位錄音的 SXDL）主要系列之外，還有錄製 20 世紀前衛音樂，品質非常良好的幾張 HEAD 系列和收錄輕古典、輕歌劇的 SKL 系列，另外幾種不同商標的重要出版，如：Argo、Lyrita、L'Oiseau-Lyre 等，第一版的發行，也需看商標以及是否有無溝紋等，來判斷出版的先後，品質也都非常好。

　　DECCA 的平價立體聲再版系列，以 Ace of Diamond（編號開頭為 SDD）及 Eclipse（編號開頭為 ECS）二種，最受人喜歡，在美國發行的再版片則 LONDON Treasury 系列，開頭以 STS 編號。

　　DECCA 唱片公司在 1980 年被寶麗金唱片集團（PolyGram）收購，後來該集團在 1998 年又與環球音樂公司合併為環球音樂集團（Universal Music Group - UMG），因此現在歸屬於全球最大的環球音樂集團 UMG 下。

　　許多 DECCA 黃金時代的類比錄音，目前德國 Speakers Corner 唱片，復刻了 SXL 2000 系列 50 多張；SXL 6000 系列 20 多張；6 套 SET 及 BB 系列；還有 3 張 LONDON 唱片（序號 CS 6013、CS 6126、CS 6139，沒在 DECCA SXL 系列中發行過），本書也都以序號後加星號註明，市場上陸續出版了許多 CD，有 DECCA 的「傳奇再現」（Legends）系列，有唱片「三星帶花」的名盤等，都可在本書黑膠唱片圖鑑的目錄上找到出處。所以，英國 DECCA SXL 系列，沒有在美國 LONDON 唱片發行過，或者沒有被復刻再版的多張稀有唱片，特別是首版有藍框封背的，成為收藏家爭購的對象，價格特別昂貴！

◉ 美國倫敦唱片 - LONDON RECORDS

　　英國 DECCA 公司除了版權以及美國市場的開發，在美國發行的唱片品牌叫倫敦 [LONDON]，它出版的 LONDON CS、CSA 器樂系列及 OS、OSA 聲樂系列，其實就是有名的 DECCA SXL 及 SET 系列的美國版。倫敦唱片主要系列唱片，器樂編號 CS 6000 系列，聲樂 OS 開頭的系列，（CSA 及 OSA 為

盒裝系列），OS 系列以黑色內標取代 CS 系列的紅色內標。

　　版本的辨別與 DECCA 類似，一般以大、小 LONDON（Wide Band & Narrow Band）兩種內標，以及內標有否溝紋（Groove）來判斷出版先後，若是藍色封背（Blue Back）則是最早的首版片，從 1958 到 1963 年，倫敦唱片的大 LONDON 第一版（ED1-BB），都有藍色封背或藍色字封背，同樣也受到收藏家的垂青，但是價格與英國的 DECCA 卻有天壤之別，原因很多，當然與市場的喜好度以及發行量有關。

　　LONDON 系列與 DECCA 系列，它們的壓模、鋼模編號是一樣的，不是重新刻製的，除了各自擁有不同出版系列的唱片編號之外，它們最大的不同，主要是 LONDON 有不一樣的唱片內標和全部在美國設計製作的封面，另外就是英美聽眾對唱片使用與保存習慣的不同，因此在美國購買的二手唱片，若非全新或較新一點，大體上雜音都會比歐洲多一些！另外，還有多張美國發行的 LONDON 唱片，未曾在英國 DECCA 的 SXL 系列中發行過，也是大家收藏的對象。（版本請參照本書商標圖鑑的說明）。

　　大 LONDON 唱片，序號從 CS 6001 到 CS 6366 的首版（即 1958 到 1963 年的第一版），都有藍色封背或藍色字封背 [除了 CS 6333, 6334 及 6335, 三張非常稀有，若依據出版年份應該是 ED1 的時期，但是卻見不到 ED1-BB, ED2 版應該是首版]。1964 年之後，有幾張大 LONDON ED1 首版，沒有了藍色封背，應該是 1963 年製作在 1964 年才出版，序號從 CS 6367 到 CS 6378 的 ED1 首版，只有一張 CS 6368 有藍色封背，其它幾張都是白色封背，最後一張有藍色封背唱片的序號是 CS 6379。

　　LONDON 唱片在 1964 年，從序號 CS 6379 之後，第一版則改為有溝紋內標的 ED2 小 LONDON 版，Logo 不用 FFSS，改成 *LONDON ffrr*，Logo 下面列印小字體的 *FULL FREQUENCY RANGE RECORDING*，原來在商標中間的 "FULL FREQUENCY STEREO SOUND" 字樣改成 "STEROPHONIC"，但是此間在英國出版的同一 DECCA SXL 系列版本，並未改內標，還是採用 ED1, FFSS 版（一直到 1965-66 年才換成 ED2 版），之後的 ED2, ED3, ED4 & ED5，原來的 FFSS - FULL FREQUENCY STEREO SOUND 為英國 DECCA 的商標，而 LONDON ffrr - STEROPHONIC 則成為美版 LONDON 的商標（請參照本書商標圖鑑）。

註：LONDON CSA及 OSA套裝唱片編號說明

DECCA SET套裝系列編號，非常容易了解其中的唱片張數，例如：SET 227為一張，SET 228-9為兩張，SET 312-6為五張，非常清楚。
但是LONDON CSA（器樂）及OSA（聲樂）兩種盒裝系列，無論是四個或五個數字編號，都需看第二個數字，來代表張數，例如：CSA 2101, OSA 1154為一張，CSA 2201, OSA 1255為兩張，CSA 2403, OSA 1431為4張，依此類推。

*** LONDON CSA Series Number: CSA 22xx = 2LP-SET; CSA 23xx = 3LP-SET; CSA 24xx = 4LP-SET; CSA 25xx = 5LP-SET
*** LONDON OSA Series Number: OSA 11xx = 1LP-SET; OSA 12xx & 12xxx = 2LP-SET; OSA 13xx & 13xxx = 3LP-SET; OSA 14xx = 4LP-SET; OSA 15xx = 5LP-SET; OSA 16xx = 6LP-SET

INTRODUCTION

DECCA & LONDON RECORDS

● DECCA RECORDS

DECCA Records was founded in the United Kingdom in 1929. The origin of the name "DECCA" had many different theories, one of the theories was that it's a combination of the words "Dulcet - Wonderful Voice" and "Mecca - a sacred site". DECCA Records, who owned the newest "FFRR - Full Frequency Range Recording" technology in the 1950s and 1960s as well as the Decca Tree microphone recording system which was developed to record large orchestras, had produced clearer and more high-definition soundtracks than any other company. When it came to publishing stereos in 1958, it featured "FFSS" (Full Frequency Stereo Sound) as a trademark in the market and became famous.

DECCA, in addition to having a solid line-up of top performers, also produced many of the best-known records due to their distinguished producer John Culshaw (1924-1980) and DECCA's recording master Kenneth Wilkinson (1912-2004). In 1958, John Culshaw started to revise the production of opera recordings, pursuing a dynamic stage sound. He spent seven to eight years in cooperation with Georg Solti and the Vienna Philharmonic Orchestra, recording one of DECCA's most famous piece in Vienna, Wagner's Opera "The Ring of Nibelungen". Wilkinson's recordings, in DECCA and many other recordings that RCA had produced in the UK, possesses excellent character, clear positioning, balance, solidity (dynamic with deep stage), and a dynamic sense of depth that is widely recognized by experts and enthusiasts.

Other famous Decca producers and sound engineers include: Arthur Haddy; James Walker; Roy Wallace; Peter Andry; James Brown; Gordon Parry; Alan Reeve; Ken Cress; James Lock; Arthur Lilley; Colin Moorfoot; John Dunkerley; Michael Mailes; Simon Eadon; Stanley Goodal; Phillip Wade; Tryggvi Triggvason; Martin Atkinson; John Pellowe and Cyril Windebank. In this book I have also made the effort to list other recording artists and index them for the readers' reference, in addition to annotating Wilkinson's recordings.

During the golden era of records, DECCA's classical music records could be categorized as the early SXL 2000 (1958-1962) series and the SXL 6000 series that came after 1962; the boxed collection "SET" series started in 1960. Through the two different types of DECCA labels (Wide Band & Narrow Band), as well as if the labels consist of "groove" , we can determine the versions in which the records were published. some records that were issued earlier numbers were published later. Therefore, although DECCA printed the production dates on its trademarks, other details need to be in consideration in order to further determine the correct publishing year/edition. (None of the early editions of the LONDON records in the UK have production dates or publishing years on them).

Thus, these eighty or so DECCA first edition records that have the The earlier records and sleeves published by DECCA from 1958 to 1959 consist of blue border backs for its first editions (ED1-BB), but after the series SXL 2115 in 1959, though the inner labels would note the first editions, they no longer have the blue border backs. Thus, these eighty or so DECCA first edition records that have the blue border backs, and the British DECCA SXL series that had not been published by the American LONDON Records, are extremely rare, and are the most extravagant in price from being highly sought after by collectors and enthusiasts.

The price gaps between DECCA and LONDON records can be huge based on the different editions, and they mostly depend on the availability of the records as suppose to the quality of the sound; however, due to the advancement of technology, recordings after 1968 were more developed with better sound and better record quality. On the site of Arthur Salvatore, he discussed the differences between DECCA FFSS and *LONDON ffrr* based on his knowledge and personal experiences, which also further illustrated the role of sound technology development in the history of record producing and provided some interesting insights. But for collectors keen on first editions, the beauty is the same fascination of owning a time capsule, much similar to collecting first edition stamps and rare antiques, and the unique satisfaction it provides.

Aside from the main series of SXL, SET (BB, Dxxx & digital series SXDL), DECCA also

recorded contemporary music from the 20th century, the high-quality HEAD series, and the SKL series that included compilations of light classical and light opera. The first editions of other important publishing from brands such as: Argo, Lyrita, and L'Oiseau-Lyre, etc, also need to rely on the details of its trademarks and groove patterns to determine the sequence of the publishing and are all great in quality.

Ace of Diamond (beginning with SDD) and Eclipse (beginning with ECS) are the two most popular series in the DECCA affordable stereo-sonic reprint collection. The version released in the United States was the LONDON Treasury reprint series, beginning with STS as the serial number.

DECCA was acquired by PolyGram in 1980 and later merged with Universal Music in 1998 to become one of the world's largest music corporations, the Universal Music Group (UMG). This book has added asterisks after the serial numbers to the records that were reissued from the German Speakers Corner Records of the SXL 2000 series of 50-plus pieces; 20-plus pieces of the SXL 6000 series; 6 sets of SET and BB series, and the three pieces in the DECCA SXL series that had not been released, the LONDON CS 6013, CS 6126 and CS 6139. You can also find the sources to the many CD's that were published after, including the DECCA "Legends series" and the albums "Penguin 3 star with Rosette", in the catalog section of this book.

● LONDON RECORDS

Due to copyright issues and to further expand the American market, the British DECCA released records in the U.S. under the label of "LONDON". The LONDON CS, CSA instrumental series, and the OS, OSA vocal series, are actually the American version of the famous DECCA SXL and SET series. The main series from the LONDON are the instrumental CS 6000 series,

the OS series that opens with vocals, (the CSA and OSA are box sets), and the OS series with black inner labels that replaced the inner red labels of the CS series.

The method to distinguish the different editions is similar to that of the DECCA records; mostly based on the two different types of LONDON labels (Wide Band & Narrow Band) and using the groove pattern presented-or not-on the inner label to determine the version of the publishing. The earliest editions are the ones with blue backs; the first editions (ED1-BB) published during 1958 to 1963 from the LONDON all consist of the blue color back or blue prints on the back, and they are also favored by collectors, however, based on the market demands and volume that were published, the prices are much cheaper than the British DECCA versions.

The stamper and matrix numbers are the same for the LONDON and DECCA series and not remastered, aside from having different publishing serial numbers, the main difference between them is that the LONDON designed all their record covers in the U.S. and has different inner labels. It is also noted that since the listening habits and collecting methods are different amongst the British and American audiences, the second-hand records acquired in the U.S. generally would have more noise in the sound quality, unless they are kept in brand-new or moderately-used condition. Furthermore, the records published from the American LONDON label that had not been released through the British DECCA SXL series, are also very popular with the collectors (Please refer to the book's logo descriptions for the various versions).

First editions from the LONDON with serial numbers starting from CS 6001 to CS 6366 (first editions from 1958 to 1963), all have blue color backs or blue prints on the backs (CS 6333, 6334, and 6335 are the three rare exceptions; according to the publishing years they should be in the era of ED1, however ED2 might have been their first editions since there were no ED1-BB). After 1964, there were some first editions from the LONDON ED1 that were produced in 1963 but published in 1964, and thus do not have the blue backs. Out of the first ED1 editions with serial numbers starting from CS 6367 to CS 6378, only CS 6368 has a blue back, all

others have white backs; the serial numbers to the last record published with a blue back is CS 6379.

After 1964 and starting from after CS 6379, the LONDON changed their first editions to having the ED2 (Narrow Band with the groove on the inner labels), the logo is changed from FFSS to *LONDON ffrr*, and the fine print *"FULL FREQUENCY RANGE RECORDING"* was added under the logo; the "FULL FREQUENCY STEREO SOUND" that was in the middle of the trademark was also changed to "STEREOPHONIC".

However, the same series that got published in the U.K. as the DECCA SXL, do not have the change in the inner labels, and have the ED1, FFSS version (The change to ED2 happened between 1965-66 instead). For the ED2, ED3, ED4, and ED5 that followed, the original "FFSS-FULL FREQUENCY STEREO SOUND" remained the trademark for the British DECCA, and *"LONDON ffrr* – STEREOPHONIC" became the trademark for the American LONDON (Please refer to the book's label descriptions).

*** Note: Instructions for the serial numbers of the LONDON CSA and OSA

It is easy to determine the number of records in each DECCA SET based on its serial numbers. Ex. SET 227 is a single, SET 228-9 has two pieces, and SET 312-6 has five pieces.

With the LONDON CSA (instrumental) and OSA (vocal) box sets, no matter if they are 4-digits serial numbers or 5-digit serial numbers, the second number determines the number of records in the set. Ex. CSA 2101, OSA 1154 each have singles, CSA 2201, OSA 1255 each have two pieces, and CSA 2403, OSA 1431 each have four pieces.

* LONDON CSA Series Number: CSA 22xx = 2LP-SET; CSA 23xx = 3LP-SET; CSA 24xx = 4LP-SET; CSA 25xx = 5LP-SET
* LONDON OSA Series Number: OSA 11xx = 1LP-SET; OSA 12xx & 12xxx = 2LP-SET; OSA 13xx & 13xxx = 3LP-SET; OSA 14xx = 4LP-SET; OSA 15xx = 5LP-SET; OSA 16xx = 6LP-SET

目錄

CONTENTS

ABBREVIATIONS 英文縮寫

Asterisk after the series number, e.g. Decca SXL 2001 or London CS 6013*

 Means: it was reissued by Speakers Corner.

* [序號後加星號，表示有 Speakers Corner 的復刻片，如 Decca SXL 2001* 或 London CS 6013*]

() after the series number, e.g. Decca SXL 2153 (SXL 2107-8, ©=SDD 257)

 Means: SXL 2153 (is one of the SXL 2107-8, ©= the equivalent reissue)

() 在序號後的括號，如 Decca SXL 2153 （SXL 2107-8, ©=SDD 257）

 表示：SXL 2153 （是 SXL2107-8 中的一張，©= 相同錄音的再版編號）

℗1958 © 1959; @1958 = Produced in 1958, released in 1959; @ =1958 Edition （1958 年版）

℗ & © symbols are not copy right, ℗= produced or producer; © = copy, released year

AS List = Arthur Salvatore Supreme LP Recordings List (from www.high-endaudio.com)

 AS-DIV = The Divinity List (finest sounding records)

 AS-DG = The Demi-Gods List

 AS List = The Basic List

 AS List-H = The Honorable Mentions

 AS List-F = His Favorite Recordings (not considers the sonics)

BB = Blue Border or Blue Back Cover （中文請參照本書前言中，唱片內標與版本）

ED1 = 1st Label

 DECCA: Wide Band Grooved (WBG), rim text "Original Recording By.." at 10 o'clock

 LONDON: FFSS, Wide Band Grooved (WBG)

ED2 = 2nd Label

 DECCA: Wide Band Grooved (WBG), rim text "Made in England" at 10 o'clock

 LONDON: *ffrr*, Grooved, rim text "Made in England" at 11 o'clock

ED3 = 3rd Label

 DECCA: Wide Band Non-Grooved (WB), rim text "Made in England" at 10 o'clock

 LONDON: *ffrr,* Non-Grooved, rim text "Made in England" at 11 o'clock

ED4 = 4th Label

 DECCA: Narrow Band (NB), "Made in England"

 LONDON: *ffrr,* "Made in England" at left above the STEREOPHONIC

ED5 = 5th Label

 DECCA: Dutch Narrow Band (NB), "Made in Holland" at bottom rim

 LONDON: *ffrr,* "Made in Holland" at bottom rim

G. Top 100 = The British Gramophone Magazine TOP 100

 [留聲機雜誌百大古典唱片]

Japan 300 = Best 300 CD & LP [Japan - Ongaku No Tomo (Ontomo Mook) 1984-2011]

 [日本音樂之友社出版的定期刊物 - 唱片藝術（レコード芸術）（Record Geijutsu），
 針對古典樂最基本的 300 個曲目（後來有陸續擴充），選出最受好評的版本，稱之為唱
 片藝術 - 名曲名盤 300]

Penguin = [The Penguin Stereo Record Guide ℗1975 ©1977; ℗ ©1982; ℗ ©1984]

Penguin ★★★ ❀ = The Penguin Guide 3 star rating with Rosette（企鵝三星帶花）

 (❀ Rosettes indicate that they are of extra special quality)

Penguin ★★★ = The Penguin Guide 3 star rating (outstanding performance and recording)

Penguin ★★（★）= Brackets round one or more of the star indicate some reservations

 about its inclusion & readers are advised to refer to the text.

RM = Robert Moon's "Full Frequency Stereophonic Sound", ratings for Early London/
Decca Classical Recordings – Performance Rating (1-10) +Sound Rating (1-10) = Maximum
rating is RM 20

Robert Moon 在他的 "FFSS" 一書中，對早期 London/Decca 唱片的評價， 演出（1-10 分）+ 音效
（1-10 分），最高 RM 20 分。

TASEC = TAS Editor's Choice (Harry Pearson – HP's List 2014)

 [TAS 主編哈利 · 皮爾森（HP）2014 年的榜單]

TASEC ✷✷ = Best of the Bunch [TAS 主編哈利 · 皮爾森的 12 張發燒天碟榜單]

TAS-OLD = HP's Old List [TAS 主編哈利 · 皮爾森的舊榜單]

TAS2016 & TAS2017 = TAS Super LP List 2016 & 2017, by Jonathan Valin

TAS SM 67-138++, (SM = Ratings from Sid Marks) [TAS 雜誌 Sid Marks 的正面評價]

TAS 65-176++ = TAS issue 65, page 176 [即 TAS 第 65 期，176 頁]

TAS xx /xxx+, ++, +++ = (+, ++ & +++) indicate the TAS degree of praise

[代表 TAS 雜誌正面評價的多寡]

$ & $+	= Reference Price from 15-30 & 30-50 Usd
$$ & $$+	= Reference Price from 50-75 & 75-100 Usd
$$$ & $$$+	= Reference Price from 100-170 & 170-200 Usd
$$$$	= Reference Price from 200-300 Usd
$$$$$	= Reference Price from 300 Usd & Very expensive

There are more and more vinyl collectors, so the prices is climbing every year. Prices also depend on the different conditions and pressings of the records. Some are higher because they are newer; some are lower because they are older or simply came from good luck of online bidding.

The prices are only for readers' reference. [價格只是作為讀者的參考]

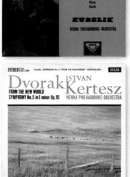
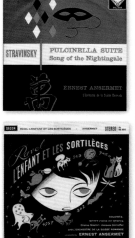
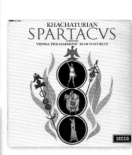
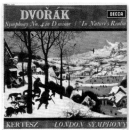

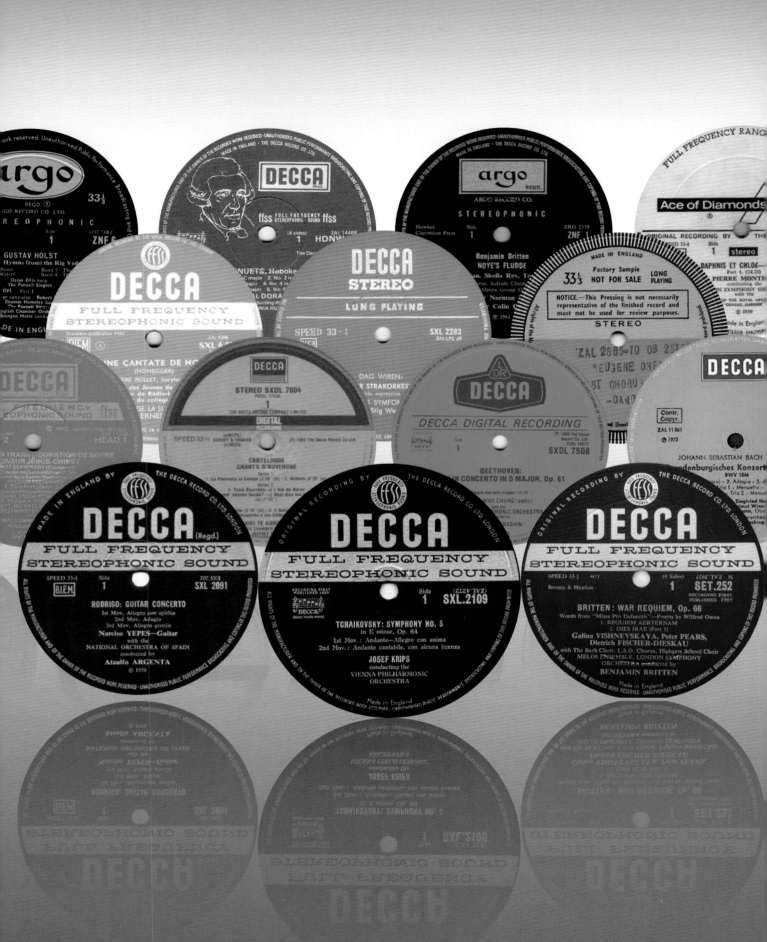

DECCA RECORDS
封面與內標

根據查證，只有極少數LONDON的古典音樂唱片是在美國製作，所有刻片、壓片及商標全都是在英國製作，出口到美國後，只在美國裝上LONDON的封面

　　DECCA 唱片以及 LONDON 早期 ED1 的內標都以 FFSS Logo 發行，LONDON 唱片在 1964 年，從序號 CS 6379 之後，第一版則改為有溝紋內標的 ED2 小 LONDON 版，Logo 不用 FFSS，改成 *LONDON ffrr* Logo，下面列印了小字體的 *FULL FREQUENCY RANGE RECORDING*，原來商標中間大寫的 FULL FREQUENCY STEREO SOUND 字樣改成 STEROPHONIC，但是此間在英國出版的同一 DECCA SXL 系列版本，並未改內標，還是採用 ED1, FFSS 版（一直到 1965-66 年才換成 ED2 版），所以之後發行的 ED2, ED3, ED4 & ED5 版本，原來的 [FFSS - FULL FREQUENCY STEREO SOUND] 成為英國 DECCA 的商標，[*LONDON ffrr* - STEROPHONIC] 則為美版 LONDON 的商標，純粹是市場推廣因素，並非兩種不一樣的錄音技術。

　　DECCA 古典音樂唱片的主要出版，分早期 SXL 2000（1958-1962）和 SXL 6000（1962 年之後）系列，套裝版則是 1960 年開始出版的 SET 系列，所有系列編號先後的順序，並不代表出版時間的先後，有些編號在前，卻在後來才出版。從 1958 到 1959 年，DECCA 早期發行的唱片 SXL 2001-2115 的封套，首版片有藍框封背（Blue Border Back ED1），但是到了 1959 年，系列號 SXL 2116 之後，唱片內標一樣是 ED1 的首版片，則沒有了藍框封背，因此之前有藍框封背的 ED1，更代表是首版的發行。內標版本一般分大、小 DECCA (Wide Band & Narrow Band) 兩種，DECCA 唱片的製作年份，都打印在商標，但是早期在美國出版的 LONDON 唱片，都未打印製作及出版年份。所以發行版本的辨識，需要從其它方面來鑑定，除了封面商標與封背外，還需看內標有否溝紋（Groove），也需看內標外圍 Dead Wax 地區中，鋼模、鋼印的編號與代碼，來判斷出版的先後。

　　DECCA 以及 LONDON 唱片，因版本的不同，價差甚大，一併附上古典音樂版的主要商標圖片，以便開始收藏唱片的朋友作為參考。

Cover & Logo 封套與商標

 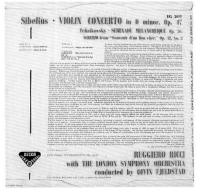

Blue Border Back（首版藍框封背）及Blue Text Sleeve（首版藍字封背），序號SXL 2001-2115

DECCA（ED1, 早期版）　　　　DECCA （ED1, 後期版）

封面商標1958-1962（SXL 2000 series）

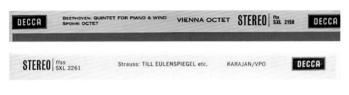

封面商標 1962年之後（SXL 6000 series & SET series）

Decca 唱片的版本

ED1 = 第一版本, 從 1958 年到 1966 年

大 DECCA（WBG），離內標外圍 15mm 有溝槽，Original Recording by the Decca co. ltd. London 在內標外圍 10 點鐘方向

ED2 = 第二版本, 從 1964 年到 1968 年

大 DECCA（WBG），離內標外圍 15mm 有溝槽，"Made in England" 在內標外圍 10 點鐘方向

ED3 = 第三版本, 從 1968 年到 1970 年

大 DECCA（WB），內標內無溝槽，"Made in England" 在內標外圍 10 點鐘方向

ED4 = 第四版本, 從 1970 年到 1980 年

小 DECCA（NB），較小的 DECCA 字樣在銀色長方形框內，其左上角有 "Made in England" 字樣

ED5 = 第五版本, 從 1980 年開始，在荷蘭壓片，內標 6 點鐘下緣有 "Made in Holland" 字樣

註：從1968年開始，ED3和ED4之後的唱片製作，採用更好品質的Vinyl原料，加上使用了新進的刻片設備，更能承現母帶中所錄製的甜美高頻，明顯地改良了音效的品質。

所有系列編號先後的順序，並不代表出版時間的先後，有些編號在前，卻在後來才出版。

　　ED1 從 1958 到 1966 年都有首版，而 ED2 從 1964 到 1968 年也有首版，因此在 1964 到 1966 年間，有哪些 ED2 版是首版，哪些是原 ED1 的再版，最難分辨，容易造成混淆，本書依序號編輯，對此間發行的 ED2 首版也都加以註明（詳情請參考本書）。

　　所有的 SXL 2000 系列唱片，只有一張 SXL 2306 的 ED2 是首版，它在 1966 年才發行，在 SXL 6000 系列中，最後一張依序號出現的 ED1 是 SXL 6248，它在 1966 年出版之後〔筆者發現有兩張 SXL 6336 及 SXL 6363，在 1968 年（ED2 版的最後一年），不知為何還用 ED1 商標出版〕。

● DECCA SXL 2000系列（首版發行的商標）

ED1 (BB) 首版：從 1958 發行到 1959 年，SXL 2001 到 SXL 2115

ED1 首版：從 1959 到 1962 年，SXL 2115 到 SXL 2316（只有一張 SXL 2306 的 ED2 是首版）

● DECCA SXL 6000 系列（首版發行的商標）

ED1 首版：從 1962 到 1964 年， SXL 6000 到 SXL 6119

ED1 及 ED2 首版：從 1964 到 1966 年，SXL 6120 到 SXL 6248（詳情請參照本書）

ED2 首版：從 1966 到 1968 年，SXL 6249 到 SXL 6371，此間所發行的 ED2 都是首版，只有兩張 SXL 6336 及 SXL 6363(ED1 是首版) 另外兩張 SXL 6339 及 SXL 6355 沒有 ED2（ED3 是首版）。

ED3 首版：從 1968 到 1970 年，SXL 6372 到 SXL 6441，只有一張 SXL 6376 ED2 才是首版，另外一張 SXL 6435（ED4 是首版）。

ED4 首版：從 1970 到 1980 年，SXL 6442 到 SXL 69xx，只有一張 SXL 6448 ED3 才是首版。

ED5 首版：在荷蘭壓片，序號從 SXL 69xx 開始。（詳情參照本書內容）

DECCA 唱片的母版、鋼模、鋼印編碼

　　筆者在上一本書，黑膠唱片聖經收藏圖鑑上，特別地介紹了 MERCURY 唱片以及 RCA 唱片，內標邊緣鋼模刻印中編號與代碼的意義，每一家唱片公司都會有自己的代號與編碼，工程師在刻片後會在鋼模上留下記錄，尤其是母帶編號、刻片師名稱代碼、母版、鋼模及鋼印編號、甚至有壓片工廠的代碼等等的製作資訊，這些編碼就位於黑膠唱片上，在商標外圍的無痕溝槽內，藉由反射光可清楚地看到，它們能幫助大家去查明壓片紀錄與版本，這些資訊，對於講究收藏的人都非常重要。

◉ 從母帶到壓片鋼模製作的流程

1. 從母帶刻製母帶膠盤（Lacquer Master），每張脆弱的母帶製版膠盤，只能翻製一片原版金屬鋼模（Metal Master）

2. 一片原版金屬鋼模（Metal Master），可翻製數個金屬母版（Metal Mother）

3. 每片金屬母版（Metal Mother），可翻製數個金屬母版鋼模（Metal Mother Stampers）

4. 一片金屬母版鋼模（Metal Mother Stamper)，可翻製數個壓片鋼印（Master Lacquer Stamper）

5. 每張壓片鋼印（Master Lacquer Stamper 或 Lacquer Matrix Stamper），可壓製約 2000 張唱片，直到鋼印損壞為止。

◉ 內標左側九點鐘方位──金屬母版（Metal Mother）的編號

　　在內標左側九點鐘方位，藉由反射光隱約可看到 1, 2 等數字，是金屬母版的編號，它是由原版金屬鋼模翻製而成，用來製作金屬母鋼模，數字愈小代表版本愈早。

◉ 內標右側三點鐘方位──金屬母鋼模（Metal Mother Stamper）的英文字母代碼

　　在內標左側三點鐘方位，藉由反射光隱約可看到如 B 或 U 等英文字母，是金屬母版鋼模的字母編號，Decca 用白金漢 "BUCKINGHAM" 一字的字母，來代替 1 到 10 的數字。

　　1=B, 2=U, 3=C, 4=K, 5=I, 6=N, 7=G, 8=H, 9=A, 10=M, 11=BB, 18=BH, 21=UB, 等

　　B 代表由金屬母版翻製出的第一個金屬母版鋼模，U 則是第二個，依此類推，BG 則為第 27

註解：[理論上來説，有著 Metal Mother number 1 和 Metal Mother Stamper 字母 B 的唱片，代表是最早製作的第一版本，應該有著最佳音效，但是假若它是在即將更換新鋼模前，由第一版的舊鋼模，最後所壓製成的，就不能保證完全如此]

◉ 在內標六點鐘方位下面的鋼模刻印代號

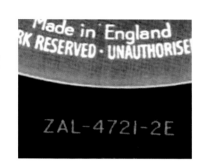

在內標六點鐘方位下面可清楚地看到，代表母帶的編號以及壓片鋼印編號的刻印，

例如：Decca SXL 2199

第一面刻著：ZAL-4721-2E, 第二面刻著：ZAL-4722-1E

ZAL（XZAL）代表立體聲錄音，ARL（XARL）則是單聲道錄音

數字 4721 及 4722 是 Decca（London）的母帶編號

數字 2E 的 2 及 1E 的 1， 代表壓片鋼印的編號

字母 2E 的 E 及 1E 的 E，是刻片工程師名稱的代碼

這些代碼在早期的 ED1 內標上，也倒印在序列編號的上方

註解：*[數字愈小代表版本愈早，版本愈早音效愈好，所以這個代碼，備受收藏者關注。但是有些唱片因銷售量少，沒有重新翻製或更換新鋼模，之後再版的唱片，還是用第一版的舊鋼模來壓製，音效就不能保證較佳。換句話說，有著1E-1E代碼的第一版，但是不幸是由老舊的鋼模壓製出來的唱片，它的音效，不一定會比第二或第三版鋼模先壓出來的唱片好。]

◉ DECCA有許多刻片工程師，他們的名稱代碼如下：

List of Decca Engineers from 1957 to 1972:

A= Guy Fletcher. B= Ronald Mason. C= Trevor Fletcher. D= Jack Law.

E= Stanley Goodall. F= Cyril Windebank. G= Ted Burket, K= Tony Hawkins.

L= George Bettyes. W= Harry Fisher.

註解：*[在Decca SXL 2000 系列中，刻片較多的工程師是 E、D、K；在Decca SXL 6000 系列中，刻製較多的工程師是 E、G、L和 W 。我也盡力將這些鋼模刻印代號，標註在本書的 Remark 欄中]

● 內標上方十二點鐘方位——稅號代碼（Tax Code）

早期 Decca 的唱片，在內標上有打印英國官方在 1973 年之前，決定貨物稅率的稅號代碼，這些代碼，對於 Decca 唱片收藏者並不是很重要，因為 Decca 唱片，在商標上都有印上生產的年份（但是沒有標示出版的日期）， 早期的 ED1 版本，在內標內 9 點鐘的方位，靠近溝紋的地方，印著 "Recording First Published ℗19xx"，後來更改為只有 ℗19xx，在 ED2 之後，改印在內標內 6 點鐘的方位，生產及發行的年份（℗19xx ©19xx）也有印在封背上。這些稅號代碼，只是表示產品打稅的年份，並非壓片或發行的日期，但是它們還是能夠幫助我們，去了解 60 年代早期，唱片發行的大約年份，尤其是 London 唱片，早期的發行，在商標以及藍色封背上都沒有標示生產與發行的年份，倫敦唱片在 1962 年，從系列編號 CS 62xx 開始，才在封背上標示發行年份，在 1972 年間，從系列編號 CS 67xx 開始，才將生產年份印在內標上。

稅號代碼大約年份如下：

CT - from 1948（1948-1958）

RT - from 1955（1958-1959）

ET - from 1959（1959-1961）

OT - from 1961

ZT - from 1962

MT - from 1963（1962-1963）

KT - from 1963（* Some earlier productions also embossed with KT?）

JT - 1968 - 1973,（Ed2, ED3, ED4）

　　1973 年 4 月 1 號以後就沒有稅號代碼

DECCA RECORDS
COVER & LABEL

According to my research in this subject matter, I am convinced that the Decca and London Records were pressed from the same Masters in the UK. Only few of them were made after 1970 from the USA. The same Decca pressings with London's label were produced in the UK and later exported to the USA. London Records only provided their own designed covers & inner sleeves. In the following section I will provide the reasons behind my conviction.

From 1958 "FFSS" was the same Logo on the label for all the early Decca & London's ED1 issues. During 1964 London Records changed the label design from the "FFSS" logo to "*LONDON ffrr*". There was a new slogan below the logo in small fonts "*FULL FREQUENCY RANGE RECORDING*" and in the middle of the label "FULL FREQUENCY STEREO SOUND" was changed to "STEREOPHONIC". This was the beginning of the so-called "ED2" of the London Records. In the meantime, the same UK Decca issues still used the ED1 FFSS label until 1966.

After the release of London ED2, the logo [FFSS - FULL FREQUENCY STEREO SOUND] became the trade mark of UK-DECCA and the logo [*LONDON ffrr* - STEREOPHONIC] became the trademark for the London Records. The main reason for this had to be the consideration of the new promotion in the USA market. As a matter of fact, the records are from the same productions.

The main series of the classical music category from Decca Records were the early released SXL 2000 series (1958-1962), SXL 6000 series (after 1962) & SET series (from 1960). The order of the series numbers do not signify the order of the year of publication. Some LPs with earlier series numbers were published later.

The early first pressing of the Decca Records have the Blue Border back cover. Only those are considered the first issue of ED1 label (ED1, BB), published from 1958 to 1959, SXL 2001 to SXL 2115. No Blue Border back covers were issued after SXL 2116 for the ED1, 1st label. In order to identify the record versions, we also need to recognize other details of each record, especially on the inner labels and the matrix numbers which are embossed in the dead wax area.

Prices for Decca & London Records vary because of the conditions, but they also greatly depend on the pressings and versions.

Cover & Logo

Blue Border Back (ED1, 1st) &
Blue Text Sleeve (ED1, 1st),
DECCA Series SXL 2001-2115

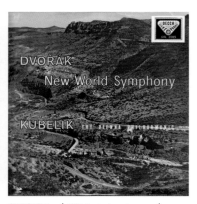

DECCA（ED1, early issue）　　　　DECCA （ED1, later issue）

Cover Logo 1958-1962（SXL 2000 series）

Cover Logo after 1962（SXL 6000 series & SET series）

Label & Version

ED1 = First Label, from 1958 to 1966

 Wide Band Grooved (WBG), rim text "Original Recording by the Decca co. ltd." at 10 o'clock

ED2 = 2nd Label, from 1964 to 1968

 Wide Band Grooved (WBG), rim text "Made in England" at 10 o'clock

ED3 = 3rd Label, from 1968 to 1970

 Wide Band Non-Grooved (WB), rim text "Made in England" at 10 o'clock

ED4 = 4th Label, from 1970 to 1980

 Narrow Band (NB), "Made in England"

ED5 = 5th Label, from 1980, pressing in Holland.

 Dutch Narrow Band (NB), "Made in Holland" at bottom rim

*Note: ED3 & ED4 pressings made after 1968 were made with the superior cutting heads and mastering amplifiers which could reveal the sweet high frequencies on the original tape & improved the acoustic quality.

Useful information about the labels & versions for the Vinyl collectors & sellers:

⬤ DECCA SXL 2000 series (1st label)

ED1, 1st (BB): 1958-1959, SXL 2001 to SXL 2115

ED1, 1st: 1959-1962, SXL 2115 to SXL 2316, except SXL 2306, ED2 is the 1st label

⬤ DECCA SXL 6000 series (1st label)

ED1, 1st: 1962-1964, SXL 6000 to SXL 6119

ED1, 1st & ED2, 1st: 1964-1966, SXL 6120 to SXL 6248. ED1 labels were issued until 1966, but ED2 label appeared from 1964, there are about 48 ED2, 1st label issued from1964 to 1966. It caused confusion to verify which ED2 label is a first issue & which one is a reissue from the ED1 (details see the book)

ED2, 1st: 1966-1968, SXL 6249 to SXL 6371, except SXL 6336 & SXL 6363 (ED1, 1st); SXL 6339 & SXL 6355 (ED3, 1st)

ED3, 1st: 1968-1970, SXL 6372 to SXL 6441, except SXL 6376 (ED2, 1st) & SXL 6435 ED4, 1st)

ED4, 1st: 1970-1980, SXL 6442 to SXL 69xx, except SXL 6448 (ED3, 1st)

ED5, 1st: 1980-, From SXL 69xx

The Matrix Numbers (Embossed in the dead wax area)

In my previous book (Collector's Illustrated Vinyle Bible), I have introduced the meaning of different matrix codes which are embossed in the dead wax area from the MERCURY & RCA Records. In Addition to the identification of Vinyl Label & Cover, there is some interesting & important information for the Decca (London) vinyl collectors about the Matrix numbers on the off grooved area. They can help us identify the vinyl pressing & the edition. It is quite important to know these matrix codes for the advanced vinyl collectors.

⦿ Production from Master Tape to Master Lacquer

Master Tape - Cutting the Lacquer Master - One soft Lacquer Master could produce only one Metal Master Several Metal Mothers were made from this Metal Master Each Metal Mother could produce several Metal Mother Stampers A Metal Mother Stamper could produce several Master Lacquer (Lacquer Matrix) Stampers A Master Lacquer (Lacquer Matrix) Stamper could produce about 2000 discs before it had to be replaced.

⦿ Metal Mother Number - at 9 o'clock position left side label

There is a number engraved like "1" or "2". This is the Metal Mother number made from the Metal Master. The lower the number on the label, the earlier the Metal Mother was used for the record.

⦿ Metal Mother Stamper Letter - at 3 o'clock position right side label

There is a letter engraved like "B" or "U". That is the code of the Metal Stamper number.

Decca used the word "B U C K I N G H A M" to represent the numbers 1 through 10 for the Stamper. (First Stamper from the Metal Mother is B)

1=B, 2=U, 3=C, 4=K, 5=I, 6=N, 7=G, 8=H, 9=A, 10=M, 11=BB, 18=BH, 21=UB, etc.

If the letter code is BG means 17st Stamper

*[It is nice to have a record with Metal Mother number 1 & Stamper letter B (best sonic), but one cannot be sure that it has the best sound. For example, when the record was the last pressed before a change of stamper, then the sound was significantly affected]

⦿ Matrix Number - at 6 o'clock position below the label

This Matrix number, in the early issue (ED1) also printed upside-down above the series number on each side of the label, is the file number for the Master Tape & Lacquer Matrix used for this side.

For example: Decca SXL 2199

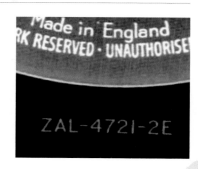

The matrix number engraved, side 1, **ZAL- 4721-2E**; Side 2, **ZAL-4722-1E**

ZAL (XZAL) means it is stereo. ARL (XARL) means it is mono issue

4721 or **4722** is Decca (or London) file number of the Master Tape used for this side.

1 or **2** is the running number of the Master Lacquer (Lacquer Matrix). The 1 of 1E means first master lacquer & 2 of 2E means third master lacquer made from that recording.

*[The lower the Matrix number the earlier the pressing was made (better sonic in earlier pressings), this is what many collectors are most concerned about. But for those LP sold in small numbers, there can be pressings for a long period with stampers originated from the same Mother and Matrix.]

● E is the code for Cutting Engineer

List of Decca Engineers from 1957 to 1972:

A= Guy Fletcher. B= Ronald Mason. C= Trevor Fletcher. D= Jack Law.

E= Stanley Goodall. F= Cyril Windebank. G= Ted Burket. K= Tony Hawkins.

L= George Bettyes. W= Harry Fisher.

*In the Decca classical music SXL 2000 series, most of the records cutted from engineer E, D & K & In the SXL 6000 series are from E, G, L & W. I have tried to put the Lacquer matrix & the code of the cutting engineers in the remarks of this Discography

● Tax Code - at 12 o'clock position above the label

Many early Decca records also have the Tax code on the label, this tax code is the official code used in UK before 1973 to determinate the sales tax %.

It is not so important for the Decca collector, because all the Decca records mentioned the production year on the label. In early ED1, issues printed "Recording First Published 19xx", at the 9 o'clock position inside the label near the groove. Afterwards Decca changed the text, printed only ℗19xx. After the ED2 issues the production year ℗19xx was printed at the 6 o'clock position inside the label. The release year (℗19xx ©19xx) is also mentioned in the back sleeve.

UK tax codes embossed in the label and / or in the matrix are indication of the tax year it was issued, but not a definite indicator of Release or Pressing Date. However, it is helpful for us to find the approximate Release or Pressing year for the early 60's London records, because there is neither any production or released year on the Label nor in the Blue-Back cover. The released year appeared on the back cover of London Records since 1962 from series no. CS 62xx & the production year was printed on the label during 1972 from CS 67xx.

Useful information for the Tax Codes:

CT - from 1948 (1948-1958) RT - from 1955 (1958-1959)

ET - from 1959 (1959-1961) OT - from 1961

ZT - from 1962 MT - from 1963 (1962-1963)

KT - from 1963 (* Some earlier productions also embossed with KT?)

JT - 1968 - 1973, (Ed2, ED3, ED4) No Tax Code were used after 01.04.1973

DECCA LABEL （唱片內標）

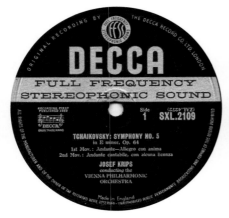

ED 1, Wide Band, Pancake

Deep groove 4-5mm near the outer edge of the label

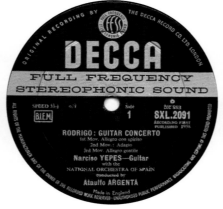

ED1,（WBG）"Original Recordings BY.."

Deep groove 15mm near the outer edge of the label

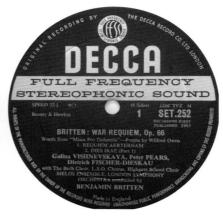

ED1,（WBG, "Original Recording By..")，SET Series

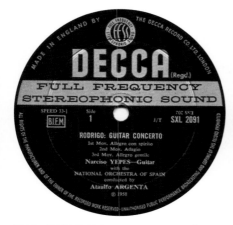

ED2,（WBG,"Made in England"）

Deep groove 15mm near the outer edge of the label

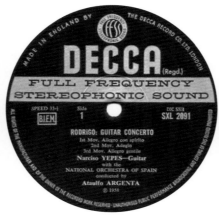

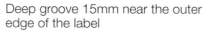

ED3,（WB,"Made in England"），No Groove

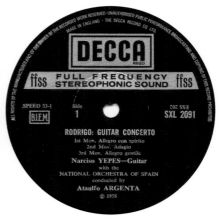

ED4,（NB,"Made in England"）

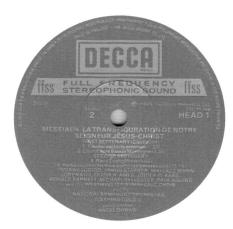

ED4,（NB, "Made in England"）,
HEAD Series

ED4,（NB, "Made in England"）, BB
Series

ED5, Dutch Narrow Band

ED5, Dutch Narrow Band,（Head
Series）

ED5, Dutch-Philips Label

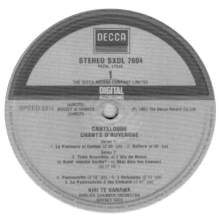

Dutch Digital Silver-Blue Label

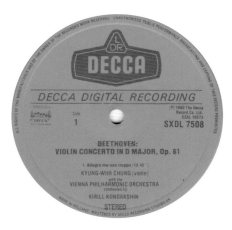

Dutch Digital Blue Label

German 1st, Balck-Gold Label

German Late issue Label

French Label

Australian Label

Swedish Label

White Promote Label

Test pressing Label

SKL Series Label

HDN Series Label

ARGO ZNF Series ED1, (Oval)

ARGO ZRG Series ED1, (Oval)

ARGO ZNF ED4,（Square）

ARGO ZRG ED4,（Square）

Ace of Diamond, Grooved Label

Ace of Diamond, Non-Grooved

LYRITA, Grooved Label

LYRITA, Non-Grooved Label

Decca eclipse Label - 1

Decca eclipse Label - 2

Decca eclipse Label - 3

SONATAS FOR SOLO VIOLIN
RUGGIERO RICCI

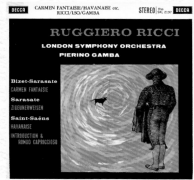

CARMEN FANTAISIE/HAVANAISE etc. RICCI/LSO/GAMBA · STEREO · DECCA

RUGGIERO RICCI
LONDON SYMPHONY ORCHESTRA
PIERINO GAMBA

Bizet-Sarasate
CARMEN FANTAISIE
Sarasate
ZIGEUNERWEISEN
Saint-Saëns
HAVANAISE
INTRODUCTION &
RONDO CAPRICCIOSO

SMETANA
MÁ VLAST

Vyšehrad
Vltava
Blaník

KUBELIK
VIENNA PHILHARMONIC ORCHESTRA

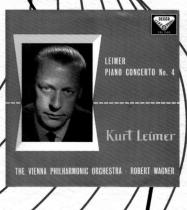

LEIMER
PIANO CONCERTO No. 4

Kurt Leimer

THE VIENNA PHILHARMONIC ORCHESTRA · ROBERT WAGNER

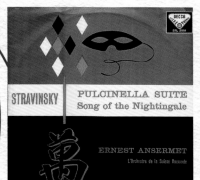

STRAVINSKY
PULCINELLA SUITE
Song of the Nightingale

ERNEST ANSERMET
L'Orchestre de la Suisse Romande

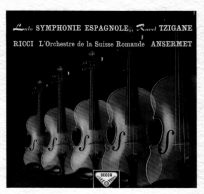

Lalo SYMPHONIE ESPAGNOLE · Ravel TZIGANE
RICCI L'Orchestre de la Suisse Romande ANSERMET

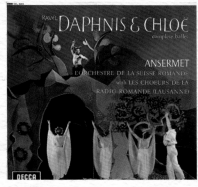

RAVEL
DAPHNIS & CHLOÉ
complete ballet

ANSERMET
L'ORCHESTRE DE LA SUISSE ROMANDE
with LES CHOEURS DE LA
RADIO ROMANDE (LAUSANNE)

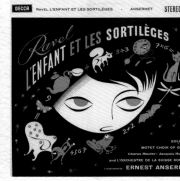

Ravel L'ENFANT ET LES SORTILÈGES · ANSERMET · STEREO

Ravel L'ENFANT ET LES SORTILÈGES

MOTET CHOIR OF GE
Chorus Master : Jacques Hor
and L'ORCHESTRE DE LA SUISSE ROM
conducted by ERNEST ANSERM

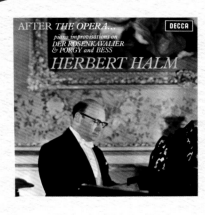

AFTER THE OPERA...
piano improvisations on
DER ROSENKAVALIER
& PORGY and BESS
HERBERT HALM

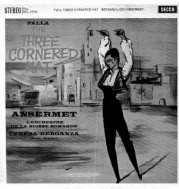

STEREO SXL 2296 · Falla: THREE CORNERED HAT · BERGANZA/OSR/ANSERMET · DECCA

FALLA
THE THREE CORNERED HAT

ANSERMET
L'ORCHESTRE
DE LA SUISSE ROMANDE
TERESA BERGANZA

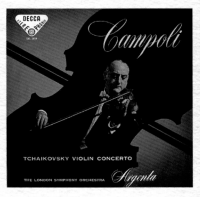

Campoli

TCHAIKOVSKY VIOLIN CONCERTO
THE LONDON SYMPHONY ORCHESTRA
Argenta

Kirsten Flagstad

Sibelius
SONG RECITAL

DECCA - LONDON（笛卡-倫敦）
黑膠唱片同樣錄音版本的目錄對照圖鑑

◉ [Decca — London唱片] 同樣錄音版本的對照圖鑑與索引

　　最受歡迎的笛卡唱片立體聲系列，在英國發行的 SXL、SET 系列唱片與在美國發行的 CS、OS、OSA 系列唱片，都是同樣的錄音，但是有多張錄製卻只在英國 DECCA 發行，同樣的情況，也有多張錄製只在美國 LONDON 發行，加上他們有自己不同的系列編碼以及封面設計，對於一般的收藏者來說，非常容易造成混淆，所以我們需要一個詳細正確的對照表。許多有關 DECCA 唱片的介紹與評論，都是針對早期的發行或是一些珍貴的名盤，Robert Moon 和 Michael Gray 的 "Full Frequency Stereophonic Sound" 一書，也是只有介紹到 1963 年，在這本 DECCA 與 LONDON 唱片，相互對照的目錄圖鑑中，筆者將 DECCA（LONDON）唱片，從 1958 到 1983 年發行的所有類比錄音，依系列序號來編纂，並且加以說明，很清楚地能查明，前面所提到的問題。在 DECCA（LONDON）唱片的製作中，許多優秀的演出與錄音，並非只侷限在早期的發行，在 1500 多張的唱片中，網羅了許多優秀的演奏家，不但曲目眾多，幾乎有一半（700 多張）的錄音，音樂與音響的評價都非常的高。

　　筆者除了將所有 DECCA 類比錄音的唱片，編列了本書上冊 DECCA 對照 LONDON 和下冊 LONDON 對照 DECCA 的圖鑑、內容介紹和索引之外，因為篇幅關係，也另外編輯一本附冊（黑膠唱片聖經收藏索引），將這些最佳演奏與音效的 DECCA (LONDON) 唱片，依演奏者姓名排序，編列榜單，並附上所有 DECCA 與 LONDON 唱片，系列序號的相互對照表，以便有興趣收藏的讀者，進一步的參考。

　　在本圖鑑的上冊中（黑膠唱片聖經收藏圖鑑 II），依英國 DECCA 唱片系列序號來對照美版 LONDON 唱片，所有在 LONDON 沒有出版過的唱片，都加以註明。另外還有多張唱片只在美國 LONDON 唱片發行，沒在英國 DECCA SXL、SET 系列中出版，簡單列表如下：（詳情請參照黑膠唱片聖經收藏圖鑑 III 中的內容介紹）

ILLUSTRATED DISCOGRAPHY OF DECCA – LONDON RECORDS
Index of Equivalent Recordings

⊙ [Decca - London Records] Index of Equivalent Recordings

The most popular Decca Record Stereo series, the SXL, SET series released in the UK and the CS, OS, OSA series released in the United States are the same recordings. However, many recordings were released only in the UK DECCA. The same happened to multiple recordings issued only in the United States under LONDON, and they have their own different series of coding and cover design. This can be very confusing for general collectors, therefore we need a detailed and correct equivalent index. Many of DECCA's reviews were directed at early releases or on some of the most famous and rare disc titles like the "Full Frequency Stereophonic Sound" by Robert Moon and Michael Gray. They only contained commentary from 1963 and earlier. From my catalog of the DECCA and LONDON RECORDS in this book, which portrays both companies' records with pictures organized by series and serial numbers from 1958 until 1983 side by side, one can clearly identify and clear up the confusion for the general collector.

In addition to this book there will be a booklet (Collector's Vinyl Records Bible) for additional reference in text format available:
: A list of best analog recordings (performance and sound quality) of Decca (London)
: A complete equivalent index for DECCA versus LONDON
: A complete equivalent index for LONDON versus DECCA's

Below is a list of serial numbers for all LONDON RECORDS released which did not release for the UK DECCA SXL & SET Series: (For details, please refer to the Collector's Illustrated Vinyl Bible III)

LIST: London CS, CSA, OS, OSA series (No Decca SXL & SET issue)
美國LONDON系列有發行，但是在DECCA SXL, SET系列中，沒有出版的唱片編號表

London CS 6013* (=LXT 5348)	London CS 6028 [©=SDD 446 + 134]	London CS 6029, (Spain)
London CS 6030 (=SWL 8005, 10" LP)	London CS 6032 (=SWL 8005, 10" LP)	London CS 6034 (©=ECS 822; SDD 243)
London CS 6035 (©=SDD 243; ECS 822)	London CS 6039 (©=ECS 595, LXT 5460)	London CS 6050, (Spain)
London CS 6053	London CS 6059; (=LXT 5446, ©=ECS 746)	London CS 6060 (©=ECS 692)
London CS 6080 (=LXT 5369)	London CS 6082 (=LXT 5280, ©=ECS 807)	London CS 6083 (=LXT 5290)
London CS 6084 (©=ECS 663, SPA 183)	London CS 6086 (=LXT 5305, ©=ECS 578)	London CS 6087 (=LXT 5325)
London CS 6088 (©=SPA 421, part)	London CS 6091 (=SWL 8017, 10" LP)	London CS 6097 [=SWL 8010 (10" LP)]
London CS 6102 (=SXL SKL 4043)	London CS 6108 (=LXT 5306, ©=SPA 221)	London CS 6109 (©=ECS 796)
London CS 6110 (©=ECS 643)	London CS 6111 (©=STS 15024)	London CS 6112;(=LXT 5278)
London CS 6117 (=LXT 5241)	London CS 6118 (=LXT 5245)	London CS 6119 (©=ECS 640)
London CS 6120 (=LXT 5232)	London CS 6121 (=LXT 5288)	London CS 6126*(©=ECS 576)
London CS 6128; (=SWL 8009, 10" LP)	London CS 6130 (Spain)	London CS 6139* ; (©=ECS 772, 773)
London CS 6140 (©=ECS 766)	London CS 6148	London CS 6152
London CS 6159 (©=STS 15151)	London CS 6169 (©=ECS 687)	London CS 6172 (=Part of SXL 2219)
London CS 6173 (©=SDD 201)	London CS 6181 (©=SDD 201)	London CS 6185 (©=SPA 314)
London CS 6201, No Decca SXL (Spain)	London CS 6202, No Decca SXL (Spain)	London CS 6220 (©=SDD 203)
London CS 6221 (©=SDD 204)	London CS 6246; (=SWL 8500, Decca 10" LP)	London CS 6247; (=SWL 8018, 10'' LP)

London CS 6325, No Decca SXL	London CS 6339; (=SWL 8502, 10" LP only)	London CS 6356; No Decca SXL (Spain)
London CS 6370 (=ARGO ZRG 5372)	London CS 6423; No Decca SXL	London CS 6424; No Decca SXL
London CS 6425; No Decca SXL	London CS 6730; (Decca=SPA 127)	London CS 6753; No Decca SXL
London CS 6805; No Decca SXL	London CS 6823; No Decca SXL	London CS 6824; No Decca SXL
London CS 6944; (©=SPA 257)	London CS 6955; No Decca SXL	London CS 6956; No Decca SXL
London CS 6987 (©=SPA 206)	London CS 7005; No Decca SXL	London CS 7015; No Decca SXL
London CS 7046; No Decca SXL	London CS 7068; No Decca SXL	London CS 7147; No Decca SXL
London CS 7149; (=Decca SET D95D 6)	London CS 7154; (=Decca SET D95D 6)	London CS 7155; (=Decca SET D95D 6)
London CS 7165; (=Decca SET D95D 6)	London CS 7166; (=Decca SET D95D 6)	London CS 7221; No Decca SXL
London CS 7238 (=L'. Lyre DSLO 47)	London CS 7242; No Decca SXL	London CS 7246; (=Decca D222D 6)
London CS 7252; No Decca SXL	London CS 7258; No SXL (=Decca D222D 6)	London CSA
London CSA 2205; (©=ECS 530)	London CSA 2222; No Decca SET	London CSA 2224; No Decca SET
London CSA 2246; [=SXL 6753 (part)]	London CSA 2301; [5BB 130-1, SDD 186-7)]	London CSA 2303; (©=ESC 620-1)
London CSA 2308; (©=GOS 540-2)	London CSA 2309; ((©=SDDB 294-7)	London CSA 2401; No Decca SET
London CSA 2402 [=SXL 6059-62]	London OS	London OS 25054; (=Decca SKL 4027)
London OS 25061; No Decca SXL	London OS 25082; No Decca SXL	London OS 25101; (©=ECS 826; SDD 212)
London OS 25102; No Decca SXL	London OS 25107; No Decca SXL	London OS 25114; No Decca SXL
London OS 25115; (©=SDD 382)	London OS 25116; (©=SDD 324)	London OS 25118; No Decca SXL

London OS 25119; No Decca SXL	London OS 25120; No Decca SXL	London OS 25121; No Decca SXL
London OS 25123; No Decca SXL	London OS 25141; No Decca SXL	London OS 25194; No Decca SXL
London OS 25202; No Decca SXL	London OS 25203; No Decca SXL	London OS 25204; No Decca SXL
London OS 25205 (©=GOS 551-3)	London OS 25229; No Decca SXL	London OS 25230; No Decca SXL
London OS 25234 (=Decca SKL 4121)	London OS 25271; (©=ARGO ZRG 5179)	London OS 25282; No Decca SXL
London OS 25321; (©=SDD 197)	London OS 25331; (©=ARGO ZNF 1; ZK 1)	London OS 25332; (©=ARGO ZRG 5277)
London OS 25333; (©=ARGO SPA 267)	London OS 25731; (©=ARGO 5325)	London OS 25735; ©=ARGO 5333)
London OS 25795; (©=ARGO 5362)	London OS 25800; (©=ZRG 5371; ECS 661)	London OS 25832; No Decca SXL
London OS 25902; No Decca SXL [Decca SKL 4925-6 (highlights)]	London OS 25903; No Decca SXL [Decca SKL 4006-7 (highlights)]	London OS 25904; No Decca SXL [Decca SKL 4081-2 (highlights)]
London OS 25906; (SKL 4542; ©=SPA 27)	London OS 25920; No Decca SXL	London OS 25950; No Decca SXL
London OS 25951; No Decca SXL	London OS 26025 (=Decca SXL 21213-M)	London OS 26028 [Decca SKL 4809]
London OS 26052; (©=SDD R459)	London OS 26054; No Decca SXL	London OS 26093; No Decca SXL
London OS 26114; No Decca SXL	London OS 26115; No Decca SXL	London OS 26153; No Decca SXL
London OS 26181 (=Decca SXL 20557-B)	London OS 26183; No Decca SXL	London OS 26205; No Decca SXL
London OS 26206; No Decca SXL	London OS 26207; No Decca SXL	London OS 26218; No Decca SXL
London OS 26248 (SET 520-1, part)	London OS 26251; No Decca SXL	London OS 26258; No Decca SXL
London OS 26276; No Decca SXL	London OS 26277; No Decca SXL	London OS 26304; No Decca SXL
London OS 26306; No Decca SXL	London OS 26316; No Decca SXL	London OS 26317; No Decca SXL

London OS 26320; No Decca SXL	London OS 26321; No Decca SXL	London OS 26346; No Decca SXL
London OS 26347; No Decca SXL	London OS 26381; No Decca SXL	London OS 26408; No Decca SXL
London OS 26431; No Decca SXL	London OS 26436; No Decca SXL	London OS 26442; No Decca SXL
London OS 26448; No Decca SXL	London OS 26493; No Decca SXL	London OS 26499; No Decca SXL
London OS 26537; (©=SDD 507)	London OS 26577; No Decca SXL	London OS 26594; No Decca SXL
London OS 26603; No Decca SXL	London OSA	London OSA 1101; (=LXT 5338, only)
London OSA 1102; No Decca SXL	London OSA 1103; No Decca SXL	London OSA 1104; (©=SDD 314)
London OSA 1155; [=Decca SKL 4579]	London OSA 1171; No Decca SXL	London OSA 1201; No Decca SET, [=Decca SKL 4006-7, (9BB 162-7)]
London OSA 1202 [=Decca SKL 4038-9]	London OSA 1207; No Decca SET	London OSA 1209 [=Decca SKL 4081-2, (9BB 156-61)]
London OSA 1215; No Decca SET, [=Decca SKL 4119-20, (9BB 156-61)]	London OSA 1216; No Decca SET	London OSA 1217; No Decca SET, [=Decca SKL 4146-7]
London OSA 1248; No Decca SET, [=Decca SKL 4504-5]	London OSA 1250; (=ARGO ZPR 257-8)	London OSA 1251; (=ARGO ZPR 259-260)
London OSA 1252; (=ARGO ZPR 124-5)	London OSA 1256; (©=ARGO DPA 571-2)	London OSA 1258; No Decca SET, [=Decca SKL 4624-5, (9BB 162-7)]
London OSA 1262; No Decca SET, [=Decca SKL 4708-9]	London OSA 1277; No Decca SET, [=Decca SKL 4925-6)]	London OSA 1294; (©=GOS 617)
London OSA 1301; (©=GOS 583-4)	London OSA 1310; (©=GOS 525-7)	London OSA 1311; (©=GOS 566-7; Decca 6.35217 DX; LXT 5155-7)
London OSA 1312; (©=GOS 543-5; Decca 417 185-1 & SMA 25019)	London OSA 1315; No Decca SET, (=ARGO ZPR 126-8)	London OSA 1316; No Decca SET, (=ARGO ZPR 201-30)

London OSA 1317; No Decca SET, (©=GOS 607-8 & 6.35225 DX, Germany)	London OSA 1318: No Decca SET (=ARGO ZPR 251-3)	London OSA 1320; No Decca SXL (©= ARGO ZRG 5271)
London OSA 1323; No Decca SET, [=Decca SKL 4138-40 (9BB 162-7)]	London OSA 1326; No Decca SET, (=ARGO ZPR 186-8)	London OSA 1362; No Decca SET, (=ARGO ZPR 183-5)
London OSA 1363; No Decca SET, (=ARGO ZRG 313-5) No Decca SXL	London OSA 1367; No Decca SET, (=ARGO ZPR 135-7) No Decca SXL	London OSA 1374; No Decca SET, (=ARGO ZPR 161-3)
London OSA 1403; (©=GOS 574-6)	London OSA 1407; (=ARGO ZPR 132-4)	London OSA 1408; (=ARGO ZPR 244-7)
London OSA 1409; No Decca SET, (=ARGO ZPR 149-152)	London OSA 1410; No Decca SET, (=ARGO ZPR 153-6)	London OSA 1411; No Decca SET, (=ARGO ZPR 232-5)
London OSA 1412; No Decca SET, (=ARGO ZPR 138-41)	London OSA 1413; No Decca SET, (=ARGO ZPR 142-5)	London OSA 1414; No Decca SET, (=ARGO ZPR 197-200)
London OSA 1415; No Decca SET, (=ARGO ZPR 157-60)	London OSA 1427; No Decca SET, (=ARGO2 ZPR 221-4),	London OSA 1428; No Decca SET, (=ARGO ZPR 164-7)
London OSA 1429; No Decca SET, (=ARGO ZPR 168-71)	London OSA 1430; No Decca SET, (=ARGO ZRG 5407)	London OSA 1501; No Decca SXL, [Decca SKL 5188-9], (©=GOS 562-5)
London OSA 1503; (=ARGO ZPR 192-6)	London OSA 12101; (©=GOS 634-5)	London OSA 12103 [=Decca SKL 5158-9]
London OSA 12104 [Decca SKL 5188-9]	London OSA 12110 [Decca SKL 5277-8]	London OSA 13122; (©=GOS 660-2)
London Treasury	London SRS 63509 (No Decca SET, SXL & London OSA)	London SRS 63516 (No Decca SET, SXL & London OSA)
London SRS 63523 (No Decca SET, SXL & London OSA)	London SRS 64503 (No Decca SET, SXL & London OSA)	London SRS 64504 (No Decca SET, SXL & London OSA)
London STS 15081-2 (=GOS 558-9)	London STS 15155-6; (©=GOS 602-3)	

DECCA
SXL SERIES

SXL 2000 - SXL 2316

Label **Decca SXL 2000** (©=GOS 551-3; London SRS 63509; LXT 5159-61)
London SRS 63509, =Decca GOS 551-3

Tchaikovsky: <Eugene Onegin, Op.24, Complete Opera>, Mira Vershevich (Mezzo-Soprano), Valeria Heybalova (Soprano), Biserka Tzveych (Mezzo-Soprano), Melanie Bugarinovich (Mezzo-Soprano), Dushan Popovich (Baritone), Drago Startz (Tenor), Miro Changalovich (Bass), Alexander Veselinovich (Bass), Ilya Gliforievich (Bass), Stepan Andrashevich (Tenor), Oscar Danon conducting the Orchestra of the National Opera, Belgrade. ℗1958 *[6 x Original Single Sided "STEREO" Test Pressings (Never commercially issued in the Decca SXL 2000 Series), Originally issued as Mono only Decca LXT 5159-61. (London issue only in Richmond Opera Treasury Series SRS 63509 & selected highlights in London OS 25205, = Ace of Diamonds GOS 551-3. ©1968)]

Remark & Rating
Pink-Blue "Pancake" Test Pressing label, Ultral rare!! $$$$$

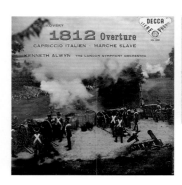

Label **Decca SXL 2001*** (©=SDD 112, SPA 108)
London CS 6038 (©=STS 15221)

Tchaikovsky: <1812 Overture, Op.49>, <Capriccio Italien, Op.45>, <Marche Slave, Op.31>, The London Symphony Orchestra conducted by Kenneth Alwyn. Producer: Michael Williamson. Recorded by Kenneth Wilkinson, May 1958 in Kingsway Hall, London. ℗1958

Remark & Rating
ED1, BB, 2E-1E, Rare! $$
RM17, Penguin★★★, AS list (Speakers Corner), (K. Wilkinson)

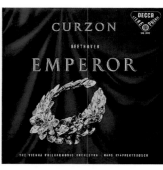

Label **Decca SXL 2002*** (©=SPA 334)
London CS 6019

Beethoven: <Piano Concerto No.5 in E Flat Major Op.73 "Emperor">, Clifford Curzon (piano), The Vienna Philharmonic Orchestra conducted by Hans Knappertsbusch. Recorded by James Brown, June 1957 in the Sofiensaal, Vienna. ℗1958

Remark & Rating
ED1, BB, 3E-3K, $$
RM14, Penguin ★★(★)

Label **Decca SXL 2003** (©=SDD 105)
London CS 6037 (©=STS 15038)

Beethoven: <Symphony No.5 in C Minor "Fate", Op.67>, L'Orchestra de la Suisse Romande-Ernest Ansermet. Recorded by Roy Wallace, May 1958 in the Victoria Hall, Geneva. ℗1958

Remark & Rating
ED1, BB, 1E-1E, $$
RM14

Label Decca SXL 2004 (©=SDD 138)
 London CS 6052 (©=STS 15018)

Tchaikovsky: <Symphony No.6 in B Minor, "Pathetique", Op.74>, The Vienna Philharmonic Orchestra-Jean Martinon. Recorded by Kenneth Wilkinson, April 1958 in the Sofiensaal, Vienna. ℗1958

Remark & Rating
ED1, BB, 6E-3E, Rare!! $$$+
(K. Wilkinson)

Label Decca SXL 2005 (©=SDD 128)
 London CS 6020 (©=STS 15007)

Dvorak: <Symphony No.9 in E Minor "The New World", Op.95>, The Vienna Philharmonic Orchestra-Rafael Kubelik. Recorded by James Brown, October 1956 in the Sofiensaal,Vienna. ℗1958 (℗ by John Culshaw)

Remark & Rating
ED1, BB, 3E-2E, $$
RM15

Label Decca SXL 2006 (©=SPA 88)
 London CS 6010 (©=STS 15015)

Mendelssohn: <Violin Concerto in E Minor Op.64>; Bruch: <Violin Concerto No.1 in G Minor, Op.26>, Ruggiero Ricci (Violin), The London Symphony Orchestra-Piero Gamba. Recorded by Cyril Windebank in Kingsway Hall, London. ℗1958

Remark & Rating
ED1, BB, 2E-1K, Very rare!! $$$+
RM16, Penguin ★★★

Label Decca SXL 2007 (©=SDD 109, SPA 376)
 London CS 6005 (©=STS 15002)

Rossini-Respighi: <Boutique Fantasque-Ballet>; Dukas: <L'apprenti Sorcier>, The Israel Philharmonic Orchestra-Georg Solti. Recorded by James Brown, March 1957 at the Tifferet Cinema, Rishon-le-Zion. ℗1958 (℗ by James Walker & John Culshaw)

Remark & Rating
ED1, BB, 7E-6E, rare! $$
RM14

Label Decca SXL 2008*
 London CS 6015

[Overtures in HIFI], Various Overtures from Adam: <Si J'Etais Roi >; Auber: <Le Domino Noir >; Herold: <Zampa>; Reznicek: <Donna Diana>; Suppe: <Pique Dame>; Nicolai: <The Merry Wives Of Windsor>, The Paris Conservatoire Orchestra-Albert Wolff. Recorded by Ken Cress, November 1957 in the Salle de la Mutualité, Paris. ℗1958 (℗ by John Culshaw)

Remark & Rating
ED1, BB, 3E-2E, $$
RM15

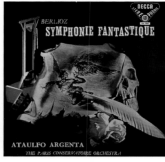

Label **Decca SXL 2009* (©=SDD 115)**
London CS 6025 (©=STS 15006)

Berlioz: <Symphony Fantastique, Op.14>, The Paris Conservatoire Orchestra-Ataulfo Argenta. Recorded by Ken Cress, November 1957 in the Salle de la Mutualité, Paris. ℗1958 (℗ by John Culshaw)

Remark & Rating
ED1, BB, 3E-3E, Very rare!! $$$$
RM15

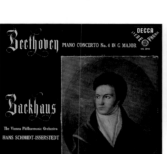

Label **Decca SXL 2010 (©=SPA 403)**
London CS 6054

Beethoven: <Piano Concerto No.4 in G Major, Op.58>, Wilhelm Backhaus (piano), The Vienna Philharmonic Orchestra-Hans Schmidt-Isserstedt. Recorded by Alan Abel, April 1958 in the Sofiensaal, Vienna. ℗1958

Remark & Rating
ED1, BB, 1E-1E, rare! $$$
RM12

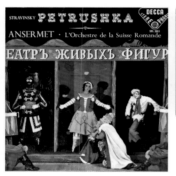

Label **Decca SXL 2011* (©=SDD 240, ECS 819)**
London CS 6009

Stravinsky: <Petrushka> Complete Ballet (Original Edition), L'Orchestre de la Suisse Romande-Ernest Ansermet. Recorded by Roy Wallace, November 1957 in the Victoria Hall, Geneva. ℗1958

Remark & Rating
ED1, BB, 2E-3E, Very rare!! $$$$$
RM15, TASEC44

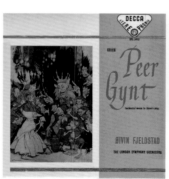

Label **Decca SXL 2012* (©=SDD 111; SPA 421)**
London CS 6049

Grieg: <Peer Gynt, Incidental music to Ibsen's play>, The London Symphony Orchestra-Øivin Fjeldstad. Produced by Michael Williamson, recorded by Alan Reeve & Cyril Windebank, February 1958 in Kingsway Hall, London. ℗1958

Remark & Rating
ED1, BB, 2E-2E, Very rare!! $$$$
RM19, TASEC, Penguin ★★(★)

Label **Decca SXL 2013 (©=SDD 117)**
London CS 6016 (©=STS 15001)

Brahms: <Symphony No.1 in C Minor, Op.68>, The Vienna Philharmonic Orchestra-Rafael Kubelik. Recorded by James Brown, September 1957 in the Sofiensaal, Vienna. ℗1958

Remark & Rating
ED1, BB, 1K-1K, Very rare!! $$$
RM14

Label **Decca SXL 2014 (SXL 2208-10)**
London OS 25076 (OSA 1303)

Giordano: <Andrea Chenier, Highlights>, Renata Tebaldi; Mario Del Monaco; Ettore Bastianini; Fernando Corena, Chorus & Orchestra of The St. Cecilia Academy, Rome-Gianandrea Gavazzeni. Recording by Roy Wallace,1957 in Rome. ℗1958 (Highlights from SXL 2208-10 & OSA 1303)

Remark & Rating
ED1, BB, 1E-1E

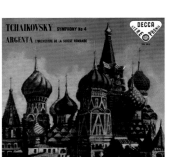

Label **Decca SXL 2015 (©=ECS 742, part)**
London CS 6048

Tchaikovsky: <Symphony No.4 in F Minor, Op.36>, L'Orchestre de la Suisse Romande-Ataulfo Argenta. Recorded by Roy Wallace, September 1958 in the Victoria Hall, Geneva. ℗1958

Remark & Rating
ED1, BB, 2E-2E, Very rare!! $$$
RM12

Label **Decca SXL 2016 (©=SPA 73)**
London CS 6014

Johann Strauss: <Vienna Holiday Concert>, The Vienna Philharmonic Orchestra-Hans Knappertsbusch. Recorded by James Brown, October 1957 in the Sofiensaal, Vienna. ℗1958

Remark & Rating
ED1, BB, 3E-3E, Very rare! $$$+
RM10

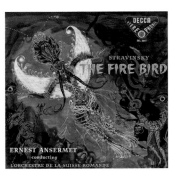

Label **Decca SXL 2017* (©=SDD 246, ECS 817)**
London CS 6017 (CSA 2308) (©=STS 15139)

Stravinsky: Ballet <The Firebird>, L'Orchestre de la Suisse Romande-Ernest Ansermet. ℗1958

Remark & Rating
ED1, BB, 2E-3E, Rare!! $$$+
RM13, TASEC, Penguin ★★(★)

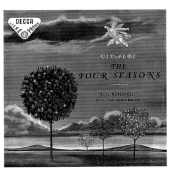

Label **Decca SXL 2019 (©=SPA 201)**
London CS 6044 (©=STS 15043)

Vivaldi: <The Four Seasons (Le Quattro Stagioni)>, Werner Krotzinger (Violin Solo), The Stuttgart Chamber Orchestra-Karl Münchinger. ℗1958

Remark & Rating
ED1, BB, 2E-2K, Very rare!! $$$+
RM13

Label **Decca SXL 2020*** (©=SDD 216, ECS 797)
 London CS 6006

[España], Rimsky Korsakov: <Capriccio Espagnol>; Granados: <Andalusia>; Chabrier: <Espana>; Moszkowsky: <Spanish Dances>, The London Symphony Orchestra-Ataulfo Argenta. Recorded by Gordon Parry, December 1956 and January 1957 in Kingsway Hall, London. ℗1958

Remark & Rating
ED1, BB, 5E-4E, Very rare!! $$$$
RM19, TASEC, Penguin ★★★, AS list (Speakers Corner)

Label **Decca SXL 2021*** (©=SDD 139, SPA 203)
 London CS 6058 (©=STS 15051)

Meyerbeer (arr. Lambert): <Les Patineurs-Ballet>; Massenet: <Le Cid-Ballet Music>, The Israel Philharmonic Orchestra-Jean Martinon. Recorded by James Brown, 1958 in the Heikhal Hatabut, Frederic R. Mann Auditorium, Tel-Aviv. ℗1958 (℗ by John Culshaw) [* Le Cid, Penguin ★★]

Remark & Rating
ED1, BB, 3E-3E, Rare! $$
RM14, Penguin ★★★

Label **Decca SXL 2022-3** (©=SDD 113-4)
 London OSA 1205

Lehar: <The Merry Widow, complete recording>, Hilde Gueden, Per Grunden, Waldemar Kmentt, Emmy Loose & Karl Donch. Chorus & Orchestra of Vienna State Opera-Robert Stolz. Recorded by Kenneth Wilkinson, March 1958 in the Sofiensaal, Vienna. ℗1958

Remark & Rating
ED1, BB, 1E-1E-2E-1E, Very rare! $$$
Penguin ★★(★), (K. Wilkinson)

Label **Decca SXL 2024** (©=SDD 177, ECS 769)
 London CS 6041 (CSA 2305, ©=STS 15039)

Chopin: [Piano Music Of Chopin, Vol. 2], <Impromptus No.1-4>, <Berceuse, Op.57>, <Barcarolle, Op.60>, <Nocturne, Op.9 no.3>, <Scherzo, Op.39>, Wilhelm Kempff (Paino). ℗1958 *(Volume 1, CS 6040 = SXL 2081; Volume 3, CS 6042 = SXL 2025)

Remark & Rating
ED1, BB, 1E-1K, Rare! $$
RM14, Penguin ★★(★)

Label **Decca SXL 2025** (©=SDD 195, ECS 770)
 London CS 6042 (CSA 2305, ©=STS 15050)

Chopin: [Piano Music Of Chopin, Vol. 3], <Sonata No.2 in B-Flat Minor, Op.35>, <Sonata No.3 in B Minor, Op.58>, Wilhelm Kempff (Paino). ℗1958 *(Volume 1, CS 6040 = SXL 2081; Volume 2, CS 6041 = SXL 2024)

Remark & Rating
ED1, BB,1E-1E, Rare! $$
RM14, Penguin ★★(★)

Label Decca SXL 2026 (©=SDD 110, ECS 775)
 London CS 6047 (©=STS 15015)

Mendelssohn: <Violin Concerto in E Minor>; Bruch: <Scottish Fantasia>, Alfredo Campoli (Violin), The London Philharmonic Orchestra-Adrian Boult. Recorded by Kenneth Wilkinson, May 1958 in Kingsway Hall.℗1958

Remark & Rating
ED1, BB, 1E-1E, Very rare!! $$$
RM14, Penguin ★★, (K. Wilkinson)

Label Decca SXL 2027 (©=SDD 375)
 London CS 6043 (©=STS 15022)

Debussy: <"Jeux"-Poeme Dance>, Debussy-Ravel: <Danse>; Dukas: <"La Peri"- Poeme Dance>, L'Orchestre De La Suisse Romande-Ernest Ansermet. Produced by James Walker, recorded by Roy Wallace, April-May 1958 in the Victoria Hall, Geneva. ℗1958 ©1959

Remark & Rating
ED1, BB, 1E-1E, Very rare! $$$+
RM19

Label Decca SXL 2028* (©=SDD 230)
 London CS 6051

Schubert: <Octet in F Major for Clarinet, Horn, Bassoon and Strings, Op.166>, The Vienna Octet-Willi Boskovsky (Violin), Philip Matheis (Violin), Gunther Breitenbach (Viola), Nikolaus Hubner (Cello), Johann Krump (Double-Bass), Alfred Boskovsky (Clarinet), Josef Veleba (Horn), Rudolf Hanzl (Bassoon). Recorded by James Brown, March 1958 at Sofiensaal, Vienna. ℗1958

Remark & Rating
ED1, BB, 2E-3E, rare! $$
RM16, Penguin ★★★

Label Decca SXL 2029 (©=SPA 183)
 London CS 6011 (©=STS 15263)

Tchaikovsky: <Violin Concerto in D Major, Op.35>, Alfredo Campoli (violin) with The London Symphony Orchestra-Ataulfo Argenta. ℗1958

Remark & Rating
ED1, BB, 1E-1E, Very rare!! $$$$
RM16, Penguin ★★★

Label Decca SXL 2030* (©=SDD 248, ECS 794)
 London OS 25005

Sibelius: [Kirsten Flagstad-Song Recital], <Om Kvällen>; <Var Det En Dröm>; <Höstkväll, Demanten På Marssnön>; <Flickan Kom Ifrån Sin Älsklings Möte>; <Arioso, Våren Flyktar Hastigt>; <Se'n Har Jag Ej Frågat Mera>; <Men Min Fågel Märks Dock Icke>; <På Verandan Vid Havet>; <Den Första Kyssen>; <Svarta Rosor>; <Säf, Säf, Susa>; <Kom Nu Hit, Död!>. Kirsten Flagstad (soprano) with The London Symphony Orchestra-Øivin Fjeldstad. (Includes Insert Sheet) ℗1958

Remark & Rating
ED1, 1K-1K, Very rare!! $$$
Penguin ★★★ (✿)

Label **Decca SXL 2031-2 (©=GOS 577-8)**
London OSA 1203

Wagner: <Die Walküre, Act III-complete>; <Act II-Todesverkündigung, Siegmund! Sieh' auf mich!>, Starring Kirsten Flagstad as Brünnhilde, Otto Edelmann as Wotan, Marianne Schech as Sieglinde, Set Svanholm as Siegmund, Oda Balsborg as Gerhild, Grace Hoffmann as Waltraute, etc., The Vienna Philharmonic Orchestra & Vienna State Opera Chorus-Georg Solti. (20 pages Booklet) Produced by John Culshaw. Recorded by James Brown, May 1957 in the Sofiensaal, Vienna. ℗1958 (*This earlier recording is not the same "Walküre" recording in the Solti's "Ring Cycle", see Decca SET 312-6)

Remark & Rating
ED1, 1E-3K-1E-1E, rare! $$
Penguin ★★★

Label **Decca SXL 2034 (©=SDD 188)**
London CS 6055

Rachmaninov: <Piano Concerto No.1 in F Sharp Minor, Op.1>; Tchaikovsky: <Concert Fantasia in G Major, Op.56>, Peter Katin (piano), The London Philharmonic Orchestra-Adrian Boult. ℗1958

Remark & Rating
ED1, BB, 1K-2K, $$
RM12

Label **Decca SXL 2035 (©=SDD 237) (SXL 2087-90)**
London OS 25045 (OSA 1402)

Mozart: <Le Nozze di Figaro (Marriage of Figaro), Highlights>, Cesare Siepi, Hilde Gueden, Lisa della Casa, Suzanne Danco, Alfred Poell, The Vienna Philharmonic Orchestra-Eric Kleiber. Recorded by James Brown, June 1955 in the Redoutensaal, Vienna. ℗1958 ©1960 (Highlights from SXL 2087-90 & OSA 1402)

Remark & Rating
ED1, 1K-2K, $
Penguin ★★(★), G.Top 100

Label **Decca SXL 2037* (©=SDD 141, ECS 755)**
London CS 6062 (©=STS 15052)

Bizet: <Carmen Suite>, <L'Arlesienne Suite>, L'Orchestre de la Suisse Romande-Ernest Ansermet. Recorded by Roy Wallace, April 1958 in the Victoria Hall, Geneva. ℗1958

Remark & Rating
ED1, BB, 3E-2E, Very rare!! $$$
RM17

Label Decca SXL 2039-41 (©=GOS 594-6)
 London OSA 1306

Puccini: <La Fanciulla Del West (The Girl of the Golden West),
Complete recording>, Renata Tebaldi (Soprano), Mario Del Monaco
(Tenor), Cornell Macneil (Baritone), Giorgio Tozzi (Bass), The Chorus
and Orchestra of the Accademia Di Santa Cecilia, Rome-Franco
Capuana (12 pages Booklet in Decca & 27 pages Booklet in London
OSA). Recorded by Roy Wallace, August 1958 in Rome. ℗1958

Remark & Rating
ED1, 3G-3G-3G-3G-3G-3G (early Grey Box with Blue Spine)
$$$
Penguin ★★★& ★★(★)

Label Decca SXL 2042 (©=ECS 818)
 London CS 6031 (CSA 2308)

Stravinsky: <Le Sacre Du Printemps>, L'Orchestre De La
Suisse Romande-Ernest Ansermet. Recorded by Roy Wallace,
May 1957 in the Victoria Hall, Geneva. ℗1958

Remark & Rating
ED1, BB, 1K-3K, $$$
RM13, TASEC

Label Decca SXL 2043 (©=SDD 287)
 London OS 25020

[Renata Tebaldi - Operatic Recital], <Le Nozze Di Figaro>,
<Adraina Lecouvreur>, <Lodoletta>, <William Tell>, <Cecilia>,
The Orchestra of the Accademia di Santa Cecilia, Rome-
Alberto Erede. ℗1958

Remark & Rating
ED1, BB, 5K-4E, $$

Label Decca SXL 2044 (©=SDD 221, ECS 809)
 London CS 6026 (©=STS 15594)

Chopin: <Les Sylphides-Ballet>; Delibes: <La Source-Ballet
Selection>, The Paris Conservatoire Orchestra-Peter Maag.
Recorded by Ken Cress, November 1957 at La Maison de la
Mutualité, Paris. ℗1958 (℗ by John Culshaw)

Remark & Rating
ED1, BB, 1E-1E, $$$
RM15, TAS 13-91+

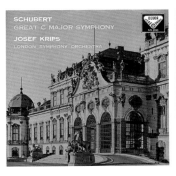

Label Decca SXL 2045* (©=SDD 153; SPA 467)
 London CS 6061 (©=STS 15140)

Schubert: <Symphony No.9 in C Major "The Great">, The
London Symphony Orchestra-Josef Krips. Recorded by
Kenneth Wilkinson, May 1958 in Kingsway Hall, London.
℗1958

Remark & Rating
ED1, BB, 1E-1E, Rare!! $$+
RM18, Penguin ★★★(❀), AS list-F, (K. Wilkinson)

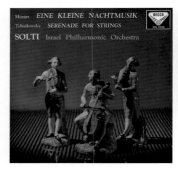

Label **Decca SXL 2046 (©=SDD 205)**
London CS 6066 (©=STS 15141)

Tchaikovsky: <Serenade In C Major for String Orchestra, Op.48>; Mozart: <Eine Kleine Nachtmusik, K.525>, The Israel Philharmonic Orchestra-Georg Solti. Recorded by James Brown in the Hejkhal Hatarbut- Frederick R. Mann Auditorium, Tel Aviv. ℗1958 (℗ by John Culshaw)

Remark & Rating
ED1, BB, 4E-2E, $$
RM15

Label **Decca SXL 2047 (©=SDD 133)**
London CS 6007 (©=STS 15012)

[Memories of Vienna], Johan Strauss: <Blue Danube Waltz>, <Accelerations>, <Rose from the South>, <Emperor Waltz>, <Pizzicato Waltz (Johan & Josef Strauss)>, The Vienna Philharmonic Orchestra-Josef Krips. ℗1958

Remark & Rating
ED1, BB, 2E-1K, rare! $$
RM15

Label **Decca SXL 2048* (©=SDD 308, 391; SPA 535)**
London OS 25075

[Carlo Bergonzi Operatic Recital], Verdi: <Aida>, <Il Trovatore>, <Luisa Miller>, <Un ballo in Maschera>, <La forza del destino>, <La Traviata>; Ponchielli: <La Gioconda>; Puccini: <Tosca>, <La Boheme>, <Manon Lescaut>. Carlo Bergonzi (tenor) with Orchestra of Accademia di Santa Cecilia, Rome-Gianandrea Gavazzen. ℗1958

Remark & Rating
ED1, BB, 2E-2E, $$
Penguin ★★(★)

Label **Decca SXL 2049 (©=SDD 207)**
London OS 25038

[Great Sacred Songs] Mendelssohn: <Hear My Prayer-O for the Wings of a Dove>, <Jerusalem, from "St.Paul">; Gounod: <O Divine Redeemer>; Parry: <Jerusalem, Op.208>; Liddle: <Abide With Me>; <Silent Night, Holy Night (arr. Woodgate); <Jubilate, (arr. Woodgate) >; <O Come, All Ye Faithful (arr. Woodgate)>. Kirsten Flagstad (soprano), The London Philharmonic Orchestra-Adrian Boult. ℗1958

Remark & Rating
ED1, BB, 3K-1E, $$

Label Decca SXL 2050-3 (©=GOS 571-3)
 London OSA 1404

Richard Strauss: <Arabella>, with Hilde Gueden, George London, Otto Edelmann, Lisa Della Casa, Chorus of Vienna State Opera & The Vienna Philharmonic Orchestra-Georg Solti. (50 pages Booklet) ℗1958 ©1959 (*Hard to find the original ED1 with Red Wallet)

Remark & Rating
ED1, 2E-3E-2E-1K-2E-1E-1K-1K (Plastic, Red Wallet, Blue Wallet), rare!! $$$ - $$$$
Penguin ★★★

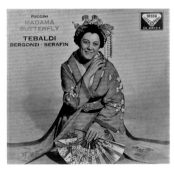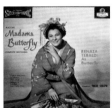

Label Decca SXL 2054-6 (=Decca D4D 3)
 London OSA 1314 (=OSA 1406, 4LP-SET)

Puccini: <Madama Butterfly>, Renata Tebaldi, Carlo Bergonzi, Fiorenza Cossotto, Chorus & Orchestra of The St.Cecilia Academy, Rome-Tullio Serafin (20 pages booklet). Recorded July 1958 in Rom. ℗1958 ©1959 (3LP-SET)

Remark & Rating
ED1, BB, $$$
Penguin ★★(★)

Label Decca SXL 2057
 No London CS

[Stereophonic Frequency Test Record], side 1 : Left Hand Channel, side 2 : Right Hand Channel. ℗1958

Remark & Rating
ED1, 2F-2F, $+

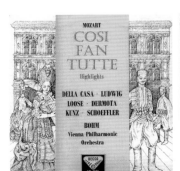

Label Decca SXL 2058 (©=SDD 208)
 London OS 25047 (OSA 1312)

Mozart: <Cosi fan tutte, Highlights>, Lisa Della Casa (soprano); Christa Ludwig (soprano); Emmy Loose (soprano); Anton Dermota (tenor); Erich Kunz (baritone); Paul Schoeffler (bass-baritone), The Chorus Of The Vienna State Opera & The Vienna Philharmonic Orchestra-Karl Böhm. Recorded 16-21 May 1955, in the Redoutensaal, Vienna. ℗1958 **(No complete SXL Set exists, the complete Set is London OSA 1312, Decca copy is Ace of Diamond GOS 543-5)

Remark & Rating
ED1, 1K-1K, Rare!! $$

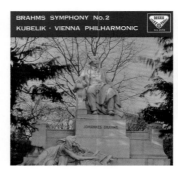

Label Decca SXL 2059 (©=SDD 118)
 London CS 6004

Brahms: <Symphony No.2 in C Minor, Op.73>, The Vienna Philharmonic Orchestra-Rafael Kubelik. Recorded in the Sofiensaal, Vienna, 1957. ℗1958

Remark & Rating
ED1, BB, 4E-3E, $$$
RM14

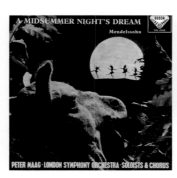

Label Decca SXL 2060* (©=SDD 159, SPA 451)
 London CS 6001 (©=STS 15084)

Mendelssohn: <A Midsummer Nights Dream>, Incidental Music, Jennifer Vyvyan (Soprano); Marion Lowe (Soprano) & Female Chorus of the Royal Opera House, Covent Garden, The London Symphony Orchestra-Peter Maag. Recorded by:Cyril Windebank & Kenneth Wilkinson, February 1957 in Kingsway Hall, London. ℗1958

Remark & Rating
ED1, BB, 6D-5E, Very rare!! $$$$
RM19, Penguin ★★(★), TAS 38-137+, AS list (Speakers Corner), (K. Wilkinson)

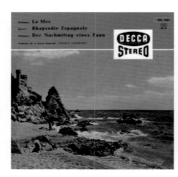
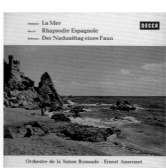
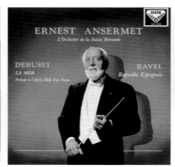

Label Decca SXL 2061 (German & Spain pressing only, UK Decca ©=SDD 214)
 London CS 6024 (©=STS 15109)

Debussy: <La Mer>, <Prelude a l'Apres-Midi d'un Faune>; Ravel: <Rapsodie Espagnole>, L'Orchestre de la Suisse Romande-Ernest Ansermet. Recorded October 1957 in the Victoria Hall, Geneva. ℗1958 [German & Spain pressing only, rare! No UK SXL, Decca ℗=SDD 214]

Remark & Rating
GD1, (Black-Gold label, $$$, Blak-Silver, $$)
RM16

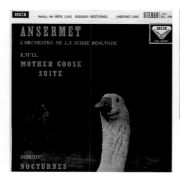

Label Decca SXL 2062* (©=SDD 374, ECS 815, 816; DPA 619)
 London CS 6023

Ravel: <Mother Goose Suite>; Debussy: <La Mer>, <Nocturnes>, L'Orchestre de la Suisse Romande-Ernest Ansermet. Producer: James Walker. Recorded by Roy Wallace, October-November 1957 in the Victoria Hall, Geneva. ℗1960

Remark & Rating
ED1, BB, 2E-2E, $$$
RM18

Label **Decca SXL 2064-5* (©=SDD 161-2)**
London CSA 2202 (=CS 6056-7, ©=STS 15096-7)

Smetana: <My Fatherland (Ma Vlast)> Symphony Poem with Vysˇehrad, Moldau, Sárka, From Bohemia's meadows and forests, Tábor, and Blaník, Vienna Philharmonic Orchestra-Rafael Kubelik. Recorded by James Brown, April 1958 in the Sofiensaal, Vienna. ℗1958

Label **Decca SXL 2067 (©=SDD 121)**
London CS 6065 (©=STS 15008)

Mendelssohn: <Symphony No.4 in A Major, "Italian", Op.90>; Schubert: <Symphony No.5 in B Flat Major>, The Israel Philharmonic Orchestra-Georg Solti. Recorded by James Brown, 1958 in the Heikhal Hatabut, Fredric R. Mann Auditorium, Tel-Aviv. ℗1959 (℗ by John Culshaw)

Label **Decca SXL 2068 (©=SDD 143, 426)**
London OS 25044

[Great Scenes From Wagner-For Bass-Baritone] Der Fliegende Holländer: <Die Frist Ist Um>; Die Meistersinger Von Nürnberg: <Fliedermonolog-Was Duftet Doch Der Flieder>, <Wahnmonolog-Wahn! Wahn! Überall Wah>; Die Walküre: <Leb' Wohl, Du Kühnes, herrliches Kind! (Wontan's Farewell)>. George London (bass-baritone) with The Vienna Philharmonic Orchestra-Hans Knappertsbusch. ℗1959

Label **Decca SXL 2069-72 (©=GOS 597-9)**
London OSA 1405

Verdi: <La Forza del Destino>, Renata Tebaldi, Mario Del Monaco, Fernando Corena, Chorus and Orchestra of L'Accademia di Santa Cecilia, Rome-Francesco Molinari-Pradelli. ℗1958

Label **Decca SXL 2074-5 (©=GOS 581-2)**
London OSA 1204

Wagner:<"Die Walküre", Act 1 (Complete)>, <"Götterdämmerung", Dawn and Siegfried's Rhine journey and Siegfried's funeral music>, Kirsten Flagstad (soprano) as Sieglinde, Set Svanholm (tenor) as Siegmund and Arnold van Mill as Hunding (bass), The Vienna Philharmonic OrchestraHans-Hans Knappertsbusch. Recorded in Sofiensaal,Vienna, 1956. (10 pages Booklet) ©1958

Label　Decca SXL 2076* (©=SDD 181; SPA 505)
　　　　London CS 6064 (©=STS 15086)

Rachmaninov: <Piano Concerto No.2 in C Minor, Op.18>; Balakirev: <Islamey-Oriental Fatasia>, Julius Katchen (piano), The London Symphony Orchestra-Georg Solti. Recorded by Kenneth Wilkinson, June 1958 in Kingsway Hall, London. ℗ 1958 by John Culshaw ©1959

Remark & Rating
ED1, BB, 4E-2E, $$
RM14, Penguin ★★(★), TAS-SM86+, (K. Wilkinson)

Label　Decca SXL 2077* (©=SDD 276, SPA 398)
　　　　London CS 6067 (©=STS 15054)

Sibelius: <Violin Concerto in D Minor, Op.47>; Tchaikovsky: <Serenade Melancolique, Op.26>* , <Scherzo from "Souvenir d'un lieu cher", Op.42, no.2>*, Ruggiero Ricci (violin), The London Symphony Orchestra-Øivin Fjelstad. Recorded by Alan Reeve, Gordon Parry, February 1958 in Kingsway Hall, London. ℗1958 ©1959 by John Culshaw [* Tchaikovsky is Penguin ★★★}

Remark & Rating
ED1, 2E-1K (Blue Text Sleeve), Very rare!!! $$$$
RM15, Penguin ★★(★)

Label　Decca SXL 2078-80
　　　　London OSA 1308

Puccini:<Turandot>, Renate Tebaldi, Mario del Monanco, Inge Borkh, Gaetano Fanelli, Chorus & Orchestra of The Accademia di Santa Cecilia, Rome-Alberto Erede. (20 pages Booklet) ℗1959

Remark & Rating
ED1, 1E-2E-1E-2E-2E-3D (Box), Very rare!! $$$

Label　Decca SXL 2081 (©=SDD 140; ECS 768)
　　　　London CS 6040 (CSA 2305, ©=STS 15029)

Chopin: [Piano Music Of Chopin, Vol. 1], <Ballade No.3, Op.47>, <Andante Spianato et Grande Polonaise, Op.22>, <Fantasie in F Minor, Op.49>, <Polonaise No.7, Op.61>, Wilhelm Kempff (Paino). ℗1959 *(Volume 2, CS 6041 = SXL 2024; Volume 3, CS 6042 = SXL 2025)

Remark & Rating
ED1, BB, 4K-4E, Rare! $$
RM14, Penguin ★★

Label　Decca SXL 2082
　　　　London CS 6008 (©=STS 15596)

[Johann Strauss Concert], <Champagne Polka>, <Wiener Blut Waltz>, <Pizzicato Polka (Fürstin Ninetta)>, <Liebeslieder Waltz>, <Heiterer Mut Polka>, <Explosions Polka>, <Weiner Bonbons Waltz>, <Persian March>, <"Waldmeister" Overture>, The Vienna Philharmonic Orchestra-Willi Boskovsky. Producer: John Culshaw. Recorded by James Brown, December 1957 in the Sofiensaal, Vienna. ℗1959

Remark & Rating
ED1, BB, 1E-1E, $+
RM17

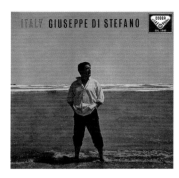

Label Decca SXL 2083 (©=SPA 313)
 London OS 25065

[Italy, (La Voce D'Italia], Italian Songs: <Parlami d'amore Mariù>, <Munasterio 'e Santa-Chiara>, <Firenze sogna>, <Canta pe'me>, <Che t'aggia dì>, <Come è bello far l'amore quanno è sera>, <'A canzone 'e Napule>, <Sicilia bedda>, <Ti voglio tanto bene>, <Fili d'oro>, <Chitarra Romana>, <Addio, sogni di gloria>, performed by Guiseppe di Stefano, with orchestra conducted by Dino Oliveri. Recorded by Roy Wallace, July-August 1958 in Rome. ℗1958 ©1959

Remark & Rating
ED1, BB, 2E-1E, Very rare! $$$
Penguin ★★★

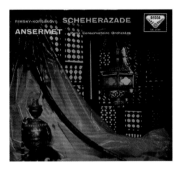

Label Decca SXL 2084-5 (©=SDD 371-2, DPA 581-2)
 London CSA 2201 (=CS 6002-3)

Delibes: Ballet <Coppelia> , L'Orchestre de la Suisse Romande-Ernest Ansermet (8 pages Boklet). Recorded by Roy Wallace, April 1957 in the Victoria Hall, Geneva. ℗1959

Remark & Rating
ED1, (Gatefold, 1K-1K-3E-5K, $$$$)Very rare!! (Box, 1K-3E-5K-1K, $$+)
RM15, Penguin ★★(★), Japan 300

Label Decca SXL 2086 (©=SDD 151)
 London CS 6018 (©=STS 15126)

Rimsky-Korsakov: <Scheherazade - Symphonic Suite, Op.35>, The Paris Conservatoire Orchestra-Ernest Ansermet. Recorded by James Brown, September 1954 in the Maison de la Mutualité, Paris. ℗1959

Remark & Rating
ED1, BB, 1D-1D, $$$+
RM15

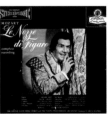

Label Decca SXL 2087-90 (©=GOS 585-7)
 London OSA 1402

Mozart: <Le Nozze di Figaro (Marriage of Figaro)>, Cesare Siepi, Hilde Gueden, Lisa della Casa, Suzanne Danco, Alfred Poell, Vienna Philharmonic Orchestra-Erich Kleiber. (32 pages Booklet) Recorded by James Brown, June 1955 in the Redoutensaal, Vienna. ℗1959 (Original ED1with memorial issue design box plastic wallet)

Remark & Rating
ED1, 5E-4F-4F-3E-3F-2K-4F-4K, Very rare!!! $$$$$+
Penguin ★★★(✧), G.Top 100

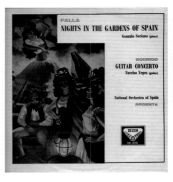

Label **Decca SXL 2091* (©=SDD 446, part; SPA 233)**
 London CS 6046 (©=STS 15199)

Falla: <Night in the Garden of Spain>* & Rodrigo: <Concerto for Guitar and Orchestra>**, Narcisco Yepes (guitar), The National Orchestra of Spain-Ataulfo Argenta. Recorded by Spanish Columbia. ℗1958 [©= *Falla in SDD 446, Penguin★★★ & Rodrigo in **SPA 233]

Remark & Rating
ED1, BB, 2E-3E, Very rare!! $$$+ (ED2, 3E-5E, $$)
RM18, TASEC65, Penguin ★★(★) Japan 300

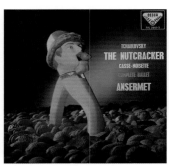

Label **Decca SXL 2092-3* (©=SDD 378-9, DPA 569-70)**
 London CSA 2203 (=CS 6068 & CS 6069, ©=STS 15433)

Tchaikovsky: <The Nutcracker (casse-noisette), Op.71, Complete Ballet in Two Acts>, L'Orchestre de la Suisse Romande-Ernest Ansermet (8 pages Booklet). Producer: James Walker. Recorded by Roy Wallace, October 1958. ℗1959

Remark & Rating
ED1, Gatefold, 1E-1E-1E-1K, rare! $$$
RM19, Penguin ★★★

Label **Decca SXL 2094-6 (©=GOS 591-3)**
 London OSA 1307

Boito: <Mefistofele> complete recording, Cesare Siepi (bass), Renata Tebaldi (soprano), Mario Del Monaco (tenor), Chorus & Orchestra of The St. Cecilia Academy, Rome-Tullio Serafin (25 pages Booklet). Recorded by Roy Wallace, 1958 in Rome. ℗1958 @1959

Remark & Rating
ED1, Red box, 1E-1E-1K-1E-1E-1E, Very rare!! $$$
Penguin ★★(★)

Label **Decca SXL 2097 (©=SDD 124, SPA 318)**
 London CS 6033

Liszt: <Piano Concertos No.1 in E-Flat Major & No.2 in A Major>, Julius Katchen (piano), The London Philharmonic Orchestra-Altaufo Argenta. Recorded by Gordon Parry, January 1957 in Kingsway Hall, London. ℗1958

Remark & Rating
ED1, BB, 3K-2E, Rare! $$
RM14, Penguin ★★★

Label **Decca SXL 2098 (©=SDD 174; ECS 828)**
 London CS 6027 (©=STS 15085)

Haydn: <Symphony No.94 in G Major "Surprise">, <No. 99 in E Flat Major>, The Vienna Philharmonic Orchestra-Josef Krips. ℗1958

Remark & Rating
ED1, 2E-1K, Rare! $$
RM11

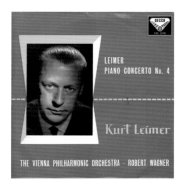

Label Decca SXL 2100
No London CS

Kurt Leimer: <Piano Concerto No.4>, Kurt Leimer (piano), The Vienna Philharmonic Orchestra conducted by Robert Wagner. Recorded in the Sofiensaal, Vienna, September 1958. ℗1958 *[Ultra rare !!! Most difficult to find from all my DECCA collections, it took 10 years !!!

Remark & Rating
ED1, BB, 1K-1K, Ultra rare!!! $$$$$

Label Decca SXL 2101-3 (SET 382-4)
London OSA 1309

Wagner: <Das Rheingold>, Kirsten Flagstad as Frica, George London as Wotan, Claire Watson as Freia, Set Svanholm as Loge, Jean Madeira as Erda, Gustav Neidlinger as Alberich, Paul Kuen as Mime, Eberhard Wächter as Donner, Waldemar Kmentt as Froh, Walter Kreppel, Kurt Böhme, Oda Balsborg, Hetta Plumacher, Ira Malaniuk. The Vienna Philharmonic Orchestra & Vienna State Opera Chorus-Georg Solti. (56 pages Booklet) Produced by John Culshaw. ℗1959 (=SET 382-4)

Remark & Rating
ED1, (Early Grey Box) $$$
TASEC, AS list-H

Label Decca SXL 2104 (©=SDD 119)
London CS 6022 (©=STS 15003)

Brahms: <Symphony No.3 in F Major, Op.90>, The Vienna Philharmonic Orchestra-Rafael Kubelik. Recorded in the Sofiensaal, Vienna, September 1957. ℗1959

Remark & Rating
ED1, BB, 4E-1E, Rare! $$
RM12

Label Decca SXL 2105
London CS 6077 (©=STS 15057)

[Invitation to the Dance], Falla: <Three Dances from "The Three Cornered Hat" >; Ravel: <Bolero>, <Alborado del Gracioso>; Weber-Berlioz: <Invitation to the Dance>, The Paris Conservatoire Orchestra-Albert Wolff. Recorded by Kenneth Wilkinson, November 1958 in the Maison de la Chimie, Paris. ℗1959

Remark & Rating
ED1, BB, 1D-1D, $$$
RM13, (K. Wilkinson)

Label Decca SXL 2106 (©=SDD 226)
London CS 6096 (©=STS 15111)

Beethoven: <Piano Concerto No.3 in C Minor, Op.37>, <Rondo in B Flat Major>, Julius Katchen (Piano), The London Symphony Orchestra-Pierino Gamba. ℗1959

Remark & Rating
ED1, BB, 1E-2E, Rare!! $$
Penguin ★★(★)

Label **Decca SXL 2107-8*** (©=SDD 354-5, DPA 603-4)
London CSA 2204 (=CS 6075-6)

Tchaikovsky: <Swan Lake, Op.20, complete Ballet>, L'Orchestre de la Suisse Romande-Ernest Ansermet. Producer: James Walker. Recorded by Roy Wallace, October-November 1958 in the Victoria Hall, Geneva. ℗1959

Remark & Rating
ED1, 1E-2D-1E-2E, Very rare!! $$$$
RM18, Penguin ★★(★)

 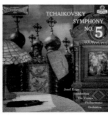

Label **Decca SXL 2109** (©=SDD 142)
London CS 6095 (©=STS 15017)

Tchaikovsky: <Symphony No.5 in E Minor, Op.64>, Josef Krips, The Vienna Philharmonic Orchestra-Josef Krips. Recorded by James Browm, September 1958 in the Sofiensaal, Vienna. ℗1959

Remark & Rating
ED1, BB, 2D-1E, rare!! $$$
RM13

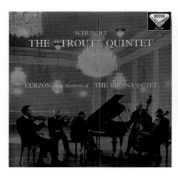

Label **Decca SXL 2110*** (©=SDD 185)
London CS 6090

Schubert: <"The Trout", Piano Quintet in A Major, D.667>, Clifford Curzon (Piano) and Members of The Vienna Octet, Willi Boskovsky (Violin), Günther Breitenbach (Viola), Nikolaus Hübner (Cello), Johann Krump (Double-Bass). Producer: John Culshaw. Recorded by James Brown in November 1957.℗1958

Remark & Rating
ED1, BB, 2D-2E, Rare!! $$$
RM18, Penguin ★★★, AS list-F

 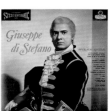

Label **Decca SXL 2111** (©=SDD 390)
London OS 25081

[Di Stefano Operatic Recital], Opera Excerpts from Giodano, Puccini, Massenet, Bizet, Gounod, Giuseppe Di Stefano (tenor) with The Tonhalle Orchestra, Zurich-Franco Patane. ℗1959

Remark & Rating
ED1, BB, 1E-1E, Rare! $$$

Label **Decca SXL 2112** (©=ECS 645)
London CS 6074 (©=STS 15056)

Weber: [Overtures], <Der Freischutz>, <Preciosa>, <The Ruler of the Spirits>, <Abu Hassan>, <Oberon>, <Euryanthe>, L'Orchestre de la Suisse Romande-Ernest Ansermet. @1959

Remark & Rating
ED1, BB, 2E-3D, Very rare! $$$
RM14

Label **Decca SXL 2113* (©=SDD 281)**
London CS 6036

Rimsky-Korsakov: <Christmas Eve (La Nuit De Noel) Suite>, <Sadko, Musical Picture>, <Flight of the Bumble Bee (Le Vol Du Bourdon) from Tale of Tsar Saltan>, <Chanson Russe (Dubinnushka)>, L'Orchestre De La Suisse Romande-Ernest Ansermet. Producer: James Walker. Recorded by Roy Wallace, May 1957 in the Victoria Hall, Geneva. ℗1958

Remark & Rating
ED1, BB, 1K-2K, Very rare!! $$$$
RM16, Penguin ★★★

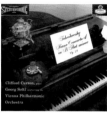

Label **Decca SXL 2114* (©=SDD 191)**
London CS 6100 (©=STS 15471)

Tchaikovsky: <Piano Concerto No.1 in B Flat Major>, Clifford Curzon (Piano), The Vienna Philharmonic Orchestra-Georg Solti. Recorded by James Brown, October 1958 in the Sofiensaal, Vienna. ℗1959 (℗ by John Culshaw)

Remark & Rating
ED1, BB, 2E-1D, Rare! $$
Penguin ★★(★)

Label **Decca SXL 2115 (©=SDD 470)**
London CSA 2302, [CSA 2302-1=CS 6103]

Handel: <Organ Concertos Volume 1, Nos. 1, 2, 3,4>, Karl Richter (organ) with Chamber Orchestra directed by Karl Richter. Recorded by Martin Fouqué, July 1958 at the Markuskirche, Munich. ℗1959

Remark & Rating
ED1, BB, 1E-1E, Rare!! $$ (Last BB in this series)
RM14, Penguin ★★(★)

Label **Decca SXL 2116 (©=SDD 104; ECS 671)**
London CS 6070 (©=STS 15055)

Beethoven: <Symphony No.4 in B Flat Major, Op.60>, <Coriolan Overture, Op.62>, L'Orchestre de la Suisse Romande-Ernest Ansermet. Recorded by Roy Wallace, October 1958 in the Victoria Hall, Geneva. ℗1958

Remark & Rating
ED1, 1E-3E, $$+
RM15

Label **Decca SXL 2117-20 (©=GOS 604-6)**
London OSA 1401

Mozart: <Don Giovanni>, Suzanne Danco, Lisa Della Casa, Hilde Gueden, Anton Dermota, Cesare Siepi, Fernando Corena, Kurt Boehme, Walter Berry, The Chorus of the Vienna State Opera & Vienna Philharmonic Orchestra-Josef Krips (29 pages Booklet). Recorded in Redoutensaal & Konzerthaus,Vienna, 1955. ℗1958

Remark & Rating
ED1, 3E-2E-3D-1K, Very rare!!! $$$$
Penguin ★★★

Label **Decca SXL 2121**
London CS 6093 (=CS 6777)

Beethoven: <Symphony No.7 in A Major, Op.92>, The Vienna Philharmonic Orchestra-Georg Solti. Recorded by James Brown, October 1958 in the Sofiensaal, Vienna. ℗1959

Remark & Rating
ED1, 3K-2K, $+
RM13

Label **Decca SXL 2122**
London OS 25021

[Great Tenor Arias], Mario Del Monaco Recital No.4. Verdi: <Un Ballo In Maschera>, <Ernani>; Giordano: <Fedora>; Zandonai: <Giulietta e Romeo>; Puccini: <Madama Butterfly>; Massenet: <Le Cid>; Bizet: <Carmen>; Meyerbeer: (L'Africaine>; Donizetti: <Lucia De Lammermoor>, New Symphony Orchestra of London-Alberto Erede. Recorded in 1956. @1959

Remark & Rating
ED1, 3E-5E, rare! $

Label **Decca SXL 2123**
London OS 25139

[Virginia Zeani Puccini Arias]: <Gianni Schicchi>, <Turandot>, <La Boheme>, <Madama Butterfly>, <Suor Angelica>, <Manon Lescaut>, <Tosca>, <La Rondine>, Virginia Zeani (soprano) with Orchestra of the Accademia Di Santa Cecilia, Rom-Franco Patane. @1959

Remark & Rating
ED1, 2D-2D, (Pancake), Very rare! $$+

Label **Decca SXL 2124**
London CS 6092

Beethoven: <Symphony No.5 in C Minor "Fate", Op.67>, The Vienna Philharmonic Orchestra-Georg Solti. Recorded by James Brown, September 1958 in the Sofiensaal, Vienna. ℗1959

Remark & Rating
ED1, 1K-1K, rare!! $$
RM14

Label **Decca SXL 2125 (5BB 130-1, ©=SDD 186)**
London CSA 2301, (3-1 =CS 6071 ©=STS 15366-7)

J.S. Bach: <Brandenburg Concertos, No.1 in F Major & No.6 in B flat Major> Volume 1, Stuttgart Chamber Orchestra-Karl Münchinger. Recorded by Roy Wallace, October 1958 in the Victoria Hall, Geneva. @1959 [= London CS 6071, No single issue, one of the London 3-LP Box Set CSA 2301]

Remark & Rating
ED1, 1E-2E, $$
RM16

Label **Decca SXL 2126 (5BB 130-1, ©=SDD 187)**
London CSA 2301, (3-2 =CS 6072 ©=STS
15366-7)

J.S. Bach: <Brandenburg Concertos, No.2 in F Major & No.5 in D Major> Volume 2, Stuttgart Chamber Orchestra-Karl Münchinger. Recorded by Roy Wallace, October 1958 in the Victoria Hall, Geneva. @1959 [= London CS 6072, No single issue, one of the London 3-LP Box Set CSA 2301]

Remark & Rating
ED1, 1E-1E, $$
RM16

Label **Decca SXL 2127 (5BB 130-1, ©=SDD 188)**
London CSA 2301, (3-3 =CS 6073 (©=STS
15366-7)

J.S. Bach: <Brandenburg Concertos, No.3 in G Major & No.4 in G Major> Volume 3, Stuttgart Chamber Orchestra-Karl Münchinger. Recorded by Roy Wallace, October 1958 in the Victoria Hall, Geneva. @1959 [= London CS 6073, No single issue, one of the London 3-LP Box Set CSA 2301]

Remark & Rating
ED1, 1E-1E, $$
RM16

Label **Decca SXL 2128* (©=SDD 125, SPA 384)**
London CS 6098 (©=STS 15010)

Adolphe Adam: <Giselle - Ballet>, The Paris Conservatoire Orchestra-Jean Martinon. Recorded by Kenneth Wilkinson, November 1958 in the Maison de la Chimie, Paris. ℗1959

Remark & Rating
ED1, 1E-1E, rare! $$+
RM16, TAS 61-127++, Penguin ★★★ (SPA 384), AS List-H, (K. Wilkinson)

Label **Decca SXL 2129-31 (©=GOS 614-6)**
London OSA 1304

Verdi: <Il Trovatore>, Del Monaco, Tebaldi, Simionato, Tozzi, The Chorus of Maggio Musicale Fiorentino & Orchestra Suisse Romande-Alberto Erede. (21 pages Booklet) ℗1959

Remark & Rating
ED1, 1E-1E-1E-1K-2E-3E, Very rare!! $$+

Label **Decca SXL 2132 (©=SDD 224)**
London OS 25106

[Berganza Sings Rossini], <Il barbiere di Siviglia>, <L'italiana in Algeri>, <Stabat Mater>, <Semiramide>, <La Cenerentola>. Teresa Berganza with London Symphony Orchestra-Alexander Gibson. Recorded by Kenneth Wilkinson, February 1959 in Walthamstow Assembly Hall, London. ©1959

Remark & Rating
ED1, 1E-1E, $$
Penguin ★★★, (K. Wilkinson)

Label Decca SXL 2133 (SXL 2022-3)
 London OS 25077 (OSA 1205)

Lehar: <The Merry Widow, Highlights>, Hilde Gueden, Per Grunden, Waldemar Kmentt, Emmy Loose & Karl Donch. Chorus & Orchestra of Vienna State Opera-Robert Stolz. Recorded by Kenneth Wilkinson, March 1958 in the Sofiensaal, Vienna. ℗1959

Remark & Rating
ED1, 1K-1K, Pancake, $
Penguin ★★(★), (K. Wilkinson)

Label Decca SXL 2134 (©=SDD 217)
 London CS 6101 (©=STS 15031)

Berlioz: Overtures <Le Carnaval Romain, Op.9>, <Benvenuto Cellini, Op.Op.23>, <Beatrice Et Benedict>, <Le Corsaire, Op.21> & <Rackoczy March From "La Damnation De Faust" Op.24>, The Paris Conservatoire Orchestra-Jean Martinon. Recorded by Kenneth Wilkinson, November 1958 at La Maison de la Chimie, Paris. ℗1959 ©1960

Remark & Rating
ED1, 1K-1K, Very rare!! $$$
RM15, (K. Wilkinson)

Label Decca SXL 2135 (©=SDD 122, 331, part)
 London CS 6107 (©=STS 15087)

Mozart: <Symphony No.32 in C Major, K.318>, <No.38 in D Major "Prague", K.504> The London Symphony Orchestra-Peter Maag. Recorded by Kenneth Wilkinson, January 1959 in Kingsway Hall, London. ℗ ©1959 [2 kinds of ED1 Cover, original ED1 with Flipback Scalloped Sleeve]

Remark & Rating
ED1, 1E-1E, (2M-3M), Very rare!!! $$$+ - $$$$
RM14, (K. Wilkinson)

Label Decca SXL 2136* (©=SDD 293, 373)
 London CS 6079 (©=STS 15042)

Debussy: <La Boite a Joujoux-Children's Ballet>, <Printemps-Symphonic Suite>, L'Orchestre de la Suisse Romande-Ernest Ansermet. Producer: James Walker. Recorded by Roy Wallace, May 1957 in the Victoria Hall, Geneva. ℗1959

Remark & Rating
ED1, 1E-3E, Very rare!! $$$$
RM20, Penguin ★★★

Label **Decca SXL 2141* (©=ECS 642)**
London CS 6116 (©=STS 15108)

Glazunov : <The Seasons, Op.67 - Complete Ballet>, The Paris Conservatoire Orchestra-Albert Wolff. ℗1959 by John Culshaw ©1960

Remark & Rating
ED1, 1M-1M, Very rare!!! $$$
RM13, Penguin ★★(★)

Label **Decca SXL 2145 (©=SDD 209)**
London OS 25103

[Kirsten Flagstad Sings Songs From Norway], Songs from Grieg; Alnes; Lie & Eggen, The London Symphony Orchestra-Øivin Fjeldstad. Recorded by Gordon Parry, January 1959 in Walthamstow Assembly Hall, London. ℗1959 by John Culshaw ©1960

Remark & Rating
ED1, 1E-1E, Very rare!! $$$

Label **Decca SXL 2150-2**
London OSA 1305

Britten: <Peter Grimes, Opera in 3 acts and a prologue>, Peter Pears, Claire Watson, Lauris Elms, James Pease, David Kelly, Owen Brannigan, with other supporting soloists, Royal Opera House Orchestra, Covent Garden-Benjamin Britten (12 pages Booklet). Recorded by Kenneth Wilkinson, December 1958 in Walthamstow Town Hall. ℗1959 (Highlights=SXL 2309)

Remark & Rating
ED1, pancake, rare!! (ED1, Box SET, 9L-6E-8L-11L-5E-8L, $$)
TAS2016, Penguin ★★★(❀), G.Top 100, (K. Wilkinson)

Label **Decca SXL 2153 (SXL 2107-8, ©=SDD 257)**
London CS 6127 (CSA 2204, ©=STS 15598)

Tchaikovsky: <Swan Lake, Op.20, Ballet Highlights>, L'Orchestre de la Suisse Romande-Ernest Ansermet. Producer: James Walker. Recorded by Roy Wallace, October-November 1958 in the Victoria Hall, Geneva. ℗ ©1959

Remark & Rating
ED1, 2E-1E, $$+
RM18, Penguin ★★(★)

Label **Decca SXL 2154 (©=SDD 175)**
London CS 6129 (©=STS 15083)

Richard Strauss: <Also Sprach Zarathustra, Op.30>, Solo violin-Willi Boskovsky, The Vienna Philharmonic Orchestra-Herbert von Karajan. ℗1959 ©1960

Remark & Rating
ED1, 3E-2E, (3D-1K), Very rare!!! $$$
RM12, Penguin ★★(★)

Label **Decca SXL 2155* (©=ECS 670)**
London CS 6134

Lalo: < Symphony Espagnole, Op.21>; Ravel: <Tzigane (1924)>, Ruggiero Ricci (violin), L'Orchestre De La Suisse Romande-Ernest Ansermet. ℗1959 ©1960

Remark & Rating
ED1, 2E-2D, Very rare!! $$$$$
RM12

Label **Decca SXL 2156 (©=SDD 130)**
London CS 6131 (©=STS 15061)

Schubert: <Symphony No.8 in B Minor "The Unfinished", D.759>, <Symphony No.2 in B Flat, D.125>, The Vienna Philhamronic Orchestra-Karl Münchinger. ℗1959

Remark & Rating
ED1, 3E-1E, $$
RM12

Label **Decca SXL 2157 (©=SDD 200)**
London CS 6132 (©=STS 15361)

Beethoven: <Septet in E Flat Major, Op. 20>, Willi Boskovsky (violin), G. Breitenbach (viola), N. Hübner (violoncello), J. Krump (double bass), A. Boskovsky (clarinet), J. Veleba (horn), R. Hanzl (bassoon), Members of the Vienna Octet. Recorded by James Brown, December 1959 in the Sofiensaal, Vienna. ℗1959 ©1960

Remark & Rating
ED1, 1E-3M, Rare! $$
RM18, Penguin ★★★

Label **Decca SXL 2158 (©=SDD 256)**
London CS 6063 (©=STS 15053)

Beethoven: <Quintet in E Flat Major, Op.16>*; Spohr: <Octet in E Major>**, Walter Panhoffer (Piano), Members Of The Vienna Octet. Recorded by James Brown, * June 1957 & ** March 1959 in the Sofiensaal, Vienna. ℗1960

Remark & Rating
ED1,1D-1E, Rare! $$
RM16, Penguin ★★★

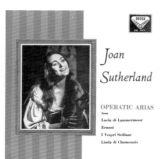

Label **Decca SXL 2159 (©=SDD 146, JB 97)**
London OS 25111

[Joan Sutherland - Operatic Arias], Donizetti: <Lucia di Lammermoor>*, <Linda di Chamounix>*, Verdi: <Ernani>, <I Vespri Siciliani>, Orchestra of the Accademia Di Santa Cecilia, Rom-John Pritchard. Recorded by Kenneth Wilkinson, April 1959 at La Maison de la Chimie, Paris. @1959 *[Donizetti: Penguin ★★★(✸)]

Remark & Rating
ED1, 2E-2E
Penguin ★★★(✸), (K. Wilkinson)

Label **Decca SXL 2160-2* (©=SDD 301-3)**
London CSA 2304 (=CS 6135-7)

Tchaikovsky: <Sleeping Beauty, Op.66>, L'Orchestre de la Suisse Romande-Ernest Ansermet. Recorded by Roy Wallace, March & April 1959 in the Victoria Hall, Geneva. @1959

Remark & Rating
ED1, 1E-2E-1E-1E-1E-1E, Very rare!! $$$
RM14, Penguin ★★(★), Japan 300

Label **Decca SXL 2163 (©=SDD 474)**
London CS 6149 (©=STS 15268)

[Vienna Carnival], Johann Strauss: <Eljen a Magyar!>, <Banditen Polka>, <Künstlerleben>, <Unter Donner und Blitzen>, <Morgenblatter>; Josef Strauss: <Sphärenklänge>, <Plappermäulchen>, <Mein Lebenslauf ist Lieb' und Lust>, The Vienna Philharmonic Orchestra-Willi Boskovsky. Recorded by James Brown, September 1958 in the Sofiensaal, Vienna. ℗1959 ©1960

Remark & Rating
ED1, 1E-2E, $
RM14, Penguin ★★★

Label **Decca SXL 2164* (©=SDD 170)**
London CS 6147 (©=STS 15090)

Ravel: <Daphnis et Chloe (Complete Ballet)>, London Symphony Orchestra & Chorus of Rotal Opera House, Convent Garden-Pierre Monteux. Producer: John Culshow, Recorded by Alan Reeve, April 1959 in Kingsway Hall, London. ℗1959 ©1960

Remark & Rating
ED1, 2K-2K, $$
RM19, Penguin ★★★(✿), G.Top 100, AS list-F

Label **Decca SXL 2165 (©=SDD 103)**
London CS 6145 (=CS 6778)

Beethoven: <Symphony No.3 in E Flat Major "Eroica", Op.55>, The Vienna Philharmonic Orchestra-Georg Solti. ℗1959 ©1960

Remark & Rating
ED1, 3E-3D, $+
RM12

Label **Decca SXL 2166 (©=SDD 131)**
London CS 6150 (©=STS 15016)

Tchaikovsky: <Symphony No.4 in F Minor, Op.36>, The Paris Conservatoire Orchestra-Albert Wolff. Recorded by Kenneth Wilkinson, May 1959 in La Maison de la Chimie, Paris. ℗1959 ©1960

Remark & Rating
ED1, 1E-1E, rare!! $$$+
(K. Wilkinson)

Label **Decca SXL 2167-9**
 London OSA 1313

Verdi: <Aiida>, Renata Tebaldi (soprano), Giulietta Simionato (mezzo-soprano), Carlo Bergonzi (tenor), Cornell MacNeil (baritone), Arnold Van Mill (bass), with supporting soloists, Singverein der Gesellschaft der Musikfreunde and The Vienna Philharmonic Orchestra-Herbert von Karajan (32 pages Booklet). Produced by John Culshow & recorded by James Brown, September 1959 in the Sofiensaal, Vienna. ℗1959

Remark & Rating
ED1, $$
TASEC44, Penguin ★★★, AS list-H, Japan 300-CD

Label **Decca SXL 2170-1 (=Decca D5D 2)**
 London OSA 1208

Puccini: <La Boheme>, Renata Tebaldi, Gianna d'Angelo (sopranos), Carlo Bergonzi (tenor), Ettore Bastianini (baritone), Cesare Siepi (bass), Chorus & Orchestra of the Accademia di Santa Cecilia Rome-Tullio Serafin (32 pages Booklet). Recorded by Roy Wallace, August 1959 in Rome. ℗1959

Remark & Rating
ED1, $$$
Penguin ★★(★)

Label **Decca SXL 2172 (©=SDD 137, SPA 385)**
 London CS 6151

Brahms: <Piano Concerto No.1 in D Minor, Op.15>, Julius Katchen (piano), The London Symphony Orchestra-Pierre Monteux. ℗1960

Remark & Rating
ED1, 1D-2D, $$
RM14, (K. Wilkinson)

Label **Decca SXL 2173***
 London CS 6157 (©=STS 15407)

Grieg: <* Piano Concerto in A Minor, Op.16>, London Symphony Orchestra-Øivin Fjeldstad; Franck: <** Variations Symphoniques>; Litolff: <*** Scherzo from Concerto Symphonique No.4, Op.102>, Clifford Curzon (piano), London Philharmonic Orchestra-Adrian Boult. Recorded by *Alan Reeve, **James Brown & ***Kenneth Wilkinson, *1955, **1959 in Kingsway Hall & ***1958 in Walthamstow Assembly Hall, London. ℗1960 (℗ by John Culshaw)

Remark & Rating
ED1, 4D-2D, $
RM16, Penguin ★★★, AS-DG list (Speakers Corner)

Label **Decca SXL 2174* (©=SDD 194; SPA 374)**
 London CS 6146 (reissue=CS 6779)

Suppe: Overtures <Light Cavalry>, <Poet and Peasant>, <Pique Dame>, <Morning, Noon and Night in Vienna>, The Vienna Philharmonic Orchestra-Geor Solti. ℗1959 ©1960

Remark & Rating
ED1, 1E-2E, $+
RM16, Penguin ★★(★), AS list (Speakers Corner)

Label **Decca SXL 2175 (SXL 2078-80)**
London OS 25193 (OSA 1308)

Puccini:<Turandot, Highlights>, Renate Tebaldi, Mario del Monanco, Inge Borkh, Gaetano Fanelli, Chorus & Orchestra of The Accademia di Santa Cecilia, Rome-Alberto Erede. ℗1959 ©1960 (Highlights from SXL 2078-80 & OSA 1308)

Remark & Rating
ED1, 2S-2S

Label **Decca SXL 2176 (©=SDD 428; SPA 505)**
London CS 6153 (©=STS 15046)

Rachmaninov: <Rhapsody On A Theme of Paganini, Op.43>, Dohnanyi: <Variations On A Nursery Tune>, Julius Katchen (piano), London Philharmonic Orchestra-Adrian Boult. Recorded by Kenneth Wilkinson, 1959 in Kingsway Hall, London. ℗1959 ©1960

Remark & Rating
ED1, 2G-2G, $$
RM15, Penguin ★★★, R2D4, (K. Wilkinson)

Label **Decca SXL 2177 (©=SDD 452)**
London CS 6154 (©=STS 15362)

Wolf-Ferrari: [Music from Wolf-Ferrari (Jewels Of Wolf-Ferrari)], <Overeture- Susana's Secret>, <Overeture- La dama boda>,<Intermezzo- The Campiello>, <The School for Father> & <Orchestral Suite- The jewels of the Madonna>, Paris Conservatoire Orchestra-Nello Santi. ℗1959 ©1960

Remark & Rating
ED1, 2E-2E, $+
RM16, Penguin ★★(★)

Label **Decca SXL 2178 (=London CS 6099 & 6188, (©=SPA 401)**

Beethoven: <Piano Concerto No.1 in C Major, Op.15> & <Piano Concertos No.2 In B-Flat Major, Op.19>, Wilhelm Backhaus (piano), The Vienna Philharmonic Orchestra-Hans Schmidt-Isserstedt. ℗1959

Remark & Rating
ED1, 1E-1E, $$
RM15 & 16, Penguin ★★(★)

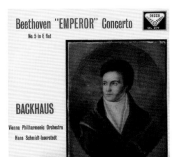

Label **Decca SXL 2179 (©=SPA 452)**
London CS 6156

Beethoven: <Piano Concerto No.5 in E Flat Major, Op.73 "Emperor">, Wilhelm Backhaus (piano), The Vienna Philharmonic Orchestra-Hans Schmidt-Isserstedt. Recorded by James Brown, June 1959 in the Sofiensaal, Vienna. ℗1959 ©1960

Remark & Rating
ED1, 2E-2E, $$
Penguin ★★★

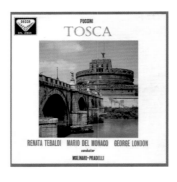 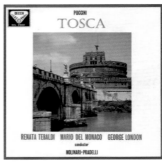

Label **Decca SXL 2180-1**
 London OSA 1210

Puccini: <Tosca, Complete Opera>, Renata Tebaldi (soprano), Mario Del Monaco (tenor), George London (bass-baritone), Silvio Maionica (bass), Fernando Corena (bass), Piero De Palma (tenor), Giovanni Morese (bass) & Ernesto Palmerini. Chorus & The Orchestra of the Accademia Di Santa Cecilia-Francesco Molinar Pradelli (24 pages Booklet). ℗1960 [(ED1 : Red, Green & White Wallet Folder]

Remark & Rating
ED1, 2E-2E-2E-2E, rare!! $$+-$$$

Label **Decca SXL 2182**
 London CS 6089 (=STS 15030)

Rossini: Overtures <William Tell>, <La Cenerentola>, <Semiramide>, <La Gazza Ladra>, The Paris Conservatoire Orchestra-Peter Maag. ℗1959 ©1960

Remark & Rating
ED1, 1D-2E, Very rare! $$$+
RM16, AS list-H (STS 15030)

Label **Decca SXL 2183**
 London CS 6106 (©=STS 15123)

Liszt: Piano Music <Polonaise No.1 in C Minor>, <Polonaise No. 2 in E Major>, <"Dante" Sonata (Après une Lecture du Dante)>, <Consolations Nos.1-6>, Peter Katin (piano). Recorded at Decca Studio 1, West Hampstead, December 1958. ℗1959 ©1960

Remark & Rating
ED1, 5E-2E, Very rare! $$
RM16

Label **Decca SXL 2184**
 London OS 25138

Wagner: [Birgit Nilsson, excerpts from Tristan Und Isolde], <Act 1: Prelude>, <Act 2: Mild Und Leise (Liebestod)>,-<Act 1, Scene 3: Weh, Ach Wehe! Dies Zu Dulden>. Brigit Nilsson (soprano); Grace Hoffman (mezzo-soprano) with The Vienna Philharmonic-Hans Knappertsbusch. ℗1959 ©1960

Remark & Rating
ED1, 1E-1E, rare! $$
Penguin ★★(★)

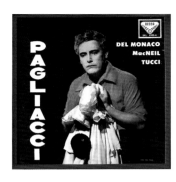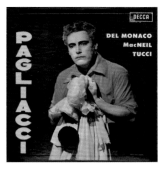

Label Decca SXL 2185-6 (Part of SXL 2253-5)
 London OSA 1212 (Part of OSA 1330)

Leoncavallo: <I Pagliacci, complete opera>, Mario del Monaco (tenor), Cornell MacNeil (baritone), Gabriella Tucci (soprano), Renato Capecchi (baritone) and Piero de Palma (tenor). Orchestra and Chorus of the Accademia di Santa Cecilia, Rome-Francesco Molinari-Pradelli. (12 pages Booklet) @1960 (=Part of SXL 2253-5 & OSA 1330) [Plastic Wallet gatefold sleeve- ED1, Box Set- ED1 & ED2]

Remark & Rating
ED1, 1E-1E-1E-1E, $$$ (Wallet or Box Set)
Japan 300

Label Decca SXL 2187 (©=SDD 471)
 London CSA 2302, [CSA 2302-1=CS 6104]

Handel: <Organ Concertos Volume 2, Opus 4, Nos. 5, 6, 7, 8>, Karl Richter (organ) with Chamber Orchestra directed by Karl Richter. Recorded by Martin Fouqué, July 1958 at the Markuskirche, Munich. ℗1959

Remark & Rating
ED1, 1D-1D
RM14, Penguin ★★(★)

Label Decca SXL 2188 (©=SDD 136, ECS 776)
 London CS 6138 (©=STS 15011)

Stravinsky: <Song of Nightingale-Symphonic Poem>, <Pulcinella Suite>, L'Orchestre de la Suisse Romande-Ernest Ansermet. Recorded by Kenneth Wilkinson, December 1959. ℗1959 ©1960

Remark & Rating
ED1, 2E-2E, Very rare!! $$$
RM16, Penguin ★★★, (K. Wilkinson)

Label Decca SXL 2189
 London CS 6179

Britten: <Nocturne, Op.60>, Peter Pears with the Strings of the London Symphony Orchestra, <4 Sea Interludes & Passacaglia from Peter Grimes, Op.33>, The Orchestra of the Royal Opera House, Covent Garden-Benjamin Britten. Producer: James Walker. Recorded by Alan Reeve in Walthamstow Town Hall, September 1959. @1960

Remark & Rating
ED1, 1E-1E, $$
RM19, Penguin ★★★, TAS2016, AS List-H

Label **Decca SXL 2190 (©=SPA 402)**
London CS 6094

Beethoven: <Piano Concerto No.3 in C Minor, Op.37>, <**Sonata No.14 In C Sharp Minor, Op. 27, No. 2 ("Moonlight")>, Wilhelm Backhaus (piano), The Vienna Philharmonic Orchestra-Hans Schmidt-Issersetedt. ℗1959 ©1960 (**Sonata No. 14 is Penguin ★(★), not in CS 6094)

Remark & Rating
ED1, 1E-1E, $$+
RM14, Penguin ★★(★)

Label **Decca SXL 2191 (©=SDD 360)**
London OS 25896

[Recital of Lute Songs], Peter Pears (tenor) with Julian Bream (lute). ©1960

Remark & Rating
ED1, 1E-1E, Rare! $

Label **Decca SXL 2192 (SXL 2094-6)**
London OS 25083 (OSA 1307)

Boito: <Mefistofele, Highlights>, "Prologue in heaven", "Dai prati, dai campi", "Son lo spirito che nega", "Dlmmi, se credi, Enrico", " Colma il tuo cor", "Ecco il mondo", etc., Cesare Siepi (bass), Renata Tebaldi (soprano), Mario Del Monaco (tenor), Chorus & Orchestra of The St. Cecilia Academy, Rome-Tullio Serafin. Recorded by Roy Wallace, 1958 in Rome. ℗1958 ©1960 (**Highlights from SXL 2094-6 & OSA 1307. Another selected highlights published later in 1973 from this recording is Decca SET 558 = OS 26274)

Remark & Rating
ED1, 1K-1K, $+

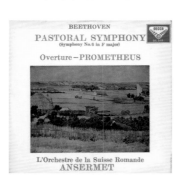

Label **Decca SXL 2193 (©=SDD 106)**
London CS 6160 (©=STS 15064)

Beethoven: <Symphony No.6 in F Major "Pastoral", Op.68>, <Prometheus Overture, Op.43>, L'Orchestre de la Suisse Romande-Ernest Ansermet. Recorded by Roy Wallace, October 1959 in the Victoria Hall, Geneva. ℗1959

Remark & Rating
ED1, 1E-1E, $+
RM13

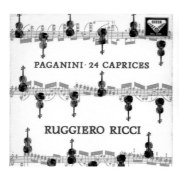

Label **Decca SXL 2194 (©=ECS 803)**
London CS 6163

Paganini: <24 Caprices Op.1, Nos. 1-24, for unaccompanied violin>, Ruggiero Ricci (violin). Recorded by Roy Wallace at Victoria Hall, Geneva, April 1959. @1960

Remark & Rating
ED1, 2E-2E, Very rare!!! $$$ - $$$$
RM16, Penguin ★★★

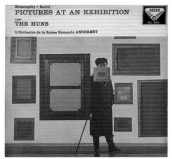

Label **Decca SXL 2195 (©=SPA 229)**
 London CS 6177

Mussorgsky-Ravel: <Pictures at an Exhibition>; Liszt: <The Huns>, L'Orchestre de la Suisse Romande-Ernest Ansermet. Recorded by Roy Wallace, 1959 in Victoria Hall, Geneva. ℗1960

Remark & Rating
ED1, 1E-1E, $$$
RM13

Label **Decca SXL 2196* (©=SDD 171; ECS 740; SPA 550)**
 London CS 6133 (©=STS 15088)

Mozart: <Notturno in D Major for 4 Orchestras, K.286>, <Serenada Notturna in D Major, K.239>, <Overture to "Lucio Silla", K.135>, <Interludes from "King Thamos", K.345>, The London Symphony Orchestra-Peter Maag. Recorded by Kenneth Wilkinson, December 1959 in Walthamstow Assembly Hall, London ℗1960

Remark & Rating
ED1, 1E-2E, $$$
RM19, Penguin ★★★, (K. Wilkinson)

Label **Decca SXL 2197* (©=SDD 420; ECS 808; DPA 629)**
 London CS 6165

Bizet-Sarasate: <Carmen Fantasy, Op.25>; Sarasate: <Zigeunerweisen, Op.20, No.1>; Saint-Saëns: <Havanaise, Op.83>, <Introduction & Rondo Capriccioso, Op.28>, Ruggiero Ricci (violin), London Symphony Orchestra-Pierino Gamba. Recorded by Alan Reeve, September 1959 in Kingsway Hall, London. ℗ ©1960

Remark & Rating
ED1, 2E-1E, Very rare & expensive !!! $$$$$
RM16, AS list-H

Label **Decca SXL 2198* (©=DPA 549-50, part)**
 London CS 6182

[Philharmonic Ball], Johan Strauss: <Auf der Jagd>, <Frühlingstimmen>, <Blue Danube>, <Egyptian March>, <Perpetuum Mobile>; Josef Strauss: <Delirien>, <Pizzicato Polka>, <Ohne Sorgen>, <Transaktionen>. The Vienna Philharmonic Orchestra-Willi Boskovsky. Producer: John Culshaw. Recorded by Christopher Raeburn, April & September 1959. ℗ ©1960

Remark & Rating
ED1, 1E-1E, $
RM18, Penguin ★★★

Label **Decca SXL 2199**
 No London CS

[The Instruments of the Orchestra], Side one: The Strings, The Bass; Side two: The Woodwind, The Percussion. Arranged, presented and accompanied by Sir Malcolm Sargent (16 pages booklet). Recorded by Arthur Bannister, December 1959 at the Decca Studios (West Hampstead Studio 1), London. ℗ ©1960

Remark & Rating
ED1, 2E-2E, Rare!! $$

Label **Decca SXL 2200**
London OS 25155

Schubert: <Die Schöne Müllerin, Op.25, D.795>, Peter Pears (tenor) and Benjamin Britten (piano). ℗ ©1960

Remark & Rating
ED1, 2E-2E, Rare! $
Penguin ★★★

Label **Decca SXL 2201 (©=SDD 472)**
London CSA 2302, [CSA 2302-1=CS 6105]

Handel: <Organ Concertos Volume 3, Nos 9, 10, 11, 12>, Karl Richter (organ) with Chamber Orchestra directed by Karl Richter. Recorded by Martin Fouqué, July 1958 at the Markuskirche, Munich. ℗1959 ©1960

Remark & Rating
ED1, 1D-1D
RM14, Penguin ★★(★)

Label **Decca SXL 2202 (SXL 2054-6)**
London OS 25084 (OSA 1314)

Puccini: <Madam Butterfly-Highlights>, Renata Tebaldi, Carlo Bergonzi, Fiorenza Cossotto, Chorus & Orchestra of The St.Cecilia Academy, Rome-Tullio Serafin. Recorded July 1958 in Rom. ℗1958 ©1960 (Highlights from SXL 2054-6 & OSA 1314)

Remark & Rating
ED1,1E-1D

Label **Decca SXL 2204* (©=SDD 310)**
London CS 6142 (©=STS 15063)

J.S. Bach: "Musical Offering, (arranged by Münchinger)", <Ricercare a 3, Canons>, <Trio-Sonata>, <Ricercare a 6>, Stuttgart Chamber Orchestra-Karl Münchinger. Recorded by James Brown, September 1959 in the Sofiensaal, Vienna. @1960

Remark & Rating
ED1, 1E-1E, rare! $$+
RM15, Penguin ★★(★)

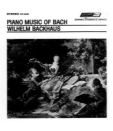

Label **Decca SXL 2205 (©=Decca 16.41387, Germany)**
No London CS (=London STS 15065)

J.S. Bach: [Piano Recital], <English Suite No.6 in D Minor, BWV 811>,< French Suite No.5 in G Major, BWV 816>, <Prelude and Fugue in G Major, Book I, No.15 of "Das Wohltemperierte Klavier ", BWV 860>, <Prelude and Fugue in G Major, Book II, No.39 of "Das Wohltemperierte Klavier", BWV 884>. Wilhelm Backhaus (piano). ℗1958 [* London issue is Treasure series STS 15065, No CS issue]

Remark & Rating
ED1, 1M-2M, Very rare!! $$$$+

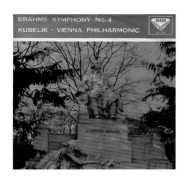 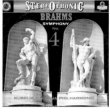

Label Decca SXL 2206 (©=SDD 120)
 London CS 6170 (©=STS 15004)

Brahms: <Symphony No.4 in E Minor, Op.98>, The Vienna Philharmonic Orchestra-Rafael Kubelik. Recorded in Sofiensaal,Vienna, 1956. @1960

Remark & Rating
ED1, 1E-1E, $$
RM13

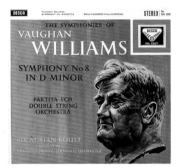

Label Decca SXL 2207 (©=SDD 199; ECS 644)
 London CS 6078 (©=STS 15216)

Vaughan Williams: *<Symphony No.8, in D Minor>, **<Partita For Double String Orchestra>, The London Philharmonic Orchestra-Adrian Boult. Recorded by Kenneth Wilkinson, *September & **November 1956 in Kingsway Hall, London. ℗1959

Remark & Rating
ED1, 1D-1D, Rare! $$
RM16, Penguin ★★(★), (K. Wilkinson)

Label Decca SXL 2208-10 (©=GOS 600-1)
 London OSA 1303

Giordano: <Andrea Chenier>, Renata Tebaldi; Mario Del Monaco; Ettore Bastianini; Fernando Corena, Chorus & Orchestra of The St. Cecilia Academy, Rome-Gianandrea Gavazzeni (20 pages Booklet). Recording by Roy Wallace,1957 in Rome. ℗1958

Remark & Rating
ED1, 1E-2K-2K-3E-1E-2E, (Box Set & Wallet), rare! $$ - $$$
Penguin ★★★

Label Decca SXL 2211 (©=SDD 154)
 No London CS

Faure: <Requiem>, Suzanne Danco (soprano), Gerard Souzay (baritone) with L'Union Chorale De La Tour De Peilz-Robert Mermoud (chorus master) and L'Orchestre De La Suisse Romande-Ernest Ansermet. Recording by Roy Wallace, October 1955 in the Victoria Hall, Geneva. ℗1960

Remark & Rating
ED1, 1M-1M, $$

Label **Decca SXL 2212*** (©=SDD 168)
No London CS

Ravel: <L'Enfant Et Les Sortilèges>, The Motet Choir of Geneva-Jacques Horneffer (chorus master) and L'Orchestre De La Suisse Romande-Ernest Ansermet. ℗1960

Remark & Rating
ED1, 1D-1D, Very rare!! $$$+
Penguin ★★(★), AS List (Speakers Corner)

Label **Decca SXL 2213**
London OS 25122

[Cesare Siepi Operatic Arias], Punchielli: <La Gioconda>, Boito: <Mefistofele>, Rossini: <Il Barbiere Di Siviglia>, Verdi: <La Forza Del Destino>, Cesare Siepi (Bass), Giulietta Simionato (Mezzo Soprano), Renata Tebaldi (Soprano). ©1960

Remark & Rating
ED1, 3M-4M, rare!! $$+

Label **Decca SXL 2214** (©=SDD 116)
London CS 6141 (©=STS 15062)

Mozart: <Piano Concerto No.27 in B Flat Major, K.595>, <Sonata No.11 in A Major "Alla Turca", K.331>, Wilhelm Backhaus (piano), The Vienna Philharmonic Orchestra-Karl Bohm. @1960

Remark & Rating
ED1, 1D-2D, Very rare!! $$$$+
RM10, Penguin ★★(★), Japan 300

Label **Decca SXL 2215-7** (©=GOS 501-3; SDD 218)
No London CS, (©=London SRS 63507)

Mozart: <Die Zauberflöte, (The Magic Flute)>, Hilde Gueden; Wilma Lipp; Emmy Loose; Leopold Simoneau; Walter Berry; Kurt Böhme, Vienna State Opera Chorus & Vienna Philharmonic Orchestra-Karl Böhm. Recorded by James Brown, May 1955 in the Redoutensaal, Vienna. (16 pages Booklet) ℗ 1960 *[DECCA reissue is Ace of Diamond GOS 501-3; German issue is SAD 2219-11 T; London issue only in Richmond Opera Treasury Series SRS 63507 & London OS 25046 (highlights)]

Remark & Rating
ED1, 1E-1E & 1E-2E, Very rare!!! (Red,White, plastic wallet & Box set) $$$$$

Label Decca SXL 2218*
London CS 6187

Prokofiev: <Peter and the Wolf>, with Beatrice Lillie; Saint-Saëns: *<Carnival of the Animals>, Julius Katchen (piano), London Symphony Orchestra condcted by Skitch Henderson. Producer: John Culshaw. Recorded by Kenneth Wilkinson, February 1960 in Kingsway Hall, London. @1960 (* Carnival of the Animals in AS list)

Remark & Rating
ED1, 3M-3E, Very rare! $$
RM18, *AS List (Speakers Corner), (K. Wilkinson)

Label Decca SXL 2219 (©=SDD 258)
London CS 6172 (part) & CS 6173 (part)

[Bach Organ Recital], Bach: <Toccata & Fugue in D Minor, BWV 565>, <Fantasia and Fugue in G Minor, BWV 542>, <Prelude and Fugue in E Minor, BWV 548>, <Passacalia & Fugue in C Minor, BWV 582>, Karl Richter at the organ of the Victoria Hall, Geneva. @1960 *[BWV 565 & 582 in London CS 6172; BWV 542 & 548 in London CS 6173]

Remark & Rating
ED1, 1E-2E, $$$
RM14

Label Decca SXL 2220 (©=SDD 178)
London CS 6081 (©=STS 15058)

Mozart: <Symphonies No.35 in D Major, K.385 "Haffner">, <Symphonies No.41 in C Major, K.551 "Jupiter", The Israel Philharmonic Orchestra-Josef Krips. @1959

Remark & Rating
ED1, 2E-2D, Rare!!! $$+

Label Decca SXL 2221* (©=SDD 282)
London CS 6012

Rimsky-Korsakov: <The Tale of Tsar Saltan, Suite Op.57>, <May Night Overture>, <Russian Easter Festival, Overture on Liturgical Themes, Op.36>, L'Orchestre de la Suisse Romande-Ernest Ansermet. ℗1959

Remark & Rating
ED1, 1E-1E, Very rare!! $$$+
RM16, Penguin ★★★

Label Decca SXL 2222 (©=ECS 691)
London CS 6021 (©=STS 15047)

Brahms: [Piano Recital], <Six Pieces, Op.118>, <Capriccio in Bm, Op.76, No.2>, <Rhapsody in Bm, Op.79, No.1>, <Intermezzo, Op.117, No.1; Op.116, No.6 & Op.119, No.2, No.3>, Wilhelm Backhaus (piano). ℗1958

Remark & Rating
ED1, 10E-2E, Very rare!! $$$$
RM13, Penguin ★★(★)

Label **Decca SXL 2223** (©=SDD 157, ECS 758)
No London CS (=STS 15019)

Schumann: <Symphony No.1 in B Flat Major "Spring" Op.38>, <Symphony No.4 in D Minor, Op.120>, The London Symhphony Orchestra-Josef Krips. Recorded by Gordon Parry, October 1956 in Kingsway Hall, London. ℗1960 [Decca reissue is Eclipse ECS 758 & Ace of Diamond SDD 157; London is STS 15019, no CS issue]

Remark & Rating
ED1, 1M-1M, $$+

Label **Decca SXL 2224** (©=SDD 215; ECS 780)
London OS 25039

Mahler: <Kindertotenlieder>, <Lieder Eines Fahrenden Gesellen>, Kirsten Flagstad (soprano), The Vienna Philharmonic Orchestra-Adrian Boult. Recorded by James Brown, May 1957 in the Sofiensaal, Vienna. ℗1958 ©1960

Remark & Rating
ED1, 1K-1E, $$

Label **Decca SXL 2225-7**
London OSA 1302

Ponchielli: <La Gioconda> Complete, Cerquetti, Simionata, Del Monaco, Siepi, The Chorus and Orchestra of Maggio Musicale Fiorentino-Gianandrea Gavazzeni. (27 pages Booklet) ℗1981

Remark & Rating
ED1, 1E-1K-2E-3 K-1E-3 F, Very rare!!! $$$$$

Label **Decca SXL 2228** (©=SDD 102; ECS 739)
London CS 6184 (©=STS 15068)

Beethoven: <Symphony No.2 in D Major, Op.36>, <Leonore Overture No.2, Op.72>, L'Orchestre de la Suisse Romande-Ernest Ansermet. ℗1960

Remark & Rating
ED1, 1E-1E, rare!! $$$+
RM14

Label **Decca SXL 2229**
London CS 6186

Mendelsohn: <A Midsummer Night's Dream (Incidental Music)>; Schubert: <Rosamunde, Op.26 (Incidental Music)>, L'Orchestre de la Suisse Romande-Ernest Ansermet. Recorded by Roy Wallace, January 1960 in the Victoria Hall, Geneva. ℗1960

Remark & Rating
ED1, 1E-1E, $$$
RM13

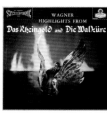

Label **Decca SXL 2230 (SET 382-4 & SXL 2031-2)**
London OS 25126 (OSA 1309 & 1203)

Wagner: [Rheingold And Walküre Highlights], <Rheingold>, starring: Kirsten Flagstad, George London, Set Svanholm, Gustav Neidlinger, Paul Kuen, Eberhard Wächter, Oda Balsborg, etc., (Highlights from SET 382-4), <Walküre>, starring: Kirsten Flagstad as Brünnhilde , Otto Edelmann as Wotan, Oda Balsborg as Gerhild, Grace Hoffmann as Waltraute, etc., (Highlights from SXL 2031-2), The Vienna Philharmonic Orchestra-Georg Solti. Produced by John Culshaw. ℗1958 ©1960

Remark & Rating
ED1, 2E-2E
Penguin ★★★

Label **Decca SXL 2231**
London CS 6174 (©=STS 15152)

Ravel: <String Quartet in F Major>; Prokofiev< String Quartet No.2 in F Major, Op.92>, The Carmirelli Quartet. ℗1959 ©1960

Remark & Rating
ED1, 1M-1M, $$$
RM15

Label **Decca SXL 2232***
London CS 6196

Searle: <Symphony No.1, Op.23>; Seiber: <Elegy for Viola & Small Orchestra>, <3 Fragments from "A Portrait of the Artist as a Young Man">, London Philharmonic Orchestra conducted by Adrian Boult & Matyas Seiber. Producer: Roy Minshull. Recorded by Kenneth Wilkinson, March 1960 in Kingsway Hall, London.@1960

Remark & Rating
ED1, 3E-1E, $$
RM18, TAS2017(Speakers Corner ADEC 2232), (K. Wilkinson)

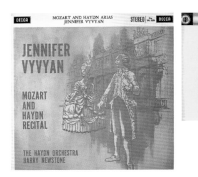

Label **Decca SXL 2233 (©=ECS 635)**
London OS 25231

[Jennifer Vyvyan-Mozart and Handel Recital], Mozart: <Two Concert Arias, K.272 & K.505>; Haydn: <Scena Di Berenice>, Jennifer Vyvyan (soprano), The Vienna Haydn Orchestra-Harry Newstone. ©1960

Remark & Rating
ED1, 2E-3E, Very rare!! $$
Penguin ★★★

Label **Decca SXL 2234 (©=SDD 286)**
No London CS

[A Ricital of Bach and Handel Arias], Bach: <"Mass in B Minor", Qui sedes & Agnus Dei>, <"St. Matthew Passion", Grief for sin>, <"St. John Passion", All is fullfilled>; Handel: <"Messiah", O thou that tellset good tidings & He was despised>, <"Samson", Return O God of Hosts>, <"Judas Maccabaeus", Father of Heaven>. Kathleen Ferrier (contralto) with The London Philharmonic Orchestra-Sir Adrian Boult. Last recording from Ferrier in 1952 & re-record the orchestral parts to this stereo version. Recorded by Kenneth Wilkinson & James Walker in the Kingsway Hall, London, in October 1952 & March 1960. ℗1960

Remark & Rating
ED1, 1E-1E, $$
Penguin ★★★, (K. Wilkinson)

Label **Decca SXL 2235 (©=SDD 107, SPA 237)**
London CS 6183 (©=STS 15067)

Beethoven: <Symphony No.7 in A Major, Op.92>, <Fidelio Overture, Op.72>, L'Orchestre de la Suisse Romande-Ernest Ansermet. Recorded by Roy Wallace, January 1960 in the Victoria Hall, Geneva. @1960

Remark & Rating
ED1, 1E-1E, $$
RM12

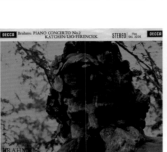

Label **Decca SXL 2236 (©=SDD 223; SPA 458)**
London CS 6195

Brahms: <Piano Concerto No.2 in B Flat Major, Op.83>, Julius Katchen (piano), The London Symphony Orchestra-Janos Ferencsik. @1960

Remark & Rating
ED1, 2E-1E, $$+
RM14

Label **Decca SXL 2237* (©=SDD 239; ECS 820, 821)**
London CS 6190

Stravinsky: <Symphony in C Major (1940)>, <Symphony in 3 Movements (1945)>, L'Orchestre de la Suisse Romande-Ernest Ansermet. ℗1960

Remark & Rating
ED1, 1E-2E, &&
RM14

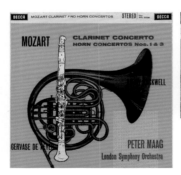

Label **Decca SXL 2238* (©=SDD 331, part)**
London CS 6178 (©=STS 15597)

Mozart: <Clarinet Concerto in A Major, K.622>*, <Horn Concerto No.1 in D Major, K.412 & No.3 in E Flat Major, K.447>, Gervase De Peyer (Clarinet), Barry Tuckwell (Horn), London Symphony Orchestra-Peter Maag. Producer: Ray Minshull. Recorded by Kenneth Wilkinson, November 1959 in Kingsway Hall, London. ℗1960 [* Penguin ★★★, in SDD 331]

Remark & Rating
ED1, 2E-1E, &&
RM19, Penguin ★★★, (K. Wilkinson)

Label **Decca SXL 2239**
London CS 6192 (©=STS 15045)

[All-time Popular Favourites], Tchaikovsky: <The Nutcracker Suite, Op.71a>; Schubert (arr. Weninger): <March Militaire>; Weber (orch. Berlioz): <Invitation to the waltz, Emanuel Brabec (cello solo)>, Nicolai: <The Merry Wives of Windsor (Overture)>, The Vienna Philharmonic Orchestra-Hans Knapperbusch. Recorded by James Brown, February 1960 in the Sofiensaal, Vienna. ℗1960

Remark & Rating
ED1, 2E-1E, Very rare!! $$$$

Label **Decca SXL 2240**
London CS 6193 (©=STS 15153)

[Ruggiero Ricci Solo Recital], Bartok: <Sonata for Solo Violin>; Stravinsky: <Elégie>; Prokofiev: <Sonata for Violin Solo, Op.115>; Hindemith: <Sonata for Violin Solo, Op.31, Nos.1 & 2>, Ruggiero Ricci (violin). @1960

Remark & Rating
ED1, 1E-1E, Very rare!! $$$$
RM15

Label **Decca SXL 2241**
London CS 6161

Beethoven: Piano Sonatas <Sonata No.21, Op.53 "Waldstein">, <Sonata No.23, Op.57 "Appassionata">, Wilhelm Backhaus (piano). @1960

Remark & Rating
ED1, 1E-1E, $$$
Penguin ★★(★), Japan 300

Label **Decca SXL 2242 (SXL 2167-9)**
London OS 25206 (OSA 1313)

Verdi: <Aida, Highlights>, Renata Tebaldi (soprano), Giulietta Simionato (mezzo-soprano), Carlo Bergonzi (tenor), Cornell MacNeil (baritone), Arnold Van Mill (bass), with supporting soloists, Singverein der Gesellschaft der Musikfreunde and The Vienna Philharmonic Orchestra-Herbert von Karajan. Produced by John Culshow & recorded by James Brown, September 1959 in the Sofiensaal, Vienna. ℗1959 ©1960 (Highlights from SXL 2167-9 & OSA 1313)

Remark & Rating
ED1, 3L-1E, $
TASEC44, Penguin ★★★, AS list, Japan 300-CD

Label **Decca SXL 2243* (©=SDD 180)**
London CS 6194

Albeniz: <Iberia>; Turina: <Danzas Fantasticas>, L'Orchestre de la Suisse Romande-Ernest Ansermet. Producer: James Walker. Recorded by Roy Wallace, May 1960 in Victoria Hall, Geneva. ©1960

Remark & Rating
ED1, 3E-2E, Very rare!! $$$$
RM16, Penguin ★★(★) AS-DG list (Speakers Corner)

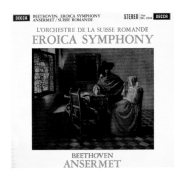

Label **Decca SXL 2244**
London CS 6189 (©=STS 15069)

Beethoven: <Symphony No.3 in E Flat Major "Eroica", Op.55>, L'Orchestre de la Suisse Romande-Ernest Ansermet. Recorded by Roy Wallace, April 1960 in the Victoria Hall, Geneva. @1960

Remark & Rating
ED1, 2E-1E, Very rare!! $$$

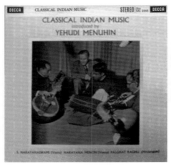

Label **Decca SXL 2245**
London CS 6213 (©=STS 15094)

[Classic Indian Music], K.S.Narayanaswami (Veena), Narayana Menon (Veena), Palghat Raghu (Mridongam), introduced by Yehudi Menuhin. ℗1960

Remark & Rating
ED1, 1E-1E, $$+

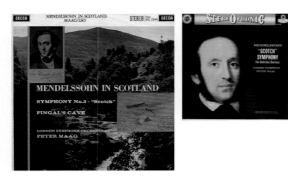

Label **Decca SXL 2246* (©=SDD 145, SPA 503)**
London CS 6191 (©=STS 15091)

[Mendelssohnln in Scotland], <Symphony No.3, "Scotch", Op.56>, <The Hebrides Overture-Fingal's Cave, Op.26>, The London Symphony Orchestra-Peter Maag. Recorded by Alan Reeve & Kenneth Wilkinson, April 1960 in Kingsway Hall, London. ℗ ©1960

Remark & Rating
ED1, 3D-3E, (1E-1E), Very rare!!! $$$-$$$$
RM20, Penguin ★★★, G.Top 100, TAS 44-178, (K. Wilkinson)

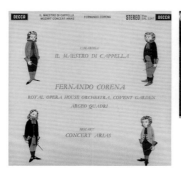

Label **Decca SXL 2247**
London OS 25219

Cimarosa: <Il Maestro di Cappella>; Mozart: <Concerto Arias for Bass>, Fernando Corena (bass) with the Orchestra of the Royal Opera House, Covent Garden-Argeo Quadri. Recorded by Kenneth Wilkinson, June 1960 in Kingsway Hall, London. ℗ ©1960

Remark & Rating
ED1, 1E-1E, $
(K. Wilkinson)

Label **Decca SXL 2248 (SXL 2170-1)**
London OS 25201 (OSA 1208)

Puccini: <La Boheme, Highlights>, Tebaldi, Bergonzi, Siepi, The Orchestra and Chorus of the Accademia di Santa Cecilia Rome-Tullio Serafin. Recorded by Roy Wallace, August 1959 in Rome. ℗1959 ©1960 (Highlights from SXL 2170-1 & OSA 1208)

Remark & Rating
ED1, 1E-1E
Penguin ★★(★)

Label **Decca SXL 2249* (©=SDD 123, SPA 377)**
London CS 6198 (©=STS 15009)

Brahms: Hungarian Dances, <No.5 in G Minor, No.6 in D Major, No.7 in A Major, No.12 in D Minor, No.13 in D Major, No.19 in B Minor, No.21 in E Minor, No.1 in G Minor>; Dvorak: Slavonic Dances, <Op.46, no.1 in C Major; no.3 in A Flat Major; no.8 in G minor>, <Op. 72, no.1 in B Major; no. 2 in E Minor>, The Vienna Philharmonic Orchestra-Fritz Reiner. Producer: Erik Smith. Recorded by James Brown, June 1960 in the Sofiensaal, Vienna. ℗1959 ©1961

Remark & Rating
ED1, 1E-3E, Very rare!! $$$ - $$$$
RM17, Penguin ★★(★)

Label **Decca SXL 2250** (©=SDD 127, SPA 406, part)
London CS 6199 (©=STS 15070)

Johann Strauss: <Graduation Ball - Ballet> arranged by Dorati, Weber: <Le Spectre De La Rose (Invitation to the dance, Op.65) - Ballet>Boskovsky, Vienna Philharmonic Orchestra-Willi Boskovsky. Recorded by James Brown, 29 May - 1 June 1960 in the Sofiensaal, Vienna ℗1960 ©1961

Remark & Rating
ED1, 1E-1E, $$
RM14, Penguin ★★(★)

Label **Decca SXL 2251** (©=SDD 193)
London OS 25225

[Arias of the 18th Century], Gluck: <Orfeo Ed Euridice>, <Paride ed Elena>, <Alceste>; Cherubini: <Medea>; Pergolesi: <La Serva Padrona>; Handel: <Giulio Cesare>; Paisiello: <Nina, Pazza Per Amore>, Teresa Berganza (soprano) with The Orchestra of the Royal Opera House, Covent Garden-Alexander Gibson. ℗1960

Remark & Rating
ED1, 2L-2L, $$
Penguin ★★★

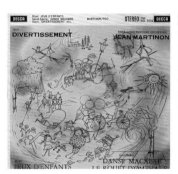

Label **Decca SXL 2252*** (©=SDD 144, ECS 782, 801)
London CS 6200

Ibert: <Divertissemen>, Saint-Saens: <Danse Macabre, Op.40 & Le Rourt D'Omphale, Op.31>, Bizet: <Jeux D'Enfants>, The Paris Conservatoire Orchestra-Jean Martinon. Recorded by Alan Reeve & Kenneth Wilkinson, June 1960 in the Salle de la Mutualité, Paris. ℗1960 ©1961

Remark & Rating
ED1, 1E-1E, Very rare!! $$$+ RM16, TAS SM 67-138++, Penguin ★★★, AS list (Speakers Corner), (K. Wilkinson)

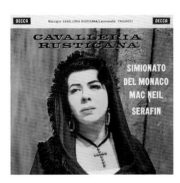
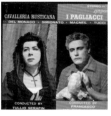

Label **Decca SXL 2253-5** (©=GOS 588-10; SDD 418, part)
London OSA 1330 (=OSA 1212+1213)

Mascagni: <Cavalleria Rusticana>, Giulietta Simionato & Mario Del Monaco; Leoncavallo: <Pagliacci>, Mario Del Monaco & Gabriella Tucci, Orchestra and Chorus of the Accademia di Santa Cecilia, Rome conducted by Tullio Serafin & Francesco Molinari-Pradelli. (15 pages booklet) @1960

Remark & Rating
ED1, 2E-1E-1E-2E-1E-1E, $$$
Japan 300-CD

Label **Decca SXL 2256***
London OS 25232 (OSA 1214)

[Art Of The Prima Donna, Vol. 1], Arne: <Artaxerxes- "The Soldier Tir'd">; Handel: <Samson- "Let The Bright Seraphim">; Bellini: <Norma- "Casta Diva" (And Cabaletta)>, <I Puritani- Polonaise, "Son Vergin Vezzosa">; Thomas: <Hamlet- "The Mad Scene">; Delibes: <Lakme- "The Bell Song">; Meyerbeer:<Les Huguenots- "O Beau Pays">; Verdi: <Rigoletto- "Caro Nome">. Joan Sutherland (soprano) with The Royal Opera House Orchestra, Covent Garden-Molinari-Pradelli. Recorded by Kenneth Wilkinson. @1960

Remark & Rating
ED1, 1E-1E
Penguin ★★★, G.Top 100, (K. Wilkinson)

THE ART OF THE PRIMA DONNA
JOAN SUTHERLAND

THE ART OF THE PRIMA DONNA
JOAN SUTHERLAND

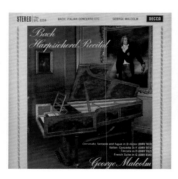

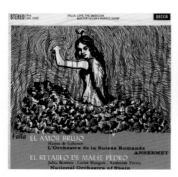

Label **Decca SXL 2256-57***
London OSA 1214

[Art Of The Prima Donna, Vol. 1 & 2], Joan Sutherland, Royal Opera House Orchestra, Covent Garden-Molinari-Pradelli. Recorded by Kenneth Wilkinson, August 1960 in Kingsway Hall, London. @1960

Remark & Rating
ED1, BB, 1E-1E-1E-1E, $$
Penguin ★★★, G.Top 100, (K. Wilkinson)

Label **Decca SXL 2257***
London OS 25233 (OSA 1214)

[Art Of The Prima Donna, Vol. 2], Rossini: <Semiramide: "Bel Raggio" >; Bellini: <I Puritani- "Qui la voce">, <La Sonnambula- "Come per Sereno">; Gounod: <Faust- "The jewel song">, <Romeo Et Juliet- "The waltz song">; Verdi: <Otello- "The willow song">, < La Traviata- "Ah, fors'é lui; Sempre libera">; Mozart: <Die Entführung Aus Dem Serail- "Martern aller arten">. Joan Sutherland (soprano) with The Royal Opera House Orchestra, Covent Garden-Molinari-Pradelli. Recorded by Kenneth Wilkinson. @1960

Remark & Rating
ED1, 1E-1E
Penguin ★★★, G.Top 100, (K. Wilkinson)

Label **Decca SXL 2258 (SXL 2180-1, ©=SDD 334)**
London OS 25218 (OSA 1210)

Puccini: <Tosca, Highlights>, Renata Tebaldi (soprano), Mario Del Monaco (tenor), George London (bass-baritone), Silvio Maionica, Fernando Corena, Piero De Palma (tenor), Giovanni Morese & Ernesto Palmerini. The Chorus & Orchestra of the Accademia Di Santa Cecilia-Francesco Molinar Pradelli. ℗1960 ©1961 (Highlights from SXL 2180-1 & OSA 1210)

Remark & Rating
ED1, 1E-2E

Label **Decca SXL 2259 (©=SDD 272; ECS 788)**
London CS 6197 (©=STS 15491)

J.S.Bach: [Harpsichord Recital], <Chromatic Fantasia and Fugue in D Minor, BWV 903>, <Italian Concerto in F, BWV 971>, <Toccata in D Major, BWV 912>, French Suite in G Major, BWV 816>, George Malcolm (harpsichord). Recorded in Decca Studio No.2. ℗1960 ©1961

Remark & Rating
ED1, 2W-1E, $
RM17, Penguin ★★★

Label **Decca SXL 2260 (©=SDD 134)**
London STS 15014 [CS 6028 (part), (No London CS)]

Falla: <El Amor Brujo (Love The Magician)>*, Ansermet-L'Orchestre De La Suisse Romande, recorded October 1955 at the Victoria Hall, Geneva. Falla: <El Retablo de Maese Pedro (Master Peter's Puppet Show)>**, Ataulfo Argenta-The National Orchestra of Spain (Recorded by Spanish Columbia). ℗1960 ©1961 [* Penguin ★★; ** Penguin ★★★ in London CS 6028] (Reissue only Ace of Diamond SDD 134, 1E-1E & London STS 15014)

Remark & Rating
ED1, 1E-1E, Very rare!!! $$$$$
RM20, Penguin ★★ & Penguin ★★★

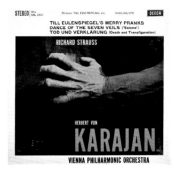

Label Decca SXL 2261 (©=SDD 211)
London CS 6211

Richard Strauss: <Death and Transfiguration, Op.24>, <Till Eulenspiegel's Merry Pranks>, <Dance of the 7 Veils (Salome)>, The Vienna Philharmonic Orchestra-Herbert von Karajan. Recorded by James Brown in the Sofiensaal, Vienna, 1960. ℗1961

Remark & Rating
ED1, 2E-2E, $$
RM16

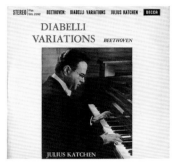

Label Decca SXL 2262
London CS 6203

Beethoven: <33 Variations on a Waltz by Diabelli, Op.120>, Julius Katchen (piano). Recorded by Kenneth Wilkinson, October 1960 in West Hampstead Studio 1, London. ℗ ©1961

Remark & Rating
ED1, 1E-1E, $$
(K. Wilkinson)

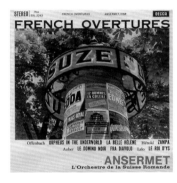

Label Decca SXL 2263 (©=SDD 192, ECS 827)
London CS 6205

[French Overtures], Offenbach: <Orpheus In The Underworld>, <La Belle Helene>; Herold: <Zampa>; Auber: <Le Domino Noir>, <Fra Diavolo>; Lalo: <Le Roi D'ys>, L'Orchestre De La Suisse Romande-Ernest Ansermet. Recorded by Roy Wallace, May 1960 in the Victoria Hall, Geneva. ℗1961

Remark & Rating
ED1, 1E-1E, Very rare!! $$$
RM16

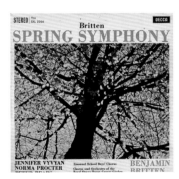

Label Decca SXL 2264 (©=Jubilee 410 171)
London OS 25242

Britten: <Spring Symphony>, - Jennifer Vyvyan (Soprano) - Norma Procter (Contralto) - Peter Pears (Tenor) - The Orchestra and Chorus of the Royal Opera House, Covent Garden - Chorus of Boys from Emanuel Scholl, London - Benjamin Britten. Recorded by Kenneth Wilkinson, November 1960 in Kingsway Hall, London. ℗1960 ©1961

Remark & Rating
ED1, 2E-2E, $
Penguin ★★★, AS List-H (Jubilee 410 171), (K. Wilkinson)

Label **Decca SXL 2265* (©=SDD 411)**
London CS 6206 (©=STS 15441)

Corelli: <Conceto Groosso No.8 in G Minor (Christmas Concerto); Pachelbel: <Kanon, arranged by Münchinger>; Ricciotti: < Concerto No.2 in G Major> and Gluck: <Chaconne>, Stuttgart Chamber Orchestra-Karl Münchinger. ℗1961

Remark & Rating
ED1, 1E-1E, rare! $$$
RM16, Penguin ★★★, Japan 300

Label **Decca SXL 2266***
London CS 6204

[Rossini Overtures], <The Thieving Magpie>, <The Silken Ladder>, <The Barber Of Seville>, <Semiramide>, <William Tell>, The London Symphony Orchestra-Pierino Gamba. ℗1961

Remark & Rating
ED1, 2E-1E, rare! $$+
RM14, Penguin ★★★, AS List (Speakers Corner)

Label **Decca SXL 2267 (SXL 2039-41, ©=SDD 333)**
London OS 25196 (OSA 1306)

Puccini: <La Fanciulla Del West (The Girl of the Golden West), Highlights>, Renata Tebaldi (Soprano), Mario Del Monaco (Tenor), Cornell Macneil (Baritone), Giorgio Tozzi (Bass), The Chorus and Orchestra of the Accademia Di Santa Cecilia, Rome-Franco Capuana. Recorded by Roy Wallace, August 1958 in Rome. ℗1958 ©1961 [Highlights from SXL 2039-41 & OSA 1306]

Remark & Rating
ED1
Penguin ★★★

Label **Decca SXL 2268 (©=SDD 496, SDD 151; ECS 735)**
London CS 6212

Rimsky-Korsakov: <Scheherazade Symphonic Suite, Op. 35>; Borodin: <Polovtsian Dances from Prince Igor>, L'Orchestre De La Suisse Romande-Ernest Ansermet. Recorded by Roy Wallace, 1960 in Victoria Hall, Geneva. ℗©1961

Remark & Rating
ED1, 1D-1D, $$
RM15, Penguin ★★(★)

Label **Decca SXL 2269 (©=SPA 119)**
London CS 6209

Tchaikovsky: <Romeo and Juliet - Fantasy Overture>; Richard Strauss: <Don Juan, Op.20>, The Vienna Philharmonic Orchestra-Herbert Von Karajan. ℗ ©1961

Remark & Rating
ED1, 1E-1E, $$+
RM15, Penguin ★★★

Label **Decca SXL 2270*** (©=ECS 686)
London CS 6207

Mozart: <Eine kleine Nachtmusik, K.525>, <Divertimento No.1 in D Major, K.136>, <A Musical Joke, KV. 522)>, Stuttgart Chamber Orchestra-Karl Münchinger. Producer: James Walker. Recorded by Roy Wallace, October-November 1960 in Victoria Hall, Geneva. ℗1960 ©1961

Remark & Rating
ED1, 1L-1L, Very rare! $$$
RM17

Label **Decca SXL 2271**
London OS 25244

[A Recital by Graziella Sciutti], Rossini: <"Il Barbiere di Siviglia", Una Voce Poco Fa>; Donizetti: <"La Figlia Del Reggimento", Convien Partir>, <"Don Pasquale", Quel Guardo Il Cavaliere... So Anch' Io La Virtu Magica>; Bellini: <"I Capuletti Ed I Montecchi", Eccomi In Lieta Vesta... Oh! Quante Volte, Oh Quante>; Mozart: <"Cosi Fan Tutte", Una Donna A Quindici Anni>, <"Le Nozze Di Figaro", Giunse Alfin Il Momento... Deh Vieni, Non Tardar>, <Chi Sà, Chi sà, Qual Sia, K.882>, <Nehmt Meinen Dank, K.383>. Graziella Sciutti (soprano) with The Vienna Philharmonic Orchestra-Argeo Quadri. ©1961

Remark & Rating
ED1, 1E-2E, Very rare!! $$$

Label **Decca SXL 2272** (©=SDD 198)
London CS 6214

Mozart: <Serenade No.7 in D Major, K.250 "Haffner", The Vienna Philharmonic Orchestra-Karl Münchinger. ℗ ©1961

Remark & Rating
ED1, 4E-1E, rare! $$
RM13

Label **Decca SXL 2273**
London CS 6210 (©=STS 15092)

Ravel: <Daphnis et Chloe (suite No.2)>, <Alborada del gracioso>, <Le tombeau de Couperin>, <Valses nobles ét sentimentales>, L'Orchestre de la Suisse Romande-Ernest Ansermet. Recorded by Roy Wallace, November 1960 in Victoria Hall, Geneva. ℗1961

Remark & Rating
ED1, 1L-2L, Very rare!! $$$
RM12

Label **Decca SXL 2274** (©=SDD 108, SPA 328)
London CS 6143 (©=STS 15089)

Beethoven: <Symphony No.9 in D Minor, "Choral", Op.125>, Joan Sutherland (soprano), Norma Procter (contralto), Anton Dermota (tenor), Arnold Van Mill (bass), Chorale du Brassus & Choeur des jeunes de l'eglise nationale vaudoise with L'Orchestre de la Suisse Romande-Ernest Ansermet. Recorded by Roy Wallace, May 1959 in the Victoria Hall, Geneva. ℗1960 ©1961

Remark & Rating
ED1, 1E-1E, $$
RM14, Penguin ★★★

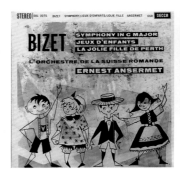

Label **Decca SXL 2275** (©=SDD 231, ECS 801)
London CS 6208

Bizet: <Symphony in C Major>, <Jeux d'Enfants, op.22>, <La Jolie Fille de Perth>, L'Orchestre de la Suisse Romande-Ernest Ansermet. Recorded by Roy Wallace, October-November 1960 in the Victoria Hall, Geneva. ℗1960 ©1961

Remark & Rating
ED1, 2E-1L, $$$
RM16, Penguin ★★(★)

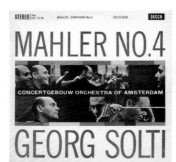

Label **Decca SXL 2276**
London CS 6217 (=CS 6781)

Mahler: <Symphony No.4 in G Major>, Silvia Stahlman (soprano), The Concertgebouw Orchestra of Amsterdam-Georg Solti. Recorded by Kenneth Wilkinson, February 1961 in the Concertgebouw, Amsterdam. ℗ by John Culshaw ©1961

Remark & Rating
ED1, 1E-1E, $$
RM14, Penguin ★★, (K. Wilkinson)

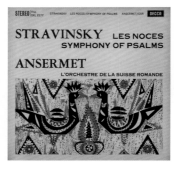

Label **Decca SXL 2277** (©=SDD 238; ECS 820)
London CS 6219

Stravinsky: <Les Noces>, <Symphony Of Psalms>, L'Orchestre de la Suisse Romande-Ernest Ansermet. Recorded by Roy Wallace, January 1961 in Victoria Hall, Geneva ℗ ©1961

Remark & Rating
ED1, 2L-1L, $$
RM12

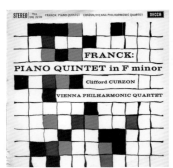

Label **Decca SXL 2278** (©=SDD 277)
London CS 6226

Franck: <Piano Quintet in F Minor>, Curzon Clifford (piano) with the Vienna Philharmonic String Quartet (Willi Boskovsky-1st violin; Otto Strasser-2nd violin; Rudolf Streng-Viola; Emanuel Brebec-Cello). @1961

Remark & Rating
ED1, 5E-4E, rare!! $$
RM14, Penguin ★★(★)

Label **Decca SXL 2279 (©=SDD 126, SPA 398)**
London CS 6215

Tchaikovsky: <Violin Concerto in D Major, Op.35>; Dvorak: <Violin Concerto in A Minor, Op.53>, Riggiero Ricci (violin), London Symphony Orchestra-Malcolm Sargent. Ⓟ ©1961

Remark & Rating
ED1, 1E-2E, Very rare!!! $$$$$

Label **Decca SXL 2280**
London CS 6216 (=CS 6780)

Offenbach: <Gaite Parisienne>* , arranged by Rosenthal, Gounod: <**Faust - Ballet Music>, The Orchestra Of The Royal Opera House, Covent Garden-Georg Solti. Recorded by Alan Reeve & Kenneth Wilkinson, **January & *May 1960 in Kingsway Hall, London. Ⓟ ©1961

Remark & Rating
ED1, 2E-2E, $$
RM16, (K. Wilkinson)

Label **Decca SXL 2281-2 (Part of SXL 2253-5)**
London OSA 1213 (Part of OSA 1330)

Mascagni: <Cavalleria Rusticana>, Giulietta Simionato & Mario Del Monaco, Accademia di Santa Cecilia, Rome-Tullio Serafin. @1961 (=Part of SXL 2253-5 & OSA 1330)

Remark & Rating
ED1, 2E-3E-1E-1E, $$$

Label **Decca SXL 2283**
London CS 6430, (ED2 1st)

Lars-Erik Larsson: <Pastoralsvit (Suite) Op.19,"Liten Marsch">; Dag Wiren: <Serenade Op.11>, Stockholm Symphony Orchestra-Stig Westerberg. Ⓟ1960 ***(Decca SXL issued only from Sweden, English pressing only London CS 6430)

Remark & Rating
Swedish ED only, Rare! $

Label **Decca SXL 2284**
London CS 6230

Haydn: <Symphonies No.100 in G Major, "The Military">, <No.83 in G Minor, "The Hen">, The Vienna Philharmonic Orchestra-Karl Münchinger. Recorded by James Brown, April 1961 in the Sofiensaal, Vienna. Ⓟ ©1961

Remark & Rating
ED1, 1D-1D, Very rare !! $$$

Label **Decca SXL 2285**
London CS 6218

Tchaikovsky: <Swan Lake, Highlights>, The Concertgebouw Orchestra of Amsterdam-Anatole Fistoulari. Producer: John Culshaw. Recorded by Kenneth Wilkinson, February 1961 in the Concertgebouw, Amsterdam. ℗ ©1961

Remark & Rating
ED1, 2E-2E, $$+
RM17, Penguin ★★★, (K. Wilkinson)

Label **Decca SXL 2286 (©=SDD 291)**
London CS 6231

Mozart: <Quartet No.20 in D Major, K.499 (Hoffmeister)>, <Quartet No.22 in B Flat Major, K.589 (2nd Prussian)>, The Vienna Philharmonic String Quartet (Willi Boskovsky-1st violin; Otto Strasser-2nd violin; Rudolf Streng-Viola; Emanuel Brebec-Cello). Recorded by James Brown, March 1961 in the Sofiensaal, Vienna. ℗ ©1961

Remark & Rating
ED1, 1D-1D, $$+
RM16, Penguin ★★★

Label **Decca SXL 2287 (©=SDD 239, 425 & 425)**
London CS 6225

Debussy: <* Images Pour Orchestre>; Stravinsky: <* Symphony For Wind Instruments>; Ravel: <** Pavane Pour Une Infante Defunte>, L'Orchestre de la Suisse Romande-Ernest Ansermet. Recorded by Roy Wallace, **November 1960 & *March 1961 in Victoria Hall, Geneva. ℗ ©1961 [Stravinsky (SDD 239) is Penguin **(*)]

Remark & Rating
ED1, 2E-2D, $$+
RM13, Penguin ★★(★)

Label **Decca SXL 2288 (©=SDD 473)**
London CS 6232

[Thousand And One Nights In Vienna], Johann Strauss: <Tausend und eine Nacht Waltz>, <Kaiser Waltz>, <Wo die Zitronen blühen Waltz>, <Napoleon March>, <Fledermaus-Quadrille>; Josef Strauss: <Feuerfest Polka>, <Jokey Polka>; C.M. Ziehrer: <Facherpolonaise>; Johann Strauss Senior : <Loreley-Rheinklange Waltz>. The Vienna Philharmonic Orchestra-Willi Boskovsky. ℗ ©1961

Remark & Rating
ED1, 6T-5T, $$

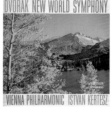

Label **Decca SXL 2289* (©=SPA 87)**
London CS 6228 (©=STS 15101)

Dvorak: <Symphony No.9 (No.5) in E Minor "New World", Op.95>, The Vienna Philharmonic Orchestra-Istvan Kertesz. Producer: Ray Minshull. Recorded by James Brown, March 1961 at Sofiensaal, Vienna. ℗1961

Remark & Rating
ED1, 2E-1E, Very rare!!! $$$$$
RM17, Penguin ★★★, AS List-F (Speakers Corner)

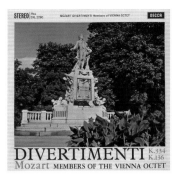

Label **Decca SXL 2290 (©=SDD 251)**
No London CS (©=STS 15304)

Mozart: <Divertimento in D Major No.17, K.334>, <Divertimento in D Major, K.136>, Memberts of the Vienna Octet.Recorded by James Brown, April 1961 in the Sofiensaal, Vienna. ℗1961

Remark & Rating
ED1, 2E-1E, Rare! $$$
Penguin ★★★, Japan 300

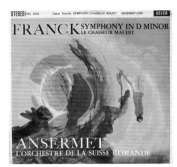

Label **Decca SXL 2291 (©=SDD 320)**
London CS 6222

Franck: <Symphony in D Minor>, <Le Chasseur Maudit (The Accursed Huntsman)>, L'Orchestre de la Suisse Romande-Ernest Ansermet. Recorded by Roy Wallace, March 1961 in the Victoria Hall, Geneva. ℗1961

Remark & Rating
ED1, 2L-2L, $$+

Label **Decca SXL 2292* (©=SDD 399, part)**
London CS 6223

Prokofiev: <Classical Symphony in D Major, Op.25 "Classical">* , <March & Scherzo>; Glinka: <Kamarinskaya>, <A Life for the Czar Overture>; Borodin: <In the Steppes of Central Asia>, L'Orchestre de la Suisse Romande-Ernest Ansermet. Recorded by Roy Wallace, March 1961 in the Victoria Hall, Geneva. ℗1961 [* Prokofiev Symphony in Decca SDD 399, Penguin★★(★)]

Remark & Rating
ED1, 1E-1E, Very rare!! $$$
RM13, Penguin ★★(★)

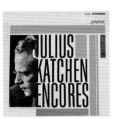

Label **Decca SXL 2293 (©=SPA 110)**
London CS 6235 (©=STS 15115)

[Julius Katchen Encores], Bach: <Jesu, Joy of Man's Desiring>; Brahms: <Rhapsody No.2 in G Minor, Op.79>; Beethoven: <Sonata No.8 in C Minor, Op.13 "Pathetique">; Liszt: <Hungarian Rhapsody No.12>; Mendelssohn: <On Wings of Song, Rondo Capriccioso>; Chopin: <Polonaise in A Flat & Fantasie-Impromptu in C Sharp Minor>; Debussy: <Clair de Lune>; De Falla: <Ritual Fire Dance>, Julius Katchen (piano). Recorded by Kenneth Wilkinson, June 1961 at West Hampstead Studio 1, London. ℗1961

Remark & Rating
ED1, 6W-1E, $$
(K. Wilkinson)

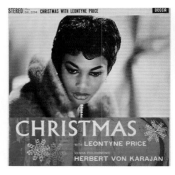

Label **Decca SXL 2294 (©=JB 38)**
London OS 25280

[Christmas with Leontyne Price], A Christmsa Offering: <Silent Night>, <Hark! The Herald Angels Sing>, <We Three Kings of Orient Are>, <Angels We Have Heard On High>, <O Tannenbaum>, <God Rest Ye Merry, Gentlemen>, <It Came Upon The Midnight Clear>, <Vom Himmel Hoch>, Sweet Li'l Jesus>, <Schubert (arr. Sabatini): Ave Maria>, <Adam (arr. Totzauer): O Holy Night>, <Bach-Gounod (arr. Sabatini): Ave Maria>, <Mozart: Alleluja, K.165>. Leontyne Price with The Vienna Philharmonic Orchestra-Herbert von Karajan. ℗1961

Remark & Rating
ED1, 1E-1E, $$
Penguin ★★(★), R2D4

Label **Decca SXL 2295**
London OS 25281

[Hilde Gueden Sings Operetta Evergreens], Entry of Mariza, Sag Ja (Kalman); Mein Liebeslied muss ein Walzer sein, Du sollst der Kaiser meiner Seele sein (Stolz); Kosende Wellen, Hor ich Cymbalklange (Lehar); Heut konnt einer sein Gluck bei mir machen (Fall); Nuns Chorus, Mein Herr Marquis, Held meiner Traume, Wiener Blut (Strauss); Set nicht bos (Zeller), Vienna State Opera Orchestra & Opearetta Chorus-Robert Stolz. Recorded by James Brown, April - May 1961 in the Sofiensaal, Vienna. ℗ 1961 by Christopher Raeburn ©1962

Remark & Rating
ED1, 1D-1D, Rare!, $$$

Label **Decca SXL 2296* (©=SDD 321)**
London CS 6224

Falla: <The Three Cornered Hat (Complete Ballet)>, <La Vida Breve-Interlude & Dance>, L'Orchestre de la Suisse Romande-Ernest Ansermet. Producer: James Walker. Recorded by Roy Wallace, February 1961 in Victoria Hall, Geneva. ℗1961

Remark & Rating
ED1, 3E-1E, Very rare!!! $$$$$
RM19, Penguin ★★(★), TAS2017 (45rpm), AS list-F (Speakers Corner), Japan 300

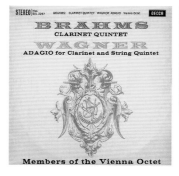

Label **Decca SXL 2297 (©=SDD 249)**
London CS 6234

Brahms: <Clarinet Quintet in B Minor, Op.115>**(*); Wagner: <Adagio for Clarinet and String>***, Alfred Boskovsky (clarinet), Members of the Vienna Octet. @1962 [Brahms-Penguin ★★(★); Wagner-Penguin ★★★]

Remark & Rating
ED1, 1D-1D, $$
RM16, Penguin ★★(★) & ★★★

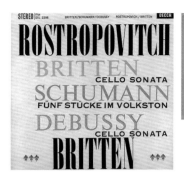

Label **Decca SXL 2298***
London CS 6237

Britten: <Sonata in C for Cello and Piano, Op.65>; Debussy: <Sonata for Cello & Piano>; Schumann: <Fünf Stücke im Volkston>, Mstislav Rostropovich (cello), Benjamin Britten (piano). @1962

Remark & Rating
ED1, 1E-1E, $$$$
RM16, Penguin ★★★

Label **Decca SXL 2299**
London OS 25312

[The Art of Oda Slobodskaya], Side A: <A Recital Of Russian Songs>*, Rimsky-Korsakov (arr. Ippolitov-Ivanov): <Three Folksongs>*; Gretchaninov: <Lullaby>*, <The Dreary Steppe>*,<Like an Angelm>*, <My Country>*; Borodin: <From my Tears Sprang Flowers>*, <The Sea Princess>*; Balakirev: <Hebrew Melody>*; Tchaikovsky: <Eugene Onegin-Tatiana's Letter Scene>*; Side B: <Child Love Song>; Rachmaninov: <To The Children>, <The Little Island>, <The Soldier's Wife>; Prokofiev: <Dunyushka>; Blanter: <In the Forest of the Front Line>, <Katyusha>; Stravinsky: <Three Tales for Children>. Oda Slobodskaya (soprano) and Ivor Newton (piano). [Side A was dubbed from 78 RPM, mono recording by Kenneth Wilkinson* in 1945 & 1946; Side B, Stereo recording by Arthur Lilley, Feb. 1961.] ©1961

Remark & Rating
ED1, 2E-2E, Very rare!! $$$
(K. Wilkinson)

Label **Decca SXL 2300-1 (©=SDD 386-7, DPA 589-90)**
London CSA 2206

J.S. Bach: [The Four Orchestral Suites], <No.1 in C Major, BWV.1066>, <No.2 in B Minor, MWV.1067>, <No.3 in D Major, BWV. 1068>, <No.4 in D Major, BWV.1069>, Soloists: (Oboes) Fritz Fischer, Hans-Peter Weber, Gustav Steinert; (Bassoon) Herbert Anton; (Harpsichord) Germaine Vaucher-Clerc; (Flute) Jean-Pierre Rampal; (Trumpets) Adolf Scherbaum, Kondrad Reinecke, Ernst Moehlheinrich; (Timpani) Karl Schad, The Stuttgart Chamber Orchestra-Karl Münchinger. Recorded by Alan Reeve, June 1961 in the Victoria Hall, Geneva. @1962

Remark & Rating
ED1, 1E-1E-1E-1E, $$$

Label **Decca SXL 2302* (©=SDD 169, SPA 120)**
London CS 6236

Handel: <The Water Music>, <The Royal Fireworks>, The London Symphony Orchestra-George Szell. Producer: John Culshaw. Recorded by Kenneth Wilkinson, August 1961 in Watford Town Hall. @1962

Remark & Rating
ED1, 1E-1E, Very rare!! $$$
RM19, Penguin ★★★, (K. Wilkinson)

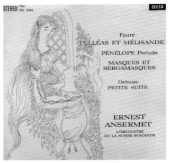

Label **Decca SXL 2303 (©=SDD 388)**
London CS 6227

Faure: <Masques & Bergamasques, Op.112>, <Pelleas & Melisande, Op.80>, <Penelope Prelude>; Debussy: <Petite Suite>*, L'Orchestre de la Suisse Romande-Ernest Ansermet. Ⓟ1961 ©1962 [*Debussy is Penguin ★(★)]

Remark & Rating
ED1, 6E-4E, $$
RM16, Penguin ★★★

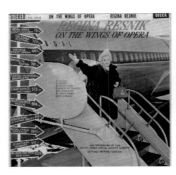

Label **Decca SXL 2304 (©=SDD 222)**
London OS 25316

[Regina Resnik - On the Wings of Opera], Arias from: Carmen; Jeanne D'Arc; Samson Et Dalila; Die Walküre; Il Trovatore; Don Carlos. Regina Resnik (mezzo-soprano) with Orchestra of The Royal Opera House Covent Garden-Edward Downes. ©1962

Remark & Rating
ED1, 1E-1E, $$

Label **Decca SXL 2305 (©=SDD 400)**
London CS 6244

Holst: <The Planets, Op.32>, The Vienna Philharmonic Orchestra-Herbert von Karajan. Ⓟ ©1962

Remark & Rating
ED2 1st, 5W-3W, Very rare!! $$$

Label **Decca SXL 2306**
London CS 6240

Prokofiev; <Romeo & Juliet Suites, Op.64 BIS, (Highlights)>, L'Orchestre de la Suisse Romande-Ernest Ansermet. Recorded by Roy Wallace, November 1961 in the Victoria Hall, Geneva. Ⓟ1962 ©1966

Remark & Rating
ED2 1st, 5W-3W, Very rare!! $$$

Label **Decca SXL 2306-7 (©=SPA 226)**

Prokofiev; <Romeo & Juliet Suites, Op.64 BIS, (Highlights)> & <Selection from Ciderella Suite>, L'Orchestre de la Suisse Romande-Ernest Ansermet. Recorded by Roy Wallace, November 1961 in the Victoria Hall, Geneva. Ⓟ ©1962

Remark & Rating
ED1, 1E-1E-1D-1D, Very rare!!! $$$$$

Label **Decca SXL 2307**
London CS 6242

Prokofiev; <Ciderella Suite, (Highlights)>, L'Orchestre de la Suisse Romande-Ernest Ansermet. Recorded by Roy Wallace, November 1961 in the Victoria Hall, Geneva. ℗ ©1962

Remark & Rating
ED1, !D-1D, Very rare!! $$$
RM15

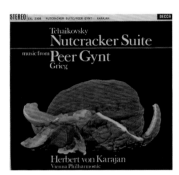

Label **Decca SXL 2308**
London CS 6420, (ED2 1st)

Tchaikovsky: <Nutcracker suite (Casse noisette) Op. 71a>, Grieg: <Peer Gynt Suite>, The Vienna Philharmonic Orchestra-Karajan. Produced by John Culshow & recorded by Gorgon Parry & James Brown, September 1961 in the Sofiensaal, Vienna. ℗1962 (London ©1964)

Remark & Rating
ED1, 1E-3E, $$
Penguin ★★★

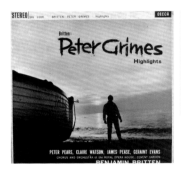

Label **Decca SXL 2309 (SXL 2150-2)**
London OS 26004 (OSA 1305)

Britten: <Peter Grimes, Highlights>, Watson, Elms, Pears, Nilsson, Lanigan, Pease, Royal Opera House Orchestra, Covent Garden-Benjamin Britten. Recorded by Kenneth Wilkinson, December 1958 in Walthamstow Town Hall. ℗1959 ©1962 (Highlights from SXL 2150-2 & OSA 1305)

Remark & Rating
ED1, 1E-1E
Penguin ★★★, (K. Wilkinson)

Label **Decca SXL 2310**
London OS 25330

Schumann: <Heine-Dichterliebe Op.48> and< Four Other Heine Song>, Eberhard Wachter (bass-baritone) and Alfred Brendel (piano). ℗©1962

Remark & Rating
ED1, 1D-2D, $$$
RM18, TAS2016, AS List-H

Label **Decca SXL 2311**
London CS 6241

Franck Martin: <Concerto for 7 Wind Instruments, Timpani, Percussion and String Orchestra>, <Etudes for String Orchestra>, L'Orchestre de la Suisse Romande-Ernest Ansermet. Producer: James Walker. Recorded by Roy Wallace, November 1961 in Victoria Hall, Geneva.@1962

Remark & Rating
ED1, 1D-2D, $$$
RM18, TAS2016, AS List-H

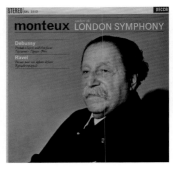

Label **Decca SXL 2312* (©=SDD 425)**
London CS 6248 (©=STS 15356)

Debussy: <Prelude a l'apres midi d'un faune>, <Nocturnes - Nuages, Fetes>; Ravel: <Pavane pour une infante defunte>, <Rapsodie Espagnole>, The London Symphony Orchestra-Pierre Monteux. Recorded by Kenneth Wilkinson, December 1961 in Kingsway Hall, London. @1962

Remark & Rating
ED1, 3D-1D, $$$
RM15, Penguin ★★(★), (K. Wilkinson)

Label **Decca SXL 2313***
London CS 6252

Ferdinand Herold: <La fille mal Gardee (The Wayward Daughter)>, Orchestra of the Royal Opera House, Covent Garden-John Lanchbery. Producer: Ray Minshall. Recorded by Arthur Lilley, February-March 1962 in Kingsway Hall. @1962

Remark & Rating
ED1, 1E-3E, Very rare!! $$$+ (ED2, 2E-3E, $$)
RM20, TASEC ★★, Penguin ★★★, AS list

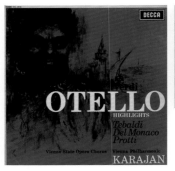

Label **Decca SXL 2314 (SET 209-11)**
London OS 25701 (OSA 1324)

Verdi: <Otello, Highlights>, Mario del Monaco, Renata Tebaldi, Aldo Protti, Fernando Corena, Tom Krause, The Vienna Philharmonic Orchestra-Herbert von Karajan. ℗1961 ©1962 (Highlights from SET 209-11 & OSA 1324)

Remark & Rating
ED1, 5W-4W
Penguin ★★(★)

Label **Decca SXL 2315 (SET 212-4)**
London OS 25702 (OSA 1327)

Donizetti: <Lucia di Lammermoor, Highlights>, Sutherland, Cioni, Merrill, Siepi, etc., Chorus & Orchestra of L'Accademia Di Santa Cecilia, Rome-John Pritchard. Recorded by Kenneth Wilkinson, 29 July - 7 August 1961 in Rome. ℗1961 ©1962 (Highlights from SET 212-4 & OSA 1327)

Remark & Rating
ED1, 1G-1G
Gramophone, Grand Prix du Disc, Japan 300, (K. Wilkinson)

Label **Decca SXL 2316 (SET 218-20)**
London OS 25703 (OSA 1329)

Handel: <Messiah (Excerpts)>, Joan Sutherland (soprano), Grace Bumbry (alto), Kenneth McKellar (tenor), David Ward (bass), The London Symphony Orchestra and Chorus-Adrian Boult. Recorded by Kenneth Wilkinson, August 1961 in Kingsway Hall, London. ℗1961 ©1962 (Part of SET 218-20 & OSA 1329)

Remark & Rating
ED1, 2G-1G
(K. Wilkinson)

DECCA
SXL SERIES

SXL 6000 - SXL 7013

Label **Decca SXL 6000***
London CS 6322

Khachaturian: Ballet Suite <Spartacuss> & <Gayaneh>, The Vienna Philharmonic Orchestra-Aram Khachaturian. Producer: Erik Smith. Recorded by James Brown, March 1962. ℗ ©1962

Remark & Rating
ED1, 2E-2E, Very rare!! $$$
RM17, TASEC65, Penguin ★★★, AS list

Label **Decca SXL 6001**
London CS 6323

Khachaturian: <Symphony No.2 (The Bell)>, The Vienna Philharmonic Orchestra-Aram Khachaturian. Producer: Erik Smith. Recorded by James Brown, March 1962. ℗ ©1962

Remark & Rating
ED1, 1G-1G, Rare! $$
RM18, TASEC65, Penguin ★★(★), AS list

Label **Decca SXL 6002**
London CS 6251

Adolphe Adam: <Giselle - Ballet>, TheVienna Philharmonic Orchestra-Herbert von Karajan. ℗ ©1962

Remark & Rating
ED1, 3E-4E, $

Label **Decca SXL 6003 (©=SDD 189)**
London OS 25320

Honegger: <Symphony for Strings>, <A Christmas Cantata>, Pierre Mollet (baritone), LOrchestre de la Suisse Romande-Ernest Ansermet. Recorded by Roy Wallace, 1961 at the Victoria Hall, Geneva. ℗ ©1962

Remark & Rating
ED1, 1E-1E, $$

Label **Decca SXL 6004 (©=SDD 129; ECS 754)**
London CS 6243 (©=STS 15541)

J.S.Bach: Orchestral Suites <No.2 in B Minor, BWV.1067>, <No.3 in D, BWV.1068>, <Sonata from Cantata No.31>, <Sinfonia from Cantata No.12>, L'Orchestre de la Suisse Romande-Ernest Ansermet. ℗ ©1962

Remark & Rating
ED1, 1E-1E, rare!, $$
RM14

Label **Decca SXL 6005 (©=SDD 206)**
London OS 25726

[Spanish & Italian Songs], A Program of Spanish & Italian Songs from Luigi Cherubini; Marc Antonio Cesti; Giovanni Battista Pergolesi; Alessandro Scarletti; J. Guridi; Felix Lavilla; Joaquin Turina; Enrique Granados.Theresa Berganza (mezzosoprano) and Felix Livilla (piano). ℗ ©1962

Remark & Rating
ED1, 2W-1E, $

Label **Decca SXL 6006**
London CS 6324

Holst: <The Hymn of Jesus, Op.37>*, BBC Symphony Orchestra & Chorus, <The Perfect Fool, Op.39 (Ballet music)>, <Egdon Heath, Op.47>, London Philharmonic Orchestra-Adrian Boult. Recorded by* Alan Reeve & Kenneth Wilkinson in Kingsway Hall, London. ℗ by Christopher Raeburn ©1962

Remark & Rating
ED1, 2E-2E, $
RM18, TAS-OLD, Penguin ★★★, (K. Wilkinson)

Label **Decca SXL 6007**
London OS 25327

[Folk Songs], <The brisk young widow>, <O waly, waly>, <Sweet Polly Oliver>, <Early one morning>, <The bonny Earl O'Moray>, <The ash grove>, <Come you not from Newcastle>, etc., Peter Pears (tenor) and Benjamin Britten (piano). ℗ ©1962

Remark & Rating
ED1, (ED2, 3W-1E, 15 Usd)
Penguin ★★★

Label **Decca SXL 6008 (SET 224-6)**
London OS 25710 (OSA 1332)

Verdi: <Rigoletto, Highlights>, Renato Cioni, Cornell MacNeil, Mario del Monaco, Cesare Siepi, Stefania Malagu, Joan Sutherland, Anna Di Stasio, Fernando Coren, Chorus & Orchestra of the Accademia Di Santa Cecilia, Rome-Nino Sanzogno. ℗ ©1962 (Highlights from SET 224-6 & OSA 1332)

Remark & Rating
ED1, 1W-1W

Label **Decca SXL 6009 (SET 218-20)**
London OS 25711 (OSA 1329)

Handel: <Messiah (Choruses)>, John McCarthy (chorusmaster), The London Symphony Chorus and Orchestra-Adrian Boult. Recorded by Kenneth Wilkinson, August 1961 in Kingsway Hall, London. ℗1961 (Part of SET 218-20 & OSA 1329)

Remark & Rating
ED1, 1G-1G, $
(K. Wilkinson)

Label **Decca SXL 6010 (SET 218-20)**
London OS 25712 (OSA 1329)

Handel: <Messiah (Excerpts)>, Joan Sutherland (soprano), Grace Bumbry (alto), The London Symphony Orchestra and Chorus-Adrian Boult. Recorded by Kenneth Wilkinson, August 1961 in Kingsway Hall, London. ©1962 (Part of SET 218-20 & OSA 1329)

Remark & Rating
ED1, 3W-2W, $
(K. Wilkinson)

Label **Decca SXL 6011 (GOS 607-8)**
London OS 25713 (OSA 1317)

Puccini: <Manon Lescaut, Highlights>, Del Monaco, Tebaldi, Borriello, Orchestra of the Accademia Di Santa Cecilia, Rom-Francesco Molinari-Pradelli. Recorded by Roy Wallace, July 1954 in Rome. ℗1960 ©1965 (Highlights from London OSA 1317)

Remark & Rating
ED1, 2E-1G

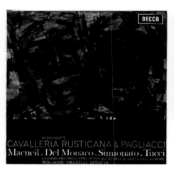
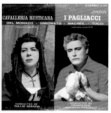

Label **Decca SXL 6012 (SXL 2185-6; 2253-5; 2281-2)**
London OS 25334 (OSA 1330)

Leoncavallo: <I Pagliacci (Highlights)>; Mascagni: <Cavalleria Rusticana (Highlights)>, Simionato, Del Monaco, Simionata, Del Monaco, MacNeil, Tucci, Orchestra and Chorus of the Accademia di Santa Cecilia, Rome conducted by Francesco Molinari-Pradelli & Tullio Serafin. ©1961 (Hiighlights from SXL 2185-6; SXL 2253-5; SXL 2281-2 & London OSA 1330)

Remark & Rating
ED1, 3E-3E, $

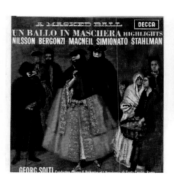
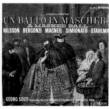

Label **Decca SXL 6013 (SET 215-7)**
London OS 25714 (OSA 1328)

Verdi: <A Masked Ball (Un Ballo in Maschera), Highlights>, Birgit Nilsson, Carlo Bergonzi, Cornell MacNeil, Giulietta Simionato, Silvia Stalhman, Tom Krause, Fernando Corena, Orchestra & Chorus of L'Accademia Di Santa Cecilia, Rom-Georg Solti. ℗1962 (Highlights from SET 215-7 & OSA 1328)

Remark & Rating
ED1, 2G-1G

Label **Decca SXL 6014 (=LXT 6014 & 5016)**
No London CS (=London LL 1182)

Beethoven: <33 Variations on a Waltz of Diabelli, Op.120>, Wilhelm Backhaus (piano). Recorded in 1954 © 1955. *[Only LXT 5016 & 6014 Mono issue (=London LL 1182), No SXL 6014 Stereo issue]

Remark & Rating
Orange-Silver 1L-1L, rare! $

Label **Decca SXL 6015-6 (=SET 201-3, part)**
London OSA 1249 (OSA 1319)

Johann Strauss: <Die Fledermaus>, Hilde Gueden, Erika Köth, Waldemar Kmentt, Eberhard Wäechter, Walther Berry, Eirc Kunz, Regina Resnik with The Vienna State Opera Chorus & The Vienna Philharmonic Orchestra-Herbert von Karajan. (36 pages Booklet) Produced by John Culshaw. Recorded in the Sofiensaal, Vienna, June 1960. ℗1960 ©1962

Remark & Rating
ED1, $
Penguin ★★(★)

Label **Decca SXL 6017 (SET 221-3)**
London OS 25715 (OSA 1331)

Francesco Cilea: <Adriana Lecouvreur, Highlights>, Tebaldi, Monaco, Simionato, Fioravanti, Orchestra & Chorus of the Accademia di Santa Cecilia, Rome-Franco Capuana. Recorded by Kenneth Wilkinson, July 1961 in Rome. ℗1962 ©1963 (Highlights from SET 221-3 & OSA 1331)

Remark & Rating
ED1, 4G-1G
(K. Wilkinson)

Label **Decca SXL 6018 (©=SDD 179; ECS 767)**
London CS 6327

Shostakovich: <Symphony No.5 in D Minor, Op.47>, L'Orchestre de la Suisse Romande-Istvan Kertesz. @1962

Remark & Rating
ED1, 2G-2W, Rare! $$$
RM15

Label **Decca SXL 6020 (©=SDD 182)**
London CS 6333 (CSA 2306)

Haydn: [The Paris Symphonies], <Symphony No.82 in C Major, "L'ours" (The Bear)>, <Symphony No.86 in D Major>, L'Orchestra de la Suisse Romande-Ernest Ansermet. Recorded by Roy Wallace, April 1962 in the Victoria Hall, Geneva, Switzerland. ℗1962 [**No.82 is with No.83 in London CS 6333 but No.86 is in London CS 6334]

Remark & Rating
ED1, 2G-1G, $$
RM13

Label **Decca SXL 6021 (©=SDD 183)**
London CS 6334 (CSA 2306)

Haydn: [The Paris Symphonies], <Symphony No.83 in G Minor "La Poule" (The Hen)>, <Symphony No.87 in A Major>, L'Orchestra de la Suisse Romande-Ernest Ansermet. Recorded by Roy Wallace, April 1962 in the Victoria Hall, Geneva, Switzerland. ℗1962 [*No.87 is with No.86 in London CS 6333, No.83 is in London CS 6333]

Remark & Rating
ED1, 1G-3W, $$
RM14

Label **Decca SXL 6022 (©=SDD 184)**
London CS 6335 (CSA 2306)

Haydn: [The Paris Symphonies], <Symphony No.84 in E Flat Major "La Reine" (The Queen)>, <No.85 in B Flat Major>, L'Orchestra de la Suisse Romande-Ernest Ansermet. Recorded by Roy Wallace, April 1962 in the Victoria Hall, Geneva, Switzerland. ℗1962

Remark & Rating
ED1, 1G-1G, $$
RM14

Label **Decca SXL 6023***
London CS 6329

Brahms: <Piano Concerto No.1 In D Minor Op.15>, Clifford Curzon (piano) with the London Symphony Orchestra conducted by George Szell. Producer: John Culshaw. Recorded by Kenneth Wilkinson in May, June 1962. ℗1962

Remark & Rating
ED1, 2G-3G, $$
RM19, Penguin ★★★, TAS2016, G.Top 100, (K. Wilkinson)

Label **Decca SXL 6024 (©=SPA 202)**
London CS 6330

[Bohemian Rhapsody], Smetana: <The Bartered Bride - Overture, Polka, Furiant>, <Moldau (Vltava)>; Dvorak: <Slavonic Dances - Op.46, no.1, no.3 & no.8; Op.72, no.1 & no.2>, The Israel Philharmonic Orchestra-Istvan Kertesz. ℗1962

Remark & Rating
ED1, 1G-1G, Rare!, $$
RM16, Penguin ★★★

Label **Decca SXL 6025 (©=SDD 421)**
London CS 6328

Beethoven: Overtures <Leonore No.1, Op.138>, <Leonore No.2, Op.72A, <Leonore No.3, Op.72A>, <Fidelio, Op.72B>, The Israel Philharmonic Orchestra-Lorin Maazel. ℗1962

Remark & Rating
ED1, 3W-2W, $
RM14

Label **Decca SXL 6026* (©=SDD 417)**
London CS 6332 (©=STS 15364)

Bartok: <Divertimento for String Orchestra>*; Vivaldi: < Concerto Grosso in B Minor, Op.3 No.10>**, <Concerto Grosso in D Minor, Op.3 No.11>**, Moscow Chamber Orchestra-Rudolf Barshai. Recorded by Kenneth Wilkinson, June & July 1962. @1962 (* Bartok is Penguin ★★★; ** Vivaldi is Penguin ★★)

Remark & Rating
ED1, 1D-1D, $
RM17, TAS2016, Penguin ★★★, (K. Wilkinson)

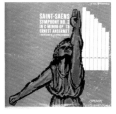

Label **Decca SXL 6027 (©=SPA 228, part)**
London CS 6331 (©=STS 15154)

Saint-Saëns: <Symphony No.3 in C Minor, Op.78>, L'Orchestre de la Suisse Romande-Ernest Ansermet. Recorded by Roy Wallace, May 1962 in the Victoria Hall, Geneva. @1962

Remark & Rating
ED1, 1E-1E, Very rare!! $$$
RM14, Penguin ★★(★)

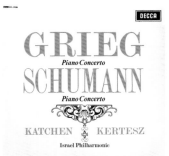

Label **Decca SXL 6028 (©=SDD 422)**
London CS 6336

Grieg: <Piano Concerto in A Minor, Op.16>; Schumann: <Piano Concerto in A Minor, Op.54>, Julius Katchen (piano), The Israel Philharmonic Orchestra-Istvan Kertesz. ©1962

Remark & Rating
ED1, $+
RM14, Penguin ★★(★)

Label **Decca SXL 6029**
No London CS

Johann Strauss: "Great Waltzes", <An der Schoene Blauen Donau, Op.314>, <Winer Blut Waltz, Op.354>, <Kaiser Walzer, Op.437>, <Tausend und Eine Nacht Waltz, Op.346>; Josef Strauss: <Transaktionen, Op.184>, <Sphärenklänge, Op.235>, The Vienna Philharmonic Orchestra-Willi Boskovsky. ℗1958 & 1960 ©1962

Remark & Rating
ED1, 1E-1E, $
Penguin ★★(★)

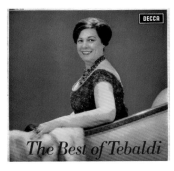

Label **Decca SXL 6030**
London OS 25729

[The Best of Tebaldi], Puccini: <La Boheme>, <Tosca>, <La Funciulla Del West>, <Madama Butterfly>, <Turandot>; Giordano: <Andrea Chenier>; Cilea: <Adriana Lecouvreur>; Boito: <Mefistofele>. Renata Tebaldi (soprano), conducted by Serafin, Capuana, Pradelli, Erede, & Gavazzeni with the Orchestra of the St.Cecilia Academy, Rome. ℗1962

Remark & Rating
ED1,1E-1E, $

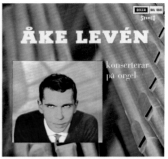

Label **Decca SXL 6031 (No UK Decca)**
No London CS (DECCA SXL 6031 Black-Gold label)

[Åke Levén Konserterar På Orgel (Organ Recital)], Works and arrangements from G.F. Händel: <Hornpipe>, <Lentement>; Jeremiah Clarke: < March for the Prince of Denmark>; John Stanley: <Trumpet tune>; André Campra: <Rigaudon, A-dur>; Eugene Gigout: <Toccata, h-moll>; Henry Lindroth: <Gammal fäbodpsalm>; Otto Olsson: <O quot undis lacrimarum>, <O sacrum convivium>; Vilhelm Stenhammar: <Mellanspel ur kantaten "Sången">. Åke Levén (organ), recorded in the Gustaf Vasa Church, Stockholm. (No UK Decca, Decca SXL issued only from Sweden, pressed in Germany. @1962) (Very hard to find, Ultra rare !!!)

Remark & Rating
Black-Gold Label, Ultra rare!!! $$

Label **Decca SXL 6032 (=LXT 6032)**
No London CS

[The Art of Advocacy], <Cricketers Everywhere>; <Shakespeare Birthday Celebration Luncheon>, Lord Norman Birkett. Recording from the BBC Sound Archives. @1962 (Decca LXT 6032, Mono, Q LXT 3032)

Remark & Rating
ED1, Rare!!

Label **Decca SXL 6033**
London OS 25742

[Birgit Nilsson sings Verdi], Verdi: <Macbeth>, <Nabucco>, <La Forza Del Destino>, <Don Carlos>, Orchestra & Chorus of the Royal Opera House, Covent Garden-Argeo Quadri. Recorded by Kenneth Wilkinson, August 1962 in Watford Town Hall, London. ℗1962 by Christopher Raeburn

Remark & Rating
ED1, 2E-1E, $
(K. Wilkinson)

 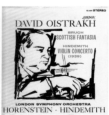

Label **Decca SXL 6035* (©=SDD 465)**
London CS 6337

Bruch: <Scottish Fantasia, Op.46>, Osian Ellis (harp), London Symphony Orchestra-Jascha Horenstein; Hindemith: <Violin Concerto (1939)>, London Symphony Orchestra-Paul Hindemith, David Oistrakh (violin). Producer: John Culshaw. Recorded by Alan Reeve & Michael Mailes, September 1962. ℗1963

Remark & Rating
ED1, 1E-1E, Very rare!! $$$$$, (ED2 1E-1E, $$$$)
RM20, Penguin ★★★, AS List-H (Speakers Corner)

Label **Decca SXL 6036*** (©=SDD 156; ECS 795)
London CS 6338 (©=STS 15046)

Borodin: <String Quartet No.2 in D Major>; Shostakovich: <String Quartet No.8, Op.110>, The Borodin Quartet - Rostislav Dubinsky (violin), Jaroslav Alexandrov (violin), Dmitry Shebalin (viola), Valentin Berlinsky (cello). Producer: Erik Smith, recorded in September 1962. ℗1962

Remark & Rating
ED1, 1E-1E, Very rare!! $$$
RM18, Penguin ★★★, TAS2017 (Speakers Corner ADEC 6036)

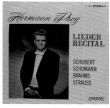

Label **Decca SXL 6037**
London OS 25757

[Hermann Prey Lieder Recital], Songs by Schubert, Schumann, Brahms & Strauss, Hermann Prey (baritone), Karl Engel (piano). ℗1963

Remark & Rating
ED1, 1E-1E, $

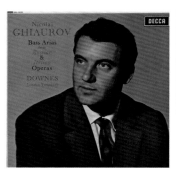

Label **Decca SXL 6038**
London OS 25769

[Bass Arias from Russian & Italian Operas], Rimsky-Korsakov: <"Sadko" Viking Aria>; Mussorgsky: <"Boris Godunov" Pimen's Recitation>; Tchaikovsky: <"Eugene Onegin" Prince Gremin's Aria; Rachmaninov: <"Aleko" Aleko's Cavatina>; Verdi: <"Don Carlos" King Philip's Aria>, <"Nabucco" Zaccaria's Prayer>; Mozart: <"Don Giovanni" Leporello's Aria>, Nicolai Ghiaurov (bass), The London Symphony Orchestra-Edward Downes. Recorded by Arthur Lilley in Kingsway Hall. ℗1963

Remark & Rating
ED1, 1G-1G, $

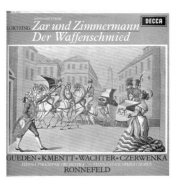

Label **Decca SXL 6039** (©=SDD 462)
London OS 25768

Lortzing: <Zar Und Zimmermann, Highlights>, <Der Waffenschmied, Highlights>, Gueden, Wachter, Czerwenka, Kmentt, The Vienna Volksoper Orchestra and Vienna State Opera Chorus-Peter Ronnefeld. ℗1963

Remark & Rating
ED1, 1E-1E
Penguin ★★(★)

Label **Decca SXL 6040**
London CS 6340

[Tales from the Vienna Woods (G'schichten aus dem Wiener Wald)], Anton Karas (Zither), The Vienna Philharmonic Orchestra-Willi Boskovsky. Producer: Christopher Raeburn. Recorded by James Brown, November 1962 in the Sofiensaal, Vienna. ℗1963

Remark & Rating
ED1, 2E-1E
RM17, Penguin ★★(★)

 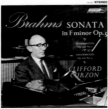

Label **Decca SXL 6041 (©=SDD 498)**
London CS 6341 (©=STS 15272)

Brahms: <Sonata No.3 in F Minor, Op.5>, <Intermezzo in E Flat, Op.117 No.1>, <Intermezzo in C Major, Op.119 No.3>, Clifford Curzon (piano) ℗1963

Remark & Rating
ED1, 1E-1E, $
Penguin ★★★

Label **Decca SXL 6042**
London OS 25778

[Kirsten Flagstad in Memorium], Wagner: <Die Walküre-War es so Schmählich>, Otto Edelmann (Bass), The Vienna Philharmonic-Georg Solti; <Das Rheingold-Wotan, Gemahl! Erwache!>, <Die Walkure-Der Männer Sippe, Du Bist Der Lenz & Wessendonck Songs>, etc., Kirsten Flagstad (soprano); George London (baritone); Claire Watson (soprano), The Vienna Philharmonic Orchestra-Georg Solti & Hans Knappertsbusch. ©1963

Remark & Rating
ED1, 2D-1E, $

 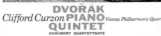

Label **Decca SXL 6043 (©=SDD 270)**
London CS 6357

Dvorak: <Piano Quintet in A Major>; Schubert: <Quartettsatz in C Minor>, Clifford Curzon (piano), The Vienna Philharmonic Quartet - Otto Strasser (violin), Rudolf Streng (viola), Robert Scheiwein (Cello). ©1963

Remark & Rating
ED1, 1E-1E, rare! $$+
Penguin ★★★

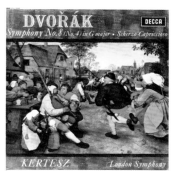

Label **Decca SXL 6044***
London CS 6358

Dvorak: <Symphony No.8 (No.4) in G Major, Op.88>, <Scherzo Capriccioso>, London Symphony Orchestra-Istvan Kertesz. Recorded by Kenneth Wilkinson. ℗1963

Remark & Rating
ED1, 3G-3G, $
TAS2016, Penguin ★★★, AS List-H (D6D 7), (K. Wilkinson)

Label **Decca SXL 6045 (©=SDD 176)**
London OS 25782

[Teresa Berganza Sings Mozart], <Le Nozze Di Figaro: Non so piu, Voi, Che Sapete>, <La Clemenza Di Tito: Parto, Parto, (Gervase Di Peyer-clarinet)>, <Recitative: Ch'io mi Scordi Di Te?; Temerari & Ei Parte>, <Aria: Non Temer (K. 505); Per Pieta, (Geoffrey Parsons-piano)>, <Cosi Fan Tutte: Come Scoglio; E Amore un Ladroncello>, Teresa Berganza (mezzo-soprano) with the London Symphony Orchestra-John Pritchard. ℗1963

Remark & Rating
ED1, 1D-1D, $$
Penguin ★★★

Label **Decca SXL 6046**
London OS 25783

[Tom Krause Recital], Songs By Sibelius & Richard Strauss, Tom Krause (baritone), John Williams (guitar), Pentti Koskimies (piano). ℗1963

Remark & Rating
ED1, 2W-1D, $$

Label **Decca SXL 6049**
London CS 6346

Mozart: [Wind Music Vol. 3], <Serenade in B Flat, K.361 for 13 Instruments>, London Wind Soloist-Jack Brymer. ©1963 (=London CS 6346, the cover is Volume 1)

Remark & Rating
ED1, 1E-1E
RM16, Penguin ★★★

Label **Decca SXL 6050**
London CS 6347

Mozart: [Wind Music Vol. 1], <Serenade in E Flat, K.375>, <Divertimento in E Flat, K.166>, <Divertimento in F, K.213>, London Wind Soloist-Jack Brymer. ©1963 (=London CS 6347, the cover is Volume 2)

Remark & Rating
ED1, 1E-1E
RM16, Penguin ★★★

Label **Decca SXL 6051**
London CS 6348

Mozart: [Wind Music Vol. 2], <Serenade in C Minor, K.388>, <Divertimento in B Flat, K.186>, <Divertimento in F, K.253>, London Wind Soloist-Jack Brymer. ©1963 (=London CS 6348, the cover is Volume 3)

Remark & Rating
ED1, 1E-3W
RM16, Penguin ★★★

Label **Decca SXL 6052**
London CS 6349

Mozart: [Wind Music Vol. 4], <Divertimento in B Flat, K.240>,<Divertimento in E Flat, K.252>, <Divertimento in E Flat, K.226>, <Adagio in F, K.410>, London Wind Soloist-Jack Brymer. ©1963

Remark & Rating
ED1, 1E-1E
RM16, Penguin ★★★

Label **Decca SXL 6053**
London CS 6350

Mozart: [Wind Music Vol. 5], <Divertimento in B Flat, K.270>, <Divertimento in B Flat, K.227>, <Divertimento in E Flat, K.289>, <Adagio in B Flat, K.411>, London Wind Soloist-Jack Brymer. ©1963

Remark & Rating
ED1, 2E-1E
RM16, Penguin ★★★

Label **Decca SXL 6054** (©=SDD 155; SPA 495)
London CS 6351 (©=STS 15071)

Mozart: <Clarinet Concerto in A Major, K.622>, <Flute and Harp Concerto in C Major, K.299>, Alfred Prinz (clarinet); Werner Tripp (flute); Hubert Jellinek (harp), The Vienna Philharmonic Orchestra-Karl Münchinger. Recorded by James Brown, September 1962 in the Sofiensaal, Vienna. ©1963 by Christopher Raeburn

Remark & Rating
ED1, 2E-2E, rare! $$
Penguin ★★★, AS list-H (SDD 155)

Label **Decca SXL 6055 (©=SDD 290 & 340)**
 London CS 6352

Mozart: <Divertimento in B Flat Major, K.287>* ; Michael Haydn: <Divertimento in G Major>, Members of The Vienna Octet - Anton Fietz & Philipp Matheis (violin); Günther Breitenbach (viola); Nikolaus Hübner (cello); Johann Krump (bass); Josef Veleba & Wolfgang Tömlock (horn). ©1962 [* Mozart's Divertimento in SDD 290, Penguin ★★(★)]

Remark & Rating
ED1, 1E-1E, rare! $$
Penguin ★★(★)

Label **Decca SXL 6056**
 London CS 6354

Mozart: <Symphony No.33 in B Flat Major, K.319>, <Symphony No.39 in E Flat Major, K.543>, The Vienna Philharmonic Orchestra-Istvan Kertesz. ©1963

Remark & Rating
ED1, 1E-1E, Very rare!! $$+
Penguin ★★

Label **Decca SXL 6057**
 London CS 6359

Rachmaninov: <Piano Concerto No.3 in D Minor, Op.30>, Vladimir Ashkenazy (Piano), The London Symphony Orchestra-Anatole Fistoulari. ℗1963

Remark & Rating
ED1, 1E-2E, (ED2, 3L-3L, £30)
Penguin ★★(★)

Label **Decca SXL 6058**
 London CS 6360

Tchaikovsky: <Piano Concerto No.1 in B Flat Minor, Op.23>, Vladimir Ashkenazy (piano), The London Symphony Orchestra-Lorin Maazel. ℗1963 [*SXL 6840 is the reissue]

Remark & Rating
ED1, 3E-3E, $$
Penguin ★★★

Label **Decca SXL 6059 (=London CS 6361, one of CSA 2402)**
 London CSA 2402 (=Decca SXL 6059, 6060, 6061, 6062)

Brahms: <Symphony No.1 in C Minor, Op.68>, L'Orchestre de la Suisse Romande-Ernest Ansermet. ℗1963 [=London CS 6361, no single issue, one of the London Box-Set CSA 2402]

Remark & Rating
ED1, 1W-1W, rare! $$+

Label Decca SXL 6060 (=London CS 6362, one of CSA 2402)

Brahms: <Symphony No.2 in C Minor, Op.73>, <Tragic Overture Op.81>, L'Orchestre de la Suisse Romande-Ernest Ansermet. Recorded by Roy Wallace at the Victoria Hall, Geneva. ℗1963 [=London CS 6362, no single issue, one of the London Box-Set CSA 2402]

Remark & Rating
ED1, 2W-5W, rare! $$$

Label Decca SXL 6061 (=London CS 6363, one of CSA 2402)

Brahms: <Symphony No.3 in F Major, Op.90>, <Variation On A Theme Of Haydn, Op.56a>, (St.Antoni Chorale), L'Orchestre de la Suisse Romande-Ernest Ansermet. ℗1963 [=London CS 6363, no single issue, one of the London Box-Set CSA 2402]

Remark & Rating
ED1, 2W-2W, rare! $$

Label Decca SXL 6062 (=London CS 6364, one of CSA 2402)

Brahms: <Symphony No.4 in E Minor, Op.98>, <Academic Festival Overture, Op.80>, L'Orchestre de la Suisse Romande-Ernest Ansermet. Romande-Ernest Ansermet. Recorded by Roy Wallace at the Victoria Hall, Geneva. ℗1963 (=London CS 6364, no single issue, one of the London Box-Set CSA 2402)

Remark & Rating
ED1, 3W-3W, rare! $$+

Label Decca SXL 6063
London CS 6365

Beethoven: Piano Sonatas <Sonata No.28 in A Major, Op.101>, <Sonata No.17 in D Minor, Op.31, no. 2>, Wilhelm Backhaus (piano). ℗1963

Remark & Rating
ED1, 1E-1E, rare!! $$+

Label Decca SXL 6064
London CS 6366

Beethoven: Piano Sonatas <Sonata No.12 in A Flat, Op.26>, <Sonata No.18 in E Flat, Op.31, no.3>, Wilhelm Backhaus (piano). Recorded by Alan Abel at the Victoria Hall, Geneva. ©1963

Remark & Rating
ED1, 1E-2E, rare!! $$+

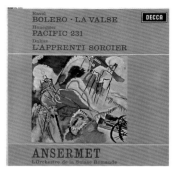

Label **Decca SXL 6065***
London CS 6367

Ravel: <Bolero>, <La Valse>; Honegger: <Pacific 231>; Dukas: <The Sorcerer's Apprentice>, L'Orchestra de la Suisse Romande-Ernest Ansermet. ©1964

Remark & Rating
ED1, 2E-2D, rare!! $$$
Penguin ★★★

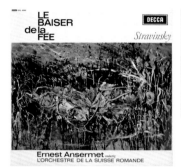

Label **Decca SXL 6066 (©=SDD 244)**
London CS 6368

Stravinsky: Ballet <Le Baiser De La Fee (The Fairy's Kiss)>, L'Orchestre De La Suisse Romande-Ernest Ansermet. ©1963

Remark & Rating
ED1, 3E-2E, rare!! $$
TASEC (CSA 2308)

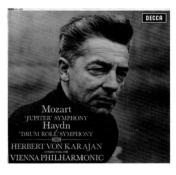

Label **Decca SXL 6067**
London CS 6369

Mozart: <Symphony No.41 in C Major, K.551, "Jupiter">, Haydn: <Symphony No.103 in E Flat Major "Drum Roll">*, The Vienna Philharmonic Orchestra-Herbert Von Karajan. Recorded by Gordon Parry at the Sofiensaal, Vienna. ℗1963 by John Culshaw *(Haydn is Penguin ★★)

Remark & Rating
ED1, 2E-1E, rare!! $$
Penguin ★★(★)

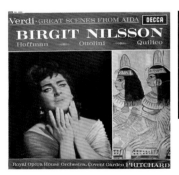 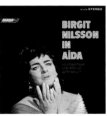

Label **Decca SXL 6068**
London OS 25798

Verdi: [Great Scenes From Aida (Birgit Nilsson in Aida)], Grace Hoffman, Luigi Ottolini, Louis Quilico, Orchestra of the Royal Opera House, Covent Garden-John Pritchard. ©1963

Remark & Rating
ED1, 2E-2E, $

Label **Decca SXL 6069**
London OS 25797

Schubert: <Schwanengesang>, Hermann Prey (baritone) and Walter Klien (piano). ©1963

Remark & Rating
ED1, rare! $$

Label **Decca SXL 6073 (SET 247-8)**
London OS 25776 (OSA 1254)

[Joan Sutherland, Command Performance Volume 1], Weber: <"Oberon" Ocean! thou mighty monster>; Massenet: <"Le Cid" Pleurez mes yeux>; Meyerbeer: <"Dinorah" Ombre légere Shadow spong>; Leoncavallo: <"Pagliacci" Stridono lassù>; Verdi: <"Masnadieri" Tu del mio Carlo>, <"Luisa Miller" Tu puniscimi, o Signore>; Rossini: <"Cambiale di matrimonio" Vorrei spiegarvi>; Bellini: <"Beatrice di Tenda" Deh! se un'urna>. Joan Sutherland (soprano), John Dobson (tenor), Ambrosian Singers and The London Symphony Orchestra-Richard Bonynge. Recorded by Arthur Lilley, Kenneth Wilkinson & Michael Mailes in Kingsway Hall. ℗1963

Remark & Rating
ED1, 4G-3G
Penguin ★★★, (K. Wilkinson)

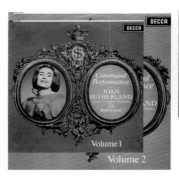

Label **Decca SXL 6073-4 (=SET 247-8)**
London OSA 1254, (ED1) (OS 25776, 25777)

[Joan Sutherland, Command Performance Volume 1 & 2], Joan Sutherland (soprano) with supporting soloists and choruses, London Symphony Orchestra-Richard Bonynge. Recorded by Arthur Lilley, Kenneth Wilkinson & Michael Mailes in Kingsway Hall. ℗1963 (=SET 247-8)

Remark & Rating
ED1, 4G-3G & 1D-1D, $
Penguin ★★★, (K. Wilkinson)

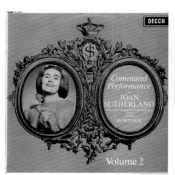

Label **Decca SXL 6074 (SET 247-8)**
London OS 25777 (OSA 1254)

[Joan Sutherland, Command Performance Volume 2], Julius Benedict: <The gipsy and the bird>; Arditti: <Parla!>, <Il bacio>; Ricci: <Crispino e la comare. Io non sono più 'Annetta>, Tosti: <Ideale>, <La serenata>; Leoncavallo: <Mattinata>; Bishop: <Lo, here the gentle lark>; Flotow: <Martha-The last rose of summer>; Wallace: <Maritana-Scences that are brightest>; Balfe: <Bohemian girl-I dreamt I dwelt>; Bishop: <Clari-Home sweet home>. Joan Sutherland (soprano) with The London Symphony Orchestra & Chorus-Richard Bonynge. Recorded by Arthur Lilley, Kenneth Wilkinson & Michael Mailes in Kingsway Hall. ℗1963

Remark & Rating
ED1, 1D-1D
Penguin ★★★, (K. Wilkinson)

Label **Decca SXL 6075 (©=SDD 313)**
London OS 25799

[Regine Crespin-Italian Operatic Arias], Verdi: <Tacea La Notte>, <Morro Ma Prima in Grazia>, <Willow Song and Prayer>; Ponchielli: <Suicidio>; Mascagni: <Voi Lo Sapete>; Puccini: <Un Bel Di>; Boito: <L'Altra Notte>, The Royal Opera House Orchestra-Edward Downes. ©1963 [2 kinds of cover for ED1, the stampers for this one is 1G-1G, the different one is 2G-2G]

Remark & Rating
ED1, 1G-1G, $$

Label **Decca SXL 6076***
London CS 6371

Liszt: <Sonata in B Minor>, <Liebestraum No.3>, <Valse Oublée No.1>, <Gnomenreigen>, <Berceuse>, Clifford Curzon (piano). Recorded by Gordon Parry at the Sofiensaal, Vienna. Ⓟ by John Culshaw ©1963

Remark & Rating
ED1, 4E-2E, rare! $$
Penguin ★★★

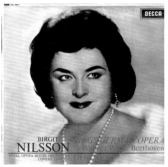
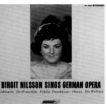

Label **Decca SXL 6077**
London OS 25807, (ED1)

[Birgit Nilsson Sings German Opera], Wagner: <"Tannhäuser" Dich teure Halle>, <"Die Walküre" Der Männer sippe ; Du bist der Lenz>, <"Lohengrin" Einsam in trüben Tagen>; Weber: <"Oberon" Ozean du Ungeheuer>, <"Der Freischütz" Leise, Leise>; Beethoven: <"Fidelio" Abscheulicher>, Birgit Nilsson (soprano) with the Royal Opera House Orchestra, Covent Garden conducted by Edward Downes. Recorded by James Lock & Kenneth Wilkinson Ⓟ1963 by John Culshaw

Remark & Rating
(K. Wilkinson)

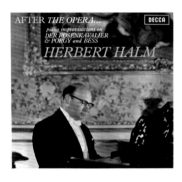

Label **Decca SXL 6078**
No London CS

[After the Opera], Piano Improvisations - Richard Strauss: <Der Rosenkavalier Fantasia> & George Gershwin: <Porgy and Bess Fantasia>, Piano & arranged by Herbert Halm. Recorded by Jack Law, in the Sofiensaal, Vienna, May 1963. @1963 *[One of the most difficult to find from all my DECCA collections, it took many years !!!]

Remark & Rating
ED1, 2E-1E, Ultral rare!!! $$

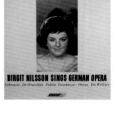

Label **Decca SXL 6079 (©=SDD 429)**
London OSA 1154, (ED1)

Verdi: <Scenes from Falstaff>, Fernando Corena (bass-baritone), Ilva Ligabue, Regina Resnik, Renato Capecchi, etc., New Symphony Orchestra of London-Edward Downes. Ⓟ ©1963

Remark & Rating
ED1, 1G-1G, $

Label **Decca SXL 6080 (SET 232-4)**
London OS 25874 (OSA 1361)

Handel: <Alcina, Highlights>, Sutherland, Bergonza, Freni, Flagello, Sinclair, Sciutti, Alva, The London Symphony Orchestra-Richard Bonynge. Ⓟ1962 ©1963 (Highlights from SET 232-4 & OSA 1361)

Remark & Rating
ED1, 1R-1R, $

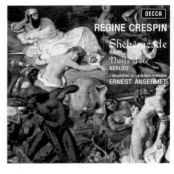

Label **Decca SXL 6081***
London OS 25821, (ED1)

Ravel: <Sheherazade (Song cycle)>; Berlioz: <Nuits D'ete>, Regine Crespin (soprano), L'Orchestre De La Suisse Romande-Ernest Ansermet. Recorded by James Lock, September 1963 at Victoria Hall, Geneva (Switzerland). ℗1963

Remark & Rating
ED1, 1E-1E, rare! $$
Penguin ★★★

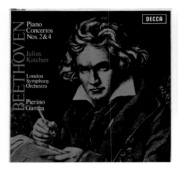

Label **Decca SXL 6082 (©=SDD 228)**
London CS 6374 (©=STS 15212)

Beethoven: <Piano Concerto No.2 in B Flat Major, Op.19>*, <Piano Concerto No.4 in G Major, Op.58>**, Julius Katchen (Piano), The London Symphony Orchestra-Pierino Gamba. Recorded in 1957 ℗1963 ©1964 [* No.2 is Penguin ★★(★); No.4 is Penguin ★(★)]

Remark & Rating
ED1, 1E-1E, rare! $$
Penguin ★★(★)

Label **Decca SXL 6083**
London OS 25833

[Robert Merrill Recital], Arias from "Otello", "Un ballo in Maschera", "La forza del destino", "Andrea Chenier", "Il Trovatore", "Don Carlos", "Pagliacci", Robert Merrill (baritone), New Symphony Orchestra of London-Edward Downes. ℗ ©1963

Remark & Rating
ED1, 1E-1E, $$

Label **Decca SXL 6084**
London CS 6375

Sibelius: <Symphony No.1 in E Minor, Op.39>, <Karelia Suite, Op.11>, The Vienna Philharmonic Orchestra-Lorin Maazel. Recorded by Gordon Parry, September 1963 in the Sofiensaal, Vienna. ℗1963 ©1964

Remark & Rating
ED1, 3G-3G, $
Penguin ★★★

Label **Decca SXL 6085**
London CS 6376

Tchaikovsky: <Symphony No.5 in E Minor, Op.64>, The Vienna Philharmonic Orchestra-Lorin Maazel. ℗1963 ©1964

Remark & Rating
ED1, 5F-5F

Label Decca SXL 6086 (©=SDD 172; ECS 762)
 London CS 6378

Schubert: <Symphony No.4 in C Minor, "Tragic", D.417>,
<Symphony No.5 in B-flat, D.485>, The Vienna Philharmonic
Orchestra-Karl Münchinger.℗1963 ©1964

Remark & Rating
ED1, 1G-1G, rare! $

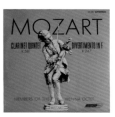
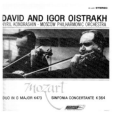

Label Decca SXL 6087 (©=SDD 289, 290)
 London CS 6379

Mozart: <Clarinet Quintet, K.581>, <Divertimento in F, K.247>*,
Members Of The Vienna Octet - Alfred Boskovsky (clarinet),
Anton Fietz & Philipp Matheis (violin), Günther Breitenbach
(viola), Nikolaus Hübner (cello), Johann Krump (double-bass),
Josef Veleba & Wolfgang Tombock (horn). ℗1963 ©1964 [*
Mozart's Divertimento in SDD 290, Penguin ★★(★)]

Remark & Rating
ED1, 1G-2G, rare! $$
Penguin ★★(★)

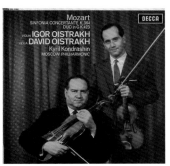
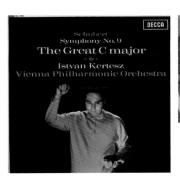

Label Decca SXL 6088* (©=SDD 445)
 London CS 6377

Mozart: <Sinfonia Concertante K.364>, <Duo in G Major
K.473>, David & Igor Oistrakh (violin), Moscow Philharmonic
Orchestra-Kyril Kondrashin. Recorded 27 September 1963 at
Decca Studios 3. ℗1963 ©1964

Remark & Rating
ED1, 1B-1B, rare! $$$
Penguin ★★(★), TAS2016

Label Decca SXL 6089 (SXLJ 6644; D105D 5)
 London CS 6381, (ED2 1st)

Schubert: <Symphony No.9 in C Major "The Great", D.944>,
The Vienna Philharmonic Orchestra-Istvan Kertesz. Recorded
in 1957 ℗1964

Remark & Rating
ED1, 2G-2G, rare! $$
Penguin ★★★

Label Decca SXL 6090 (SXLJ 6644; D105D 5)
 London CS 6382, (ED2 1st)

Schubert: <Symphony No.8 in B Minor "The Unfinished",
D.759>, Overtures <Des Teufels Lustschloss, D.84>, <In
the Italian style in C Major, D.591>, <Fierabras, D.796>, The
Vienna Philharmonic Orchestra-Istvan Kertesz. Recorded in
1957 ℗1964

Remark & Rating
ED1, 1G-1G, rare! $$
Penguin ★★★

Label **Decca SXL 6091 (©=SDD 480)**
London CS 6383, (ED2 1st)

Mozart: <Symphony No.36 "Linz", K.425>, <Eine Kleine Nachtmusik, K.525>, <March in C, K.408/1>, The Vienna Philharmonic Orchestra-Istvan Kertesz. ℗1964

Remark & Rating
ED1, 1E-1E, rare! $$+
Penguin ★★(★)

Label **Decca SXL 6092 (©=SDD 254)**
London CS 6384, (ED2 1st)

Schubert: Quartets <In D Minor "Death and The Maiden", D.810>, <In E Flat, Op.125, No.1, D.87>, Vienna Philharmonic Quartet-Willi Boskovsky & Otto Strasser (violin), Rudolf Streng (viola), Robert Scheiwein (cello). ℗ ©1964

Remark & Rating
ED1, rare! &&
Penguin ★★★

Label **Decca SXL 6093 (©=SDD 285)**
London CS 6385, (ED2 1st)

Haydn: <Quartet in E Flat Op.33 no.2 "Joke">, <Quartet in F Op.3 no.5 "Serenade">, <Quartet in D Minor Op.76 no.2 "Fifths">, The Janacek Quartet. ℗1964

Remark & Rating
ED1, 1W-1W, rare! $$$
Penguin ★★★

Label **Decca SXL 6094**
London CS 6386, (ED2 1st)

Wagner: <Lohengrin - Prelude Act 1>, Götterdämmerung - Siegfried's Funeral March>, <Die Meistersinger - Overture>, <Parsifal - Prelude - Good Friday Music>, (Ansermet Conducts Series), L'Orchestre De La Suisse Romande-Ernest Ansermet. ℗1964

Remark & Rating
ED1, rare! $$

Label **Decca SXL 6095**
London CS 6387, (ED2 1st)

Sibelius: <Symphony No. 4 in A Minor, Op. 63>, <Tapiola Symphonic Poem, Op.112>, L'Orchestre De La Suisse Romande-Ernest Ansermet. ℗1964

Remark & Rating
ED1, 1G-1G, $$

Label **Decca SXL 6096 (©=SDD 101)**
London CS 6388, (ED2 1st)

Beethoven: <Symphony No.1 in C Major, Op.21>, <Symphony No.8 in F Major, Op.93>, L'Orchestre de la Suisse Romande-Ernest Ansermet. ℗1964 [* There is a early recordings of the same symphonies recoded in 1956 (London CS 6120, ℗ 1959, No Decca SXL issue, only LXT 5232, mono issue)]

Remark & Rating
ED1, 1G-1G, rare! $$

Label **Decca SXL 6097**
London CS 6389, (ED2 1st)

Beethoven: Piano Sonatas <Sonata No.1 in F Minor, Op.2 no.1 >, <Sonata No.5 in C Minor, Op.10 no.1>, <Sonata No.6 in F Major, Op10 no.2>, <Sonata No.7 in D Major, Op.10 no.3>, Wilhelm Bachhaus (piano). ℗ ©1964

Remark & Rating
ED1, 1E-2E, Very rare!! $$$

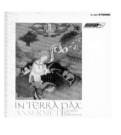

Label **Decca SXL 6098 (©=DPA 594, part)**
London OS 25847, (ED1)

Frank Martin: <In Terra Pax>, Ursula Buckel (soprano), Marga Höffgen (contalto), Ernst Haefliger (tenor), Pierre Mollet (baritone), Jakob Stampfli (bass), with L'Orchestre de la Suisse Romande and The Union Chorale et Choeur, Et Choeur DesDames de Lausanne conducted by Ernest Ansermet. ℗1964

Remark & Rating
ED1, 1G-1G, $$
Penguin ★★★

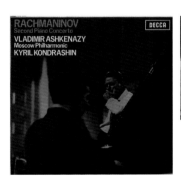
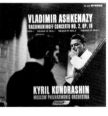

Label **Decca SXL 6099**
London CS 6390, (ED2 1st)

Rachmaninov: <Piano Concerto No.2 in C Minor, Op.27>, Vladimir Ashkenazy (piano), Moscow Philharmonic Orchestra-Kiril Kondrashin. ℗ ©1964

Remark & Rating
ED1, 5W-7W, $$

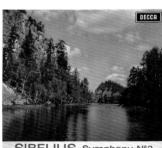

Label **Decca SXL 6100 (©=SPA 282)**
London CS 6391, (ED2 1st)

Sibelius: <Symphony No.2 in D>, L'Orchestre de la Suisse Romande-Ernest Ansermet. ℗ ©1964

Remark & Rating
ED1, 2G-1G, rare! $$

Label **Decca SXL 6101 (©=Jubilee JB 9)**
London CS 6392, (ED2 1st)

J.S.Bach: Harpsichord Concerti <No.1 in D Minor, BWV 1052>, <No.2 in E Major, BWV 1053>, George Malcolm (harpsichord), The Stuttgart Chamber Orchestra-Karl Munchinger. ©1964

Remark & Rating
ED1, 1E-1E, $
Penguin ★★★

Label **Decca SXL 6102 (©=SDD 318)**
London CS 6393, (ED2 1st)

Pergolesi: <Concerti Armonici Nos. 1-4>, The Stuttgart Chamber Orchestra-Karl Münchinger. ©1964

Remark & Rating
ED1, 1E-1E, $
Penguin ★★(★)

Label **Decca SXL 6103 (©=SDD 250)**
London CS 6394, (ED2 1st) (©=STS 15207)

Dvorak: <Quartet in F Major, Op.96 "American">, <Quartet in D Minor, Op.34>, The Janacek Quartet- Jiri Travnicek & Adolf Sykora (violin), Jiri Kratachvil (viola), Karel Krafka (cello). ℗ ©1964

Remark & Rating
ED1, 2E-1E, rare! $$+
Penguin ★★★

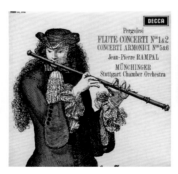

Label **Decca SXL 6104 (©=SDD 319)**
London CS 6395, (ED2 1st)

Pergolesi: <Flute Concerti Nos. 1 & 2>, <Concerti Armonici Nos. 5-6>, Jean-Pierre Rmpal (flute), The Stuttgart Chamber Orchestra-Karl Münchinger. ©1964

Remark & Rating
ED1, 1E-1E, $
Penguin ★★★

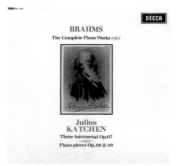

Label **Decca SXL 6105 (©=SDD 532, SDDA 261-9)**
London CS 6396, (ED2 1st)

Brahms: "Complete Piano Works Volume 1", <Three intermezzi, Op.117>, <Piano pieces, Op.118>, <Piano pieces, Op.119>, Julius Katchen (piano). Recorded by Kenneth Wilkinson, June 1962 in Decca Studios. ℗ ©1964

Remark & Rating
ED1, 3G-2G, $
(K. Wilkinson)

Label **Decca SXL 6106**
 London OS 25866

[ay-ay-ay], Spanish and Latin American Songs by Luigi Alva, New Symphony Orchestra of London-Iller Pattacini. Recorded by Kenneth Wilkinson. ℗ 1964 by Christopher Raeburn

Remark & Rating
(K. Wilkinson)

Label **Decca SXL 6107**
 London OS 25869, (ED1)

[Richard Strauss Lieder], <Zueignung, Nichts>, <Die Nacht>, <Breit Über Mein Haupt>, <Wie Sollten Wir Geheim Sie Halten>, <All Mein Gedanken>, <Du Meines Herzens Krönelein>, <Ach Lieb Ich Muss Nun Scheiden>, <Ach Weh Mir Unglückhalftem Mann>, <Ruhe- Meine Seele, Morgen!>, <Nachtgang>, <Ich Trage Meine Minne>, <Befreit>, <Bruder Liederlich>, <Freundliche Vision>, <Mit Deinen Blauen Augen>. Hermann Prey (baritone) and Gerald Moore (piano). (Sung in German, texts with English translations) ©1964

Remark & Rating
ED1, 3E-2E, $

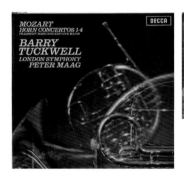

Label **Decca SXL 6108 (©=SDD 364)**
 London CS 6403, (ED2 1st)

Mozart: <Horn Concerto No. 1 in D Major, K.412>, <Horn Concerto No. 2 in E Flat Major, K.417>, <Horn Concerto No. 3 in E Flat Major, K.447>, <Horn Concerto No. 4 in E Flat Major, K.495>, <Fragment from Horn Concerto in E Major, K.App.98a>, Barry Tuckwell (horn), The London Symphony Orchestra-Peter Maag. ℗ ©1964

Remark & Rating
ED1, 1E-1E, $
Penguin ★★★

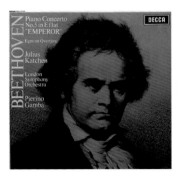

Label **Decca SXL 6109 (©=SDD 225)**
 London CS 6397, (ED2 1st) (©=STS 15210)

Beethoven: <Piano Concerto No.5 in E Flat, Op.73 "Emperor">, <Egmont Overture, Op.84>, Julius Katchen (piano), The London Symphony Orchestra-Pierino Gamba. ©1964

Remark & Rating
ED1, 2E-3E, $
Penguin ★★(★)

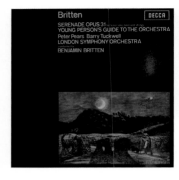

Label Decca SXL 6110
 London CS 6398, (ED2 1st)

Britten: <Serenade Op.31, For tenor solo, horn & strings>, Peter Pears (tenor) & Barry Tuckwell (horn); <Young Person's Guide to the Orchestra>, London Symphony Orchestra-Benjamin Britten. Recorded by Kenneth Wilkinson. ©1964

Remark & Rating
ED1, 1E-2E, $
Penguin ★★★, (K. Wilkinson)

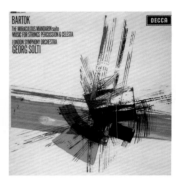

Label Decca SXL 6111*
 London CS 6399, (ED2 1st) (Reissue=CS 6783)

Bartok: <The Miraculous Madarin Suite, Op.19>, <Music For Strings, Percussion & Celesta>, London Symphony Orchestra-Georg Solti. Ⓟ ©1964

Remark & Rating
ED1, 4W-1W, $$
Penguin ★★★, AS-DG list (Speakers Corner Reissue), TAS 72++

Label Decca SXL 6112 (©=SDD 427)
 London CS 6400, (ED2 1st)

Mozart: <Flute Concerto In D Major, K.314>, Claude Monteux (flute); Bach: <Suite No. 2 In B Minor>; Gluck: <Orphée Et Eurydice>, London Symphony Orchestra-Pierre Monteux. Recorded by Kenneth Wilkinson. Ⓟ1964 by Christopher Raeburn

Remark & Rating
ED1, 1E-1E, $$
(K. Wilkinson)

Label Decca SXL 6113*
 London CS 6401, (ED2 1st)

Mahler: <Symphony No.1 in D Major "The Titan">, The London Symphony Orchestra-Georg Solti. Ⓟ ©1964

Remark & Rating
ED1, 1E-3E, $
Penguin ★★★

Label Decca SXL 6114
 No London CS

[Bruno Prevedi Sings Great Italian Arias], Giodano: <"Andrea Chénier", Un di all'azzurro spazio>, <"Fedora" Amor ti vieta>; Verdi: <"Il trovatore", Ah si, ben mio>, <"La forza del destino", La vita è inforno>. Bruno Prevedi (tenor) with the Orchestra of The Royal Opera House Covent Garden-Edward Downes. Ⓟ ©1964

Remark & Rating
ED1, 2E-1E, $

Label **Decca SXL 6115**
London CS 6402, (ED2 1st)

Dvorak: <Symphony No.7 (No.2) in D Minor, Op.70>, London Symphony Orchestra-Istvan Kertesz. Recorded by Kenneth Wilkinson. ℗ ©1964

Remark & Rating
ED1, 1E-1E, $
Penguin ★★★, AS List-H (D6D 7), (K. Wilkinson)

Label **Decca SXL 6116 (©=SDD 213, 574)**
London OS 25876, (ED1)

Handel: <Arias from Julius Caesar>, Joan Sutherland (soprano), Margreta Elkins, Marilyn Horne (mezzo-sopranos), Monica Sinclair (contralto), Richard Conrad (tenor), Hubert Dawkes (Harpsichord Continuo), New Symphony Orchestra of London-Richard Bonynge. ℗ ©1964

Remark & Rating
ED1, 2L-2L
Penguin ★★★

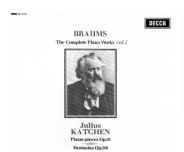

Label **Decca SXL 6118 (©=SDD 533, SDDA 261-9)**
London CS 6404, (ED2 1st)

Brahms: "Complete Piano Works Volume 2", <Piano Pieces, Op. 76>, <Fantasias, Op. 116>, Julius Katchen (piano). Recorded by Kenneth Wilkinson, May 1962 in Decca Studios. ℗ ©1964

Remark & Rating
ED1, 2L-2L, $
(K. Wilkinson)

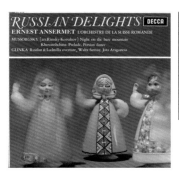

Label **Decca SXL 6119**
London CS 6405, (ED2 1st)

[Russian Delights], Mussorgsky: <Night On The Bare Mountain>. <Prelude>, <Dance Of The Persian Slaves>; Glinka: <Russlan And Ludmilla - Overture>, <Waltz Fantasy>, <Jota Aragonesa>, L'Orchestre de la Suisse Romande-Ernest Ansermet. Recorded by James Lock, May 1964 at the Victoria Hall, Geneva. ℗ ©1964

Remark & Rating
ED1, 2E-2L, $$+

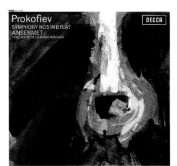
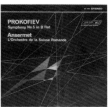

Label **Decca SXL 6120 (©=SDD 399, part)**
London CS 6406, (ED2 1st)

Prokofiev: <Symphony No.5 In B Flat, Op. 100 >, L'Orchestre de la Suisse Romande-Ernest Ansermet. Recorded by James Lock, May 1964 at the Victoria Hall, Geneva. ℗ ©1964

Remark & Rating
ED1 ?, ED2, 1L-1L, $$
Penguin ★★(★)

Label **Decca SXL 6121**
London CS 6407, (ED2 1st)

Bartok: <Dance Suite>, <Two Portraits, Op. 5>, <Rumanian Dances>, L'Orchestra de la Suisse Romande-Ernest Ansermet. Recorded by James Lock, May 1964 at the Victoria Hall, Geneva. ℗ ©1964

Remark & Rating
ED1, 1L-1L, $$

Label **Decca SXL 6122 (SET 236-8)**
London OSA 1151 (OSA 1364)

Puccini: <Il Tabarro (The Clock)>, Merrill; Tebaldi; Monaco, Chorus & Orchestra of The Maggio Musicale Fiorentino-Lamberto Gardelli. ℗1962 (Part of SET 236-8 & OSA 1364)

Remark & Rating
ED1, 2E-1E, $
AS list (SET 236-8)

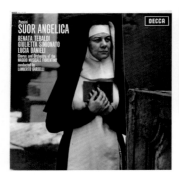

Label **Decca SXL 6123 (SET 236-8)**
London OSA 1152 (OSA 1364)

Puccini: <Suor Angelica>, Tebaldi; Simionato; Danieli, Chorus & Orchestra of The Maggio Musicale Fiorentino-Lamberto Gardelli. ℗1962 (Part of SET 236-8 & OSA 1364)

Remark & Rating
ED1, 4G-4G, $
AS list (SET 236-8)

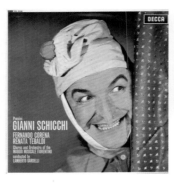

Label **Decca SXL 6124 (SET 236-8)**
London OSA 1153 (OSA 1364)

Puccini: <Gianni Schicchi>, Fernando Corena (bass), Renata Tebaldi (soprano), Chorus & Orchestra of The Maggio Musicale Fiorentino-Lamberto Gardelli. @1963 (Part of SET 236-8 & OSA 1364)

Remark & Rating
ED1, 1E-1E, $$
AS list (SET 236-8)

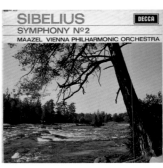

Label **Decca SXL 6125**
London CS 6408, (ED2 1st)

Sibelius: <Symphony No.2 In D Major, Op. 43>, The Vienna Philharmonic Orchestra-Lorin Maazel. @1963

Remark & Rating
ED1, 1L-1L, $
Penguin ★★★

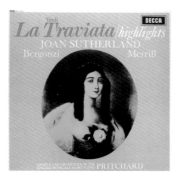

Label **Decca SXL 6127 (SET 249-51)**
London OS 25886, (ED1) (OSA 1366)

Verdi: <La Traviata, Highlights>, Joan Sutherland, Carlo Bergonzi & Robert Merrill, Chorus and Orchestra of the Maggio Musicale Fiorentino, conducted by John Pritchard. (6 Text pages) ℗1963 ©1964 (Highlights from SET 249-51 & OSA 1366)

Remark & Rating
ED1 ?, ED2, 1E-1E
Penguin ★★★

Label **Decca SXL 6128 (SET 239-41)**
London OS 25887, (ED1) (OSA 1365)

Bellini: <La Sonnambula, Highlights>, Joan Sutherland, Nicola monti, Sylvia Stahlman, Fernando Corena, Margreta Elkins, Chorus & Orchestra of the Maggio Musicale Fiorentino Orchestra, Rome-Richard Bonynge. ℗1962 ©1964 (Highlights from SET 239-41 & OSA 1365)

Remark & Rating
ED1, 2G-2G

Label **Decca SXL 6129 (©=SDD 534, SDDA 261-9)**
London CS 6410, (ED2 1st)

Brahms: "Complete Piano Works Volume 3", <Sonata in C Major, Op. 1>, <Sonat in F Sharp Minor, Op. 2>, Julius Katchen (piano). Recorded by Kenneth Wilkinson, 1963 & 1964 in Decca Studios. ℗ ©1964

Remark & Rating
ED1, 1E-3W, $
(K. Wilkinson)

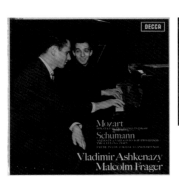

Label **Decca SXL 6130**
London CS 6411, (ED2 1st)

Mozart: <Sonate For 2 Pianos In D Major, K.448 >; Schumann: <Andante And Variations For 2 Pianos, 2 Cellos And Horn>, <Etude In Form of A Canon, Op. 56, No. 4 (Arr. Debussy)>, Vladimir Ashkenazy & Malcolm Frager (piano), Barry Tuckwell (horn), Amaryllis Fleming & Terence Weil (cello). @1964

Remark & Rating
ED1, 1E-1E, $

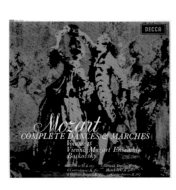

Label **Decca SXL 6131 (D121D 10)**
London CS 6412, (ED2 1st)

Mozart: [Complete Dances & Marches, Volume 1], <March In D, K.215>, <6 German Dances, K.509>, <6 Contredanses, K.462>, <March In C, K.408/1>, <6 German Dances, K.567>, <4 Contredanses, K.267>, Vienna Mozart Ensemble-Willi Boskovsky. Recorded by Gordon Parry in the Sofiensaal, Vienna. ℗ ©1964

Remark & Rating
ED1, 1W-1W,
Penguin ★★★

Label Decca SXL 6132 (D121D 10)
 London CS 6413, (ED2 1st)

Mozart: [Complete Dances & Marches, Volume 2], <March In D, K.408/2>, <12 German Dances, K.586>, <2 Minuets With Contredanses, K.463>, <March In C, K.408/3>, <7 Minuets, K.65a>, Vienna Mozart Ensemble-Willi Boskovsky. Recorded by Gordon Parry in the Sofiensaal, Vienna. ℗ ©1964

Remark & Rating
ED1, 1W-1W
Penguin ★★★

Label Decca SXL 6133 (D121D 10)
 London CS 6414, (ED2 1st)

Mozart: [Complete Dances & Marches, Volume 3], <March In D, K.249>, <6 German Dances, K.600>, <March In D, K.335/1>, <12 Minuets, K.568>, Vienna Mozart Ensemble-Willi Boskovsky. Recorded by Gordon Parry in the Sofiensaal, Vienna. ℗ ©1964

Remark & Rating
ED1, 1W-1W
Penguin ★★(★)

Label Decca SXL 6134
 London CS 6415, (ED2 1st)

Richard Strauss: <Don Juan, Op.20>, <Death & Transfiguration, Op.24>, The Vienna Philharmonic Orchestra-Lorin Maazel. ℗ ©1964

Remark & Rating
ED1, 3W-2W, $
Penguin ★★★

Label Decca SXL 6135
 London CS 6416, (ED2 1st)

Schubert: <Sonata No.17 in D Major, Op.53, D.850>, <Impromptu in G Flat, Op.90, no.3, D899/3>, <Impromptu in A Flat, Op.90, no.4, D.899/4>, Clifford Curzon (piano). Recorded by Gordon Parry, June 1964 in the Sofiensaal, Vienna. ℗ by John Culshaw @1964

Remark & Rating
ED1 ?, ED2, 3W-2W, $
Penguin ★★★

Label Decca SXL 6136* (©=JB 55)
 London CS 6417, (ED2 1st)

Kodaly: [Music of Kodaly], <Háry János Suite>, <Dances Of Galanta - Arias From "Háry János">, with Olga Szönyi (soprano), The London Symphony Orchestra-Istvan Kertesz. Recorded by Kenneth Wilkinson. @1964

Remark & Rating
ED1, 1E-2W, $
Penguin ★★★, AS-DG list (Speakers Corner),Japan 300, (K. Wilkinson)

Label **Decca SXL 6137**
London CS 6418, (ED2 1st)

[Pas de Deux], Ballet Music by Drigo, Minkus, Auber &
Helsted, The London Symphony Orchestra-Richard Bonynge.
Ⓟ ©1964

Remark & Rating
ED2, 1W-1W, (1st), $
Penguin ★★★

Label **Decca SXL 6138 (©=JB 121, part)**
London CS 6419, (ED2 1st)

Britten: <Symphony for Cello & Orchestra, Op.68>**; Haydn:
<Cello Concerto in C>* , Mstislav Rostropovich (cello), English
Chamber Orchestra-Benjamin Britten. Recorded by Gordon
Parry in Kingsway Hall, London. Ⓟ by John Culshaw ©1964
*(AS list, part of JB 121); **(Reissued in Decca SXL 6641)

Remark & Rating
ED1, 2W-1W, $$
Penguin ★★★, AS List (JB 121)

Label **Decca SXL 6139**
London OS 25893, (ED2)

Verdi: [Choruses], Choruses from Trovatore, Nabucco,
I Lombardi, La Battaglia di Legnano, Aida, Attila, Otello,
Chorus and Orchestra of L'Accademia di Santa Cecilia, Rome
conducted by Carlo Franci. @1964

Remark & Rating
ED2, 1G-1G
Penguin ★★(★)

Label **Decca SXL 6140**
London OS 25894, (ED2)

[Italian & German Arias], Mario del Monaco (tenor), Orchestra
of the Accademia di Santa Cecilia, Rome conducted by Carlo
Franci. Ⓟ ©1964

Remark & Rating
ED1 ?, ED2, 1G-1G, $

Label **Decca SXL 6141 (©=SPA 227)**
London CS 6345 (©=STS 15524)

Respighi: <Fountains of Rome>, <Pipnes of Rome>,
L'Orchestre de la Suisse Romande-Ernest Ansermet. Ⓟ1965

Remark & Rating
ED1, 1E-1E, rare! $ $
RM15

Label **Decca SXL 6142 (SET 242-6)**
London OS 25898 (OSA 1508)

Wagner: <Siegfried, Forging Scene & Final Duet>, Wolfgang Windgassen, Brigit Nilsson, Gerhard Stolze, The Vienna Philharmonic Orchestra-Georg Solti. (6 pages Insert) Produced by John Culshaw. ℗1963 ©1964 (Part of SET 242-246 & OSA 1508)

Remark & Rating
ED2, 1G-1G, (1st)
Penguin ★★★

Label **Decca SXL 6143**
London CS 6422, (ED2 1st)

Chopin: <4 Ballades No.1-No.4, Op.23, 38, 47 & 52>, <3 Nouvelles Etudes No.1-No.3, Op Posth.>, Vladimir Ashkenazy (piano). ℗1965

Remark & Rating
ED1, 4L-2W, $
Penguin ★★★, Japan 300-CD

Label **Decca SXL 6144**
London OS 25899

[Duets Of Love And Passion], Samson Et Dalila; Otello; Carmen; Aida, James McCraken (tenor) & Sandra Warfield (mezzo-soprano), Orchestra Of The Royal Opera House, Covent Garden-Edward Downes. ℗1965

Remark & Rating
ED1, 2G-1G

Label **Decca SXL 6146**
London OS 25905

Richard Strauss: <Der Rosenkavalier (excerpts)>, Regine Crespin, Elisabeth Söderström, Hilde Gueden, Heinz Holecek, The Vienna Philharmonic Orchestra-Silvio Varviso. (6 Text pages) ℗ 1964 by Christopher Raeburn

Remark & Rating
ED1, 1W-1W, $
Penguin ★★★

Label **Decca SXL 6147**
London OS 25911

[Nicolai Ghiaurov, Russian & French Arias], <A Life For The Tsar>, <The Demon>, <Lolanta>, <Prince Igor>, <Faust>, <Manon>, <Les Huguenots>, <La Jolie Fille De Perth>, <Carmen>. Nicolai Ghiaurov (bass), The Lodon Symphony Orchestra & Chorus-Edward Downes. (4 Text pages) ℗1965

Remark & Rating
ED1, 4L-4L, $

Label **Decca SXL 6148 (©=SDD 309)**
London CS 6431, (ED2 1st) (©=STS 15220)

Beethoven: <Beethoven String Quartets No.10 in E flat Op.74>, <No.11 in F minor Op.95>, The Weller Quartet, Walter Weller & Alfred Staar (Violin), Helmut Weis (Viola), Ludwig Beinl (Cello). Recorded at Sofiensaal, Vienna, Oktober 1964. ℗1965

Remark & Rating
ED1, 1L-1L, rare!! $$$
Penguin ★★(★)

Label **Decca SXL 6149**
London OS 25910

[Marilyn Horne Recita], Rossini: <"Semiramide" Eccomi al fine, Ah! quel giorno ognor rammento>,< "L'Italiana In Algeri" Cruda sorte!>, "La Cenerentola" Nacquè all'affanno, Non più mesta>; Meyerbeer: <"Le Prophete" O prêtres de Baal, O toi, qui m'abandonne>, <"Les Huguenots" Nobles seigneurs, Salut!, Une dame>; Mozart: <"La Clemenza di Tito" Parto, parto>; Donizetti:<"La Figlia Del Reggimento" Deciso è dunque, Le richezze>. Marilyn Horne (soprano) with The Orchestra of the Royal Opera House, Covent Garden conducted by Henry Lewis. Recorded by Michael Mailes, August 1964 in Kingsway Hall, London. ℗ ©1965

Remark & Rating
ED1, 3G-2G

Label **Decca SXL 6150 (©=SDD 325)**
London CS 6433, (ED2 1st) (©=STS 15247)

Mozart: <Divertimento in D, K. 205>, <March in D, K. 290>, <Cassation in B Flat, K. 99>, Members of the Vienna Octet. ℗1965

Remark & Rating
ED1, 1L-1L, rare!! $$
Penguin ★★★

Label **Decca SXL 6151 (©=SDD 322)**
London CS 6432, (ED2 1st) (©=STS 15245)

Brahms: String Quartets, <Quartet No.1 in C Minor, Op.51, no.1> & <Quartet No.2 in A Minor, Op.51, no.2>, The Weller Quartet. Recorded at Sofiensaal, Vienna, October 1964. ℗1964

Remark & Rating
ED1, 1L-1L, rare!! $$$
Penguin ★★★

Label **Decca SXL 6152**
London OS 25912

[Renata Tebaldi Recital], Verdi: <Don Carlos>, <Un ballo in maschera>; Puccini: <Turando>, <La Rondine>; Ponchielli: <La Gioconda>; Mascagni: <Cavalleria Rusticana>; Cilea: <L'Arlesiana>. Renata Tebaldi (soprano) with New Philharmonia Orchestra-Oliviero di Fabritiis. ℗1965

Remark & Rating
ED1, 1G-1G, $
Penguin ★★★(❀)

Label **Decca SXL 6153 (©=SDD 385)**
London OS 25921

Pergolesi: <Stabat Mater>, Judith Raskin (soprano), Maureen Lehane (contralto), Orchestra Rossini di Napoli-Franco Caracciolo. (Revision & Organ Part by M. Zanon) ℗ ©1965

Remark & Rating
ED1, 1G-1G, $

Label **Decca SXL 6154 (SET 239-41)**
London OS 25922 (OSA 1373)

Bellini: <I Puritani, Highlights>, Joan Sutherland, Pierre Duval, Ezio Flagello, Renato Capecchi, Margreta Elkins, Orchestra and Chorus of the Maggio Musicale Fiorentino-Richard Bonynge. ℗1963 ©1965 (Highlights from SET 239-41 & OSA 1373)

Remark & Rating
ED2, 2G-2G

Label **Decca SXL 6155 (SXL 6015-6 & SET 201-3)**
London OS 25923 (OSA 1249 & OSA 1319)

Johan Strauss: <Die Fledermaus, Highlights>, Hilde Gueden, Waldemar Kmentt, Eberhard Wäechter, Walther Berry, Eirc Kunz, Regina Resnik, Vienna State Opera Chorus & The Vienna Philharmonic Orchestra-Herbert von Karajan. ℗1961 ©1962 (Highlights from SET 201-3; SXL 6015-6 & OSA 1249; OSA 1319)

Remark & Rating
ED1, 1G-1G
Penguin ★★★

Label **Decca SXL 6156 (SET 256-8)**
London OS 25924 (OSA 1368)

Bizet: <Carmen, Highlights>, Regina Resnik, Mario Del Monaco, Joan Sutherland, L'Orchestre de la Suisse Romande-Thomas Shippers. ℗1963 ©1965 (Highlights from SET 256-8 & OSA 1368)

Remark & Rating
ED1, rare, (ED2, 3L-2G)

Label **Decca SXL 6157**
London CS 6429, (ED2 1st)

Tchaikovsky: <Symphony No.4 in F Minor, Op.36>, The Vienna Philharmonic Orchestra-Lorin Maazel. Ⓟ ©1964

Remark & Rating
ED1, 1W-2W, $
Penguin ★★★

Label **Decca SXL 6158**
London CS 6434, (ED2 1st)

[Music For Two Pianos], Rachmaninov: <Suite No. 2, Op.17>; Milhaud: <Scaramouche - Suite>; Poulenc: <Sonata 1918 (Revised 1939)>; Lutoslawski: <Variations On A Theme Of Paganini>, Bracha Eden & Alexander Tamir (piano). Recorded by Kenneth Wilkinson, September 1964 in Decca Studios. Ⓟ ©1965

Remark & Rating
ED1, 1W-1W, $$
Penguin ★★★, (K. Wilkinson)

Label **Decca SXL 6159**
London CS 6426, (ED2 1st)

Tchaikovsky: <Symphony No.1 "Winter Daydreams">,The Vienna Philharmonic Orchestra-Lorin Maazel. Ⓟ1964 ©1965

Remark & Rating
ED1, 1W-1W, $+
Penguin ★★(★)

Label **Decca SXL 6160 (©=SDD 535, SDDA 261-9)**
London CS 6444, (ED2 1st)

Brahms: "Complete Piano Works Volume 4", <Waltzes, Op. 39>, <Two Rhapsodies, Op. 79>, <Four Ballades, Op. 10>, Julius Katchen (piano). Recorded by Kenneth Wilkinson, May 1962 in Decca Studios. @1965

Remark & Rating
ED1, 2W-3W, $+
Penguin ★★(★), (K. Wilkinson)

Label **Decca SXL 6161**
London OS 25927

Schubert & Schumann: "Goethe Lieder" with Hermann Prey (baritone) & Karl Engel (piano). Recorded by Gordon Parry, February 1964 at Decca Studios. ℗ ©1965

Remark & Rating
ED1, rare!, $ (ED2, 3W-2W)

Label **Decca SXL 6162**
London CS 6427, (ED2 1st)

Tchaikovsky: <Symphony No.2 In C Minor, Op. 17, 'Little Russia' >, The Vienna Philharmonic Orchestra-Lorin Maazel. ℗1964 ©1965

Remark & Rating
ED2, 1W-1W, (1st)

Label **Decca SXL 6163**
London CS 6428, (ED2 1st)

Tchaikovsky: <Symphony No.3 in D Major, Op.29 "Polish">, The Vienna Philharmonic Orchestra-Lorin Maazel. ℗1964 ©1965

Remark & Rating
ED2, 1W-1W, (1st)
Penguin ★★(★)

Label **Decca SXL 6164**
London CS 6409, (ED2 1st)

Tchaikovsky: <Symphony No.6 in B Minor, Op.74 "Pathetique">, The Vienna Philharmonic Orchestra-Lorin Maazel. ℗1964 ©1965

Remark & Rating
ED2, 2W-1W, (1st)

Label **Decca SXL 6165**
London CS 6439, (ED2 1st)

Berlioz: \<Le Carnival Romain\>, \<Beatrice Et Benedict\>, \<Le Corsaire\>, \<Benvenuto Cellini\>, \<Music From Le Damnation De Faust\>, (Ansermet Conducts Series), L' Orchestre De La Suisse Romande-Ernest Ansermet. ℗1965

Remark & Rating
ED1, 2L-4L, $$

Label **Decca SXL 6166**
London CS 6436, (ED2 1st)

Mendelssohn: \<Symphony No.4 in A Major, "Italian", Op.90\>, (Ansermet Conducts Series), L' Orchestre de la Suisse Romande-Ernest Ansermet. ℗1965

Remark & Rating
ED2, 1G-1G (1st)

Label **Decca SXL 6167**
London CS 6437, (ED2 1st)

Debussy: \<La Mer\>, \<Khamma\>, \<Rhapsody for Clarinet & Orchestra\>, (Ansermet Conducts Series), Robert Gugolz (clarinet), L' Orchestre de la Suisse Romande-Ernest Ansermet. Recorded by James Brown, November - December 1964 in the Victoria Hall, Geneva. ℗1965

Remark & Rating
ED1, 2G-2G, rare! $$

Label **Decca SXL 6168 (©=SPA 204; Jubilee JB 10)**
London CS 6438, (ED2 1st)

Chabrier: \<Rhapsody Espana\>, \<Suite Pastorale\>, \<Joyeuse Marche\>, \<Danse Slave & Fete Polonaise from "Le Roi malgre lui"\>, (Ansermet Conducts Series), L' Orchestre de la Suisse Romande-Ernest Ansermet. ℗1965

Remark & Rating
ED1, 3G-1W, $$
Penguin ★★(★), AS List

Label **Decca SXL 6169 (©=SDD 440)**
London CS 6443, (ED2 1st)

Dvorak: \<Symphony No.8 in G Major, Op.88\>, The Vienna Philharmonic Orchestra-Herbert von Karajan. ℗1965

Remark & Rating
ED2, 1L-1L (1st), $$

Label **Decca SXL 6170 (©=SDD 383)**
London CS 6442, (ED2 1st) (©=STS 15387)

Beethoven: [Complete Music for Wind Band], <Quintet for 3 horns, oboe, and bassoon>, <Sextet for 2 clarinets, 2 horns, and 2 bassoons, Op. 71>, <Octet in E Flat Major, Op.103, for 2 oboes, 2 clarinets, 2 horns, and 2 bassoons>, <March in B flat for 2 clarinets, 2 horns, 2 bassoons>, <Rondino in E Flat Major, for 2 oboes, 2 clarinets, 2 horns, 2 bassoons, G.146>, London Wind Soloists directed by Jack Brymer. ℗1965

Remark & Rating
ED1, 1L-1L
Penguin ★★★

Label **Decca SXL 6171 (=SDD 241)**
London OS 25929, (ED2)

Stravinsky: <Renard, (A Burlesque)>, Gerald English (tenor), John Mitchinson (tenor), Peter Glossop (bass), Joseph Rouleau (bass), <Scherzo A La Russe (Symphony Version)>, <Mavra>, Joan Carlyle, Kenneth McDonald, Helen Watts and Monica Sinclair, L' Orchestre de la Suisse Romande-Ernest Ansermet (Sung in English, 6 pages English text). ℗1965

Remark & Rating
ED2, 1W-2G, (1st) rare!, $$
Penguin ★★★

Label **Decca SXL 6172**
London CS 6435, (ED2 1st)

Brahms: <Symphony No.2 in D Major, Op.73>, The Vienna Philharmonic Orchestra-Istvan Kertesz. Recorded by Gordon Parry, May 1964 Sofiensaal, Vienna. ℗ ©1965 **(Decca SXL 6676 is the repressing in 1974)

Remark & Rating
ED2, 2W-1W (1st), rare! $$

Label **Decca SXL 6173 (©=SDD 376)**
London CS 6441, (ED2 1st)

Schubert: <String Quintet in C Major, Op. 163, D.956>, <String Trio in B Flat, D.471>, The Vienna Philharmonic Quartet - Willi Boskovsky (violin); Otto Strasser (violin); Rudolf Streng (viola); Robert Scheiwein (cello). Recorded by Gordon Parry, March 1964 in the Sofiensaal, Vienna. ℗1965

Remark & Rating
ED2, 1W-1W (1st), rare! $

Label **Decca SXL 6174**
London CS 6440, (ED2 1st)

Chopin: <Piano Concerto No. 2 in F Minor, Op.21>* ; J.S.Bach: <Clavier Concerto in D Minor (BWV. 1052)>** , Vladimir Ashkenazy (piano), London Symphony Orchestra-David Zinman. Recorded by James Lock & Kenneth Wilkinson, January 1965 in Kingsway Hall, London. ℗1965 [* Chopin' s concerto is Penguin ★★★, reissued in SXL 6693; ** Bach' s concerto is Penguin ★★]

Remark & Rating
ED2, 1G-1G, (1st)
Penguin ★★★, (K. Wilkinson)

Label **Decca SXL 6175**
London OS 25937

Britten: <Cantata Misericordium, Op.69>; <Sinfonia da Requiem, Op.20>, Pears & Fischer-Dieskau. London Symphony Orchestra & Chorus, New Philharmonic Orchestra--Benjamin Britten. Recorded by Gordon Parry, James Lock, Kenneth Wilkinson. ℗1965 by John Culshaw

Remark & Rating
ED1, 2W-2W, $
Penguin ★★★, (K. Wilkinson)

Label **Decca SXL 6176**
London OS 25936

[Neapolitan Songs], Guisseppe di Stefano (tenor), New Symphony Orchestra-Iller Pattacini. ℗1965

Remark & Rating
ED1, 1W-2W, $

Label **Decca SXL 6177**
No London CS

Decca Classical Stereo Sampler Album. ℗1965

Remark & Rating
ED2, 2W-1W, (1st)

Label **Decca SXL 6178**
London OS 25938 (OSA 1502)

Wagner: ["Liebesnacht" Love Duet Tristan und Isolde], Birgit Nilsson (soprano), Regina Resnik (mezzo soprano), Fritz Uhl (tenor), Tom Krause (baritone), The Vienna Philharmonic Orchestra-Georg Solti. Producer: John Culshow, recorded in the Sofiensaal, Vienna. ℗1961

Remark & Rating
ED1, 2G-3G, $+

Label **Decca SXL 6179**
London CS 6445, (ED2 1st)

Viotti: <Violin Concerto No. 3 in A Minor>, Giuseppe Prencipe (violin); Boccherini: <Symphony in C Minor>, Orchestra Rossini Di Napoli-Franco Caracciolo. ℗1965

Remark & Rating
ED2, 1W-2W, (1st), rare! $

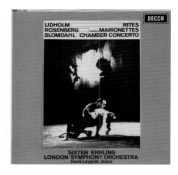

Label Decca SXL 6180
 No London CS

Ingvar Lidholm: <Rites>; Hilding Rosenberg: <"Marionettes" Overture>; Karl-Birger Blomdahl: <Chamber Concerto for Piano, Woodwind and Percussion>, Hans Leygraf (Swedish pianist), The London Symphony Orchestra-Sixten Ehrling. Recorded at Kingsway Hall, London, Feburay 1965. ℗1965

Remark & Rating
ED1, 1W-1W, rare! $+

Label Decca SXL 6181
 London CS 6446, (ED2 1st)

[The Art Of Arturo Benedetti Michelangeli], Beethoven: <Sonata No.32 in C Minor, Op.111>; Baldassarre Galuppi: <Sonata No.5 in C>; Scarlatti: <3 Sonatas in C Minor, in C Major & in A Major>. Arturo Benedetti Michelangeli (piano) ℗1965

Remark & Rating
ED2, 2E-2E, (1st), Very rare!! $$$
Penguin ★★★

Label Decca SXL 6182 (©=SDD 278)
 London CS 6448, (ED2 1st) (One of CSA 2214)

Haydn: String Quartets Op. 33 <No. 1 In B Minor>, <No. 2 In E Flat Major "The Joke">, <No. 3 In C Major "The Birds">, performed by The Weller Quartet, Walter Weller (violin), Alfred Staar (violin), Helmut Weis (viola), Ludwig Beinl (cello). ℗1965

Remark & Rating
ED2, 4L-5L, (1st), rare! $$

Label Decca SXL 6183 (©=SDD 279)
 London CS 6449 (One of CSA 2214)

Haydn: String Quartets Op. 33 <No. 4 In B Flat Major>, <No. 5 In G Major "How Do You Do?">, <No. 6 In D Major>, performed by The Weller Quartet, Walter Weller (violin), Alfred Staar (violin), Helmut Weis (viola), Ludwig Beinl (cello). ℗1965

Remark & Rating
ED2, 1W-1W, (1st), rare! $$

Label Decca SXL 6184 (©=SDD 443)
 London CS 6450, (ED2 1st)

Mendelssohn: <Violin Concerto in E Minor>; Bruch: <Violin Concerto No. 1 in G Minor>, Ion Voicou (violin), The London Symphony Orchestra-Rafael Fruhbeck de Burgos. ℗1965

Remark & Rating
ED2, 2W-1W, (1st), rare! $$

Label **Decca SXL 6185**
London OS 25942

[Songs from the Land of the Midnight Sun], by Grieg, Rangstrom, Sibelius. Birgit Nilsson (soprano) with Vienna Opera Orchestra-Bertil Bokstedt. Recorded by Gordon Parry & James Brown, April 1965 in the Sofiensaal, Vienna. ℗1965 by Christopher Raeburn

Remark & Rating
ED1, 1W-1W, test pressing, grooved, rare!! $+

Label **Decca SXL 6186**
London CS 6453, (ED2 1st)

Schubert: <Symphony No.3 in D Major, D.200>, <Symphony No.6 in C Major, D.589>, The Vienna Philharmonic Orchestra-Karl Münchinger. ℗1965

Remark & Rating
ED1, 1W-1W, rare! $

Label **Decca SXL 6187**
London CS 6452, (ED2 1st)

Tchaikovsky: <Swan Lake Suite, Op.20> and <Sleeping Beauty Suite, Op.66>, The Vienna Philharmonic Orchestra-Herbert von Karajan. ℗1965

Remark & Rating
ED1, 1W-1W, $
Penguin ★★(★)

Label **Decca SXL 6188**
London CS 6454, (ED2 1st)

Adolphe Adam: <Le Diable A Quatre, Complete Ballet>, The London Symphony Orchestra-Richard Bonynge. ℗1965 by Christopher Raeburn

Remark & Rating
ED1, rare! $$
Penguin ★★★, AS List-H

Label **Decca SXL 6189 (©=SDD 227)**
London CS 6451, (ED2 1st) (©=STS 15211)

Beethoven: <Piano Concerto No.1 in C Major, Op.15>, <Choral Fantasia, Op.80>, Julius Katchen (piano), The London Symphony Orchestra-Pierino Gamba. ℗1965

Remark & Rating
ED1, 1W-1W, $+
Penguin ★★★

Label **Decca SXL 6190**
London OS 25939, (ED1)

[Joan Sutherland sings Verdi], Arias from <Ernani>, <I Masnadieri>, <Luisa Miller>, <Atilla>, <Rigoletto>, <La Traviata>, <I Vespri Siciliani>. Various orchestras conducted by Nello Santi, Richard Bonynge, Francesco Molinari-Pradelli, John Pritchard, ℗1963

Remark & Rating
ED1, 1W-3W
Penguin ★★★

Label **Decca SXL 6191**
London OS 25941

[Joan Sutherland sings Händel], Arias from Alcina, Giulio Cesare, Messiah, Samson, Joan Sutherland (soprano) with London Symphony Orchestra; New Symphony Orchestra Of London & Orchestra Of The Royal Opera House, Covent Garden conducted by Francesco Molinari-Pradelli; Richard Bonynge and Sir Adrian Boult. ℗1965

Remark & Rating
ED2, 1W-1W, (1st), $

Label **Decca SXL 6192**
London OS 25940

[Joan Sutherland sings Bellini], Arias and scenes from <Beatrice di Tenda>, <I Puritani>, <Norma>, <La Sonnambula>, Ezio Flagello & Renato Capecchi, Chorus & Orchestra of the Royal Opera House, Covent Garden conducted by Francesco Molinari-Pradelli; Chorus and Orchestra of the Maggio Musicale Fiorentino and London Symphony Orchestra conducted by Richard Bonynge. ℗1965

Remark & Rating
ED2, 1W-2L, (1st)
Penguin ★★(★)

Label **Decca SXL 6193**
London OS 25943

[Joy To The World], Joan Sutherland (soprano), Richard Bonynge conducting the New Philharmonia Orchestra and Ambrosian Singers. ℗1965

Remark & Rating
ED2, 3D-2L, (1st)

Label **Decca SXL 6194**
No London CS

[Varda Nishry Piano Recital], Works from Rameau, Ravel & Franck, Varda Nishry (piano). @1965

Remark & Rating
ED2, 2L-2L, (1st), $

Label　Decca SXL 6195
　　　　London OS 25949

[Jenny Lind songs], Elisabeth Soderstrom (soprano), Jan Eyron (piano). (Insert with notes, texts & translation) Recorded by Olle Swembel, Nov. & Dec. 1964 in Stockholm. ℗ ©1966

Remark & Rating
ED2, 2W-2W, (1st), rare!! $

Label　Decca SXL 6196
　　　　London CS 6464, (ED2 1st)

Shostakovich: <String Quartet No.10>; Berg: <String Quartet>,The Weller Quartet-Walter Weller (violin), Alfred Staar (violin), Helmut Weis (viola), Ludwig Beinl (cello). ℗1965

Remark & Rating
ED2, 1W-1W, (1st), Very rare! $$

Label　Decca SXL 6197 (D121D 10)
　　　　London CS 6459, (ED2 1st)

Mozart: [Complete Dances & Marches, Volume 4], <Contredanse "La Bataille", K.535>, <Minuets, K.103, No.1-6>, <Contredanse "Il Trionfo Delle Donne", K.607>, <Minuets, K.103, No. 7-10>, <March In D, K.445>, <Minuets, K.103, No.11-14>, <5 Contradanses "Non Più Andrai", K.609>, <Minuets, K.103, No.15-19>, Vienna Mozart Ensemble-Willi Boskovsky. Recorded by Gordon Parry in the Sofiensaal, Vienna. ℗ ©1965

Remark & Rating
ED2, 1W-1W, (1st)
Penguin ★★★

Label　Decca SXL 6198 (D121D 10)
　　　　London CS 6460, (ED2 1st)

Mozart: [Complete Dances & Marches, Volume 5], <Overture & 3 Contredanses, K.106>, <6 Minuets, K.105>, <6 German Dances, K.571>, <March In D, K.189>, <6 Minuets, K.599>, <Contredanse In B Flat, K.123>, <Gavotte In B Flat, K.300>, <Contredanse "Les Filles Malicieuses", K.610>, Vienna Mozart Ensemble-Willi Boskovsky. Recorded by Gordon Parry in the Sofiensaal, Vienna. ℗ ©1965

Remark & Rating
ED2, 2W-3W, (1st)
Penguin ★★★

Label　Decca SXL 6199 (D121D 10)
　　　　London CS 6461, (ED2 1st)

Mozart: [Complete Dances & Marches, Volume 6], <4 Minuets (Hurdy-Gurdy), K.601>, <2 Contredanses, K.603>, <4 German Dances (Hurdy-Gurdy), K.602>, <Minuets, K.176 No. 1-4>, <Minuets, K.176 No. 5-10>, <March In D, K.237>, <Minuets, K.176 No. 11-15>, Vienna Mozart Ensemble-Willi Boskovsky. Recorded by Gordon Parry in the Sofiensaal, Vienna. ℗ ©1965

Remark & Rating
ED2, 2W-4W, (1st)
Penguin ★★★

Label **Decca SXL 6200 (LXT 6200)**
London RB 100

[The Voice Of Winston Churchill], Winston Churchill's Speeches. (Mono=LXT 6200 & London RB 100) ⓟ1964 ©1965

Remark & Rating
ED2, 1K-3K, (1st)

Label **Decca SXL 6201**
London OS 25948

[McCracken on Stage], Operatic Recital - Arias from Verdi: <Trovatore>, <Forza del Destino>, <Otello>; Gounod: <Faust>; Wagner: <Meistersinger>, <Tannhäuser>; Puccini: <Fanciulla del West>; Weber: <Freischütz>; Leoncavallo: <Pagliacci>. James McCracken (Tenor) with The Vienna Opera Orchestra-Dietfried Bernet. (4 pages insert) ⓟ 1965

Remark & Rating
ED2, 1G-2G, (1st), rare!

Label **Decca SXL 6202**
London CS 6462, (ED2 1st)

Bruckner: <Symphony No.9 in D Minor>, The Vienna Philharmonic Orchestar-Zubin Mehta. ⓟ 1965

Remark & Rating
ED1, 2G-2G, $+
Penguin ★★(★)

Label **Decca SXL 6203**
London CS 6458, (ED2 1st)

Prokofiev: <Selections from the Stone Flower>, L'Orchestre De La Suisse Romande-Silvio Varviso. ⓟ 1965

Remark & Rating
ED2, 2W-2W, (1st), $+
Penguin ★★(★), AS list-H

Label **Decca SXL 6204 (©=ECS 824; SPA 230)**
London CS 6456, (ED2 1st)

Ravel: <Daphnis et Chloe (Ballet)>, L'Orchestre de la Suisse Romande-Ernest Ansermet. ⓟ1965

Remark & Rating
ED1, 2W-2W, (1st), rare! $$
TASEC

Label **Decca SXL 6205 (©=ECS 759)**
London CS 6457, (ED2 1st)

Schumann: <Symphony No.2 in C Major, Op.61>, <Manfred Overture>, (Ansermet Conducts Series), L'Orchestre de la Suisse Romande-Ernest Ansermet. ℗1965

Remark & Rating
ED2, 1W-2W, (1st), $

Label **Decca SXL 6206**
London CS 6463, (ED2 1st)

Tchaikovsky: <Hamlet-Fantasy Overture, Op.67>, <Romeo & Juliet-Fantasy Overture>, The Vienna Philharmonic Orchestra-Lorin Maazel. ℗1965

Remark & Rating
ED1, 1G-1G, $

Label **Decca SXL 6207**
London OS 25946

Wolf: <Moricke Lieder>; Pfitzner:<Eichendorff Lieder>, Hermann Prey (baritone) and Gerald Moore (piano). ℗1965

Remark & Rating
ED1, 2W-2W, rare! $

 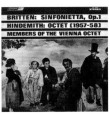

Label **Decca SXL 6208 (©=SDD 531)**
London CS 6465, (ED2 1st)

Britten: <Sinfonietta, Op.1>, Hindemith: <Octet (1957-58)>; Member of the Vienna Octet. ℗1965

Remark & Rating
ED1, 1W-2W, $+

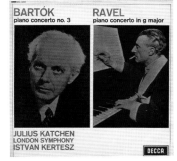 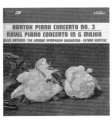

Label **Decca SXL 6209 (©=SDD 486)**
London CS 6487, (ED2 1st)

Bartok: <Piano Concerto No.3>; Ravel: <Piano Concerto in G Major>, Julius Katchen (piano), London Symphony Orchestra-Istvan Kertesz. Recorded by Kenneth Wilkinson in Kingsway Hall, London. ℗1966 [*TAS lsit is Linn Recut 01]

Remark & Rating
ED2, 4L-5L, (1st), rare! $$
TASEC =* Linn Recut 01, Penguin ★★★, (K. Wilkinson)

Label **Decca SXL 6210 (SET 262-4)**
London OS 25947 (OSA 1375)

Rossini: <L'Italiana in Algeri, Highlights>, Teresa Berganza, Luigi Alva, Fernando Corena, Orchestra and Chorus of Maggio Musicale Fiorentino-Silvio Varviso. ℗1964 ©1965 (Highlights from SET 262-4 & OSA 1375)

Remark & Rating
ED1, 1G-1G, $
Penguin ★★★

Label **Decca SXL 6212**
London CS 6469, (ED2 1st) (=CS 6784)

Bartok: <Concerto For Orchestra>, <Dance Suite>, London Symphony Orchestra-George Solti. Recorded by Kenneth Wilkinson in Kingsway Hall, London. ℗1965 by John Culshaw

Remark & Rating
Penguin ★★★, AS list-F, TAS 65-176++, (K. Wilkinson)

Label **Decca SXL 6213 (©=SDD 323; ECS 760)**
London CS 6470, (ED2 1st)

Shumann: <Symphony No.3 in E Flat "Rhenish">; Medelssohn:< A Midsummer Night's Dream Overture>, London Symphony Orchestra-Rafael Frühbeck de Burgos. ℗1965

Remark & Rating
ED1, 2W-1W, rare! $

Label **Decca SXL 6214**
London CS 6471, (ED2 1st)

Schumann: <Fantasia In C Major Op. 17>, <Etudes Symphony Op. 13>, Vladimir Ashkenazy (piano). ℗1965

Remark & Rating
ED1, 3W-2W, $
Penguin ★★(★)

Label **Decca SXL 6215**
London CS 6472, (ED2 1st)

Chopin: <Scherzo No .4, Op. 54>, <Nocturne, Op. 62, no 1>; Debussy: <Lisle joyeuse>; Ravel: <Gaspard de la nuit>, Vladimir Ashkenazy (piano). ℗1965

Remark & Rating
ED1, 1W-1W
Penguin ★★★

Label Decca SXL 6217 (©=SDD 536, SDDA 261-9)
London CS 6473, (ED2 1st)

Brahms: "Complete Piano Works Volume 5", <Hungarian Dances 1 - 21 (4 Hands)>, Julius Katchen (piano) ; Jean-Pierre Marty (2nd piano). ℗1965

Remark & Rating
ED2, 1W-1W, (1st), $
Penguin ★★★, (K. Wilkinson)

Label Decca SXL 6218 (©=SDD 538, SDDA 261-9)
London CS 6474, **[Not CS 6158 & © ist not STS 15150]

Brahms: "Complete Piano Works Volume 7", <Variations and Fugue on a Theme by Händel, Op. 24>, <Variations on a Theme by Paganini, Op. 35>, Julius Katchen (piano), recorded from K. Wilkinson in 1962, ℗1965.
**[SXL 6218 (Tax code is KT, Matrix Stamper: ZAL 6957 + 6958) might not be the same recording of London CS 6158 (Tax code of CS 6158 is "CT" & Matrix Stamper: ZAL 4197 + 4198). CS 6158 must be produced in 1958 and issued in 1960 with ED1, Blue Back sleeve, the reissue with the same stampers is London STS 15150, ©1965, Decca issue is LXT 5484 (mono only), ℗1958. (SXL 6218 =LXT 6282)]
**Robert Moon's rating RM14 for the CS 6158 & equivalent to SXL 6218 was a mistake, different performance & recording (*Performance speed: CS 6158 side 2, Paganini is 21' 28", SXL 6218 side 2, Paganini is 20' 09")]

Remark & Rating
ED1, 1W-1W, $
(K. Wilkinson)

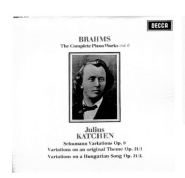

Label Decca SXL 6219 (©=SDD 537, SDDA 261-9)
London CS 6477, (ED2 1st)

Brahms: "Complete Piano Works Volume 6", <Variations on a theme by Schumann, Op. 9>, <Variations on an original theme, Op. 21, no. 1>, <Variations on a Hungarian song, Op. 21, no. 2>, Julius Katchen (piano). ℗1965

Remark & Rating
ED2, 1W-4W, (1st), $
Penguin ★★★

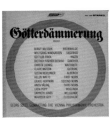

Label Decca SXL 6220 (SET 292-7)
London OSA 1604 (part)

Wagner: <Götterdämmerung, Highlights>, Nilsson, Windgassen, Frick, Fischer-Dieskau, etc., The Vienna Philharmonic Orchestra & Vienna State Opera Chorus-Georg Solti. Produced by John Culshaw. ℗1965 (Highlights from SET 292-7 & OSA 1604)

Remark & Rating
ED2, 4G-6G, (1st)
TASEC, Penguin ★★★, AS list-H

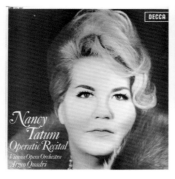

Label **Decca SXL 6221**
London OS 25955

[Nancy Tatum Opetatic Recital], Arias from Weber: <Oberon>, <Der Freischütz>; Wagner: <Tannhäuser>; Verdi: <Ernani>, <Aida>, <Trovatore>; Ponchielli: <Gioconda>, Vienna Opera Orchestra-Argeo Quadri. ℗ ©1966

Remark & Rating
ED1, 1G-2G, $

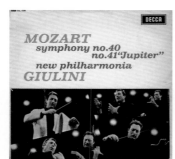

Label **Decca SXL 6225***
London CS 6479, (ED2 1st)

Mozart: <Symphony No. 40 in G Minor, K. 550>, <Symphony No. 41 in C Major, K. 551, "Jupiter">, New Philharmonia Orchestra-Carlo Maria Guilini. ℗1965

Remark & Rating
ED1, 1G-1G, $$
TAS2016

Label **Decca SXL 6226**
London CS 6481, (ED2 1st)

Haydn: <Symphony No. 22 in E Flat Major "The Philosopher">, <Symphony No. 90 in C Major>, L'Orchestre de la Suisse Romande-Ernest Ansermet. ℗1966

Remark & Rating
ED2, 1W-2W, (1st), $

Label **Decca SXL 6227 (©=SDD 464)**
London CS 6480, (ED2 1st) (©=STS 15289)

Bruckner: <Symphony No.4 in E Flat Major "Romantic">, The London Symphony Orchestra-Istvan Kertesz. Recorded by Kenneth Wilkinson. ℗1966

Remark & Rating
ED2, 2W-5W, (1st), rare! $
Penguin ★★★, (K. Wilkinson)

Label **Decca SXL 6228 (©=SDD 539, SDDA 261-9)**
London CS 6482, (ED2 1st)

Brahms: "Complete Piano Works Volume 8", <Sonata In F Minor, Op. 5>, <Scherzo In E Flat Minor, Op. 4>, Julius Katchen (piano). ℗1966

Remark & Rating
ED1, 1W-1W, $
(K. Wilkinson)

Label Decca SXL 6230 (©=SDD 245)
 London OS 25978

Stravinsky-Pergolesi: <Pulcinella, Complete Baller with Song)>, Marilyn Tyler (soprano), Carlo Franzini (tenor), Boris Carmeli (bass), L'Orchestre de la Suisse Romande-Ernest Ansermet. ℗1966

Remark & Rating
ED1, 1G-1G, Very rare! $$$

Label Decca SXL 6231 (©=SDD 461)
 No London CS

Franz Lehar: <Der Zarewitsch & Graf von Luxembourg, Highlights> Hilde Gueden & Waldemar Kmentt with the Orchestra and Chorus of the Vienna Volksoper-Max Schönherr. ℗1966

Remark & Rating
ED1, 1G-1G, $
Penguin ★★(★)

Label Decca SXL 6232
 London CS 6483, (ED2 1st)

Beethoven: <Symphony No.3 in E Flat Major "Eroica", Op.55>, The Vienna Philharmonic Orchestra-Hans Schmidt-Isserstedt. ℗1966

Remark & Rating
ED1, 2G-1G, Very rare! $$+ (ED2, $)
Penguin ★★★

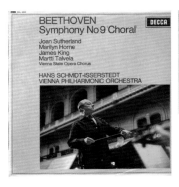

Label Decca SXL 6233
 London OSA 1159 (=OS 25974)

Beethoven: <Symphony No.9 in D Minor, "Choral", Op.125>, Sutherland, Horne, King, The Vienna Philharmonic Orchestra-Hans Schmidt-Isserstedt. ℗1966

Remark & Rating
ED1, 2G-6G, rare! $+
Penguin ★★★

Label Decca SXL 6234
 No London CS

[Mario del Monaco-Recital], Songs from: Perosi, Rossini, Beethoven, Bizet, Verdi, Franck, Handel, etc., with Brian Runnett (at the Organ of the Victoria Hall, Geneva). ℗1966

Remark & Rating
ED2, 3G-2G, (1st), rare! $$

Label **Decca SXL 6235**
London CS 6486, (ED2 1st)

[Favourite Overtures of the 19th Century (Overtures To Forgotten Operas)], The London Symphony Orchestra-Richard Bonynge. ℗1966

Remark & Rating
ED2, 2G-2G, (1st), $

Label **Decca SXL 6236**
London CS 6488, (ED2 1st)

Sibelius: <Symphony No.5 in E Flat, Op.82>,<Symphony No.7 in C Major, Op.105>, The Vienna Philharmonic Orchestra-Lorin Maazel. ℗1966

Remark & Rating
ED2, 3G-4W, (1st), $
Penguin ★★(★)

Label **Decca SXL 6237**
No London CS

[Decca Stereo Sampler Album 1966], Various pieces of the Classical, Opera, Jazz, Easy Listening. ℗1966

Remark & Rating
ED2, 1L-1L, (1st)

Label **Decca SXL 6238-41**
London CSA 2403

[Vienna Chamber Music Festival], Mozart: <Clarinet Quintet K.581, (The Vienna Octet)>, <March K.445, Minuets K.103 nos.11-14 & nos.15-19>, <5 Contradances K.609 "Non piu Andrai"> ; Beethoven: <Septet op.20 (The Vienna Mozart Ensemble-Willi Boskovsky)>; Schubert: <Piano Quintet D.667 "The Trout", Clifford Curzon (piano)>, <Octet D.803 (The Vienna Octet)>; Haydn: <String Quartet op.33 no.2 "The Joke" (The Weller Quartet)>. Recorded from 1958 to 1964. ℗1966

Remark & Rating
ED2, 2G-2W-1E-3M-1W-1W-2E-3E, (1st), rare!! $$$

Label **Decca SXL 6242-4 (ⓒ=SDDC 298-300)**
London CSA 2307 (CS 6496-8)

[Invitation to a Strauss Festival], Famous works from Johann Strauss family- Johann Strauss I: <Radetsky March Op.228> Johann Strauss II: <Champagne Polka Op.211; Wiener Blut (Vienna Blood) Waltz Op.354; Kaiser Waltz (Emperor Waltz) Op.437; G'schichten Aus Dem Wienerwald (Tales From The Vienna Woods) Waltz Op.325, etc.>, Josef Strauss: <Sphärenklänge, Op.235; Feuerfest Polka Op.269; Eingesendet Polka Op.240, etc.> & Eduard Strauss: <Bahn Frei Polka Op.45>, The Vienna Philharmonic Orchestra-Willi Boskovsky. ℗1959 (side A,C, D), 1960 (side B) & 1966 (side E,F) ⓒ1967

Remark & Rating
ED2, 3W-2W-1E-2E-6T-1W, (1st), $
Penguin ★★★

Label **Decca SXL 6245**
No London CS

[Spirituals & Zoltan Kodály: Folk Songs], Felicia Weathers (soprano), Georg Fischer (piano), Karl Scheid (guitar). ℗1966

Remark & Rating
ED2, 2G-3G, (1st), rare! $
Penguin ★★★

Label **Decca SXL 6246 (D121D 10)**
London CS 6489, (ED2 1st)

Mozart: [Complete Dances & Marches, Volume 7], <March in C, K.214>, <5 Minuets, K.461>, <Contredanse, K.587>, <6 Minuets, K.164>, <12 Minuets, K.585>, Vienna Mozart Ensemble-Willi Boskovsky. Recorded by Gordon Parry in the Sofiensaal, Vienna. ℗ ©1966

Remark & Rating
ED1, 1W-3L, $
Penguin ★★★

Label **Decca SXL 6247 (D121D 10)**
London CS 6490, (ED2 1st)

Mozart: [Complete Dances & Marches, Volume 8], <March in D, K.335, no. 2>, <2 minuets, K.604>, <3 German dances, K.605>, <6 Ländler, K.606>, <4 Contredanses, K.101>, <6 minuets, K.104>, <March in F, K.248>, <6 minuets, K.61h> Vienna Mozart Ensemble-Willi Boskovsky. Recorded by Gordon Parry in the Sofiensaal, Vienna. ℗ ©1966

Remark & Rating
ED1, 1W-1W, $
Penguin ★★★

Label **Decca SXL 6248, (D121D 10) [*Before SXL 6248 some ED2 is the 1st issue]**
London CS 6491, (ED2 1st)

Mozart: [Complete Dances & Marches, Volume 9], <Minuet In C, K. 409>, <6 German Dances, K. 536>, <Minuet In E Flat, K. 122>, <March In D, K. 290>, <3 Minuets, K. 363>, <La Chasse, K. 320f>, <8 Minuets, K. 315a>, <3 Contradanses, K. 535a>, <2 Minuets, K. 61g And K. 94>, <2 Contredances For Graf Czernin, K. 270a>, <Contredanse "Das Donnerwetter", K. 534>, Vienna Mozart Ensemble-Willi Boskovsky. Recorded by Gordon Parry in the Sofiensaal, Vienna. ℗ ©1966

Remark & Rating
ED1, 1W-1W, $
Penguin ★★★

Label Decca SXL 6249 [*From SXL 6249 all the ED2 is the 1st issue]
London OS 25981

[Gwyneth Jones Operatic Recital], Beethoven: <Fidelio>; Cherubini: <Medea>; Wagner: <Der fliegende Holländer>; Verdi: <Il trovatore>, <La forza del destino>. Gwyneth Jones (soprano) with Members of the Vienna State Opera Chorus and The Vienna Opera Orchestra-Argeo Quadri. Recorded in the Sofiensaal, Vienna. ℗1966

Remark & Rating
ED2, 3W-2G, (1st), rare!

Label Decca SXL 6251
No London CS

[Easter Sunday in Rome 1966], Mass celebrated in St.Peters square by his holiness Pope Paul VI. Producer: Andrew Hale-White, Engineer: Arthur Bannister. ℗1966

Remark & Rating
ED2, 1st, 1W-1W, $

Label Decca SXL 6252
London CS 6494, (ED2 1st)

Mozart: <Piano Quintet In E Flat Major For Piano And Wind Instruments, K.452>; Beethoven: <Piano Quintet In E Flat Major For Piano And Wind Instruments, Op.16>, Vladimir Ashkenazy (piano) with the London Wind Sololists. ℗1966 by Christopher Raeburn

Remark & Rating
ED2, 1st, 1W-1W, $
Penguin ★★★

Label Decca SXL 6253
London CS 6495, (ED2 1st)

Dvorak: <Symphony No.6 (No.1) in D Major, Op.60>, <Overture "Carnival">, London Symphony Orchestra-Istvan Kertesz. Recorded by Kenneth Wilkinson. ℗1966

Remark & Rating
ED2, 1st, 1W-2L, $
Penguin ★★★, AS List-H (D6D 7), (K. Wilkinson)

Label Decca SXL 6254
London OSA 1160

William Shield: <"Rosina" - Comic Opera>, Margreta Elkins, Robert Tear, Elizabeth Harwood, Monica Sinclair, Kenneth Macdonald, London Symphony Orchestra & The Ambrosian Singers-Richard Bonynge. ℗1966

Remark & Rating
ED2, 1st,1G-1G, rare! $

Label **Decca SXL 6255**
London OS 25992

[Joan Sutherland sings Noel Coward], with guest appearance of Noel Coward, Orchestra & Chorus conducted by Richard Bonynge. ℗1966

Remark & Rating
ED2, 1st, 1G-3G

Label **Decca SXL 6256**
London CS 6485, (ED2 1st)

[New Year's Concert], The Vienna Philharmonic Orchestra-Wili Boskovsky. ℗1966

Remark & Rating
ED2, 1st, 1W-1W
Penguin ★★(★)

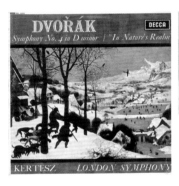

Label **Decca SXL 6257**
London CS 6526

Dvorak: <Symphony No.4 in D Minor, Op.13>, <Overture "In Nature's Realm">, London Symphony Orchestra-Istvan Kertesz. Recorded by Kenneth Wilkinson. ℗ ©1967

Remark & Rating
ED2, 1st, 1W-1W
Penguin ★★★, AS List-H (D6D 7), (K. Wilkinson)

Label **Decca SXL 6258 (©=SDD 330)**
London CS 6502, (ED2 1st)

Mozart: <String Quartet In D Major, K.575 "Prussian No.1">, <String Quartet In F Major, K.590 "Prussian No.3">, The Weller Quartet - Walter Weller & Alfred Staar (violin); Helmut Weis (viola); Ludwig Beinl (cello). ℗1966

Remark & Rating
ED2, 1st, 2G-1G, rare! $$
Penguin ★★★

Label **Decca SXL 6259**
London CS 6501, (ED2 1st)

Mozart: <Piano Concerto No.8 in C, K.246>, <Piano Concerto No.9 in E Flat, K.271>, <Rondo in A, K.386>, Vladimir Ashkenazy (piano) with The London Symphony Orchestra-Istvan Kertesz. Recorded by Kenneth Wilkinson, June 1966 in Kingsway Hall, London. ℗1966

Remark & Rating
ED2, 1st, 2G-2G
Penguin ★★★(✸), (K. Wilkinson)

Label **Decca SXL 6260**
London CS 6500, (ED2 1st)

Schubert: <Piano Sonata No.13 In A Major, Op.120, D.664>, <Sonata No.14 In A Minor, Op.143, D.784>, <Hungarian Melody, D.817>, <Twelve Waltzes Op.18, D.145>, Vladimir Ashkenazy (piano). ℗1966

Remark & Rating
ED2, 1st, 1G-5G, $
Penguin ★★★(❀)

Label **Decca SXL 6261 (SET 228-9 & 292-7)**
London OS 25991 (OSA 1218 & 1604)

[Closing Scenes From Richard Strauss], <"Salome" Dance of the Seven Veils> & Wagner: <"Gotterdammerung" Immolation Scene>, Brigit Nilsson (soprano) with The Vienna Philharmonic Orchestra-Georg Solti. ℗1962 & 1965 @1966 (Highlights from SET 228-9; SET 292-7 & OSA 1218; OSA 1604)

Remark & Rating
ED2, 1G-8W

Label **Decca SXL 6262**
London OS 25994

[Geraint Evans Operatic Recital], Händel: <Berenice: Si trai ceppi>, <Semele: Leave me radiant light>; Mozart: <Le nozze di Figaro: Non più andrai>, <Don Giovanni: Madamina, il catalogo>, <Die Zauberflöte: Der Vogelfänger>, <Loca del Cairo: Ogni momento>; Beethoven: <Fidelio: Ha! welch ,ein Augenblick!>; Leoncavallo: <Pagliacci: Prologue; Si può>; Donizetti: <Don Pasquale: Un fuoco insolito>; Verdi: <Otello: Credo>, <Falstaff: Ehi! Paggio! ... Lonore! Ladri!>; Britten: <Midsummer nights dream: Bottoms dream>; Mussorgsky: <Boris Godunov: Tchelkalovs aria>. Geraint Evans (baritone), L'Orchestre de la Suisse Romande-Bryan Balkwill. ℗1966

Remark & Rating
ED2, 1G-2G
Penguin ★★★

Label **Decca SXL 6263 (©=SPA 127)**
London CS 6503 (=CS 6785)

[Romantic Russia], Glinka: <Russlan And Ludmilla (Overture)>; Mussorgsky: <Khovanshchina Prelude>, <Night On Bald Mountain>; Borodin: <Prince Igor-Overture & Polovtsian Dances>, London Symphony Orchestra And Chorus-Georg Solti. ℗1966 ***(This recording is reissued in London CS 6785)

Remark & Rating
ED2, 2G-1G, rare! $$
Penguin ★★★, AS List

Label **Decca SXL 6264**
No London CS (©=STS 15173)

Britten: [School Concert], <Psalm 150>, <Gemini Variations>, <Songs from "Friday Afternoons">, Choir Of Downside School Purley. Director of the Music: Derek Herdman with Viola Tunnard (piano) conducted by Benjamin Britten. ℗1966

Remark & Rating
ED2, 1G-1G
Penguin ★★★

Label **Decca SXL 6265**
No London CS

Petterson: <Symphony No.2>, Swedish Radio Symphony Orchestra-Stig Westerberg. Recorded in association with Swedish Radio. Producer: Nils Castegren. ℗1966

Remark & Rating
ED2, 1W-1W, rare!! $$

Label **Decca SXL 6266 (©=SDD 384)**
London OS 25996

J.S. Bach: <Cantata No.45 "Es Ist Dir Gesagt">, <Cantata No.105 "Herr, Gehe Nicht Ins Gericht mit deinem Knecht">, L'Orchestre de la Suisse Romande-Ernest Ansermet. ℗1966 (** Canatata No.105, Gehe Nicht ins "Gerecht" on the record cover must be "ins Gericht", a print error)

Remark & Rating
ED2, 3G-1G
Penguin ★★(★) (SDD 384)

Label **Decca SXL 6267**
London OS 25995

[Pilar Lorengar Operatic Recital], <La Boheme: Si mi chiamano Mimi>; <La Rondine: Che il bel sogno di Doretta>; <Madama Butterfly: Un bel di>; <Turandot: Tu che di gel sei cinta>; <Gianni Schicchi: O mio babbino caro>; < Rusalka: Mesicku na nebi hlubokém>; <Louise: Depuis le jour>; <Carmen: C'est des Contrebandiers ... Je dis, que rien ne m'épouvante>; <Les Pêcheurs des Perles: Me voilà seule>; <Manon: Gavotte>. Pilar Lorengar (soprano) with the Orchestra of the Academia di Santa Cecilia-Giuseppe Patane. ℗1966

Remark & Rating
ED2, 4G-2G, rare!

Label **Decca SXL 6268**
London CS 6508

Ildebrando Pizzetti: <La Pisanella>, <Concerto Dell' Estate>, L'orchestre de la Suisse Romande-Lamberto Gardelli. ℗1966

Remark & Rating
ED2, 1W-2W, rare! $

Label **Decca SXL 6269**
London CS 6509

Glazunov: <The Seasons, Op. 67>, <Concert Waltze No. 1 in D, Op. 47>, <Concert Waltze No. 2 in F, Op. 51>, (Ansermet Conducts Series), L'Orchestre De La Suisse Romande-Ernest Ansermet. ℗1967

Remark & Rating
ED2, 1K-1K, $
Penguin ★★(★)

Label **Decca SXL 6270**
London CS 6510

Beethoven: <Symphony No.7 in A Major, Op. 92>, <Prometheus Overture, Op. 43>, The Vienna Philharmonic LOrchestra-Claudio Abbado. ℗1966

Remark & Rating
ED2, 2W-2W, $+

Label **Decca SXL 6271 (SET 285-7)**
London OS 26007 (OSA 1381)

Gioachino Rossini: <Il Barbiere Di Siviglia (Barber of Seville), Highlights>, Berganza, Ghiaurov, Ausensi, Corena, Benelli, Orchestra Rossini di Napoli-Silvio Varviso. ℗1965 ©1967 (Highlights from SET 285-7 & OSA 1381)

Remark & Rating
ED2, 2G-4W
Penguin ★★(★)

Label **Decca SXL 6272 (SET 288-91)**
London OS 26008

J.S. Bach: <Matthaus Passion, (excerpts)>, Ameling, Hoffgen, Pears, Wunderlich, Prey, Krause, Blankenburg, The Stuttgart Hymnus Boy's Choir & The Stuttgart Chamber Orchestra-Karl Münchinger. ℗1965 ©1966

Remark & Rating
ED2, 4W-2W
Penguin ★★(★), AS List-H (excerpts)

Label **Decca SXL 6273**
London CS 6511

Dvorak: <Symphony No.5 (No.3) in F Major, Op.76 (Originallly Op.24, published as Op.76)>, <Overture "My Home">, London Symphony Orchestra-Istvan Kertesz. Recorded by Kenneth Wilkinson in Kingsway Hall, London. ℗1966

Remark & Rating
ED2, 3G-2G, $
Penguin ★★★, AS List-H (D6D 7), (K. Wilkinson)

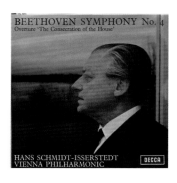

Label **Decca SXL 6274**
London CS 6512

Beethoven: <Symphony No.4 in B Flat Major, Op.60>, <Consecration of the House (Die Weihe des Hauses) Overture, Op.124>, The Vienna Philharmonic Orchestra-Hans Schmidt-Isserstedt. ©1967

Remark & Rating
ED2, 1W-1W, $
Penguin ★★★

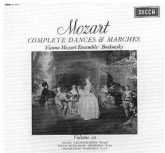

Label **Decca SXL 6275 (D121D 10)**
London CS 6513

Mozart: [Complete Dances & Marches, Volume 10], <Ballet "Les petits riens", K.299b>, <Ballet music from Idomeneo, K.367>, <Idomeneo March, K.206>, Vienna Mozart Ensemble-Willi Boskovsky. Recorded by Gordon Parry in the Sofiensaal, Vienna. ℗ ©1967

Remark & Rating
ED2, 1W-2W
Penguin ★★★

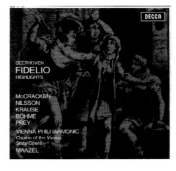

Label **Decca SXL 6276 (SET 272-3)**
London OS 26009 (OSA 1259)

Beethoven: <Fidelio, Highlights>, Birgit Nilsson, James McCracken, Tom Krause, Hermann Prey, The Vienna Philharmonic Orcheatra-Lorin Maazel. ℗1964 ©1967 (Highlights from SET 272-3 & OSA 1259)

Remark & Rating
ED2, 1G-1G

Label **Decca SXL 6281**
No London CS

Robert Still: <Elegie for Baritone & Small Orchestra>, John Carol Case (baritone); Edmund Rubbra: <Choral Suite "Inscape" for Mixed Choir, Strings and Harp, Op.122>, Renata Scheffel-Stein (harp), with the Ambrosian Singers directed by John McCarthy and The Jacques Orchestra conducted by Myer Fredman. Recorded in Kingsway Hall, London, November 1966. ℗ ©1967

Remark & Rating
ED2, 1W-1W, rare! $

Label **Decca SXL 6282-4, (=SET 231 + SXL 2261 & SXL 6067)**

[Vienna Philharmonic Festival], *Brahms: <Symphony No.3 in F Major, Op.90>, <Tragic Overture, Op.81>; **Richard Strauss: <Death and Transfiguration, Op.24>, <Till Eulenspiegel's Merry Pranks>, <Dance of the 7 Veils (Salome)>; ***Mozart: <Symphony No.41 in C Major, K.551, "Jupiter">, *** Haydn: <Symphony No.103 in E Flat Major "Drum Roll">, The Vienna Philharmonic Orchestra conducted by Herbert von Karajan. ℗1967 (*SET 231 = CS 6249; **SXL 2261 = CS 6211 & ***SXL 6067 = CS 6369)

Remark & Rating
ED2, 2G/2G, 3E/3E, 6W/3W, rare!! $$

Label **Decca SXL 6285***
London CS 6519

Richard Strauss: <Horn Concertos Nos.1-2>; Franz Strauss: <Horn Concerto, Op.8>* , Barry Tuckwell (horn), London Symphony Orchestra-Istvan Kertesz. Recorded by Kenneth Wilkinson, July 1966 in Kingsway Hall, London. ℗1967 [* Franz Strauss is Penguin ★(★)]

Remark & Rating
ED2, 1W-1W
Penguin ★★(★), (K. Wilkinson)

Label **Decca SXL 6286**
London CS 6522

Prokofiev: <Suite from Romeo & Juliet>, <Chout (The Buffoon), Suite from the Ballet, Op.21 bis.>, The London Symphony Orchestra-Claudio Abbado. ℗1967

Remark & Rating
ED2, 3L-1G, $
Penguin ★★(★)

Label **Decca SXL 6287***
London CS 6521 (©=STS 15358))

Falla: <El Amor Brujo>, Nati Mistral (soprano); Ravel: <Pavane pour une infante défunte>, <Alborada del gracioso>; Granados: <Intermezzo from Goyescas>, New Philharmonia-Rafael Frühbeck de Burgos. Recorded by Kenneth Wilkinson. ℗1967

Remark & Rating
ED2, 1G-1G, rare! $$
Penguin ★★★, (K. Wilkinson), AS List (Speakers Corner)

Label **Decca SXL 6288**
London CS 6523

Dvorak: <Symphony No.1 in C Minor, Op.3, "Bells of Zlonice">, London Symphony Orchestra-Istvan Kertesz. Recorded by Kenneth Wilkinson. ℗1967

Remark & Rating
ED2, 4W-1W, $
Penguin ★★★, AS List-H (D6D 7), (K. Wilkinson)

 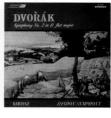

Label **Decca SXL 6289**
London CS 6524

Dvorak: <Symphony No.2 in B Flat Major, Op.4>, London Symphony Orchestra-Istvan Kertesz. Recorded by Kenneth Wilkinson. ℗1967

Remark & Rating
ED2. 3W-1W, $
Penguin ★★★, AS List-H (D6D 7), (K. Wilkinson)

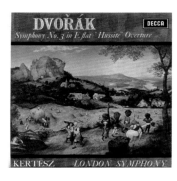

Label Decca SXL 6290
 London CS 6525

Dvorak: <Symphony No.3 in E Flat Major, Op.10>,<Hussite Overture>, London Symphony Orchestra-Istvan Kertesz. Recorded by Kenneth Wilkinson. ℗1967

Remark & Rating
ED2, 2W-1W, $
Penguin ★★★, AS List-H (D6D 7), (K. Wilkinson)

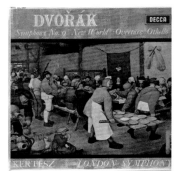

Label Decca SXL 6291 (©=SPA 87)
 London CS 6527

Dvorak: <Symphony No.9 in E Minor " New World", Op.95>, <Overture "Othello" Op.93>, London Symphony Orchestra-Istvan Kertesz. Recorded by Kenneth Wilkinson. ℗1967 (TAS list is the late Japanese issue=London Jpn K38C 70003)

Remark & Rating
ED2, 1W-1W, $
TAS-OLD, AS list-F (D6D 7), Penguin ★★★, Japan 300, (K. Wilkinson)

Label Decca SXL 6292-5, (=SET 227 + SXL 2179 + SXL 6089 + SXL 6125)

[Vienna Philharmonic Festival for VPO 125th Anniversary], *Wanger: <Rienzi Overture>, <The FLying Dutchman Overture>, <Tannhauser-Overture and Bacchanale>, conducted by Georg Solti; **Beethoven: <Piano Concerto No. 5 in E Flat "Emperor">, Wilhelm Backhaus (Piano), conducted by Hans Schmidt-Isserstedt; ***Schubert: <Symphony No. 9 in C, "The Great">, conducted by Istvan Kertesz; ****Sibelius: <Symphony No. 2 in D Major>, conducted by Lorin Maazel. (Includes Booklet) ℗1967 (*SET 227 = CS 6245 & CS 6782; **SXL 2179 = CS 6156; ***SXL 6089 = CS 6381; ****SXL 6125 = CS 6408)

Remark & Rating
2E-2E,4W-4L,1L-1L,3W-5W, rare! $$

Label Decca SXL 6296
 No London CS

[Münchinger Miniatures], <Bach: Fugue, Suite>; <Mozart: Les Petits Riens>;< Vivaldi: Concerto Alla Rustica>; <Grieg: "Holberg" Suite>; <Vivaldi: Concerto "Alla Rustica">; Schumann; Schubert, etc., Stuttgart Chamber Orchestra-Karl Münchinger. ℗1967

Remark & Rating
ED2, 3W-2W

Label **Decca SXL 6297**
London CS 6532

Mozart: <Piano Concerto No.20 in D Minor>, <Piano Concerto No. 25 in C Major>, Julius Katchen (piano), Stuttgart Chamber Orchestra-Karl Munchinger. ℗1967

Remark & Rating
ED2, 1W-1W, rare! $$

Label **Decca SXL 6298**
London CS 6529

[Preludes], Liszt: <Les Preludes>; Wagner: <Preludes to "Lohengrin" (Acts 1 & 3)>, <Prelude to "Parsifal">, <Prelude to "Meistersinger">, The Vienna Philharmonic Orchestra-Zubin Mehta. ℗1967 by Christopher Raeburn [* Liszt, Penguin ★★(★)]

Remark & Rating
ED2, 2W-2W, $+
Penguin ★★(★)

Label **Decca SXL 6299**
London OS 26014

[Felicia Weathers - Verdi & Puccini Arias], Verdi: <"Don Carlo", Tu che la vanità ; Non pianger, mia compagna>, <"Otello", Willow song ; Ave Maria>; Puccini: <"Manon Lescant", In quelle trini morbide ; Sola perduta, abbandonata>, <"Turandot", Tu che di gel sei cinta>, <"Madama Butterfly", Un bel dì>, <"Suor Angelica", Senza mamma>, <"Gianni Schicchi", O mio bambino>. Felicia Weathers (soprano) with The Vienna State Opera Orchestra-Argeo Quadri. ℗1967

Remark & Rating
ED2,1G-1G

Label **Decca SXL 6300**
London CS 6535

Beethoven: Piano Sonatas <Sonata No.25 in G Major, Op.79>, <Sonata No.31 in A Flat, Op.110>, <Sonata No.4 in E Flat, Op.7, "Grand Sonata">, Wilhelm Backhaus (piano). ℗1967

Remark & Rating
ED2, 3W-2W, Very rare!! $$+

Label **Decca SXL 6301**
London CS 6534

Mozart: <Piano Sonata No. 12 in F>, <Piano Sonata No. 10 in C>, <Piano Sonata No. 4 in E Flat>, <Piano Sonata No. 5 in G>, <Rondo in A Minor>, Wilhelm Backhaus (piano). ℗1967

Remark & Rating
ED2, 2W-2W, Very rare!! $$+
Penguin ★★(★)

Label **Decca SXL 6302**
London CS 6536

Lalo: <Namouna - Excerpts>, <Divertissement - Andantino>, <Rapsodie Pour Orchestre>, (Ansermet Conducts Series), L'Orchestre De La Suisse Romande-Ernest Ansermet. ℗1967

Remark & Rating
ED2, 2W-2W, rare! $$
Penguin ★★★

Label **Decca SXL 6303**
London CS 6533

Brahms: <Sonata in F Minor, for two pianos, Op. 34>; Saint-Saëns: <Variations for two pianos on a theme of Beethoven, Op. 35>, Pianos: Bracha Eden & Alexander Tamir. ℗1967

Remark & Rating
ED2, 2W-2W, $+
Penguin ★★(★)

Label **Decca SXL 6304**
London CS 6537

Richard Strauss: <Le Bourgois Gentilhomme-Suite, Op.60>, <Der Rosenkavalier-First Waltz Sequence>, with Friedrich Gulda (piano), Willi Boskovsky (violin), and Emmanuel Brabec (violoncello), The Vienna Philharmonic Orchestra-Lorin Maazel. ℗1967

Remark & Rating
ED2, 1W-1W, $

Label **Decca SXL 6305**
London OS 26021

Boito: <Mefistofele (selections)>, Nicolai Ghiaurov, Franco Tagliavini, Chorus & Orchestra of the Rome Opera-Silvio Varviso. ℗1967

Remark & Rating
ED2, 1G-1G, $

Label **Decca SXL 6306**
London OS 26018

[Elena Suliotis Recital], Donizetti: <Anna Bolena-Final Scene>; Verdi: <Macbeth>,<Luisa Miller>, <Un Ballo in Maschera>, Elena Suliotis (soprano) with the Rome Opera Orchestra-Oliviero Fabritiis. ℗1967

Remark & Rating
ED2, 1G-1G

Label **Decca SXL 6307 (=TELDEC 16.41759)**
No London CS

[Oskar Werner reading poems by Goethe Schiller], Poems by Goethe: "Promrtheus", "Der Fischer", "Erlkönig", "Der Zauberlehrling", "Der Gott und die Bajadere", "Warum gabst du uns die Tiefen Blicke", "An die Ture will ich Schleichen", "Der du von dem Himmel Bist", " Pygmalion", "Brautnacht", "Heidenroslein"; Poems by Schiller: "Der Taucher", "Der Handschulh", "Die Burgschaft", "Die Kraniche des Ibykus". ℗1967

Remark & Rating
ED2, WBG, rare! $

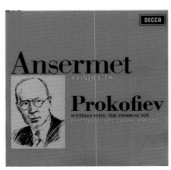

Label **Decca SXL 6308**
London CS 6538

Prokofiev: <Scythian Suite, Op.20>, <The Prodical Son, Symphonic Suite Op.46> , (Ansermet Conducts Series), L'Orchestra de la Suisse Romande-Ernest Ansermet. ℗1967

Remark & Rating
ED2, 1W-1W, rare! $
AS List

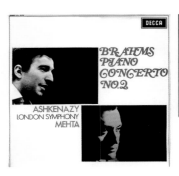 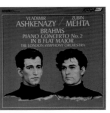

Label **Decca SXL 6309**
London CS 6539

Brahms: <Piano Concerto No.2 in B Flat Major>, Vladimir Ashkenazy (piano), London Symphony Orchestra-Zubin Mehta. ℗1967

Remark & Rating
ED2, 3W-2W

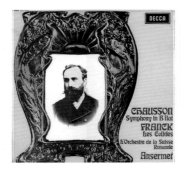

Label **Decca SXL 6310 (=SDD 451)**
London CS 6540 (©=STS 15294)

Chausson: <Symphony in B Flat Major>; Franck: <Les Éolides Symphonic Poem>, L'Orchestra de la Suisse Romande-Ernest Ansermet. ℗1967

Remark & Rating
ED2, 1W-2W, rare! $

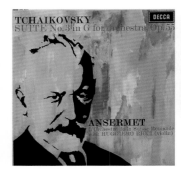

Label **Decca SXL 6311**
London CS 6543

Tchaikovsky: <Suite No.3 in G Major for Orchestra, Op.55>, Ruggiero Ricci (violin), L'Orchestre de la Suisse Romande-Ernest Ansermet. ℗1967

Remark & Rating
ED2, 1W-2W, rare! $$

Label　Decca SXL 6312
　　　　London CS 6542

Tchaikovsky: <Suite No.4 For Orchestra " Mozartiana">; Respighi: <Suite For Orchestra "Rossiniana">, Ruggiero Ricci (violin), L'Orchestre de la Suisse Romande-Ernest Ansermet. ℗1967

Remark & Rating
ED2, 1W-1W, $$
AS list-H

Label　Decca SXL 6313
　　　　London CS 6541 (CSA 2308)

[What Everyone should know about music], spoken by Ernest Ansermet, L'Orchestre de la Suisse Romande-Ernest Ansermet. ℗1967

Remark & Rating
ED2, 3W-2W, Very rare! $+

Label　Decca SXL 6314
　　　　London OS 26030

[Sibelius Songs], <Flickan kom>, <Hennes budskap>, <Jägargossen>, <Längtan heter min arfvedel>, <På verandan vid havet>, <Romeo>, <Marssnön>, <Kullervon valitus>, <Höstkväll>, <Den första kyssen>, <Systrar, i bröder>, <Våren flyktar hastigt>, <Necken>, <Långsamt som qvållskyn>, <Jag är ett trad>, <Norden>, Sung in Swedish or Finnish. Tom Krause (baritone) and Pentti Koskimies (piano). (2 pages texts with English translations) ℗1967 by Christopher Raeburn

Remark & Rating
ED2, 1G-1G, $+

Label　Decca SXL 6315
　　　　No London CS (©=STS 15162)

[Madrigals] to 3; 4; 5. and 6 parts, apt both for Voyals & Voyces, Newly composed by John Wilbye, 1609. The Wilbye Consort-Peter Pears. ℗1967

Remark & Rating
ED2, 2G-6W
Penguin ★★(★)

Label　Decca SXL 6316
　　　　London OS 26032

Benjamin Britten: <Les Illuminations, for Tenor & String orchestra, Op.18>, <Variation on a theme of Frank Bridge, Op.10>, Peter Pears (tenor), English Chamber Orchestra-Benjamin Britten. ℗1967 by Christopher Raeburn

Remark & Rating
ED2, 1G-2G

Label **Decca SXL 6318**
No London CS

J.S.Bach & C.P.E. Bach: <Music for 4 Harpsichords>, George Malcolm, Valda Aveling, Geoffrey Parsons & Simon Preston (harpsichords), English Chamber orchestra-Raymond Leppard. ℗1967

Remark & Rating
ED2, 2G-3L

Label **Decca SXL 6319 (©=SDD 416)**
No London CS

Louis Spohr: <Nonet in F, Op.31>, <Double Quartet in E Minor, Op.87>, Members Of The Vienna Octet. ℗1967

Remark & Rating
ED2, 1G-1G

Label **Decca SXL 6320**
No London CS

[Romantic Overtures], Weber: <Preciosa>; Schumann: <Genovena>; Schubert: <Overture in D Major, D.556>; Cherubini: <Anacreon>; Mendelssohn: <Calm Sea & Prosperous Voyage>, The Vienna Philharmonic Orchestra-Karl Münchinger. ℗1967

Remark & Rating
ED2, 1G-1G, $

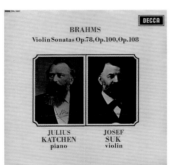

Label **Decca SXL 6321 (©=SDD 542)**
London CS 6549

Brahms: <Violin Sonata No. 1 in G Major, Op. 78>, <Sonata No. 2 in A Major, Op. 100>, <Sonata No. 3, in D Minor, Op. 108>, Josef Suk (violin); Julius Katchen (piano). ℗1967

Remark & Rating
ED2, 3W-4W
Penguin ★★(★), (K. Wilkinson)

Label **Decca SXL 6322**
London CS 6550

Brahms: <Piano Concerto No.2 in B Flat Major>, Wilhelm Backhaus (piano) with The Vienna Philharmonic Orchestra-Karl Bohm. ℗1967

Remark & Rating
ED2, 1W-1W, $$
Penguin ★★(★), AS List, TAS 78/146+, Japan 300

Label **Decca SXL 6323**
 London CS 6553

Tchaikovsky: <Symphony No.4 in F Minor, Op.36>, Los Angeles Philharmonic-Zubin Mehta. Produced by John Culshow, recorded in Royce Hall, University of California, L.A. ℗1967 ***(Another "Tchaikovsky No.4" from Mehta's later recording which published in 1980 in the Decca Box SET D95D 6 is London CS 7155, No SXL issue)

Remark & Rating
ED2, 1W-1W, $
Penguin ★★(★)

Label **Decca SXL 6324**
 London CS 6554

Stravinsky: <Petrushka (1947 Version)>, <Circus Polka>, with Shibley Boyes (solo piano), Los Angeles Philharmonic-Zubin Mehta. Produced by John Culshow, recorded in Royce Hall, University of California, L.A. ℗1967

Remark & Rating
ED2, 1W-1W, $

Label **Decca SXL 6325**
 London CS 6552

Schoenberg: <Verklärte Nacht (Transfigured Night), Op.4>; Scriabin: <Poem of Ecstasy>, The Los Angeles Philharmonic Orchestra-Zubin Mehta. Produced by John Culshow, recorded in Royce Hall, University of California, L.A. ℗1967

Remark & Rating
ED2, 2W-2W
Penguin ★★★, AS list-F

Label **Decca SXL 6326**
 London OS 26039

[James King Operatic Recital], Weber: <"Der Freischutz", Nein! Länger trag ich nicht die Qualen, durch die Wälder>; Beethoven: <"Fidelio", Florestan's Aria, Gott! Welch dunkel hier>; Wagner: <"Rienzi", Rienzi's Prayer>, <"Lohengrin", Lohegrin's Farewell>, <"Tannhäuser", Hör' an ··· Inbrünst im Herzen>, <"Die Meistersinger", The Prize Song>. James King (tenor) with The Vienna Opera Orchestra-Dietfried Bernet. ℗1967

Remark & Rating
ED2, 2G-2G, $

Label **Decca SXL 6327**
 London OS 26042

[The Heroic Bariton-Tom Krause], Tom Krause baritone Arias - Mozart: Don Giovanni <Finch' han dal vino>, <Deh vieni alla finestra>; Rossini: William Tell <Sois immobile>; Leoncavallo: La Bohème <Scuoti, o vento>; Giordano: Andrea Chenier <Nemico della patria>; Borodin: Prince Igor <Igor's aria>; Wagner: Tannhäuser <O du, mein holder Abendstern>, Der Fliegende Holländer <Die Frist ist um>, The Vienna State Opera Orchestra-Argeo Quadri, recorded in Sofiensaal, Vienna. ℗1967

Remark & Rating
ED2,1G-1G

Label Decca SXL 6328
London CS 6559

Mussorgsky: "Two Complete Performances Of Pictures At An Exhibition", <Original Piano Version, Vladimir Ashkenazy (piano), recorded in Kingsway Hall>; <Ravel Orchestral Version, UCLA, Los Angeles Philharmonic-Zubin Mehta, recorded in Royce Hall>. Ⓟ1967

Remark & Rating
ED2, 3W-1W, $
Penguin ★★(★)

Label Decca SXL 6329
London CS 6556

Beethoven: <Symphony No.6 in F Major "Pastoral", Op.68>, <Egmont Ouverture Op.84>, The Vienna Philhamonic Orchestra-Hans Schmidt-Isserstedt. Ⓟ1967

Remark & Rating
ED2, 1G-2G, $
Penguin ★★

Label Decca SXL 6330
No London CS (=STS 15077)

Mozart: "Serenades Volume 1", <Serenade No.4 in D, K.203>, <Horn Rondo, K.371>, Vienna Mozart Ensemble-Willi Boskovsky. Ⓟ1967

Remark & Rating
ED2, 1G-4G, $
Penguin ★★★

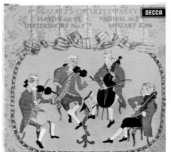
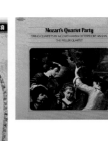

Label Decca SXL 6331
No London CS (=London STS 15168)

[Mozart's Quartet Party], Mozart: <String Quartet In G, K.156>; Haydn: <Quartet In D, Op.1, No.3>; Dittersdorf: <Quartet No.5 In E Flat>; Vanhal: <Quartet In F>, The Weller Quartet. Ⓟ1967

Remark & Rating
ED2, 2W-1W, rare! $$

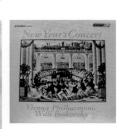

Label Decca SXL 6332
London CS 6555

[New Year's Concert], The Vienna Philharmonic Orchestra-Willi Boskovsky. Ⓟ1967

Remark & Rating
ED2, 1L-1L
Penguin ★★(★)

Label **Decca SXL 6333**
 London OS 26043

[Regina Crespin Song Recital], Schumann; <Five Poems of Mary Stuart Op.135>; Wolf: <In der Frühe>, <Der Gärtner>, <Dass verlassene Mägdlein>, <Ich hab in Penna einen Liebsten>, <Anakreons Grab>, <Verschwiegene Liebe>; Debussy: <Trois Chansons de Bilitis>; Poulenc: <Banalites>, <La Courte Paille>, <Chansons villageoises>,< Deux poemes de Louis Aragon>, Regina Crespin (soprano), John Wustman (piano). Recorded May 1967 in Kingsway Hall, London. ℗1967 ©1968

Remark & Rating
ED2, 1G-5G, $

Label **Decca SXL 6334**
 London CS 6562

Chopin: <The Four Scherzi, Op.20, 31, 39 & 54>, <Prelude In C Sharp Minor, Op.45>, <Barcarolle, Op.60>, Vladimir Ashkenazy (piano). ℗1967 ©1968

Remark & Rating
ED2, 1W-2W
Penguin ★★★, Japan 300-CD

Label **Decca SXL 6335**
 London CS 6563

Beethoven: <Piano Sonata No.29 in B Flat Major, Op.106 "Hammerklavier">, Vladimir Ashkenazy (piano). ℗1968

Remark & Rating
ED2, 1W-6W, $
Penguin ★★

Label **Decca SXL 6336**
 London OS 26053

[Nancy Tatum Recital Of American Songs], Songs from MacDowell, Gold, Manning, Copland, Baber, Thomson, etc., Nancy Tatum (soprano), Geoffrey Parsons (piano). (Insert included) ℗1967 ©1968

Remark & Rating
ED1, 1G-1G, rare! $

Label **Decca SXL 6337 (©=SDD 424)**
 No London CS

Johann Christian Bach: <6 Symphonies For Wind - No.1 in E flat Major, No.2 in B flat Major, No.3 in E flat Major, No.4 in B flat Major, No.5 in E flat Major, No.6 in B flat Major>, London Wind Sololist-Jack Brymer. ℗ ©1968

Remark & Rating
ED2, 1W-1W, $

Label **Decca SXL 6338 (©=SDD 450)**
No London CS (©=STS 15078)

Haydn: <The 7 Wind Divertimenti for 2 Oboes, 2 Horns & 2 Bassoons>, James Brown & Terence MacDonagh (oboes), Alan Civil & Ian Harper (horns), Roger Birnstingl, Ronald Waller (bassoons), London Wind Soloists-Jack Brymer. ℗1968

Remark & Rating
ED2, 1W-1W, $
Penguin ★★(★)

Label **Decca SXL 6339**
No London CS (=STS 15169)

Gluck: <"Don Juan", Complete Ballet>, Simon Preston (Harpsichord Continuo), Academy of St Martins-Neville Marriner. ℗1968

Remark & Rating
ED2 ?, (ED3, 2W-6W), $
Penguin ★★★

Label **Decca SXL 6340**
London CS 6567

Brahms: <Serenade No.1 in D Major, Op.11>, London Symphony Orchestra-Istvan Kertesz. ℗1968

Remark & Rating
ED2, 1W-3W
Penguin ★★★, AS List-H (JB 86)

Label **Decca SXL 6341**
No London CS (=London STS 15164)

[Romantic Songs by Rossini, Bellini, Donizetti], Lydia Marimpietri (soprano); Ugo Benelli (tenor), Enrico Fabbro (piano). (Insert included) ℗1968

Remark & Rating
ED2, 1G-1G

Label **Decca SXL 6342**
London CS 6569

Rachmaninov: <Symphony No.2 in E Minor, Op.27>, Orchestre de la Suisse Romande-Paul Kletzki. ℗1968

Remark & Rating
ED2, 1W-2W, $

Label **Decca SXL 6343**
London CSA 2101 (CS 6568, 6575)

Berlioz: <Symphonie Fantastique, Op.14>, <Overture "Le Corsaire" Op.21>, L'Orchestre de la Suisse Romande-Ernest Ansermet. (** In CSA 2101 includes bonus disc of Ansermet rehearsing the Symphonie Fantastique) ℗1968

Remark & Rating
ED2, 1W-2W, $

Label **Decca SXL 6344**
London CS 6570

[Dances Of Old Vienna], Schubert; J.Strauss; Lanner, Boskovsky Ensemble-Willi Boskovsky. ℗1968

Remark & Rating
ED2-1W-2W, $

Label **Decca SXL 6345**
London OS 26064

[Marilyn Horne- Arias from French Operas], <Bizet: Carmen>; <Saint-Saëns: Samson Et Dalila>; <Thomas: Mignon>; <Massenet: Werther>, The Vienna Opera Orchestra conducted by Henry Lewis. ℗1968

Remark & Rating
ED2, 6G-4G, $

Label **Decca SXL 6346**
London CS 6573

Prokofiev: <Sonata No.7 in B Flat, Op.83>, <Sonata No.8 in B Flat, Op.84>, <2 Pieces fron 'Romeo and Juliet', Op.75>, Vladimir Ashkenazy (piono). ℗1968

Remark & Rating
ED2, 2W-1W, rare! $$
Penguin ★★★

Label **Decca SXL 6347**
London OS 26063

Schubert: [18 Songs], <Beim Wind>e, <Der Jüngling An Der Quelle>, <An Eine Quelle>, <An Die Untergehende Sonne>, <Geheimnis>, <An Die Laute>, <An Mein Klavier>, <Trost Im Liede>, <Die Götter Griechenlands>, <Die Erste Liebe>, <Das Rosenband>, <Sprache Der Liebe>, <Versunken>, <An Die Entfernte>,< Heimliches Lieben>, <An Die Nachtigall>, <Vom Mitleiden Mariæ>, <Epistel>. Werner Krenn (tenor) with Gerald Moore (piano). ℗1968

Remark & Rating
ED2, 1G-1G

Label **Decca SXL 6348***
London CS 6574

Dvorak: [Concert Overtures], <In Nature's Realm Op.91>, <Carnival Op.92>, <Othello Op.93>, <Scherzo Capricioso Op.66>, London Symphony Orchestra-Istvan Kertesz. ℗1968

Remark & Rating
ED2, 4W-2W, rare! $
Penguin ★★★

Label **Decca SXL 6349**
London OS 26067

[Marilyn Horne Sings Bach And Handel], Marilyn Horne (soprano) with The Vienna Cantata Orchestra-Henry Lewis. ℗1968 by Christopher Raeburn ©1969

Remark & Rating
ED2, 2G-2G, $

Label **Decca SXL 6350**
No London CS

Bizet: <Symphony in C Major>, L'Arlesienne Suites, Orchestra de la Suisse Romande, Gibson. ℗1968

Remark & Rating
ED2, 2W-2W, $+

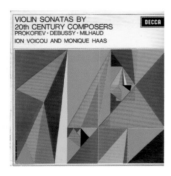

Label **Decca SXL 6351**
No London CS

[Violin Sonatas by 20th Century Composers], Prokofiev: <Sonata No. 2 in D, Op. 94>; Milhaud: <Sonata No. 2>; Debussy: <Sonata in G Minor>, Ion Voicou (violin) and Monique Haas (piano). ℗1968

Remark & Rating
ED2, 1W-1W, rare! $$

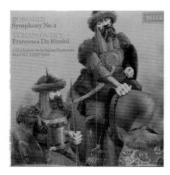

Label **Decca SXL 6352**
London CS 6578

Borodin: <Symphony No.2 in B Minor>; Tchaikovsky: <Francesca Da Rimini, Op.32 (Frantasia after Dante)>, L'Orchestra de la Suisse Romande-Silvio Varviso. ℗1968

Remark & Rating
ED2, 2W-1W, $

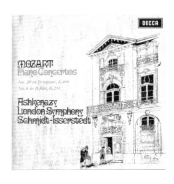

Label **Decca SXL 6353**
London CS 6579

Mozart: Piano Concertos <No. 6 in B Flat, K.238> & <No. 20 in D Minor, K.466>, Vladimir Ashkenazy (piano), The London Symphony Orchestra-Hans Schmidt-Issersetedt. ℗1968

Remark & Rating
ED2, 1W-1W
Penguin ★★(★)

Label **Decca SXL 6354**
London CS 6580

Mozart: <Piano Concerto No.23 in A Major, K.488 >, <Piano Concerto No.24 in C Minor, K.491>, Clifford Curzon (piano), The London Symphony Orchestra-Istvan Kertesz. ℗1968

Remark & Rating
ED2, 1W-1W, $
Penguin ★★(★)

Label **Decca SXL 6355***
London CS 6581, (ED2)

Albeniz: <Suite Espanol>, New Philharmonia Orchestra-Rafael Frühbeck de Burgos. Recorded by Alan Reeve & Kenneth Wilkinson, November 1967 in the Kingsway Hall, London. ℗1968 ©1969

Remark & Rating
ED3, 1G-1G (1st), rare! $$+
TAS2016, Penguin ★★★, AS-DG list, (K. Wilkinson)

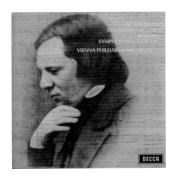
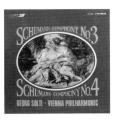

Label **Decca SXL 6356 (D190D 3)**
London CS 6582, (ED2) (CSA 2310)

Schumann: <Symphony No.3 "Rhenish" in E flat Major, Op.97>, <Symphony No.4 in D Minor, Op.120>, The Vienna Philharmonic Orchestra-Georg Solti. ℗1968 (*Complete 4 Symphnies=SXL 6356, 6486, 6487, also in the Box Set London CSA 2310 & late issue Decca D190D 3)

Remark & Rating
ED2, 1W-1W, $
Penguin ★★★, AS list-H (D190D 3)

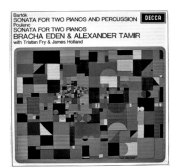

Label **Decca SXL 6357**
London CS 6583, (ED2)

Bartok: <Sonata for Two Pianos & Percussion>; Poulenc: <Sonata for Two Pianos>, Bracha Eden & Alexander Tamir (pianos) ℗1968

Remark & Rating
ED2, 1W-1W, $

Label **Decca SXL 6358**
London CS 6584, (ED2)

Beethoven: Piano Sonatas <Sonata No.9 in Emajor, Op.14 no.1>, <Sonata No.11 in B Flat Major, Op.22>, <Sonata No.20 in G Major, Op.49 no.2>, Wilhelm Bachhaus (piano). Ⓟ1968

Remark & Rating
ED2, 1G-2G, $$

Label **Decca SXL 6359**
London CS 6585, (ED2)

Beethoven: Piano Sonatas <Sonata No.2 in A Major, Op.2 no.2>, <Sonata No.10 in G Major, Op.14 no.2>, <Sonata No.19 in G Minor, Op.49 no.1>, Wilhelm Bachhaus (piano). Ⓟ1968

Remark & Rating
ED2, 1G-1G, $$

Label **Decca SXL 6360**
London CS 6586, (ED2) (London CSA 2247)

Handel: [Overtures & Sinfonias, Vol. I], English Chamber Orchestra-Richard Bonynge. Ⓟ1968

Remark & Rating
ED2, 1G-1G, $

Label **Decca SXL 6361**
London OS 26075

[Richard Strauss Lieder], Felicia Weathers with Georg Fischer (piano). Ⓟ1968

Remark & Rating
ED2, 1G-1G

Label **Decca SXL 6362**
No London CS

[Decca Stereo Sampler Album 1968], Ⓟ ©1968

Remark & Rating
ED2, 1W-1W, $

Label Decca SXL 6363 [*Last ED1"Original WBG" Label in this series]
London CS 6587, (ED2)

Mendelssohn: <Symphony No.3, "Scottish", Op.56>, <Symphony No.4 in A Major, "Italian", Op.90>, The London Symphony Orchestra-Claudio Abbado. Recorded by Kenneth Wilkinson, 6 - 8 February 1968 in Kingsway Hall, London. ℗1968 *[Last ED1"Original WBG" Label in this series]

Remark & Rating
ED1, 1G-1G, rare! $$ (ED2, 1G-1G, $)
Penguin ★★★ (K. Wilkinson)

Label Decca SXL 6364
London CS 6591, (ED2)

Sibelius: <Symphony No.3, Op.52>,<Symphony No.6, Op.104>, The Vienna Philharmonic Orchestra-Lorin Maazel. ℗1968

Remark & Rating
ED2, 1G-1G, $
Penguin ★(★★)

Label Decca SXL 6365
London CS 6592, (ED2 ?, ED3, 1G-1G)

Sibelius: <Symphony No. 4 in A Minor, Op. 63>, <Tapiola>, The Vienna Philharmonic Orchestra-Lorin Maazel. ℗1968

Remark & Rating
ED2, 1G-1G, $
Penguin ★★★

Label Decca SXL 6366
No London CS (=STS 15170)

Mozart: "Serenades Volume 2", <Divertimento No.1 in E Flat, K.113>,<Divertimento No.2 in D major, K.131>, Vienna Mozart Ensemble-Willi Boskovsky. ℗1968

Remark & Rating
ED2, 1W-1W, rare! $
Penguin ★★★

Label Decca SXL 6367
London CS 6593, (ED2)

Richard Strauss: <Don Quixote, Op.35>, Emanuel Brabec (cello), Josef Staar (viola), The Vienna Philharmonic Orchestra-Lorin Maazel. ℗1968

Remark & Rating
ED2, 1W-1W, $
Penguin ★★(★)

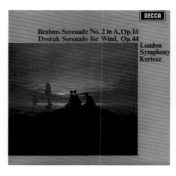

Label Decca SXL 6368
London CS 6594, (ED2 ?, ED3, 1W-1W)

Brahms: <Serenade No. 2 in A, Op.16>*, Dvorak: <Serenade for Wind, Op.44>**, London Symphony Orchestra-Istan Kertesz. Recorded by Kenneth Wilkinson in Kingsway Hall, London. ℗1968 [* Penguin ★★(★); ** Penguin ★★★]

Remark & Rating
ED2, 1W-1W, rare! $
Penguin ★★(★)& ★★★, (K. Wilkinson)

Label Decca SXL 6369
London CS 6595 & 6596 (in CSA 2309)

Handel: <12 Grand Concertos (Concerti Grossi) No.1-No.4, Op.6>, Thurston Dart (Harpsichord), Andrew Davis (Organ), Academy of St Martins in the Fields-Neville Marriner. ℗1968 [=London CS 6595 & 6596 (in CSA 2309)]

Remark & Rating
ED2, 2G-2G
Penguin ★★★

Label Decca SXL 6370
London CS 6597 (in CSA 2309)

Handel: <12 Grand Concertos (Concerti Grossi) No.5-No.8, Op.6>, Thurston Dart (Harpsichord), Andrew Davis (Organ), Academy of St Martins in the Fields-Neville Marriner. ℗1968 [=London CS 6597 (in CSA 2309)]

Remark & Rating
ED2, 2G-2G
Penguin ★★★

Label Decca SXL 6371
London CS 6596 & 6595 (in CSA 2309)

Handel: <12 Grand Concertos (Concerti Grossi) No.9-No.12, Op.6>, Thurston Dart (Harpsichord), Andrew Davis (Organ), Academy of St Martins in the Fields-Neville Marriner. ℗1968 [London CS 6596 & 6595 (in CSA 2309)]

Remark & Rating
ED2, 2G-2G
Penguin ★★★

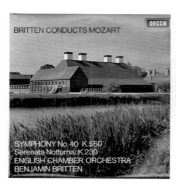

Label Decca SXL 6372
London CS 6598, (ED3, 1st)

Mozart: <Symphony No.40 in G Minor, K.550>, <Serenade No.6, K.239>, Engliash Chamber Orchestra-Benjamin Britten. ℗1968

Remark & Rating
ED3, (1st), 1W-1W, $
Penguin ★★(★)

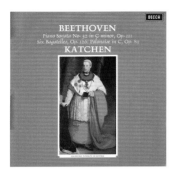

Label **Decca SXL 6373**
London CS 6599, (ED3, 1st)

Beethoven: <Piano Sonata No.32 in C Minor, Op.111>, <6 Bagatelles, Op.126>, <Polonaise in C Major, Op.89>, Julius Katchen (piano). ℗1968

Remark & Rating
ED3, (1st), 1W-1W, $

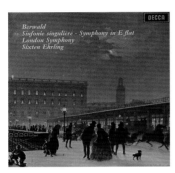

Label **Decca SXL 6374**
London CS 6602, (ED3, 1st)

Berwald: <Symphony No.3 in C Major, (Singuliere)>, <Symphony No.1 in E Flat>, London Symphony Orchestra-Sixten Ehrling. Recorded in Kingsway Hall. London, May 1968, in collaboration of the Royal Library, Stockholm. ℗1968

Remark & Rating
ED3, (1st), 1W-1W, $
Penguin ★★★

Label **Decca SXL 6375**
London CS 6603, (ED3, 1st)

Vivaldi: <Bassoon Concerto in A Minor>; Weber: <Bassoon Concerto in F Major>; Hummel: <Trumpet Concerto in E Flat>; Leopold Mozart: <Trumpet Concerto in D Major>, Henri Helaerts (bassoon) & Michel Cuvit (trumpet), L'Orchestre de la Suisse Romande-Ernest Ansermet. Recorded by Kenneth Wilkinson at Victoria Hall, Geneva. ℗1968 ©1969

Remark & Rating
ED3, (1st), 1W-3W, $
(K. Wilkinson)

Label **Decca SXL 6376** [*Last ED2 "WBG" Label in this series]
London OS 26081

[Gwyneth Jones - Scenes from Verdi], from Aida; Don Carlos; Macbeth; Otello, Gwyneth Jones with The Orchestra of the Royal Opera House, Covent Garden conducted by Edward Downes. ℗1968 ©1969

Remark & Rating
ED2, 1R-2R, $

Label **Decca SXL 6377**
London OS 26087

[Luciano Pavarotti - Aries by Verdi and Donizetti], Vienna Opera Orchestra-Edward Downes. ℗1968 ©1969

Remark & Rating
ED3, (1st), 1G-1G, $
Penguin ★★★

Label **Decca SXL 6378**
London CS 6604, (ED3, 1st)

Messiaen: <Le Merle Bleu>, <Regard de l'Esprit de Joie>, <Regard du silence>, Liszt: <St. Francois de Paule marchant sur les flots>, <Piano Piece No. 2 in A Flat>, <Nuages gris>, <La lugubre gondola No. 1>, <Wilde Jagd>, Jean-Rodolphe Kars (piano). ℗1968 ©1969

Remark & Rating
ED3, (1st), 1W-3W, $

Label **Decca SXL 6379**
London CS 6609, (ED3, 1st)

Richard Strauss: <Also Sprach Zarathustra, Op.30>, Los Angeles Philharmonic Orchestra-Zubin Mehta. ℗1968 ©1969

Remark & Rating
ED3, (1st), 2G-1G, $
TAS-OLD

Label **Decca SXL 6380**
London CS 6606, (ED3, 1st) (CSA 2224)

Tchaikovsky: <Symphony No.5 in E Minor, Op.64>, The Israel Philharmonic Orchestra-Zubin Mehta. ℗1968 ©1969

Remark & Rating
ED3, (1st), 2W-3W, $

Label **Decca SXL 6381**
London CS 6607, (ED3, 1st) (CSA 2224)

Dvorak: <Symphony No.7 in D Minor>, The Israel Philharmonic Orchestra-Zubin Mehta. ℗1968 ©1969

Remark & Rating
ED3, (1st), 2W-2W, $

Label Decca SXL 6382 (©=JB 101)
 London CS 6608, (ED3, 1st)

Richard Strauss: <Ein Heldenleben>, David Frisina (Solo Violin), The Los Angeles Philharmonic Orchestra-Zubin Mehta. ℗1968 ©1969

Remark & Rating
ED3, (1st), 2G-2G
Penguin ★★★, TAS 30-141+

Label Decca SXL 6383 (©=JB 47)
 London CS 6605, (ED3, 1st)

[Overtures Of Old Vienna], Overtures from Johann Strauss: <Die Fledermaus>, <Prinz Methusalem>; Otto Nicolai: <Die Lustigen Weiber Von Windsor>; Nikolaus von Reznicek: <Donna Diana>; Richard Heuberger: <Der Opernball>. The Vienna Philharmonic Orchestra-Willi Boskovsky. ℗1968 by Christopher Raeburn ©1969

Remark & Rating
ED3, (1st), 2G-1G
Penguin ★★★

Label Decca SXL 6384
 No London CS

[Madrigals by Thomas Weelkes], The Wilbye Consort directed by Peter Pears. ℗1968 ©1969

Remark & Rating
ED3, 1K-1K
Penguin ★★★

Label Decca SXL 6385
 No London CS

Haydn: <Harpsichord Concerto & Overture in D Major>, J.C.Bach: <Harpsichord Concerto in A Major>; George Malcom (harpsichord), Academy of St. Martins in the Fields-Neville Marriner. ℗1968 ©1969

Remark & Rating
ED3, 1G-1G
Penguin ★★★

Label Decca SXL 6386
 London OS 26106

Brahms: <"Rinaldo"- Cantata for Tenor, Male Chorus and Orchestra, Op.50>, <"Schicksalslied (Song of Destiny)"- for Chorus and Orchestra, Op.54>, James King (tenor), Ambrosian Chorus & New Philharmonia Orchestra-Claudio Abbado. ℗ ©1969

Remark & Rating
ED3, 2G-2G

Label **Decca SXL 6387 (©=SDD 540)**
London CS 6611, (ED3, 1st)

Brahms: <Piano Trio No.1 in B Major, Op.8>, <Piano No.3 in C Minor, Op.101>, Julius Katchen (piano); Josef Suk (violin); Janos Starker (cello). ℗ ©1969

Remark & Rating
ED3, 1W-1W, rare! $$
Penguin ★★★, (K. Wilkinson)

Label **Decca SXL 6388**
London CS 6613 (ED3 ?, ED4, 1W-1W)

Copland: <Lincoln Portrait> for the Speaker and Orchestra, Gregory Peck (Narrator); Kraft: <Concerto for Four Percussion Soloists and Orchestra>, William Kraft (Timpani & Percussion), <Contextures: Riots-Decade '60>, The Los Angeles Philharmonic Orchestra-Zubin Mehta. ℗ ©1969

Remark & Rating
ED3, 1W-1W, rare! $$
Penguin ★★★

Label **Decca SXL 6389**
London CS 6614, (ED3, 1st)

Brahms:<Hungarian Dances Nos.1-10>; Dvorak:<Slavonic Dances, Op.46>, Bracha Eden and Alexander Tamir (Piano Four-Hands). ℗ ©1969

Remark & Rating
ED3, 1W-2W, $

Label **Decca SXL 6390**
London CS 6612, (ED3, 1st) (©=London 414 440-1)

Schoenberg: <Chamber Symphony No.1, Op.9>, <Variations Op.31>, Los Angeles Philharmonic-Zubin Mehta. ℗ ©1969

Remark & Rating
ED3, 1W-1W, $
Penguin ★★★, TAS2017, AS-DG List (London 414 440-1)

Label **Decca SXL 6391**
London OS 26099

Britten: <Songs & Proverbs of William Blake, Op.74>, <Holy Sonnets of John Donne, Op.35>, Peter Pears (tenor), Dietrich Fischer-Dieskau (baritone), Benjamin Britten (piano). Recorded by Kenneth Wilkinson. (Insert included) ℗ ©1969

Remark & Rating
ED3, 3G-4G, $
Penguin ★★★, (K. Wilkinson)

Label **Decca SXL 6392 (©=ECS 790, part)**
 London OS 26098

J.S. Bach: <Cantatas No.67, No.101, No.130>, Ameling, Watts, Krenn, Krause, Lausanne Pro Arte Chorus & Orchestra de la Suisse Romande-Ernest Ansermet. ℗1969

Remark & Rating
ED3, 1G-1G

Label **Decca SXL 6393**
 London CS 6617, (ED3, 1st)

Britten: <The Suites for Cello Op.72 & Op.80>, Mstislav Rostropovich (cello). ℗1969 ©1970

Remark & Rating
ED3, 3W-1W, rare! $$
Penguin ★★★

Label **Decca SXL 6394**
 London CS 6616, (ED3, 1st)

Honegger: <Symphony No.3 "Liturgique" (1945-46)>, <Symphony No.4 "Deliciae Basilienses" (1946)>, (Ansermet Memorial Album - His Last Recordings), L'Orchestre de la Suisse Romande-Ernest Ansermet. ℗1969

Remark & Rating
ED3, 1W-1W, rare! $$

Label **Decca SXL 6395**
 London CS 6615, (ED3, 1st)

Lalo: <Scherzo For Orchestra (1884)>, Magnard: <Symphony No.3, Op.11 (1902)>, (Ansermet Memorial Album - His Last Recordings), L'Orchestre de la Suisse Romande-Ernest Ansermet. ℗1969

Remark & Rating
ED3, 1W-2W, $

Label **Decca SXL 6396**
 London CS 6619, (ED3, 1st)

Beethoven: <Symphony No.5 in C Minor "Fate", Op.67> & <Symphony No.8 in F Major, Op.93>, The Vienna Philharmonic Orchestra-Hans Schmidt-Isserstedt. ℗1969

Remark & Rating
ED3, 3W-3W
Penguin ★★★, Japan 300-CD

Label Decca SXL 6397
 London CS 6621, (ED3, 1st)

J.S.Bach: <Sinfonia Concertante in C for flute, oboe, violin & cello>, <Sinfonia in E flat>; Salieri: <Sinfonia in D>, <Concertto in C for flute & oboe>, English Chamber Orchestra-Richard Bonynge. ℗1969

Remark & Rating
ED3, 4W-2W

Label Decca SXL 6398*
 London CS 6620, (ED3, 1st)

Janacek: <Sinfonietta (1926)>, Hindemith: <Symphonic Metamorphoses on Themes of Weber (1945)>, London Symphony Orchestra-Cludio Abbado. ℗1969

Remark & Rating
ED3, 1W-1W
Penguin ★★★, AS List (Speakers Corner)

Label Decca SXL 6399
 London CS 6622, (ED3, 1st)

Rachmaninov: <Symphony No.3 in D Minor, Op.30>; Mussorgsky: <Night on the Bare Mountain>, Orchestre de la Suisse Romande-Paul Kletzki. ℗1969

Remark & Rating
ED3, 1W-1W, $
Penguin ★★★

Label Decca SXL 6400
 London OS 26103

J.S.Bach: <Magnificat in D Major>, <Cantata No.10>, Elly Ameling (soprano); Hanneke Van Bork (soprano); Helen Watts (contralto); Werner Krenn (tenor); Tom Krause (bass) & Marius Rintzler (bass), Vienna Academy Choir, The Stuttgart Chamber Orchestra-Karl Münchinger. ℗1969

Remark & Rating
ED3, 1G-1G
Penguin ★★★

Label Decca SXL 6401
 London CS 6624, (ED3, 1st)

Respighi:<Pines of Rome>, <The Birds>, <Fountains of Rome>, London Symphony Orchestra-Istvan Kertesz. ℗1969

Remark & Rating
ED3, 1W-1W, $
Penguin ★★★

Label **Decca SXL 6402**
London CS 6625, (ED3, 1st)

Mozart: <Symphony No.31 in D, K.297 "Paris">, <No.32 in D, K.385 "Haffner">, <No.35 in G, K.318>, Klassische Philharmonie Stuttgart-Karl Münchinger. ℗1969

Remark & Rating
ED3,1W-1W, rare! $

Label **Decca SXL 6403**
London CS 6626, (ED3, 1st)

Stravinsky: <The Rite of Spring>,<Five Easy Pieces>, <Three Easy Pieces>, Bracha Eden & Alexander Tamir (piano-four hands). ℗1969 ©1970

Remark & Rating
ED3, 3W-1W, rare! $$

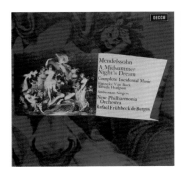

Label **Decca SXL 6404**
London OS 26107

Mendelssohn: <A Midsummer Night's Dream>, New Philharmonia Orchestra-Rafael Frübeck de Burgos. ℗1969 by Christopher Raeburn

Remark & Rating
ED3, 4G-3G, $
Penguin★★(★)

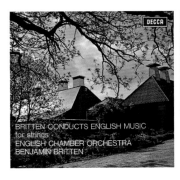

Label **Decca SXL 6405**
London CS 6618, (ED3, 1st)

[Britten Conducts English Music For Strings], Britten: <Simple Symphony>; Elgar: <Introduction and Allegro for strings, Op.47>; other works from Purcell, Delius & Bridge, English Chamber Orchestra-Bejamin Britten. ℗1969

Remark & Rating
ED3, 1W-1W, $
Penguin ★★★, AS list (JUBILEE 410 171)

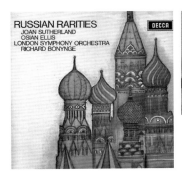

Label **Decca SXL 6406**
London OS 26110

[Russian Rarities], Gliere: <Concerto for Coloratura and Orchestra Op.82>, <Concerto for Harp and Orchestra, Op.74> & Songs by Stravinsky, Cui, Gretchaninov, Joan Sutherland (soprano), Osian Ellis, (harp), London Symphony Orchestra-Richard Bonynge. ℗1969

Remark & Rating
ED3, 1G-1G
Penguin ★★(★), AS List

Label **Decca SXL 6407**
London CS 6627, (ED3, 1st)

Burgmüller: <La Peri - Romantic Ballet in two acts>, London Symphony Orchestra-Richard Bonynge. ℗1969

Remark & Rating
ED3, 1W-1W

Label **Decca SXL 6408**
London CS 6628, [ED3, 1st, last ED3 from CS series]

Franck: <Violin Sonata in A Major>; Brahms: <Trio for Violin, Horn & Piano in E Flat Major, op.40>, Itzhak Perlman (violin); Barry Tuckwell (horn) & Vladimir Ashkenazy (piano). ℗1969

Remark & Rating
ED3, 1W-1W, $
Penguin ★★★

Label **Decca SXL 6409**
London OS 26111

Mozart: <Complete Masonic Funeral Music>, Werner Krenn (tenor), Tom Krause (bass), Edinburgh Festival Chorus & London Symphony Orchestra-Istvan Kertesz. ℗1969

Remark & Rating
ED3, 1G-1G, $
Penguin ★★★

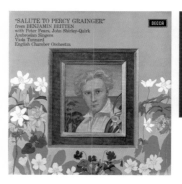

Label **Decca SXL 6410**
London CS 6632, (ED4, 1st)

[Salute to Percy Grainger], from Benjamin Britten with Peter Pears, John Shirley-Quirk, Viola Tunnard (piano), The Ambrosian Singers (John McCarthy-chorus master) & The English Chamber Orchestra-Benjamin Britten. (Insert included) ℗1969

Remark & Rating
ED3, 1G-1G
Penguin ★★★

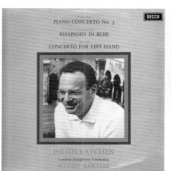
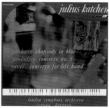

Label **Decca SXL 6411 (©=SDD 486)**
London CS 6633, (ED4)

Prokoviev: <Piano Concerto No.3>; Ravel: <Piano Concerto For Left Hand>; Gershwin: <Rhapsody In Blue>* , Julius Katchen (piano), London Symphony Orchestra-Istvan Kertesz. Recorded by Kenneth Wilkinson in Kingsway Hall, London. ℗1969 ©1970 [*Gershwin is Penguin ★★(★)]

Remark & Rating
ED3, 2W-2W, $
Penguin ★★★ &★★(★)(K. Wilkinson)

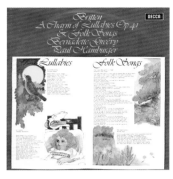

Label **Decca SXL 6413**
No London CS (=London STS 15166)

Britten: <A charm of lullabies, Op.41>; <10 Folk-Song Arrangements>, Bernadette Greevy (vocalist) ; Paul Hamburger (piano). ℗1969 ©1970

Remark & Rating
ED3, 2G-2G

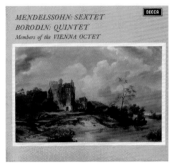

Label **Decca SXL 6414 (©=SDD 410)**
London CS 6636, ED4, 1st)

Mendelssohn:<Piano Sextet in D Major>, Borodin: <Piano Quintet in C Minor>, Members of the Vienna Octet-Walter Panhoffer (Piano), Anton Fietz (Violin), Gunther Breitenbach (Viola), Wilhelm Hubner (Viola), Ferenc Mihaly (Cello), Burghard Krautler (Double-Bass). ℗1969

Remark & Rating
ED3, 1W-2W
Penguin ★★★

Label **Decca SXL 6415**
London CS 6637, (ED4, 1st)

[A Piano Recital by Ivan Davis - The Art of the Piano Virtuoso], works from Liszt, Chopin, Moszkowski, Schumann, Liapounov, Rimsky-Korsakov. ℗1969

Remark & Rating
ED3, 1L-1L, $

Label **Decca SXL 6416**
London CS 6638, (ED4, 1st)

Beethoven: Piano Sonatas <Sonata No.3 in C Major, Op.2 no.3>, <Sonata No.13 in E Flat Major, Op.27 no.1>, <Sonata No.24 in F Sharp Major, Op.78, "A Therese">, Wilhelm Bachhaus (piano). ℗1969 ©1970

Remark & Rating
ED3, 1W-1W, rare!! $$+

Label **Decca SXL 6417**
London CS 6639, (ED4, 1st)

Beethoven: Piano Sonatas <Sonata No.16 in G Major, Op.31 no.1>, <Sonata No.22 in F Major, Op.54>, <Sonata No.27 in E Minor, Op.90>, Wilhelm Bachhaus (piano). ℗1969 ©1970

Remark & Rating
ED3, 1W-1W, rare!! $$+

Label Decca SXL 6418
No London CS

Gottfried von Einem: <Philadelphia Symphony>, The Vienna Philharmonic Orchestra-Zubin Mehta; Schubert: <Symphony No.8, D.759 "Unfinished">, The Vienna Philharmonic Orchestra-Josef Krips. ℗1969 ©1970

Remark & Rating
ED3, 1W-2L

Label Decca SXL 6419
London CS 6641, (ED4, 1st)

[Vienna Imperial - New Year Concert 1970], The Vienna Philharmonic Orchestra-Willi Boskovsky. ©1970

Remark & Rating
ED3, 1W-1W
Penguin ★★★

Label Decca SXL 6420
No London CS (=STS 15171)

Mozart: "Serenades Volume 3", <Serenade No.3 in D Major, K.185>, <Eine kleine Nachtmusik, K.525>, Vienna Mozart Ensemble-Willi Boskovsky. ℗1969 by Christopher Raeburn ©1970

Remark & Rating
ED3, 2G-1G, $
Penguin ★★★

 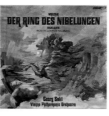

Label Decca SXL 6421
London OSA 1440 (highlights)

Wagner: <The Golden Ring, Highlights>, The Vienna Philharmonic Orchestra & Vienna State Opera Chorus-Georg Solti. Produced by John Culshaw. ℗1969

Remark & Rating
ED3, 4W-3W
Penguin ★★★, AS list-H & AS list-F

Label Decca SXL 6422
London CS 6643, (ED4, 1st)

[French Opera Overtures], Auber: <Marco Spada>; Adam: <Giralda>, <La Poupee de Nuremberg>; Lecocq: <La Fille de Madame Angot>; Thomas: <Mignon>; Planquette: <Les Cloches de Corneville>; Auver: <Lestocq>; Boieldeu: <La Calife de bagdad>, The New Philharmonia Orchestra-Richard Bonyngy. ℗1969 ©1970

Remark & Rating
ED3, 3W-3W, $

Label **Decca SXL 6423 (©=SDD 442)**
 London CS 6644, (ED4, 1st)

Beethoven: <String Quartet No.12 in E-Flat, Op.127>; Haydn: <String Quartet No.83 in B-Flat, Op.103>, The Weller Quartet. Recorded in Sofiensaal, Vienna, 1968 October. ℗1969 ©1970

Remark & Rating
ED3, 3W-2W, rare! $$

Label **Decca SXL 6424**
 No London CS (=STS 15167)

[Hilde Gueden Sings Children's Songs From Many Lands], Hilde Gueden (soprano), Vienna Volksoper Orchestra-George Fischer. Recorded by James Brown. ℗1969 by Christopher Raeburn ©1970 (=London Treasury Series STS 15167)

Remark & Rating
ED3, 2G-1G, Very rare!! $$

Label **Decca SXL 6426**
 London CS 6649, (ED4, 1st)

Schubert: <Sonata in A Minor "Arpeggione" , D.821>; Frank Bridge: <Sonata for Cello and Piano>, Mstislav Rostropovich (cello) and Benjamin Britten (piano). ℗1969

Remark & Rating
ED3, 1W-3W, Very rare !!! $$$$$
Penguin ★★(★), Japan 300

Label **Decca SXL 6427**
 No London CS

Schubert: <Symphony No.9 in C major, D.944>, Stuttgart Chamber Orchestra-KarlMünchinger. ℗1969 ©1970

Remark & Rating
ED3, 3W-3W, $
Penguin ★★(★)

Label **Decca SXL 6428**
 London OS 26141

[Songs by Tchaikovsky and Britten], Britten: <The Poet's Echo (Pushkin)>; Tchaikovsky: <6 Songs>, Galina Vishnevskaya (soprano) and Mistislav Rostropovich (piano). ℗1969 ©1970

Remark & Rating
ED3, 3W-3W, Rare! $

Label **Decca SXL 6429**
 No London CS

[Mario Del Monaco Sings Verdi], National Orchestra of Monte Carlo Opera-Nicola Rescigno. ℗1969 ©1970

Remark & Rating
ED3, 6G-1G, $

Label **Decca SXL 6430**
 No London CS

[Baroque Flute Sonatas]: Loeillet, Gaultier, Handel, Telemann, Vinci and Blavet. Andre Pepin (flute), Raymond Leppard (harpsichord), Claude Viala (cello). ℗1969 ©1970

Remark & Rating
ED3, 1W-1W

Label **Decca SXL 6431**
 No London CS

Sibelius: <Symphony No. 4 in A Minor, Op. 633>; Sallinen:< Mauermusik>, The Finnish Radio Symphony Orchestra-Paavo Berglund. ℗1969 ©1970

Remark & Rating
ED3, 2S-1G, $+
Penguin ★★(★)

Label **Decca SXL 6432**
 No London CS

Kokkonen: <Symphony No.3>; Sibelius: <Tapiola>, The Finnish Radio Symphony Orchestra-Paavo Berglund. ℗ ©1969

Remark & Rating
ED3, 1G-1G, $+
Penguin ★★(★)

Label **Decca SXL 6433**
 No London CS

Sibelius: <Symphony No.5 in E Flat, Op.82>; Rautavaarar:<Requiem In Our Time (For Wind)>, Helsinki Philharmonic Orchestra-Jorma Panula. ℗1969 ©1970

Remark & Rating
ED2, 1G-1G, $+

Label Decca SXL 6434
 No London CS

Sibelius: <Lemminkainen>, <Maid of Saari>, <Finlandia>; Bergman: <Aubade Op.48>, Helsinki Philharmonic Orchestra-Jorma Panula. ℗1969 ©1970

Remark & Rating
ED3, 1G-5G, $

Label Decca SXL 6435
 London CS 6657, (ED4, 1st)

Delius: <Piano Concerto in C Minor>; Debussy: <Fantaisie for Piano and Orchestra>, Jean-Rodolphe Kars (piano), London Symphony Orchestra-Alexander Gibson. Recorded May 1969 in Kingsway Hall, London. ℗ ©1970

Remark & Rating
ED4, (1st), 3W-2W
Penguin ★★★

Label Decca SXL 6436
 London CS 6656, (ED4, 1st)

Beethoven: Dances & Romances - <Twelve Contretänze>, <Romance in F Major for Violin and Orchestra>, <Nos. 2, 3 and 8 from "Twelve German Dances">, <Romance in G Major for Violin and Orchestra>, <Eleven Vienna Dances>, The Vienna Mozart Ensemble-Willi Boskovsky. ℗1969 ©1970

Remark & Rating
ED3, rare! $+, (ED4 2W-2W)

Label Decca SXL 6437
 London CS 6658, (ED4, 1st)

Beethoven: <Symphony No.1 in C Major, Op. 21>, <Symphony No.2 in D Major, Op.36>, The Vienna Philharmonic Orchestra-Hans Schmidt-Issersetedt. ℗1969 ©1970

Remark & Rating
ED3, 1G-2G, $
Penguin ★★(★)

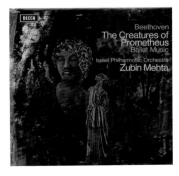

Label Decca SXL 6438
 London CS 6660, (ED4, 1st)

Beethoven: <Creatures Of Prometheus>, The Israel Philharmonic Orchestra-Zubin Mehta. ℗1969 ©1970

Remark & Rating
ED3, 1W-1W
Penguin ★★(★), AS List-H

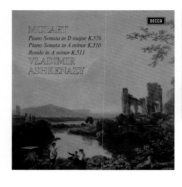

Label Decca SXL 6439
 London CS 6659, (ED4, 1st)

Mozart: <Piano Sonata in D Major, K.576>, <Sonata in A Minor, K.310>, <Rondo in A Minor, K.511>, Vladimir Ashkenazy (piano). ℗1970

Remark & Rating
ED3, 1W-1W, $
Penguin ★★★

Label Decca SXL 6440
 London CS 6661, (ED4, 1st)

Bloch: <Schelomo - Hebraic Rhapsody for Violoncello Solo & Full Orchestra>, <Voice in the Wilderness - Symphonic Poem for Orchestra with Violoncello Obbligato>, Janos Starker (cello), The Israel Philharmonic Orchestra-Zubin Mehta. ℗1969 ©1970

Remark & Rating
ED3, 2W-1C, (2W-2W), Very rare!! $$
AS List

Label Decca SXL 6441
 No London CS

Giovanni Gabrieli: <Sonatas and Canzonas>, Brian Runnett (harpsichord), Stuttgart Chamber Orchestra-Karl Münchinger. ℗1969 ©1970

Remark & Rating
ED3, 1W-1W, $+

Label Decca SXL 6442
 London CS 6663, (ED4, 1st)

Richard Strauss: <Sinfonia Domestica, Op.53>, Los Angeles Philharmonic Orchestra-Zubin Mehta. Recorded in Royce Hall, University of California, LA. ℗1969 ©1970

Remark & Rating
ED4, 1st, 1W-1W

Label Decca SXL 6443
 London OS 26146

[Great Scenes from Verdi], Nicolai Ghiaurov (bass), Ambrosian Singers & London Symphony Orchestra-Claudio Abbado. (Insert included) ℗1969 ©1970

Remark & Rating
ED4, 1st, 1G-1G
Penguin ★★★

Label **Decca SXL 6444**
London CS 6664, (ED4, 1st)

Stravinsky: <Rite of Spring (Sacre du Printemps)>, <Eight Instrumental Miniatures for 15 Players>, Los Angeles Philharmonic Orchestra-Zubin Mehta. ℗1969 ©1970

Remark & Rating
ED4, 1st, 1W-1W, $
Penguin ★★(★), AS list-H

Label **Decca SXL 6445**
London CS 6665, (ED4, 1st)

Hindemith: <Mathis Der Mahler>; Lutoslawski: <Concerto for Orchestra), L'Orchestra de la Suisse Romande-Paul Kletzki. ℗1969 ©1970

Remark & Rating
ED4, 1G-2G
TAS2017, TAS Top 100 20th Century Classic, Penguin ★★(★)

Label **Decca SXL 6446**
London OS 26147

Mahler: <Kindertotenlieder>; Wagner: <Wesendonk-Lieder>, Marilyn Horne (soprano), Royal Philarmonic Orchestra-Henry Lewis. ℗1969 by Christopher Raeburn ©1970

Remark & Rating
ED4, 1G-2G

Label **Decca SXL 6447**
London CS 6668, (ED4, 1st)

Beethoven: <Symphony No.7 in A Major, Op.92>, <Overture Leonora No.3, Op.72a>, The Vienna Philharmonic Orchestra-Hans Schmidt Isserstedt. ℗1970 ©1970

Remark & Rating
ED4, 1st, 4W-2W
Penguin ★★(★)

Label **Decca SXL 6448** [*Last ED3 label in SXL Series]
London CS 6670, (ED4, 1st)

Tchaikovsky: <Overture Solennelle 1812, Op.49>, <Fantasy Overture 'Romeo and Juliet'>, Los Angeles Philharmonic Orchestra-Zubin Mehta. ℗1970 ©1970

Remark & Rating
ED3, 1W-1W, $
Penguin ★★★, AS list-H

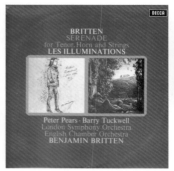
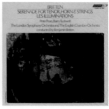

Label **Decca SXL 6449**
 London OS 26161

Britten: <Serenade, Op.31, (For tenor, horn & string)>, <Illuminations, Op.18, (For tenor & string)>, Peter Pears (tenor), Barry Tuckwell (horn), The London Symphony Orchestra & English Chamber Orchestra-Benjamin Britten. Recorded by Kenneth Wilkinson. ℗1967 ©1970

Remark & Rating
ED4, 1st, 4W-2R
Penguin ★★★, AS List-H, (K. Wilkinson)

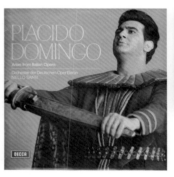

Label **Decca SXL 6450**
 London CS 6671, (ED4, 1st)

Britten: <Young Person's Guide to the Orchestra>, <Variation on a theme of Frank Bridge>* , London Symphony Orchestra & * English Chamber Orchestra-Benjamin Britten. Recorded by Kenneth Wilkinson. ℗1967 ©1967

Remark & Rating
ED4, 1st, $
Penguin ★★★, Japan 300, (K. Wilkinson)

Label **Decca SXL 6451**
 London OS 26080

[Placido Domingo - Arias from Italian Opera], Arias from Fedora, Aida, Lucia di Lammermoor, Il Trovatore, I Pagliacci, Turandot etc. Placido Domingo with Orchester der Deutschen Oper Berlin-Nello Santi. ℗1968 ©1970

Remark & Rating
ED4, 2G-2G

Label **Decca SXL 6452-61 (=SXLA 6452)**
 London CSP 2

Beethoven: <The Complete 32 Piano Sonatas>, Wilhelm Backhaus (piano). Includes all his stereo recordings from 1958-1969, (10 LP-Box complete with 24 pages booklet, ©1970). [(London CS 6161=Decca SXL 2241), (London CS 6246=Decca SWL 8500, No SXL issue), (CS 6247=SWL 8018, No SXL issue), (CS 6365=SXL 6063), (CS 6366=SXL 6064), (CS 6389=SXL 6097), (CS 6535=SXL 6300), (CS 6584=SXL 6358), (CS 6585=SXL 6359), (CS 6638=SXL 6416), (CS 6639=SXL 6417).] **There is no UK Decca SXL or USA London CS issue for <Sonata No.8, Op.13, "Pathetique" & No.14, Op.27, "Moonlight">, only issued in Decca 10 LP (SWL 8016) or Decca Australian issue (SXLA 7506), and <Sonata No.29, Op.106 "Hammerklavier"> only issued in Decca LXT 2777, 1950's mono recording. ©1969

Remark & Rating
ED4, (10 LP SET, all 1W-1W), $$$$

Label **Decca SXL 6462**
 London CS 6672, (ED4, 1st)

Kreutzer: <Grand Septet in E Flat Major, Op.62>; Berwald: <"Stor" Septet in B Flat Major>, Members Of The Vienna Octet - Alfred Boskovsky (clarinet); Wolfgang Tombӧck (horn); Ernst Pamperl (bassoon); Anton Fietz (violin); Gunther Breitenbach (viola); Ferenc Mihaly (cello); Burghard Kräutler (double-Bass). ℗ ©1970

Remark & Rating
ED4, 1st, 2W-2W

Label **Decca SXL 6463 (©=SDD 423)**
 London CS 6673, (ED4, 1st)

Dvorak: <Quintet in G Major, Op.77>; Spohr: <Quintet in C Minor for Piano & Winds, Op.52>, Menbers of the Vienna Octet. ℗ ©1970

Remark & Rating
ED4, 2W-1W, rare! $
Penguin ★★★

Label **Decca SXL 6464 (©=SDD 419)**
 London CS 6674, (ED4, 1st)

Beethoven: <Quintet in C Major>, <Sextet in E Flat Major>, Members Of The Vienna Octet - Anton Fietz (violin); Wilhelm Hübner (violin); Gunther Breitenbach (viola); Philipp Matheis (viola); Ferenc Mihaly (cello); Wolfgang Tombӧck (horn); Volker Altmann (horn). ℗ ©1970

Remark & Rating
ED4, 1W-2W, rare!

Label **Decca SXL 6465***
 London CS 6675, (ED4, 1st)

Beethoven:<Egmont, Complete incidental music>, Pilar Lorengar and Klausjuergen Wussow with The Vienna Philharmonic Orchestra-Georg Szell. ℗ ©1970

Remark & Rating
ED4, 2W-2W
Penguin ★★(★)

Label **Decca SXL 6466**
 London CS 6676, (ED4, 1st)

Grieg: <Sonata in E Minor Op.7>, <Nocturne Op.54, No.4>; Mendelssohn: <Capriccio Op.33, No.1>, <Variations Serieuses Op.54>, Alicia de Larrocha (piano). ℗1970

Remark & Rating
ED4, 1W-1W

Label　Decca SXL 6467
　　　　London CS 6677, (ED4, 1st)

[Alicia de Larrocha Plays Spanish Piano Music of the 20th
Century], works from Halffter, Surinach, Nin-Culmell, Mompou
& Montsalvatge. Alicia de Larrocha (piano). ℗1970

Remark & Rating
ED4, 2W-2W

Label　Decca SXL 6468
　　　　No London CS

[Welsh Music for String], Gareth Walters: <Divertimento>; William Mathias:
<Divertimento Op.7>, <Prelude, Aria & Finale Op.25>; Grace Williams: <Sea
Sketches>, English Chamber Orchestra-David Atherton. ℗ ©1970

Remark & Rating
ED4,1W-1W, rare!

Label　Decca SXL 6469
　　　　London CS 6679, (ED4, 1st)

Prokofiev: <Symphony No.1 in D Major, Op.25 "Classical">,
<Symphony No.3 in C Minor, Op.44>, The London Symphony
Orchestra-Claudio Abbado. ℗ ©1970

Remark & Rating
ED4, 2W-2W
TAS2017, Penguin★★(★), AS list-H

Label　Decca SXL 6470-5 (SXLB 6470)
　　　　London CSP 1

Beethoven: [The 9 Symphonies], The Vienna Philharmonic
Orchestra-Hans Schmidt-Issersetedt. @1970

Remark & Rating
ED4, (6 LP SET), $+

Label　Decca SXL 6476-80 (SXLC 6476 ©=Decca
　　　　D8D 6)
　　　　London TCH S-1

Tchaikovsky: [Complete Symphony Nos.1- 6], The Vienna
Philharmonic Orchestra-Lorin Maazel. ℗1970 ***(SXL 6159
+ 6162 + 6163 + 6157 + 6058 + 6164 = CS 6426 + 6427 +
6428 + 6429 + 6376 + 6409)

Remark & Rating
ED4, (5 LP SET), $$
Penguin ★★(★)

Label **Decca SXL 6481 (©=SDD 441)**
 No London CS

Schubert: <Quintet in C Major, Op.163>, <Quartettsatz in C Minor, Op.posth.>,The Weller Quartet, Walter Weller (violin I); Alfred Starr (violin II); Helmut Weiss (viola); Robert Scheiwein (cello I); Dietfried Gurtler (cello II). ℗ ©1970

Remark & Rating
ED4, 1W-1W, $

Label **Decca SXL 6482**
 London CS 6680

Saint-Saëns: <Symphonie No.3 in C Minor Op.78>, Anita Priest (organ), Los Angeles Philharmonic-Zubin Mehta. Recorded in Royce Hall, U.C.L.A. ℗ ©1971

Remark & Rating
ED4, 2K-4K
Penguin ★★★, AS list-H & AS list-F

Label **Decca SXL 6483 (SXLJ 6644; D105D 5)**
 London CS 6682

Schubert: <Symphony No.4 in C Minor, "Tragic", D.417>, <Symphony No.5 in B Flat, D.485>, The Vienna Philharmonic Orchestra-Istvan Kertesz. ℗1970 ©1971

Remark & Rating
ED4, 4W-2W
Penguin ★★(★), Gramophone

Label **Decca SXL 6484**
 London CS 6694

[Bracha Eden & Alexander Tamir Two Piano Encores], works from Rachmaninov, Khachaturian, Weinberger, Poulenc, Schubert, Brahms, Arensky & Schumann. ℗1970 ©1971

Remark & Rating
ED4, 2W-2W

Label **Decca SXL 6485**
London CS 6693

[A Liszt Recital], <Sonata in B minor>, <Etudes d'execution transcendance No.4>, <Mazeppa>, <Annees de pelerinage>, <Premiere Annee "Suisse" No.6>, <Liebestraum No.3>, Pascal Roge (piano). ℗ ©1970

Remark & Rating
ED4, 1W-2W
Penguin ★★★

Label **Decca SXL 6486 (D190D 3)**
London CS 6696 (CSA 2310)

Schumann: <Symphony No.1 in B Flat Major, Op.38 "Spring">, <Overture, Scherzo & Finale Op.52>, The Vienna Philharmonic Orchestra-Georg Solti. ℗1970 ©1970 (*4 Symphnies=SXL 6356, 6486, 6487 in the Box Set London CSA 2310 & late issue Decca D190D 3)

Remark & Rating
ED4, 1W-1W
Penguin ★★(★), AS list-H (D190D 3)

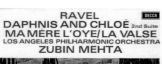

Label **Decca SXL 6487 (D190D 3)**
London CS 6697 (CSA 2310)

Schumann: <Symphony No.2 in C Major, Op.61>, <Overture "Julius Caesar" Op.128>, The Vienna Philharmonic Orchestra-Georg Solti. ℗1970 ©1970 ***(The London CS 6697 is in the Box Set CSA 2310, The 4 Symphies isuued from Decca are SXL 6356, 6486 & 6487 & the late issue is Decca D190D 3)

Remark & Rating
ED4, 2W-2W
Penguin★★★, AS list-H (D190D 3)

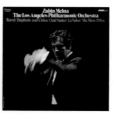

Label **Decca SXL 6488**
London CS 6698

Ravel: <Daphnis and Chloe, 2nd Suite>, <Ma Mere L'Oye>, <La Valse>, Los Angeles Philharmonic-Zubin Mehta. Recorded in Royce Hall, U.C.L.A. ℗1970 by Christopher Raeburn ©1971

Remark & Rating
ED4, 2W-3W

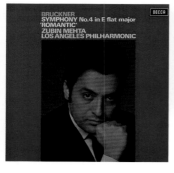

Label **Decca SXL 6489**
London CS 6695

Bruckner: <Symphony No.4 in E Flat Major "Romantic">, Los Angeles Philharmonic Orchestra-Zubin Mehta. ℗1970

Remark & Rating
ED4, 6W-3W

Label **Decca SXL 6490**
London OS 26182

[Haydn & Mozart Discoveries], "Haydn and Mozart Arias", Dietrich Fischer-Dieskau (baritone) with The Vienna Haydn Orchestra conducted by Reinhard Peters. Sleeve notes: Christopher Raeburn ℗1970 ©1971

Remark & Rating
ED4, 1G-1G
Penguin ★★★

Label **Decca SXL 6491**
London CS 6699

Carl Nielsen: <Symphony No.5>, L'Orchestre de la Suisse Romande-Paul Kletzki. ℗1970 ©1971

Remark & Rating
ED4,1W-1W
Penguin ★★(★)

Label **Decca SXL 6493**
London CS 6710

Sibelius: <Violin Concerto in D Minor, Op.47>; Tchaikovsky: <Violin Concerto in D Major>, Kyung-Wha Chung (violin) with The London Symphony Orchestra-Andre Previn. ℗ ©1970

Remark & Rating
ED4, 2W-2W, $
Penguin ★★★, AS list-F

Label **Decca SXL 6494**
London CS 6706

Bruckner: <Symphony No.1 in C Minor>, The Vienna Philharmonic Orchestra-Claudio Abbado. ©1971

Remark & Rating
ED4,1W-1W
Penguin ★★★

Label **Decca SXL 6495**
London CS 6707

[Happy New Year], The Vienna Philharmonic Orchestra-Willi Boskovsky. ℗ ©1970

Remark & Rating
ED4, 1W-1W
Penguin ★★★

Label **Decca SXL 6496**
London CS 6711 (London CSA 2247)

Handel: [Overtures & Sinfonias, Vol. II], Leader: Emanuel Hurwitz; Valda Aveling & Brian Runnett (harpsichord), English Chamber Orchestra-Richard Bonynge. Recorded by Kenneth Wilkinson. ℗ ©1970

Remark & Rating
ED4, 1W-2W
(K. Wilkinson)

Label **Decca SXL 6497**
London OS 26186

Kodaly: <Psalmus Hungaricus, Op.13>*, Lajos Kozma with the Brighton Festival Chorus & Wandsworth School Boys' Choir; [Peacock Variations] - <The Peacock (Folksong for unaccompanied male chorus> & <Variation on a Hungarian Folk Song (The Peacock)>, London Symphony Orchestra & Chorus-Istvan Kertesz. Recorded by Kenneth Wilkinson & Colin Moorfoot, June 1970 in Kingsway Hall, London. ℗1970 by Christopher Raeburn (*AS list, part of JB 122)

Remark & Rating
ED4, 4W-3W
Penguin ★★★, AS list (JB 122), (K. Wilkinson)

Label **Decca SXL 6498**
London OS 26192

[Luciano Pavarotti Sings Tenor Arias from Italian Opera], Vienna Opera Orchestra & Chorus conducted by Nicola Rescigno; New Philharmonia Orchestra conducted by Leone Magiera. ℗ ©1971

Remark & Rating
ED4, 2G-1G

Label **Decca SXL 6499**
No London CS (=STS 15301)

Mozart: "Serenades Volume 4", <Serenade No.1 in Dmajor, K.100>, <A Music Joke (Ein Musikalischer Spass), K.522>, Viener Mozart Ensemble-Willi Boskovsky. ℗ ©1971

Remark & Rating
ED4, 1W-1W
Penguin ★★★

Label **Decca SXL 6500**
No London CS (=STS 15302)

Mozart: "Serenades Volume 5", <Divertimento in G Major, K.63>, <Cassation No.2 in B flat Major, K.99>, Vienna Mozart Ensemble-Willi Boskovsky. ℗ ©1971

Remark & Rating
ED4, 1W-2W
Penguin ★★★

Label **Decca SXL 6501**
London OS 26199

[Arias From Forgotten Operas], Huguette Tourangeau (mezzo-soprano) with L'Orchestra de la Suisse Romande-Richard Bonynge. Ⓟ ©1971

Remark & Rating
ED4, 1G-1G

Label **Decca SXL 6502**
London CS 6714

[A Schubert Recital], <Fantasia "The Wanderer" in C Major, Op.15>, <Impromptu D.946 in E flat minor, No.1 & in E flat, No.2>, Jean-Rodolphe Kars (piano). Ⓟ ©1971

Remark & Rating
ED4, 3W-2W, rare!

Label **Decca SXL 6503**
London CS 6715

Beethoven: <Piano Concerto No.3, Op.37>, <32 Variations on an original theme for solo piano in C Minor>, Radu Lupu (piano), The London Symphony Orchestra-Lawrence Foster. Ⓟ1971

Remark & Rating
ED4, 2W-2W

Label **Decca SXL 6504**
London CS 6716

Schubert: <Piano Sonata No.14 in A Minor, Op.143, D.789>; Brahms: <Rhapsody No.1, Op.79>, <3 Intermezzi, Op.117>, Radu Lupu (piano). Ⓟ1971

Remark & Rating
ED4, 1W-2W
Penguin ★★(★)

Label **Decca SXL 6505**
London CS 6717

Bruckner: <Symphony No.3 in D Minor (Leopold Nowak, 1889 edition)>, The Vienna Philharmonic Orchestra-Karl Böhm. Ⓟ1971

Remark & Rating
ED4, 4W-6W
Penguin ★★(★), Japan 300-CD

Label **Decca SXL 6506**
London OS 26216

[Schubert & Schumann Lieder], 18 Lieders, <9 from Schubert's Lieder>; <9 from Schumann's Heine Lieder>, Werner Krenn (tenor), Erik Werba (piano). (Text insert included) ℗1971 by Christopher Raeburn

Remark & Rating
ED4, 1G-1G

Label **Decca SXL 6507**
London CS 6718

Janacek: <Taras Bulba>, <Lachian Dances>, The London PhilharmonicOrchestra-Francois Huybrechts. ℗ ©1971

Remark & Rating
ED4, 1D-1D
Penguin ★★(★), AS List-H

Label **Decca SXL 6508**
London CS 6719

[Ashkenazy Plays Liszt], <From the Douze Etudes D'Execution Transcendante Nos 1, 2, 3, 5, 8, 10, 11>, <Gortschakoff-Impromptu>, <Mephisto Waltz>, Vladimir Ashkenazy (piano). ℗ ©1971

Remark & Rating
ED4, 2W-1D
Penguin ★★(★)

Label **Decca SXL 6510**
London CS 6721

Dvorak: <Symphonic Variations, Op.78>, <The Golden Spinning-Wheel, Op.109>, The London Symphony Orchestra-Istvan Kertesz. ℗ ©1971

Remark & Rating
ED4, 1G-1G
Penguin ★★★

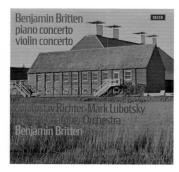
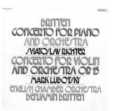

Label **Decca SXL 6512**
London CS 6723

Britten: <Concerto for Violin and Orchestra> & <Concerto for Piano and Orchestra>, Mark Lubotsky (violin) & Sviatoslav Richter (piano), English Chamber Orchestra-Benjamin Britten. Recorded by Kenneth Wilkinson. ℗1971

Remark & Rating
ED4, 1W-1W
Penguin ★★★, AS List-H, (K. Wilkinson)

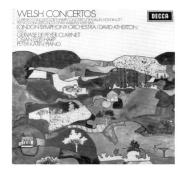

Label **Decca SXL 6513**
No London CS

[Three Welsh Concertos], Alun Hoddinott: <Harp Concerto, Op.11>, Osian Ellis (harp), <Clarinet Concerto, Op.3>, Gervase De Peyer (clarinet); William Mathias: <Piano Concerto, No.3, Op.40>, Peter Katin (piano) with London Symphony Orchestra conducted by David Atherton. ℗1971 ©1972

Remark & Rating
ED4, 1W-1W, rare!!, $
Penguin ★★★, AS List

Label **Decca SXL 6514**
No London CS

[Manfred Jungwirth sings German Lieder], Music by Schubert, Schumann, Brahms, Wolf, R. Strauss. Manfred Jungwirth (bass) with Friedrich Brenn (piano). (4 pages text & translation insert) ℗ 1971 ©1972

Remark & Rating
ED4, 1G-2G, rare! $

Label **Decca SXL 6515-21 (SXLD 6515 ©=Decca D6D 7)**
London DVO S-1

Dvorak: [The Complete Nine Symphonies], London Symphony Orchestra-Istvan Kertesz. Recorded by Kenneth Wilkinson. ©1971 (7LPs Box set with booklet), =SXL 6044, 6115, 6253, 6257, 6273, 6288, 6289, 6290, 6291

Remark & Rating
ED4, (7 LP SET), $$
Penguin ★★★(⚘), AS List-H (D6D 7), (K. Wilkinson)

Label **Decca SXL 6522**
London OS 26240

[A Lieder Recital], Robert Schumann: <Lieder, Op.35 (nos. 1-12>; Yrjo Kilpinen: <Lieder and Tunturilauluja>, Martti Talvela (bass), Irwin Gage (piano). ℗1971 ©1972

Remark & Rating
ED4, 1G-2G, $

Label **Decca SXL 6523**
London CS 6727

Beethoven: <Eroica Variations in E Flat, Op.35 (Eroica Theme & Fugue)>; Schubert: <Moments Musicaux, Op.94>, Clifford Curzon (piano). ℗1971

Remark & Rating
ED4, 1W-1W
Penguin ★★★

Label **Decca SXL 6524**
London OS 26241

[Renata Tebaldi - Christmas Festival], The New Philharmonia Orchestra & The Ambrosian Singers conducted by Anton Guadagno. ℗ ©1971

Remark & Rating
ED4, 2G-2L

Label **Decca SXL 6525**
London OS 26246

[Pilar Lorengar - Prima Donna In Vienna], Music by Mozart, Beethoven, Weber, Wagner, Korngold, R.Strauss, J.Strauss, Zeller, Kalman. Pilar Lorengar (soprano), Vienna State Opera Orchestra-Walter Weller. ℗1971 ©1972

Remark & Rating
ED4, 1W-1W

Label **Decca SXL 6526**
London CS 6731

[Welcome the New Year], The Vienna Philharmonic Orchestra-Willi Boskovsky. ℗1971

Remark & Rating
ED4, 2W-3W
Penguin ★★★

Label **Decca SXL 6527**
London CS 6732

Scriabin: <Prometheus-The Poem of Fire>, <Piano Concerto in F sharp minor>, Vladimir Ashkenazy (piano), London Philharmonic Orchestra-Lorin Maazel. Recorded by Kenneth Wilkinson & Stanley Goodall. ℗1971 by Christopher Raeburn ©1972

Remark & Rating
Penguin ★★★, (K. Wilkinson)

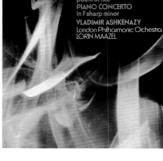
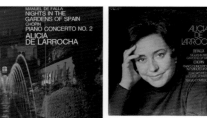

Label **Decca SXL 6528**
London CS 6733

De Falla: <Nights in the Gardens of Spain>; Chopin: <Piano Concerto No.2, Op.21>, Alice De Larrocha (piano), L'Orchestre de la Suisse Romande-Sergiu Comissiona. ℗1971 ©1972

Remark & Rating
ED4, 2W-3W
Penguin ★★★

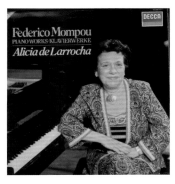

Label Decca 410 287-1
London 410 287-1

Federico Mompou: Piano Works <Impresiones intimas>, <Preludio VII a Alicia de Larrocha>, <Musica callada IV>, <Cancons I dansas>, Alicia de Larrocha (piano). Recorded by Simon Eadon, July 1983 in the Walthamstow Town Hall, London. @1984 (* Another Penguin ★★★(❀)recording from Alica De Larrocha is Decca-London 410 289-1)

Remark & Rating
Another Penguin ★★★(❀) from Larrocha
Penguin ★★★(❀)

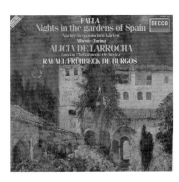

Label Decca 410 289-1
London 410 289-1

De Falla: <Nights in the Gardens of Spain>; Albeniz: <Turina>, Alice De Larrocha (piano), London Philharmonic Orchestra-Rafael Frühbeck De Burgos. Recorded by Stan Goodal, July 1983 in the Walthamstow Town Hall, London. @1984 (* Another Penguin ★★★(❀)recording from Alica De Larrocha)

Remark & Rating
Another Penguin ★★★(❀) from Larrocha
Penguin ★★★(❀)

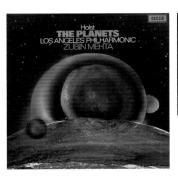

Label Decca SXL 6529*
London CS 6734

Holst: <The Planets, Op.32>, Los Angeles Philharmonic Orchestra conducted by Zubin Mehta and Los Angeles Master Chorale by Roger Wagner. ℗1971 ** In the HP's Best of the Bunch List, also in the TAS list: Top 100- 20th Century Classical Music Recordings.

Remark & Rating
ED4, 2W-4W, $
TASEC * *, TAS Top 100 20th Century Classic,
Penguin ★★(★) , AS List-H

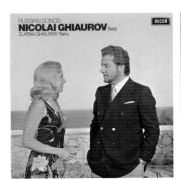

Label Decca SXL 6530
London OS 26249

[Russian Songs], Songs from Tchaikovsky; Borodin; Glinka; Rubinstein & Dargomizhsky. Nicolai Ghiaurov (bass), Zlatina Ghiaurov (piano). (Insert included) ℗1971 by Christopher Raeburn ©1972

Remark & Rating
ED4, 1G-1G

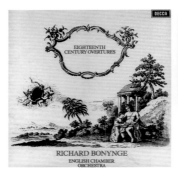

Label **Decca SXL 6531**
London CS 6735

[18th Century Overtures], English Chamber Orchestra-Richard Bonynge. ℗1971

Remark & Rating
ED4, 1G-1G

Label **Decca SXL 6532**
London CS 6736

Prokofiev: <Violin Concerto No.1 in D>; Glazunov: <Violin Concerto in A Minor>, Josef Sivo (violin), L'Orchestra de la Suisse Romande-Horst Stein. ℗1971

Remark & Rating
ED4, 1W-1W, $

Label **Decca SXL 6533**
London CS 6737

Josef Suk: <Serenade for Strings, Op.6>; Hugo Wolf: <Italian Serenade>; Richard Strauss: <Introduction for String Sextet from Capriccio, Op. 85>, Stuttgart Chamber Orchestra-Karl Münchinger. ℗1972

Remark & Rating
ED4, 2W-1W

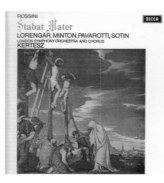

Label **Decca SXL 6534**
London OS 26250

Rossini: <Stabat Mater>, Pilar Lorengar, Luciano Pavarotti, Yvonne Minton, Hans Sotin, London Symphony Orchestra-Istvan Kertesz. ℗1971 ©1972

Remark & Rating
ED4, 3G-4L
Penguin ★★★(❀)

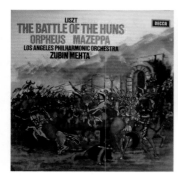

Label **Decca SXL 6535**
London CS 6738

Liszt: <Battle Of Huns, Symphonic Poem No. 11>, <Orpheus, Symphonic Poem No. 4>, <Mazeppa, Symphonic Poem No. 6>, Los Angeles Philharmonic-Zubin Mehta ℗1972

Remark & Rating
ED4, 4W-2W
Penguin ★★★

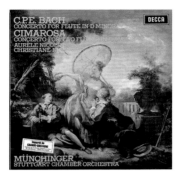

Label **Decca SXL 6536**
London CS 6739

C.P.E. Bach: <Concerto for Flute in D Minor>; Domenico Cimarosa: <Concertos for 2 Flutes in G Major>, Aurele & Christiane Nicolet (Flute), Stuttgart Chamber Orchestra-Karl Münchinger. @1972

Remark & Rating
ED4, 1W-2W

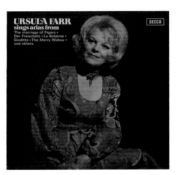

Label **Decca SXL 6537**
No London CS

[Ursula Farr sings Operatic & Operetta Arias, Volume I], Arias from The Marriage of Figaro, Der Freischutz, La Boheme, Giuditta, The Merry Widow and others. Ursula Farr (soprano), Vienna Volksoper Orchestra-Franz Bauer-Theussel. @1972 (Volume II is SXL 6598)

Remark & Rating
ED4, 1G-2G, Very rare!! $

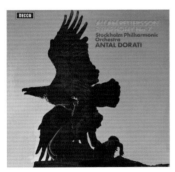

Label **Decca SXL 6538**
London CS 6740

Pettersson: <Symphony No.7>, Stockholm Philharmonic Orchestra-Antal Dorati. @1972

Remark & Rating
ED4, 1W-1W
Penguin ★★★

Label **Decca SXL 6539**
London CS 6741

Mozart: <Symphony No.38, K.504 "Prague">; Schubert: <Symphony No.8, "Unfinished">, English Chamber Orchestra-Benjamin Britten. @1972

Remark & Rating
ED4, 2W-2W
Penguin ★★★

Label **Decca SXL 6540 (SET 465-7)**
London OS 26254 (OSA 1396)

Handel: <Messiah Highlights>, Joan Sutherland (soprano), Huguette Tourangeau (contralto), Werner Krenn (tenor), Tom Krause (bass), Ambrosian Singers & English Chamber Orchestra-Richard Bonynge. @1972

Remark & Rating
Penguin ★★(★)

Label **Decca SXL 6541**
London CS 6744

[Ballet Music And Entr'Actes From French Operas], London Symphony Orchestra-Richard Bonynge. Recorded by James Lock. ℗1972 ©1973

Remark & Rating
ED4, 1G-1G

Label **Decca SXL 6542**
London CS 6745

Sibelius: <Finlandia Op.26, No.7>, <Night-Ride And Sunrise, Op.55>, <Pohjola's Daughter, Op.49>, <En Saga, Op.9>, L'Orchestre de la Suisse Romande-Horst Stein. @1972

Remark & Rating
ED4, 1W-2W
Penguin ★★★

Label **Decca SXL 6543**
London CS 6746

Dvorak: Symphonic Poems <Water Goblin, Op.107>, <The Noonday Witch, Op.108>, Overtures - <My Home, Op.62>, <The Hussite, Op.67>, The London Symphony Orchestra-Istvan Kertesz. ℗ ©1972

Remark & Rating
ED4, 7G-2G
Penguin ★★★

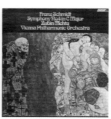

Label **Decca SXL 6544**
London CS 6747

Franz Schmidt: <Symphony No.4 in C Major>, The Vienna Philharmonic Orchestra-Zubin Mehta. @1972

Remark & Rating
ED4, 2Y-6Y
Penguin ★★★

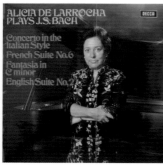
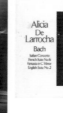

Label **Decca SXL 6545**
London CS 6748

J.S. Bach: <Concerto in the Italian Style, BWV 971>, <French Suite No.6, BWV 817>, <Fantasia in C Minor, BWV 906>, <English Suite No.2, BWV 807>, Alicia de Larrocha (piano). Recorded by Colin Moorfoot. @1972

Remark & Rating
ED4, 1W-1W

Label **Decca SXL 6546**
London CS 6749

Schumann: <Allegro Op. 8>, <Romance Op. 28 no.2>, <Novelette Op. 21 no.8>, <Kreislerriana Op.16>, Alicia de Larrocha (piano). @1972

Remark & Rating
ED4, 2W-1W
Penguin ★★(★)

Label **Decca SXL 6547**
London CS 6750

[Romantic Cello Concertos], Auber: <Cello Concerto No. 1 in A Minor>; Popper: <Cello Concerto in E Minor>; Massenet: <Fantasy for Cello and Orchestra>, Jascha Silberstein (cello), L'Orchestre De La Suisse Romande-Richard Bonynge. Recorded by James Lock. @1972

Remark & Rating
ED4, 4W-3W, rare! $

Label **Decca SXL 6548**
London OS 26262

[Presenting Maria Chiara], Soprano Arias from Italian Operas: Donizetti; Bellini; Boito; Puccini; Mascagni. Maria Chiara (soprano), Vienna Volksoper Orcheatra-Nello Santi. @1972

Remark & Rating
ED4, 1G-3G
Penguin ★★★(❀)

Label **Decca SXL 6549**
No London CS

Beethoven: <Symphony No.8 in F Major, Op.93>, concucted by Cladio Abbado; Schubert: <Symphony No.8 in B Minor "The Unfinished">, conducted by Josef Krips, With The Vienna Philharmonic Orchestra. @1972

Remark & Rating
ED4, 1W-4W
Penguin ★★(★)

Label **Decca SXL 6550***
London CS 6752

Varese: <Arcana>, <Integrales>, <Ionisation>, Los Angeles Percussion Ensemble-William Kraft (director), Los Angeles Philharmonic-Zubin Mehta. @1972

Remark & Rating
ED4, 1W-1W
TAS2017, Penguin ★★★, AS-DIV list

Label **Decca SXL 6551**
London CS 6754

[French Music For Two Pianos], Poulenc: <Concerto in D Minor>; Debussy: <Prelude a L'Apres-Midi d'un Faune>, <Petite Suite>; Satie: <Trois Morceaux en Forme de Poire >, Bracha Eden & Alexander Tamir. @1972

Remark & Rating
ED4, 2W-2W

Label **Decca SXL 6552 (SXLJ 6644; D105D 5)**
London CS 6772

Schubert: <Symphony No.1 in D Major, D.82>, <Symphony No.2 in B-Flat, D.125>, The Vienna Philharmonic Orchestra-Istvan Kertesz. @1972

Remark & Rating
ED4, 1W-1W
Penguin ★★(★)

Label **Decca SXL 6553 (SXLJ 6644; D105D 5)**
London CS 6773

Schubert: <Symphony No.3 in D Major, D.200>, <Symphony No.6 in C Major, D.589>, The Vienna Philharmonic Orchestra-Istvan Kertesz. ℗ by Christopher Raeburn @1972

Remark & Rating
ED4, 2W-2W
Penguin ★★(★)

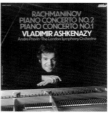

Label **Decca SXL 6554**
London CS 6774

Rachmaninov: <Piano Concerto No.1 in F Sharp Minor, Op.1>, <Piano Concerto No.2 in C Minor>, Vladimir Ashkenazy, London Symphony Orchestra-Andre Previn. Recorded by Kenneth Wilkinson in Kingsway Hall, London. @1972

Remark & Rating
ED4, 9W-9W
Penguin ★★★, Japan 300, (K. Wilkinson)

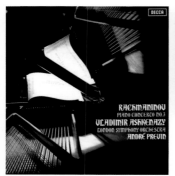
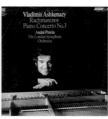

Label **Decca SXL 6555**
London CS 6775

Rachmaninov: <Piano Concerto No.3 in D Minor, Op.30>, Vladimir Ashkenazy, London Symphony Orchestra-Andre Previn. Recorded by Kenneth Wilkinson in Kingsway Hall, London. @1972

Remark & Rating
ED4, 5W-5W
Penguin ★★(★), Gramophone, (K. Wilkinson)

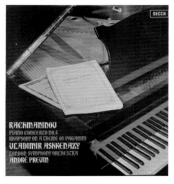

Label **Decca SXL 6556**
 London CS 6776

Rachmaninov: <Piano Concerto No.4 in G Minor, op.40>, <Rhapsody on a Theme of Paganini>, Vladimir Ashkenazy (paino), The London Symphony Orchestra-Andre Previn. Recorded by Kenneth Wilkinson in Kingsway Hall, London. @1972

Remark & Rating
ED4, 9W-5W
Penguin ★★★, Japan 300, (K. Wilkinson)

Label **Decca SXL 6557**
 London CS 6809

Vivaldi: <The Four Seasons>, Konstanty Kulka (violin); Igor Kipnis (harpsichord), Stuttgart Chamber Orchestra-Karl Münchinger. Recorded by Martin Fouque & James Lock at Ludwigsburg, W. Germany. @1973

Remark & Rating
ED4, 1W-1W
Penguin ★★★

Label **Decca SXL 6558-61 (SXLE 6558 ©=Decca D7D 4)**
 London CSP 4

Sibelius: [The Seven Symphonies], The Vienna Philharmonic Orchestra-Lorin Maazel. Recorded from1964-1968. @1972 (=SXL 6084, 6125, 6236, 6364, 6365)

Remark & Rating
ED4, (4 LP SET)

Label **Decca SXL 6562**
 London CS 6786

Tchaikovsky: <Manfred Symphony>, The Vienna Philharmonic Orchestra-Lorin Maazel. @1972

Remark & Rating
ED4, 1W-1W

Label **Decca SXL 6563**
 London CS 6787

Shostakovich: <Symphony No.1 in F Minor>, <Symphony No.9 in E Flat>, L'Orchestre De La Suisse Romande-Walter Weller. Recorded by James Lock at Victoria Hall, Geneva.@1973

Remark & Rating
ED4

Label **Decca SXL 6564**
No London CS

Britten: <String Quartet No.1 in D Major Op.25> & <No.2 in C Major, Op.36>, Allegri String Quartet. Recorded by James Lock. @1972

Remark & Rating
ED4, 1W-1W
Penguin ★★★

Label **Decca SXL 6565-7 (SXLF 6565)**
London CSA 2311

Rachmaninov: [The Four Piano Concertos & Rhapsody on a theme of Paganini], Vladimir Ashkenazy (piano), London Symphony Orchestra-Andre Previn. @1972 (=SXL 6554, 6555, 6556)

Remark & Rating
ED4, (3 LP Set), $
Penguin ★★★, AS list-H

Label **Decca SXL 6568**
London CS 7132

[Hits From The Hollywood Bowl], <Bolero>, <Marche Slave>, <Carmen>, <Forza Del Destino Overture>, <Poet & Peasant Overture>, Los Angeles Philharmonic-Zubin Mehta. ©1978 (**All Selections Have Been Previously Released)

Remark & Rating
ED4, 1W-1W

Label **Decca SXL 6569**
London CS 6789

Elgar: <Symphony No.1, in A-Flat, Op.55>, London Philharmonic Orchestra-Georg Solti. Recorded by Kenneth Wilkinson. @1972

Remark & Rating
ED4, 3W-3W
Penguin ★★★(❀), AS List-H, (K. Wilkinson)

Label **Decca SXL 6570**
No London CS

Alun Hoddinott: <Symphony No.3 , Op.61>, <The Sun The Great Luminary Of The Universe Op.76>, <Sinfonietta No.3, Op.71>, The London Symphony Orchestra-David Atherton. Recorded in 1972 by Colin Moorfoot. ℗1972 ©1973

Remark & Rating
ED4, 1W-1W, $
TAS-OLD, Penguin ★★★, AS list

Label **Decca SXL 6571**
London CS 6790

Berlioz: <Symphonie Fantastique, Op.14>, Chicago Symphony Orchestra-Georg Solti. Recorded by Kenneth Wilkinson in the Great Hall of the Krannert Center, University of Illinois. @1973

Remark & Rating
ED4, 5W-5W, $
Grammy, (K. Wilkinson)

Label **Decca SXL 6572**
London CS 6791

[New Year in Vienna], The Vienna Philharmonic Orchestra-Willi Boskovsky. Recorded by Gordon Parry & Phillip Wade in the Sofiensaal, Vienna. @1972

Remark & Rating
ED4, 4G-3G

Label **Decca SXL 6573**
London CS 6795

Bruch: <Violin Concerto No. 1 in G Minor, Op.26>, <Scottish Fantasia for Violin and Orchestra>, Kyung-Wha Chung (violin) with The Royal Philharmonic Orchestra-Rudolf Kempe. Recorded by James Lock, May 1972 in Kingsway Hall, London. ℗1972

Remark & Rating
ED4, 5W-5W
Penguin ★★★, AS List-H, Japan 300-CD

Label **Decca SXL 6574**
London CS 6793

Tchaikovsky: <Symphony No.4 in F Minor, Op.36>, National Symphony Orchestra, Washington D.C-Antal Dorati. Recorded by Kenneth Wilkinson & Colin Moorfoot at the Constitution Hall, Washington D.C. ℗1972 ©1973

Remark & Rating
ED4, 1W-1W, rare! $
(K. Wilkinson)

Label **Decca SXL 6575**
London CS 6794

[Ashkenazy in Concert], Chopin: <Sonata No.2, Op.35>, <Nocturnes Op.15 No.1 & 2>, <Mazurka Op.59 No.2>, < Grande Valse Op.18>, Vladimir Ashkenazy (piano). Recorded by Tryggvi Triggvason, May 1972 at Essex University. @1972

Remark & Rating
ED4, 3W-3W
Penguin ★★★

Label **Decca SXL 6576**
London CS 6806

Beethoven: <Piano Sonata No.8 in C Minor "Pathetique">, <Piano Sonata No.14 in C Sharp Minor "Moonlight">, <Piano Sonata No. 21 in C Major "Waldstein">, Radu Lupu (piano). ℗1973

Remark & Rating
ED4, 4W-3W

Label **Decca SXL 6577**
London OS 26301

[French & Spanish Songs], Music by Bizet, Debussy, De Falla, Jaoquin Nin, Marilyn Horne (mezzo-soprano) with Martin Katz (piano). Recorded by Kenneth Wilkinson, May 1972 in the Krannert Center, University of Illinois. ℗1973

Remark & Rating
ED4, 1G-1G
(K. Wilkinson)

Label **Decca SXL 6578**
London OS 26302

[Marilyn Horne-German Lieder], Music by Schubert, Schumann, Wolf, R. Strauss, Martin Katz (piano). Recorded by Kenneth Wilkinson, May 1972 in the Krannert Center, University of Illinois. ℗1973

Remark & Rating
ED4, 9G-7G, rare! $
(K. Wilkinson)

Label **Decca SXL 6579**
London OS 26303

[Serenata Tebaldi], An Evening of Italian Songs with Renata Tebaldi & Richard Bonynge (Piano). ℗1973

Remark & Rating
ED4, 3G-3G

Label **Decca SXL 6580 (©=JB 140)**
London CS 6801

Schubert: <Piano Sonata No.21 in B Flat, D.960>, <Impromptu in A Flat, Op.142 No.2, D935/2>, Clifford Curzon (piano). ℗1973

Remark & Rating
ED4, 7W-5W
Penguin ★★★ (✿)

Label Decca SXL 6581 (=Decca 6.41839 AS,
 Germany)
 London CS 6800

[Sir Georg Solti und Das Chicago Symphony Orchestra],
Richard Strauss: <Don Juan>; Wagner: <Die Meistersinger
Overture>; Rossini: <The Barber of Seville Overture>;
Beethoven: <Egmont and Leonore No.3 Overtures>, Chigago
Symphony Orchestra-Georg Solti. @1973

Remark & Rating
ED4, 1W-1W, (K. Wilkinson)

Label Decca SXL 6582
 No London CS

Stravinsky: <The Firebird>, <The Symphony in C>, L'Orchestre de la Suisse
Romande-Uri Segal. Recorded by James Lock in the Victoria Hall, Geneva. @1973

Remark & Rating
ED4, 2W-2W

Label Decca SXL 6583
 London CS 6803

Rachmaninov: <Symphony No.1 in D minor, Op.13>,
L'Orchestra de la Suisse Romande-Walter Weller. @1973

Remark & Rating
ED4, 1W-2W
Penguin ★★(★), AS List

Label Decca SXL 6584
 London OS 26305

[Marilyn Horne sings Rossini], Henry Lewis conducting the
Royal Philharmonic Orchestra and the Ambrosian Opera
Chorus. Recorded by Kenneth Wilkinson, February 1972 in
Kingsway Hall, London. ℗1973 ©1973

Remark & Rating
ED4, 1G-2G
Penguin ★★★(❀), (K. Wilkinson)

Label Decca SXL 6585
 London OS 26315

[Tebaldi and Corelli - Great Opera Duets], Duets from Manon
Lescaut, Adriana Lecouvreur, La Gioconda, Francesca da
Rimini. Renata Tebaldi (soprano) and Franco Corelli (tenor) with
L'Orchestre de la Suisse Romande-Anton Guadagno. @1973

Remark & Rating
ED4, 1G-2G, rare!!

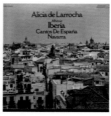

Label **Decca SXL 6586-7**
London CSA 2235

Albeniz: <Iberia>, <Navarra>, <Cantos de Espana, Op.232>, Alicia de Larrocha (piano). (16 pages Booklet) @1973

Remark & Rating
ED4, 4W-3W-6W-3W, $
Penguin ★★★

Label **Decca SXL 6588**
London CS 6812

Offenbach: <Le Papillon, Ballet-Pantomime in 2 Acts & 4 Scenes>, London Symphony Orchestra-Richard Bonynge. Recorded by Kenneth Wilkinson, January 1972 in Kingsway Hall, London. @1973

Remark & Rating
ED4, 1G-1G
TAS-OLD, Penguin ★★★, (K. Wilkinson)

Label **Decca SXL 6589 (©=SDD 541)**
London CS 6814

Brahms: <Piano Trio No. 2 in C Major, Op. 87>, <Sonata No. 2 in F Major for piano and cello, Op. 99>, Julius Katchen (piano); Josef Suk (violin); Janos Starker (violoncello). Recorded by Kenneth Wilkinson, July 1968 at the Maltings, Snape. @1973

Remark & Rating
ED4, 1W-1W
Penguin ★★★, (K. Wilkinson)

Label **Decca SXL 6590**
London OS 26328

Schubert: <Schwanengesang>, Tom Krause (bass-baritone), Irwin Gage (piano). ℗ by Christopher Raeburn @1973

Remark & Rating
ED4, 2G-1G
Penguin ★★(★)

Label **Decca SXL 6592**
London CS 6816

Elgar: <Enigma Variations Op.36>; Ives: <Symphony No.1>, Los Angeles Philharmonic Orchestra-Zubin Mehta. Recorded by Gordon Parry & James Lock, May 1972 in Royce Hall, UCLA. ℗1973

Remark & Rating
ED4, 6K-6W, $$
TASEC, Penguin ★★★

Label **Decca SXL 6594-7 (SXLG 6594)**
 London CSA 2404

Beethoven: [The Five Piano Concertos No.1-5], Vladimir Ashkenazy (piano), Chicago Symphony Orchestra-Georg Solti. ℗1973 (=SXL 6651, 6652, 6653, 6654, 6655)

Remark & Rating
ED4, (4 LP SET)
Penguin ★★★, AS list-F

Label **Decca SXL 6598**
 No London CS

[Ursula Farr Sings Operatic & Operetta Arias, Volume II], Arias from Cosi Fan Tutte, Un Ballo in Maschera, Gianni Schicchi, Martha, Der Zarewitsch and others. Ursula Farr (soprano), Vienna Volksoper Orchestra-Franz Bauer-Theussel. ℗1973 ©1974 (Volume I is SXL 6537)

Remark & Rating
ED4, 1G-1G, rare!!

Label **Decca SXL 6599**
 London CS 6818

Katchaturian: <Piano Concerto in D Flat>* ; Franck: <Symphonic Variations For Piano & Orchestra>** , Alicia de Larrocha (piano), London Philharmonic Orchestra-Rafael Fruhbeck De Burgos. Recorded in Kingsway Hall, 1972 @1973 [* Katchaturian is Penguin ★★★; Franck** is Penguin ★★★]

Remark & Rating
ED4, 1W-1W
Penguin ★★(★), AS List-H

Label **Decca SXL 6600**
 London OS 26338

Janacek: <Glagolitic Mass>, Teresa Kubiak, Anne Collins, Robert Tear, Wolfgang Schöne with Brighton Festival Chorus and Royal Philharmonic Orchestra-Rudolf Kempe. Recorded by Kenneth Wilkinson & James Lock, May 1973 in Kingsway Hall, London. @1973

Remark & Rating
EW1, 2G-3G
Penguin ★★★, (K. Wilkinson)

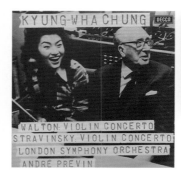

Label Decca SXL 6601
 London CS 6819

Walton: <Concerto for Violin and Orchestra>* ; Stravinsky: <Concerto in D for Violin And Orchestra>, Kyung-Wha Chung (violin) with The London Symphony Orchestra-Andre Previn. Recorded by Colin Moorfoot & Trygg Tryggvason, 1972 in Kingsway Hall, London. ℗ by Christopher Raeburn @1973 [* Walton: Penguin ★★★(✿); Stravinsky: Penguin ★★★]

Remark & Rating
ED4, 2W-1W
Penguin ★★★(✿), AS list-H

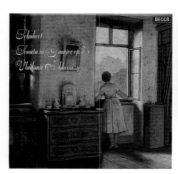
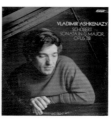

Label Decca SXL 6602
 London CS 6820

Schubert: <Piano Sonata No.18 in G, D.894>, Vladimir Ashkenazy (piano). Recorded by Colin Moorfoot. @1973

Remark & Rating
ED4, 2W-3W
Penguin ★★★

Label Decca SXL 6603
 London CS 6821

Beethoven: Piano Sonatas <No.23, in F Minor, Op.57 "Appassionata">, <No.7, Op.10, No.3 in D Major>, Vladimir Ashkenazy (piano). Recorded by Kenneth Wilkinson & Colin Moorfoot in the London Opera Centre. @1973 (* No.23 in the CD: 417 732-2, No.7 no CD release)

Remark & Rating
ED4, 1W-2W
Penguin ★★★, (K. Wilkinson)

Label Decca SXL 6604
 London CS 6822

Rachmaninov: <Etudes-Tableaux Op.39>, <Variations on a theme by Corelli, Op.42>, Vladimir Ashkenazy (piano). Recorded by Tryggvi Triggvason @1973

Remark & Rating
ED4, 7W-3W
Penguin ★★★

Label Decca SXL 6605
 No London CS

[Maria Chiara sings Verdi Arias], <I Masnadieri>, <I Vespri Siciliani>, <Otello: Canzone del Salice, Ave Maria (with Rosanne Creffield)>, <Aïda: Ritorna vincitor>, <Giovanna d'Arco>, <Simon Boccanegra>, <La forza del destino>. Maria Chiara (soprano) with Rosanne Creffield (mezzo-soprano); member of the John Alldis Choir and Orchestra of the Royal Opera House, Covent Garden-Nello Santi. Recorded by Kenneth Wilkinson. @1973

Remark & Rating
ED4, 3G-2G
Penguin ★★★, (K. Wilkinson)

Label **Decca SXL 6606**
No London CS

Alun Hoddinott: <Symphony No.5, Op.81> <Concerto For Piano No.2, Op.21, Piano: Martin Jones> <Concerto For Horn Op.65, Horn: Tuckwell>, Royal Philharmonic Orchestra- Andrew David. Recorded by Colin Moorfoot, March 1973 in Kingsway Hall. @1973

Remark & Rating
ED4, 1W-1W, rare!! $$
TAS-OLD, Penguin ★★★, AS List-H

Label **Decca SXL 6607**
No London CS

William Mathias: <Dance Overture, Op.16>, <Ave Rex, A Carol Sequence, Op.45>, <Invocation and Dance, Op.17>, <Harp Concerto, Op.50>, Osian Ellis (harp), Welsh National Opera Chorale & The London Symphony Orchestra-David Atherton. Recorded by Kenneth Wilkinson & Simon Eadon, January - February 1973 in Kingsway Hall, London. @1973

Remark & Rating
ED4, 2G-2G, rare! $$
Penguin ★★★(✿), AS List, (K. Wilkinson)

Label **Decca SXL 6608**
No London CS

Britten: <Journey of the Magi>, <Who are these children>, <Tit for Tat> & Songs by Henry Purcell, Peter Pears, John Shirley-Quirke, James Bowman, Benjamin Britten (piano). Recorded by Kenneth Wilkinson, November 1972 in The Maltings Snape. @1973

Remark & Rating
ED4, 1G-1G
Penguin ★★★, (K. Wilkinson)

Label **Decca SXL 6609**
London OS 26366

[Sherril Milnes - Great Scenes from Italian Opera], from Rossini, Bellini, Donizetti, Verdi, Ponchielli, Puccini. Sherril Milnes (baritone) with The London Philharmonic Orchestra- Silvio Varviso (6 pages Insert). Recorded by Kenneth Wilkinson, February 1972 in Kingsway Hall, London. ℗1973 ©1974

Remark & Rating
ED4, 3G-1G
(K. Wilkinson)

Label **Decca SXL 6610-3 (SXLH 6610)**
No London CS

Brahms: [The Four Symphonies], <*Variations on a Theme by Haydn>, The Vienna Philharmonic Orchestra-Istvan Kertesz. @1973 [=SXL 6172 & 6675-6678] (*Haydn Variation recorded without conductor in tribute to Istvan Kertesz who suddenly died in 1973)

Remark & Rating
ED4, (4 LP SET), $+
Penguin ★★(★)

Label **Decca SXL 6614**
No London CS (=STS 15414)

Mozart: "Serenades Volume 7", <Serenade No.7 in D, K.250, "Haffner">, Vienna Mozart Ensemble-Willi Boskovsky. Recorded by James Lock, March 1972 in the Sofiensaal, Vienna. ℗1973 ©1974

Remark & Rating
ED4, 4W-1W
Penguin ★★★

Label **Decca SXL 6615**
No London CS (=STS 15415)

Mozart: "Serenades Volume 6", <Serenade No.9 in D, K.320, "Posthorn">, Vienna Mozart Ensemble-Willi Boskovsky. Recorded by James Lock, January 1973 in the Sofiensaal, Vienna. @1973

Remark & Rating
ED4, 1W-1W
Penguin ★★★

Label **Decca SXL 6616**
London CS 6830

Mozart: <Symphony No.29 in A Major, K.201>, <No.35 in D Major, "Haffner", K.385>, The Vienna Philharmonic Orchestra-Istvan Kertesz. Recorded by James Lock. @1973

Remark & Rating
ED4, 1W-1W
Penguin ★★, Japan 300-CD

Label **Decca SXL 6617**
London CS 6831

Mozart: <Symphony No.25 in G Minor, K.183/173dB>, <No.40 in G Minor, K.550>, The Vienna Philharmonic Orchestra-Istvan Kertesz. Recorded by James Lock. ℗ by Christopher Raeburn @1973

Remark & Rating
ED4, 1W-1W, $
Penguin ★★(★)

Label **Decca SXL 6618**
No London CS

Rachmaninov: Music For 2 Pianos, <Fantasie Op.5>, <Six Pieces Op.11>, <Prelude in C Sharp Minor>, Bracha Eden & Alexander Tamir (pianos). Recorded by John Dunkerley, March 1973 in Kingsway Hall. @1973

Remark & Rating
ED4, 1W-1W

Label Decca SXL 6619
London OS 26367

[Songs my Mother Taught Me], songs by Dvorak, Mendelssohn, Massenet, Gounod, Delibes, Grieg, Liszt, Amy Worth, etc., Joan Sutherland with The New Philharmonia Orchestra-Richard Bonynge. Recorded by Kenneth Wilkinson & James Lock, August 1972 in Kingsway Hall, London. @1973

Remark & Rating
ED4, 1G-1G
(K. Wilkinson)

Label Decca SXL 6620-2
London CSA 2312

Prokofiev: <Romeo And Juliet, Op.64, Complete Ballet>, Daniel Majeske (solo violin), The Cleveland Orchestra-Lorin Maazel (8 pages Booklet). Recorded by Colin Moorfoot, Gorden Parry & Jack Law, June 1973 in the Masonic Auditorium, Cleveland. @1973

Remark & Rating
ED4, 2W-1W-2W-1W-1W-1W, $+
TASEC, Penguin ★★★, AS list-H, Japan 300

Label Decca SXL 6623
London CS 6839

Rachmaninov: <Symphony No.2 in E minor, Op.27>, London Philharmonic Orchestra-Walter Weller. Recorded May 1973 in Kingsway Hall, London. @1973

Remark & Rating
ED4, 2W-2W
Penguin ★★★

Label Decca SXL 6624
London CS 6840

Grieg: <Piano Concertos in A Minor, Op.16>; Schumann: *<Piano Concertos in A Minor, Op.54>, Radu Lupu (piano),The London Symphony Orchestra-Andre Previn. Recordied by Kenneth Wilkinson, Philip Wade, *John Dunkerley, January & *June 1973 in Kingsway Hall, London. @1973

Remark & Rating
ED4, 3G-2G
TASEC, Penguin ★★(★), (K. Wilkinson)

Label Decca SXL 6625
No London CS

[The Art of Hans Hotter], Schubert & Wolf Songs, Hans Hotter (German opera bass-baritone), Geoffrey Parsons (piano). Recorded by Gordon Parry & Philip Wade, 1973 in the Sofiensaal, Vienna. ℗ 1974 by Christopher Raeburn

Remark & Rating
ED4, 1G-3G

Label Decca SXL 6626 (SET 531-3)
No London CS

J.S. Bach: <St. John Passion, Highlights>, Harper, Howell, Hodgson, Pears, Tear, Shirley-Quirk, Wandsworth School Boys' Choir & English Chamber Orchestra-Benjamin Britten. Recorded by Kenneth Wilkinson & Colin Moorfoot in the Maltings, Snape, 1971. @1974

Remark & Rating
ED4, 1G-2G
Penguin ★★(★), (K. Wilkinson)

Label Decca SXL 6627
London CS 6841

Tchaikovsky: Tone Poems, <Francesca da Rimini - Fantasy after Dante, Op.32>, <Hamlet - Fantasy after Shakespeare, Op.67>, <Voyevode - Symphonic Ballads, Op.78>, National Symphony Orchestra, Washington D.C-Antal Dorati. Recorded by Kenneth Wilkinson & Colin Moorfoot, May 1973 in Constitution Hall, Washington D.C. @1974

Remark & Rating
ED4, 2G-2G
Penguin ★★(★), AS List, (K. Wilkinson)

Label Decca SXL 6628
No London CS

Vivaldi: Concerti for Strings, <In A Major>, <In B Flat Major for 2 Violins>, <In F Major for 3 Violins>, <In G Minor for 2 cellos>, <Sinfornia for String in B Minor & in G Major>, Lucerne Festival Strings-Rudolf Baumgartner. Recorded by Colin Moorfoot, March 1973 in the Sofiensaal, Vienna. ℗ by Christopher Raeburn @1974

Remark & Rating
ED4, 1W-1W
Penguin ★★★

Label Decca SXL 6629
London OS 26376

[Renata Tebaldi - 18th Century Arias], Martini: <Plaisir D'amour>; Sarti: <Lungi Dal Caro Bene>; Bononcini: <Deh Più A Me Non V'ascondete>; Handel: <Verdi Prati>, <Ombra Mai Fù>; Scarlatti: <Le Violette>; Paisiello: <Nel Cor Più Non Mi Sento>, etc., Renata Tebaldi (soprano) with The New Philharmonia Orchestra-Richard Bonynge. Recorded by Kenneth Wilkinson & James Lock in Kingsway Hall, London. ℗1974 ©1975

Remark & Rating
ED4, 3G-3G
(K. Wilkinson)

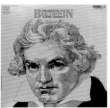

Label **Decca SXL 6630 (Decca D258D 12)**
London CS 6843 (CSP 11)

Beethoven: Piano Sonatas <No.31, Op.110 in A-flat Major>, <No.32, Op.111 in C Minor>, Vladimir Ashkenazy (piano). Recorded by James Lock & Tryggvi Tryggvason, May 1971 & July 1972 in Kingsway Hall, London. ℗1974 by Christopher Raeburn

Remark & Rating
ED4, 6W-7Y
Penguin ★★★

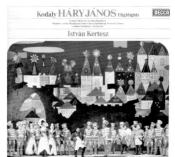
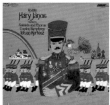

Label **Decca SXL 6631 (SET 399-400)**
London OS 26390 (OSA 1278)

Kodaly: <Hary Janos, Highlights>, Erszébet Komlossy, László Palócz, Gyorgy Melis, Zsolt Bende, Olga Szönyi & Margit László with Edinburgh Festival Chorus; Wandsworth School Boys Choir & The London Symphony Orchestra-Istvan Kertesz (4 pages Insert). ℗ ©1974

Remark & Rating
ED4, 3G-2G
Penguin ★★★, AS List-H

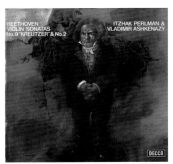

Label **Decca SXL 6632 (D92D 5)**
London CS 6845 (CSA 2501)

Beethoven: Violin Sonatas Volume 1, <No.2 in A Major, Op.12 no.2>, <No.9 in A Mainor "Kreutzer", Op.47>, Itzhak Perlman (violin) & Ashkenazy (piano). Recorded by Kenneth Wilkinson, October 1973 in Kingsway Hall, London. ℗ by Christopher Raeburn @1974

Remark & Rating
ED4, 2W-3W (White Label)
Penguin ★★★(❀), Japan 300-CD, (K. Wilkinson)

Label **Decca SXL 6633**
London CS 6848

Nielsen: <Symphony No.4, Op.29 (The Inextinguishable)>, Los Angeles Philharmonic-Zubin Mehta. @1974

Remark & Rating
ED4, 1W-1W

Label **Decca SXL 6634**
London CS 6849

Richard Strauss: <Don Quixote, op.35>, Kurt Reher (violoncello), Jan Hlinka (viola), Los Angeles Philharmonic-Zubin Mehta. Recorded by James Lock & Gordon Parry at Royce Hall Auditorium, UCLA. @1974

Remark & Rating
ED4, 4W-6W

Label Decca SXL 6635-6
 London CSA 2236

Delibes: <Sylvia-Complete Ballet>, New Philharmonia Orchestra-Richard Bonynge. Recorded by Kenneth Wilkinson. @1974

Remark & Rating
ED4, 2G-3G-1G-1G, $
Penguin ★★★, AS List, (K. Wilkinson)

Label Decca SXL 6637
 London OS 26379

[Joseph Rouleau Sings Graet French Opera Aries], Music by Verdi, Gounod, Massenet, Meyerbeer, Bizet, Thomas. Joseph Rouleau (bass) with Orchestra of the Royal Opera House, Convent Garden-John Matheson. @1974

Remark & Rating
ED4, 1G-1G, rare!!

Label Decca SXL 6638
 No London CS

J.C. Bach: <Sinfonia in E Flat Major, Op.18, No.1>, <Op.18, No.3 in D Major>, <Op.18, No.5 in E Major>, The Stuttgart Chamber Orchestra-Karl Münchinger. Recorded by James Lock, July 1973 at Schloss Ludwigsburg. @1974

Remark & Rating
ED4, 1W-1W

Label Decca SXL 6639
 No London CS

[Madrigals by Wilbye, Tomkins and Gibbons], The Wilbye Consort directed by Peter Pears. Recorded by Kenneth Wilkinson & Colin Moorfoot, April 1972 in Kingsway Hall, London. ℗ ©1974

Remark & Rating
ED4,1G-1G
(K. Wilkinson)

Label Decca SXL 6640
 No London CS

Britten: "Three Cantatas", <Cantata Misericordium Op.69>, Pears, Fisher-Dieskau, London Symphony Orchestra-Benjamin Britten; <Cantata Academica>, Vyvyan, Watts, Pears, Brannigan, London Symphony Orchestra-George Malcolm; <Cantata Rejoice In The Lamb-Festival Cantata Op.30>, Parker, Pearce, Tear, Robinson with The Choir of St.John's College, Cambridge-George Guest. Recorded by Kenneth Wilkinson, 1963, 1961 in Kingsway Hall & 1964 in the Chapel of St.John's College. @1974

Remark & Rating
ED4, 1G-1G
Penguin ★★★, (K. Wilkinson)

Label Decca SXL 6641
No London CS

Britten: <Sinfonia Da Requiem, Op.20>* , New Philharmonia Orchestra-Benjamin Britten; <Symphony for Cello and Orchestra, Op.68>** , Mstislav Rostropovich (cello), English Chamber Orchestra-Benjamin Britten. Produced by John Culshow, recorded by *Kenneth Wilkinson & Gordon Parry, 1964 in Kingsway Hall, London. ℗1964 ©1974 (** Original issue from Cello Symphony is in Decca SXL 6138 & London CS 6419, ℗1964)

Remark & Rating
ED4, 4W-6W
Penguin ★★★, (K. Wilkinson)

Label Decca SXL 6642
London CS 6859

Schumann: <Kreisleriana-8 Fantasies, Op.16>, <Humoreske Op.20>, Vladimir Ashkenazy (pino). Recorded by Tryggvi Tryggvason, October 1971 & November 1972 in Kingsway Hall, London.@1974

Remark & Rating
ED4, 4A-4A

Label Decca SXL 6643
London CS 6858

[Virtuoso Overtures], Johan Strauss: <Die Fledermaus>; Mozart: <Le Nozze Di Figaro>; Rossini: <La Gazza ladra>; Weber: <Der Freischütz>; Wagner: <Rienzi>, Los Angeles Philharmonic Orchestra-Zubin Mehta. Recorded by Gordon Parry & James Lock, 1973 in Royce Hall, UCLA. @1974

Remark & Rating
ED4, 2W-1W

Label Decca SXL 6644-8 (SXLJ 6644; D105D 5)
London CSP 6

Schubert: [The Symphonies], Overtures <Des Teufels Lustschloss, D.84>, <In the Italian style in C Major, D.591>, <Fierabras, D.796>, The Vienna Philharmonic Orchestra-Istvan Kertesz. ℗1971 [=SXL 6089, 6090, 6483, 6552, 6553]

Remark & Rating
ED4, (5 LP SET), $$
Penguin ★★(★)

Label Decca SXL 6649
London OS 26384

[Luciano Pavarotti - The World's Favourite Tenor Aria], from <Pagliacci>, <Martha>, <Carmen>, <La Boheme>, <Rigoletto>, <Faust>, <Tosca>, <Aida>, <Turandot>, <Il Trovatore>. (4 pages text insert) ℗1971, 1972 & 1974 ©1975

Remark & Rating
ED4, 1G-2G
Penguin ★★(★)

Label **Decca SXL 6650**
London OS 26391

[Pavarotti In Concert], Songs by Bononcini, Handel, Scarlatti, Bellini, Tosti, Respighi, Rossini. Orchestra Del Teatro Comunale di Bologna-Richard Bonynge. Recorded by Colin Moorfoot, July 1973 in Bologna Opera House. @1974

Remark & Rating
ED4, 1G-1G
Penguin ★★(★)

Label **Decca SXL 6651**
London CS 6853 (CSA 2404)

Beethoven: <Piano Concerto No.1 in C Major, Op.15>, <Piano Sonata No.8 in C Minor, Op.13, "Pathetique">, Vladimir Ashkenazy (piano) with The Chicago Symphony Orchestra-Georg Solti. Recorded by Kenneth Wilkinson. @1974

Remark & Rating
ED4, 6W-3W
Penguin ★★★, AS list-F, (K. Wilkinson)

Label **Decca SXL 6652**
London CS 6854 (CSA 2404)

Beethoven: <Piano Concerto No.2 In B Flat Major, Op.19 >, <Piano Sonata No.21 in C Major, Op.53, "Waldstein">, Vladimir Ashkenazy (piano) with The Chicago Symphony Orchestra-Georg Solti. Recorded by Kenneth Wilkinson. @1974

Remark & Rating
ED4, 5W-3W
Penguin ★★★, AS list-F, (K. Wilkinson)

Label **Decca SXL 6653**
London CS 6855 (CSA 2404)

Beethoven: <Piano Concerto No.3 in C Minor, Op.37>, <Piano Sonata No.26 In E Flat Major, Op. 81A, "Les Adieus">, Vladimir Ashkenazy (piano) with The Chicago Symphony Orchestra-Georg Solti. Recorded by Kenneth Wilkinson. ℗1973 ©1975

Remark & Rating
ED4, 2W-2W
Penguin ★★(★), AS list-F, Japan 300-CD, (K. Wilkinson)

Label **Decca SXL 6654**
London CS 6856 (CSA 2404)

Beethoven: <Piano Concerto No.4 in G Major, Op.58>, <Leonora No.3 Overture>, Vladimir Ashkenazy (piano) with The Chicago Symphony Orchestra-Georg Solti. @1974

Remark & Rating
ED4
Penguin ★★★, AS list-F

Label Decca SXL 6655
London CS 6857 (CSA 2404)

Beethoven: <Piano Concerto No.5 in E Flat Major, Op.73 "Emperor">, <Egmont Overture>, Vladimir Ashkenazy (piano) with The Chicago Symphony Orchestra-Georg Solti. @1974

Remark & Rating
ED4
Penguin ★★★, AS list-F

Label Decca SXL 6656
London CS 6860

Wagner: The Essential Wagner, "The Flying Dutchman" Overture; "Lohengrin" Preludes to Act1 & 3; "Die Meistersinger" Prelude; "Tristan und Isolde" Prelude and Liebestod, Vienna Philharmonic Orchestra-Horst Stein. Recorded by Gorden Parry & James Brown in the Sofiensaal, Vienna. ℗ by Christopher Raeburn @1974

Remark & Rating
ED4, 1W-1W, $
Penguin ★★(★)

Label Decca SXL 6657
No London CS

Alban Berg: <Lulu Suite>; Richard Strauss: <Final Scene of Salome>, Anja Silja (soprano), The Vienna Philharmonic Orchestra-Christoph Dohnanyi. Recorded by Gordon Parry & Philip Wade, April 1973 in the Sofiensaal, Vienna. ℗ by Christopher Raeburn @1974

Remark & Rating
ED4, 1G-1G
Penguin ★★(★)

Label Decca SXL 6658
London OS 26373

[Luciano Pavarotti - King of the High C's], Arias From The Daughter of the Regiment; La Favorita; Il Trovatore; La Boheme, etc., ©1973

Remark & Rating
ED4
Penguin ★★★

Label Decca SXL 6659
No London CS

[Popular Rissian Songs], Nicolai Ghiaurov (bass), The Kaval Orchestra and Chorus conducted & arranged by Atnas Margaritov. Recorded by Gordon Parry in the Sofiensaal, Vienna 1973. @1974

Remark & Rating
ED4, 6G-2G

Label **Decca SXL 6660-4 (SXLK 6660, ©=SDD 519; 520)**
 No London CS

Schoenberg: [Complete Works for Chamber Ensemble], London Sinfonietta-David Atherton, (20 pages booklet). Recorded by Gordon Parry & Philip Wade, 1973-1974 at Petersham. @1974 (* Pierrot Lunaire is in AS list)

Remark & Rating
ED4, 2-2-1-2-2-1-2-5-2-1W, (5 LP SET) $$
Penguin ★★★, (SDD 520, TAS2017 & AS list)

Label **Decca SXL 6665-7 (SXLM 6665)**
 London CSA 2313 (=CS 6862, 6863 & 6864)

[The Orchestral Works of Zoltan Kodaly], Philharmonia Hungarica-Antal Dorati (8 pages Booklet). Recorded by Colin Moorfoot, 1973 in Marl, Germany. @1974 (=SXL 6712, SXL 6713 & SXL6714)

Remark & Rating
ED4, 1G-1G-5G-1G-6G-4G, $
Penguin ★★★, AS List-H

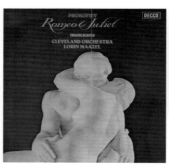
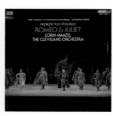

Label **Decca SXL 6668 (SXL 6620-2)**
 London CS 6865 (CSA 2312)

Prokofiev: <Romeo And Juliet, Op.64, Highlights>, Daniel Majeske (Solo Violin), The Cleveland Orchestra-Lorin Maazel. Recorded by Colin Moorfoot, Gorden Parry & Jack Law, June 1973 in the Masonic Auditorium, Cleveland. @1974

Remark & Rating
ED4
TASEC, Penguin ★★★

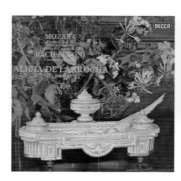
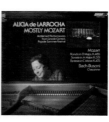

Label **Decca SXL 6669**
 London CS 6866

[Mostly Mozart, Vol. I], Mozart: <Rondo in D Major, K.485>, <Sonata in A Major, K.331>, <Fantasia in C Minor, K.475>; Bach/Busoni: <Chaconne in D Minor>, Alicia De Larrocha (piano). Recorded by Philip Wade, June 1973 in Kingsway Hall, London. @1974

Remark & Rating
ED4, 2W-4W
Penguin ★★★

Label **Decca SXL 6670**
No London CS (=STS 15416)

Mozart: "Serenades Volume 8", <Divertimento No.7 in D K.205>, <Divertimento No.11 in D K.251>, Vienna Mozart Ensemble-Willi Boskovsky. Recorded by James Lock, June 1973 in the Sofiensaal, Vienna. ℗ by Christopher Raeburn @1974

Remark & Rating
ED4, 1W-1W
Penguin ★★★

Label **Decca SXL 6671-2**
London CSA 2237

Bruckner: <Symphony No.8 in C Minor>, Los Angeles Philharmonic Orchestra-Zubin Mehta. @1974

Remark & Rating
ED4, 1W-1W-1W-1W, rare! $

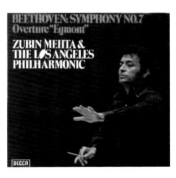
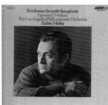

Label **Decca SXL 6673 (SXLN 6673)**
London CS 6870

Beethoven: <Symphony No.7 in A Major, Op.92>, <Egmont Overture, Op.84>, The Los Angeles Philharmonic Orchestra-Zubin Mehta. Recorded by Colin Moorfoot & Gordon Parry in Royce Hall, UCLA. ℗ by Christopher Raeburn @1974

Remark & Rating
ED4, 5W-5W
Penguin ★★★

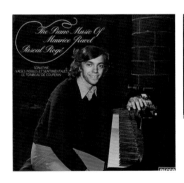
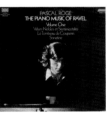

Label **Decca SXL 6674**
London CS 6873

Ravel: "The Piano Music of Ravel, Volume 1", <Valses Nobles et Sentimentales>, <Le Tombeau de Couperin>, <Sonatine>, Pascal Rogé (piano). @1974

Remark & Rating
ED4, 4A-1A

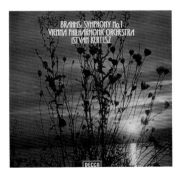
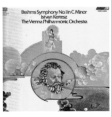

Label **Decca SXL 6675**
London CS 6836

Brahms: <Symphony No.1 In C Minor, Op.68>, The Vienna Philharmonic Orchestra-Istvan Kertesz. ℗ by Christopher Raeburn @1973

Remark & Rating
ED4, 2L-2W
Penguin ★★(★)

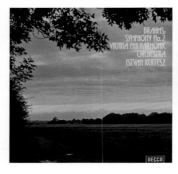

Label **Decca SXL 6676 (=SXL 6172)**
 London CS 6435, (ED2 1st)

Brahms: \<Symphony No.2 in D Major, Op.73\>, The Vienna Philharmonic Orchestra-Istvan Kertesz. Recorded by Gordon Parry, May 1964 Sofiensaal, Vienna. ℗ 1964, © 1974. (This recording is the first pressing, but not the first issue of the same performance. Original recording was issued on SXL 6172 & CS 6435 in May 1964 with different matrix numbers).

Remark & Rating
ED4
Penguin ★★(★)

Label **Decca SXL 6677**
 London CS 6837

Brahms: \<Symphony No.3 in F Major, Op.90\>, \<Variation on a Theme by Handn\>, The Vienna Philharmonic Orchestra-Istvan Kertesz. ℗ by Christopher Raeburn @1973

Remark & Rating
ED4, 1W-1W
Penguin ★★(★)

Label **Decca SXL 6678**
 London CS 6838

Brahms: \<Symphony No.4 in E Minor, Op.98\>, The Vienna Philharmonic Orchestra-Istvan Kertesz. Recorded by James Lock, at Sofiensaal, Vienna. ℗ by Christopher Raeburn @1973

Remark & Rating
ED4 2W-2W
Penguin ★★★

Label **Decca SXL 6679**
 London OS 26195

Mahler: \<Lieder Eines Fahrenden Gesellen\>, \<4 Songs from Des Knaben Wunderhorn\>, Yvonne Minton with The Chicago Symphony Orchestra-Georg Solti. (Selections from SET 469-70 & 471-2) ℗1970 ©1974

Remark & Rating
ED4, 6W-4W
Penguin ★★★

Label **Decca SXL 6680**
 London CS 6878

Ravel: \<Concerto for the Left Hand\>, \<Concerto in G\>; Faure: \<Fantasie for Piano and Orchestra\>, Alicia De Larrocha (piano), The London Philharmonic Orchestra-Rafael Frühbeck de Burgos. @1974

Remark & Rating
ED4
Penguin ★★★, TAS 9-96+

Label **Decca SXL 6681**
London CS 6879

Bruckner: <Symphony No.2>, The Vienna Philharmonic Orchestra-Horst Stein. Recorded by Philip Wade in the Sofiensaal, Vienna. @1975

Remark & Rating
ED4, 1W-1W
Penguin ★★(★)

Label **Decca SXL 6682**
London CS 6880

Bruckner: <Symphony No.6>, The Vienna Philharmonic Orchestra-Horst Stein. ℗1974 ©1975

Remark & Rating
ED4, 1W-1W
Penguin ★★(★)

Label **Decca SXL 6683**
London CS 6881

[The Piano Music of Manuel De Falla], <Cuatro Piezas Españolas>, <Three Dances from "El Sombrero de Tres Picos">, <Suite from "El Amor Brujo">, Alicia de Larrocha (piano). Recorded by Philip Wade, June 1973 in Kingsway Hall, London. @1974

Remark & Rating
ED4, 4G-2W
Penguin ★★★

Label **Decca SXL 6684 (SXLP 6684)**
No London CS

[Five Favorite Overtures], Wagner: <Die Meistersinger von Nurnberg>, Berlioz: <Les Francs-Juges>*, Rossini: <The Barber of Seville>, Beethoven: <Egmont>, <Leonora No.3>, Chicago Symphony Orchestra-Georg Solti. Recorded by Kenneth Wilkinson & James Lock, 1972 & 1974 in the Krannert Center, University of Illinois. ℗1972 & 1974* ©1974

Remark & Rating
ED4, 1W-3W
(K. Wilkinson)

Label **Decca SXL 6686-7**
London CSA 2238

Bruckner: <Symphony No.5 in B Flat Major>, The Vienna Philharmonic Orchestra-Lorin Maazel. @1974 (2 LPs in gatefold cover)

Remark & Rating
ED4, 1W-1W-1W-1W (gatefold), $
Penguin ★★(★)

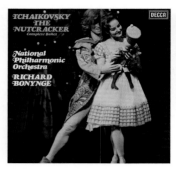

Label **Decca SXL 6688-9**
London CSA 2239 (=CS 6686, 6687)

Tchaikovsky: <The Nutcracker, Op.71> Complete Ballet, National Philharmonic Orchestra-Richard Bonynge. Recorded by James Lock, April 1974 in the Kingsway Hall, London. @1974

Remark & Rating
ED4, 3G-2G-3G-2G, $
Penguin ★★(★)

Label **Decca SXL 6690 (=SXLR 6690)**
London OS 26424

[Montserrat Caballe], Arias from Adriana Lecouvreur; I Vespri Siciliani; Sour Angelica; Rigoletto; Il Trovatore; Un Ballo in Maschera; La Sonnambula, Montserrat Caballe (soprano) with The Barcelona Symphony Orchestra-Gianfraco Masini. ℗1974 ©1975

Remark & Rating
ED4, 3G-3G

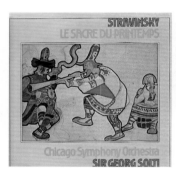

Label **Decca SXL 6691***
London CS 6885

Stravinsky: <Le Sacre du Printemos>, Chicago Symphony Orchestra-Georg Solti. Recorded by Kenneth Wilkinson & James Lock. @1974

Remark & Rating
ED4, 4W-2W, $
TASEC, Penguin ★★★, AS list, (K. Wilkinson)

Label **Decca SXL 6692**
No London CS

[New Year's Concert], The Vienna State Opera Chorus-Norbert Balatsch (chorus master) & The Vienna Philharmonic Orchestra-Willi Boskovsky. Recorded by Gordon Parry in the Sofiensaal, Vienna, 1973. ℗1974 by Christopher Raeburn

Remark & Rating
ED4, 4W-3W
Penguin ★★★

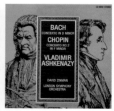

Label **Decca SXL 6693 (part of SXL 6174)**
London CS 6440, (ED2 1st) (part)

[Ashkenazy Plays Chopin]: *<Piano Concerto No.2 in F Minor, Op.21>, London Symphony Orchestra-David Zinman. Recorded by Kenneth Wilkinson, January 1965 in Kingsway Hall. ℗1965. <Ballade No.3, Op.47>, <Nocturne No.17 Op.62, no.1>, <Scherzo No.3, Op.39>, <Barcarolle Op.60>. Recorded from 1964 to1967 by Gordon Parry, Arthur Bannister, James Lock & Alex Rosner. ©1975 (* Concerto No. 2 is the reissue, part of of SXL 6174 & CS 6440)

Remark & Rating
ED4, 4W-1W
Penguin ★★★, (K. Wilkinson)

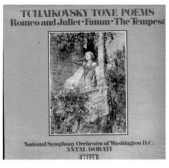

Label **Decca SXL 6694**
London CS 6891

Tchaikovsky: <Romeo and Juliet, Overture-Fantasy After Shakespeare>, <Fatum, Poeme Symphonique, Op. 77>, <The Tempest, Fantasia After Shakespeare, Op. 18>, National Symphony Orchestra of Washington D.C.-Antal Dorati. Recorded by Kenneth Wilkinson, Colin Moorfoot & Michael Mailes, April 1974 at Constitution Hall, Washington, D.C., USA. ℗1975

Remark & Rating
ED4, 2W-5W
Penguin ★★(★), (K. Wilkinson)

Label **Decca SXL 6695**
No London CS

Brahms: <Hungarian Dances>; Dvorak: <Slavonic Dances>, The London Symphony Orchestra-Willi Boskovsky. Recorded by Kenneth Wilkinson, 1974 in Kingswayhall. ℗ by Christopher Raeburn @1975

Remark & Rating
ED4, 1G-1G

Label **Decca SXL 6696**
No London CS

Brahms: <Hungarian Dances>; Dvorak: <Slavonic Dances>, The London Symphony Orchestra-Willi Boskovsky. Recorded by Kenneth Wilkinson, 1974 in Kingswayhall. ℗ by Christopher Raeburn @1975

Remark & Rating
ED4, 1G-1G
Penguin ★★★, (K. Wilkinson)

Label **Decca SXL 6697**
London CS 6893

Rachmaninov: <Suite No.1 for Two Pianos "Fantasy">, <Suite No.2 for Two Pianos>, Vladimir Ashkenazy & Andre Previn (pianos). Recorded by James Lock in All Saints Church, Petersham. @1975

Remark & Rating
ED4, 1W-1W
Penguin ★★★

Label **Decca SXL 6698**
London CS 6894

Mozart: Piano Concertos <No.21, K.467 & No.12, K.414>, Radu Lupu (piano), The English Chamber Orchestra-Uri Segal. @1975

Remark & Rating
ED4
Penguin ★★(★)

Label **Decca SXL 6699**
No London CS

Anthony Milner: <Cantata-Salutio Angelica Op.1>,< Roman Spring Op.27>, Alfreda Hodgson (contralto), Felicity Palmer (soptrano), Robert Tear (tenor), London Sinfonietta and Chorus-David Atherton. Recorded by Colin Moorfoot, 1973 & 1974 in Kingsway Hall, London. @1975

Remark & Rating
ED4, 1G-1G
Penguin ★★★, AS List

Label **Decca SXL 6700**
London CS 6895

Ravel: "The Piano Music of Ravel, Volume 2", Gaspard de la Nuit, Pavane de la Nuit & other selections, Piano-Pascal Rogé. Recorded by James Lock in All Saints Church, Petersham. @1975

Remark & Rating
ED4, 2W-1W

Label **Decca SXL 6701**
London CS 6896

[Straussiana], <Fledermaus Overture>, <Bal de Vienne - Ballet Suite for the Fledermaus, Act II, arranged by D. Gamley> & <Le Beau Danube (Blue Danube Ballet), arranged by R. Desormiere>, National Philharmonic Orchestra-Richard Bonynge. Recorded by James Lock in Kingsway Hall, London. @1975

Remark & Rating
ED4, 1W-1W
Penguin ★★★

Label **Decca SXL 6702**
London CS 6897

Prokofiev: <Symphony No.1 in D Major, Op.25 "Classical">, <Symphony No.7>, London Symphony Orchestra- Walter Weller. Recorded by James Lock, April 1974 in The Kingsway Hall, London. @1975

Remark & Rating
ED4 4W-4W
Penguin ★★★, AS List

Label **Decca SXL 6703**
London CS 6898

Ravel: <Daphnis and Chloe (Complete Ballet)>, Cleveland Orchestra & Chorus-Lorin Maazel. Recorded by Gordon Parry & Colin Moorfoot in Masonic Hall, 1974. @1975

Remark & Rating
ED4, 6W-3W
Penguin ★★(★), AS list-H

Label **Decca SXL 6704**
London CS 6899

[Waltzes by Emile Waldteufel], The Skaters Waltz, Espana & others Waldteufel Favorites, National Philharmonic Orchestra-Dauglas Gamley. Recorded by Philip Wade, 1974 in Kingsway Hall. @1975

Remark & Rating
ED4, 1W-2W
Penguin ★★★, AS list-H

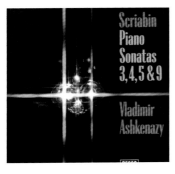

Label **Decca SXL 6705**
London CS 6920

Scriabin: <Piano Sonata No.3 in F sharp minor, Op.23> , <Sonata No.4 in F sharp, Op.30>, <Sonata No.5 in F sharp, Op.53>, <Sonata No.9 in F, Op.68>, <Moderato, quasi andante>, Vladimir Ashkenazy (piano). Recorded by Tryggvi Trygvasson in Kingsway Hall. @1975

Remark & Rating
ED4, 1W-3W
Penguin ★★★

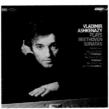

Label **Decca SXL 6706 (Decca D258D 12, part)**
London CS 6921 (=CS 7256, CSP 11)

Beethoven: Piano Sonatas <*No.8, Op.13 in C Minor "Pathétique"> , <**No.21, Op.53 in C Major "Waldstein">, <**No.26, Op.81a in E-Flat Major "Les Adieux">, Vladimir Ashkenazy (piano). Recorded by **Kenneth Wilkinson May & October 1973 in Kingsway Hall, London. ℗ ©1975. *[This No. 8 recorded in December 1972 by *Tryggvi Tryggvason, No any CD release, the No. 8 in the Complete Sonatas SET (Decca D258D 12) is from SXL 6994 (London CS 7247), recorded in 1980]

Remark & Rating
ED4, 7W-2W
Penguin ★★★, (K. Wilkinson)

Label **Decca SXL 6706 (Decca D258D 12)**
London CS 7256 (=part of CS 6921 & CSP 11)

Beethoven: Piano Sonatas <No.21, Op.53 in C Major "Waldstein">, <No.26, Op.81a in E-Flat Major "Les Adieux">, <Andante Favori in F>, Vladimir Ashkenazy (piano). Recorded by Kenneth Wilkinson May & October 1973 in Kingsway Hall, London. ℗ ©1975. *** [London CS 7256 is part of reissue of the CS 6921 & SXL 6706]

Remark & Rating
ED4
Penguin ★★★, (K. Wilkinson)

Label **Decca SXL 6707**
London CS 6923

Auber: <Marco Spada, Ballet>, The London Symphony Orchestra-Richard Bonynge. Recorded by Kenneth Wilkinson, August 1972 in Kingsway Hall, London. @1975

Remark & Rating
ED4, 1W-1W
Penguin ★★(★), (K. Wilkinson)

Label **Decca SXL 6708**
No London CS

Liszt: "Paraphrases"- <Reminiscences of Bellini's "Norma" and Mozart's "Don Giovanni">, <Fantasy on themes from Beethoven's "Ruins of Athens">, , Bracha Eden & Alexander Tami (pianos). Recorded by John Dunkerley, October 1974 in Kingsway Hall. @1975

Remark & Rating
ED4, 1W-1W

Label **Decca SXL 6709**
London CS 6925

Liszt: <Tasso-Symphonic Poem No.2>, <Mephisto Waltz No.1>, <From the Cradle to the Grave-Symphonic Poem No.13>, L'Orchestre de Paris-Georg Solti. Recorded by Kenneth Wilkinson. @1975

Remark & Rating
ED4
Penguin ★★★, (K. Wilkinson)

Label **Decca SXL 6710**
London CS 6844

Chopin: <Etudes Op.10 & Op.25>, Vladimir Ashkenazy (piano). Recorded 1971 & 1972 in Kingsway Hall by James Lock & Tryggvi Tryggvason. ℗ by Christopher Raeburn @1975

Remark & Rating
ED4
Penguin ★★★

Label **Decca SXL 6711**
London OS 26220

[The Magic of Lehar], Werner Krenn, Renate Holm, Vienna Volksoper Orchestra conducted by Anton Paulik. Recorded by James Lock & Gordon Parry, 1970 in the Sofiensaal, Vienna. ℗ 1971 by Christopher Raeburn ©1975

Remark & Rating
ED4, 3G-2G

Label Decca SXL 6712 (SXLM 6665)
London CS 6862 (CSA 2313)

Zoltan Kodaly: "Orchestral Works Vol.1", <Dances of Galanta>, <Dances of Marosszek>, <Concerto for Orchestra> & <Theatre Overture>, Philharmonia Hungarica-Antal Dorati. Recorded by Colin Moorfoot in Marl, Germany. ℗1974 ©1975

Remark & Rating
ED4
Penguin ★★★

Label Decca SXL 6713 (SXLM 6665)
London CS 6863 (CSA 2313)

Zoltan Kodaly: "Orchestral Works Vol.2", <Harry Janos Suite>, <Minuetto Serio>, <Symphony in C Mjor>, Philharmonia Hungarica-Antal Dorati. Recorded by Colin Moorfoot in Marl, Germany. 1974 ©1975 (**CS 6863 is in London Box Set CSA 2313)

Remark & Rating
ED4, 7G-1G
Penguin ★★(★), Japan 300-CD

Label Decca SXL 6714 (SXLM 6665)
London CS 6864 (CSA 2313)

Zoltan Kodaly: "Orchestral Works Vol.3" (London issue CS 6864 is Vol.2), <Peacock Varitations>, <Ballet Music>, <Summer Evening> , <Hungarian Rondo>, Philharmonia Hungarica-Antal Dorati. Recorded by Colin Moorfoot in Marl, Germany. ℗1974 ©1975

Remark & Rating
ED4, 6G-5G
Penguin ★★★, Japan 300-CD

Label Decca SXL 6715
London CS 6936

Ravel: "The Piano Music of Ravel, Volume 3", Miroirs, Jeux d'eau, Ma Mere L'oye, Piano-Pascal Rogé with Denise Françoise Rogé. Recorded by Philip Wade, December 1974 in The Kingsway Hall, London. @1975

Remark & Rating
ED4

Label Decca SXL 6716
London CS 6937

Mozart: <Double & Triple Piano Concerto>s, Pianists: Ashkenazy, Fou Tsong & Barenboim, The English Chamber Orchestra-Daniel Barenboim. Recorded by Tryggvi Trygvasson, April 1972 in Kingsway Hall. @1975

Remark & Rating
ED4, 1A-1A

Label **Decca SXL 6717**
London CS 6938

[Music For Horn And Piano], Beethoven: <Horn Sonata Op.17>; Schumann: <Adagio & Allegro, Op.70>; Danzi: <Sonata Op.28>; Saint-Saëns: <Romance Op.67>, Barry Tuckwell (horn), Vladimir Ashkenazy (piano). James Lock & Philip Wade recorded in Kingsway Hall, ℗1974. ©1975

Remark & Rating
ED4, 2A-2A

Label **Decca SXL 6718**
London OS 26428

Rachmaninov: <Songs Volume 1>, "Oh, never sing to me again", "The harvest of sorrow", etc., Elizabeth Soderstrom (soprano) and Vladimir Ashkenazy (piano). Recorded by Kenneth Wilkinson, Sept. 1974 in the Kingsway Hall, London. ℗©1975

Remark & Rating
ED4, 3G-1G
Penguin ★★★, (K. Wilkinson)

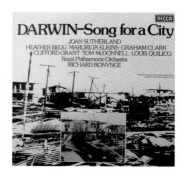

Label **Decca SXL 6719**
No London CS

Darwin: <Song for a City> - Royal Opera House Gala Concert, Saturday 25th January 1975, in aid of the Darwin Appeal Fund. Heather Begg, Clifford Grant, Margreta Elkins, Tom McDonnell, Joan Sutherland with Royal Philharmonic Orchestra-Richard Bonynge. Recorded live at the Royal Opera House, Convent Garden in association with London Weekend TV by Kenneth Wilkinson & James Lock. @1975

Remark & Rating
ED4, 1G-1G
(K. Wilkinson)

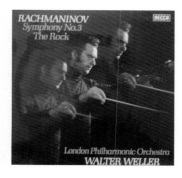

Label **Decca SXL 6720**
No London CS

Rachmaninov: <Symphony No.3 in A minor Op.44>, <"The Rock" Fantasy, Op.7>, The London Philharmonic Orchestra-Walter Weller. Reorded by James Lock, March/October 1974 in Kingsway Hall, London. ℗ by Christopher Raeburn @1975

Remark & Rating
ED4, 2W-2W
Penguin ★★(★), AS List

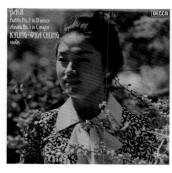

Label **Decca SXL 6721**
London CS 6940

J.S. Bach: <Partita No.2 in D Minor>, <Sonata No.3 in C Major>. Kyung-Wha Chung (violin). Recorded by James Lock, November 1974 in All Saints Church, Petersham. ℗ by Christopher Raeburn @1975

Remark & Rating
ED4, 1W-1W, rare!! $$$
Penguin ★★

Label　Decca SXL 6722
No London CS

[Franz Schubert Songs], <Im Frühling (Schulze)>, <Auf dem Wasser zu singen (Stolberg)>, <Nachstücke (Mayrhofer)>, <An die Entfernte (Goethe)>, <Lachen und Weinen (Rückert)>, <Abendstern (Mayrhofer)>, <Das Fischermädchen (Heine)>, <Sprache der Liebe (Schlegel)>, <Der Einsame (Lappe)>, <Der Geistertanz (Matthisson)>, <Atys (Mayrhofer)>, <Auflösung (Mayrhofer)>, <Nacht und Träume (Collin)>. Peter Pears (tenor) and Benjamin Britten (piano). (2 pages text insert) @1975

Remark & Rating
ED4, 3A-3G
Penguin ★★★

Label　Decca SXL 6723
London CS 6941

Elgar: <Symphony No.2, in E-Flat, Op.63>, London Philharmonic Orchestra-Georg Solti. Recorded by Kenneth Wilkinson, February 1975 in Kingsway Hall, London.@1975

Remark & Rating
ED4, 2W-2W
Penguin ★★★, (K. Wilkinson)

Label　Decca SXL 6724
No London CS (=STS 15417)

Mozart: "Serenades Volume 9", <Divertimento No.17 K.334>, Vienna Mozart Ensemble-Willi Boskovsky. Recorded by James Lock & Colin Moorfoot in the Sofiensaal, Vienna, in 1973 & 1974. ℗ by Christopher Raeburn @1975

Remark & Rating
ED4, 1W-5W
Penguin ★★★

Label　Decca SXL 6725
London CS 6943

Gottschalk: <Great Galloping Gottschalk>, <Piano Music of Louis Moreau Gottschalk>, Ivan Davis (piano). Recorded by John Dunkerley in Kingsway Hall, 1975. ℗1975 ©1976

Remark & Rating
ED4, 2W-1W
Penguin ★★★

Label **Decca SXL 6726**
London CS 6945

Verdi: "Ballet Music From Verdi Operas", <Don Carlos>, <Otello>, <I Vespri Siciliani>, Cleveland Orchestra-Lorin Maazel. Recorded by Colin Moorfoot, Gordon Parry & Jack Law in Masonic Hall, Cleveland. @1975

Remark & Rating
ED4,1G-1G
Penguin ★★★

Label **Decca SXL 6727**
London CS 6946

Gershwin: <Rhapsody in Blue>, <Cuban Overture>, <An American in Paris>, Ivan Davis (piano), Cleveland Orchestra-Lorin Maazel. Recorded by Colin Moorfoot, Gordon Parry & Jack Law, July 1974 in Masonic Hall, Cleveland. @1975

Remark & Rating
ED4, 7G-6G

Label **Decca SXL 6728**
London CS 6947

Brahms: <Piano Concerto No.1 in D Minor, Op.15>, Ladu Lupu (piano), London Philharmonic Orchestra-Edo De Waart. Recorded by Colin Moorfoot, November 1974 in Kingsway Hall, London. @1975

Remark & Rating
ED4, 1W-1W
Penguin ★★★

Label **Decca SXL 6729**
London CS 6948

Schubert: <Symphony No.9 in C major, D.944>, The Israel Philharmonic Orchestra-Zubin Mehta. Recorded by James Lock, @1977

Remark & Rating
ED4, 1W-3W
Penguin ★★(★)

Label **Decca SXL 6730**
London CS 6949

Bartok: <Concerto for orchestra>, <Hungarian pictures>, London Philharmonic Orchestra-Zubin Mehta. Recorded by James Lock, March 1975 in Kingway Hall, London. @1976

Remark & Rating
ED4, 1W-3W
Penguin ★★★, AS List

Label **Decca SXL 6731**
London CS 6950

Rimsky-Korsakov: <Scheherazade>, Los Angeles Philharmonic-Zubin Mehta. Recorded by Colin Moorfoot & Gordon Parry, April 1974 in Royce Hall, UCLA. ℗ by Christopher Raeburn ©1975

Remark & Rating
ED4 1W-1W, $$
Penguin ★★(★), AS List

Label **Decca SXL 6732**
London CS 6951

Berlioz: <Harold In Italy, Op.16> Daniel Benyamini (viola), The Israel Philharmonic Orchestra-Zubin Mehta. Recorded by James Lock & Gordon Parry, December 1974 in Binyanei Ha'ouma, Jerusalem. ©1975

Remark & Rating
ED4, 2W-3W

Label **Decca SXL 6733**
London CS 6952

Chopin: <24 Peludes Op.28>, <Berceuse in D Flat, Op.57>, Alicia de Larrocha (piano). Recorded by Colin Moorfoot, May 1974 in Kingsway Hall, London. ℗1975 ©1976

Remark & Rating
ED4

Label **Decca SXL 6734**
London CS 6953

[Favourite Spanish Encores], Mateo Albéniz: <Sonata in D>; Isaac Albéniz:<Rumores de la Caleta-Malagueña-No.6>, <Pavana-Capricho, Op.12>, <Puerta De Tierra-Bolero-No.5>, <Malagueña, Op.165, no.3>, <Tango, Op.165, no.2>, <Sevilla-Sevillanas, No.3>; P.A. Soler: <Sonata in G Minor & in D>; Granados: <Valenciana O Calesera-Danza Española No.7>, <Andaluza-Danza Española No.5>; J.Turina: <Sacro-Monte, Op.55, no.5>, <Zapateado, Op.8, no.3>. Alicia De Larrocha (piano). Recorded by Colin Moorfoot, June 1974 in Kingsway Hall, London. ℗1975 ©1976

Remark & Rating
ED4, 2W-1W, rare! $
Penguin ★★★

Label **Decca SXL 6735**
London CS 6954

Stravinsky: <Le Sacre Du Printemps (The Rite of Spring)>, Vienna Philharmonic Orchestra-Lorin Maazel. Recorded by Gorden Parry & Jack Law, 1974 in the Sofiensaal, Vienna. @1976

Remark & Rating
ED4, 2W-2W, $

Label **Decca SXL 6736 (D92D 5)**
London CS 6958 (CSA 2501)

Beethoven: Violin Sonatas Volume 2, <No.4 In A Minor, Op.23>, <No.5 in F Major, Op.24,"Spring"> Itzhak Perlman (violin), Vladimir Ashkenazy (piano). Recorded by Colin Moorfoot, May-June 1974 in Kingsway Hall, London. @1976

Remark & Rating
ED4, 2A-1A
Penguin ★★★, Japan 300

Label **Decca SXL 6737**
London CS 6967

[Concertos In Contrast], Haydn: <Trumpet Concerto>; Weber: <Clarinet Concerto>; Vivaldi: <Piccolo Concerto>; Wieniawski: <Polonaise in D, Op.4>, <Scherzo-Tarantelle, Op.16>, Los Angeles Philharmonic Orchestra-Zubin Mehta. Recorded by Colin Moorfoot & Gordon Parry. ℗ by Christopher Raeburn @1975

Remark & Rating
ED4, 2K-1K

Label **Decca SXL 6738**
No London CS

[The Art of Hans Hotter Vol.2], Lieder by Loewe, Wolf, Strauss, Brahms. Hans Hotter (German opera bass-baritone), Geoffrey Parsons (piano). Recorded by Gordon Parry & Philip Wade, 1973 in the Sofiensaal, Vienna. ℗1975 by Christopher Raeburn ©1976

Remark & Rating
ED4, 1G-3G, rare!

Label **Decca SXL 6739 (=SXLI 6739)**
London CS 6961

Schubert: <Piano Sonata No.17 in D Major, D.850 (Op.53)>, <Four German Dances, D.366>, Vladimir Ashkenazy (piano). Recorded by John Dunkerley, April 1975 in All Saints Church, Petersham. @1976

Remark & Rating
ED4, 1W-1W. rare!
Penguin ★★★

Label **Decca SXL 6740**
No London CS

[New Year's Concert, 1975, (Live from Vienna)], The Vienna Philharmonic-Willi Boskovsky. Recorded by Colin Moorfoot & Jack Law, 1st January 1975 in the Musikvereinsaal, Vienna. @1975

Remark & Rating
ED4, 2G-3G

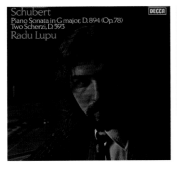

Label **Decca SXL 6741**
London CS 6966

Schubert: <Piano Sonata No.18 in G Minor, D.894>, <Two Scherzi D.593>, Radu Lupu (piano). Recorded by Colin Moorfoot in Kingsway Hall, London. ℗1975 ©1976

Remark & Rating
ED4, 1W-2W
Penguin ★★★

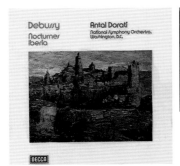

Label **Decca SXL 6742**
London CS 6968

Debussy: <Nocturnes>, <Iberia (Images Pour Orchestre No.2)>, National Symphony Orchestra with the Ladies of the Oratorio Society of Washington. D.C.-Antal Dorati. @1975.

Remark & Rating
ED4
Penguin ★★★, AS List

Label **Decca SXL 6743**
London CS 6970

[Highlights from Wagner's Ring] <Ride of the Valkyries>, <Wotan's Farewell & Magic Fire Music>, <Siegfried's Funeral March>, <Rhine Journey>,<Immolation of the Gods>, <Forest Murmurs>, <Entrance Of The Gods Into Valhalla>, The National Symphony Orchestra, Washington D.C.-Antal Dorati. Recorded by Colin Moorfoot, Kenneth Wilkinson & Michael Mailes in Constitution Hall, Washington, D.C. in 1975. @1976

Remark & Rating
ED4, 2W-1W
Penguin ★★(★), (K. Wilkinson)

Label **Decca SXL 6744-5**
London CSA 2242

Mahler: <Symphony No.2 in C Minor (Resurrection)>, Ileana Cotrubas (soprano), Christa Ludwig (mezzo-soprano), Vienna Philharmonic Orchestra-Zubin Mehta. Recorded by James Lock, Colin Moorfoot & Jack Law, 1975 in The Sofiensaal, Vienna. @1975

Remark & Rating
ED4, $
TAS-Old, Penguin ★★★

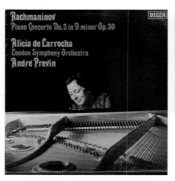

Label **Decca SXL 6746**
London CS 6977

Rachmaninov: <Piano Concerto No.3 in D Minor>, Alicia de Larrocha (piano), London Symphony Orchestra-Andre Previn. Recorded by Kenneth Wilkinson, Oct. 1974 in the Kingsway Hall, London. @1975

Remark & Rating
ED4, 2W-1W
(K. Wilkinson)

Label **Decca SXL 6747**
London OS 26443

Mozart: <Trinitatis Mass, K.167>, Elly Ameling (soprano) & Haydn: <Kleine Orgelmess>, Peter Planyavsky (organ), The Vienna State Opera Chorus & The Vienna Philharmonic-Karl Münchinger. Recorded by Colin Moorfoot & Philip Wade, 1974 in the Sofiensaal, Vienna. @1976

Remark & Rating
ED4, 1G-1G

Label **Decca SXL 6748**
London OS 26444

Schubert: <Rosamunde Von Cypern - Incidental Music in Four Acts, D.797 (Op.26)>, <Overture Die Zauberharfe, D.644>, Rohangiz Yachmi (contralto), The Vienna State Opera Chorus & The Vienna Philharmonic Orchestra-Karl Münchinger. Recorded by Colin Moorfoot & Philip Wade, November 1974 in the Sofiensaal, Vienna. @1975

Remark & Rating
ED4, 1G-2K
Penguin ★★★ AS list-H

Label Decca SXL 6749
 London CS 6978

[The Richard Strauss Album], <Also Sprach Zarathrustra>, <Till Eulenspiegel>, <Don Juan>, The Chicago Symphony Orchestra-Georg Solti. Recorded by Kenneth Wilkinson & James Lock. @1976

Remark & Rating
ED4, 2W-2W
Penguin ★★★ Grammy, (K. Wilkinson)

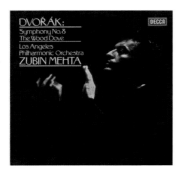

Label Decca SXL 6750
 London CS 6979

Dvorak: <Symphony No.8 in G Major, Op.88>, <The Wood Dove, Op.110>, Los Angeles Philharmonic Orchestra-Zubin Mehta. Recorded by James Lock, May 1975 in Royce Hall, U.C.L.A. @1976

Remark & Rating
ED4, 1W-1W

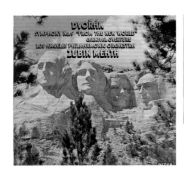

Label Decca SXL 6751
 London CS 6980

Dvorak: <Symphony No.9 "New World", Op.95>, <Carnival Overture>, Los Angeles Philharmonic Orchestra-Zubin Mehta. Recorded by James Lock, May 1975 in Royce Hall, U.C.L.A. @1976

Remark & Rating
ED4, 1W-1W, $
AS list

Label Decca SXL 6752 (©=JB 139)
 London CS 6981

Richard Strauss: <An Alpine Symphony, Op.64>, Los Angeles Philharmonic Orchestra-Zubin Mehta. Recorded by James Lock, 1975 in the Royce Hall, UCLA. @1976

Remark & Rating
ED4
Penguin ★★★

Label Decca SXL 6753 [=CSA 2246 (part)]

Charles Ives: <Symphony No. 2>, <Decoration Day, from "Holiday Symphony">, <Variations on America (Orchestrated William Schuman)>, Los Angeles Philharmonic Orchestra-Zubin Mehta. Recorded by James Lock, May 1975 in Royce Hall, UCLA. @1976 (** Part of London Box SET CSA 2246)

Remark & Rating
ED4, 2W-1W
Penguin ★★★

Label **Decca SXL 6754**
 London CS 6983

Tchaikovsky: <Symphony No.5 in E Minor, Op.64>, Chicago Symphony Orchestra-Georg Solti. Recorded by Kenneth Wilkinson & James Lock, May 1975 at Medinah Temple, Chicago. ℗1976

Remark & Rating
ED4, 4W-1W
(K. Wilkinson)

Label **Decca SXL 6755**
 London CS 6988

Johann Christian Bach: <Sinfonias Op.18, No.2, 4 & 6>; Telemann: *<Don Quichotte Suite>, Stuttgart Chamber Orchestra-Karl Münchinger. Recorded by Kenneth Wilkinson, Colin Moorfoot & *James Lock, June 1975 & *July 1973 in Ludwigsburg. ℗1976

Remark & Rating
ED4, 4W-1W
Penguin ★★★ (K. Wilkinson)

Label **Decca SXL 6756**
 London CS 6989

Liszt: <Sonata in B Minor>; Schumann: <Fantasia In C Major, Op.17>, Alicia de Larrocha (piano). Recorded by Philip Wade, June 1975 in Kingsway Hall, London. ℗1977 ©1978

Remark & Rating
ED4, 1A-1A

Label **Decca SXL 6757**
 London CS 6990

[Concertos from Spain], Montsalvatge: <Concerto Breve for Piano & Orchestra>; Surinach: <Concerto for Piano & Orchestra>, Alicia de Larrocha (piano), The Royal Philharmonic Orchestra-Rafael Frühbeck de Burgos. Recorded by Philip Wade, June 1975 in Kingsway Hall, London. ℗1977

Remark & Rating
ED4, 1W-1W, $
TAS2016, AS list-H

Label **Decca SXL 6758**
 No London CS

Dvorak: <Serenades for String Orcheatra in E Major, Op.22>*; Suk: <Serenades for String Orcheatra, Op.6>**, Stuttgart Chamber Orchestra-Karl Münchinger. Recorded by Kenneth Wilkinson*; Colin Moorfoot* and James Lock**, 1975 & 1971 in Ludwigsburg ℗1976

Remark & Rating
ED4, 1W-3W
(K. Wilkinson)

Label Decca SXL 6759
 London CS 6992

Saint-Saens: <Violin Concerto No.3 in B Minor, Op.61>;
Vieutemps: <Violin Concerto No.5 in A Minor, Op.37>, Kyung-
Wha Chung (violin) with The London Symphony Orchestra-
Lawrence Foster. Recorded by James Lock, 1974 & 1975 in
Kingsway Hall, London. @1976

Remark & Rating
ED4, 1W-2W, $
Penguin ★★★ AS list-H, Japan 300-CD

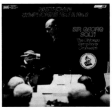

Label Decca SXL 6760 (11BB 188-96)
 London CS 6926 (CSP 9)

Beethoven: <Symphony No.1 in C Major, Op. 21>,
<Symphony No.8 in F Major, Op.93>, Chicago Symphony
Orchestra-Georg Solti. Recorded by Kenneth Wilkinson and
James Lock at Medinah Temple. ℗1975 © 1976

Remark & Rating
ED4
Penguin ★★(★), (K. Wilkinson)

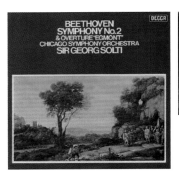
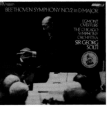

Label Decca SXL 6761 (11BB 188-96)
 London CS 6927 (CSP 9)

Beethoven: <Symphony No.2 in D Major, Op.36>, <Egmont
Overture, Op.84>, Chicago Symphony Orchestra-Georg Solti.
Recorded by Kenneth Wilkinson. ℗1975 © 1976

Remark & Rating
ED4
Penguin ★★★ (K. Wilkinson)

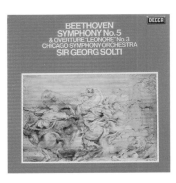

Label Decca SXL 6762 (11BB 188-96)
 London CS 6930 (CSP 9)

Beethoven: <Symphony No.5 in C Minor "Fate", Op.67>,
<Leonore Overture>, Chicago Symphony Orchestra-Georg
Solti. Recorded by Kenneth Wilkinson. ℗1975 © 1976

Remark & Rating
ED4
Penguin ★★★ (K. Wilkinson)

Label Decca SXL 6763 (11BB 188-96)
 London CS 6931 (CSP 9)

Beethoven: <Symphony No.6 in F Major "Pastoral", Op.68>,
Chicago Symphony Orchestra-Georg Solti. Recorded by
Kenneth Wilkinson. ℗1975 © 1976

Remark & Rating
ED4
Penguin ★★(★), (K. Wilkinson)

Label　Decca SXL 6764 (11BB 188-96)
　　　London CS 6932 (CSP 9)

Beethoven: <Symphony No.7 in A Major, Op.92>, <Coriolan Overture>, Chicago Symphony Orchestra-Georg Solti. Recorded by Kenneth Wilkinson. ℗ 1975 © 1976

Remark & Rating
ED4
Penguin ★★★ (K. Wilkinson)

Label　Decca SXL 6765
　　　No London CS

Massenet: "Songs", Huguette Tourangeau (mezzo-soprano), Reginald Kilbey (solo cello), Richard Bonynge (piano). (8 pages text insert) Recorded by Philip Wade, July 1975 in Kingsway Hall, London. @1976

Remark & Rating
ED4, 1G-1G

Label　Decca SXL 6766
　　　No London CS

[Grieg Favourites], <Holberg Suite>, <Tow Elegiac Melodies>, <Two Norwegian Melodies>, <Aase's Death>, <March from Sigurd Jorsalfar>, National Philharmonic Orchestra-Willi Boskovsky. Recorded by Kenneth Wilkinson, December 1974 in Kingsway Hall, London. ℗ by Christopher Raeburn @1976

Remark & Rating
ED4, 1W-1W
(K. Wilkinson)

Label　Decca SXL 6767 (15BB 218-20)
　　　London CS 7062 (CSA 2314)

Prokofiev: Piano Concertos <No.1 in D Flat Major, Op.10> & <No.2 in G Minor, Op.16>, Vladimir Ashkenazy (piano), London Symphony Orchestra-Andre Previn. Recorded by Kenneth Wilkinson in Kingsway Hall. @1976

Remark & Rating
ED4
Penguin ★★★ AS list (15BB 218-20), Japan 300-CD, (K. Wilkinson)

Label　Decca SXL 6768 (15BB 218-20)
　　　London CS 6964 (part)

Prokofiev: <Piano Concerto No.3 in C Major, Op. 26>, <Classical Symphony>, <Autumnal>, Vladimir Ashkenazy (piano), London Symphony Orchestra-Andre Previn. Recorded by Kenneth Wilkinson in Kingsway Hall. @1976

Remark & Rating
ED4
Penguin ★★(★), AS list (15BB 218-20), Japan 300-CD, (K. Wilkinson)

Label **Decca SXL 6769 (15BB 218-20)**
London CS 6964 (part) & CS 7063

Prokofiev: Piano Concertos <No.4 for left hand in B Flat Major, Op.53> & <No.5 in G Major, Op.55>, Vladimir Ashkenazy (piano), London Symphony Orchestra-Andre Previn. Recorded by Kenneth Wilkinson in Kingsway Hall. @1976

Remark & Rating
ED4
Penguin ★★★, AS list (15BB 218-20), Japan 300-CD, (K. Wilkinson)

Label **Decca SXL 6770**
London CS 6995

Dukas: <Symphony in C>, <Sorcerer's Apprentice>, London Philharmonic Orchestra-Walter Weller. Recorded by James Lock, October 1974 in Kingsway Hall, London. ℗ by Christopher Raeburn @1976

Remark & Rating
ED4. 1W-5W
Penguin ★★(★), AS List

Label **Decca SXL 6771**
London CS 6996

Schubert: <Piano Sonata No.20 in A Minor, D.959> & <No.5 in A Flat Major, D.557>, Radu Lupu (piano). Recorded by Kenneth Wilkinson & Colin Moorfoot in the Kingsway Hll, London. @1976

Remark & Rating
ED4, 2W-2W
(K. Wilkinson)

Label **Decca SXL 6772 (©=SXDL 7606)**
London OS 26453

Rachmaninov: <Songs Volume 2>, Elizabeth Soderstrom (soprano) and Vladimir Ashkenazy (piano). Recorded by Kenneth Wilkinson, August 1975 in the Kingsway Hall, London. ℗ ©1976

Remark & Rating
ED4, 2G-1G
Penguin ★★★, (K. Wilkinson)

Label **Decca SXL 6773**
London CS 6997

Prokofiev: <Violin Concertos No.1 in D & No.2 in G Minor>, Kyung Wha Chung (violin) with The London Symphony Orchestra-André Previn. Recorded by Colin Moorfoot & James Lock in Kingsway Hall, London. @1977

Remark & Rating
ED4, 1W-1W, rare! $
Penguin ★★★, AS list-H

Label **Decca SXL 6774 (SET 410-1)**
London CSA 2225, (=CS 6634, One of the CSA 2225)

J.S. Bach: <Brandenburg Concertos No.1, 2, 3>, The English Chamber Orchestra-Benjamin Britten. Recorded by Kenneth Wilkinson, December 1968 in the Maltings, Snape. ℗1969 ©1976

Remark & Rating
ED4, 2W-3W
Penguin ★★(★), (K. Wilkinson)

Label **Decca SXL 6775 (SET 410-1)**
London CSA 2225, (=CS 6634, One of the CSA 2225)

J.S. Bach: <Brandenburg Concertos No.4, 5, 6>, The English Chamber Orchestra-Benjamin Britten. Recorded by Kenneth Wilkinson, December 1968 in the Maltings, Snape. ℗1969 ©1976

Remark & Rating
ED4
Penguin ★★(★), (K. Wilkinson)

Label **Decca SXL 6776**
London CS 6993

Delibes: <Coppelia & Sylvia Highlights>, L'Orchestra de la Suisse Romande & New Philharmonia-Richard Bonynge. @1976 (Part of SXL 6635-6)

Remark & Rating
ED4

Label **Decca SXL 6777***
London CS 7003

Prokofiev: <Symphony No.6 in E-flat minor, Op.111>, London Philharmonic Orchestra-Walter Weller. Recorded by Kenneth Wilkinson, November 1975 in Kingsway Hall, London. @1976

Remark & Rating
ED4, 1W-3W, $
TASEC98 -TOP 12 Old, Penguin ★★, AS List (Speakers Corner), (K. Wilkinson)

Label **Decca SXL 6778 (SET 590-2)**
No London CS

J.S. Bach: <St. John Passion (Johannes-Passion) Highlights>, (Sung in German), Elly Ameling (Soprano), Julia Hamari (Mezzo Soprano), Dieter Ellenbeck (Tenor), Werner Hollweg (Tenor), Walter Berry (Bass Baritone), Hermann Prey (Baritone), Stuttgarter Hymnus-Chorknaben & Stuttgart Chamber Orchestra-Karl Münchinger. Recorded by Colin Moorfoot & Philip Wade, July & October 1974 in Schloss Ludwigsburg. ℗1975 ©1977

Remark & Rating
ED4, 1G-2G, Rare!
Penguin ★★(★)

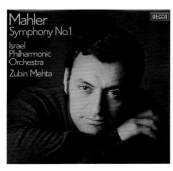

Label　Decca SXL 6779
　　　　London CS 7004

Mahler: <Symphony No.1 in D Major "The Titan">, The Israel Symphonic Orchestra-Zubin Mehta. Recorded by James Lock & Gordon Parry, 1974 in Binyanei Ha'ouma, Jerusalem. @1976

Remark & Rating
ED4, 2W-1W

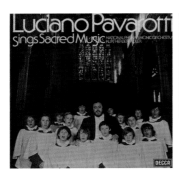

Label　Decca SXL 6781
　　　　London OS 26473

[Luciano Pavarotti Sings Sacred Music (O Holy Night)], with The Wandsworth Boys Choir; London Voices & National Philharmonic Orchestra-Kurt Herbert Adler. Recorded by James Lock, January 1976 at All Saints, Petersham. (4 pages text insert) @1976

Remark & Rating
ED4, 4G-1G
Penguin ★★(★)

Label　Decca SXL 6782
　　　　London CS 7006

[Overtures], Verdi: <The Force Of Destiny>; Beethoven: <The Creatures Of Prometheus>; Berlioz: <Roman Carnival>; Glinka: <Russlan and Ludmilla>; Brahms: <Academic Festival>; Rossini: <The Thieving Magpie>. The Cleveland Orchestra-Lorin Maazel. Recorded by Colin Moorfoot, August 1975 in the Masonic Hall, Cleveland. @1976

Remark & Rating
ED4, 1W-1W

Label　Decca SXL 6783 (Decca D 39D 4)
　　　　London CS 7007 (CSA 2405)

Brahms: <Symphony No.1 in C Minor, Op.68>, The Cleveland Orchestra-Lorin Maazel. @1976

Remark & Rating
ED4, 1W-1W, $
Penguin ★★(★)

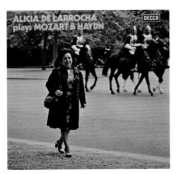

Label　Decca SXL 6784
　　　　London CS 7008

[Mostly Mozart, Vol. II], Mozart: <Piano Sonata in D Major, K.311 & in C Major, K.330>, <Fantasy in D Minor, K.397>; Haydn: <Andante & Varazioni in F Minor, Hob.XVII:6>, Alicia de Larrocha (piano). Recorded by Colin Moorfoot & Simon Eadon, Jan. 1976 in Kingsway Hall, London. @1976

Remark & Rating
ED4, 1A-2A
Penguin ★★★

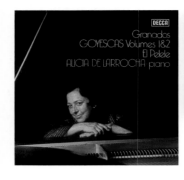

Label **Decca SXL 6785**
London CS 7009

Granados: <Goyescas Volumes 1 & 2>, <El Pelele (The Straw Doll)>, Alicia De Larrocha (piano). Recorded by Martin Smith, December 1976 in the Decca Studio. @1977

Remark & Rating
ED4, 1W-5W
Penguin ★★★

Label **Decca SXL 6786**
No London CS

Brahms: <Variations And Fugue On A Theme By Händel, Op.24>, <Fantasias, Op.116>, Pascal Rogé (piano). Recorded by Colin Moorfoot & Kenneth Wilkinson in Kingsway Hall, 1976 & 1977. @1978

Remark & Rating
ED4, 1V-3V
(K. Wilkinson)

Label **Decca SXL 6787**
No London CS

Prokofiev: <Symphony No.5 in B Flat Major, Op.100>, London Symphony Orchestra-Walter Weller. Recorded by Kenneth Wilkinson, February 1976 in Kingsway Hall, London. ℗ ©1977

Remark & Rating
ED4, 1W-2W, rare!
Penguin ★★(★), (K. Wilkinson)

Label **Decca SXL 6788**
No London CS

Britten: <A Birthday Hansel, Op.92>, <2 Scottish Folk Songs>, <Suite For Harp, Op.83>, <Canticle V - The Death Of Saint Narcissus, Op.89>, <Second Lute Song from "Gloriana", Op.53>, Peter Pears (tenor), Osian Ellis (harp). Recorded by Kenneth Wilkinson in The Maltings, Snape. @1976

Remark & Rating
ED4, 1A-1A
Penguin ★★★, (K. Wilkinson)

Label **Decca SXL 6789 (D92D 5)**
London CS 7012 (CSA 2501)

Beethoven: Violin Sonatas Volume 3, <No.3 in E Flat Major, Op.12 no.3 >, <No.8 in G Major, Op. 30 no.3>, Itzhak Perlman (violin), Vladimir Ashkenazy (piano). Recorded by John Dunkerley, August 1975 in Kingsway Hall, London. @1976

Remark & Rating
ED4, 1W-1W
Penguin ★★★

Label Decca SXL 6790 (D92D 5)
 London CS 7013 (CSA 2501)

Beethoven: Violin Sonatas Volume 4, <No.1 in D Major, Op.12 no.1>, <No.10 in G Major, Op.96>, Itzhak Perlman (violin), Vladimir Ashkenazy (piano). Recorded by John Dunkerley, August & November 1975 in Kingsway Hall, London. @1976

Remark & Rating
ED4, 3W-2W
Penguin ★★★

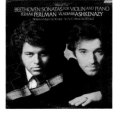

Label Decca SXL 6791 (D92D 5)
 London CS 7014 (CSA 2501)

Beethoven: Violin Sonatas Volume 5, <No.6 in A Major, Op.30 no.1> & <No.7 in C Minor, Op.30 no.2>, Itzhak Perlman (violin), Vladimir Ashkenazy (piano). Recorded by Colin Moorfoot, May 1974 in Kingsway Hall, London. @1976

Remark & Rating
ED4
Penguin ★★★

Label Decca SXL 6792 (=SXLR 6792)
 London OS 26435

[Romanzas de Zarzuelas, Music of Spain], Montserrat Caballe (soprano), Barcelona Symphony Orchestra-Eugenio Marco. Original recording of Discos Columbia, S.A, Spain, 1974 in Barcelona. ℗1974 ©1975

Remark & Rating
ED4, 1G-2K

Label Decca SXL 6793
 No London CS

Britten: <Folk Song Arrangements>, Peter Pears (tenor), Osian Ellis (harp). Recorded by Kenneth Wilkinson, March 1976 at the Maltings, Snape. ℗ ©1977

Remark & Rating
ED4, 1G-1G
Penguin ★★★, (K. Wilkinson)

Label Decca SXL 6794
 No London CS

Schubert: <Variations on a Original Theme in B Flat Major, Op.82 no.2, D.603>, <Grand Duo Sonata in C major, Op.140. D.812>, Bracha Eden and Alexander Tamir (2 pianos). Recorded by Colin Moorfoot, March 1976 in Kingsway Hall, London. @1977

Remark & Rating
ED4, 2W-2W

Label **Decca SXL 6795**
London CS 6984 (Part)

Elgar: <Enigma Variations, Op.36>, Chicago Symphony Orchestra (Recorded by James Lock in Medinah Temple, May 1974); <Overture Cockaigne (In London Town), Op.40>, London Philharmonic Orchestra conducted by Georg Solti. Recorded by Kenneth Wilkinson in Kingsway Hall, Februry 1976. @1976

Remark & Rating
ED4, 1W-1W
Penguin ★★★, (K. Wilkinson)

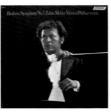

Label **Decca SXL 6796**
London CS 7017

Brahms: <Symphony No.1 in C Minor, Op.68>, The Vienna Philharmonic Orchestra-Zubin Mehta. Recorded by James Lock, February 1976 in the Sofiensaal, Vienna. ℗1977 ©1979

Remark & Rating
ED4, 1W-1W

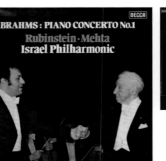
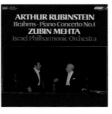

Label **Decca SXL 6797**
London CS 7018

Brahms: <Piano Concerto No.1 in D Minor, Op.15>, Artur Rubinstein (piano), The Israel Philharmonic Orchestra-Zubin Mehta. Recorded by James Lock, April 1976 in the Fredric R. Mann Auditorium, Tel Aviv. @1976

Remark & Rating
ED4, 6G-5G
Japan 300-CD

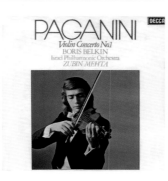

Label **Decca SXL 6798**
London CS 7019

Paganini: <Violin Concerto No.1 in D Major, Op.6>, Boris Belkin (violin), The Israel Philharmonic Orchestra-Zubin Mehta. Recorded by James Lock, April 1976 in the Fredric R. Mann Auditorium, Tel Aviv. @1977

Remark & Rating
ED4, 1W-1W
Penguin ★★★

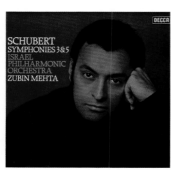

Label **Decca SXL 6799**
London CS 7020

Schubert: <Symphony No.3 in D Major, D.200>, <Symphony No.5 in B Flat Major, D.485>, The Israel Philharmonic Orchestra-Zubin Mehta. Recorded by James Lock, April 1976 in the Mann Auditorium, Tel Aviv. @1977

Remark & Rating
ED4, 1W-1W

Label **Decca SXL 6800**
London CS 7021

Hector Berlioz: <Romeo & Juliet (Orchestral excerpts)>, The Vienna Philharmonic Orchestra-Lorin Maazel. Recorded by Kenneth Wilkinson, Gordon Parry & Jack Law, December 1972 in the Sofiensaal, Vienna. @1977

Remark & Rating
ED4, 1G-2G
(K. Wilkinson)

Label **Decca SXL 6801**
London CS 7022

Chopin: "The Piano Music of Chopin, Volume 2", <Waltzs Op. 64 No.1-3 & Op. 63 No.2>, <Mazurkas Op. 63, 1-3; OP.67, 2&4, Op.68, No.4; OP.60, 61, 62>, Vladimir Ashkenazy (piano). Recorded by Kenneth Wilkinson & John Dunkerley, 1976 in All Saints Church, Petersham. @1977

Remark & Rating
ED4, 6A-1A
Penguin ★★★, (K. Wilkinson)

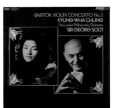

Label **Decca SXL 6802**
London CS 7023

Bartok: <Violin Concerto No. 2 in B Minor>, Kyung-Wha Chung (violin) with The London Philharmonic Orchestra-Georg Solti. Recorded by Kenneth Wilkinson, 1976 in Kingsway Hall, London. @1977

Remark & Rating
ED4, 3W-1W, $
(K. Wilkinson)

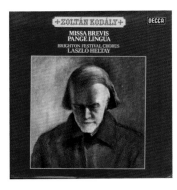

Label **Decca SXL 6803**
No London CS

Kodaly: <Missa Brevis>*, <Pange Lingua>, Brighton Festival Chorus-Laszlo Heltay. Recorded by Colin Moorfoot, 1975 & 1976 in Kingsway Hall, London. @1976 (*AS list JB 122 ='Missa Brevis')

Remark & Rating
ED4, 4G-3G
Penguin ★★★, AS list (JB 122)

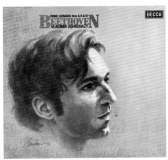
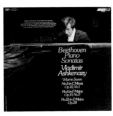

Label **Decca SXL 6804 (Decca D258D 12)**
London CS 7024 (CSP 11)

Beethoven: Piano Sonatas <No.5, Op.10 no.1 in C Minor>, <*No.6, Op.10 no.2 in F Major>, <No.15, Op.28 in D Major "Pastoral">, Vladimir Ashkenazy (piano). Recorded by John Dunkerley & *Kenneth Wilkinson, 1976 in All Saints Church, Petersham. ℗1977 ©1978

Remark & Rating
ED4, 1A-1A
Penguin ★★★, Japan 300-CD, (K. Wilkinson)

Label **Decca SXL 6805**
London OS 26574

[The Art of Regina Resnik], Arias from Carmen; Falstaff; Die Fledermaus; Die Walküre; Elektra; Il Trovatore; Don Carlo. Regina Resnik (mezzo-soprano) with Birgit Nilson, Fernando Corena & Waldemar Kmentt, the orchestra conducted by Edward Downes; Herbert von Karajan & Georg Solti. ℗1978 ©1979

Remark & Rating
ED4, 2G-1G

Label **Decca SXL 6806-7**
London CSA 2248

Mahler:<Symphony No.5 in C Sharp Minor>, <Adagio-Symphony No.10>, Los Angeles Philharmonic Orchestra-Zubin Mehta. Recorded by James Lock & Simon Eadon, April 1976 in Royce Hall UCLA. @1977

Remark & Rating
ED4, 4W-1W-2W-1W, $+
AS List

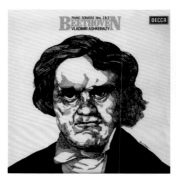

Label **Decca SXL 6808 (Decca D258D 12)**
London CS 7028 (CSP 11)

Beethoven: Piano Sonatas <No.2, Op.2 no.2 in A Major>, <No.3, Op.2 no.3 in C Major>, Vladimir Ashkenazy (piano). Recorded by Kenneth Wilkinson & John Dunkerley in Kingsway Hall, London. @1977

Remark & Rating
ED4, 1A-4A
Penguin ★★★, (K. Wilkinson)

Label **Decca SXL 6809 (Decca D258D 12)**
London CS 7029 (CSP 11)

Beethoven: Piano Sonatas <No.28, Op.101 in A Major>, <No.30, Op.109 in E Major>, Vladimir Ashkenazy (piano). Recorded by Kenneth Wilkinson & John Dunkerley in Kingsway Hall, London. ℗ by Christopher Raeburn @1977

Remark & Rating
ED4
Penguin ★★★, (K. Wilkinson)

Label **Decca SXL 6810**
London CS 7030

Chopin: "The Piano Music of Chopin, Volume 3", <Sonata No. 3 in B minor, Op.58>, <Berceuse in D flat op.57>, <3 Mazurkas Op.59, 2 Nocturnes, Op.55>. Vladimir Ashkenazy (piano). Recorded by John Dunkerley & Simon Eadon, 1975 & 1976 in Kingsway Hall, London. ℗1977 ©1978

Remark & Rating
ED4, 5A-5A
Penguin ★★★

Label **Decca SXL 6811**
London CS 7031

Bernstein: <Candide Overture>; Gershwin: <An American in Paris>; Copland: <Appalachian Spring>, Los Angeles Philharmonic Orchestra-Zubin Mehta. Recorded by James Lock, April 1976 in Royce Hall, UCLA. ℗ ©1976

Remark & Rating
ED4, 1W-1W
Penguin ★★★, AS List

Label **Decca SXL 6812**
London CS 7032

Meyerbeer: <Les Patineurs>; Massenet: <Le Cid>, National Philharmonic Orchestra-Richard Bonynge. Recorded by Kenneth Wilkinson, January 1975 in Kingsway Hall, London. ℗ ©1976

Remark & Rating
ED4
Penguin ★★★, AS List-H, (K. Wilkinson)

Label **Decca SXL 6813**
London CS 7033

Ravel: <Bolero>; Debussy: <La Mer> & <Prelude a L'apres-midi d'un faune>, Chicago Symphony Orchestra-Georg Solti. Recorded by Kenneth Wilkinson, May 1976 in the Medinah Temple, Chicago. @1977

Remark & Rating
ED4, 1W-1W
Penguin ★★(★), (K. Wilkinson)

Label **Decca SXL 6814**
London CS 7034

Tchaikovsky: <Symphony No.6 in B Minor, Op.74 "Pathetique">, Chicago Symphony Orchestra-Georg Solti. Recorded by Kenneth Wilkinson, May 1976 in the Medinah Temple, Chicago. @1977

Remark & Rating
ED4, 1W-1W
(K. Wilkinson)

Label **Decca SXL 6815**
No London CS

Bartok:<Piano Concerto No.1>, <Rhapsody for Piano & Orchestra Op.1>, Pascal Rogé (piano) with The London Symphony Orchestra-Walter Weller. Recorded by Kenneth Wilkinson & James Lock, 1974-1976 in Kingsway Hall, London. ℗ ©1977

Remark & Rating
ED4, 1W-2W
Penguin ★★(★), (K. Wilkinson)

Label **Decca SXL 6816**
No London CS

Bartok: <Piano Concertos No.2 & No.3>, Pascal Rogé (piano) with The London Symphony Orchestra-Walter Weller. Recorded by Kenneth Wilkinson & James Lock, 1974 & 1976 in Kingsway Hall, London. ℗ ©1977

Remark & Rating
ED4, 3K-1W
Penguin ★★, (K. Wilkinson)

Label **Decca SXL 6817**
No London CS

[Prosit! 150 Years of Josef Strauss], <Delirien Walzer>, <Jokey-Polka schnell>, <Heiterer Mut, Polka Francaise>, <Transactionen, Walzer>, <Feuerfest! Polka Francaise>, <Dorfschwalben aus Österreich, Walzer>, <Ohne Sorgen, Polka schnell>, <Im Fluge, Polka schnell>, <Mein Lebenslauf ist Lieb' und Lust, Waltzer>, <Plappermäulchen! Musikalischer Scherz, Polka schnell>. The Vienna Philharmonic Orchestra-Willi Boskovsky. Recorded by James Lock in the Sofiensaal, Vienna, 1976. @1976

Remark & Rating
ED4, 1W-1W
Penguin ★★★(❀)

Label **Decca SXL 6818**
London CS 7038

Mendelssohn: <Symphony No.1 in C Minor, Op.11> & <Symphony No.5 in D Minor, Op.107 "Reformation">, The Vienna Philharmonic Orchestra-Christoph von Dohnányi. Recorded by James Lock in the Sofiensaal, Vienna, 1976. @1977

Remark & Rating
ED4, 1W-1W
Penguin ★★(★)

Label **Decca SXL 6819**
London CS 7039

Schumann: <Symphony No.1 in B Flat Major, Op.38 "Spring">, < Symphony No.4 in D Minor, Op.120>, Vienna Philharmonic Orchestra-Zubin Mehta. Recorded Recorded by James Lock, June 1976 in the Sofiensaal, Vienna. ℗ by Christopher Raeburn @1977

Remark & Rating
ED4, 1W-1W
Penguin ★★★

Label **Decca SXL 6820**
No London CS

[Classics for Brass Band], Holst: <A Moorside Suite>; Ireland: <Comedy Overture>; Elgar: <The Severn Suite>; Bliss: <Kenilworth>, Grimethorpe Colliery Band-Elgar Howarth. Recorded by Michael Mailes, June 1976 in Huddersfield Town Hall. @1977

Remark & Rating
ED4, 1W-1W
Penguin ★★★

Label Decca SXL 6821
London CS 6890

Tchaikovsky: <Music from The Nutcracker, Op.71>, National Philharmonic Orchestra-Richard Bonynge. Highlights compiled by Ray Crick, recorded by James Lock, April 1974 in the Kingsway hall, London ℗1974 ©1978 (Complete Ballet recording is SXL 6688-9 or CSA 2239)

Remark & Rating
ED4, 1G-1G

Label Decca SXL 6822
London CS 7043

Respighi: Symphonic Poems <Feste romane (Roman Festival)>, <Pini di Roma (Pines Of Rome)>, Cleveland Orchestra-Lorin Maazel. Recorded by Kenneth Wilkinson, May 1976 in the Masonic Hall, Cleveland. @1977

Remark & Rating
ED4. 1W-1W, $$
TASEC ★★, Penguin ★★★, (K. Wilkinson)

Label Decca SXL 6823
London CS 7044

Franck: <Symphony in D Minor>, <Symphonic Variations for Piano & Orchestra>, Pascal Rogé (piano), The Cleveland Orchestra-Lorin Maazel. Recorded by Colin Moorfoot, May 1976 in Masonic Hall, Cleveland. @1977

Remark & Rating
ED4, 2W-2W
Penguin ★★(★)

Label Decca SXL 6824
London CS 7045

J.S. Bach: <Das Musikalishe Opfer-The Musical Offering>, Stuttgart Chamber Orchestra-Karl Münchinger. Recorded in July 1976 at Schloss Ludwigsburg by James Lock. @1977

Remark & Rating
ED4, 1W-2W
Penguin ★★

Label Decca SXL 6825 (SXLR 6825)
London OS 26497

[Montserrat Caballe Sings Arias], from <Macbeth>, <Il Trovatore>, <Cavalleria Rusticana>, <Turandot>, <La Wally>, <Gioconda>, <Andrea Chenier>. Barcelona Symphony Orchestra-Armando Gatto & Anton Guadagno. @1977

Remark & Rating
ED4, 1G-1G

Label Decca SXL 6826
 No London CS

[Grand Opera Choruses], Choruses from <Boris Godunov>; <Nabucco>; <Otello>; <Madama Butterfly>; <Die Meistersinger von Nürnberg>; <Tannhäuser>; <Parsifal>; <Fidelio>. Vienna State Opera Chorus & Vienna Philharmonic Orchestra with various conductors. ℗1961-1976 ©1977

Remark & Rating
ED4, 1G-1G, rare!! $
Penguin ★★★

Label Decca SXL 6827
 London CS 7048

[Richard Bonynge conducts Massenet], Scenes Alsaciennes, Scenes Dramatiques, Marches des Princesses from Cendrillon. National Philharmonic Orchestra-Richard Bonynge. Recorded by Kenneth Wilkinson in Kingway Hall. @1977

Remark & Rating
ED4, 1W-1W
Penguin ★★★, AS List-H, (K. Wilkinson)

Label Decca SXL 6828
 London OS 26449

[Joan Sutherland & Luciano Pavarotti Duets], <La Traviata>, <Sonnambula>, <Linda di Chamounix>,< Aida>, <Otello>. National Philharmonic Orchestra-Richard Bonynge. Recorded by Kenneth Wilkinson & James Lock in the Kingsway Hall, 1976. @1977

Remark & Rating
ED4
Penguin ★★★, (K. Wilkinson)

Label Decca SXL 6829 (11BB 188-96)
 London CS 7049 (CSP 9)

Beethoven: <Symphony No.3 in E Flat Major "Eroica", Op.55>, Chicago Symphony Orchestra-Georg Solti. Recorded by Kenneth Wilkinson & James Lock in the Medinah Temple, Chicago. ℗ 1975 © 1976

Remark & Rating
ED4, 1W-1W
Penguin ★★★, (K. Wilkinson)

Label Decca SXL 6830 (11BB 188-96)
 London CS 7050 (CSP 9)

Beethoven: <Symphony No.4 in B Flat Major, Op.60>; Weber: <Oberon Overture>, Chicago Symphony Orchestra-Georg Solti. Recorded by Kenneth Wilkinson & James Lock in the Medinah Temple, Chicago. ℗ 1975 © 1976

Remark & Rating
ED4
Penguin ★★(★), (K. Wilkinson)

Label Decca SXL 6831
London CS 7051

Brahms: Piano Pieces Op. 118 - <No.1, Intermezzo in A Minor & No.2 in A Major>, <No.3, Ballade in G Minor>, <No.4, Intermezzoin F Minor>, <No.5, Romanze in F Major>, <No.6, Intermezzo in E Flat Minor>; Piano Pieces Op. 119 - <No.1, Intermezzo in B Minor; No.2, in E Minor; No.3, in C Major>, <No.4, Rhapsody in E Flat Major>; <Rhapsody in G Minor, Op.79, No.2>, Radu Lupu (piano). Recotrded by Colin Moorfoot, July 1976 in Kingsway Hall, London. ℗1978

Remark & Rating
ED4, 1G-2V
Penguin ★★★

Label Decca SXL 6832
London OS 26433

Rachmaninov: <Songs Volume 3>, Elizabeth Soderstrom (soprano) and Vladimir Ashkenazy (piano). Recorded by Kenneth Wilkinson, 1976 at all Saints Church, Petersham & Decca Studio. ℗ ©1977

Remark & Rating
ED4, 2A-1A
Penguin ★★★, (K. Wilkinson)

Label Decca SXL 6833
London CS 7055

Mozart: <Symphony No.34 in C Major> & <No.39 in E Flat Major>, The Israel Philharmonic Orchestra-Zubin Mehta. Recorded by James Lock, 1974 & 1976 in Binyanei Ha'ouma, Jerusalem. @1977

Remark & Rating
ED4, 1W-1W

Label Decca SXL 6834 (Decca D 39D 4)
London CS 7094 (CSA 2405)

Brahms: <Symphony No.2 in C Minor, Op.73>, <Tragic Overture, Op.81>, The Cleveland Orchestra-Lorin Maazel. Recorded by Colin Moorfoot in the Masonic Hall, Cleveland. @1977

Remark & Rating
ED4, 2G-1G

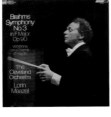

Label Decca SXL 6835 (Decca D 39D 4)
London CS 7095 (CSA 2405)

Brahms: <Symphony No.3 in F Major, Op.90>, <Variations on a Theme of Haydn, Op.56a>, The Cleveland Orchestra-Lorin Maazel. Recorded by Colin Moorfoot in the Masonic Hall, Cleveland. @1977

Remark & Rating
ED4, 1G-1G

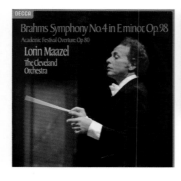

Label **Decca SXL 6836 (Decca D 39D 4)**
London CS 7096 (CSA 2405)

Brahms: <Symphony No.4 in E Minor, Op.98>, <Academic Festival Overture, Op.80>, The Cleveland Orchestra-Lorin Maazel. Recorded by Colin Moorfoot in the Masonic Hall, Cleveland. @1977

Remark & Rating
ED4, 1G-1G

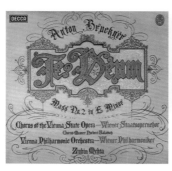

Label **Decca SXL 6837**
London OS 26506

Bruckner: <Te Deum>, <Mass No.2 in E Minor>. Judith Blegen, Margarita Lilova, Chorus of the Vienna State Opera & Vienna Philharmonic Orchestra-Zubin Mehta. Recorded by James Lock in the Sofiensaal, Vienna. ℗ by Christopher Raeburn @1977

Remark & Rating
ED4, 2G-1G

Label **Decca SXL 6838**
London CS 7061

Shostakovich: <Symphony No.10 in E minor>, London Philharmonic Orchestra-Bernard Haitink. Recorded by Colin Moorfoot, January 1977 in Kingsway Hall, London. ℗ ©1977

Remark & Rating
ED4, 1W-2W, $
Penguin ★★(★), AS list-H

Label **Decca SXL 6839**
London OS 26510

[The Art of Pavarotti], Arias from L'Elisir d'Amore, Maria Stuarda, Fille du Regiment, Lucia, Verdi Requiem, Rigoletto, Turandot, Un Ballo in Maschera, Rossini Stabat Mater, Macbeth, recorded from 1968-76. @1977

Remark & Rating
ED4, 3G-1G
Penguin ★★★

Label **Decca SXL 6840**
No London CS

Tchaikovsky: <Piano Concerto No.1>, (produced in 1963, Original issue is SXL 6058=CS 6360); Mussorgsky: <Pictures at an Exhibition>, (produced in 1967), Vladimir Ashkenazy (piano), London Symphony Orchestra-Lorin Maazel. @1977

Remark & Rating
ED4, 3W-8W
Penguin ★★★

Label **Decca SXL 6841**
London OS 26524

[Presenting Sylvia Sass (Opera's Sensational New Star)], Aarias from Turandot, Tosca, Manon Lescaut, Butterfly, Aida, Macbeth, Lombardi, London Symphony Orchestra-Lamberto Gardelli. Recorded by Colin Moorfoot at Kingsway Hall, London. ℗ by Christopher Raeburn @1977

Remark & Rating
ED4, 1G-3G

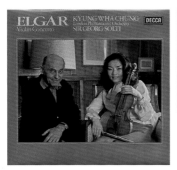

Label **Decca SXL 6842**
London CS 7064

Elgar: <Violin Concerto in B Minor>, Kyung-Wha Chung (violin) with The London Philharmonic Orchestra-Georg Solti. Recorded by Kenneth Wilkinson, February 1977 in Kingsway Hall, London. ℗ by Christopher Raeburn ©1978

Remark & Rating
ED4, 1Y-2Y
(K. Wilkinson)

Label **Decca SXL 6843**
London CS 7065

[Showcase], <Overtures & Preludes from Rossini, Verdi, Weber>; <Nocture & Scherzo, Op.61, No.7, No.1 from Mendelssohn>, The Israel Philharmonic Orchestra-Zubin Mehta. Recorded by James Lock, Feb. 1977 in The Mann Auditorium, Tel Aviv. ℗ by Christopher Raeburn @1978

Remark & Rating
ED4, 2F-2F

Label **Decca SXL 6844**
London CS 7066

Mozart: <Symphony No.40 in G Minor, K.550>, <Eine Kleine Nachtmusik>, The Israel Philharmonic Orchestra-Zubin Mehta. Recorded by James Lock, Feb. 1977 in The Mann Auditorium, Tel Aviv. @1978

Remark & Rating
ED4, 1G-3Y

Label **Decca SXL 6845**
London CS 7067

Schubert: <Symphony No.4 "Tragic">, < Symphont No.8 "Unfinished">, The Israel Philharmonic Orchestra-Zubin Mehta. Recorded by James Lock in the Mann Auditorium, Tel Aviv. @1978

Remark & Rating
ED4, 4V-4V

Label **Decca SXL 6846**
No London CS

Respighi: <Ancient Airs & Dances Suites Nos.1, 2 & 3>, London Philharmonic Orchestra-Jesus Lopez-Cobos. Recorded by James Lock & John Pellowe, November 1978 in Kingsway Hall, London. ℗1979 ©1980

Remark & Rating
ED4
AS list-H

Label **Decca SXL 6847**
London OS 26527

Britten: <Prelude & Fugue Op.29>, <Phaedra, Op.93>, <Sacred and profane, eight medieval lyrics, op. 91>, <A Wealden Trio>, <Sweet was the Song>, <The Sycamore Tree>, <A shepherd's carol>, Janet Baker (mezzo-soprano) with The Wilbye Consort-Peter Pears (conductor) & English Chamber Orchestra-Bejamin Britten. Recorded by Kenneth Wilkinson, John Dunkerley & Simon Eadon. ℗ ©1977

Remark & Rating
ED4, 3G-3G
Penguin ★★★, AS List, (K. Wilkinson)

Label **Decca SXL 6848**
London CS 7072

Elgar: <Pomp & Circumstance Military Marches, Op.30, No.1-No.5>, <Overture Cockaigne (In London Town), Op.40>, <The National Anthem "God Save The Queen">, London Philharmonic Orchestra-Georg Solti. Recorded by Kenneth Wilkinson, 1976-1977 in Kingsway Hall, London. @1977

Remark & Rating
ED4, 1W-2W
Penguin ★★★, (K. Wilkinson)

Label **Decca SXL 6849**
No London CS

Shostakovitch: <Suite on Poems of Michelangelo, Op.145, (Truth; Morning; Love; Separation; Anger; Dante; To the Exile; Creativity; Night; Death; Immortality)>. Sung in Russian, John Shirley-Quirck (baritone), Vladimir Ashkenazy (piano). Recorded by Kenneth Wilkinson & John Dunkerly in St. John's Smith Square, London, Oct. 1976 and Apr. 1977. @1978

Remark & Rating
ED4, 1G-1G
(K. Wilkinson)

Label **Decca SXL 6851**
London CS 7073

Chausson: <Poème, Op.25>; Saint-Saëns: <Introduction and Rondo Capriccioso, Op.28>, <*Havanaise Op.83>; Ravel: <*Tzigane>. Kyung-Wha Chung (violin), Royal Philharmonic Orchestra-Charles Dutoit. Recorded by Colin Moorfoot & *Kenneth Wilkinson, April 1977 in Kingsway Hall, London. ℗1978 ©1979

Remark & Rating
ED4, 3G-2G, rare!
Penguin ★★★, (K. Wilkinson)

Label Decca SXL 6852
No London CS

Prokofiev: <Symphony No.3 in C Minor, Op.44>, <Scythian Suite "Ala Et Lolly" Op.20>, London Philharmonic Orchestra-Walter Weller. Recorded by Kenneth Wilkinson, March & April 1977 in Kingsway Hall, London. @1978

Remark & Rating
ED4, 1G-2Y
(K. Wilkinson)

Label Decca SXL 6853 (Decca D249D 4)
London CS 7075

Tchaikovsky: <Manfred Symphony on Byron's Drama Op.58>, The New Philharmonia Orchestra-Vladimir Ashkenazy. Recorded by Kenneth Wilkinson, 1977 in Kingsway Hall, London. @1978

Remark & Rating
ED4, 4Y-4Y
AS list-H, (K. Wilkinson)

Label Decca SXL 6854
London CS 7076

Tchaikovsky: <Violin Concerto in D Major>, <Valse-Scherzo, Op.34>, Boris Belkin (violin), New Philharmonia Orchestra-Vladimir Ashkenazy. Recorded by Kenneth Wilkinson, 1977 in Kingsway Hall, London. @1977

Remark & Rating
ED4, 1W-1W
AS List, (K. Wilkinson)

Label Decca SXL 6855
No London CS

Debussy: "Piano Works Volume 1", <Pour le piano>, <Mazurka>, <Deux arabesques>, <Suite bergamasque>, <Reveries>, <Estampes>, <Danse bohémienne>. Pascal Rogé (piano). Recorded by Colin Moorfoot, May 1977 in Kingsway Hall, London. @1978

Remark & Rating
ED4, 1G-2G
Penguin ★★★

Label Decca SXL 6856
London CS 7078

Wagner: <The Flying Dutchman, Overture>, <Tannhäuser, Overture>, <Die Meistersinger, Prelude>, <Tristan und Isolde, Prelude and Liebestod>, Chicago Symphony Orchestra-Georg Solti. Recorded by Kenneth Wilkinson in 1977, 1976 & 1972. @1978

Remark & Rating
ED4, 3G-1G
Penguin ★★★, AS list-H, (K. Wilkinson)

Label Decca SXL 6857
 London CS 7080

Tchaikovsky: <Suite No.3 in G Major, Op.55>, The Vienna Philharmonic-Lorin Maazel. Recorded by James Lock, 1977 in the Sofiensaal, Vienna. @1978

Remark & Rating
ED4, 3G-1G, rare!

Label Decca SXL 6858
 No London CS

[Luciano Pavarotti Sings Duets], with Montserrat Cabelle, Mirella Freni, Joan Sutherland, Renata Tebaldi, Rolando Panerai & Nicolai Ghiarov. @1979

Remark & Rating
ED4, 3G-2G

Label Decca SXL 6859
 No London CS

[The Art of Nicolai Ghiaurov], Arias from Faust, Boris Godunov, Il Barbiere di Siviglia, Eugene Onegin, I Puritani, Lucia di Lammermoor, Don Carlo, Mephistopheles, La Boheme. @1979

Remark & Rating
ED4, 2G-2G

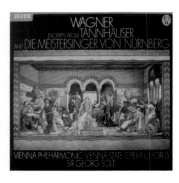

Label Decca SXL 6860
 No London CS

Wagner: "Excerpts from Tannhäuser & Die Meistersinger von Nürnberg", <Tannhäuser: Overture & Venusberg Music; Pilgrims' Chorus>, <Die Meistersinger: Overture And Chorale; Prelude; Dance Of The Apprentices···>, The Vienna Philharmonic Orchestra-Georg Solti. ℗1971 & 1976 ©1979

Remark & Rating
ED4

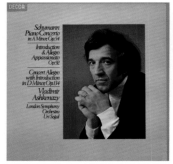

Label Decca SXL 6861
 London CS 7082

Schumann: <Piano Concerto In A Minor, Op.54>, <Introduction And Allegro Appassionato, Op.92>, <Concert Allegro With Introduction In D Minor, Op.134>, Vladimir Ashkenazy (piano) with The London Symphony Orchestra-Uri Segal. Recorded by Kenneth Wilkinson in 1976-77, ℗1978 by Christopher Raeburn

Remark & Rating
ED4, (ED5, 1Y-6G)
Penguin ★★★, (K. Wilkinson)

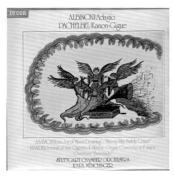

Label **Decca SXL 6862**
London CS 7102

Albinoni: <Adagio>; Pachelbel: <Kanon-Gigue>, J.S.Bach: <Cantatas> & Handel: <Organ Concerto in F, Op.4>, Stuttgart Chamber Orchestra-Karl Münchinger. Recorded by John Dunkerley, October 1977 in the Evangelisches Schlosskirche, Ludwigsburg, Germany. @1978

Remark & Rating
ED4, 1G-1G

Label **Decca SXL 6863**
London CS 7084

Liszt: Symphonic Poems, <Prometheus, No.5, G.99>, <Les Preludes, No.3, G.97>, <Festklänge, No.7, G.101>, London Philharmonic Orchestra-Georg Solti. Recorded by Kenneth Wilkinson, April & June 1977 in Kinghsway Hall, London. @1978

Remark & Rating
ED4
Penguin ★★★, AS List-H, (K. Wilkinson)

Label **Decca SXL 6864**
London OS 26557

[Maria Chiara Sings Arias], from Adriana Lecouvreur, Andrea Chénier, L'amico Fritz, La wally, Loreley, Iris, National Philharmonic Orchestra-Kurt Herbert Adler. ℗1977 ©1978

Remark & Rating
ED4, 3W-3W

Label **Decca SXL 6865**
London CS 7085

[Mostly Mozart, Vol.III], Mozart: <Piano Sonata_ in F Major, K.332>. <Sonata in C Major, K.545>, <Sonata in D Major, K.576>; Bach-Cohen: <Beloved Jesu, We are here>, <Sancity us thy goodness>, Piano-Alica De Larrocha. Recorded by Colin Moorfoot, June 1977 in Kingsway Hall, London. @1978

Remark & Rating
ED4, 2G-1W

Label **Decca SXL 6866**
London OS 26558

[Granados Spanish Songs], Tonadillas & Canciones "Amatorias", Granados: <9 Tonadillas, 3 Majas Dolorosas & 6 Canciones Amatorias>. Pilar Lorengar (soprano), Alicia de Larrocha (piano). Recorded by John Dunkerley, 1977 in The Rosslyn Hill Chapel. @1978

Remark & Rating
ED4, 1Y-1Y

Label **Decca SXL 6867**
 London CS 7086

Johann Strauss: <Graduation Ball, (Ballet in One Act)>, arranged by Dorati, The Vienna Philharmonic Orchestra-Antal Dorati. Recorded by James Lock & Colin Moorfoot. @1978

Remark & Rating
ED4, 1G-1G

Label **Decca SXL 6868**
 London CS 7087

Scriabin: Piano Sonatas <No.2 "Sonata Fantasy", Op.19>; <No.7 "White Mass", Op.64>; <*No.10, Op.70>, <Quatre Morceaux Op.56>, <Deux Poemes Op.32>, <Two Dances Op.73>. Vladimir Ashkenazy (piano). Recorded by John Dunkerley, June 1977 in Kingsway Hall, London & *All Sant's Church, Petersham. @1978

Remark & Rating
ED4, 2Y-1Y
Penguin ★★★

Label **Decca SXL 6869**
 London OS 26559

Rachmaninov: <Songs Volume 4>, Elizabeth Soderstrom (soprano) and Vladimir Ashkenazy (piano). Recorded by Colin Moorfoot, June 1977 in Rosslyn Hill Chapel. ℗ ©1978

Remark & Rating
ED4, I1-U1
Penguin ★★★

Label **Decca SXL 6870**
 London OS 26560

[O Solo Mio - Pavarotti], Favourite Neapolitan Songs, Luciano Pavarotti (tenor) with Orchestra of the Teatro communale, Bologna-Anton Guadagno & National Philharmonic Orchestra-Gian Carlo Chiaramello. Recorded by Colin Moorfoot, Andrew Pinder & Martin Atkinson, 1977 in Bologna & 1979 in Kingsway Hall, London. ℗ ©1979

Remark & Rating
ED4, 3G-2G
Penguin ★★★

Label **Decca SXL 6871 (Decca D258D 12)**
 London CS 7088 (CSP 11)

Beethoven: Piano Sonatas <No.17, Op.31 no.2 in D Minor "Tempest">, <No.18, Op.31 no.3 in E-Flat Major "The Hunt">, Vladimir Ashkenazy (piano). @1978

Remark & Rating
Penguin ★★★

Label **Decca SXL 6872**
No London CS

Percy Grainger: <Salute to Percy Grainger Vol. 2>, with Peter Pears, John Shirley-Quirk, Anna Reynolds, Wandsworth Boys Choir, Linden Singers & English Chamber Orchestra-Steuart Bedford. Recorded by Kenneth Wilkinson, 1972 & 1976 in the Maltings, Snape, Suffolk. @1978

Remark & Rating
ED4, 4Y-2Y
(K. Wilkinson)

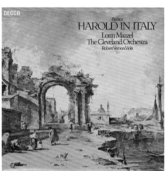

Label **Decca SXL 6873**
London CS 7097

Berlioz: <Harold In Italy>, Robert Vernon (viola), The Cleveland Orchestra-Lorin Maazel. Recorded in the Masonic Auditorium, Cleveland by Colin Moorfoot. @1978

Remark & Rating
ED4, 1G-1G

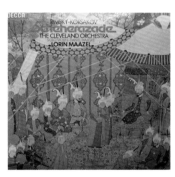

Label **Decca SXL 6874**
London CS 7098

Rimsky-Korsakov: <Scheherazade>, Daniel Majeske (solo violin), The Cleveland Orchestra-Lorin Maazel. Recorded by Colin Moorfoot, October 1977 in the Masonic Hall, Cleveland. @1978

Remark & Rating
ED4, 1G-1G, rare! $
AS list-H

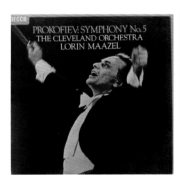

Label **Decca SXL 6875**
London CS 7099

Prokofiev: <Symphony No.5 in B Flat, Op.100>, The Cleveland Orchestra-Lorin Maazel. Recorded by Colin Moorfoot, Oct. 1977 in the Masonic Auditorium, Cleveland. ℗ ©1978

Remark & Rating
ED4, 1G-2Y, rare! $+
AS List

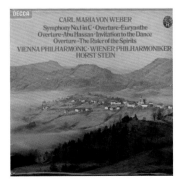

Label **Decca SXL 6876**
No London CS

Weber: <Symphony No.1 in C Major>, Overtures <Euryanthe>; <The Ruler of the Spirits>; <Abu Hassan>, <Invitation to the Dance, Op.65>, The Vienna Philharmonic Orchestra-Horst Stein. Recorded by Stanley Goodall, October 1977 in the Sofiensall, Vienna. @1978

Remark & Rating
ED4, 1G-2G

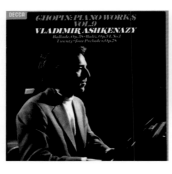

Label **Decca SXL 6877**
London CS 7101

Chopin: "The Piano Music of Chopin, Volume 9", <Ballade No.2, Op.38>, <Grande Valse Brillante Op.34>, <24 Preludes Op.28>, Vladimir Ashkenazy (piano). Recorded by Kenneth Wilkinson & John Dunkerley. @1978

Remark & Rating
ED4
Penguin ★★★, (K. Wilkinson)

Label **Decca SXL 6878**
No London CS

Kodaly: <Hymn of Zrinyi (for baritone solo & Mixed Chorus a cappella)>, Benjamin Luxon (baritone), <Psalm 114>, <Laudes Organi (for mixed Chorus & Organ), Gillian Weir (organ), Brighton Festival Chorus-Laszlo Heltay. Recorded by Stanley Goodall, November 1977 in Guildford Cathedral. @1978

Remark & Rating
ED4, 1G-3V

Label **Decca SXL 6879**
London CS 7103

Mozart: <Symphony No.25 G Minor K.183> & <No.29 in A Major K.201>, English Chamber Orchestra-Benjamin Britten. Recorded by Kenneth Wilkinson, February & September 1971 in the Maltings, Snape. @1978.

Remark & Rating
ED4, $
Penguin ★★★, Gramophone, (K. Wilkinson)

Label **Decca SXL 6880**
No London CS

[Star Wars], John Williams: <Star Wars-Suite from 20th Century-Fox Film>, Richard Strauss: <2001>, Gustav Holst: <Jupiter & Mars from 'The Planets'>, Los Angeles Philharmonic Orchestra-Zubin Mehta. @1978

Remark & Rating
ED4, 1Y-2Y

Label **Decca SXL 6881**
London CS 7104

Mozart: Piano Concertos <No.17, K.453 & No.21, K.467>, Vladimir Ashkenazy (piano), Philharmonia Orchestra-Vladimir Ashkenazy. Recorded by Kenneth Wilkinson & Andrew Pinder, December 1977 in the Kingsway Hall, London. @1979

Remark & Rating
ED4, 1G-5G
Penguin ★★★, (K. Wilkinson)

Label **Decca SXL 6882**
No London CS

Bartok: <The Miraculous Mandarin, Op.19>, <Two Portraits, Op.5>, The Vienna Philharmonic Orchestra-Christoph Von Dohnanyi. Recorded by Colin Moorfoot, John Pellowe & James Brown, 1977 &1979 in the Sofiensaal, Vienna. @1981

Remark & Rating
ED4

Label **Decca SXL 6883**
London CS 7106

Stravinsky: <Petrouchka - Burlesque in Four Parts (Revised 1947 version)>, The Vienna Philharmonic Orchestra-Christoph Von Dohnanyi. Recorded by Colin Moorfoot, December 1977 in the Sofiensaal, Vienna. @1978

Remark & Rating
ED4, 1G-1G

Label **Decca SXL 6884 (Decca D249D 4)**
London CS 7107

Tchaikovsky: <Symphony No.5 in E Minor, Op.64>, Philharmonia Orchestra-Vladimir Ashkenazy. Recorded by Kenneth Wilkinson, December 1977. @1978

Remark & Rating
ED4, 2G-2G
Penguin ★★★, AS List, (K. Wilkinson)

Label **Decca SXL 6885 (©=SDD 275)**
London ZM 1001

John Williams: <Suite From "Star Wars">, <Suite from "Close Encounters Of The Thrid Kind">, Los Angeles Philharmonic Orchestra-Zubin Mehta. @1978

Remark & Rating
ED4, 1Y-2Y

Label **Decca SXL 6886**
London CS 7108

Beethoven: <Piano Concerto No.4 in G Major, Op.58>, <Sonatas No.19 & No.20, Op.49, Nos. 1 & 2>, Ladu Lupu (piano), The Israel Philharmonic Orchestra-Zubin Mehta. Recorded by Simon Eadon, February 1977 in the Mann Auditorium, Tel Aviv. ℗©1978 [** Lupu's another Beethoven Concertos with Mehta: (No. 1 & 2 in SXDL 7502 (LDR 10006), Penguin ★★★); (No.3, SXDL 7507 (LDR 71005), Penguin ★★(★) & (No.5, SXDL 7503 (LDR 10005), Penguin ★★(★)]

Remark & Rating
ED4, 1G-1G

Label **Decca SXL 6887**
London CS 7109

Mozart: <Piano Concerto No.25 in C Major, K.503> & <No. 27 in B Flat Major, K.595>, Alicia de Larrocha (piano), London Philharmonic Orchestra-Georg Solti. Recorded by Kenneth Wilkinson, December 1977 in Kingsway Hall, London. ℗ ©1978

Remark & Rating
ED4, 2G-3G
(K. Wilkinson)

Label **Decca SXL 6888 (=SXLR 6888)**
London OS 26575

[Montserrat Caballe - Falla Seven Popular Spanish Songs], The Maiden and the Nightingale & other Songs by Granados and Turina, Montserrat Caballe (soprano) with Miguel Zanetti (piano). ℗1978 ©1979

Remark & Rating
ED4, Test pressing, 1Y-1Y
Penguin ★★★

Label **Decca SXL 6889 (Decca D258D 12)**
London CS 7111 (CSP 11)

Beethoven: Piano Sonatas <No.13, Op.27 no.1 in E-Flat Major "quasi una fantasia">, <No.14, Op.27 no.2 in C-Sharp Minor "Moonlight">, <No.16, Op.31 in G Major>, Vladimir Ashkenazy (piano). @1979

Remark & Rating
ED4, 1G-4G
Penguin ★★★

Label **Decca SXL 6890 (Decca D151D 4)**
London CS 7201, ED5 (CSA 2406)

Brahms: <Symphony No.4 in E Minor, Op.98>, Chicago Symphony Orchestra-George Solti. Recorded by Kenneth Wilkinson & Colin Moorfoot in Medinah Temple, Chicago. ℗ ©1978

Remark & Rating
ED4, 1G-1G
Penguin ★★★, Grammy, (K. Wilkinson)

Label **Decca SXL 6891**
London CS 7115

Schubert:< Symphony No.6>, <Die Zauberhafe Overture>, <Rosamunde Excerpts>, The Israel Philharmonic Orchestra-Zubin Mehta. Recorded by James Lock in the Mann Auditorium, Tel Aviv. ℗ ©1979

Remark & Rating
ED4, 1W-3W

Label **Decca SXL 6892**
London CS 7114

Schubert: <Symphony No.1 in D Major, D.82>, <Symphony No.2 in B-Flat, D.125>, The Israel Philharmonic Orchestra-Zubin Mehta. Recorded by James Lock in the Mann Auditorium, Tel Aviv. Ⓟ ©1979

Remark & Rating
ED4, 2G-1G

Label **Decca SXL 6893**
No London CS

Britten: <String Quartet No.3, Op.94>, Recorded by Kenneth Wilkinson, March 1978 in the Maltings, Snape, Suffilk. <String Quartet No.2 in C, Op.36>** , (**Recorded in association with the British Council in 1963, 1st issued is Decca ARGO ZRG 5372=London CS 6370, Ⓟ1963). The Amadeus Quartet - Norbert Brainin & Sigmund Nissel (violins), Peter Schidlof (viola), Martin Lovett (cello). Ⓟ ©1978

Remark & Rating
ED4, 2Y-6Y
Penguin ★★★, (K. Wilkinson)

Label **Decca SXL 6894**
No London CS

Tchaikovsky: <Symphony No.6 in B Minor, Op.74 "Pathetique">, Royal Philharmonic Orchestra-Kazimierz Kord. Recorded by Arthur Lilley, 1978 in the Kingsway Hall, London. @1979

Remark & Rating
ED4, 1G-1G, rare! $

Label **Decca SXL 6895**
London CS 7118

Tchaikovsky: 1812 Overture, Capriccio Italien, Marche Slave, Detroit Symphony Orchestra-Antal Dorati. Recorded by Colin Moorfoot, 1978 in the United Artists Auditorium, Detroit. Ⓟ1978

Remark & Rating
ED4, 1B-1B

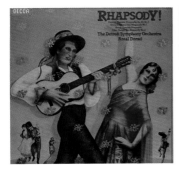

Label **Decca SXL 6896**
London CS 7119

[Rhapsody!], Dvorak: <Slavonic Rhapsody Op.45 No.3>; Enesco: <Roumanian Rhapsody No.1>; Ravel: <Spanish Rhapsody> & Liszt: <Hungarian Rhapsody No.2>, The Detroit Symphony Orchestra-Antal Dorati. Recorded by Kenneth Wilkinson, Colin Moorfoot & David Frost, April 1978 in the United Artist's Auditorium, Detroit. @1979

Remark & Rating
ED4, 2G-3G
Penguin ★★★, (K. Wilkinson)

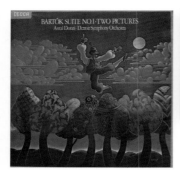

Label **Decca SXL 6897**
London CS 7120

Bartok: <Suite No.1, Op.3>, <Two Pictures, Op.10>, The Detroit Symphony Orchestra-Antal Dorati. Recorded by Kenneth Wilkinson, Colin Moorfoot & David Frost, April 1978 in the United Artist's Auditorium, Detroit. @1979

Remark & Rating
ED4, 1G-1G
AS List-H, (K. Wilkinson)

Label **Decca SXL 6898**
London OS 26578

Mahler: <Lieder eines Fahrenden Gesellen (Songs of a Wayfarer)> & <Five Rückert Songs>. Marilyn Horne with The Los Angeles Philharmonic-Zubin Mehta. Recorded by James Lock & Simon Eadon, March 1978 in Royce Hall, U.C.L.A. ℗ ©1979

Remark & Rating
ED4

Label **Decca SXL 6899**
London CS 7121

Beethoven: <Piano Concerto No.5 in Eflat Major, Op.73 "Emperor">, Alicia de Larrocha (piano), Los Angeles Philharmonic-Zubin Mehta. Recorded by Simon Eadon, James Lock & Michael Mailes, 1978 in Royce Hall, UCLA. @1979

Remark & Rating
ED4, 1G-1G
Penguin ★★(★)

Label **Decca SXL 6900**
London OS 26579

[Elisabeth Soderstrom Sings Songs for Children], Mussorgsky: <The Nursery-Song Cycle>; Prokofiev: <The Ugly Duckling, Op.18>; Grechaninov: <The Lane (5 Children's Songs), Op.89. Vladimir Ashkenazy (piano). Recorded by C.Moorfoot, R.Beswick, J.Walker & S.Eadon. @1979

Remark & Rating
ED4, 3Y-3Y
Penguin ★★★

Label **Decca SXL 6901**
No London CS

Grieg: <Incidental Music From Peer Gynt>, Royal Philharmonic Orchestra-Walter Weller. Recorded by John Dunkerley in the Kingsway Hall, London.℗ ©1979

Remark & Rating
ED4, 1G-1G
Penguin ★★(★)

Label Decca SXL 6902 (Decca D151D 4)
 London CS 7200, (ED4) (CSA 2406)

Brahms: <Symphony No.3 in F Major, Op.90>, <Academic Festival Overture, Op.80>, Chicago Symphony Orchestra-Georg Solti. Recorded by Kenneth Wilkinson, Colin Moorfoot & Michael Mailes, January 1979 in the Medinah Temple, Chicago. ℗ ©1979

Remark & Rating
ED4, rare!
Penguin ★★★, Grammy, (K. Wilkinson)

Label Decca SXL 6903
 London CS 7127, (ED5)

Bizet: <L'arlesienne suites 1 & 2>, <Jeux d'enfants>, The Cleveland Orchestra-Lorin Maazel. Recorded by Colin Moorfoot, Stanley Goodall, Andrew Pinder & Martin Atkinson in the Masonic Auditorium, Cleveland. @1980

Remark & Rating
ED5, 2G-2G

Label Decca SXL 6904
 London CS 7128, (ED4)

Debussy: <Nocturnes - Nuages; Fetes; Sirenes>, <Iberia (Images no.2) - Par les rues et par les chemins; Les parfums de la nuit; Le matin d'un jour de fete>, <Jeux>, The Cleveland Orchestra-Lorin Maazel. Recorded by Colin Moorfoot, Stanley Goodall & Andrew Pinder, May 1978 in the Masonic Auditorium, Cleveland. ℗ ©1979

Remark & Rating
ED4, 1G-1G
AS List-H

Label Decca SXL 6905
 London CS 7129, (ED4)

Debussy: <La Mer>; Scriabin: <Le Poème de L'Extase, Op.54>, The Cleveland Orchestra-Lorin Maazel. @1979

Remark & Rating
ED4, 5G-4G

Label Decca SXL 6906
 London CS 7130, (ED4)

Shostakovich: <Symphony No.15 in A Major>, London Philharmonic Orchestra-Bernard Haitink. Recorded by Colin Moorfoot, March 1978 in Kingsway Hall, London. @1979

Remark & Rating
ED4, 1G-2G
Penguin ★★★(❀), AS list

Label **Decca SXL 6908**
No London CS

Prokofiev: <Symphony No.4, Op.47/112>, <*Russian Overture, Op.72>, London Philharmonic Orchestra-Walter Weller. Recorded by Kenneth Wilkinson & *John Dunkerley, Nov. 1977 & *1978 in the Kingsway Hall, London. ℗ ©1979

Remark & Rating
ED4, 1G-3G, $
AS List, (K. Wilkinson)

Label **Decca SXL 6909**
London CS 7133, (ED4)

[Overture], Overtures from Nicolai, Schreker, Wolf, Weber, Mahler, Goldmark, Goetz, National Philharmonic Orchestra-Kurt Herbert Adler. Recorded by Kenneth Wilkinson in the Kingsway Hall, 1978. ℗1978 ©1980

Remark & Rating
ED4, 2G-1G
(K. Wilkinson)

Label **Decca SXL 6910**
London CS 7134, (ED4)

Schumann: <Carnaval, Op.9_>; Schubert: <Piano Sonata No.13 in A Major, Op.120, D.664>, <Impromptu in Flat Major, Op.90, No.4, D.899>, Alicia de Larrocha (piano). Recorded by Simon Eadon & Andrew Pinder, June 1978 in Rosslyn Hill Chapel. @1980

Remark & Rating
ED4, 1G-1G

Label **Decca SXL 6911**
London CS 7135, (ED4)

Chopin: "The Piano Music of Chopin, Volume 14", <Sonata in C Minor, Op.4>, <Mazurka in A Minor, Op.68, No.2>, <Nocturne in E Minor, Op.72, No.1>, <Polonaise Op.71, No.2>, etc., Vladimir Ashkenazy (piano). Recorded by John Dunkerley & Simon Eadon in the Kingsway Hall, London. @1980

Remark & Rating
ED4
Penguin ★★★

Label **Decca SXL 6912**
No London CS

Sibelius: <Pelleas et Melisande - Incidental Music, Op.49>, <The Tempest (Der Sturm), Op.109, Nos 1 & 2>, Orchestre de la Suisse Romande-Horst Stein. Recorded by Colin Moorfoot @1979

Remark & Rating
ED4, 2V-2V, rare! $
Penguin ★★★

Label **Decca SXL 6913 (Decca SET D95D 6)**
London CS 7148, ED4

Tchaikovsky: <Symphony No.1, "Winter Daydreams">, <Marche Slave*>, Los Angeles Philharmonic Orchestra-Zubin Mehta. Recorded by James Lock & Gordon Parry* in the Royce Hall, UCLA,1972* & 1977. @1979

Remark & Rating
ED4
AS List (D95D 6)

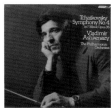

Label **Decca SXL 6919 (Decca D249D 4)**
London CS 7144, (ED4)

Tchaikovsky: <Symphony No.4, in F Minor, Op.36>, The Philharmonia Orchestra-Vladimir Ashkenazy. Recorded by Kenneth Wilkinson, August 1978 in Kingsway Hall, London. ℗ ©1979

Remark & Rating
ED4, rare! $
Penguin ★★★, (K. Wilkinson)

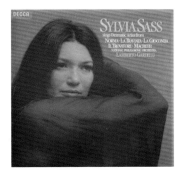

Label **Decca SXL 6921**
No London CS

[Sylvia Sass Sings Dramatic Arias], from Norma, La Traviata, La Gioconda, National Philharmonic Orchestra-Lamberto Gardelli. Recorded by Colin Moorfoot, Jult 1978 in Walthamstow Town Hall. @1979 (Most of the Decca issues after series number SXL 6921 are Holland pressing)

Remark & Rating
ED4, 1G-2G

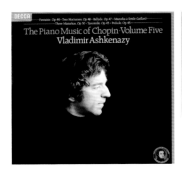

Label **Decca SXL 6922**
London CS 7150, (ED4)

Chopin: "The Piano Music of Chopin, Volume 5", <Polonaises Op.49>, <3 Mazurkas Op.50; 2 Nocturnes, Op.48>,<Ballade Op.47 & Preludes Op.45>, <Tarentelle, Op. 43>,Vladimir Ashkenazy (piano). Recorded by John Dunkerley & Simon Eadon. @1980

Remark & Rating
ED4
Penguin ★★★

Label **Decca SXL 6923**
London OS 26611, (ED4)

[Portait of Pilar Lorengar] Recital: Don Carlo, Tosca, Madam Butterfly, Lohengrin, Goyescas, etc., Pilar Lorengar (soprano) with The London Philharmonic Orchestra-Jesus Lopez-Cobos. Recorded by Kenneth Wilkinson & John Pellowe, Dec. 1978 in the Kingsway Hall, London ℗ ©1980

Remark & Rating
ED4
(K. Wilkinson)

Label Decca SXL 6924 (Decca D151D 4)
London CS 7198, ED5 (CSA 2406)

Brahms: <Symphony No.1 in C Minor, Op.68>, Chicago Symphony Orchestra-George Solti. Recorded by Kenneth Wilkinson & Colin Moorfoot, January 1979 at Medinah Temple, Chicago. ℗1979 ©1981

Remark & Rating
ED5
Penguin ★★(★), Gramophone, (K. Wilkinson)

Label Decca SXL 6925 (Decca D151D 4)
London CS 7199, (ED5) (CSA 2406)

Brahms: <Symphony No.2 in C Minor, Op.73>, <Tragic Overture, Op.81>, Chicago Symphony Orchestra-George Solti. Recorded by Kenneth Wilkinson & Colin Moorfoot, May 1978 at Medinah Temple, Chicago. ℗1979 ©1981

Remark & Rating
ED4, 1W-1W, rare!
Penguin ★★(★), (K. Wilkinson)

Label Decca SXL 6926
London CS 7159, (ED4)

Rachmaninov: <Symphonic Dances>, <Russian Rhapsody> played by Vladimir Ashkenazy and André Previn on 2 pianos. Recorded by John Dunkerley, January 1979 in Kingsway Hall, London. ℗1979 ©1979 & 1980

Remark & Rating
ED4, 4G-3G
Penguin ★★★

Label Decca SXL 6927
London CS 7160, (ED4)

Shostakovich: <Symphony No.4 in C Minor, Op.43>, London Philharmonic Orchestra-Bernard Haitink. Recorded by John Dunkerley, Jan.1979 in the Kingsway Hall, London. ℗ ©1979 [*** Beside SXL 6838 (No.10); 6906 (No.15) & SXL 6927 (No.4), Haitink's Shostakovich Symphnies in the list Penguin ★★★ are all digital recordings: No.1 - SXDL 7515 (LDR 71017); No.2 - SXDL 7535 (LDR 71035); No.5 - SXDL 7551 (LDR 71051); No.7 - D213D 2 (LDR 10015); No.8 - SXDL 7621 (LDR 71121); No.12 - SXDL 7577 (LDR 71077); No.14 - SXDL 7532 (LDR 71032).]

Remark & Rating
ED4, rare! $
Penguin ★★(★), AS List

Label Decca SXL 6928
No London CS

Debussy: "Piano Works Vol. 3", < Oeuvres de Piano>, <Préludes Book 1>, <Children's Corner>. Pascal Rogé (piano). Recorded by Colin Moorfoot & Peter Cook in Rorrlyn Hill Chapel. ℗1980 ©1981

Remark & Rating
ED5, 1G-2G, (1st)
Penguin ★★★

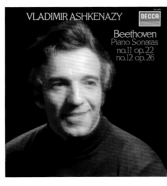

Label Decca SXL 6929 (Decca D258D 12)
London CS 7162, (ED5, 1st) (CSP 11)

Beethoven: Piano Sonatas <No.11, Op.22 in B-Flat Major>, <No.12, Op.26 in A-Flat Major "Funeral March">, Vladimir Ashkenazy (piano). ℗ 1980 © 1981

Remark & Rating
ED5, 1G-2G, (1st)
Penguin ★★(★)

Label Decca SXL 6930
London OS 26612, (ED5, 1st)

[Joan Sutherland sings Wagner], Music from Rienzi, Holländer, Tannhäuser, Lohengrin, Walküre, Tristan, Meistersinger, National Philharmonic Orchestra-Richard Bonynge. Recorded by John Pellowe & Kenneth Wilkinson at Kingsway Hall. ℗ ©1979 @1980

Remark & Rating
ED5, 1G-3G
(K. Wilkinson)

Label Decca SXL 6931
No London CS

Schubert: <Piano Sonata in A Minor, D.845> & <Sonata in E Major, D.157>, Radu Lupu (piano). Recorded by John Dunkerley & Peter Cooke, 1979 in Kingsway Hall, London. @1979

Remark & Rating
ED4, 4G-2G, $

Label Decca SXL 6932
London CS 7163 (ED5, 1st)

Massenet: <Cigale (Ballet in 2 Acts)>, <Valse Tres Lente>, National Philharmonic Orchestra-Richard Bonynge. Recorded by James Lock & John Pellowe, 1978 in the Kingsway Hall, London. @1980

Remark & Rating
ED5, 2G-1G, (1st)
AS List-H

Label Decca SXL 6933
London OS 26613, (ED5, 1st)

[Joan Sutherland sings Mozart], <Allelujah from Exsultate jubilate, K. 165>; <Vorrei spiegarvi, o Dio, K. 418>; <Le Nozze di Figaro>; <Ch'io mi scordi di te? Non temer K. 505>; <Die Zauberflote>. Joan Sutherland & National Philharmonic Orchestra. Richard Bonynge. Recorded by Kenneth Wilkinson, 1978 in the Kingsway Hall, London. ℗1979 ©1980

Remark & Rating
ED5, 2G-1G, (1st)
Penguin ★★(★), (K. Wilkinson)

Label **Decca SXL 6935 (=SXLR 6935)**
London OS 26617, (ED5, 1st)

[Monserrat Caballe Recital], Spanish Songs from Granados; Falla; Albeniz; Rodrigo; Obrados; Vives. Monserrat Caballe (operatic soprano) with Miguel Zanetti (piano). (6 pages text) Original recording of Discos Columbia, S.A, Spain in 1979. ℗©1981

Remark & Rating
ED5, 2G-2G, (1st), rare!
Penguin ★★★

Label **Decca SXL 6936 (=SXLR 6936)**
London OS 26618, (ED5, 1st)

[Montserrat Caballe Recital - Arie Antiche] : Arias by Vivaldi, Pergolesi, Giordani, Constanzi, Marcello, Paisiello & Lotti, Monserrat Caballe (operatic soprano) with Miguel Zanetti (piano). (SXLR 6936, original recording of Discos Columbia S.A. Spain. ℗1979 ©1980)

Remark & Rating
Matrix: ESS 1814-15, 2G-2G (Spain), Very rare!!!

Label **Decca SXL 6937**
London CS 7167, (ED5, 1st)

Bartok: <Piano Concerto No.2 & No.3>, Vladimir Ashkenazy (piano), The London Philharmonic Orchestra-Georg Solti. Recorded by Kenneth Wilkinson, Andrew Pinder & Martin Atkinson in the Kingsway Hall, London. ℗1980 ©1981

Remark & Rating
ED5, 1G-1G, (1st)
Penguin ★★★(❁), AS List-H, (K. Wilkinson)

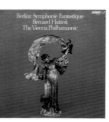

Label **Decca SXL 6938**
London CS 7168, (ED4)

Berlioz: <Symphonie Fantastique Op.14>, The Vienna Philharmonic Orchestra-Bernard Haitink. Recorded by James Lock, April 1979 in the Sofiensaal, Vienna. ℗ ©1979

Remark & Rating
ED4, 4G-2G, (1st), rare! $
AS List-H

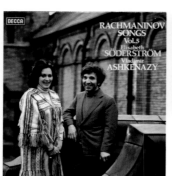

Label **Decca SXL 6940**
London OS 26615, (ED5, 1st)

Rachmaninov: <Songs Volume 5>, Elizabeth Soderstrom (soprano) and Vladimir Ashkenazy (piano). Recorded by Simon Eadon, Martin Atkinson, John Dunkerley & Peter Olenius, in all Saints Church, Petersham. ℗ ©1980

Remark & Rating
ED5, 2G-3G, (1st)
Penguin ★★★

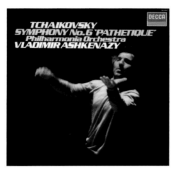

Label Decca SXL 6941 (Decca D249D 4)
 London CS 7170, (ED5, 1st)

Tchaikovsky: <Symphony No.6 in B Minor, Op.74 "Pathetique">, The Philharmonia Orchestra-Vladimir Ashkenazy. Recorded by John Dunkerley, May 1979 in the Kingsway Hall, London. @1981

Remark & Rating
ED5, 5G-1G
Penguin ★★★

Label Decca SXL 6942
 London OS 26591, (ED5, 1st)

[Operatic Arias], by Mascagni, Mozart, Puccini, Rossini, Verdi. Leona Mitchell (soprano), National Philharmonic Orchestra-Kurt Herbert Adler. @1980

Remark & Rating
ED5, 1G-1G

Label Decca SXL 6943
 London OS 26592, (ED5, 1st)

[Elisabeth Schwarzkopf - To My Friends], Elisabeth Schwarzkopf (soprano) sings Various Songs from Brahms, Grieg, Wolf, Loewe. Geoffrey Parsons (piano). Producer: Walter Legge; Recording engineer: James Lock. @1981

Remark & Rating
ED5, 1G-1G
Penguin ★★★

Label Decca SXL 6944
 London CS 7171, (ED5, 1st)

Franck: <Sonata in A Major for Violin and Piano>; Debussy: <Sonata for Violin and Piano>, Kyung-Wha Chung (violin) and Radu Lupu (piano). Recorded by Colin Moorfoot & John Pellowe in the Kingsway Hall, London. ℗ by Christopher Raeburn ©1980

Remark & Rating
ED5, 1G-1G, $
Penguin ★★★ (❀)

Label Decca SXL 6945
 No London CS

Prokofiev: <Symphony No.2, Op.40>, *<The Love of Three Oranges Suite, Op.33a>, The London Philharmonic Orchestra-Walter Weller. Recorded by John Dunkerley & *Kenneth Wilkinson, May 1978 & *Nov. 1977 in the Kingsway Hall, London. ℗1979 ©1980

Remark & Rating
ED4, 2G-2G
Penguin ★★★ (❀), AS List, (K. Wilkinson)

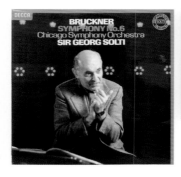

Label **Decca SXL 6946**
London CS 7173, (ED5, 1st)

Bruckner: <Symphony No.6>, Chicago Symphony Orchestra-Georg Solti. Recorded by Kenneth Wilkinson, James Lock, Colin Moorfoot & Michael Mailes, January & June 1979 in the Medinah Temple, Chicago. @1980

Remark & Rating
ED5, 1G-1G
AS List, (K. Wilkinson)

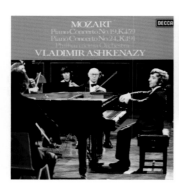

Label **Decca SXL 6947**
London CS 7174, (ED5, 1st)

Mozart: Piano Concertos <No.19 in F Major, K.459> & <No.24 in C Minor, K.491>, Vladimir Ashkenazy (piano), The Philharmonia Orchestra-Vladimir Ashkenazy. Recorded by Kenneth Wilkinson & John Dunkerley, 1978 & 1979 in the Kingsway Hall, London. ℗1980 ©1981

Remark & Rating
ED5, 4G-2G, rare!
Penguin ★★★, (K. Wilkinson)

Label **Decca SXL 6949**
London CS 7177, (ED5, 1st)

Scarlatti: Sonatas in F Major, K.6, G Minor, K.8, D Minor, K.9, K.10, C Minor, K.11, G Major, K.13, E Major, K.28; Soler: Sonata in D linor, C# Minor, D Major, G Minor, F# Major, F Major, Alicia de Larrocha (piano). Recorded by Simon Eadon, Sept. 1979 in The Decca Studio 3, West Hampstead.@1981

Remark & Rating
ED5

Label **Decca SXL 6950**
London CS 7178, (ED5, 1st)

[Carlos Bonell-Showpieces for Guitar], Includes works by Villa-Lobos, Chopin, Llobet, Tarrega, Weiss, Albeniz, Chapi, Paganini and Valverde. Recorded by Arthur Lilley in West Hampstead Studios. ℗1981 ©1981

Remark & Rating
ED5, 1G-1G
Penguin ★★(★)

Label **Decca SXL 6951**
London CS 7179, (ED5, 1st)

[Mostly Mozart, Vol. IV], Mozart: <Piano Sonata in E flat Major, K. 282>, <Piano Sonata in A Minor, K.310>; Beethoven: <Bagatelles, Op.33>, Alicia de Larrocha (piano). Recorded by Simon Eadon, Sept. 1979 in The Decca Studio, West Hampstead. @1980

Remark & Rating
ED5, 1G-2V
Penguin ★★★

Label Decca SXL 6952
 London CS 7180, (ED5, 1st)

J.S. Bach: <Clavier Concerto in F Minor, BWV 1056>; Haydn: <Concerto in D Major, Hob.XVIII:2>; Mozart: <Piano Concerto No.12 in A Major, K.414>, Alicia de Larrocha (piano), The London Sinfonietta-David Zinman. Recorded by Simon Eadon, 1979 & 1980 in Kingsway Hall, London. @1981

Remark & Rating
ED5, 4F-2F
Penguin ★★★

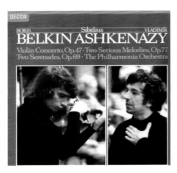

Label Decca SXL 6953
 London CS 7181

Sibelius: <Violin Concerto in D Minor, Op.47>, <Two Serious Melodies, Op.77>, <Two Sserenades, Op.69>, Boris Belkin (violin), Philharmonia Orchestra-Vladimir Ashkenazy. Recorded by Kenneth Wilkinson in Kingsway Hall, London. @1980

Remark & Rating
ED5, 1G-1G
Penguin ★★(★), (K. Wilkinson)

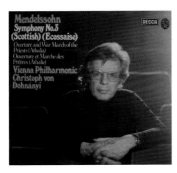

Label Decca SXL 6954
 London CS 7184

Mendelssohn: <Symphony No.3, "Scottish", Op.56>, <Overture and War March of the Priests (Athalia), Op.74>, The Vienna Philharmonic Orchestra-Christoph Von Dohnanyi. Recorded by Colin Moorfoot & James Lock. ℗ by Christopher Raeburn @1980

Remark & Rating
ED5, 3A-2G
Penguin ★★(★)

Label Decca SXL 6955
 No London CS

Tchaikovsky: <Piano Concerto No.1 in Bflat Minor, Op.23>, Myung-Whun Chung (piano) & <Variations on a Rococo Theme for Cello>, Myung-Wha Chung (cello), Los Angeles Philharmonic Orchestra-Charles Dutoit. Recorded by Stanley Goodall, Colin Moorfoot & Martin Atkinson, 1979 in the Royce Hall, UCLA. ℗1980 ©1981

Remark & Rating
ED5, 2G-2G, $
Penguin ★★★

Label Decca SXL 6956
 No London CS

Falla: <El Sombrero De Tres Picos (The three-cornered hat)>; Chabrier: <Espana>; Rimsky-Korsakov: <Capriccio Espagnol, op.34>, Los Angeles Philharmonic Orchestra-Jesus Lopes-Cobos. Recorded by Stanley Goodall, Colin Moorfoot & Martin Atkinson, Aug. 1979 in Royce Hall, UCLA. ℗ ©1981

Remark & Rating
ED5, 1G-2V, rare! $

Label **Decca SXL 6957**
No London CS

Debussy: "Piano Works Vol. 2", <Images Books 1 and 2>, <L'Isle joyeuse> <D'un cahier desquisses>, <Masques>, Pascal Rogé (piano). (6 pages text & translation insert) Recorded by Colin Moorfoot & Simon Eadon in St. George the Martyr, London. ℗ ©1981

Remark & Rating
ED5, 2G-2G, rare!
Penguin ★★★

Label **Decca SXL 6959**
London CS 7189

Richard Strauss: <An Alpine Symphony, Op.64>, Symphony Orchestra of the Bavarian Radio-Georg Solti. Recorded by Stanley Goodall, David Frost, Nigel Gaylor, September 1979 in Herkulesaal, Munich. ℗ ©1980

Remark & Rating
ED5, 1G-1G
Penguin ★★★

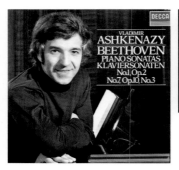

Label **Decca SXL 6960 (Decca D258D 12)**
London CS 7190 (CSP 11)

Beethoven: Piano Sonatas <No.1, Op.2 no.1 in F Minor>, <No.7, Op.10 no.3 in D Major>, Vladimir Ashkenazy (piano). ℗ © 1981

Remark & Rating
ED5
Penguin ★★★

Label **Decca SXL 6961 (Decca D258D 12)**
London CS 7191 (CSP 11)

Beethoven: Piano Sonatas <No.4, Op.7 in E-Flat Major "Grand Sonata">, <No.9, Op.14 no1 in E Major>, <No.10, Op.14 no.2 in G major>, Vladimir Ashkenazy (piano). ℗ © 1981

Remark & Rating
ED5
Penguin ★★★

Label **Decca SXL 6962 (Decca D258D 12)**
London CS 7192 (CSP 11)

Beethoven: Piano Sonatas <No.22, Op.54 in F Major>, <No.24, Op.78 in F-Sharp Major "À Thérèse">, <No.25, Op.79 in G Major >, <No.27, Op.90 in E Minor>, Vladimir Ashkenazy (piano). ℗ © 1981

Remark & Rating
ED5
Penguin ★★★

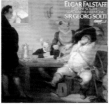

Label Decca SXL 6963
London CS 7193

Elgar: <Falstaff, Symphonic Study Op.68> & <In the South (Alassio), Concert Overture Op.50>, London Philharmonic Orchestra-Georg Solti. Recorded by Kenneth Wilkinson. @1980

Remark & Rating
ED5
(K. Wilkinson)

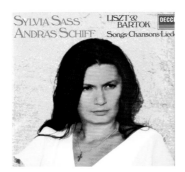

Label Decca SXL 6964
No London CS

Liszt: <8 Songs>; Bartok: <5 Songs>, Sylvia Sass (soprano), Andras Schiff (piano). Recorded by Stanley Goodall, in the Sofiensaal, Vienna. ℗ by Christopher Raeburn @1981

Remark & Rating
ED5, rare!
Penguin ★★★

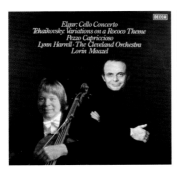

Label Decca SXL 6965
London CS 7195

Elgar: <Cello Concerto, Op.85>; Tchaikovsky: <Variations on a Rococo Theme, Op.33>, <Pezzo Capriccioso, op.62>, Lynn Harrell (cello), The Cleveland Orchestra-Lorin Maazel. Recorded by Colin Moorfoot & Martin Atkinson, Oct. 1979 in the Massonic Auditorium, Cleveland. @1980

Remark & Rating
ED5, 3G-4V, rare!
Penguin ★★★

Label Decca SXL 6966
London CS 7196

Rimsky-Korsakov: <Suite from the opera Le Coq d'or>, <Capriccio Espagnol, Op. 34>, <Russian Easter Overture, Op. 36 >, The Cleveland Orchestra-Lorin Maazel. Recorded by Colin Moorfoot & Martin Artkinson at Masonic Auditorium, Cleveland. @1980

Remark & Rating
ED5
Penguin ★★★, AS List-H

Label Decca SXL 6968
No London CS

Liszt: <Annees de Pelerinage, deuxieme annee-Italie (Years of Pilgrimage, second year-Italy)>, Pascal Rogé (piano). Recorded by John Pellowe & John Dunkerley, Kingsway Hall, London. ℗1980 ©1981

Remark & Rating
ED5

Label **Decca SXL 6969**
London CS 7197

Max Reger: <Variations & Fugue on a Theme by Telemann Op.134>, Brahms: <Variation & Fugue on a Theme.by Handel Op.24>, Jorge Bolet (piano). Recorded by John Dunkerley, Kingsway Hall, London. @1981

Remark & Rating
Dutch Silver-Blue
Penguin ★★★

Label **Decca SXL 6970**
London OS 26652

[Mirella Freni-Renata Scotto In Duet], Bellini: <Morma, Bianca e Fernando>; Mozart: <Le nozze di Figaro>; Mercadante: <Le due illustri rivali>, National Philharmonic Orchestra-Leone Magier & Lorenzo Anselm. Recorded by Colin Moorfoot & John Pellowe, 1978 in Walthamstow Town Hall. @1981

Remark & Rating
ED5
Penguin ★★(★)

Label **Decca SXL 6971**
London OS 26660

[Leontyne Price Sings Arias from Verdi] : <Aida>,<Otello>, <Ernani>, <Ballo in Maschera>, The Israel Philharmonic Orchestra-Zubin Mehta. Recorded by James Lock, July 1980 in the Mann Auditorium, Tel Aviv. @1981

Remark & Rating
Dutch Silver-Blue
Penguin ★★(★)

Label **Decca SXL 6972**
No London CS

Tchaikovsky: <Songs, Melodies, Chansons, Lieder, Vol.1>, Elisabeth Soderstrom (soprano), Vladimir Ashkenazy (piano). Recorded by Colin Moorfoot & Simon Eadon in St. George the Martyr, London. @1982 (Volume 2 is DECCA SXDL 7606)

Remark & Rating
ED5, 1G-2G
Penguin ★★★

Label **Decca SXL 6973**
No London CS

Sibelius: <Four Lengends From the Kalevala, Op.22>, Lemminkäinen and the Maidens of Saari; Swan of Tuonela; Lemminkäinen in Tuonela; Lemminkäinen's Homefaring, L'Orchestre De La Suisse Romande-Horst Stein. Recorded In Victoria Hall, Geneva. @1980

Remark & Rating
ED5, rare!!

Label Decca SXL 6974
 No London CS

Mussorgsky: <Songs and Dances of Death>; Rachmaninov : <Songs>, Martti Talvela (bass), Ralf Gothoni (piano). Recorded by John Pellowe in the Kingsway Hall, London. (6 pages texts & translation insert) @1981

Remark & Rating
Dutch Silver-Blue
Penguin ★★★

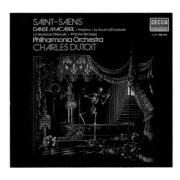

Label Decca SXL 6975
 London CS 7204

Saint-Saëns: "Danse Macabre - Symphonic poems", <Phaéton, Op. 39>, <Le rouet d'Omphale, Op. 31>, <Danse macabre, Op. 40>, <La jeunesse d'Hercule, Op. 50>, <March héroïque, Op. 35>, The Philharmonia Orchestra-Charles Dutroit. Recorded by John Dunkerley, June 1980 in Kingsway Hall, London. @1981

Remark & Rating
Dutch Silver-Blue, $$
Penguin ★★★(❀), A List-H

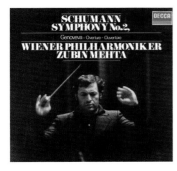

Label Decca SXL 6976
 London CS 7206

Schumann: <Symphony No.2>, <Genoveva Overture>, Vienna Philharmonic Orchestra-Zubin Mehta. Recorded by James Lock, June 1981 in the Sofiensaal, Vienna. ℗1981 by Christopher Raeburn ©1982

Remark & Rating
Dutch Silver-Blue, rare! $

Label Decca SXL 6977
 London CS 7205

Rossini: <William Tell Overture>; Beethoven: <Leonore Overture No.3>; Tchaikovsky: <Capriccio Italein>; Rimsky-Korsakov: <Capriccio Espagnol>, The Israel Philharmonic Orchestra-Zubin Mehta. Recorded by James Lock in the Mann Auditorium, Tel Aviv. @1982

Remark & Rating
Dutch Silver-Blue
AS List-H

Label Decca SXL 6978
 London CS 7207

Schumann: <Piano Concerto in A Minor, Op.54>; Rachmaninov: <Piano Concerto No.2 in C Minor, Op.18>, Alicia de Larrocha (piano), Royal Philharmonic Orchestra-Charles Dutoit. Recorded by Simon Eadon in Kingsway Hall, London. @1981

Remark & Rating
ED5

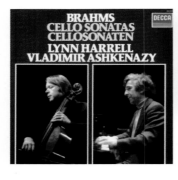

Label **Decca SXL 6979**
London CS 7208

Brahms: Cello Sonatas <No.1 In E Minor, Op.38>, <No.2 In F Major, Op.99>, Lynn Harrell (cello) , Vladimir Ashkenazy (piano). @1981

Remark & Rating
Dutch Silver-Blue
Penguin ★★(★)

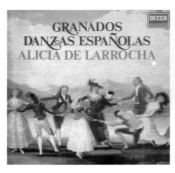

Label **Decca SXL 6980**
London CS 7209

Granados:<12 Danzas Espanolas>, Alicia de Larrocha (piano). Recorded by Simon Eadon, Sept. 1980 in The Decca Studio No.3, West Hampstead.@1982

Remark & Rating
Dutch Silver-Blue
Penguin ★★★

Label **Decca SXL 6981**
London CS 7210

Chopin: "The Piano Music of Chopin, Volume15", <Variations (sur un air national allemand)>,<Polonaise Op.71, no.1> <Polonaise in Gm, A flat, B flat minor, G sharp minor>, <Rondo in C minor & Op.5>, <Rondeau à la Mazurka>,Vladimir Ashkenazy (piano). Recorded by John Pellowe, Colin Moorfoot, John Dunkerley & Simon Eadon, 1979-1980 in the Kingsway Hall, London. @1981

Remark & Rating
Dutch Silver-Blue
Penguin ★★★, Gramophone

Label **Decca SXL 6982**
London CS 7211

Mozart: <Piano Concerto No.22, K.482>, <Concert Rondo K.382>, Vladimir Ashkenazy (piano), Philharmonia Orchestra-Vladimir Ashkenazy. Recorded by Kenneth Wilkinson & John Dunkerley, 1978 & 1980 in Kingsway Hall, London. Ⓟ by Christopher Raeburn @1981

Remark & Rating
Dutch Silver-Blue
Penguin ★★★, (K. Wilkinson)

Label **Decca SXL 6983**
London CS 7239

Borodin: <String Quartets No.1 in A Major> & <No.2 in D Major>, The Fitzwilliam String Quartet. Recorded by John Dunkerley & John Pellowe, December 1979 in the Maltings, Snape & November 1980 in the Kingsway Hall, London. Ⓟ ©1981

Remark & Rating
Dutch Silver-Blue
Penguin ★★★

Label Decca SXL 6984 (Decca D134D 2)
 London OS 26666 (OSAD 12113)

Puccini: <Tosca, Highlights>, Freni, Pavarotti, Milnes, National Philharmonic Orchestra-Nicola Rescigno. ℗1979 ©1982

Remark & Rating
Dutch Silver-Blue

Label Decca SXL 6985
 No London CS

Hugo Wolf: Symphonic Poem <Penthesilea> & <Der Corregidor-Suite>, L'Orchestra de la Suisse Romande conducted by Horst Stein. Recorded by Colin Moorfoot in the Victoria Hall, Geneva. @1981

Remark & Rating
Dutch Silver-Blue

Label Decca SXL 6986 (D83D 3)
 London OSA 13125 (part)

[Luciano Pavarotti - Cavalleria Rusticana (Mascagni) & * I Pagliacci (Leoncavallo) Highlights], with Mirella Freni, Julia Varady, Ingvar Wixell, Piero Cappuccilli, National Philharmonic Orchestra conducted by Gianandrea Gavazzeni & Giuseppe Patané. Recorded by Kenneth Wilkinson, James Lock, John Dunkerley, June 1976 in Kingsway Hall, London. (* Recorded in April 1977) ℗1978 ©1981

Remark & Rating
ED5
(K. Wilkinson)

Label Decca SXL 6987 (D132D 4; OSA 1443)
 London OSA 1443 (part)

Mozart: <The Marriage of Figaro Highlights>, Van Dam, Cotrubas, Tomowa-Sintow, The Vienna Philharmonic Orchestra-Herbert von Karajan. Part of Decca D132D 4 & London OSA 1443 ℗1979 by Christopher Raeburn ©1981

Remark & Rating
Dutch Silver-Blue

Label Decca SXL 6988
 London OS 26434

[Music Of My Country (Zarzuela Arias)], Placido Domingo (tenor), Orquesta Sinfonica de Barcelona-Luis A. Garcia-Navarro. Recorded in 1974 by Fabrica de Discos Columbia, distributed by Polygram Distribution, 1980. ℗1974 ©1981

Remark & Rating
ED5, 2A-2A

Label **Decca SXL 6989**
London CS 7220

Mozart: Piano Quartets, <Quartet No.1 in G, K.478>, <Quartet No.2 in Es K.493>, Members of the Musikvereinquartett with Andre Previn (piano). Recorded by John Dunkerley, January 1981 in Kingsway Hall. London. @1982

Remark & Rating
Dutch Silver-Blue, rare!
Penguin ★★★

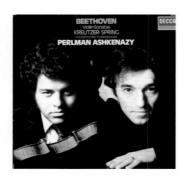

Label **Decca SXL 6990 (Part of SXL 6632 & 6736) [=London CS 6845 & 6958]**

Beethoven: <Violin Sonata No.9 in A Major, Op.47 "Kreutzer">, < *No.5 in F Major, Op.24,"Spring">, Itzhak Perlman (violin), Vladimir Ashkenazy (piano). Recorded by Kenneth Wilkinson & *Colin Moorfoot, October 1973 & *June 1974 in Kingsway Hall, London. ℗1974 by Christopher Raeburn ©1981 (Original issue=SXL6632, ℗1974 & SXL 6736, ℗1976)

Remark & Rating
Dutch Silver-Blue
Penguin ★★★, (K. Wilkinson)

Label **Decca SXL 6991**
London OS 26437

[Joan Sutherland & Luciano Pavarotti Duets], <Lucia di Lammermoor>,<Rigoletto>, <L'Elisier d'Amore>, <La Fille du Re'giment>, <I Puritani>, LSO, ECO & ROHCG-Richard Bonynge. ℗1975 ©1982

Remark & Rating
Dutch Silver-Blue
Penguin ★★★

Label **Decca SXL 6994 (Decca D258D 12)**
London CS 7247 (CSP 11)

Beethoven: Piano Sonatas <*No.8, Op.13 in C Minor "Pathétique"> , <No.19, Op.49 no.1 in G Minor>, <No.20, Op.49 no.2 in G Major>, <**No.23, Op.57 "Appassionata" in F Minor> , Vladimir Ashkenazy (piano). Recorded in 1980 @1982 *(This No.8 is a 1980 recording, the No.8 in SXL 6706 (London CS 6921 & CS 7256) is a early recording in 1974), **(The No.23 in SXL 6603 is a early recording in 1970),

Remark & Rating
Dutch Silver-Blue
Penguin ★★★

Label **Decca SXL 6995**
London CS 7235

Chopin: "The Piano Music of Chopin, Volume 7 (1838-9)", <Sonata No.2, Op.35>, <Scherzo No.3, Op.39>, <Polonaises Op.40>, <Mazurkas Op.41>, Vladimir Ashkenazy (piano). @1982

Remark & Rating
Dutch Silver-Blue
Penguin ★★★

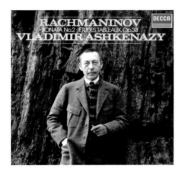

Label **Decca SXL 6996**
London CS 7236

Rachmaninov: <Piano Sonata No.2, Op.36>, <Etudes-tableaux Op.33>, Piano-Vladimir Ashkenazy. Recorded by John Dunkerley in 1977, 1980 & 1981. ℗ ©1982

Remark & Rating
Dutch Silver-Blue
Penguin ★★★

Label **Decca SXL 6997 (Decca D222D 6)**
London CS 7240

Mozart: Piano Sonatas (Volume 1), <Sonata in B Flat Major, K.333>, <Sonata in C Major, K.545>, <Sonata in C Minor, K.457> & <Fantasia in C Minor, K.475>, Andras Schiff (piano). Recorded by Arthur lilley, 1980. ℗1981 ©1983 [* Volume 2 = CS 7246; Volume 3 = CS 7258. Complete Sonatas 6LP-Box= Decca D222D 6 & German DECCA 6.35571-5 @1981]

Remark & Rating
Dutch Silver-Blue
Penguin ★★★

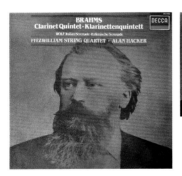

Label **Decca SXL 6998**
London CS 7241

Brahms: <Clarinet Quintet in B Minor, Op.115>, Alan Hacker (clarinet); Hugo Wolf: <Italian Serenade>, Fitzwilliam String Quartet. Recorded by John Dunkerley & John Pellowe in 1979 & 1981, @1982

Remark & Rating
Dutch Silver-Blue
Penguin ★★(★)

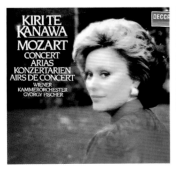

Label **Decca SXL 6999**
London OS 26661

Mozart: <Concert Arias- K.272, K.79 (K.73d), K.583, K.582, K.490, K.528, K.383>, Kiri Te Kanawa (soprano) with the Vienna Chamber Orchestra-Gyorgy Fischer. Recorded by James Lock & Simon Eadon in the Sofiensaal, Vienna. ℗1981 ©1982 (Also in the Box-Set Decca D251D5)

Remark & Rating
Dutch Silver-Blue
Penguin ★★★

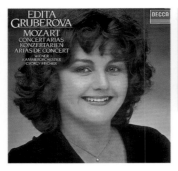

Label **Decca SXL 7000**
London OS 26662

Mozart: <Concert Arias- K.578, K.374, K.83, K.217>, Edita Gruberova (soprano) with the Vienna Chamber Orchestra-Gyorgy Fischer. Recorded by James Lock & Simon Eadon in the Sofiensaal, Vienna. ℗1981 ©1983 (Also in the Box-Set Decca D251D5)

Remark & Rating
Dutch Silver-Blue
Penguin ★★★

Label **Decca SXL 7001**
London OS 26663

Mozart: <Concert Arias - K.255, K.77 (73e), K.577, K.82, K.23, K.505>, Teresa Berganza (soprano) with The Vienna Chamber Orchestra-Gyorgy Fischer. Recorded by James Lock & Simon Eadon in the Sofiensaal, Vienna ℗1981 ©1984 (Also in the Box-Set Decca D251D5)

Remark & Rating
Dutch Silver-Blue
Penguin ★★★

Label **Decca SXL 7004**
London CS 6984 (part)

Schoenberg: <Variations Op.31>* ; Brahms: <Variations on a theme by Haydn, Op.56a>, Chicago Symphony Orchestra-Georg Solti. Recorded by Kenneth Wilkinson & James Lock in the Medinah Temple, Chicago, 1974 & 1977. ℗1982 (* Schoenberg's Variation is in London CS 6984)

Remark & Rating
Dutch Silver-Blue
Penguin ★★, (K. Wilkinson)

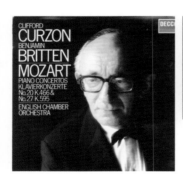

Label **Decca SXL 7007**
London CS 7251

Mozart: Piano Concertos <No.20, K.466 & No.27, K.595>, Clifford Curzon (piano), The English Chamber Orchestra-Benjamin Britten. Recorded by Kenneth Wilkinson, Sept. 1970 in the Maltings, Snape. ℗1982

Remark & Rating
Dutch Silver-Blue, $
Penguin ★★★(❀), AS list-F, Japan 300, (K. Wilkinson)

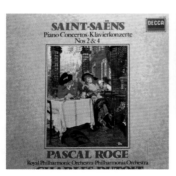

Label **Decca SXL 7008**
London CS 7253

Saint-Saëns: <Piano Concerto No. 2, Op.22 & No 4, Op.44>. Piano-Pascal Rogé, Royal Philharmonic Orchestra-Charles Dutoit. ℗1981 ©1983

Remark & Rating
Dutch Silver-Blue
Penguin ★★★, AS List-H (D244D 3)

Label **Decca SXL 7010**
London CS 7254

Mozart: Piano Concertos <No.15, K.450 & No.16, K.451>, Vladimir Ashkenazy (piano), Philharmonia Orchestra-Vladimir Ashkenazy. Recorded by John Dunkerley in the Kingsway Hall, London. @1984

Remark & Rating
Dutch Silver-Blue
Penguin ★★★

Label **Decca SXL 7011 (Decca D258D 12)**
London CS 7255 (CSP 11)

Beethoven: Piano Sonatas <No.29, Op.106, in B-Flat Major "Hammerklavier">, <Andante Favori in F Major, WoO 57>, Vladimir Ashkenazy (piano). Recorded 1980 & 1981 in Kingsway Hall by James Walker. ℗1981 ©1983

Remark & Rating
Dutch Silver-Blue
Penguin ★★

Label **Decca SXL 7012 (Decca D258D 12)**
London CS 7111 & CS 7247 (CSP 11)

Beethoven: Piano Sonatas <No.8, Op.13 in C Minor "Pathétique">, <No.14, Op.27 no.2 in C-Sharp Minor "Moonlight">, <No.23, Op.57 in F Minor "Appassionata">, Vladimir Ashkenazy(piano). @1983 (Selections from SXL 6889 & 6994)

Remark & Rating
Dutch Silver-Blue
Penguin ★★★

Label **Decca SXL 7013**
London OS 26669

[Mattinata], songs from Bellini, Beethoven, Cladara, Ciampi, Donizetti, Durante, Giordano, Gluck, Leoncavallo, Rossini & Tosti, Luciano Pavarotti with Philharmonia Orchestra-Piero Gamba (1977) & National Philharmonic Orchestra-A.Tonini (1982). Recorded by Kenneth Wilkinson, April 1977 in the Kingsway Hall & Aug. 1982 in the Walthamstow Town Hall, London. @1983

Remark & Rating
Dutch Silver-Blue
Penguin ★★(★), (K. Wilkinson)

Label **Decca SXLA 6452 (=SXL 6452-61)**
 London CSP 2

Beethoven: <The Complete 32 Piano Sonatas>, Wilhelm Backhaus (piano). Includes all his stereo recordings from 1958-1969, (10 LP-Box complete with 24 pages booklet, ©1970). [(London CS 6161=Decca SXL 2241), (London CS 6246=Decca SWL 8500, No SXL issue), (CS 6247=SWL 8018, No SXL issue), (CS 6365=SXL 6063), (CS 6366=SXL 6064), (CS 6389=SXL 6097), (CS 6535=SXL 6300), (CS 6584=SXL 6358), (CS 6585=SXL 6359), (CS 6638=SXL 6416), (CS 6639=SXL 6417).] **There is no UK Decca SXL or USA London CS issue for <Sonata No.8, Op.13, "Pathetique & No.14, Op.27, "Moonlight">, only issued in Decca 10" LP (SWL 8016) or Decca Australian issue (SXLA 7506), and <Sonata No.29, Op.106 "Hammerklavier"> only issued in Decca LXT 2777, 1950's mono recording. ©1969

Remark & Rating
ED4, (10 LP SET, all 1W-1W), $$$$

Label **Decca SXLA 7506 (Australian issue)**
 Decca SWL 8016

Beethoven: Piano Sonatas <No.8, Op.13 in C Minor "Pathétique">, <No.14, Op.27 no.2 in C-Sharp Minor "Moonlight">, <**No.26, Op.81a in E flatr "Les Adieux">, Wilhelm Backhaus (piano). [** No. 26 not in the Decca SWL 8016 (10" LP), SXLA 7506 is a Australian issue ED1, (No.8 & No. 14, No Decca SXL & London CS issue)]

Remark & Rating
Japan 300

Label **Decca SXLB 6470 (=SXL 6470-5)**
 London CSP 1

Beethoven: [The 9 Symphonies], The Vienna Philharmonic Orchestra-Hans Schmidt-Issersetedt. @1970

Remark & Rating
ED4, (6 LP SET), $+

Label **Decca SXLC 6476 (=Decca SXL 9476-80, D 8D 6)**
 London TCH S-1

Tchaikovsky: [Complete Symphony Nos.1-6], The Vienna Philharmonic Orchestra-Lorin Maazel. ℗1970 ***(SXL 6159 + 6162 + 6163 + 6157 + 6058 + 6164 = CS 6426 + 6427 + 6428 + 6429 + 6376 + 6409)

Remark & Rating
ED4, (5 LP SET), $$
Penguin ★★(★)

Label Decca SXLD 6515 (=SXL 6515-21, ©=Decca D6D 7)
London DVO S-1

Dvorak: [The Complete Nine Symphonies], London Symphony Orchestra-Istvan Kertesz. Recorded by Kenneth Wilkinson. ©1971 (7LPs Box set with booklet), =SXL 6044, 6115, 6253, 6257, 6273, 6288, 6289, 6290, 6291

Remark & Rating
ED4, (7 LP SET), $$
Penguin ★★★(✿), AS List-H (D6D 7), (K. Wilkinson)

Label Decca SXLE 6558
London CSP 4

Sibelius: [The Seven Symphonies], The Vienna Philharmonic Orchestra-Lorin Maazel. Recorded from1964-1968. @1972 (=SXL 6084, 6125, 6236, 6364, 6365)

Remark & Rating
ED4, (4 LP SET)

Label Decca SXLF 6565 (=SXL 6565-7)
London CSA 2311

Rachmaninov: [The Four Piano Concertos & Rhapsody on a theme of Paganini], Vladimir Ashkenazy (piano), London Symphony Orchestra-Andre Previn. @1972 (=SXL 6554, 6555, 6556)

Remark & Rating
ED4, (3 LP Set), $
Penguin ★★★, AS list-H

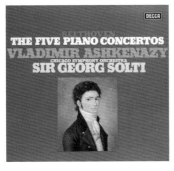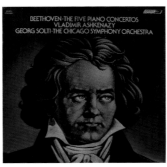

Label Decca SXLG 6594 (=SXL 6594-7)
London CSA 2404

Beethoven: [The Five Piano Concertos No.1-5], Vladimir Ashkenazy (piano), Chicago Symphony Orchestra-Georg Solti. ℗1973 [Decca SXLG 6594-7, ©=SXL 6651, 6652, 6653, 6654, 6655]

Remark & Rating
ED4, (4 LP SET)
Penguin ★★★, AS List-F

Label Decca SXLH 6610 (=SXL 6610-3)

Brahms: [The Four Symphonies], <*Variations on a Theme by Haydn>, The Vienna Philharmonic Orchestra-Istvan Kertesz. @1973 [=SXL 6172 & 6675-6678] (*Haydn Variation recorded without conductor in tribute to Istvan Kertesz who suddenly died in 1973)

Remark & Rating
ED4, (4 LP SET), $+
Penguin ★★(★)

Label Decca SXLI 6739 (=SXL 6739)
 London CS 6961

Schubert: <Piano Sonata No.17 in D Major, D.850 (Op.53)>, <Four German Dances, D.366>, Vladimir Ashkenazy (piano). Recorded by John Dunkerley, April 1975 in All Saints Church, Petersham. @1976

Remark & Rating
ED4, 1W-1W. Rare!
Penguin ★★★

Label Decca SXLJ 6644 (=SXL 6644-8)
 London CSP 6

Schubert: [The Symphonies], Overtures <Des Teufels Lustschloss, D.84>, <In the Italian style in C Major, D.591>, <Fierabras, D.796>, The Vienna Philharmonic Orchestra-Istvan Kertesz. ℗1971 [=SXL 6089, 6090, 6483, 6552, 6553]

Remark & Rating
ED4, (5 LP SET), $$
Penguin ★★(★)

Label Decca SXLK 6660 (=SXL 6660-4 ©=SDD 519; 520)

Schoenberg: [Complete Works for Chamber Ensemble], London Sinfonietta-David Atherton, (20 pages booklet). Recorded by Gordon Parry & Philip Wade, 1973-1974 at Petersham. @1974 (* Pierrot Lunaire is in AS list)

Remark & Rating
ED4, 2-2-1-2-2-1-2-5-2-1W, (5 LP SET) $$
Penguin ★★★, (SDD 520, TAS2017 & AS list)

Label **Decca SXLM 6665 (=SXL 6665-7)**
London CSA 2313 (=CS 6862, 6863 & 6864)

[The Orchestral Works of Zoltan Kodaly], Philharmonia Hungarica-Antal Dorati (8 pages Booklet). Recorded by Colin Moorfoot, 1973 in Marl, Germany. @1974 (=SXL 6712, SXL 6713 & SXL6714)

Remark & Rating
ED4, 1G-1G-5G-1G-6G-4G, $
Penguin ★★★

Label **Decca SXLN 6673 (=SXL 6673)**
London CS 6870

Beethoven: <Symphony No.7 in A Major, Op.92>, <Egmont Overture, Op.84>, The Los Angeles Philharmonic Orchestra-Zubin Mehta. Recorded by Colin Moorfoot & Gordon Parry in Royce Hall, UCLA. ℗ by Christopher Raeburn @1974

Remark & Rating
ED4, 5W-5W
Penguin ★★★

Label **Decca SXLP 6684 (=SXL 6684)**

[Five Favorite Overtures], Wagner: <Die Meistersinger von Nurnberg>, Berlioz: <Les Francs-Juges>*, Rossini: <The Barber of Seville>, Beethoven: <Egmont>, <Leonora No.3>, Chicago Symphony Orchestra-Georg Solti. Recorded by Kenneth Wilkinson & James Lock, 1972 & 1974 in the Krannert Center, University of Illinois. ℗1972 & 1974* ©1974

Remark & Rating
ED4, 1W-3W
(K. Wilkinson)

Label **Decca SXLR 6690 (=SXL 6690)**
London OS 26424

[Montserrat Caballe], Arias from Adriana Lecouvreur; I Vespri Siciliani; Sour Angelica; Rigoletto; Il Trovatore; Un Ballo in Maschera; La Sonnambula, Montserrat Caballe (soprano) with The Barcelona Symphony Orchestra-Gianfraco Masini. ℗1974 ©1975

Remark & Rating
ED4, 3G-3G

Label **Decca SXLR 6792 (=SXL 6792)**
London OS 26435

[Romanzas de Zarzuelas, Music of Spain], Montserrat Caballe (soprano), Barcelona Symphony Orchestra-Eugenio Marco. Original recording of Discos Columbia, S.A, Spain, 1974 in Barcelona. ℗1974 ©1975

Remark & Rating
ED4, 1G-2K

Label **Decca SXLR 6825 (=SXL 6825)**
London OS 26497

[Montserrat Caballe Sings Arias], from <Macbeth>, <Il Trovatore>, <Cavalleria Rusticana>, <Turandot>, <La Wally>, <Gioconda>, <Andrea Chenier>. Barcelona Symphony Orchestra-Armando Gatto & Anton Guadagno. @1977

Remark & Rating
ED4, 1G-1G

Label **Decca SXLR 6888 (=SXL 6888)**
London OS 26575

[Montserrat Caballe - Falla Seven Popular Spanish Songs], The Maiden and the Nightingale & other Songs by Granados and Turina, Montserrat Caballe (soprano) with Miguel Zanetti (piano). ℗1978 ©1979

Remark & Rating
ED4, Test pressing, 1Y-1Y
Penguin ★★★

Label **Decca SXLR 6935 (=SXL 6935)**
London OS 26617

[Monserrat Caballe Recital], Spanish Songs from Granados; Falla; Albeniz; Rodrigo; Obradors; Vives. Monserrat Caballe (operatic soprano) with Miguel Zanetti (piano). (6 pages text) Original recording of Discos Columbia, S.A, Spain in 1979. ℗©1981

Remark & Rating
ED5, 2G-2G, rare!
Penguin ★★★

Label **Decca SXLR 6936 (=SXLR 6936)**
London OS 26618

[Montserrat Caballe Recital - Arie Antiche] : Arias by Vivaldi, Pergolesi, Giordani, Constanzi, Marcello, Paisiello & Lotti, Monserrat Caballe (operatic soprano) with Miguel Zanetti (piano). (SXLR 6936, original recording of Discos Columbia S.A. Spain. ℗1979 ©1980)

Remark & Rating
Matrix: ESS 1814-15, 2G-2G (Spain), Very rare!!!

DECCA
SET SERIES

Label Decca Ring 1-22 [=D100D 19 & SET 382-4 (SXL 2101-3); SET 312-6; 242-6 & SET 292-7]
London Ring S-1, [=OSA 1309; 1509; 1508 & 1604]

Wagner: <Der Ring des Nibelungen>, Vienna Philharmonic Orchestra-Georg Solti. ℗1959 Original Recording. The Complete "Ring Cycle" of 22 individual records, with each "Ring Cycle" in its own wooden-spined slip-case, slides into the wooden display casket. Case 1: (RING 1-3) "Das Rheingold", (35 pages booklet) ℗1959; Case 2: (RING 4-8) "Die Walküre", (46 pages booklet) ℗1966; Case 3: (RING 9-13) "Siegried", (42 pages booklet) ℗1963; Case 4: (RING 14-18) "Götterdämmerung", (40 page booklet) ℗1965; Case 5: (RING 19-22), Guide & Introduction to "Der Ring des Nibelungen" by Deryck Cooke (the respected Ring expert), (42 page booklet). Recorded in the Sofiensaal, Vienna, produced by John Culshaw. ©1968

Remark & Rating
$$$$
TASEC, Penguin ★★★(❀), G.Top 100, Grammy, AS list, Japan 300

Label Decca SET 201-3 (=SXL 6015-6 & D247D 3)
London OSA 1319 (=OSA 1249, part)

Johan Strauss: <The Gala Performance of "Die Fledermaus">, Hilde Gueden, Erika Köth, Waldemar Kmentt, Eberhard Wäechter, Walther Berry, Eirc Kunz, Regina Resnik, consists of songs and arias sung by the guest artists Renata Tebaldi, Birgit Nilsson, Joan Sutherland, Mario del Monaco and others, The Vienna State Opera Chorus & The Vienna Philharmonic Orchestra-Herbert von Karajan. @1960

Remark & Rating
ED1, 4E-2E-2E-1E-1E-2E, $$
Penguin ★★(★)

Label Decca SET 204-8 (=D41D 5)
London OSA 1502

Wagner: <Tristan und Isolde>, Birgit Nilsson, Fritz Uhl, Regina Resnik, Tom Krause, Arnold van Mill, The Vienna Philharmonic Orchestra-Georg Solti. Producer: John Culshow, recorded in Sofiensaal, Vienna. (5LPs with 1 additional Demo record "Project Tristan") @1961

Remark & Rating
ED1, WBG, $$
Penguin ★★★, AS list-H

Label Decca SET 209-11 (=Decca D55D 3)
London OSA 1324

Verdi: <Otello>, Mario del Monaco, Renata Tebaldi, Aldo Protti, Fernando Corena, Tom Krause, The Vienna State Opera Chorus & Vienna Philharmonic Orchestra-Herbert von Karajan. Producer: John Culshaw (34 pages Booklet) @1961

Remark & Rating
ED1, WBG, $$
Penguin ★★(★), Japan 300

Label **Decca SET 212-4 (©=GOS 663-5)**
London OSA 1327

Donizetti: <Lucia di Lammermoor>, Sutherland, Cioni, Merrill, Siepi, etc., Chorus & Orchestra of L'Accademia Di Santa Cecilia, Rome-John Pritchard (28 pages Booklet). Recorded by Kenneth Wilkinson, 29 July - 7 August 1961 in Rome. ℗1961 ©1962

Remark & Rating
ED1, $$
Penguin ★★★, Grand Prix du Disc, Japan 300, (K. Wilkinson)

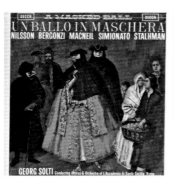

Label **Decca SET 215-7**
London OSA 1328

Verdi: <A Masked Ball (Un Ballo in Maschera)>, Birgit Nilsson, Carlo Bergonzi, Cornell MacNeil, Giulietta Simionato, Silvia Stalhman, Tom Krause, Fernando Corena, Orchestra & Chorus of L'Accademia Di Santa Cecilia, Rom-Georg Solti. (28 pages Booklet) (℗ by John Culshaw, Christopher Raeburn, Ray Minshull) @1962

Remark & Rating
ED1, 2D-2D-4D-2D-3D-2D, $

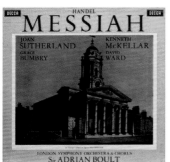

Label **Decca SET 218-20 (D104D 3)**
London OSA 1329

Handel: <Messiah>, Joan Sutherland (soprano), Grace Bumbry (alto), Kenneth McKellar (tenor), David Ward (bass), George Malcolm (harpsichord), Ralph Downes (organ), John McCarthy (chorus-master), The London Symphony Orchestra & Chorus-Adrian Boult (7 pages booklet). Recorded by Kenneth Wilkinson, August 1961 in Kingsway Hall, London. @1961

Remark & Rating
ED1, 1D-1D-2D-2D-1D-1D, $
Penguin ★★, (K. Wilkinson)

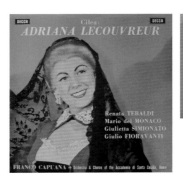

Label **Decca SET 221-3**
London OSA 1331

Francesco Cilea: <Adriana Lecouvreur>, Renata Tebaldi, Mario del Monaco, Giulietta Simionato, Chorus and Orchestra of L'Accademia di Santa Cecilia, Rome-Franco Capuana. (40 pages Booklet) Recorded by Kenneth Wilkinson, July 1961 in Rome. ©1962

Remark & Rating
ED1, rare! $
Penguin ★★(★), (K. Wilkinson)

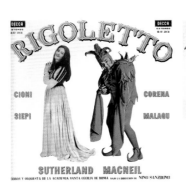
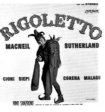

Label **Decca SET 224-6 (©=GOS 655-7)**
London OSA 1332

Verdi: <Rigoletto>, Renato Cioni, Cornell MacNeil, Mario del Monaco, Cesare Siepi, Stefania Malagu, Joan Sutherland, Anna Di Stasio, Fernando Coren, Chorus & Orchestra of the Accademia Di Santa Cecilia, Rome-Nino Sanzogno. @1962

Remark & Rating
ED1, 1E-2E-1E-1E-2E-1E, $
Penguin ★★(★)

Label **Decca SET 227**
 London CS 6245 (=CS 6782)

[The Vienna Philharmonic Play Wagner], <"Rienzi" Overture>, <"The FLying Dutchman" Overture>, <"Tannhäuser" - Overture and Bacchanale>, The Vienna Philharmonic Orchestra-Georg Solti. ℗1962 (* London CS 6782 is the reissue from London CS 6245 & Decca SET 227)

Remark & Rating
ED1, 2E-2E

Label **Decca SET 228-9**
 London OSA 1218

Richard Strauss: <Salome>, Birgit Nilsson (soprano), Grace Hoffman (mezzo-soprano), Eberhard Wächter (baritone) Gerhard Stolze (tenor), Waldemar Kmentt (tenor), The Vienna Philharmonic Orchestra-Georg Solti. (24 pages Booklet) Recorded by James Brown, Oct 1961 at Sofiensaal, Vienna. (℗ by John Culshaw) ©1962

Remark & Rating
ED1,$
TAS2016, Top 100 20th Century Classic, G.Top 100, Penguin ★★★, Grammy

Label **Decca SET 230**
 London OSA 1105 (OS 25322)

[Salvador Dali In Venice], Scarlatti: <The Spanish Lady and the Roman Cavalier>; Confalonieri: <Gala (featuring Cosmic Divertissement by Dali)>; Salvador Dali: <Dali paints a picture>, <Dali speaks about his art>. Scarlatti vocal duet setting with chamber orchestra, arranged by Giulio Confalonieri for the Dali Exhibition of that year, Fiorenza Cossotto (contralto), Lorenzo Alvary (baritone), Complesso strumentale Italiano-Giulio Confalonieri. @1962

Remark & Rating
ED1, 1D-1D, rare! $$

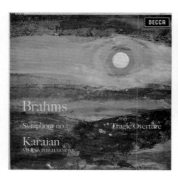

Label **Decca SET 231 (©=SDD 284)**
 London CS 6249

Brahms: <Symphony No.3 in F Major, Op.90>, <Tragic Overture, Op.81>, The Vienna Philharmonic Orchestra-Herbert Von Karajan. @1962

Remark & Rating
ED1, 1E-1E, rare!! $$$

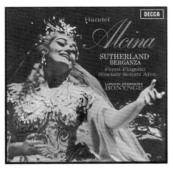
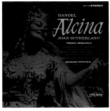

Label Decca SET 232-4 (ⓒ=GOS 509-11)
London OSA 1361

Handel: <Alcina>, Sutherland, Bergonza, Freni, Flagello, Sinclair, Sciutti, Alva, London Symphony Chorus & Orchestra-Richard Bonynge. (22 pages booklet) @1962

Remark & Rating
ED1, $$

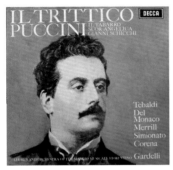

Label Decca SET 236-8 (=SXL 6122-4)
London OSA 1364 (=OSA 1151-3)

Puccini: Il Triticco, <Il Tabarro (The Clock)>; <Suor Angelica>; <Gianni Schicchi>, Merrill; Tebaldi; Monaco; Simionato; Danieli; Corena, Chorus & Orchestra of The Maggio Musicale Fiorentino-Lamberto Gardelli. @1962

Remark & Rating
ED1, rare!, $$
AS list-H

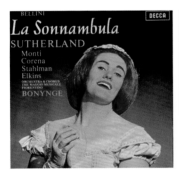

Label Decca SET 239-41
London OSA 1365

Bellini: <La Sonnambula>, Joan Sutherland, Nicola monti, Sylvia Stahlman, Fernando Corena, Margreta Elkins, Chorus & Orchestra of the Maggio Musicale Fiorentino Orchestra, Rome-Richard Bonynge. (36 pages Booklet) ℗1962

Remark & Rating
ED1, $$
Penguin ★★(★)

Label Decca SET 242-6
London OSA 1508

Wagner: <Siegfried>, Wolfgang Windgassen, Brigit Nilsson, Hans Hotter, Gerhard Stolze, Gustav Neidlinger, Kurt Bohme, Marga Hoffgen, The Vienna Philharmonic Orchestra & Vienna State Opera Chorus-Georg Solti. Recorded in the Sofiensaal, Vienna, produced by John Culshaw. @1963

Remark & Rating
ED1, $$
TASEC, G.Top 100, Penguin ★★★, Grammy, Japan 300, AS list-H

Label Decca SET 247-8 (SXL 6073-4)
London OSA 1254

[Command Performance], Joan Sutherland (soprano) with supporting soloists and choruses, London Symphony Orchestra-Richard Bonynge. Recorded by Arthur Lilley, Kenneth Wilkinson & Michael Mailes in Kingsway Hall. ℗1963 (=SXL 6073-4)

Remark & Rating
ED1, $
Penguin ★★★, (K. Wilkinson)

Label **Decca SET 249-51**
 London OSA 1366

Verdi, <La Traviata>, Joan Sutherland, Carlo Bergonzi & Robert Merrill, Chorus and Orchestra of the Maggio Musicale Fiorentino-John Pritchard. (32 pages Booklet) @1963

Remark & Rating
ED1, $$
Penguin ★★(★)

Label **Decca SET 252-3**
 London OSA 1255

Britten: <War Requiem, Op 66>, Galina Vishnevskaya, Peter Pears and Dietricht Fischer-Diskau and Simon Preston (organ), London Symphony Orchestra and the Melos Ensemble-Benjamin Britten. (12 pages Booklet) Producer: John Culshaw. Recordied by Kenneth Wilkinson, Jan. 1963 in the Kingsway Hall, London. @1963

Remark & Rating
ED1, 1D-2E-5E-1D, $
Penguin ★★★(❀), AS List-H, (K. Wilkinson)

Label **Decca SET 254-5**
 London CSA 2213 (=CS 6342-3)

[The Art of the Prima Balleriina Vol.1 & Vol.2], London Symphony Orchestra-Richard Bonynge. @1963 (CSA 2213=CS 6342 & CS 6343, 10 pages booklet)

Remark & Rating
ED1, 1E-1E-1E-1E, $
Penguin ★★★

Label **Decca SET 256-8**
 London OSA 1368

Bizet: <Carmen> Complete Opera, Regina Resnik, Mario del Monaco, Joan Sutherland, Tom Krause, L'Orchestre de la Suisse Romande-Thomas Shippers. @1963

Remark & Rating
ED1, $

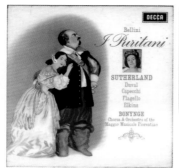

Label **Decca SET 259-61**
 London OSA 1373

Bellini: <I Puritani, Complete opera>, Joan Sutherland, Pierre Duval, Ezio Flagello, Renato Capecchi, Margreta Elkins, Orchestra and Chorus of the Maggio Musicale Fiorentino-Richard Bonynge. (28 pages booklet) @1963

Remark & Rating
ED1, $

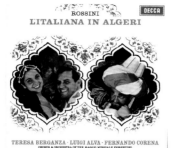
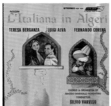

Label **Decca SET 262-4**
 London OSA 1375

Rossini: <L'Italiana in Algeri>, Teresa Berganza, Luigi Alva, Fernando Corena, Orchestra and Chorus of Maggio Musicale Fiorentino-Silvio Varviso. (32 pages Booklet) @1964

Remark & Rating
ED1, $
Penguin ★★★

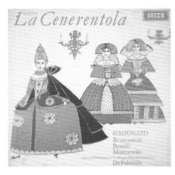

Label **Decca SET 265-7**
 London OSA 1376

Rossini: <La Cenerentola>, Simionato, Montarsolo, Benelli, Bruscantini, Chorus & Orchestra of the Maggio Musicale Fiorentino-Oliviero De Fabritiis. (30 pages booklet) @1964

Remark & Rating
ED1, $

Label **Decca SET 268-9**
 London OSA 1257

[The Age of Belcanto], Joan Sutherland, Marilyn Horne and Richard Conrad, London Symphony Orchestra & New Symphony Orchestra of London-Richard Bonynge. (40 pages Booklet) @1964

Remark & Rating
ED1, 3G-1G-3G-2G

Label **Decca SET 270-1**
 London OSA 1261

Schubert: <Die Winterreise, D.911>, Schumann: <Dichterliebe, Op.48>, Peter Pears (tenor) & Benjamin Britten (piano). (12 pages Booklet) Recorded by Kenneth Wilkinson. @1965

Remark & Rating
ED2, $
Penguin ★★★(❀), (K. Wilkinson)

Label **Decca SET 272-3**
 London OSA 1259

Beethoven: <Fidelio>, Birgit Nilsson, James McCracken, Tom Krause, Hermann Prey, The Vienna Philharmonic Orcheatra-Lorin Maazel. @1964

Remark & Rating
ED1, $

Label **Decca SET 274-6**
London OSA 1378

Britten: <Albert Herring>, A comic opera in 3 Acts. Peter Pears, Sylvia Fischer, John Noble, Edgar Evans, Sheila Rex, Benjamin Britten conducting the English Chamber Orchestra. Produced by John Culshaw, recorded by Kenneth Wilkinson. (36 pages Booklet) @1964

Remark & Rating
ED1 + ED4, $
Penguin ★★(★), AS List, (K. Wilkinson)

Label **Decca SET 277-9**
London OSA 1379

Debussy: <Pelleas Et Melisande>, Erna Spoorenberg, Camille Maurane, George London, Guus Hoekman, L'Orchestre de la Suisse Romande-Ernest Ansermet. (30 pages Booklet) ℗1964 ©1965

Remark & Rating
ED1, $

Label **Decca SET 280-1**
London OSA 1260

Donizetti: <Don Pasquale>, Fernando Corena, Juan Oncina, Graziella Sciutti,Tom Krause, Vienna Opera & Chorus-Istvan Kertesz. (30 pages Booklet) @1965

Remark & Rating
ED2, 4G-4G-3G-3G, $
Penguin ★★(★)

Label **Decca SET 282-4**
London OSA 1380

Verdi: <Macbeth>, Taddei; Nilson; Prevedi, Chorus & Orchestra of the Accademia di Santa Cecilia, Rome-Thomas Schippers. (28 pages booklet) @1964

Remark & Rating
ED1, $$

Label **Decca SET 285-7**
London OSA 1381

Gioachino Rossini: <Il Barbiere Di Siviglia (Barber of Seville)>, Berganza, Ghiaurov, Ausensi, Corena, Benelli, Orchestra Rossini di Napoli-Silvio Varviso. (36 pages Booklet) @1965

Remark & Rating
ED2, 2G-1G-1G-2G-2G-2G, $
Penguin ★★(★)

Label Decca SET 288-91
 London OSA 1431

J.S. Bach: <Matthaus Passion>, Ameling, Hoffgen, Pears, Wunderlich, Prey, Krause, Blankenburg, The Stuttgart Hymnus Boy's Choir & The Stuttgart Chamber Orchestra-Karl Münchinger. (34 pages booklet) @1965

Remark & Rating
ED2, $
Penguin ★★★, AS List-H

Label Decca SET 292-7
 London OSA 1604

Wagner: <Götterdämmerung>, Briget Nilsson, Wolfgang Windgassen, Gustav Neidlinger, Gottlob Frick, Claire Watson, Dietrich Fischer-Dieskau, Christa Ludwig, Lucia Popp, Gwyneth Jones, Maureen Guy, Helen Watts, Grace Hoffman, Anita Välkki, The Vienna Philharmonic Orchestra & Vienna State Opera Chorus-Georg Solti. (40 pages Booklet) Recorded in the Sofiensaal, Vienna, produced by John Culshaw. @1965

Remark & Rating
ED2, $$
TASEC, Penguin ★★★, AS list-H, G. Top 100

Label Decca SET 298-300
 London OSA 1382

Verdi: <Nabucco>, Elena Suliotis (soprano), Bruno Prevedi (tenor), Tito Gobbi (baritone), Carlo Cava (bass), Chorus & Orchestra of The Vienna State Opera-Lamberto Gardelli. (28 pages Booklet) ℗1965 ©1966

Remark & Rating
ED1, $
Penguin ★★★

Label Decca SET 301 (1BB 101-3)
 London OSA 1156

Britten: <Curlew River>, Pears; Shirley-Quirk; Drake; Blackburn, English Opera Group-Benjamin Britten & Viola Tunnard. (8 pages Booklet) Produced by John Culshaw, recorded in Orford Parich Church. @1966

Remark & Rating
ED2, $
Penguin ★★★, AS-DG list (1BB 101-3)

Label Decca SET 302 (©=SPA 476)
 London OSA 1157

Mozart: <Requiem Mass In D Minor, K.626>, Elly Ameling (soprano), Marilyn Horne (mezzo-soprano), Ugo Benelli (tenor), The Vienna State Opera Chorus & Philharmonic Orchestra-Istvan Kertesz. @1966

Remark & Rating
ED2, 2G-3G, $
Penguin ★★(★)

Label **Decca SET 303-4**
London CSA 2215

J.S. Bach: <Die Kunst Der Fuge (The Art of Fugue)>, The Stuttgart Chamber Orchestra-Karl Münchinger. (18 pages booklet) @1965

Remark & Rating
ED1, $

Label **Decca SET 305-8**
London OSA 1432

Verdi: <Don Carlos>, Carlo Bergonzi; Renata Tebaldi; Dietrich Fischer-Dieskau; Nicolai Ghiaurov, Chorus & Orchestra of the Royal Opera House, Covent Garden-Georg Solti. (36 pages booklet) @1966

Remark & Rating
ED2, $
Penguin ★★★

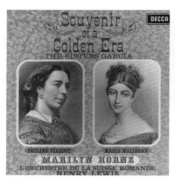

Label **Decca SET 309-10**
London OSA 1263

[Marilyn Horne - Souvenir of a Golden Era], Music by Rossini, Bellini, Beethoven, Gluck, Gounod, Meyerbeer, Verdi. L'Orchestre de la Suisse Romande & The Geneva Opera Chorus-Henry Lewis. (22 pages booklet) @1966

Remark & Rating
ED1, rare!, $$

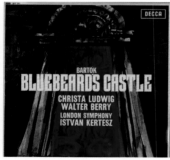

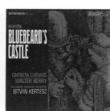

Label **Decca SET 311**
London OSA 1158 (=OS 25968)

Bartok: <Duke Bluebeard's Castle>, (Sung in the original Hungarian) Walter Berry, Christa Ludwig, London Symphony Orchestra-Istvan Kertesz. @1966

Remark & Rating
ED1, 1G-1G, $
Penguin ★★★, TAS2017

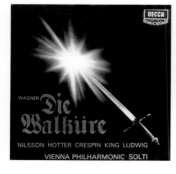

Label **Decca SET 312-6**
London OSA 1509

Wagner: <Die Walküre>, Starring Brigit Nilsson as Brünnhilde, James King as Siegmund, Regine Crespin as Sieglinde, Hans Hotter as Wotan, Gottlob Frick as Hunding, Christa Ludwig as Fricka, etc., The Vienna Philharmonic Orchestra & Vienna State Opera Chorus-Georg Solti. Recorded in the Sofiensaal, Vienna, produced by John Culshaw. @1966

Remark & Rating
ED2, 1st, $$
Penguin ★★★, AS list-H, G. Top 100

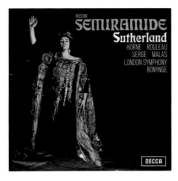

Label Decca SET 317-9
London OSA 1383

Rossini: <Semiramide>, Joan Sutherland (soprano), Marilyn Horne (contralto), Joseph Rouleau (bass), Ambrosian Chorus & London Symphony Orchestra-Richard Bonynge. (32 pages Booklet) @1966

Remark & Rating
ED2, $
Penguin ★★★

Label Decca SET 320-2
London OSA 1384

Bellini: <Beatrice di Tenda>, Joan Sutherland, Josephine Veasey, Luciano Pavarotti, Cornelius Opthof, London Symphony Orchestra conducted by Richard Bonynge. (28 pages Booklet) @1967

Remark & Rating
ED2, $
Penguin ★★(★)

Label Decca SET 323-4
London CSA 2216

Bruckner: <Symphony No.7>* ; Wagner: <Siegfried Idyll, (original scoring)>** , The Vienna Philharmonic Orchestra-Georg Solti. @1966 [* Bruckner: Penguin ★★; Wagner: Penguin ★★(★)]

Remark & Rating
ED2, 2W-1W-1W-2L, $
Penguin ★★(★)

Label Decca SET 325-6*
London CSA 2217

Mahler: <Symphony No.2 in C Minor (Resurrection)>, Harper, Watts, Chicago Symphony Orchestra-Georg Solti. @1966

Remark & Rating
ED2, $
Penguin ★★★

Label Decca SET 327-30
London OSA 1433

Gounod: <Faust - An Opera in 5 Act>, Franco Corelli, Nicolai Ghiaurov, Joan Sutherland, Robert Massard, Monica Sinclair, Margaret Elkins, Raymond Myers, The Ambrosian Opera Chorus & The Choir of Highgate School with The London Symphony Orchestra-Richard Bonynge. (47 pages Booklet) @1966

Remark & Rating
ED2, $

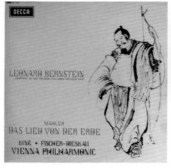

Label **Decca SET 331**
London OS 26005

Mahler: <Das Lied von der Erde>, James King, Dietrich Fischer-Dieskau, The Vienna Philharmonic Orchestra-Leonard Bernstein. @1966

Remark & Rating
ED2, 1G-1G, $
TAS2016, Penguin ★★★ & ★★(★)

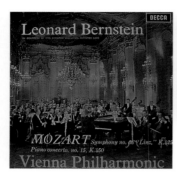

Label **Decca SET 332***
London CS 6499 (CSA 2233)

Mozart: <Symphony No.36, K.425 "Linz">, <Piano Concerto No.15, K.450>, Leonard Bernstein (piano), Vienna Philharmonic Orchestra-Leonard Bernstein. Recorded by Gordon Parry, 1966 at Sofiensaal, Vienna @1967

Remark & Rating
ED2, $$
Penguin ★★(★), TAS2016

Label **Decca SET 333-4 (©=SPA 583-4)**
London OSA 1265

Brahms: <Ein Deutsches Requiem, Op.45>, <Alto Rhapsody>, <Nänie>, Agnes Giebel; Hermann Prey; Helen Watts, L'Orchestre & Chorus de la Suisse Romande-Ernest Ansermet. (12 pages booklet) @1967

Remark & Rating
ED2, $

Label **Decca SET 335-6**
London CSA 2219

Bruckner: <Symphony No.8 in C Minor>, The Vienna Philharmonic Orchestra-Georg Solti. @1968

Remark & Rating
ED2, 1W-1W-1W-3W
Penguin ★★(★)

Label **Decca SET 337 (SET 280-1)**
London OS 26013 (OSA 1260)

Donizetti: <Don Pasquale, Highlights>, Fernando Corena, Juan Oncina, Graziella Sciutti, Tom Krause, Vienna State Opera Orchestra & Chorus-Istvan Kertesz. ℗1964 ©1967 (Highlights from SET 280-1 & OSA 1260)

Remark & Rating
Penguin ★★★

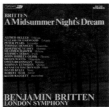

Label **Decca SET 338-40**
London OSA 1385

Britten: <A Midsummer Night's Dream>, Alfred Deller; Elizabeth Harwood; Peter Pears; John Shirley-Quirk, London Symphony Orchestra-Benjamin Britten. (27 pages Booklet) Produced by John Culshaw, recorded in Walthamstow Assembly Hall. @1966

Remark & Rating
Penguin ★★★, AS List

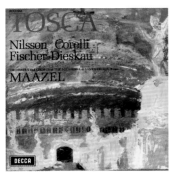

Label **Decca SET 341-2**
London OSA 1267

Puccini: <Tosca>, Birgit Nilsson, Franco Corelli, Dietrich Fischer-Dieskau, Orchestra of the Accademia Di Santa Cecilia, Rom-Lorin Maazel. (32 pages booklet) @1967

Remark & Rating
ED2. 5G-3G-1G-3G

Label **Decca SET 343-4**
London OSA 1266

Mascagni: <Cavalleria Rusticana>, Elena Suliotis; Mario Del Monaco; Tito Gobbi; Stefania Malagu, Side 4: A Solo Recital by Elena Suliotis, The Rome Orchestra & Chorus-Silvio Varviso. (20 pages Booklet) @1967

Remark & Rating
ED2, 1G-2G-2G-1G

Label **Decca SET 345 (SET 265-7)**
London OS 26026 (OSA 1376)

Rossini: <La Cenerentola, Highlights>, Simionato, Montarsolo, Benelli, Bruscantini, Chorus & Orchestra of the Maggio Musicale Fiorentino-Oliviero De Fabritiis. ℗1964 ©1967 (Highlights from SET 265-7 & OSA 1376)

Remark & Rating
ED2

Label **Decca SET 346-8**
London OSA 1386

J.S. Bach: <Christmas Oratorio>, Elly Ameling (soprano), Helen Watts (contralto), Werner Krenn (tenor), Tom Krause (bass), Stuttgart Chamber Orchestra-Karl Münchinger. (19 pages booklet) ℗1967

Remark & Rating
ED2

Label Decca SET 349-50
 London OSA 1268

[Love Live Forever-The Romance of Musical Comedy], excerpts from operettas and musical comedies, sung in the original languages, Joan Sutherland (soprano), The Ambrosian Light Opera Chorus & New Philharmonia Orchestra-Richard Bonynge. (32 pages Booklet) ℗1967

Remark & Rating
ED2, 2W-2W-2W-2W

Label DECCA SET 351 (OSA 1270)
 (London=OS 26038, one of the OSA 1270)

Karl Heinrich Graun: <Montezuma (excepts)>, Joan Sutherland; Lauris Elms; Monica Sinclair, Joseph Ward and others with The London Philharmonic Orchestra & The Ambrosian Singers-Richard Bonynge. @1967

Remark & Rating
ED3, 1G-1G, $

Label DECCA SET 352 (OSA 1270)
 (London=OS 26040, one of the OSA 1270)

Giovanni Bononcini: <Griselda (excepts)>, Joan Sutherland; Lauris Elms; Monica Sinclair, and others with The London Philharmonic Orchestra & The Ambrosian Singers-Richard Bonynge. @1968

Remark & Rating
ED2

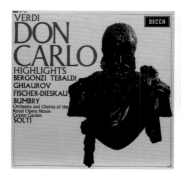

Label Decca SET 353 (SET 305-8)
 London OS 26041 (OSA 1432)

Verdi: <Don Carlos, Highlights>, Carlo Bergonzi; Renata Tebaldi; Dietrich Fischer-Dieskau; Nicolai Ghiaurov, Orchestra & Chorus of the Royal Opera House, Covent Garden-Georg Solti. ℗1966 ©1967 (Highlights from SET 305-8 & OSA 1432)

Remark & Rating
Penguin ★★★

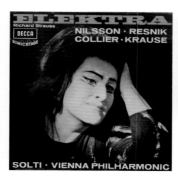

Label Decca SET 354-5*
 London OSA 1269

Richard Strauss: <Elektra>, Birgit Nilsson, Regina Resnik, Marie Collier, Gerhard Stolze, Tom Krause, The Vienna Philharmonic Orchestra-Georg Solti. @1967 by John Culshaw

Remark & Rating
ED2 & ED4, $
TAS2016, Top 100 20th Century Classic, Penguin ★★★

Label Decca SET 356 (1BB 101-3)
London OSA 1163

Britten: <The Burning Fiery Furnace>, Pears; Shirley-Quirk; Drake; Tear; Dean; Leeming, English Opera Group-Benjamin Britten & Viola Tunnard. (8 pages Booklet) Produced by John Culshaw, recorded by Kenneth Wilkinson in Orford Parich Church. @1967

Remark & Rating
ED2, 1G-5G
Penguin ★★★, AS-DG list (1BB 101-3), (K. Wilkinson)

Label Decca SET 357-9
London OSA 1387

Mozart: <La Clemenzia di Tito>, Teresa Berganza, Brigitte Fassbaender, Werner Krenn, Maria Casula, Lucia Popp, Vienna State Opera Orchestra and Chorus-Istvan Kertesz. (28 pages Booklet) Recorded in the Sofiensall, Vienna. @1967

Remark & Rating
ED2, $

Label Decca SET 360-1
London CSA 2220

Mahler: <Symphony No.9 in D Minor>, London Symphony Orchestra-Georg Solti. @1967 (8 pages Booklet in CSA 2220)

Remark & Rating
ED2, $
Penguin ★★(★)

Label Decca SET 362-3
London OSA 1271

Haydn: <Die Schöpfung (The Creation)>, Ameling, Krause, Krenn, Spoorenberg, Fairhurst, Vienna Philharmonic and State Opera Chorus-Karl Münchinger. (20 pages Booklet) Recorded by James Lock, James Brown & Jack Law in the Sofiensaal, Vienna @1968

Remark & Rating
ED2, $
Penguin ★★★

Label Decca SET 364-6
London OSA 1388

Ponchielli: <La Gioconda>, Renata Tebaldi, Oralia Dominguez, Robert Merrill, Nicolai Ghiuselev, Marilyn Horne, Carlo Bergonzi, Orchestra of the Accademia Nazionale di Santa Cecilia, Rom-Lamberto Gardelli. (36 pages Booklet) ℗1967

Remark & Rating
ED2, $
Penguin ★★★

Label **Decca SET 367 (SET 298-30)**
 London OS 26059 (OSA 1382)

Verdi: <Nabucco, Highlights>, Gobbi; Suliotis; Cava; Prevedi, Chorus & Orchestra of The Vienna State Opera-Lamberto Gardelli. (8 pages Booklet) ℗1965 ©1968 (Highlights from SET 298-30 & OSA 1382)

Remark & Rating
ED2, 1G-1G
Penguin ★★★

Label **Decca SET 368-9**
 London OSA 1272

Bellini: <Norma>, Elena Suliotis; Mario Del Monaco; Fiorenza Cossotto; Carlo Cava, Orchestra Of L'Accademia Di Santa Cecilia, Rome- Silvio Varviso. (28 pages booklet) @1968

Remark & Rating
ED2, 1G-1G-1G-1G, $

Label **Decca SET 370-1**
 London CSA 2221

Liszt: <A Faust Symphony, In 3 character portraits (after Goethe)>, <2 Episodes from Lenau's Faust>, Werner Krenn (tenor) with Le Choeur Pro Arte de Lausanne and L'Orchestre de la Suisse Romande-Ernest Ansermet. (12 pages Booklet) @1968

Remark & Rating
ED2, $

Label **Decca SET 372-3**
 London OSA 1273

Donizetti:<La Fille du Regiment>, Joan Sutherland, Luciano Pavarotti, Monica Sinclair, Spiro Malas, Chorus & Orchestra of Royal Opera House, Convent Garden-Richard Bonynge. (27 pages Booklet) @1968

Remark & Rating
ED2, $
Penguin ★★★

Label **Decca SET 374-5**
 London OSA 1275

Verdi: <Requiem>, Sutherland, Horne, Pavarotti, Talvela, Vienna State Opera Chorus & Vienna Philharmonic Orchestra-Georg Solti (12 pages Booklet). Recorded by Gordon Parry, October 1967 in the Sofiensaal, Vienna. @1968

Remark & Rating
ED2, $
Penguin ★★★, Grammy

Label **Decca SET 376-8**
London OSA 1389

Cherubini: <Medea>, Gwyneth Jones; Bruno Prevedi; Justino Diaz; Fiorenzo Cossotto; Pilar Lorengar, Chorus & Orcheatra of Accademia Di Santa Cecilia, Rome-Lamberto Gardelli. (20 pages booklet) @1968

Remark & Rating
ED2, $

Label **Decca SET 379-81**
London OSA 1390

Britten:<Billy Budd>, Glossop, Pears, Langdon, Ambrosian Opera Chorus & London Symphony Orchestra-Benjamin Britten. Recorded by Gordon Parry & Kenneth Wilkinsonin at Kingsway Hall, London. ℗1968 by John Culshaw

Remark & Rating
TAS2016, Top 100 20th Century Classical,
Penguin ★★★, AS-DG list, (K. Wilkinson)

Label **Decca SET 382-4 (=SXL 2101-3)**
London OSA 1309

Wagner: <Das Rheingold>, Kirsten Flagstad as Frica, George London as Wotan, Claire Watson as Freia, Set Svanholm as Loge, Jean Madeira as Erda, Gustav Neidlinger as Alberich, Paul Kuen as Mime, Eberhard Wächter as Donner, Waldemar Kmentt as Froh, Walter Kreppel, Kurt Böhme, Oda Balsborg, Hetta Plumacher, Ira Malaniuk. The Vienna Philharmonic Orchestra & Vienna State Opera Chorus-Georg Solti. (56 pages Booklet) Recorded in the Sofiensaal, Vienna, produced by John Culshaw. ℗1959 (=SXL 2101-3)

Remark & Rating
ED2, $
TASEC, Penguin ★★★, AS list-H, G.Top 100

Label **Decca SET 385-6***
London CSA 2223 (=CS 6600, CS 6601)

Mahler: <Symphony No.3 in D Minor>, Chicago Symphony Orchestra-Georg Solti. Recorded by Gordon Parry and James Lock, January 1968 at Kingsway Hall, London. (12 pages Booklet) @1969

Remark & Rating
ED3, 1W-1W-1W-1W

Label **Decca SET 387-9**
London OSA 1391

Delibes: <Lakme>, Joan Sutherland; Alain Vanzo; Gabriel Bacquier, Monte Carlo National Opera Orchestra-Richard Bonynge. (27 pages Booklet) @1968

Remark & Rating
ED3, 2G-1G-1G-1G-2G-1G, $
Penguin ★★★, AS-DG list

Label **Decca SET 390 (SET 312-6)**
London OS 26085 (OSA 1509)

Wagner: <Die Walküre, Highlights>, Starring: Brigit Nilsson as Brünnhilde, James King as Siegmund, Regine Crespin as Sieglinde, Hans Hotter as Wotan, Gottlob Frick as Hunding, Christa Ludwig as Fricka, etc., Vienna Philharmonic Orchestra & Vienna State Opera Chorus-Georg Solti. ℗1966 ©1968 (Highlights from SET 312-6 & OSA 1509)

Remark & Rating
ED3
Penguin ★★★

Label **Decca SET 391 (SET 317-9)**
London OS 26086 (OSA 1383)

Rossini: <Semiramide, Highlights>, Joan Sutherland (soprano), Marilyn Horne (contralto), Joseph Rouleau (bass), Ambrosian Chorus & London Symphony Orchestra-Richard Bonynge. ℗1966 ©1969 (Highlights from SET 317-9 & OSA 1383)

Remark & Rating
ED3
Penguin ★★★

Label **Decca SET 392-3**
London OSA 1276

[Covent Garden Anniversary Album], recorded in association with many friends of Covent Garden, Tito Gobbi, Yvonne Minton, Peter Pears, Joan Sutherland & other 22 artists, Chorus & Orchestra of Convent Garden, conducted by R. Bonynge, E. Downes, R. Goodall, W. Walton & G. Solti. (30 pages booklet) @1968

Remark & Rating
ED3, 1G-3W-2G-1G, Rare!! $$

Label **Decca SET 394-6**
London OSA 1392

Catalani: <La Wally>, Renata Tebaldi, Mario Del Monaco, Justino Diaz, Piero Cappuccilli, Monte Carlo National Opera Orchestra-Fausto Cleva. (28 pages Booklet) @1969

Remark & Rating
ED3, $

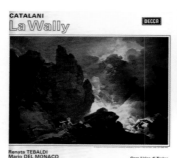

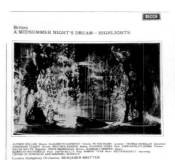

Label **Decca SET 397 (SET 338-40)**
London OS 26097 (OSA 1385)

Britten: <A Midsummer Night's Dream, Highlights>, Alfred Deller; Elizabeth Harwood; Peter Pears; John Shirley-Quirk, London Symphony Orchestra-Benjamin Britten. ℗1966 ©1969 (Highlights from SET 338-40 & OSA 1385)

Remark & Rating
ED3
Penguin ★★★

Label **Decca SET 398**
 London OS 26100

J.S. Bach: <Easter Oratorio>, Elly Ameling (soprano), Helen Watts (contralto), Werner Krenn (tenor), Tom Krause (bass), Stuttgart Chamber Orchestra-Karl Münchinger. (8 pages Booklet) @1969

Remark & Rating
ED3, $
Penguin ★★★

Label **Decca SET 399-400**
 London OSA 1278

Kodaly: <Hary Janos> A Comic Opera, Peter Ustinov (narrator), Erszébet Komlossy, László Palócz, Gyorgy Melis, Zsolt Bende, Olga Szönyi & Margit László with Edinburgh Festival Chorus; Wandsworth School Boys Choir & The London Symphony Orchestra-Istvan Kertesz. @1969

Remark & Rating
ED3, $
Penguin ★★(★)

Label **Decca SET 401-2**
 London OSA 1279

Verdi: <La Traviata>, Lorengar, Fischer-Dieskau, Aragall, Chorus and Orchestra of The Deutsche Oper, Berlin-Lorin Maazel. Recorded in 1963. (26 pages booklet) @1969

Remark & Rating
ED3, 3G-4G-2G-1G
Penguin ★★(★)

Label **Decca SET 403-4**
 London OSA 1280

Leoncavallo:<I Pagliaccil>, McCracken, Lorengar, Merrill, Krause, Chorus & Orcheatra of Accademia Di Santa Cecilia, Rome-Lamberto Gardelli. (19 pages booklet) @1969

Remark & Rating
ED3, 2G-1G-1G-2G

Label **Decca SET 406-8 (RING 1-22)**
 London RDN S-1

Wagner: <Der Ring des Nibelungen>, Guide & Introduction to "Der Ring des Nibelungen", explanation and analysis of Wagners system of leitmotifs by Deryck Cooke (the respected Ring expert) with 193 music examples, The Vienna Philharmonic Orchestra & Vienna State Opera Chorus-Georg Solti. Recorded in the Sofiensaal, Vienna, produced by John Culshaw. @1969 [One of the case in the DECCA deluxe Set: RING 1-22, The Complete "Ring Cycle"]

Remark & Rating
ED3, $
Penguin ★★★

Label Decca SET 409 (SET 282-4)

Verdi: <Macbeth, Highlights>, Taddei; Nilson; Prevedi, The Accademia di Santa Cecilia, Rome-Thomas Schippers. ℗1964 ©1969

Remark & Rating
ED3

Label Decca SET 410-11 (SXL 6774-5)
London CSA 2225 (CS 6634-5)

J.S. Bach: <The Six Brandenburg Concertos, No.1-6, BWV 1046-1051>, Benjamin Britten conducting the English Chamber Orchestra. Recorded by Kenneth Wilkinson, 1968 in the Maltings, Snape. @1969

Remark & Rating
ED3, 1W-2W-1W-1W, $$
Penguin ★★(★), (K. Wilkinson)

Label Decca SET 412-5
London OSA 1434

Mozart: <Don Giovanni>, Donald Gramm, Gabriel Bacquier, Joan Sutherland, Marilyn Horne, Pilar Lorengar, Werner Krenn, English Chamber Orchestra-Richard Bonynge. (56 pages Boolet) ℗1969 ©1970

Remark & Rating
ED3, $

Label Decca SET 416-7
London OSA 1281

Dvorak: <Requiem Mass, Op.89>, Pilar Lorengar, Erzsébet Komlóssy, Robert Ilosfalvy, Tom Krause, Ambrosian Singers & London Philharmonic Orchestra-Istvan Kertesz (16 pages booklet), Recorded by Gordon Parry & James Lock, December 1968 in Kingsway Hall.on. @1969

Remark & Rating
ED3, $
Penguin ★★★

Label Decca SET 418-21
London OSA 1435 (OSAL)

Richard Strauss: <Der Rosenkavalier>, Regine Crespin; Manfred Jungwirth; Yvonne Minton; Otto Wiener & Luciano Pavarotti as The Singer, Vienna Philharmonic Orchestra-Georg Solti. (72 pages Booklet) Recorded by Jack Law, James Lock & Gordon Parry in the Sofiensaal, Vienna. @1969

Remark & Rating
ED3+ED4
Penguin ★★★

Label Decca SET 422
London OS 26121

Zandonai:<Francesca da Rimini, Highlights>, Mario del Monaco, Magda Olivero, Annamaria Gasparini, Monte Carlo National Opera Orchestra-Nicola Rescigno. (4 pages Booklet) ℗1969 ©1970

Remark & Rating
ED3, 2G-1G

Label Decca SET 423 (SET 346-8)
London OS 26128

J.S. Bach: <Christmas Oratorio, Highlights>, Elly Ameling (soprano), Helen Watts (contralto), Werner Krenn (tenor), Tom Krause (bass), Stuttgart Chamber Orchestra-Karl Münchinger. ℗1967 ©1970

Remark & Rating
ED3

Label Decca SET 424-6 (=RCA LSC 6166)
London OSA 1394

Bellini: <Norma, (Complete opera)>, Joan Sutherland, Marilyn Horne, John Alexander and Richard Cross, London Symphony Orchestra and chorus-Richard Bonyge. Original recording in 1965 (=RCA LSC 6166) ℗1968 ©1970

Remark & Rating
ED3, $
Penguin ★★★

Label Decca SET 427-9 (=RCA LSC 6158)
London OSA 1393

Verdi: <Aida>, Leontyne Price, Jon Vickers, Robert Merrill, Rome Opera House Orchestra & Chorus-Georg Solti. Recorded by Lewis Layton. ℗1962 ©1970 (=RCA LSC 6158)

Remark & Rating
ED4, $
Penguin ★★★

Label Decca SET 430 (SET 320-2)
London OS 26140 (OSA 1384)

Bellini: <Beatrice di Tenda, Highlights>, Joan Sutherland, Josephine Veasey, Luciano Pavarotti, Cornelius Opthof, London Symphony Orchestra conducted by Richard Bonynge. ℗1969 ©1970 (Highlights from SET 320-2& OSA 1384)

Remark & Rating
ED3
Penguin ★★(★)

Label Decca SET 431 (SET 327-30)
 London OS 26139 (OSA 1433)

Gounod: <Faust, Highlights>, Franco Corelli; Nicolai Ghiaurov; Joan Sutherland; Robert Massard; Monica Sinclair; Margaret Elkins; Raymond Myers, The Ambrosian Opera Chorus; The Choir of Highgate School; The London Symphony Orchestra-Richard Bonynge. ℗1969 ©1970 (Highlights from SET 327-30 & OSA 1433)

Remark & Rating
ED3, 1G-1G

Label Decca SET 432 (SET 357-9)
 London OS 26138 (OSA 1387)

Mozart: <La Clemenzia di Tito, Highlights>, Teresa Berganza, Brigitte Fassbaender, Werner Krenn, Maria Casula, Lucia Popp, Vienna State Opera Orchestra and Chorus-Istvan Kertesz. ℗1969 ©1970 (Highlights from SET 357-9 & OSA 1387)

Remark & Rating
ED3

Label Decca SET 433-4
 London CSA 2226

Adolphe Adam: <Giselle - Ballet>, Monte Carlo National Opera Orchestra-Richard Bonynge. (16 pages booklet) ℗1969 ©1970

Remark & Rating
ED3 + ED4, $

Label Decca SET 435-6
 London OSA 1283

Giordano: <Fedora>, Magda Olivero; Mario del Monaco; Tito Gobbi, Chorus & L'Orchestre National de l'Opera de Monte Carlo-Lamberto Gardelli. (31 pages booklet) @1969

Remark & Rating
ED3, $
Penguin ★★(★)

Label Decca SET 438 (1BB 101-3)
 London OSA 1164

Britten: <The Prodigal Son, Op.81>, Pears; Shirley-Quirk; Drake; Tear, English Opera Group-Benjamin Britten & Viola Tunnard. Produced by John Culshaw, Ray Minshull, recorded in Orford Parich Church. (12 pages Booklet) ℗1969 ©1970

Remark & Rating
ED4, 4G-4G,
Penguin ★★★, AS-DG list (1BB 101-3)

Label Decca SET 439 (One of SET 439-440)
London OS 26130 (OSA 1282)

"Tebaldi Festival, Volume 1", Tannhäuser, Lohengrin, Tristan und Isolde (Wagner); Carmen (Bizet); Samson et Dalila (Saint-Saens); Manon (Massenet), National Philharmonic Orchestra-Anton Guadagno. ℗1969 ©1970

Label Decca SET 439-40
London OSA 1282 (=OS 26130, OS 26113)

[A Tebaldi Festival], Tannhäuser, Lohengrin, Tristan und Isolde (Wagner); Carmen (Bizet); Samson et Dalila (Saint-Saens); Manon (Massenet), Anton Guadagno-National Philharmonic Orchestra. Aida (Verdi); La Boheme (Puccini); La Regata Veneziana (Rossini); Granada (Lara); Estrellita (Ponce); Catari Catari (Cardillo); A Vucchella (Tosti); Non ti scordar di me (De Curtis); If I loved you (Rodgers), Richard Bonynge conducting the National Philharmonic Orchestra. Recorded in the Kingsway Hall, London. (27 pages Booklet) ℗1969 ©1970

Remark & Rating
ED4, 2G-2G-2G-3G

Label Decca SET 440 (One of SET 439-440)
London OS 26113 (OSA 1282)

"Tebaldi Festival, Volume 2", Aida (Verdi); La Boheme (Puccini); La Regata Veneziana (Rossini); Granada (Lara); Estrellita (Ponce); Catari Catari (Cardillo); A Vucchella (Tosti); Non ti scordar di me (De Curtis); If I loved you (Rodgers), The New Philharmonia Orchestra-Richard Bonynge. ℗1969 ©1970

Label Decca SET 443-4
London OSA 1285

Christoph Willibald Gluck: <Orfeo ed Euridice>, Opera in 3 Acts, Marilyn Horne, Pilar Lorengar, Helen Donath, Orchestra & Chorus of the Royal Opera House Covent Garden-Georg Solti. (19 pages booklet) @1970

Remark & Rating
ED4, 3G-3G-3G-3G
Penguin ★★(★)

Label Decca SET 445

Britten: <The Golden Vanity, Op.78>, a vaudeville for boys and piano after the ballad by Colin Graham; <Childrens Crusade>, a ballad for Childrens voices and Orchestra, Wandsworth School Boys' Choir-Russell Burgess (conductor) & Benjamin Britten (piano). (8 pages Booklet) @1970

Remark & Rating
ED4, 1G-1G
Penguin ★★★

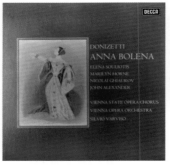

Label **Decca SET 446-9**
London OSA 1436

Donizetti: <Anna Bolena>, Elena Souliotis, Marilyn Horne, Nicolai Ghiaurov, John Alexander, Vienna State Opera Chorus & Orchestra-Silvio Varviso. (36 pages booklet) ℗1970

Remark & Rating
ED4, 5G-3G-4G-3G-3G-5G-3G-3G
Penguin ★★(★)

Label **Decca SET 450 (SET 364-6)**
London OS 26162 (OSA 1388)

Ponchielli: <La Gioconda, Highlights>, Tebaldi, Horne, Bergonzi, Merrill, Orchestra of the Accademia Nazionale di Santa Cecilia, Rom-Lamberto Gardelli. ℗1967 ©1970 (Highlights from SET 364-6 & OSA 1388)

Remark & Rating
ED4
Penguin ★★★

Label **Decca SET 451 (SET 341-2)**
London OS 26163 (OSA 1267)

Puccini: <Tosca, Highlights>, Nilsson, Corelli, Fischer-Dieskau, Orchestra of the Accademia Di Santa Cecilia, Rom-Lorin Maazel. ℗1967 ©1970 (Highlights from SET 341-2 & OSA 1267)

Remark & Rating
ED4

Label **Decca SET 452 (SET 379-81)**
London OS 26164 (OSA 1390)

Britten: <Billy Budd, Highlights>, Glossop, Pears, Langdon, Ambrosian Opera Chorus & London Symphony Orchestra-Benjamin Britten. ℗1968 ©1970 (Highlights from SET 379-81 & OSA 1390)

Remark & Rating
ED4

Label **Decca SET 453 (SET 274-6)**
London OS 26165 (OSA 1378)

Britten; <Albert Herring, Highlights>, Peter Pears, Sylvia Fischer, John Noble, Edgar Evans, Sheila Rex, Benjamin Britten conducting the English Chamber Orchestra. ℗1964 ©1971 (Highlights from SET 274-6 & OSA 1378)

Remark & Rating
ED4

Label Decca SET 454-5
London OSA 1286 (=OS 26166-7)

[Romantic French Arias (French Opera Gala)], Arieas from Offenbach, Meyerbeer, Auber, Charpentier, Bizet, Massenet, Gounod & Lecocq, Joan Sutherland with Members of the Chorus of the Grand Theatre, Geneva & Orchestra de la Suisse Romande-Richard Bonynge. (18 pages Booklet) @1970

Remark & Rating
ED4, 1G-1G-3G-1G

Label Decca SET 456
London OS 26168

Duets From Bellini's <Norma>* & Rossini's <Semirande>** , Joan Sutherland & Marilyn Horne, London Symphony Orchestra-Richard Bonynge. @1970 [* Bellini : Penguin ★★(★); Rossini: Penguin ★★★)

Remark & Rating
ED4, 3G-3G
Penguin ★★★ & ★★(★)

Label Decca SET 457 (SET 228-9)
London OS 26169 (OSA 1218)

Richard Strauss: <Salome, Highlights>, Nilsson; Stolze; Waechter, Vienna Philharmonic Orchestra-Georg Solti. ℗1962 ©1970 (Highlights from SET 228-9 & OSA 1218)

Remark & Rating
ED4
Penguin ★★★

Label Decca SET 458 (SET 368-9)
London OS 26170 (OSA 1272)

Bellini: <Norma, Highlights>, Elena Suliotis; Mario Del Monaco; Fiorenza Cossotto; Carlo Cava, Orchestra Of L'Accademia Di Santa Cecilia, Rome- Silvio Varviso. ℗1968 ©1970 (Highlights from SET 368-9 & OSA 1272)

Remark & Rating
ED4

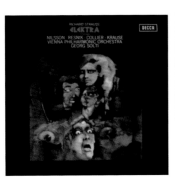

Label Decca SET 459 (SET 354-5)
London OS 26171 (OSA 1269)

Richard Strauss: <Elektra, Highlights>, Birgit Nilsson, Regina Resnik, Marie Collier, Gerhard Stolze, Tom Krause, The Vienna Philharmonic Orchestra-Georg Solti. ℗1967 ©1970 (Highlights from SET 354-5 & OSA 1269)

Remark & Rating
ED4
TAS Top 100 20th Century Classic

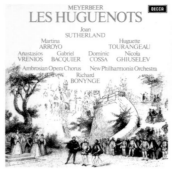

Label **Decca SET 460-3**
London OSA 1437

Meyerbeer: <Les Huguenots>, Joan Sutherland, Martina Arroyo, Huguette Tourangeau, Ambrosian Opera Chorus & New Philharmonia Orchestra-Richard Bonynge. (48 pages Booklet) @1970

Remark & Rating
ED4, 1G-2G-1G-1G-1G-2G-2G-1G
Penguin ★★★

Label **Decca SET 464**
London OS 26176

Verdi: "Four Sacred Pieces", <Ave Maria>, <Stabat Mater>, <Laudi Alla Vergine>, <Te Deum>, Yvonne Minton (contralto), Los Angeles Master Chorale-Roger Wagner & Los Angeles Philharmonic Orchestra-Zubin Mehta. Recorded in Royce Hall, UCLA. ©1970

Remark & Rating
ED4, 4G-4G

Label **Decca SET 465-7**
London OSA 1396

Handel: <Messiah>, Joan Sutherland (soprano), Huguette Tourangeau (contralto), Werner Krenn (tenor), Tom Krause (bass), Ambrosian Singers & English Chamber Orchestra-Richard Bonynge. (16 pages Booklet) @1970

Remark & Rating
ED4, 4G-4G-8G-5G-6G-5G
Penguin ★★(★)

Label **Decca SET 468-468A**
London FBD-S 1 (=CS 6645, 6646)

Stravinsky: <The Firebird (Complete ballet, performance & rehearses)>, New Philharmonia Orchestra-Ernest Ansermet. Last Ansermet's recording, recorded Nov.1968 in the Kingsway Hall, London ℗1968 &1969 ©1970 (2LPs)

Remark & Rating
ED4, 2W-2W-3W-2W
Penguin ★★★

Label **Decca SET 469-70**
London CSA 2227

Mahler: <Symphony No.6, A Minor>, <Lieder Eines Fahrenden Gesellen>, Yvonne Minton (contralto), Chicago Symphony Orchestra-Georg Solti. (8 pages booklet) @1970

Remark & Rating
ED4, (6.48129, Germany)
Penguin ★★★, AS list-F, Grammy

Label **Decca SET 471-2**
London CSA 2228

Mahler: <Symphony No.5 in C Sharp Minor>, <Songs From Des Knaben Wunderhorn>, Yvonne Minton (contralto), Chicago Symphony Orchestra-Georg Solti. (12 pages booklet) @1970

Remark & Rating
ED4, (6.48128, Germany)
Penguin ★★(★)

Label **Decca SET 473-4**
London CSA 2229

Delibes: <Coppelia>, L'orchestre de la Suisse Romande-Richard Bonynge. (12 pages booklet) @1970

Remark & Rating
ED4, 1W-1W,1W-4W
Penguin ★★(★)

Label **Decca SET 475 (SET 277-9)**
London OS 26185 (OSA 1379)

Debussy: <Pelleas Et Melisande, Highlights>, Erna Spoorenberg, Camille Maurane, George London, Guus Hoekman, Orchestre de la Suisse Romande-Ernest Ansermet. ℗1964 ©1971 (Highlights from SET 277-9 & OSA 1379)

Remark & Rating
ED4, rare!

Label **Decca SET 476 (SET 376-8)**
London OS 26184 (OSA 1389)

Cherubini: <Medea, Highlights>, Gwyneth Jones; Bruno Prevedi; Justino Diaz; Fiorenzo Cossotto; Pilar Lorengar, Chorus & Orcheatra of Accademia Di Santa Cecilia, Rome-Lamberto Gardelli. ℗1968 ©1971 (Highlights from SET 376-8 & OSA 1389)

Remark & Rating
ED4, rare!

Label **Decca SET 477-8**
London OSA 1287

J.S. Bach: <Mass in B Minor>, Elly Ameling (Soprano); Yvonne Minton (Soprano); Helen Watts (Contralto); Werner Krenn (Tenor); Tom Krause (Bass), Stuttgart Chamber Orchestra-Karl Münchinger. (18 pages booklet) @1971

Remark & Rating
ED4
Penguin ★★(★)

Label Decca SET 479-81
 London OSA 1397

Mozart: <Die Zauberfloete, The Magic Flute>, Opera in 2 acts, K.620, Pilar Lorengar, Christina Deutekom, Stuart Burrows, Dietrich Fischer-Dieskau, Hermann Prey, Martti Talvela, Vienna State Opera Chorus & Orchestra-Georg Solti. Recorded by Gordon Parry & James Lock. (76 pages booklet) @1970

Remark & Rating
ED4, 2G-1G-1G-3G-4A-4G
TAS2017, Penguin ★★(★), Japan 300-CD

Label Decca SET 482 (SET 382-4; SXL 2101-3)
 London OS 26194 (OSA 1309)

Wagner: <Das Rheingold, Highlights>, Kirsten Flagstad, George London, Jean Madeira, Set Svanholm, Claire Watson, Gustav Neidlinger, Kurt Böhme, Eberhard Wächter, Walter Kreppel. The Vienna Philharmonic Orchestra & Vienna State Opera Chorus-Georg Solti. ℗1959 ©1971 (Highlights from SET 382-4; SXL 2101-3 & OSA 1309)

Remark & Rating
ED4
TASEC, Penguin ★★★, AS list-H

Label Decca SET 483 (SET 401-2)
 London OS 26193 (OSA 1279)

Verdi: <La Traviata, Highlights>, Lorengar, Fischer-Dieskau, Aragall, Chorus and Orchestra of The Deutsche Oper, Berlin-Lorin Maazel. Recorded in 1963. ℗1969 ©1971 (Highlights from SET 401-2 & OSA 1279)

Remark & Rating
ED4
Penguin ★★(★)

Label Decca SET 484-6
 London OSA 1398

Verdi: <A Masked Ball (Un Ballo in Maschera)>, Renata Tebaldi, Luciano Pavarotti, Sherrill Milnes, Regina Resnik, Helen Donath, Chorus and Orchestra of L'Accademia di Santa Cecilia, Rome conducted by Bruno Bartoletti. (32 pages Booklet) @1971

Remark & Rating
ED4

Label Decca SET 487 (SET 418-21)
 London OS 26200 (OSA 1435)

Richard Strauss: <Der Rosenkavalier, Highlights>, Regine Crespin; Manfred Jungwirth; Yvonne Minton; Otto Wiener & Luciano Pavarotti as The Singer, Vienna Philharmonic Orchestra-Georg Solti. ℗1969 ©1971 (Highlights from SET 418-21 & OSA 1435)

Remark & Rating
ED4
Penguin ★★★

Label **Decca SET 488 (SET 387-9)**
London OS 26201 (OSA 1391)

Delibes: <Lakme, Highlights>, Joan Sutherland; Alain Vanzo; Gabriel Bacquier, Monte Carlo National Opera Orchestra-Richard Bonynge. ℗1968 ©1971 (Highlights from SET 387-9 & OSA 1391)

Remark & Rating
ED4
Penguin ★★★

Label **Decca SET 489 (SET 394-6)**
London OS 26202 (OSA 1392)

Catalani: <La Wally, Highlights>, Tebaldi, Monaco, Cappuccilli, National de L'Opera de Monte Carlo-Fausto Cleva. ℗1969 ©1971 (Highlights from SET 394-6 & OSA 1392)

Remark & Rating
ED4

Label **Decca SET 490 (SET343-4 & 403-4)**
London OS 26203 (OSA 1266 & 1280)

Leoncavallo:<I Pagliaccil, Highlights>; Mascagni: <Cavalleria Rusticana, Highlights>, Chorus & Orcheatra of Accademia Di Santa Cecilia, Rome conducted by Lamberto Gardelli & Silvio Varviso. ℗1971 (Highlights from SET 343-4; SET403-4 & OSA 1266; OSA 1280)

Remark & Rating
ED4

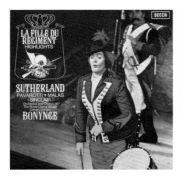

Label **Decca SET 491 (SET 372-3)**
London OS 26204 (OSA 1273)

Donizetti:<La Fille du Regiment, Highlights>, Sutherland; Pavarotti, Chorus & Orchestra of Royal Opera House, Convent Garden-Richard Bonynge. ℗1968 ©1971 (Highlights from SET 372-3 & OSA 1273)

Remark & Rating
ED4
Penguin ★★★

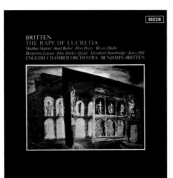

Label **Decca SET 492-3**
London OSA 1288

Britten: <The Rape of Lucretia, Chamber Opera, Op.37>, Heather Harper; Janet Baker; Peter Pears; Bryan Drake, English Chamber Orchestra-Benjamin Britten. (22 pages Booklet) ℗1971

Remark & Rating
ED4
Penguin ★★★, AS List

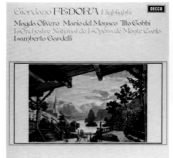

Label **Decca SET 494 (SET 435-6)**
London OS 26213 (OSA 1283)

Giordano: <Fedora, Highlights>, Magda Olivero; Mario del Monaco; Tito Gobbi, Chorus & L'Orchestre National de l'Opéra de Monte Carlo-Lamberto Gardelli. ℗1969 ©1971 (Highlights from SET 435-6 & OSA 1283)

Remark & Rating
ED4
Penguin ★★(★)

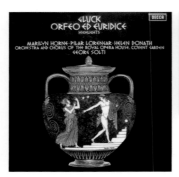

Label **Decca SET 495 (SET 443-4)**
London OS 26214 (OSA 1285)

Christoph Willibald Gluck: <Orfeo ed Euridice, Highlights>, Opera in 3 Acts, Marilyn Horne, Pilar Lorengar, Helen Donath, Orchestra & Chorus of the Royal Opera House Covent Garden-Georg Solti. @1970 (Highlights from SET 443-4 & OSA 1285)

Remark & Rating
ED4
Penguin ★★(★)

Label **Decca SET 496 (SET 412-5)**
London OS 26215 (OSA 1434)

Mozart: <Don Giovanni, Highlights>, Donald Gramm, Gabriel Bacquier, Joan Sutherland, Marilyn Horne, Pilar Lorengar, Werner Krenn, English Chamber Orchestra-Richard Bonynge. ℗1969 ©1971 (Highlights from SET 412-5 & OSA 1434)

Remark & Rating
ED43

Label **Decca SET 497-8**
London OS 26219-20

[Vienna, Women and Song (Viennese Operetta Favorites)], <The Gypsy Baron>; <A Night in Venice>; <Boccaccio>; <The Merry Widdow>; <The Land of Smiles>; <Paganini>; <Clivia>; <Bel Ami> and others, Werner Krenn (tenor) & Renate Holm (soprano) with Vienna Volksoper Orchestra-Anton Paulik. (16 pages booklet) @1971

Remark & Rating
ED4, 1G-1G-1G-2G

Label **Decca SET 499-500**
London OSA 1290

Purcell: <The Fairy Queen>, Jennifer Vyvyan, Peter Pears, Owen Brannigan, John Shirley-Quirk, Ambrosian Opera Chorus and English Chamber Orchestra-Benjamin Britten. (15pages booklet) ℗1971 ©1972

Remark & Rating
ED4
Penguin ★★★

Label **Decca SET 501-2**
London OSA 1291

Britten: <Owen Wingrave, Op.85>, An Opera for Television In Two Acts, Benjamin Luxon, Janet Baker, Nigel Douglas, Heather Harper, Peter Pears and others, The Wandsworth Boys' Choir with English Chamber Orchestra conducted by Benjamin Britten. (30 pages Booklet) ℗1971 by John Culshaw

Remark & Rating
ED4
Penguin ★★★, AS List

Label **Decca SET 503-5**
London OSA 13101

Donizetti: <L'Elisir d'Amore>, Joan Sutherland, Luciano Pavarotti, Dominic Cossa, Spiro Malas, Maria Casula, The Ambrosian Opera Chorus & English Chamber Orchestra-Richard Bonynge. (26 pages Booklet) @1972

Remark & Rating
ED4
Penguin ★★★

Label **Decca SET 506-9**
London OSA 1438

Wagner: <Tannhäuser>, with Hans Sotin, Rene Kollo, Christa Ludwig, Helga Dernesch and others, Vienna Boy's Choir & Vienna Philharmonic Orchestra-Georg Solti (36 pages Booklet). Recorded by James Lock, Gordon Parry & Colin Moorfoot, October 1970 in the Sofiensaal, Vienna. @1971

Remark & Rating
ED4
Penguin ★★★, AS list-H, Japan 300

Label **Decca SET 510-2**
London OSA 13102

Verdi: <Macbeth>, Fischer-Dieskau, Ghiaurov, Pavarotti, Ambrosian Opera Chorus & London Philharmonic Orchestra-Lamberto Gardelli. Recorded by Kenneth Wilkinson & Stanley Goodall, August 1970 in the Kingsway Hall, London. (28 pages Booklet) @1971

Remark & Rating
ED4
Penguin ★★(★), (K. Wilkinson)

Label **Decca SET 513 (SET 460-3)**
London OS 26239 (OSA 1437)

Meyerbeer: <Les Huguenots, Highlights>, Joan Sutherland, Martina Arroyo, Huguette Tourangeau, Ambrosian Opera Chorus & New Philharmonia Orchestra-Richard Bonynge. ℗1970 ©1971 (Highlights from SET 460-3 & OSA 1437)

Remark & Rating
Penguin ★★★

Label Decca SET 514-7
 London OSA 1439

Mussorgsky: <Boris Godunov> (Edited by Rimsky-Korsakov), Nicolai Ghiaurov, Ludovic Spiess, Galina Vishnevskaya, Zoltan Kélémen, Martti Talvela, Aleksei Maslennikov, Vienna Boys Choir; Sofia Radio Chorus & Vienna State Opera Chorus with The Vienna Philharmonic Orchestra-Herbert von Karajan. (30 pages Booklet) ℗1971 ©1972

Remark & Rating
ED4, $
TASEC, Penguin ★★★, AS list-H

Label Decca SET 518-9
 London CSA 2231

Mahler: <Symphony No.7 in E Minor>, Chicago Symphony Orchestra-Georg Solti (8 pages Booklet). Recorded in the Krannert Center for the Performing Arts, University of Illinois, Champaign-Urbana. ℗1971

Remark & Rating
ED4, 1W-1W-1W-2W
Penguin ★★★, Grammy

Label Decca SET 520-1
 London OSA 1292

[Prima Donna in Paris], Regine Crespin, French Songs & Arias, Vienna Volksoper Orchestra-Georges Sebatian & L'Orchestre de la Suisse Romande-Alain Lombard. (16 pages booklet) ℗1971 ©1972

Remark & Rating
ED4, 1G-1G-1G-3G

Label Decca SET 522 (SET 446-9)
 London OS 26253 (OSA 1436)

Donizetti: <Anna Bolena, Highlights>, Elena Souliotis, Marilyn Horne, Nicolai Ghiaurov, John Alexander, Vienna State Opera Chorus & Orchestra-Silvio Varviso. ℗1970 ©1972 (Highlights from SET 446-9 & OSA 1436)

Remark & Rating
ED4
Penguin ★★(★)

Label Decca SET 523-4
 London CSA 2232 (=CS 6742-3)

<Homage To Pavlova>, music by Luigini, Tchaikovsky, Saint-Saens, Massenet, Rubinstein, Kreisler, Delibes, etc., London Symphony Orchestra-Richard Bonynge. (20 pages booklet) ℗1972

Remark & Rating
ED4

Label **Decca SET 525-6**
London OSA 1293

Elgar: <The Dream of Gerontius, Op.38>, Peter Pears; Yvonne Minton; John Shirley-Quirk, Choir of King's College, Cambridge, London Symphony Choir & Orchestra-Benjamin Britten. (12 pages Booklet) @1972

Remark & Rating
ED4, 8G-2G-2G-2G
Penguin ★★★

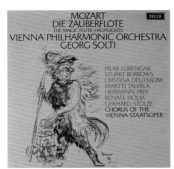

Label **Decca SET 527 (SET 479-81)**
London OS 26257 (OSA 1397)

Mozart: <Die Zauberfloete, The Magic Flute, K.620, Highlights>, Pilar Lorengar, Christina Deutekom, Stuart Burrows, Dietrich Fischer-Dieskau, Hermann Prey, Martti Talvela, Vienna State Opera Chorus & Orchestra-Georg Solti. Recorded by Gordon Parry & James Lock. (8 pages Booklet) ℗1970 ©1972 (Highlights from SET 479-81 & OSA 1397)

Remark & Rating
ED4

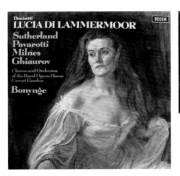

Label **Decca SET 528-30**
London OSA 13103

Donizetti: <Lucia di Lammermoor>, Joan Sutherland, Sherrill Milnes, Nicolai Ghiaurov, Luciano Pavarotti, Chorus & Orchestra of the Royal Opera House, Covent Garden-Richard Bonynge (40 pages booklet). Recorded by Kenneth Wilkinson & James Lock, 1971 in the Kingsway Hall, London. ℗1972 by Christopher Raeburn

Remark & Rating
ED4
Penguin ★★★, (K. Wilkinson)

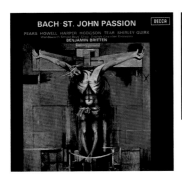

Label **Decca SET 531-3**
London OSA 13104

J.S. Bach: <St. John Passion>, Harper, Howell, Hodgson, Pears, Tear, Shirley-Quirk, Wandsworth School Boys' Choir & English Chamber Orchestra-Benjamin Britten. (15 pages booklet) Recorded by Kenneth Wilkinson & Colin Moorfoot, 1971 in the Maltings, Snape. @1972

Remark & Rating
ED4, $
Penguin ★★★, (K. Wilkinson)

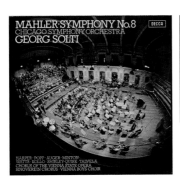

Label **Decca SET 534-5 (7BB 183-7)**
London OSA 1295

Mahler: <Symphony No.8 in E Flat (Symphony of Thousand)>, Arleen Auger, Heather Harper, Lucia Popp, Yvonne Minton, Martti Talvela, Helen Watts, Rene Kollo, John Shirley-Quirk, Singverein Chorus, Chorus of the Vienna State Opera, Vienna Boys' Choir, Chicago Symphony Orchestra-Georg Solti. Recorded by Gordon Parry & Kenneth Wilkinsonin the Sofiensaal, Vienna, August & September 1971. (8 pages booklet) @1972

Remark & Rating
ED4
Penguin ★★★(❀), (K. Wilkinson), Grammy

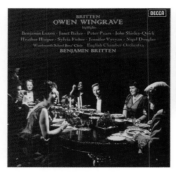

Label Decca SET 536 (SET 501-2)
 London OSA 1291 (highlights)

Britten: <Owen Wingrave, Op.85, Highlights>, An Opera for Television In Two Acts, English Chamber Orchestra-Benjamin Britten. (10 pages booklet) ℗1971 ©1972 (Highlights of SET 501-2, AS list)

Remark & Rating
ED4
AS List (SET 501-2)

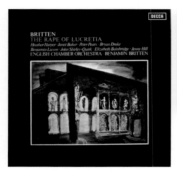

Label Decca SET 537 (SET 492-3)
 London OSA 1288 (highlights)

Britten: <The Rape of Lucretia, Chamber Opera, Op.37, Highlights>, Heather Harper; Janet Baker; Peter Pears; Bryan Drake, English Chamber Orchestra-Benjamin Britten. ℗1971 ©1972

Remark & Rating
ED4

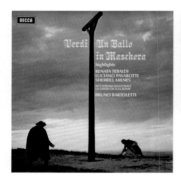
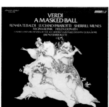

Label Decca SET 538 (SET 484-6)
 London OS 26278 (OSA 1398)

Verdi: <A Masked Ball (Un Ballo in Maschera), Highlights>, Renata Tebaldi, Luciano Pavarotti, Sherrill Milnes, Regina Resnik, Helen Donath, Chorus and Orchestra of L'Accademia di Santa Cecilia, Rome conducted by Bruno Bartoletti. ℗1970 ©1972 (Highlights from SET 484-6 & OSA 1398)

Remark & Rating
ED4

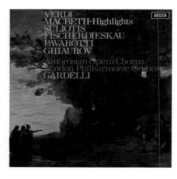

Label Decca SET 539 (SET 510-2)

Verdi: <Macbeth, Highlights>, Fischer-Dieskau, Ghiaurov, Pavarotti, Ambrosian Opera Chorus & London Philharmonic Orchestra-Lamberto Gardelli. Recorded by Kenneth Wilkinson & Stanley Goodall, August 1970 in the Kingsway Hall, London. ℗1971 ©1972

Remark & Rating
ED4
Penguin ★★★, (K. Wilkinson)

Label Decca SET 540-1
 London OSA 1296

Johann Strauss: <Die Fledermaus>, Gundula Janowitz, Eberhard Wächter, Wolfgang Windgassen, Renate Holm, Erich Kunz, Vienna Philharmonic Orchestra & State Opera Chorus-Karl Böhm. (18 pages booklet) ℗1972

Remark & Rating
ED4, 3G-3G-3G-2G

Label **Decca SET 542-4**
London OSA 13105

Verdi: <Rigoletto>, Sutherland, Pavarotti, Milnes, Tourangeau, Talvela, London Symphony Orchestra-Richard Bonynge. (40 pages booklet) @1973

Remark & Rating
ED4
Penguin ★★★

Label **Decca SET 545-7**
London OSA 13106

Offenbach: <Tells of Hoffmann>, Joan Sutherland (soprano), Placido Domingo (tenor), Gabriel Bacquier (baritone), L'orchestre de la Suisse Romande-Richard Bonynge. (36 pages Booklet) ℗1972

Remark & Rating
ED4
Penguin ★★★(❀), AS list

Label **Decca SET 548-9**
London OSA 1297

Mozart Opera Festival: <Le Nozze di Figaro>,<Idomeneo>,<Die Entführung aus dem Serail>,<Die Zauberflöte>,<Zaide>,<Così fan tutte>,<Il Re Pastore>,<Don Giovanni>, Lucia Popp, Brigitte Fassbänder, Werner Krenn, Tom Krause, Manfred Jungwirth, Vienna Haydn Orchestra-István Kertész. (20 pages booklet) Recorded by Gordon Parry in the Sofiensaal, Vienna. ℗1972 ©1973

Remark & Rating
ED4, rare!, $

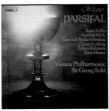

Label **Decca SET 550-4**
London OSA 1510

Wagner: <Parsifal>, Rene Kollo, Gottlob Frick, Dietrich Fisher-Dieskau, Christa Ludwig, Zoltan Kelemen & Hans Hotter, Vienna Philharmonic Orchestra-Georg Solti. Recorded by Kenneth Wilkinson & Gordon Parry. (60 pages Booklet) ℗1973 by Christopher Raeburn

Remark & Rating
ED4
Penguin ★★★, (K. Wilkinson)

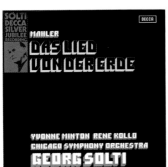

Label **Decca SET 555**
London OS 26292

Mahler: <Das Lied von der Erde>, Yvonne Minton (contralto), Rene Kollo (tenor), Chicago Symphony Orchestra-Georg Solti. Recorded by Kenneth Wilkinson & Gordon Parry, in the Krannert Center, University of Illinois. @1972

Remark & Rating
ED4, 3W-5W
Penguin ★★★, (K. Wilkinson)

Label Decca SET 556 (SET 506-9)
 London OS 26299 (OSA 1438)

Wagner: <Tannhäuser, Highlights>, with Hans Sotin, Rene Kollo, Christa Ludwig, Helga Dernesch and others, Vienna Boy's Choir & Vienna Philharmonic Orchestra-Georg Solti. ℗1971 ©1973 (Highlights from SET 506-9 & OSA 1438)

Remark & Rating
ED4
Penguin ★★★

Label Decca SET 557 (SET 514-7)
 London OS 26300 (OSA 1439)

Mussorgsky: <Boris Godunov, Highlights>, Ghiaurov, Talvela, Vishnevskaya, Maslennikov, The Vienna Philharmonic Orchestra-Herbert von Karajan. ℗1971 (Highlights from SET 514-7 & OSA 1439)

Remark & Rating
ED4
Penguin ★★(★)

Label Decca SET 558 (SXL 2094-6)
 London OS 26274 (OSA 1307)

Boito: <Mefistofele, Highlights>, "Act I: Sediam sovra quel sasso", "Act II: Il giardino, cavaliere illustre e saggio", "Act III: Morte di Margherit"a, "Epilogue: La Morte di Faust". Cesare Siepi (bass), Renata Tebaldi (soprano), Mario Del Monaco (tenor), Chorus & Orchestra of The St. Cecilia Academy, Rome-Tullio Serafin. ℗1959 ©1973 (Highlights from SXL 2094-6 & OSA 1307. Another different highlights published earlier in 1960 from this recording is Decca SXL 2192 = OS 25083)

Remark & Rating
ED4

Label Decca SET 559 (SET 528-30)
 London OS 26332 (OSA 13103)

Donizetti: <Lucia Di Lammermoor Highlights>, Joan Sutherland, Sherrill Milnes, Nicolai Ghiaurov, Luciano Pavarotti, Chorus & Orchestra of the Royal Opera House, Covent Garden-Richard Bonynge. Recorded by Kenneth Wilkinson & James Lock, 1971 in the Kingsway Hall, London. (8 pages Booklet) ℗1972 by Christopher Raeburn ©1973 (Highlights from SET 528-30 & OSA 13103)

Remark & Rating
ED4, 3G-2G
Penguin ★★★, (K. Wilkinson)

Label Decca SET 560 (SET 499-50)
 London OSA 1290 (highlights)

Purcell: <The Fairy Queen, Highlights>, Jennifer Vyvyan, Peter Pears, Owen Brannigan, John Shirley-Quirk, Ambrosian Opera Chorus and English Chamber Orchestra-Benjamin Britten. ℗1971 ©1976

Remark & Rating
ED4
Penguin ★★★

Label **Decca SET 561-3**
London OSA 13108

Puccini: <Turandot>, Sutherland, Pavarotti, Caballe, Ghiaurov, Kraus, Pears, John Alldis Choir & The London Philharmonic Orchestra-Zubin Mehta. Recorded by Kenneth Wilkinson & James Lock. (32 pages Booklet) ℗1973

Remark & Rating
ED4
TASEC, Penguin ★★★, AS list, (K. Wilkinson)

Label **Decca SET 564 (SET 503-5)**
London OS 26343 (OSA 13101)

Donizetti: <L'Elisier d'Amore, Highlights>, Joan Sutherland and Luciano Pavarotti with the Ambrosian Opera Chorus and English Chamber Orchestra-Richard Bonynge. ℗1971 ©1973 (Highlights from SET 503-5 & OSA 13101)

Remark & Rating
ED4
Penguin ★★★

Label **Decca SET 565-6***
London OSA 1299

Puccini: <La Boheme>, Freni, Pavarotti, Maffeo, Harwood, Panerai and Ghiaurov, Berlin Philharmonic Orchestra-Herbert von Karajan. Recorded by Gordon Parry, James Lock & Colin Moorfoot at Jesus Christus Kirche, Berlin. (34 pages Booklet) ℗1973

Remark & Rating
ED4
TASEC, Penguin ★★★, AS list (Speakers Corner), Japan 300

Label **Decca SET 567-8**
London OSA 12100

Schumann: <Scenes from Goethe's Faust>, Dietrich Fischer-Dieskau, Elizabeth Harwood, John Shirley-Quirk, Peter Pears, Aldeburgh Festival Singers & Wandsworth School Choir with English Chamber Orchestra-Benjamin Britten. (40 pages Booklet) ℗1973

Remark & Rating
ED4, 1G-1G-1G-2G
Penguin ★★★(❀)

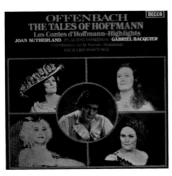 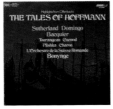

Label **Decca SET 569 (SET 545-7)**
London OS 26369 (OSA 13106)

Offenbach: <Tells of Hoffmann, Highlights>, Joan Sutherland (soprano), Placido Domingo (tenor), Gabriel Bacquier (baritone), L'orchestre de la Suisse Romande-Richard Bonynge. ℗1972 ©1974 (Highlights from SET 545-7 & OSA 13106)

Remark & Rating
ED4
Penguin ★★★, AS list

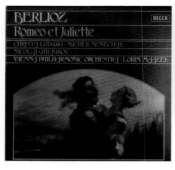
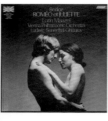

Label **Decca SET 570-1**
London OSA 12102

Berlioz: <Romero et Juliette>, Christa Ludwig (Mezzo Soprano), Michel Sénéchal (Tenor), Nicolai Ghiaurov (Bass), The Vienna Philharmonic Orchestra-Lorin Maazel. Recorded by Kenneth Wilkinson, Gondon Parry & Jack Law, 1972 in the Sofiensaal, Vienna. @1973

Remark & Rating
ED4
Penguin ★★★, (K. Wilkinson)

Label **Decca SET 572**
London OSA 1165 (AOSA 1165, =OS 26374)

Massenet: <Therese>, (World Premiere Recording) Huguette Tourangeau; Ryland Davies; Louis Quilico, New Philharmonia Orchestra-Richard Bonynge. (16 pages booklet) @1974

Remark & Rating
ED4
Penguin ★★★

Label **Decca SET 573 (SET 561-3)**
London OS 26377 (OSA 13108)

Puccini: <Turandot, Highlights>, Sutherland; Pears; Pavarotti; Ghiaurov, London Philharmonic Orchestra-Zubin Mehta. Recorded by Kenneth Wilkinson & James Lock. ℗1973 (Highlights from SET 561-3 & OSA 13108)

Remark & Rating
ED4
TASEC, Penguin ★★★, AS list, (K. Wilkinson)

Label **Decca SET 574 (SET 550-4)**

Wagner: <Parsifal, Highlights>, Rene Kollo, Gottlob Frick, Dietrich Fisher-Dieskau, Christa Ludwig, Zoltan Kelemen & Hans Hotter, The Vienna Philharmonic Orchestra-Georg Solti. Recorded by Kenneth Wilkinson & Gordon Parry. ℗1973 ©1974

Remark & Rating
ED4
Penguin ★★★, (K. Wilkinson)

Label **Decca SET 575-8 (=D56D 4)**
London OSA 1442

Mozart: <Cosi Fan Tutte>, Ryland Davies, Pilar Lorengar, Gabriel Bacquier, Tereza Berganza, Tom Krause, Jane Berbie, The London Philharmonic Orchestra-Georg Solti. (35 pages Booklet) @1974

Remark & Rating
ED4

Label **Decca SET 579 (SET 565-6)**
London OS 26399 (OSA 1299)

Puccini: <La Boheme, Highlights>, Freni, Pavarotti, Maffeo, Harwood, Panerai and Ghiaurov, Berlin Philharmonic Orchestra-Herbert von Karajan. Recorded by Gordon Parry, James Lock & Colin Moorfoot at Jesus Christus Kirche, Berlin. ℗1973 ©1974 (Highlights from SET 565-6 & OSA 1299)

Remark & Rating
ED4
Penguin ★★★

Label **Decca SET 580 (SET 542-4)**
London OS 26401 (OSA 13105)

Verdi: <Rigoletto Highlights>, Sherrill Milnes (baritone), Joan Sutherland (soprano), Luciano Pavarotti (tenor), London Symphony Orchestra-Richard Bonynge. ℗1973 ©1974 (Highlights from SET 542-4 & OSA 13105)

Remark & Rating
ED4
Penguin ★★★

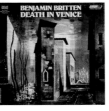

Label **Decca SET 581-3**
London OSA 13109

Britten: <Death In Venice>, Peter Pears, John Shirley-Quirk, Member of The English Opera Group & The English Chamber Orchestra-Steuart Bedford. Recorded by Kenneth Wilkinson & James Lock. (36 pages Booklet) @1974

Remark & Rating
ED4
Penguin ★★★, AS-DG list, (K. Wilkinson)

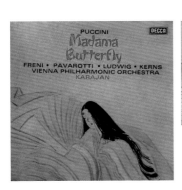

Label **Decca SET 584-6**
London OSA 13110

Puccini: <Madama Butterfly>, Mirella Freni (soprano), Christa Ludwig (mezzo-soprano), Luciano Pavarotti (tenor), Robert Kerns (baritone), Chorus of the Vienna State Opera & Vienna Philharmonic Orchestra-Herbert von Karajan. (24 pages Booklet) ℗ by Christopher Raeburn @1974

Remark & Rating
ED4
Penguin ★★★(❀), Japan 300

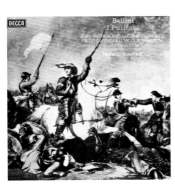

Label **Decca SET 587-9**
London OSA 13111

Bellini: <I Puritani, (Complete Opera)>, Joan Sutherland; Luciano Pavarotti; Nicolai Ghiaurov, Chorus of the Royal Opera House, Covent Garden & London Symphony Orchestra-Richard Bonynge. (40 pages Booklet) @1975

Remark & Rating
ED4
Penguin ★★★

Label Decca SET 590-2 (=Decca 7.336-8, France)

J.S. Bach: <St. John Passion (Johannes-Passion)>, (Sung in German), Elly Ameling (soprano), Julia Hamari (mezzo soprano), Dieter Ellenbeck (tenor), Werner Hollweg (tenor), Walter Berry (bass baritone), Hermann Prey (baritone), Stuttgarter Hymnus-Chorknaben & Stuttgart Chamber Orchestra-Karl Münchinger. Recorded by C.Moorfoot & M.Winding in 1974. @1975

Remark & Rating
ED4, 3G-3G-3G-3G-3G-3G, rare!!
Penguin ★★(★)

Label Decca SET 593-4

Monteverdi: <Vespro della Beata Virgine, 1610>, The Monteverdi Choir & Orchestra-John Elliott Gardiner. Recorded by Kenneth Wilkinson & Colin Moorfoot, 1974 at St.Jude's on the Hill, Hampstead Garden Suburb. (24 pages Booklet) Recorded by Kenneth Wilkinson & Colin Moorfoot, 1974 at St.Jude's on the Hill, Hampstead Garden Suburb. @1974

Remark & Rating
ED4, 6G-5G-5G-6G
Penguin ★★★, (K. Wilkinson)

Label Decca SET 595 (SET 575-8)

Mozart: <Cosi Fan Tutte, Highlights>, Ryland Davies, Pilar Lorengar, Gabriel Bacquier, Tereza Berganza, Tom Krause, Jane Berbie, London Philharmonic Orchestra-Georg Solti. ℗1974 ©1975

Remark & Rating
ED4

Label Decca SET 596-8
 London OSA 13112

Tchaikovsky: <Eugene Onegin>, Teresa Kubiak, Bernd Weikl, Stuart Burrows, Nicolai Ghiaurov; Orchestra of Royal Opera House, Covent Garden-Georg Solti. Recorded by Kenneth Wilkinson & James Lock, 1974 in the Kingsway Hall, London. @1975

Remark & Rating
ED4, $
Penguin ★★★, AS List, (K. Wilkinson)

Label Decca SET 599 (SET 596-8)

Tchaikovsky: <Eugene Onegin, Highlights>, Teresa Kubiak, Bernd Weikl, Stuart Burrows, Nicolai Ghiaurov; Orchestra of Royal Opera House, Covent Garden-Georg Solti. Recorded by Kenneth Wilkinson & James Lock, 1974 in the Kingsway Hall, London. ℗1975 ©1977

Remark & Rating
ED4
Penguin ★★★, (K. Wilkinson)

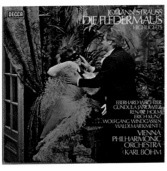

Label **Decca SET 600 (SET 540-1)**
 London OSA 1296 (highlights)

Johann Strauss: <Die Fledermaus, Highlights>, Gundula Janowitz, Eberhard Wächter, Wolfgang Windgassen, Renate Holm, Erich Kunz, The Vienna Philharmonic Orchestra-Karl Böhm. ℗1972 ©1976

Remark & Rating
ED4
Penguin ★★(★)

Label **Decca SET 601**
 London CS 7083

Richard Strauss: <Ein Heldenleben (A Hero's Life), Op.40>, the Vienna Philharmonic Orchestra-Georg Solti. Recorded by James Lock in the Sofiensaal, Vienna. @1979

Remark & Rating
ED4

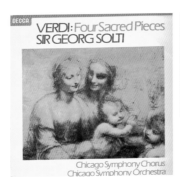

Label **Decca SET 602**
 London OS 26610

Verdi: <Four Sacred Pieces (Quattro Pezzi Sacri)>, Chicago Symphony Orchestra and Chorus-Georg Solti. Recorded by K.Wilkinson, C.Moorfoot, J.Dunkerley & M.Mailes, 1977 & 1978 in the Medinah Temple, Chicago. @1979

Remark & Rating
ED4, 1G-1G
Penguin ★★★, (K. Wilkinson)

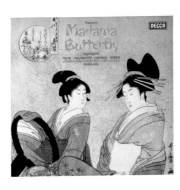

Label **Decca SET 605 (SET 584-6)**
 London OS 26455

Puccini: <Madama Butterfly, Highlights>, Mirella Freni (soprano), Christa Ludwig (mezzo-soprano), Luciano Pavarotti (tenor), Robert Kerns (baritone), Chorus of the Vienna State Opera & Vienna Philharmonic Orchestra-Herbert von Karajan. ℗1974 ©1976

Remark & Rating
ED4
Penguin ★★★

Label **Decca SET 606-8**
 London OSA 13114

Verdi: <Luisa Miller>, Pavarotti, Caballé, Milnes, Giaiotti, Reynolds, Van Allan, National Philharmonic Orchestra-Peter Maag. (20 pages Booklet) Recorded by Kenneth Wilkinson & James Lock, 1975 in the Kingsway Hall, London. @1976

Remark & Rating
ED4
Penguin ★★(★), (K. Wilkinson)

Label **Decca SET 609-11***
 London OSA 13116

Gershwin: <Porgy & Bess>, Willard White, Leona Mitchell, McHenry Boatwright, François Clemens, Cleveland Orchestra & Chorus-Lorin Maazel. World Premiere Complete Recording, (32pages Booklet) ℗1975 ©1976

Remark & Rating
ED4
TASEC＊＊, Penguin ★★★(❀), AS list-F

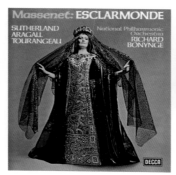
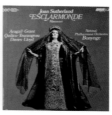

Label **Decca SET 612-4**
 London OSA 13118

Massenet: <Esclarmonde>, Joan Sutherland, Giacomo Aragall, Clifford Grant, Louis Quilico, Huguette Tourangeau, National Philharmonic Orchestra-Richard Bonynge. (24 pages Booklet) Recorded by James Lock & Philip Wade, July 1975 in Kingsway Hall, London. @1976

Remark & Rating
ED4
Penguin ★★★, AS List

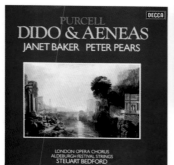

Label **Decca SET 615**
 London OSA 1170

Purcell: <Dido & Aeneas>, Janet Baker; Peter Pears, London Opera Chorus & Aldeburgh Festival String-Steuart Bedford. Recorded by Kenneth Wilkinson & James Lock, 1975 in the Kingsway Hall. ℗ by Christopher Raeburn @1978

Remark & Rating
ED4
Penguin ★★★, (K. Wilkinson)

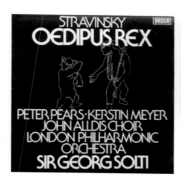

Label **Decca SET 616**
 London OSA 1168

Stravinsky: <Oedipus Rex>, Opera-Oratorio, Peter Pears, Kerstin Meyer, Donald McIntyre, Stafford Dean, Ryland Davies, Benjamin Luxon, Alec McCowen, John Alldis Choir & London Philharmonic Orchestra-Georg Solti. @1977

Remark & Rating
ED4, 1G-5G
Penguin ★★(★), AS List

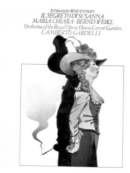

Label **Decca SET 617**
 London OSA 1169

Ermanno Wolf-Ferrari: <Il Segreto Di Susanna>, Maria Chiara; Bernd Weikl; Omar Godknow, Orchestra of the Royal Opera House, Covent Garden-Lamberto Gardelli. (12 pages Booklet) Recorded by Kenneth Wilkinson & Colin Moorfoot, 1976 in the Kingsway Hall. London. @1976

Remark & Rating
ED4, 1G-2G
Penguin ★★(★), (K. Wilkinson)

Label Decca SET 618
London OS 26525

Walton: <Balshazzar's Feast>, <Coronation Te Deum>, Benjamin Luxon (bariton), Choir of Salisbury, Winchester; Chichester Cathedral Choir; London Philharmonic Choir and Orchestra-Gerog Solti. Recorded by Kenneth Wilkinson & James Lock, March 1977 in the Kingsway Hall, London, March 1977. Ⓟ ©1977

Remark & Rating
ED4
AS List-H, (K. Wilkinson)

Label Decca SET 619 (SET 587-9)

Bellini: <I Puritani, Highlights>, Joan Sutherland; Luciano Pavarotti; Nicolai Ghiaurov, Chorus of the Royal Opera House, Covent Garden & London Symphony Orchestra-Richard Bonynge. Ⓟ1975 ©1977

Remark & Rating
ED4
Penguin ★★★

Label Decca SET 621 (D11D 3 & 6.42316)
London OSA 13115 (part)

Bizet: <Carmen, Highlights>, Tatiana Troyanos, Kiri Te Kanawa, Placido Domingo, Jose van Dam, Norma Burrowes, Jane Berbie, John Alldis Choir & London Philharmonic Orchestra-Georg Solti. (8 pages booklet). Recorded by Kenneth Wilkinson. Ⓟ1976 ©1977

Remark & Rating
ED4
Penguin ★★★, AS List, (K. Wilkinson)

Label Decca SET 622

Solti conducts Music from Borodin: <Prince Igor, The Dance of the Polovtsian> recorded in 1965; Tchaikovsky: <Eugene Onegin, Polonaise and Waltz>, recorded in 1974; Bizet: <Carmen> Tatiana Troyanos (mezzo-soprano), recorded in 1975, ROHCG, LPO & LSO-Georg Solti. (4 pages Insert) ©1978

Remark & Rating
ED4, 1G-1G
AS List (Carmen)

Label Decca SET 623 (SET 606-8)

Verdi: <Luisa Miller, Highlights>, Pavarotti, Caballé, Milnes, Giaiotti, Reynolds, Van Allan, National Philharmonic Orchestra-Peter Maag. Recorded by Kenneth Wilkinson & James Lock, 1975 in the Kingsway Hall, London. Ⓟ1976 ©1978

Remark & Rating
ED4
Penguin ★★(★), (K. Wilkinson)

Label Decca SET 624 (D2D 3)

Donizetti: <Maria Stuarda, Highlights>, Sutherland, Pavarotti, Tourangeau, Morris, Soyer, Teatro Comunale Bologna-Richard Bonynge. ⓟ1976 ©1978

Remark & Rating
ED4

Label Decca SET 625 (D13D 5)
 London OSA 1512 (part)

Wagner: <Scenes from Die Meistersinger von Nürnberg>, Norman Bailey, Rene Kollo, Hannelore Bode, Julia Hamari, Bernd Weikl, Kurt Moll, Vienna State Opera Chorus & Vienna Philharmonic Orchestra-Georg Solti. Recorded by Kenneth Wilkinson & James Lock, 1975 at Sofiensaal, Vienna. @1976

Remark & Rating
ED4
Penguin ★★(★), (K. Wilkinson)

Label Decca SET 626 (D24D 3)
 London OSA 13119 (part)

Wagner: <The Flying Dutchman, Highlights>, Norman Bailey, Janis Martin, Rene Kollo, Chicago Symphony Orchestra-Georg Solti. Recorded by Kenneth Wilkinson & James Lock, May 1976 in the Medinah Temple, Chicago. @1977

Remark & Rating
ED4, 1G-1G
AS List, (K. Wilkinson)

Label Decca SET 627
 London OSA 1173

Puccini: <Suor Angelica>, Joan Sutherland; Christa Ludwig; Isobel Buchanan, The Nationla Philharmonic Orchestra-Richard Bonynge. (12 pages booklet) Recorded by Kenneth Wilkinson & James Lock, Nov. 1978 in the Kingsway Hall, London. @1979

Remark & Rating
Penguin ★★(★), (K. Wilkinson)

Label Decca SET 628
 London CS 7110

Holst: <The Planets>, Ladies voices of the London Philharmonic Choir & London Philharmonic Orchestra-Georg Solti. Recorded by Kenneth Wilkinson & Andrew Pinder, 1978 in the Kingsway Hall, London. @1978

Remark & Rating
ED4
Penguin ★★★, AS List (MFSL), (K. Wilkinson)

Label Decca SET 629
London OSA 1172 (=OS 26580)

Lehar: <The Merry Widow, Highlights>, (Sung in English), Joan Sutherland, Werner Krenn, Regina Resnik, Ambrosian Singers & National Philharmonic-Richard Bonynge. Recorded by Kenneth Wilkinson & Colin Moorfoot, August 1977 and April 1978. ℗1978 ©1979

Remark & Rating
ED4
(K. Wilkinson)

Label Decca SET 630
London OSA 1174

Bartok: <Duke Bluebeard's Castle>, Sylvia Sass (soprano); Kolos Kováts (bass); Istvan Sztankay (speaker), London Philharmonic Orchestra-Georg Solti. Recorded by Kenneth Wilkinson & Martin Atkinson, March 1979 in the Kingsway Hall, London. ℗ by Christopher Raeburn ©1980

Remark & Rating
ED5
AS List, (K. Wilkinson)

Label Decca SET 631 (D82D 3)
London OSA 13124 (part)

Verdi: <Il Trovatore, Highlights>, Pavarotti, Sutherland, Horne, Wixell, Ghiaurov, National Philharmonic Orchestra-Richard Bonynge. Recorded by Kenneth Wilkinson in the Kingsway Hall, London. ℗1977 ©1981

Remark & Rating
Penguin ★★(★), AS List, (K. Wilkinson)

Label Decca SET 632 (D102D 3)
London OSA 13130 (part)

Verdi: <Otello, Highlights>, Carlo Cossutta, Margaret Price, Gabriel Bacquier, Peter Dvorsky, Jane Berbié, Kurt Moll, Vienna Philharmonic Orchestra-Georg Solti. Recorded Sept. 1977, in the Sofiensaal, Vienna. ℗1978 ©1981

Remark & Rating
Penguin ★★★

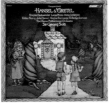

Label Decca SET 633 (D131D 2)
London OSA 12112 (part)

Humperdinck: <Hänsel und Gretel, Highlights>, Brigitte Fassbaender, Lucia Popp, Walter Berry, Julia Hamari, Anny Schlemm, Norma Burrowes, Edita Gruberova, Vienna Philharmonic Orchestra-Georg Solti. Recorded in the Sofiensaal, Vienna, 1978. ℗1978 ©1981

Remark & Rating
Penguin ★★(★)

DECCA
BB SERIES
HEAD SERIES
&OTHERS

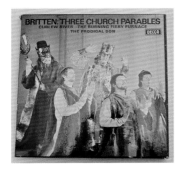

Label Decca 1BB 101-3 (=SET 301 + 356 + 438)
 London OSA 1156, 1163, 1164

Britten: [Three Church Parables] 1: <Curlew River>, Decca SET 301 or London OSA 1156; 2: <The Burning Fiery Furnace>, SET 356 or OSA 1163; 3: <The Prodidal Son>, SET 438, or OSA 1164), English Opera Group-Benjamin Britten. @1971

Remark & Rating
Penguin ★★★, AS-DG list

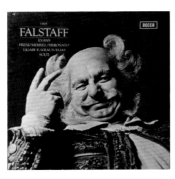

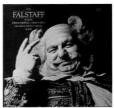

Label Decca 2BB 104-6 (=RCA LSC 6163)
 London OSA 1395

Verdi: <Falstaff>, Geraint Evans, Mirella Freni, Giulietta Simionato, Ilva Ligabue, Robert Merrill, Alfredo Kraus, Rosalind Elias, RCA Italiana Opera Orchestra and Chorus-Georg Solti. @1970 (Original recording is RCA LSC 6163)

Remark & Rating
Penguin ★★★

Label Decca 2BB 109-11 (=RCA LSC 6156)
 London OSA 1399

Wagner: <The Flying Dutchman (Der Fliegende Holländer)>, Leonie Rysanek, Rosalind Elias, George London, Giorgio Tozzi, Royal Opera House Orchestra, Covent Garden-Antal Dorati. @1961 (Original recording is RCA LSC 6156)

Remark & Rating
Penguin ★★(★)

Label Decca 2BB 112-4 (=RCA LDS 6152)
 London OSA 13100

Richard Strauss: <Ariadne Auf Naxos>, Leonie Rysanek, Roberta Peters, Sena Jurinac, Jan Peerce, Walter Berry, The Vienna Philharmonic Orchestra-Erich Leinsdorf. Recorded 1959 in Vienna. (Original recording is RCA LDS 6152)

Label Decca 3BB 107-8 (No Decca SXL)
 London CSA 2230

Debussy: <Preludes Books 1 & 2>, Piano-Jean-Rodolphe Kars. @1971

Label **Decca 4BB 115-8 (Mono, =Decca LXT 2954/5/6/7)**
London LLA 22 (Mono)

Richard Strauss: <Der Rosenkavalier>, Reining, Weber, Gueden, Erich Kleiber-Vienna Philharmonic Orchestra. ℗1967

Label **Decca 5BB 123-4 (=RCA LDS 7022)**
London OSA 1284

Rachmaninov: <24 Preludes>, Vladimir Ashkenazy (piano). Recorded by Kenneth Wilkinson & John Dunkerley @1974-5

Remark & Rating
TASEC, Penguin ★★★, AS list

Label **Decca 5BB 221-2**
London CSA 2241

Rachmaninov: <24 Preludes>, Vladimir Ashkenazy (piano). Recorded by Kenneth Wilkinson & John Dunkerley @1974-5

Remark & Rating
Penguin ★★★, Japan 300, Stevenson, (K. Wilkinson)

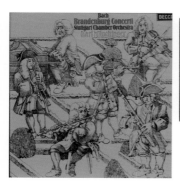

Label **Decca 5BB 130-1 (=Decca SXL 2125-7)**
London CSA 2301

J.S. Bach: [Complete Brandenburg Concertos, No.1-No.6], Stuttgart Chamber Orchestra-Karl Münchinger. Recorded by Roy Wallace, October 1958 in the Victoria Hall, Geneva. @1972

Remark & Rating
RM16, AS list-F

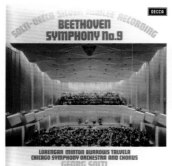

Label **Decca 6BB 121-2* (11BB 188-96)**
London CSP 8 (CSP 9)

Beethoven: <Symphony No.9 in D Minor, "Choral", Op.125>, Pilar Lorengar (soprano), Yvonne Minton (mezzo-soprano), Martti Talvela (bass), Stuart Burrows (tenor), Chicago Symphony Orchestra & Chorus-Georg Solti. Recorded by Kenneth Wilkinson & Goldon Parry, May 1972 in the Krannert Centre of the University of Illinois. ℗1972

Remark & Rating
TASEC, Penguin ★★★, AS list, (K. Wilkinson)

Label **Decca 6BB 171-2 (=JB 120)**
London CSA 2240

Bruckner: <Symphony No.4 in E Flat Major>, The Vienna Philharmonic Orchestra-Karl Böhm. Recorded by Colin Moorfoot, 1973 in the Sofiensaal, Vienna. ℗ 1974

Remark & Rating
Penguin ★★★, G.Top 100

Label **Decca 7BB 125-9 (=RCA LDS 6706)**
London OSA 1511

Wagner: <Die Walküre>, Birgit Nilsson, Gre Brouwenstijn (sopranos); Rita Gorr (mezzo-soprano); Jon Vickers (tenor); George London (bass-baritone); David Ward (bass). London Symphony Orchestra-Erich Leinsdorf. Recorded by Kenneth Wilkinson in Walthanstow Assembly Hall. (36 pages booklet) (=RCA LDS 6706) ℗1962

Remark & Rating
Penguin ★★(★), (K. Wilkinson)

Label **Decca 7BB 173-7; 178-82 & 183-7**
London CSP 7

Maler: [Symphonies Nos. 1- 9], 7BB 173-7 (No. 1, 2, 3) ; 178-82 (No. 5, 6, 7) ; 183-7 (No.4, 8, 9), Georg Solti conducted the London Symphony Orchestra (No.1 & No.9) ; Concertgebouw Orchestra (No.4) & Chicago Symphony Orchestra.

Remark & Rating
Penguin ★★(★)

Label **Decca 9BB 156-61, (=SKL 4081-2; 4119-20 & 4925-6)**
London OSA 1209, 1215 & 1277

Gilbert & Sullivan: <HMS Pinafore>, (Penguin 3*+ & AS list=Decca SKL 4081-2, London OSA 1209, ℗1960), <Iolanthe>, (=SKL 4119-20, OSA 1215, ℗1960), <The Pirates of Penzance>, (=SKL 4925-6, OSA 1277, ℗1968), The D'Oyly Carte Opera Company with The New Symphony Orchestra & The Royal Philharmonic Orchestra-Isidore Godfrey.

Remark & Rating
Penguin ★★★(❀), AS list

Label **Decca 9BB 162-7, (=SKL 4138-40; 4006-7 & 4624-5)**
London OSA 1201, 1258 & 1322

Gilbert & Sullivan: <Gondoliers> (=Decca SKL 4138-40, London OSA 1323, ℗1961), <The Mikado*> (=SKL 4006-7, OSA 1201, ℗1958), The D'Oyly Carte Opera Company with The New Symphony Orchestra Conducted by Isidore Godfrey. Also includes <The Yeomen of the Guard> (=SKL 4624-5, OSA 1258, ℗1964), The D'Oyly Carte Opera Company with The Royal Philharmonic Orchestra conducted by Sir Malcolm Sargent, ℗1974. *[Mikado is Penguin ★★(★)]

Remark & Rating
Penguin ★★★

Label **Decca 10BB 168-170**
London 2 SPC 21101/02/03

Tchaikovsky: <The Complete Swan Lake In 4 Acts, Op. 20>, Anatole Fistoulari conducting the Netherlands Radio Philharmonic Orchestra, Ruggiero Ricci (solo violin). No SXL issue. ℗1973

Label **Decca 11BB 188-96**
London CSP 9

Beethoven: [The Complete Symphonies Nos. 1- 9], Chicago Symphony Orchestra & Chorus-Georg Solti (15 pages Booklet). Recorded by Kenneth Wilkinson, James Lock & Gordon Parry. ©1975 (** Complete Symphonies : <No.1 & No.8 = Decca SXL 6760 (London CS 6926)>; <No.2 = SXL 6761 (CS 6927)>; <No.3 = SXL 6829 (CS 7049)>; <No.4 = SXL 6830 (CS 7050)>; <No.5 = SXL 6762 (CS 6930)>; <No.6 = SXL 6763 (CS 6931)>; <No.7 = SXL 6764 (CS 6932)> & <No.9 = 6BB 121-2 (CSP 8)>.

Remark & Rating
Penguin ★★(★), (K. Wilkinson)

Label **Decca 13BB 207-212 (©=SDD 513-8)**
London CSA 2243-5

Mozart: <Sonatas for Piano & Violin, Volume 1, 2, 3>, (6LPs), Szymon Goldberg (violin) and Radu Lupu (piano). ℗1975 by Christopher Raeburn ©1977

Remark & Rating
ED4, $$$
Penguin ★★★

Label **Decca 14BB 213-7**
London CSA 2301, CSA 2206, CS 6392

[Münchinger Conducts Bach], <The 6 Brandenburg Concertos> <The 4 Orchestral Suites> <Harpsichord Concertos No.1 & 2>, George Malcolm (Harpsichord), Stuttgart Chamber Orchestra.

Remark & Rating
RM16, AS list-F

Label **Decca 15BB 218-20 (=SXL 6767; 6768; 6769)**
London CSA 2314 (=CS 6964; 7062; 7063)

Prokofiev: [The Five Piano Concertos], Vladimir Ashkenazy (piano), London Symphony Orchestra condcted by Andre Previn. @1975

Remark & Rating
ED4, $
Penguin ★★★, AS List

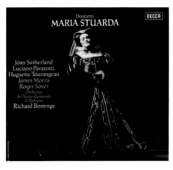

Label **Decca D 2D 3**
London OSA 13117

Donizetti: <Maria Stuarda>, Sutherland, Pavarotti, Tourangeau, Morris, Soyer, Teatro Comunale Bologna-Richard Bonynge. (20 pages Booklet) Recorded by James Lock & Colin Moorfoot, July 1975 in the Teatro Comunale, Bologna. @1976

Remark & Rating
Penguin ★★★

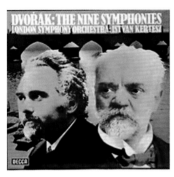

Label **Decca D 6D 7 (=SXLD 6515-21)**
London DVO S-1

Dvorak: [The Complete Nine Symphonies], London Symphony Orchestra-Istvan Kertesz. Recorded by Kenneth Wilkinson. ©1971 (Late issue from SXLD 6515-21=SXL 6044, 6115, 6253, 6257, 6273, 6288, 6289, 6290, 6291)

Remark & Rating
Penguin ★★★(❀), AS List-H (D6D 7), (K. Wilkinson)

Label **Decca D 7D 4 (SXLE 6558)**
London CSP 4

Sibelius: [The Seven Symphonies], The Vienna Philharmonic Orchestra-Lorin Maazel. Recorded from1964-1968. @1972 (=SXL 6084, 6125, 6236, 6364, 6365)

Label **Decca D 8D 6 (=SXLC 6476)**
London TCH S-1

Tchaikovsky: [Complete Symphony Nos. 1- 6], The Vienna Philharmonic Orchestra-Lorin Maazel. ℗1970 ***(SXL 6159 + 6162 + 6163 + 6157 + 6058 + 6164 = CS 6426 + 6427 + 6428 + 6429 + 6376 + 6409)

Remark & Rating
Penguin ★★(★)

Label **Decca D 9D 3 (=SXL 6583, 6623, 6720)**

Rachmaninov: [Three Symphonies],<The Rock>, L'Orchestra de la Suisse Romande (No.1) & The London Philharmonic Orchestra (No.2, No.3)-Walter Weller. @1973 (Box SET from SXL 6583, 6623 & 6720)

Remark & Rating
Penguin ★★(★)

Label **Decca D 11D 3**
London OSA 13115

Bizet: <Carmen>, Tatiana Troyanos, Kiri Te Kanawa, Placido Domingo, Jose van Dam, Norma Burrowes, Jane Berbie, The John Alldis Choir & The London Philharmonic Orchestra-Georg Solti. (36 pages booklet). Recorded by Kenneth Wilkinson, Colin Moorfoot & Nigel Gayler. @1976

Remark & Rating
Penguin ★★★, AS List (K. Wilkinson)

Label **Decca D 13D 5**
London OSA 1512

Wagner: <Die Meistersinger von Nürnberg>, Norman Bailey, Rene Kollo, Hannelore Bode, Julia Hamari, Bernd Weikl, Kurt Moll, Vienna State Opera Chorus & Vienna Philharmonic Orchestra-Georg Solti. Recorded by Kenneth Wilkinson & James Lock, 1975 at Sofiensaal, Vienna. @1976

Remark & Rating
ED4, $
Penguin ★★(★), (K. Wilkinson)

Label **Decca D 24D 3**
London OSA 13119

Wagner: <The Flying Dutchman (Der Fliegende Holländer)>, Norman Bailey, Janis Martin, Rene Kollo, Chicago Symphony Orchestra-Georg Solti. (20 pages Booklet) Recorded by Kenneth Wilkinson & James Lock, May 1976 in the Medinah Temple, Chicago. @1977

Remark & Rating
Penguin ★★★, AS list-H, (K. Wilkinson)

Label **Decca D 34D 2**
London OSA 12107

Leoni: <L'Oracolo> A Music Drama in One Act, Sutherland, Gobbi, Van Allan, Davies, Grant, Tourangeau, National Philharmonic Orchestra-Richard Bonynge. (20 pages booklet) Recorded by James Lock, Phlip Wade & Simon Eadon, 1975 in the Kingsway Hall, London. ℗©1977

Remark & Rating
Penguin ★★★

Label **Decca D 37D 3**
London CSA 2315

Tchaikovsky: <Swan Lake (Complete Ballet)>, The National Philharmonic Orchestra-Richard Bonynge. @1977

Remark & Rating
ED4, $
Penguin ★★(★)

Label Decca D 39D 4 (=SXL 6783, 6834, 6835, 6836)
London CSA 2405 (=CS 7007, CS 7094, CS 7095, CS 7096)

Brahms: [The Four Symphonies], <Tragic Overture, Op.81>, <Variations on a theme by Haydn Op.56a>, <Academic Festival Overture, Op.80>, Cleveland Orchestra-Lorin Maazel. @1977 (Box SET from SXL 6783, 6834, 6835 & 6836)

Label Decca D 48D 3
London OSA 13120

Alban Berg: <Lulu, Opera in 2 Acts>, Anja Silja, Brigitte Fassbaender, Walter Berry, Vienna Philharmonic Orchestra-Christoph von Dohnanyi. (20 pages Booklet) Recorded in 1976 in the Sofiensaal, Vienna. @1978

Remark & Rating
TAS Top 100 20th Century Classic

Label Decca D 50D 2
London OSA 12108

Haydn : <The Creation (Die Schöpfung)>, Lucia Popp, Helena Döse (sopranos>, Werner Hollweg (tenor), Benjamin Luxon (baritone), Kurt Mol (bass), Brighton Festival Chorus & Royal Philharmonic Orchestra-Antal Dorati. @1977

Label Decca D 51D 2
London OSA 12109

Janacek: <Kata Kabanova>, Elisabeth Soderstrom, Peter Dvorsky, Nadezda Kniplova, The Vienna Philharmonic Orchestra-Charles Mackerras. @1977

Remark & Rating
ED5, $
Penguin ★★★(❀), G.Top 100, AS list

Label Decca D 63D 3
London OSA 13123

Ponchielli: <La Gioconda>, Zinka Milanov, Giussepe di Stefano, Leonardo Warren, Rosalind Elias, Choir & Orchestra of Accademia di Santa Cecilia, Rome-Fernando Previtali. (Original issue is RCA LSC 6139, RCA UK SB 2027-3)

Label **Decca D 65D 3**
London OSA 13107 (OS 26329-31)

Joan Sutherland <The Voice of the Century>, Highlights of a Triumphant Career. Music by Handel; Weber; Offenbach; Bizet; Verdi; Mozart; Donizetti; Bellini; Meyerbeer; Rossini; Puccini; Gounod & Delibes, Joan Sutherland (soprano). (23 pages booklet) @1973

Label **Decca D 78D 3**
London CSA 2316

Tchaikovsky: <Sleeping Beauty (Complete Ballet)>, The National Philharmonic Orchestra-Richard Bonynge. @1978

Label **Decca D 82D 3 (SET 631=highlights)**
London OSA 13124

Verdi: <Il Trovatore>, Pavarotti, Sutherland, Horne, Wixell, Ghiaurov, National Philharmonic Orchestra-Richard Bonynge. (28 pages Booklet) Recorded by Kenneth Wilkinson in the Kingsway Hall, London. @1977

Remark & Rating
Penguin ★★, AS List, (K. Wilkinson)

Label **Decca D 83D 3**
London OSA 13125 (OSAD 13125)

[Luciano Pavarotti - Cavalleria Rusticana (Mascagni) & * I Pagliacci (Leoncavallo)], with Mirella Freni, Julia Varady, Ingvar Wixell, Piero Cappuccilli, National Philharmonic Orchestra conducted by Gianandrea Gavazzeni & Giuseppe Patané. Recorded by Kenneth Wilkinson, James Lock, John Dunkerley, June 1976 in Kingsway Hall, London. (* Recorded in April 1977) ℗1978

Remark & Rating
Penguin ★★(★), (K. Wilkinson)

Label **Decca D 86D 3**
London OSA 13127

Nicolai: <The Merry Wives of Windsor>, Karl Ridderbusch; Helen Donath; Wolfgang Brendel; Trudeliese Schmidt; Claes Haaken Ahnsjo; Lilian Sukis; Alexander Malta. The Bavarian Symphony Orchestra-Rafael Kubelik (24 pages booklet). Recorded by James Lock & Martin Fouque, April 1977 in the Herkulessaal, Residenz, Munich. @1977

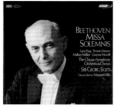

Label **Decca D 87D 2**
London OSA 12111

Beethoven: <Missa Solemnis>, Lucia Popp, Yvonne Minton, Mallory Walker, Gwynne Howell, Chicago Symphony Orchestra and Chorus conducted by Sir Georg Solti. (8 pages Booklet) Recorded by Kenneth Wilkinson, John Dunkerley & Michael Mailes, May 1977 in the Medinah Temple, Chicago. ℗1978

Remark & Rating
Grammy, (K. Wilkinson)

Label **Decca D 88D 3**
London OSA 13128

Haydn: <The Seasons (Die Jahreszeiten)>, Cotrubas, Krenn, Sotin, Brighton Festival Chorus & Royal Philharmonic Orchestra- Antal Dorati. Recorded by Kenneth Wilkinson, Colin Moorfoot & John Pellowe. ℗1978

Remark & Rating
AS List, (K. Wilkinson)

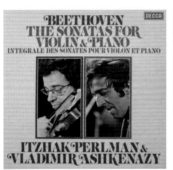

Label **Decca D 92D 5 (=SXL 6632, 6736, 6789, 6790, 6791 & 6990)**
London CSA 2501

Beethoven: [Complete Violin Sonatas], Itzhak Perlman (violin), Vladimir Ashkenazy (piano). (*** =Decca SXL 6632, 6736, 6789, 6790, 6791, (6990 late issue) & London CS 6845, 6958, 7012, 7013, 7014, Complete SET=D92D 5 ***¡) ℗1977 ©1978

Remark & Rating
Penguin ★★★(✿)

Label **Decca D 93D 3**
London OSA 13129

Donizetti: <Lucrezia Borgia>, Sutherland, Horne, Aragall, Wixell, National Philharmonic Orchestra-Richard Bonynge. ℗1978

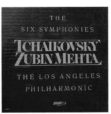

Label **Decca D 95D 6**
London CSP 10

Tchaikovsky: [The Complete Symphonies Nos. 1- 6], Los Angeles Philharmonic Orchestra-Zubin Mehta. ℗1978 **(6 LP-Box SET Decca D95D 6, Symphony No.1 = Decca SXL 6913 & London CS 7148; No.2 to No.6 = CS 7149; 7154; 7155; 7165 & 7166, No Decca SXL issue)

Remark & Rating
AS List (D95D 6)

Label **Decca D 96D 3**
 London OSA 13113

Donizetti: <La Favorita>, Luciano Pavarotti, Fiorenza Cossotto, Gabriel Bacquier, Nicolai Ghiaurov, Ileana Cotrubas, Chorus and Orchestra of the Teatro Comunale, Bologna-Richard Bonynge. (24 pages Booklet) @1978

Remark & Rating
Penguin ★★(★)

Label **Decca D100D 19 (=Decca Ring 1-22)**
 London Ring S-1 (=OSA 1309; 1509; 1508 & 1604)

Wagner: <Der Ring des Nibelungen>, Vienna Philharmonic Orchestra-Georg Solti. ℗1959 Original Recording in the Sofiensaal, Vienna, produced by John Culshaw. The Complete "Ring Cycle" of 19-LP Deluxe Box Set Narrow Band Reissue, (Das Rheingold, D100D 1-3) , (Die Walküre, D100D 4-8) , (Siegfried, D100D 9-13), (Gotterdammerung, D100D 14-19).

Remark & Rating
$$$ TASEC, Penguin ★★★(❀), G.Top 100, Grammy, Japan 300, AS list

Label **Decca D102D 3 (SET 632=part)**
 London OSA 13130

Verdi: <Otello>, Carlo Cossutta, Margaret Price, Gabriel Bacquier, Peter Dvorsky, Jane Berbié, Kurt Moll, Vienna Philharmonic Orchestra-Georg Solti. Recorded Sept. 1977, Sofiensaal, Vienna. ℗1978

Remark & Rating
Penguin ★★(★)

Label **Decca D103D 3**
 London OSA 13131

Richard Strauss: <Ariadne auf Naxos>, Edita Gruberova, Tatiana Troyanos, René Kollo, Walter Berry, Erich Kunz, London Philharmonic Orchestra-Georg Solti. (28 pages Booklet) Recorded November 1977 in Kingsway Hall, London. @1979

Remark & Rating
Penguin ★★(★)

Label **Decca D117D 2**
 London CSA 2249

Mahler: <Symphony No.3 in D Minor>, Soloist-Maureen Forrester, Los Angeles Philharmonic Orchestra conducted by Zubin Mehta. Recorded by James Lock & Simon Eadon, March 1978 in Royce Hall, UCLA. @1979.

Remark & Rating
TASEC, AS List, rare !!!

Label **Decca D130D 3**
LONDON OSA 13133

Ferdinando Paër: Opera <Leonora (L'amore Coniugale)>, Ursula Koszut, Edita Gruberova, Siegfried Jerusalem, Giorgio Tadeo, Wolfgang Brendel, Bavarian Symphony Orchestra-Peter Maag. (1979 World Premiere Recording, recorded by James Lock & Standley Goodall)

Label **Decca D131D 2 (SET 633=part)**
London OSA 12112

Humperdinck: <Hänsel und Gretel>, Brigitte Fassbaender, Lucia Popp, Walter Berry, Julia Hamari, Anny Schlemm, Norma Burrowes, Edita Gruberova, The Vienna Philharmonic Orchestra-Georg Solti. Recorded in the Sofiensaal, Vienna, 1978. ℗1978

Remark & Rating
Penguin ★★(★)

Label **Decca D132D 4**
London OSA 1443

Mozart: <The Marriage of Figaro>, Van Dam, Cotrubas, Tomowa-Sintow, The Vienna Philharmonic Orchestra-Herbert von Karajan. Recorded by Jack Law, James Lock, John Dunkerley in the Sofiensaal, Vienna, 1978. ℗1979 by Christopher Raeburn .

Label **Decca D133D 2**
London CSA 2250

Mendelssohn: <Die Erste Walpurgisnacht>, <Symphony No.2 "Lobgesang">, Horst Laubenthal, Tom Krause, Alfred Sramek, Sona Ghazarian, Edita Gruberova, The Vienna Philharmonic Orchestra conducted by Christoph von Dohnanyi. @1978

Remark & Rating
$

Label **Decca D134D 2**
London OSA 12113 (OSAD 12113)

Puccini: <Tosca>, Freni, Pavarotti, Milnes, National Philharmonic Orchestra-Nicola Rescigno. ℗1979

Label Decca D135D 2
London OSA 12114

Brahms: <Ein Deutsches Requiem (A German Requiem), Op. 45>, <Variations On A Theme By Haydn, Op.56a>, Kiri Te Kanawa (soprano), Bernd Weikl (baritone), Chicago Symphony Orchestra & Chorus-Georg Solti. Recorded by Colin Moorfoot & Kenneth Wilkinson in the Medinah Temple, Chicago. ℗1979

Remark & Rating
Grammy, (K. Wilkinson)

Label Decca D137D 2
London OSA 12115

Berlioz: <Requiem>, Kenneth Riegel (tenor), The Cleveland Orchestra & Chorus-Lorin Maazel. ℗1979

Label Decca D144D 2
London OSA 12116

Janacek: <The Makropulos Case (Vec Makropulos)>, Elisabeth Soderstrom, Peter Dvosky, Beno Blachut, Chorus of the Vienna State Opera & The Vienna Philharmonic Orchestra-Charles Mackerras. Recorded Sept. & Oct. 1978 in the Wien Film Studios. ℗1979

Remark & Rating
TAS2017, Penguin ★★★

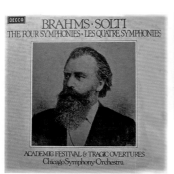

Label Decca D151D 4 (=SXL 6890, 6902, 6924, 6925)
London CSA 2406 (=CS 7125-6, 7157-8, ©=CS 7198, 7199, 7200, 7201)

Brahms: [Four Symphonies], <Academic Festival, Op.80>, <Tragic Overture, Op.81>, Chicago Symphony Orchestra-Georg Solti. Recorded by Kenneth Wilkinson, Colin Moorfoot & Michael Mailes, 1978 and 1979 in the Medinah Temple, Chicago. ℗1979 (Late issue 4 LP-Box Set = London CSA 2406; Decca SXL 6890, 6902, 6924 & 6925; ©=CS 7198, 7199, 7200, 7201)

Remark & Rating
Penguin ★★(★), (K. Wilkinson)

Label Decca D156D 3 (=6.35477)
LONDON OSA 13134

Massenet: <Don Quichotte>, Nicolai Ghiaurov, Gabriel Bacquier, Regine Crespin, L'Orchestre de la Suisse Romande-Kazimierz Kord. (24 pages Booklet in Germa version) ℗1979

Remark & Rating
Rare! $
AS-DIV list

Label **Decca D162D 4**
London OSA 1444

Mozart: <Don Giovanni>, Weikl, Bacquier, Burrows, Moll, Price, Sass, The London Philharmonic Orchestra-Georg Solti. @1979

Label **Decca D176D 3**
London OSA 13135

Richard Strauss: <Die Agyptische Helena>, (World Premiere Recording) Gwyneth Jones, Matti Kastu, Barbara Hendricks, Detroit Symphony Orchestra-Antal Dorati. (28 pages booklet) Recorded by Kenneth Wilkinson, Colin Moorfoot & Michael Mailes, May 1979 at The United Artist' Auditorium, Detroit. @1979

Remark & Rating
$
Penguin ★★★, AS-DG list, (K. Wilkinson)

Label **Decca D188D 7 (=L'Oiseau Lyre)**

Shostakovich: <The String Quartets, Nos.1 to 15>, performed by Fitzwilliam String Quartet. Recorded 1975-1979 at All Saints Church, Petersham, Surrey. @1981 (Original issue is Decca L'Oiseau Lyre DSLO 9, 11, 23, 28, 29, 30, 31)

Remark & Rating
$$
Penguin ★★★(✿), G.Top 100, AS list

Label **Decca D190D 3**
London CSA 2310

Schumann: [Complete Symphony Four Symphonies], The Vienna Philharmonic Orchestra-Georg Solti. @1970 (*4 Symphnies: No.1, SXL 6486=CS 6696; No.2, SXL 6487=CS 6697; No.3 & No.4, SXL 6356=CS 6582)

Remark & Rating
$
AS list-H (D190D 3)

Label **Decca D210D 3**
London 3LDR 10025

Massenet: <Le roi de Lahore>, Joan Sutherland (soprano) ; Huguette Tourangeau (contralto); Luis Lima (tenor); Sherrill Milnes (baritone); Nicolai Ghiaurov & James Morris (basses), National Philharmonic Orchestra-Richard Bonynge. Recorded by Kenneth Wilkinson in the Kingsway Hall, London, 1979. @1980

Remark & Rating
Penguin ★★★(✿), (K. Wilkinson)

Label **Decca D216D 4**
London OSA 1445

Haydn: <Il Ritorno di Tobia> Oratorio, sung in Italian, Barbara Hendricks & Linda Zoghby (soprano) ; Della Jones (mezzo-soprano); Philip Langridge (tenor); Benjamin Luxon(baritone), Brighton Festival Chorus and The Royal Philharmonic Orchestra-Antal Dorati. (12 pages Booklet) @1980

Remark & Rating
Penguin ★★★

Label **Decca D219D 4**
London OSA 1446

Rossini: <Guglielmo Tell (William Tell)>, Sherrill Milnes, Luciano Pavarotti, Mirella Freni, Nicolai Ghiaurov and others with the Ambrosian Opera Chorus and the National Philharmonic Orchestra conducted by Riccardo Chailly. (56page booklet) @1980

Remark & Rating
ED4
Penguin ★★★

Label **Decca D222D 6**

Mozart: <The Piano Sonatas, K.279, 280, 281, 282, 283, 309, 284, 311, 330, 331, 310, 331, 545, 332, 333, 475, 457, 533, 570, 576>, Andras Schiff (piano).

Label **Decca D224D 2 (=London LDR 10036)**

Janacek: <From the House of the Dead, (complete)>, Jiri Zahradnícek, Ivo Žídek (tenors) ; Václav Zítek (baritone), Chorus of the Vienna State Opera & The Vienna Philharmonic Orchestra-Charles Mackerras. @1980

Remark & Rating
Penguin ★★★(✿)

Label **Decca D230D 3 (=London LDR 73004)**

Bellini: <La Sonnambula>, Joan Sutherland, Pavarotti, Della Jones, Ghiaurov, National Philharmonic Orchestra-Richard Bonynge. Recorded by Kenneth Wilkinson & James Lock, January 1980 in Kingsway Hall, London. ℗ ©1982

Remark & Rating
Penguin ★★★, (K. Wilkinson)

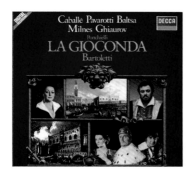

Label **Decca D232D 3 (=LDR 73005)**

Ponchielli: <La Gioconda> Complete, with Caballe, Pavarotti, Baltsa, Milnes, Ghiaurov. The National Philharmonic Orchestra-Bruno Bartoletti. ℗1981

Remark & Rating
Penguin ★★★

Label **Decca D235D 3**
London OSA 13136

Weber: <Der Freischutz>, Hildegard Behrens, Helen Donath, Rene Kollo, Kurt Moll, Wolfgang Brendel, Peter Meven, Bavarian Radio Symphony Orchestra and Chorus-Rafael Kubelik. (36 pages Booklet) Rcorded by Stanley Goodall, Simon Eadon & Matin Atkinson. @1980

Remark & Rating
Penguin ★★(★)

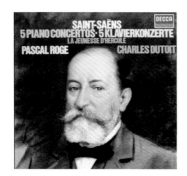

Label **Decca D244D 3**

Saint-Saëns: [5 Piano Concertos]. Pascal Rogé (piano), with Philharmonia; London Philharmonic & Royal Philharmonic Orchestra-Charles Dutoit. @1981

Remark & Rating
Penguin ★★★, AS List

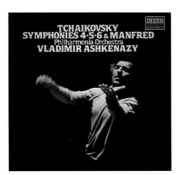

Label **Decca D249D 4 (=SXL 6853, 6884, 6919, 6941)**

Tchaikovsky: <Symphonies No.4, *No.5, No.6>, The Philharmonic Orchestra, (=SXL 6919; *SXL 6884; SXL6941), <Manfred Symphony on Byron's Drama Op.58>, (=SXL 6853), New Philharmonia Orchestra-Vladimir Ashkenazy. ℗1978-1981 @1981 (* SXL 6884, No.5 is in AS List) [**At the time when the Manfred Symphony was recorded, in 1977, the Philharmonia Orchestra was known as The New Philharmonia Orchestra.]

Remark & Rating
Penguin ★★★, AS List (*No.5), (K. Wilkinson)

Label **Decca D258D 12**
London CSP 11

Beethoven: [The Complete Piano Sonatas], Piano-Vladimir Ashkenazy. @1981 (=Decca SXL 6630; 6706 (Exludes No.8); 6804; 6808; 6809; 6871; 6889; 6929; 6960; 6961; 6962; 6994; 7011) (**The 10 CD SET is: Decca 443 706-2)

Remark & Rating
$
Penguin ★★★

Label **Decca D267D 4 (=London LDR 74001)**

Mozart: <Le Nozze Di Figaro>, Samuel Ramey, Lucia Popp, Kiri Te Kanawa, Frederica von Stade, Thomas Allen, Jane Berbié, Kurt Moll, Philip Langridge, Robert Tear, The London Philharmonic Orchestra-Georg Solti. @1982

Remark & Rating
Penguin ★★★

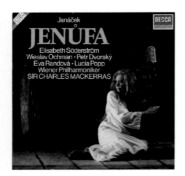

Label **Decca D276D 3 (=London LDR 73009)**

Janacek: <Jenufa, (complete)>, Elisabeth Soderstrom, Peter Dvorsky, Wies aw Ochman, Eva Randová, Chorus of the Vienna State Opera & The Vienna Philharmonic Orchestra-Charles Mackerras. @1983

Remark & Rating
Penguin ★★★(❀)

Label **Decca HDN 100-2**

Haydn: "The Piano Sonatas Of Joseph Haydn, Volume 1", <No.6 in C>, <No.33 in C minor>, <No.18 in E flat>, <No.52 in G>, <No.60 in C>, <Fantasia in C>, <No.39 in D>, <No.47 in B minor>, <No.50 in D>, <No.10 in C>, <No.38 in F>, John McCabe (piano). (8 pages Booklet) Produced by James Walker, recorded by John Dunkerley, December 1974 in All Saints Church, Petersham. ℗ ©1975

Remark & Rating
Penguin ★★★

Label **Decca HDN 103-5**

Haydn: "The Piano Sonatas Of Joseph Haydn, Volume 2", <No.31 in A flat>, <No.17 in E flat>, <No.48 in C>, <No.43 in E flat>, <No.46 in E>, <No.45 in A>, <No.36 in C>, <No.9 in D>, <No.54 in G>, <No.55 in B flat>, <No.56 in D>, <Variation in A>, John McCabe (piano). (4 pages Booklet) Produced by James Walker, recorded by John Dunkerley, May 1975 in All Saints Church, Petersham. ℗1975 ©1976

Remark & Rating
Penguin ★★★

Label **Decca HDN 106-8**

Haydn: "The Piano Sonatas Of Joseph Haydn, Volume 3", <In G Major (London 1, 4 & 42)>, <In A flat (London 35)>, <In E flat (London 59)>, <In G minor (London 32)>, <In B flat (London 20)>, <In D Major (London 30)>, <In E minor (London 53)>, <In F Major (London 57)>, <In A Major (London 41)>, John McCabe (piano). (4 pages Booklet) Produced by James Walker, recorded by John Dunkerley, September 1975 in All Saints Church, Petersham. ℗ ©1976

Remark & Rating
Penguin ★★★

Label Decca HDN 109-11

Haydn: "The Piano Sonatas Of Joseph Haydn, Volume 4", <No.5 in G>, <No.3 in F>, <No.58 in C>, <No.51 in E flat>, <No.34 in D>, <No.49 in C sharp minor>, <No.16 in D>, <Capriccio in G>, <No.19 in E minor>, <No.7 in D>, <No.44 in F>, <No.11 in B flat>, <No.40 in E flat>, <No.2 in C>, <No.13 in G>, John McCabe (piano). (4 pages Booklet) Produced by James Walker, recorded by John Dunkerley, April 1976 in All Saints Church, Petersham. ℗ ©1977

Remark & Rating
Penguin ★★★

Label Decca HDN 112-15

Haydn: "The Piano Sonatas Of Joseph Haydn, Volume 5", <No.62 in E flat>, <No.37 in E>, <No.12 in A>, <No.29 in E flat>, <No.15 in E>, <No.61 in D>, <No.8 in A>, <No.14 in C>, <Sonata in B flat (Hob. 17)>, <Variation in E flat (Hob. XVII/3)>, <Variation in D (Hob. XVII/7)>, <No.28 in D>, <In E flat (Hob. 16>, <Seven Minuets: (Hob. IX/8, Nos. 1, 2, 5, 9, 11, 10, 7)>, <The Seven Last Words Of Jesus Christ>, John McCabe (piano). (4 pages Booklet) Produced by James Walker, recorded by John Dunkerley, November-December 1976 in All Saints Church, Petersham. ℗ ©1977

Label Decca HDNA 1-6

Haydn: "The Complete Symphonies (No.1 - 19)", The Philharmonia Hungarica-Antal Dorati. Produced by James Mallinson, recorded by Colin Moorfoot at St. Bonifatius Church, Marl, Germany. (Booklet included). ℗ ©1973

Remark & Rating
$
Penguin ★★★(✿), for the entire series

Label Decca HDNB 7-12 (©=SDD 457, 458, 468)

Haydn: "The Complete Symphonies (No.20 - 35)", The Philharmonia Hungarica-Antal Dorati. Produced by James Mallinson, recorded by Colin Moorfoot at St. Bonifatius Church, Marl, Germany. (24 pages Booklet). ℗ ©1973

Remark & Rating
$
Penguin ★★★(✿), for the entire series

Label Decca HDNC 13-18 (©=SDD 414, 546-7)

Haydn: "The Complete Symphonies (No.36 - 48)", The Philharmonia Hungarica-Antal Dorati. Produced by James Mallinson, recorded by Colin Moorfoot at St. Bonifatius Church, Marl, Germany. (24 pages Booklet). ℗ ©1972

Remark & Rating
$
Penguin ★★★(✿), for the entire series

Label Decca HDND 19-22 (©=SDD 359)

Haydn: "The Complete Symphonies (No.49 - 56)", The Philharmonia Hungarica-Antal Dorati. Produced by James Mallinson, recorded by Colin Moorfoot at St. Bonifatius Church, Marl, Germany. (16 pages Booklet). ℗1970 ©1971

Remark & Rating
Penguin ★★★(✿), for the entire series

Label Decca HDNE 23-26 (©=SDD 358, part)

Haydn: "The Complete Symphonies (No.57 - 64)", The Philharmonia Hungarica-Antal Dorati. Produced by James Mallinson, recorded by Colin Moorfoot at St. Bonifatius Church, Marl, Germany. (16 pages Booklet). ℗1970 ©1971

Remark & Rating
Penguin ★★★(✿), for the entire series

Label Decca HDNF 27-30 (©=SDD 358, part)

Haydn: "The Complete Symphonies (No.65 - 72)", The Philharmonia Hungarica-Antal Dorati. Produced by James Mallinson, recorded by Colin Moorfoot at St. Bonifatius Church, Marl, Germany. (16 pages Booklet). ℗ ©1970

Remark & Rating
Penguin ★★★(✿), for the entire series

Label Decca HDNG 31-34 (©=SDD 413)

Haydn: "The Complete Symphonies (No.73 - 81)", The Philharmonia Hungarica-Antal Dorati. Produced by James Mallinson, recorded by Colin Moorfoot at St. Bonifatius Church, Marl, Germany. (20 pages Booklet). ℗ ©1971

Remark & Rating
Penguin ★★★(✿), for the entire series

Label Decca HDNH 35-40 (©=SDD 412, 431, 482-4)

Haydn: "The Complete Symphonies (No.82 - 92)", The Philharmonia Hungarica-Antal Dorati. Produced by James Mallinson, recorded by Colin Moorfoot at St. Bonifatius Church, Marl, Germany. (20 pages Booklet). ℗ ©1972

Remark & Rating
$
Penguin ★★★(✿), for the entire series

Label **Decca HDNJ 41-46**

Haydn: "The Complete Symphonies (No.93 - 104)", The Philharmonia Hungarica-Antal Dorati. Produced by James Mallinson, recorded by Colin Moorfoot & Peter Van Biene at St. Bonifatius Church, Marl, Germany. (32 pages Booklet). ℗ ©1974

Remark & Rating
Penguin ★★★(✿), for the entire series

Label **Decca HDNK 47-48**

Haydn: "The Complete Symphonies (Appendices)", <Symphony "A" & "B" in B Flat Major>, <No.22 in E Flat Major (2nd Version)>, <No.63 in C Major (1st Version)>, <No.53 & No.103 (Alternative Ending)>, The Philharmonia Hungarica-Antal Dorati. Produced by James Mallinson, recorded by Colin Moorfoot, John Dunkerley & Peter Van Biene at St. Bonifatius Church, Marl, Germany. (Gatefold cover) ℗ ©1974

Remark & Rating
Penguin ★★★(✿), for the entire series

Label **Decca HDNL 49-51**

Haydn: "The String Quartets Of Joseph Haydn, Volume 9", The 'Salomon's Quartets of 1793, dedicated to Count Anton Apponyi, <Op. 71, No.1, 2, 3>, <Op. 74, No.1, 2, 3>, The Aeolian String Quartet - Emanuel Hurwitz & Raymond Keenlyside (violins); Margaret Major (viola); Derek Simpson (cello). (16 pages Booklet). ℗ ©1973

Remark & Rating
Argo Label, $
Penguin ★★

Label **Decca HDNM 52-56**

Haydn: "The Early Quartets Of Joseph Haydn, Volume 1", <Op. 0, In E flat major>, <Op. 1, No.1, 2, 3, 4 & No.6>, <Op. 2, No.1, 2, 4 & No.6>, The Aeolian String Quartet - Emanuel Hurwitz & Raymond Keenlyside (violins); Margaret Major (viola); Derek Simpson (cello). (12 pages Booklet). Produced by Michael Bremner, recorded by Stanley Goodall. ℗ ©1974

Remark & Rating
Argo Label, $
Penguin ★★(★)

Label **Decca HDNP 57-60**

Haydn: "The Late Quartets Of Joseph Haydn, Volume 10", <Op. 76, No.1 - No.6>, <Op. 77, No.1, 2>, <Op. 103>, The Aeolian String Quartet - Emanuel Hurwitz & Raymond Keenlyside (violins); Margaret Major (viola); Derek Simpson (cello). (12 pages Booklet). Produced by Michael Bremner, recorded by Stanley Goodall. ℗ ©1974

Remark & Rating
Argo Label, $
Penguin ★★★

Label Decca HDNQ 61-66

Haydn: "The String Quartets Of Joseph Haydn, Volume 2 & 3", <Op. 9, No.1 - No.6>, <Op. 17, No.1 - No.6>, The Aeolian String Quartet - Emanuel Hurwitz & Raymond Keenlyside (violins); Margaret Major (viola); Derek Simpson (cello). (12 pages Booklet). Produced by Michael Bremner, recorded by Stanley Goodall. ℗ ©1975

Remark & Rating
Argo Label, $
Penguin ★★★

Label Decca HDNS 67-69

Haydn: "The String Quartets Of Joseph Haydn", <Op. 54, No.1 - No.3>, <Op. 55, No.1 - No.3>, The Aeolian String Quartet - Emanuel Hurwitz & Raymond Keenlyside (violins); Margaret Major (viola); Derek Simpson (cello). (8 pages Booklet). Produced by Michael Bremner. ℗ ©1975

Remark & Rating
Argo Label, $
Penguin ★★(★)

Label Decca HDNT 70-75

Haydn: "The String Quartets Of Joseph Haydn, Volume 4 & 8", <Op. 20, No.1 - No.6>, <Op. 64, No.1 - No.6>, The Aeolian String Quartet - Emanuel Hurwitz & Raymond Keenlyside (violins); Margaret Major (viola); Derek Simpson (cello). (12 pages Booklet). Produced by James Walker, recorded by Stanley Goodall & Simon Eadon. ℗ ©1976

Remark & Rating
Argo Label, $
Penguin ★★(★)

Label Decca HDNU 76-81

Haydn: "The String Quartets Of Joseph Haydn, Volume 5 & 6", <Op. 33, No.1 - No.6>, <Op. 42 in D Minor>, <Op. 50, No.1 - No.6>, The Aeolian String Quartet - Emanuel Hurwitz & Raymond Keenlyside (violins); Margaret Major (viola); Derek Simpson (cello). (16 pages Booklet). Produced by James Walker, recorded by Stanley Goodall & Simon Eadon in St. James's, Smith Square, London. ℗ ©1976

Remark & Rating
Argo Label, $
Penguin ★★★

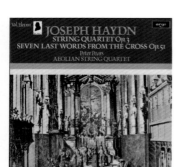

Label Decca HDNV 82-84

Haydn: "The String Quartets Of Joseph Haydn, Volume 11", <Op. 3, No.1 - No.6>, <Seven Last Words from the Cross, Op. 51, No.1 - No.7>, Peter Pears (narrator), The Aeolian String Quartet - Emanuel Hurwitz & Raymond Keenlyside (violins); Margaret Major (viola); Derek Simpson (cello). (16 pages Booklet). Produced by James Walker, recorded by Stanley Goodall & Martin Atkinson. ℗ ©1977

Remark & Rating
Argo Label, $
Penguin ★★★

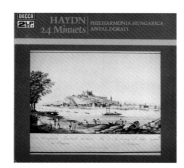

Label **Decca HDNW 90-1**

Haydn: <24 Minuets>, The Philharmonia Hungarica-Antal Dorati. Produced by James Mallinson, recorded by Colin Moorfoot at St. Bonifatius Church, Marl, Germany. (Gatefold cover) ℗ ©1976

Remark & Rating
Penguin ★★★

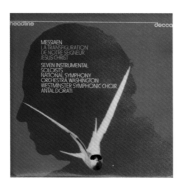

Label **Decca HEAD 1-2**

Messiaen: <La Transfiguration de Notre Seigneur Jesus Christ>, National Symphony Orchestra,Washington D.C.-Antal Dorati. Recorded by Kenneth Wilkinson & Colin Moorfoot in Constitution Hall, Washington D.C. ℗1973 ©1974

Remark & Rating
ED4, 2G-1G-2G-1G, $
TASEC, Penguin ★★★, AS list, (K. Wilkinson)

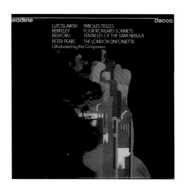

Label **Decca HEAD 3**

Lutoslawski: <* Paroles Tissees >; Lennox Berkeley: <** Four Ronsard Sonnets> and David Medford: <**Tentacles Of The Dark Nebula>, Peter Pears, (tenor), The London Sinfonietta conducted by the composers. Recorded Sept. 1972, in the Maltings, Snape. ℗1973 ©1974 [* Lutoslawsky, Penguin ★★★; Berkeley & Medford, Penguin ★★(★)]

Remark & Rating
ED4, 1G-1G, $
Penguin ★★★ & ★★(★), AS List

Label **Decca HEAD 4**

Takemitsu: <Corona (London Version)>, <For Away>, <Piano Distance>, <Undisturbed Rest>, Roger Woodword (Keyboards). Recorded by Martin Smith in Decca Studio, West Hampstead, London. ℗1973

Remark & Rating
ED4, 2W-2W
Penguin ★★★

Label **Decca HEAD 5**

Hans Werner Henze: <Compases Para Preguntas Ensimismades>, Hirofumi Fukai (viola), <Violin Concerto No.2>, Brenton Langbein (violin), London Sinfonietta-Hans Werner Henze. Recorded by Stanley Goodall at All Saints Church, Petersham, June 1973. ℗1974

Remark & Rating
ED4, 2W-1W
Penguin ★★★, AS List

Label **Decca HEAD 6**

Roberto Gerhard: <The Plague>, Chorus Washington D.C. & National Symphony Orchestra-Antal Dorati. Recorded by Colin Moorfoot, Kenneth Wilkinson & Michael Mailes. ℗1974

Remark & Rating
ED4, 1G-2G, $$$
TASEC ★ ★, Penguin ★★(★), AS-DIV list, (K. Wilkinson)

Label **Decca HEAD 7**

Harrison Birtwistle: <Verses for Ensembles>, <Nenia - The Death of Orpheus>, <The Fields of Sorrow>, Jane Manning (soprano) & The Matrix directed by Alan Hacker, London Sinfonietta-David Atherton. Recorded in Kingsway Hall, London, Jan. and May 1973. ℗1974

Remark & Rating
ED4, 2A-2A

Label **Decca HEAD 8**

Thea Musgrave: <Horn Concerto>, Barry Tuckwell (horn), <Concerto for Orchestra>, The Scottish National Orchestra conducted by Thea Musgrave & Alexander Gibson. Recorded by James Lock & Colin Moorfoot at City Hall, Glasgow. ℗1975 ©1975

Remark & Rating
ED4, 1W-1W
Penguin ★★★

Label **Decca HEAD 9**

John Cage: <Sonatas & Interludes for Prepared Piano>, Sonata I; Sonata II; Sonata III; Sonata IV; First Interlude; Sonata V; Sonata VI; Sonata VII; Sonata VIII; Second Interlude; Third Interlude. Sonata IX; Sonata X; Sonata XI; Sonata XII; Fourth Interlude; Sonata XIII; Sonatas XIV & XV "Gemini" – after the work by Richard Lippold; Sonata XVI. John Tilbury (prepared piano). Recorded by Philip Wade, December 1974 at Petersham. @1975

Remark & Rating
ED4, 1W-1W, $
TAS2017, Penguin ★★★

Label **Decca HEAD 10**
London OSA 1166

Luigi Dallapiccola: <Il Prigioniero> (First recording), Maurizio Mazzieri, Giulia Barrera, Romano Emili, Gabor Carelli, and Ray Harrell, University of Maryland Chorus & The National Symphony Orchestra Of Washington D.C.-Antal Dorati. Recorded by Kenneth Wilkinson & Colin Moorfoot, April 1974 in Constitution Hall, Washington, D.C. @1975

Remark & Rating
ED4, 1W-2W
TAS2017, Penguin ★★(★), (K. Wilkinson)

Label **Decca HEAD 11**

Roberto Gerhard: Astrological Series <Libra>, <Gemini (Duo Concetante for Violin & Pianoforte)>, <Leo>, The London Sinfonietta-David Atherton. Recorded at All Saints Church, Petersham In October 1973. ℗1975 ©1976

Remark & Rating
ED4, 1W-1W, rare! &&
TAS2016, AS List

Label **Decca HEAD 12**

Gyorgy Ligeti: "Melodien for Orchestra", "Double Concerto for Flute & Oboe", "Chamber Concerto for 13 Instrumentalists", Aurele Nicolet (flute), Heinz Holliger (oboe); The London Sinfonietta-David Atherton. Recorded by Simon Eadon, 1975 in Kingsway Hall, London. ℗ ©1976

Remark & Rating
ED4, 1W-1W, $
TAS2017, AS List, Penguin ★★★

Label **Decca HEAD 13**

Lannis Xenakis: <Synaphai Connexties for Piano and Orchestra>, Geoffrey Douglas Madge (piano), <Auroura>, <Antikhthon>, New Philharmonia Orchestra-Elgar Howarth. Recorded by Stan Goodall, November 1975 in Kingsway Hall, London. ℗ ©1976

Remark & Rating
ED4, 2W-1W
Penguin ★★★

Label **Decca HEAD 14**

[Grimethorpe Special], Elgar Howarth: <Fireworks (Variations On A Theme Of W. Hogarth Lee)>; Toru Takemitsu: <Garden Rain (Brass Band Version)>; Harrison Birtwistle: <Grimethorp Aria>; Hans Werner Henze: <Ragtimes And Habaneras>, The Grimethorpe Colliery Band-Elgar Howarth (4 pages insert). Recorded by Michael Mailes, 1976 at Huddersfield Town Hall. @1977

Remark & Rating
ED4, 1W-1W, $
TAS2016, AS List

Label **Decca HEAD 15**

Luciano Berio: <A-Ronne>, <Cries of London (for eight voices)>, Swingle II directed by Luciano Berio. Recorded by Stanley Goodall & Martin Smith. ℗ ©1976

Remark & Rating
ED4, 2G-1G
TAS2016, Penguin ★★★

Label **Decca HEAD 16**

Salman Shukur: "Oud (Arab lute)", <Improvisations on a theme of Hajjí 'Abd ul-Ghaffár from a takya in Tikrit : i. Prelude in Rást; ii. Taqsím in Rást; iii. Samá'i in Rást>, <Ghazal (Romance)>, <Mahraján fí Baghdád (Festival in Baghdad)>, <Húriyyat al-Jabal (The Mountain Fairy)>. Recorded by Stanley Goodall at Rosslyn Hill Chapel, London in 1976. @1977

Remark & Rating
ED4, 3W-2W

Label **Decca HEAD 18**

Brian Ferneyhough: <Transit>, Rosemary Hardy (soprano), Peter Hall (tenor), Roderick Earle (bass), The London Sinfonietta-Elgar Howarth. Recorded by Colin Moorfoot & John Pellowe, January 1978 in Kingsway Hall. @1978

Remark & Rating
ED4, 1G-1G, rare! $
AS List

Label **Decca HEAD 19-20**

Hans Werner Henze: <Voices>, by Sarah Walker (mezzo soprano), Paul Sperry (tenor), London Sinfonietta-Hans Werner Henze. Recorded by John Dunkerley, 1978 in Rosslyn Hill Chapel. @1978

Remark & Rating
ED4, 1G-2G-3G-3G, $
Penguin ★★★, AS List

Label **Decca HEAD 21**

Peter Maxwell Davies: <Symphony>, Philharmonia Orchestra-Simon Rattle. Recorded by Stanley Goodall, 1978 in the Kingsway Hall. London. ℗ ©1979

Remark & Rating
ED5, 1G-1G
AS List

Label **Decca HEAD 22**

Andrzej Panufnik: <Sinfonia Di Sfere>, <Sinfonia Mistica>, London Symphony Orchestra-David Atherton. Recorded by Stanley Goodall, 1978 in the Kingsway Hall. London. @1979

Remark & Rating
ED4, 3G-1G
Penguin ★★★, AS List

Label **Decca HEAD 23**

Arne Nordheim: <Greening for Orchestra>, <Doria for Tenor and Orchestra>, <Epitaffio for Orchestra and Magnetic Tape>, Peter Pears (tenor), Peter Lloyd (flute), The Royal Philharmonic Orchestra-Per Dreier. Recorded by Stanley Goodal & Martin Atkinson. @1979

Remark & Rating
ED5, 7C-4X, $

Label **Decca HEAD 24-5**

Harrison Birtwistle: <"Punch and Judy", (a tragical comedy or a comical tragedy) Opera in one act>, Stephen Roberts, Jan DeGaetani, Phyllis Bryn-Julson, David Wilson-Johnson & John Tomlinson with The London Sinfonietta-David Atherton (12 pages Booklet). Recorded by Stanley Goodall, 1979 in the Decca Studio, West Hampstead. @1980

Remark & Rating
ED5, 2G-1G, 1G-4G
AS List

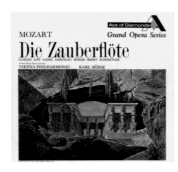 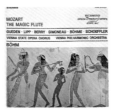

Label **Decca Ace of Diamond GOS 501-3 (=SXL 2215-7) London SRS 63507, (Richmond Series, No OSA)**

Mozart: <Die Zauberflöte, (The Magic Flute)>, Hilde Gueden; Wilma Lipp; Emmy Loose; Leopold Simoneau; Walter Berry; Kurt Böhme, Vienna State Opera Chorus & Vienna Philharmonic Orchestra-Karl Böhm. Recorded by James Brown, May 1955 in the Redoutensaal, Vienna. (16 pages Booklet) ℗1960 ** [DECCA reissue is Ace of Diamond GOS 501-3; German issue is SAD 2219-11 T; London issue only in Richmond Opera Treasury Series SRS 63507 & London OS 25046 (highlights)]

Remark & Rating
No Decca SET

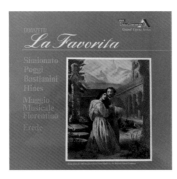 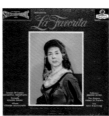

Label **Decca Ace of Diamond GOS 525-7 London OSA 1310**

Donizetti: <La Favorita>, Bice Magnani, Ettore Bastianini, Gianni Poggi, Giulietta Simionato, Jerome Hines, Orchestra of Maggio Musicale Fiorentin-Alberto Erede. @1959

Remark & Rating
No Decca SET & SXL

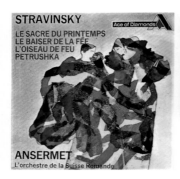
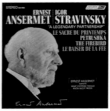

Label **Decca Ace of Diamond GOS 540-2**
London CSA 2308

[Stravinsky Works] : <The Firebird>, <Petrushka>, <Le Sacre Du Printemps>, <Le Baiser De La Fee> &1 bonus LP CS 6541: <What Everyone should know about music. Spoken by Ernest Ansermet>, L'Orchestre de la suisse romande-Ernest Ansermet. ©1967 (**Previous pressings: <Firebird, London CS 6017=Decca SXL 2017>; <Petrushka, London CS 6009=Decca SXL 2011>; <Le Sacre Du Printemps, London CS 6031=Decca SXL 2042>; <Le Baiser De La Fee, London CS 6368=Decca SXL 6066> & <CS 6541=Decca SXL 6313>)

Remark & Rating
No Decca SET [=Decca SXL 2011, 2017, 2042, 6066]
TASEC

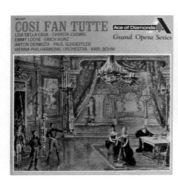

Label **Decca Ace of Diamond GOS 543-5**
London OSA 1312

Mozart: <Cosi fan tutte, (Complete recording)>, Lisa Della Casa (soprano); Christa Ludwig (soprano); Emmy Loose (soprano); Anton Dermota (tenor); Erich Kunz (baritone); Paul Schoeffler (bass-baritone), The Chorus Of The Vienna State Opera & The Vienna Philharmonic Orchestra-Karl Böhm. Recorded 16-21 May 1955, in the Redoutensaal, Vienna. (32 pages Booklet) ℗1958 ** [Original mono recording is Decca LXT 5107-9, No complete SXL Set exists, Decca SXL 2058 is the selected highlights. The copy of the complete Set is GOS 543-5; Decca 417 185-1; in Germany is SMA 25019]

Remark & Rating
No Decca SET & SXL

Label **Decca Ace of Diamond GOS 551-3 (=London**
SRS 63509)
London SRS 63509

Tchaikovsky: <Eugene Onegin, Op.24, Complete Opera>, Oscar Danon conducting the Orchestra of the National Opera, Belgrade. ℗1958 [Originally issued as Mono only Decca LXT 5159-61, SXL 2000 only test pressing, nerver issued. (London issue only in Richmond Opera Treasury Series SRS 63509 & selected highlights in London OS 25205, = Ace of Diamonds GOS 551-3. ©1968)]

Remark & Rating
No Decca SET, SXL & London OSA

Label **Decca Ace of Diamond GOS 554-7**
London SRS 64503

Richard Strauss; <Die Frau Ohne Schatten>, Rysanek, Höngen, Loose, Goltz, Hopf, Böhme, Schöffler, Vienna State Opera Chorus & Vienna Philharmonic Orchestra- Karl Böhm. @1968

Remark & Rating
No Decca SET, SXL & London OSA

Label Decca Ace of Diamond GOS 558-9
London STS 15081-2

Britten: <Prince of Pagoda, Op. 57>, Royal Opera House Orchestra, Covent Garden-Benjamin Britten, @1968.

Remark & Rating
No Decca SET, SXL & London OSA
TASEC, Penguin ★★★, AS List

Label Decca Ace of Diamond GOS 562-5
London OSA 1501（1）

Borodin: <Prince Igor> Opera in four acts and a prologue, sung in Russian, Valeria Heybalova (soprano); Melanie Bugarinovich (mezzo-soprano); Dushan Popovich (baritone); Zharko Tzveych (bass), The Chorus & Orchestra of the National Opera Belgrade-Oscar Danon. (5-LP Box & 42 pages Booklet)

Remark & Rating
No Decca SET & SXL

Label Decca Ace of Diamond GOS 566-7
London OSA 1311

Donizetti: <L'Elisir D'Amore>, Giuseppe Di Stefano, Hilde Gueden, Fernando Corena, Renato Capecchi, Luisa Mandelli, Chorus and Orchestra of Maggio Musicale Fiorentino, Andrea Morosini (chorusmaster), Conductor-Francesco Molinari-Pradelli. Recorded in 1955 @1960 [No Decca SET, (©=GOS 566-7; Decca 6.35217 DX & LXT 5155-7]

Remark & Rating
No Decca SET & SXL

Label Decca Ace of Diamond GOS 568-70
London SRS 63516

Tchaikovsky: <The Queen Of Spadesn>, Kreshimir Baronovich conducting The Chorus of the Yugoslav Army, Children's Chorus of Radio Belgrade And Orchestra Of The National Opera, Belgrad. (3-lp SET) @1969

Remark & Rating
No Decca SET, SXL & London OSA

Label Decca Ace of Diamond GOS 574-6
London OSA 1403

Gluck: <Alceste>, Kirsten Flagstad, Raoul Jobin, Alexander Young; Marion Lowe. The Geraint Jones Orchestra and Singers-Geraint Jones. (16 pages Booklet) @1960

Remark & Rating
No Decca SET & SXL

Label **Decca Ace of Diamond GOS 583-4**
London OSA 1301

Lehar: <Giuditta> - Complete Operetta, Hilde Güden, Emmy Loose, Waldemar Kmentt, Murray Dickie, Walter Berry, Oskar Czerwenka, Harald Pröglhoff, Erich Majkut, Omar Godknow, Hans Duhan, Hans Hollmann, The Vienna State Opera Orchestra-Rudolf Moralt. Recorded October 1957 in the Sofiensaal, Vienna. @1958

Remark & Rating
No Decca SET & SXL

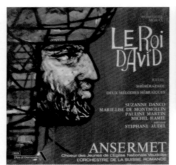

Label **Decca Ace of Diamond GOS 602-3**
London STS 15155-6

Honnegger: <Le Roi David (King David)>*, A Symphonic Psalm after a Drama by Rene Morax, Suzanne Danco (soprano); Marie-Lise de Montmollin (mezzo-soprano); Michel Hamel (tenor); Sephane Audel (narrator); Ravel: <Sheherazade (Song circle)>**, <Deux Melodies Hebraiques>**, L'Orchestre de la Suisse Romande-Ernest Ansermet. ℗1970 [* Honnegger: Penguin ★★(★); ** Ravel: Penguin ★★★, original issue is SXL 6081]

Remark & Rating
No Decca SET, SXL & London OSA
Penguin ★★(★) & ★★★

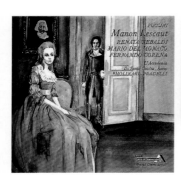

Label **Decca Ace of Diamond GOS 607-8**
London OSA 1317

Puccini: <Manon Lescaut> Complete Recording, Del Monaco, Tebaldi, Boriello, Corena, Orchestra of the Accademia Di Santa Cecilia, Rome-Francesco Molinari-Pradelli. (49 pages Libretto) Recorded by Roy Wallace, July 1954 in Rome. ℗1960 (Highlights=SXL 6011) [No Decca SET, ©=GOS 607-8 & 6.35225 DX, Germany]

Remark & Rating
No Decca SET & SXL
Penguin ★★(★)

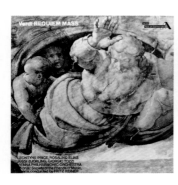

Label **Decca Ace of Diamond GOS 617-8**
London OSA 1294

Verdi: <Requiem>, Leontyne Price, Rosalind Elias, Jussi Bjoerling, Giorgio Tozzi, The Vienna Philharmonic Orchestra-Fritz Reiner. @1972 (Original recording is RCA LDS 6091, No Decca SET & SXL, =Ace Of Diamonds GOS 617)

Remark & Rating
No Decca SET & SXL

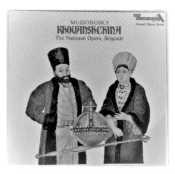

Label **Decca Ace of Diamond GOS 619-21**
London SRS 64504

Mussorgsky: <Khovanshchina>, Kreshimir Baronovich conducting The Chorus And Orchestra Of The National Opera, Belgrad. Orchestrated by Rimsky-Korsakov. (20 Pages Booklet) (3-LP SET) ℗ 1955 © 1969

Remark & Rating
No Decca SET, SXL & London OSA, rare!

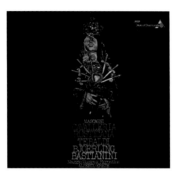
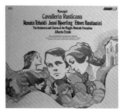

Label **Decca Ace of Diamond GOS 634-5**
London OSA 12101

Mascagni: <Cavalleria Rusticana>, Tebaldi, Bjoerling, Bastianini, Maggio Musicale Fiorentino Orchestra and Chorus-Alberto Erede. (Origianl recording is RCA LSC 6059, ℗1959 ©1974

Remark & Rating
No Decca SET & SXL
Penguin ★★(★)

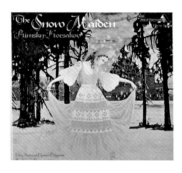

Label **Decca Ace of Diamond DECCA GOS 642-5**
No Decca SET & SXL

Mussorgsky: <The Snow Maiden>, Sofiya Jankovich; Militza Miladinovich; Valeria Heybalova; Biserka Tzveych; Lubitza Versaykoun; Drago Dimitrievich; Anita Yelinek; Stepan Andrashevich, Dushan Popovich, Nikola Janchich, Miro Changalovich, Ilya Gligorievich, Ivan Murgashki, Bogolub Grubch, Krsta Krstich. Belgrade National Opera Orchestra & Chorus-Kreshimir Baranovich. (24 Pages Booklet) ℗1957

Remark & Rating
No Decca SET, SXL & London OSA, rare!

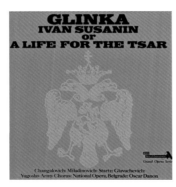

Label **Decca Ace of Diamond GOS 646-8**
London SRS 63523

Glinka: <Ivan Susanin Or A Life For The Tsar>, Oscar Danon conducting The Chorus of the Yugoslav Army, The Orchestra of the National Opera, Belgrade. (Sung in Russian with 24 Pages Booklet) ℗1956 ©1969

Remark & Rating
No Decca SET, SXL & London OSA

Label **Decca Ace of Diamond GOS 660-2**
London OSA 13122

Verdi: <Force Of Destiny (La Forza del Destino)>, Zinka Milanov, Giussepe di Stefano, Leonardo Warren, Rosalind Elias, Giorgio Tozzi, Choir & Orchestra of Accademia di Santa Cecilia, Rome-Fernando Previtali. (Original issue is RCA LSC 6406)

Remark & Rating
No Decca SET & SXL

INDEX 索引

Producer, Recording Engineer & Page (製作人、錄音師及頁數)

Composer, Performer, Orchestra & Page (作曲家、演奏者、指揮、樂團及頁數)

BIBLIOGRAPHY 參考書目

Audiophile Record Collector's Handbook (7th ED), Phil Rees

Collector's Illustrated Vinyl Bible, Alfred H.C. Wu

Full Frequency Stereophonic Sound, © 1990, Robert Moon & Michael Gray

Primyl Vinyl: PVX Newsletter–TAS Super Disc List, Vol.1 #6 & Vol.2 #1 (Updated) , Writer: Larry Toy, Editor: Bruce C. Kinch

The Penquin Stereo Record Guide (2nd Edition, 1978), E. Greenfield, R. Layton & I. March

The New Penquin Stereo Record & Cassette Guide (1982), E. Greenfield, R. Layton & I. March

The Complete Penquin Stereo Record & Cassette Guide (1984), E. Greenfield, R. Layton & I. March

The Penquin Guide To Compact Discs, Cassettes & LPs (1986), E. Greenfield, R. Layton & I. March

The Stereo Record Guide (Vol. I to Vol. IX, 1960 to1974), E. Greenfield, I. March, D.Steven

The Vinyl Bible, Max Lin

唱片收藏面面觀‧郭思蔚 著 有鹿文化

唱片聖經 - 30年來最值得購買的900張軟體 (臺灣音響論壇創刊周年附冊)

黑膠唱片聖經 (The Vinyl Bible), 林耀民 著

黑膠唱片聖經收藏圖鑒 (Collector's Illustrated Vinyl Bible), 吳輝舟 著

安塞美黑膠收藏指南 , 侯宏易 著 , 世界文物出版社

黑膠版位攻略 , 侯宏易 著 , 世界文物出版社

黑膠唱片收藏圖鑒 , 侯宏易 著 , 世界文物出版社

黑膠專書 劉漢盛 書世豪 陶忠豪 等人著 (臺灣音響論壇特刊)

黑膠唱片聖經收藏圖鑑 全系列
COLLECTOR'S ILLUSTRATED VINYL BIBLE

音樂錄音史上最光輝燦爛的文化遺產　愛樂者與發燒友必備的黑膠收藏寶典

黑膠唱片聖經
收藏圖鑑

COLLECTOR'S
ILLUSTRATED VINYL
BIBLE

■作者：吳輝舟　■定價：2200元

本書收錄了 2,340 張 20 世紀最具收藏價值的 CD 與黑膠唱片的彩色圖鑑，TAS 主編 HP 的 CD，SACD 及 LP 發燒天碟全部新舊榜單 910 張；美國絕對音響雜誌 (TAS) 經典推薦名盤 245 張；TAS20 世紀古典音樂百大榜單 200 張。

「RCA 唱片的黃金年代」最佳發燒名盤 335 張；留聲機雜誌百大古典唱片 1995 到 2008 年新舊榜單 435 張；所有 EVEREST 及 LYRITA 唱片精華 218 張；還有 135 張重要唱片公司彩色內標圖片。書中對於每張專輯都附上專輯封面圖片及詳細的歌曲介紹。

黑膠唱片聖經
收藏圖鑑 II

笛卡- 倫敦 唱片

COLLECTOR'S
ILLUSTRATED VINYL
BIBLE II

■作者：吳輝舟　■定價：2000元

英國笛卡唱片與美國倫敦唱片在黃金年代的全部名盤系列對照圖鑒 3000 多張同樣錄音版本的唱片編號及封面並列對照，還有詳細曲目、錄音師、參考價格以及相關評價註記。

黑膠唱片聖經
收藏圖鑑 III

倫敦 - 笛卡 唱片

COLLECTOR'S
ILLUSTRATED VINYL
BIBLE III

■作者：吳輝舟　■定價：2000元

美國倫敦唱片與英國笛卡唱片的全部名盤系列對照圖鑑

同樣錄音版本的唱片編號及封面並列對照，並有詳細目、錄音師、參考價格以及相關評價註記，3000 多張在黃金年代的經典名盤，讓你在紙上一次擁有。

Alfred H.C. Wu
吳輝舟　編著